ARTISTS
of the
American
West

Volume III

ARTISTS
of th

Doris Ostrander Dawdy

American West

A BIOGRAPHICAL DICTIONARY

Artists Born Before 1900

Volume III

with three-volume index

SWALLOW PRESS
Athens, Ohio Chicago London
OHIO UNIVERSITY PRESS

A SAGE BOOK OF SWALLOW PRESS

Swallow Press Books are published by
Ohio University Press Athens Ohio 45701

Library of Congress Cataloging in Publication Data
(Revised for vol. 3)

Dawdy, Doris Ostrander.
 Artists of the American West.

 Vol. 3 has subtitle: A biographical dictionary of
artists born before 1900.
 Vol. 3 has imprint: Athens, Ohio : Swallow Press.
 Includes bibliographies and index.
 1. Artists – United States – Biography. 2. Artists –
Biography. 3. West (U.S.) in art. I. Title.
N6536.D38 709′.2′2 [B] 72-91919
ISBN 0-8040-0607-5 (vol. 1)
ISBN 0-8040-0352-1 (vol. 2)
ISBN 0-8040-0851-5 (vol. 3)

Preface

Since George Catlin's first Western trip in 1832, artists have found the West irresistible. Some from abroad have called its extraordinary scenery the most beautiful in the world. Of over four thousand artists, born before 1900, who are included in *Artists of the American West* with publication of this third volume, most did some landscape work, and many did little else. A surprisingly large number of landscape painters not previously identified as having worked in the West appear in these three volumes.

Portrait painters found a ready market for their work in Western cities; San Francisco had so many of them by the late nineteenth century that city directories sometimes listed them separately. Painters of miniatures likewise benefited from the portrait market, often doing portraits on ivory.

Genre painters found a wealth of material, and captured on canvas the essence of a pioneer age. Indian life and the American cowboy were and continue to be absorbing themes for many artists. Sharecropping and plantation life in Texas were absorbing themes to Emily Rutland and Merritt Mauzey; Wyoming ranching, logging, and mining operations to Merritt Houghton; Indian ceremonial life to Tonita Peña, Steven Mopope, and other Indian artists; San Francisco's Chinatown to John Winkler and Charles Rogers.

In recent years museums have designed a number of exhibitions to reflect an era with which the public can identify even though appreciation of art for art's sake may be lacking. Such an exhibition was the University of Wyoming's Bicentennial celebration of *One Hundred Years of Artist Activity in Wyoming 1837-1937* in which art museum director James T. Forrest and author Maurice Grant Barr collaborated. Their exhibition catalogue opened with a chronology of events beginning with artist Alfred Jacob Miller's appearance in Wyoming in 1837. Individuals and museums from all over the country lent paintings, prints, and drawings for the exhibition, including two paintings by Miller. Historical subjects by untrained artists hung alongside the works of such famous artists as Henry Twachtman, Thomas Mo-

vii

ran, Sanford Robinson Gifford, Ralph Blakelock, and Thomas Hart Benton. So did the work of Wyoming's professional and amateur artists, many of whom appear in this third volume of *Artists of the American West*.

This is but one of many exhibitions of its kind the author had in mind during preparation of all three volumes of *Artists of the American West*. But volume III is especially comprehensive because three years of the research were done at the art library of the Smithsonian Institution in Washington, D.C. Housed in the building with the library are the National Museum of American Art (formerly the National Collection of Fine Arts), the National Portrait Gallery, the Archives of American Art, and the Inventory of American Paintings.

Holdings of the Archives of American Art consist of microfilmed correspondence, exhibition catalogues, newspaper clippings, artists' diaries, etc., that are also available in New York City, Boston, Detroit, and San Francisco, and will soon be available at Huntington Library and Art Gallery in San Marino, California. At the Museum of Fine Arts in Houston is a research office of the Archives of American Art.

The Inventory of American Paintings is a compilation of hundreds of thousands of paintings. It dates from the mid-seventies, and was part of the Nation's bicentennial celebration. Additional funds were later appropriated for its continuation. It was and is partly a volunteer project.

The Smithsonian issued forms called painting reports that sought the following information for each painting: name and address of owner; artist; title of painting; date of execution [many dates are approximate]; media; dimensions; brief description of the subject; and owner's comments. Except for owner's comments which were filed separately, the information was computerized and stored in a data bank. Huge looseleaf notebooks containing the alphabetized printout are now available to researchers and the general public in the Inventory office. Although the information is only as reliable as the informant—much of it came from volunteers as well as museum, library, and other paid staff—a great deal can be learned about an artist and his work through careful study of these massive notebooks.

Other invaluable research aids at the art library of the Smithsonian are its vertical files, which often contain rare materi-

al, and its extensive collection of reference books and periodicals.

Of the five years of research allocated to volume III, two took place in Northern and Southern California, Colorado, New Mexico, Arizona, Texas, Oklahoma, Utah, and Washington State. Libraries, museums, and historical societies in states the author was unable to visit sent material unavailable in Washington, D.C. The Smithsonian's inventory made it possible to list a great many places where work by specific artists can be found. Curators of exhibitions will find this information especially helpful, for many of the works to be exhibited must be borrowed.

Like its two predecessors, volume III of *Artists of the American West* is for collectors, curators, librarians, researchers, laymen, and art dealers. The series now contains names of approximately four thousand one hundred artists born before 1900 who worked in the seventeen states roughly west of the 95th meridian. Yet there are others to be discovered who found the West just as irresistible.

The series brings to a close fifteen years of full-time art research and writing. Often the work weeks exceeded the customary forty hours, but never have they been dull. The artist's urge to make a record of what is seen seems to be embodied in personalities that hold one's interest, whether the artist be professional, amateur, or untrained. Writing about them has never been a chore.

<div style="text-align: right">

DORIS OSTRANDER DAWDY
San Francisco, California

</div>

Note

Books, articles, and other information of general coverage are cited in artists' listings by last name of author, editor or compiler, or by initials. Full citations appear in the bibliography. If references apply only to a specific artist, they are fully cited in the listing rather than in the bibliography. References cited by initials are as follows:

AAA	American Art Annual
WWAA	Who's Who in American Art
AAW	Artists of the American West
NMAA-NPG	National Museum of American Art
	National Portrait Gallery Library

The word *library* is capitalized if the institution is public. If not, the library is an adjunct of an art museum, historical society, or private business, and arrangements should be made before planning to use it.

The category "Work" is not meant to be a current and complete listing of the artist's works in public and private institutions. Rather it is to provide useful leads to which specific institutions may own works by the artist. Because museum storage, exchange, and exhibition practices often make collections inaccessible for months at a time, it is good policy to make arrangements well in advance to see them.

Art directories often list an artist's work in collections that no longer exist, or that have undergone a change in name. For example, the Vanderpoel Art Association, which had a very large collection, apparently no longer exists; the National Gallery of Art of early years became the National Collection of Fine Arts in 1937 when the Andrew W. Mellon building became the National Gallery of Art; recently the National Collection of Fine Arts became the National Museum of American Art. The category "Work" contains information taken from the art directories, and may be confusing at times.

Two references used in volume III of *Artists of the American West* contain little more than the artist's name. California *Arts & Architecture* for December 1932 has been cited because it

showed where an artist working in California lived at that time; *News Notes of California Libraries* shows when an artist working in California came to the attention of staff at California State Library. In neither case does it mean the artist was a permanent resident.

Guidelines for inclusion of artists in the series are as follows: they were born before 1900; they worked in the West and have been identified as painters or illustrators or printmakers; or they traveled in the West and had sufficient talent and skill to make pictorial records of what they saw.

Entries have been designed to enable users to gauge at a glance the professional standing of the artists, the span of their lives and careers, the cities and towns in which they lived, and the years they lived in them. Occasionally an artist shows up poorly in the listing, but the author has reason to believe the artist's work is worth investigating. In these few instances the author has taken the liberty of suggesting that the artist's work may have merit.

Spellings, dates and places of birth, and other pertinent data vary from reference to reference. Often the artist wished to appear younger, or the place of birth was *near* the town or city, or the town had lost its identity through annexation or change of name. A slash is used to separate the various spellings of names and places, and conflicting dates. Often an artist's year of birth and/or death is absent from all the references. Rather than indicate it with question marks, we have left the spaces blank. For example: (1880–), or (–1942), or (–).

Whenever it could be ascertained that an artist's exhibition was a solo affair, that information is given. In the absence of such information, it is best to assume that it was a group exhibition.

McClurg's "Brush and Pencil in Early Colorado Springs," a series of six articles, is available in several Colorado libraries in typescript form. Citations of this work in volume III are sometimes from a typescript, in which case a page number is given, or from newspaper clippings at Colorado College Library in Colorado Springs. As the bibliography makes clear, the series was published in six parts in the Colorado Springs *Gazette* over a period of six weeks.

In order to show which artists actually worked in the West it was necessary to scan a great many art periodicals and books

as well as art directories. Often the artist is mentioned only in passing. Yet, meager as such information is, it can lead to a better understanding of an artist's career. As in previous volumes the *American Art Annual* has been used extensively. Volumes with art directories are these: 1898, 1900, 1903, 1905–1906, 1907–1908, 1909–1910, 1913, 1915, 1917, 1919, 1921, 1923–1924, 1925, 1927, 1929, 1931, 1932, and 1933.

ARTISTS

A

Aaron, May Todd (–)
B. La Celle, Iowa. Work: Pennsylvania Academy of Fine
Arts; Art Club of Chicago; Tulsa University; Philbrook
Art Center, Tulsa, Oklahoma; University of Oklahoma.
AAA 1933 (Pawhuska, Oklahoma); Havlice; Mallett;
WWAA 1936-1953 (Pawhuska); WWAA 1956 (Paris,
France); WWAA 1959-1966 (Chicago); Collins; Ness and
Orwig; Inventory of American Paintings, Smithsonian In-
stitution.
 Aaron exhibited a number of Southwestern landscapes in
group and solo shows, the latter mainly in Oklahoma. "Autumn
View of Pawhuska Hills," an oil, is thought to have been painted
in 1910.

Adam, Wilbur G. (1898–)
B. Cincinnati, Ohio. Work: Woodrow Wilson High School,
Cincinnati. AAA 1919-1925 (Cincinnati); AAA 1929-1933
(Chicago, Illinois); Fielding; Havlice; Mallett; WWAA
1936-1941 (Chicago and Cincinnati); Clark, 1932, 438.
 Some of Adam's landscape work was done in Glacier Na-
tional Park.

Adams, E. (–)
AAA 1900 (Park City, Utah). Member of the Society of
Utah Artists.

Adams, Frederick (1880–)
B. London, Ontario. *Who's Who in Northwest Art* (Seattle,
Washington).
 Dr. Adams exhibited with the Painters and Sculptors'
Guild of Northwest Men Painters of which he was a member. His
oil paintings have been shown at the Seattle Art Museum, the
Physicians' Art Club in New York, and in San Francisco.

1

Adomeit, George Gustav (1879-)

B. Germany. Work: Cleveland Museum of Art; Cleveland Municipal Collection. AAA 1925-1929 (Cleveland); AAA 1931-1933 (Gates Mill, Ohio); Havlice; Mallett; WWAA 1936-1962 (Cleveland); Clark, 1932, 348; *American Magazine of Art*, March 1927, 133; July 1927, 382; NMAA-NPG Library, Smithsonian Institution.

Adomeit combined a business career with painting and printmaking. He was sufficiently active in Taos, New Mexico, to be referred to as a "Taos painter" by the *American Magazine of Art* in 1927.

Clark singled out for comment Adomeit's interest in Cleveland's industrial scene which culminated in many well designed and powerful paintings.

Ahlfield, Florence (See: Tilton)

Ahrens, Carl Henry Von (1863-1936)

B. Winfield, Ontario. D. Galt, Ontario. Work: Museum of Fine Arts, Glasgow, Scotland; National Gallery of Canada, Ottawa; Parliament Buildings, Toronto. AAA 1898 (Toronto); AAA 1900 (Lamburton Mills, Ontario); AAA 1923-1924 (Rockport, Massachusetts); Benezit; Harper, 1966, 1970; Havlice; Macdonald; Mallett; AAW v. I.

Ahrens was first in the United States in 1879-1881 when he spent some time in Montana. Whether he did any sketches there is not known; he did not commence serious painting until 1887. In 1906 he studied with William Keith in California and painted several canvases of the Franciscan Missions. By late 1907 he was back in Canada, working from a studio in Toronto.

Originally a genre painter, Ahrens turned to landscapes after a visit with George Inness. Later he became known as a painter of trees.

Recognition came early to Ahrens by way of election to the Royal Canadian Academy in 1891.

Aiken, Jessie (1860-1947)

D. Colorado Springs, Colorado, ca June 23. Colorado Springs *Gazette and Telegraph*, June 23, 1947, 1/8; Mc-

Clurg typescript, 11; Colorado College Library; Colorado Springs Public Library.

Among the artists McClurg mentioned in his articles for the *Gazette and Telegraph* in 1924 was Aiken who exhibited "A Bit of Manitou Road" at Colorado College in 1900. Subsequently she turned to the painting of china and cards. The *Gazette and Telegraph* in its obituary referred to her as a pioneer of the region.

Akright, James G. (1888–)
B. Larkin, Kansas. *Who's Who in Northwest Art* (Everett, Washington).

Akright studied with Mary Stockbridge Allen in Lake Stevens, Washington. He worked in oils.

Albright, Adam Emory (1862–1957)
B. Monroe, Wisconsin. D. September 14, probably in Warrenville, Illinois. Work: Laguna Beach (California) Art Museum; City Art Museum of St. Louis; Toledo Museum of Art; Topeka (Kansas) Public Library; Illinois State Museum of Natural History and Art, Springfield; Cedar Rapids (Iowa) Public Library. AAA 1898–1900 (Chicago); AAA 1903–1913 (Edison Park, Illinois); AAA 1915–1924 (Hubbard Woods, Illinois); AAA 1925–1933 (Warrenville); Benezit; Fielding; Havlice; Mallett; WWAA 1936–1959 (Warrenville); Reinbach, 1928; "Items," *American Magazine of Art,* June 1920, 295; Minnie Bacon Stevenson, "A Painter of Childhood," *American Magazine of Art,* October 1920, 432–433; Tom Vickerman, "Gray-Haired Artist Paints Child Epics," *Magazine of the Art World,* Chicago *Evening Post,* February 18, 1930; NMAA-NPG Library, Smithsonian Institution.

It is likely that some of Albright's earliest work was done in Kansas, for he was a graduate of a Kansas university. He began his career as a landscape painter, later specializing in paintings of children at play, against landscape backgrounds. About 1917, during winter months, he began painting in warmer climates – Arizona, Southern California, South America.

Albright preferred country children as models, and he painted them in the settings in which he found them. Fishing

streams and ocean beaches predominate in his backgrounds, but an Arizona desert scene with a youngster on a horse was not unusual.

Albright, Ivan Le Lorraine (1897–)
 B. Chicago, Illinois. Work: Whitney Museum of American Art; Museum of Modern Art; Metropolitan Museum of Art; Milwaukee Art Institute; Hackley Art Gallery, Muskegon, Michigan, etc. AAA 1925–1933 (Warrenville, Illinois); Fielding; Havlice; Mallett; WWAA 1936–1941 (Warrenville); Sparks; Jacobson 1932; Laguna Beach Museum of Art, July–August 1979 exhibition catalogue; NMAA-NPG Library, Smithsonian Institution.
 Albright, whose father Adam Emory Albright began spending winters in Southern California about the time Laguna Beach was attracting artists, joined the Laguna Beach Art Association and painted traditional Southwestern subjects such as "Indian Ovens, Old Laguna, New Mexico." However, by 1930, he was well on his way to achieving recognition as a modernist painter with a style distinctively his own.

Albright, Malvin/Melvin Marr (1897–)
 B. Chicago, Illinois. Work: Museum of New Mexico, Santa Fe. AAA 1929–1933 (Warrenville, Illinois); Benezit; Havlice; Mallett; WWAA 1936–1962 (Warrenville); WWAA 1966 (Warrenville; Fort Lauderdale, Florida); WWAA 1970 (Chicago; Fort Lauderdale); Sparks; Jacobson, 1932.
 Albright who sometimes signed his work Zsissly, his real name, started out to be a painter and later turned to sculpture. Thereafter he painted intermittently, often in the West where he worked in California, Arizona, New Mexico, Kansas, and Texas.

Alderman, Grace Eugenie Barr (1877–)
 B. Parker City, Pennsylvania. Bucklin and Turner, 1932 (Newport, Nebraska).
 Alderman exhibited at the Art Institute of Omaha in 1929, and at the Omaha Woman's Club.

Allan/Allen, Mrs. Charles Beach (1874–)
 B. Detroit, Michigan. AAA 1917–1925 (Kansas City, Mis-

4

souri; summers in Long Beach, California, from 1917 to 1921); Fielding; Collins.

Allan studied at the Art Institute of Chicago, with Louis Soutter in Paris, and with Birger Sandzen. She was a member of the Laguna Beach (California) Art Association.

Allen, Clarence Canning (1897–)
B. Cleveland, Georgia. Work: Oklahoma Historical Society; William Allen White Foundation, Emporia, Kansas; Eisenhower, Truman, and Johnson libraries; University of Missouri; murals, Tulsa *World-Tribune* Building. Havlice; WWAA 1953–1970 (Tulsa, Oklahoma).

Allen, who was art director and cartoonist for the Tulsa *World,* has exhibited at the Metropolitan Museum of Art, the New York World's Fair, Witte Memorial Museum in San Antonio, Texas, and in Montreal, Canada, and Verona, Italy. He is especially well known in Oklahoma for his portraits of Will Rogers and other prominent Oklahomans, and for his illustrated articles and cartoons.

Allen, Frank Phillip, Jr. (1880–1943)
B. Grand Rapids, Michigan. D. Los Angeles, California, July 6. Withey; Castor manuscript at San Francisco Public Library.

Allen was an architect and a landscape painter. He settled in Seattle, Washington, early in this century, and there he was appointed architect and director of works for the 1909 Alaska-Yukon Pacific Exposition. This position led to his appointment as director of works for the 1915 California-Pacific Exposition in San Diego. According to Castor he exhibited some of his landscapes at the Exposition.

Allen continued to be active in Southern California until his death from an accident in the California Ship Building Company yards in Long Beach where he was employed in ship designing.

Allen, Rudolph G. (ca 1887–1969)
D. Seattle, Washington, November 7. Work: Eisenhower collection, Gettysburg farm. Seattle *Times,* November 7, 1969; art and artists' scrapbook, Seattle Public Library.

Allen was active in Seattle as a commercial artist and designer from 1917 to 1955. During his late years he painted landscapes in water color.

Ames, Edwin Isaac (1862–)
B. Loda, Illinois. Work: Monterey (California) Municipal Collection. AAA 1903–1905 (Chicago, Illinois); Benezit; Mallett; Los Angeles City Directory, 1887; Monterey Public Library.
Ames was a portrait and miniature painter who studied art in Boston, San Francisco, and Chicago. His painting "Fresh from the Vineyard" was shown at the Chicago World's Fair in 1893.

Andelin, Brigham Young (1894–)
B. Richfield, Utah. Work: Southern Utah State College; Weber College; Dixie College; Snow College; Hunter College, New York. Olpin, 1980; supplemental material, courtesy of Professor Olpin, University of Utah.
Following graduation from the University of Utah in 1916, Andelin made periodic visits to Los Angeles to study at Chouinard Art School, Otis Art Institute, and the University of Southern California. About 1925 he began a long career as an art teacher, principally at Ogden (Utah) High School.
Andelin retired in 1960, but continued to paint in various of the Western states and in Hawaii. Many of his landscapes and marines were done along the Southern California coast. During the last years of his career he turned to historical subjects such as the settlement of Utah.

Anderson, Abraham/Abram Archibald (1846/47–1940)
B. New Jersey. D. New York City, April 27. Work: Cleveland Museum of Art; Smithsonian Institution; San Joaquin Pioneer Museum and Haggin Art Galleries, Stockton, California; University of Wyoming Art Museum, etc. AAA 1900–1933 (New York City); Benezit; Fielding; Havlice; Mallett; M. Barr; Nottage, 94; Wills, 696; Denver Public Library; Anderson, *Experiences and Impressions, the Autobiography of Col. A. A. Anderson,* New York: The Macmillan Co., 1933.
Anderson, well-known as a portrait painter, described Wes-

tern scenery enthusiastically in his autobiography, but apparently did not attempt to paint it. He first visited Wyoming in the 1880s. Then he established on the Greybull River a parttime home which he named the Palette Ranch. He did some painting there according to Maurice Barr, but his principal interest in Wyoming was game and land management which led to his appointment in 1902 as superintendent of a national forest.

Anderson, Addie F. (1859–)
 B. Bernadotte, Illinois. *Who's Who in Northwest Art* (Ellensburg, Washington).
 Anderson studied in Chicago and Peoria, Illinois, and in Berlin, Germany. She worked principally in oils and pastels. She exhibited at Peoria Art Institute where she was a life member.

Anderson, Anna M. (1885–)
 B. Marshalltown, Iowa. Work: Normal School, La Grande, Oregon. *Who's Who in Northwest Art* (Portland, Oregon).
 Anderson gave private painting lessons in Portland where she had studied with Clyde Keller, Maude Wanker, and Florence Pelton. She exhibited locally in group and solo shows, and with a group at the Corcoran Gallery of Art in Washington, D.C.

Anderson, F. E. James (–)
 Work: Private collections. University of California Special Collections Library, Davis; Paul F. Faberman, Piedmont, California.
 San Francisco city directories list Anderson at different times as "artist," "architectural artist," and "watercolor artist." He was active there from 1896 to 1900. In 1896 he exhibited ten paintings of San Francisco and Monterey scenes at the 29th Exposition of the Mechanics Institute.
 Previously Anderson had been active in Portland, Oregon, and Tacoma, Washington.

Anderson, Johannes (1882–)
 B. Denmark. Work: Burlington Northern Railroad Collection. Minnesota Museum of Art catalogue, 1976, 16, 42.
 Anderson studied at the Art Institute of Copenhagen where he received favorable notice in 1907. During the 1930s he

7

had a studio in Kalispell, Montana. It is thought that some of his landscapes were painted from photographs taken by a photographer named Hileman, for they bear the latter's copyright signature.

Two paintings of particular interest in the Burlington collection measure approximately 60 × 43 inches, and are entitled "Going to the Sun Mountain" and "Two Guns White Calf." Two Guns White Calf was a handsome Piegan whose likeness graces the buffalo nickel.

Anderson, V./Viola Helen (　–　)
B. Redfield, South Dakota. Work: Mulvane Art Museum, Topeka, Kansas. AAA 1913–1915 (Providence, Rhode Island); AAA 1923–1927 (Topeka; summer 1923–1924, Attleboro, Massachusetts); Havlice; Mallett Supplement (Kingston, Pennsylvania); WWAA 1938–1941 (Attleboro); Reinbach; *American Magazine of Art,* April 1924, 210; July 1924, 355; January 1925, 54.

During the early years of her career as painter and printmaker, Anderson taught art at Washburn College in Topeka. Her specialty was portraiture.

Andrews, Cora Mae [C.M.A.] (1860–　)
B. Oneida Castle, New York. *Who's Who in Northwest Art* (Eugene, Oregon).

Andrews was mainly a self-taught painter in watercolor, oil, and pastel, who exhibited with the Oregon Society of Artists. The locale of much of her work is known as the Coburg Hills District.

Andrews, Fanny/Fannie (1869–　)
B. Natchez, Mississippi. O'Brien (Austin, Texas); Kielman; University of Texas Library, Austin.

When O'Brien published *Art and Artists of Texas* in 1935, Andrews was active in Austin. She had a studio in her home across from the Capitol, and a business known as Ye Qualitye Shoppe. Her memoirs are in the Walter E. Long file, identified as No. 1284 in Kielman.

Andrews, Jessie (1867–1919)
B. Natchez, Mississippi. O'Brien (Austin, Texas); Kielman;

University of Texas Library, Austin; Tom Allen, *Those Buried Texans*, Dallas: Hendrick-Long, 1980.

Andrews studied at the University of Texas and later taught art and German there until her retirement in 1918 – thirty years in all. Additional information about this early Texas artist who liked to paint bluebonnets – the state flower – can be found in the Walter E. Long papers, identified as No. 1284 in Kielman.

Angell, Truman Osborn (1810–1887)
B. North Providence, Rhode Island. D. Salt Lake City, Utah, October 16. Work: drawings and a painting in Church of Latter-Day Saints' church collection, Salt Lake City. Withey; Olpin, 1980; correspondence from Professor Olpin, 1982.

Angell was an architect and an amateur painter of landscapes. He settled in Salt Lake City in 1847, and served as architect to Brigham Young from 1850 to 1855.

Angman, Alfons Julius (1883–)
B. Stockholm, Sweden. AAA 1933 (Oklahoma City, Oklahoma); Havlice; Mallett; WWAA 1936–1941 (New Orleans, Louisiana); Frank Houston, "Sacrifices Fortune for Art," Oklahoma City *News*, October 16, 1932; Oklahoma City Public Library; Houston (Texas) Public Library, art and artists' scrapbook No. 5.

Angman, a Swedish businessman, spent his spare time studying painting and sculpture during business trips to various European cities. In the 1920s he left Europe for New York City expecting to make a living as an artist. After supporting himself several years at a job in an aviation factory he moved to Oklahoma City. About 1929 he opened an art school, but it was short lived. About 1935 he moved to New Orleans, and in 1939 to Houston.

Armfield, Maxwell Ashby (1881–1972)
B. Ringwood, England. D. January 23. Work: Luxembourg Gallery; Atchison, Topeka and Santa Fe Railway Co. AAA 1917 (New York City); AAA 1919 (Berkeley, California); AAA 1921 (New York City); AAA 1923–1925 (Ringwood); Benezit; Fielding; Mallett; Waters (Dorset,

England); *American Magazine of Art,* August 1918, 405; August 1920, 378; Maxwell Armfield, *An Artist in America,* London: Methuen & Co., Ltd., 1925.

Armfield was a landscape and figure painter who worked in tempera and water color. His beautifully illustrated book *An Artist in America* contains eight color and sixteen black and white illustrations. Beginning with the grain elevators of Kansas it takes the reader across country, *via* railroad, to Los Angeles and up the coast to San Francisco. Especially perceptive is his observation of desert color. "It is neither monotonous nor lavish," he wrote, "but it is concentrated and intense where it is not subtle. . . ."

Armfield spent some time painting in Los Angeles in 1918, wrote the *American Magazine of Art* in August. Then he moved on to Berkeley where his book *The Syntax of Art, Rhythmic Shape* was published by The Greenleaf Press in 1920.

Armin, Emil (1883–1971)

B. Radautz, Roumania. D. Chicago, Illinois, in July. Work: National Museum of American Art; Krannert Art Museum, University of Illinois; McNay Art Institute, San Antonio. AAA 1933 (Chicago); Havlice; Mallett; WWAA 1936–1941 (Chicago); Sparks; Riva Putnam, "Emil Armin and His Ecstatic Art," *Art World* Magazine, Chicago Evening *Post,* November 17, 1925, 5; Harold Haydon, "Emil Armin – a natural expressionist whose main subject was Chicago, where he lived," Chicago *Sun-Times,* December 29, 1972, 3; "Emil Armin Diamond Anniversary Exhibit" with foreward by Chicago artist Frances Strain Biesel; correspondence with Hilda D. Armin and Bernice Armin Fried; NMAA-NPG Library, Smithsonian Institution.

As Haydon said in his article for the *Sun-Times,* Armin's main subject was Chicago. When he did leave the city for short periods, it was to paint in Mexico and New Mexico, and briefly in Southern California. Mrs. Armin feels that he did "some of his most spectacular work while in and around Santa Fe and Taos." Frances Biesel who also worked in New Mexico wrote in the foreword to the April–May 1955 Diamond Anniversary Exhibit: His "lyrical approach to environment . . . can be seen in his many paintings of New Mexico, where he has spent much time."

Armin exhibited "Cundiyo" and "Water Street" in Santa Fe at the Southwestern Artists' annual exhibition in 1933. Other Southwestern titles are in the collections already mentioned.

Armitage, William J. (1817–1890)
B. London, England. D. San Francisco, California, in November. Work: Church of Latter-Day Saints' collections in Utah, and in Independence, Missouri. Olpin, 1980; correspondence from Professor Olpin, 1982.

Armitage, who died during a visit to San Francisco, painted biblical subjects. After moving to Utah in the late 1870s he painted for Latter Day Saints' temples in Logan and Salt Lake City. From about 1880 to 1882 he taught at the University of Deseret, now the University of Utah.

Armour, Electa M. (–)
Calhoun; Helen Ross, "Seattle Is Growing Artistic," Seattle *Town Crier*, November 8, 1913, 14; November 23, 1912, 6; December 12, 1912, 7; July 3, 1915, 9; University of Washington Library, Pacific Northwest Collection.

"Marked individuality characterizes the work of Miss Electa Armour," wrote Ross in the *Town Crier*. "Two of her paintings in oils are particularly worthy of note. One, called 'The Toilers,' is a prairie scene, having an ox team drawing an immigrant wagon in the foreground. The strain and toilsome movement of the animals and the great sweep of the prairie are finely portrayed. . . ." The other painting titled "The Landmark" Ross described as "an admirable bit of composition."

Armour was a member of the Seattle Society of Artists when it began exhibiting in 1904. Then she became a charter member of the Seattle Fine Arts Association, organized formally in 1908. She was active in these organizations well into 1915, and perhaps later.

Armstrong, Dell Heizer (See: Heizer)

Armstrong, George F. (ca 1853–1912)
D. Oakland, California, August 7. Work: Oakland Art Museum. California State Library; Oakland Museum li-

brary; Inventory of American Paintings, Smithsonian Institution.

Armstrong was an amateur painter who lived in the San Francisco Bay area. His painting in the Oakland Art Museum is an oil, 29¼ × 50 inches, entitled "Yosemite Valley."

Arouni, N. G. (1888-)
B. Syria. *Who's Who in Northwest Art* (Great Falls, Montana).

Arouni, who exhibited in Great Falls and Bozeman, Montana, was a printmaker, and a painter who worked in oil and water color.

Ashby, Ingabord Tames (See: Tames)

Atkins, Arthur (1873-1899)
B. Egremont, Cheshire, England. D. Piedmont, California, January 8. Work: Oakland Art Museum. AAW, v. I; Bruce Porter, *The Letters of Arthur Atkins,* San Francisco: A. M. Robertson, 1908; *California Art Research,* v. V, mimeo.; Porter, and others, 1916, 32, 42, 58, 167; California State Library.

California Art Research contains excerpts of reviews of Atkins' work, and other pertinent details of his career that suggest he was one of Northern California's most promising artists. Unfortunately Atkins died young, and most of his work was destroyed in two major fires — one in the 1890s, and the other in 1906 following the earthquake.

Atkins' letters, edited by Porter, were written between 1896 and 1898 from Paris where he had gone for further study. They convey a longing for Piedmont where he did much of his work. His painting "Piedmont Hills" is in the Oakland Art Museum.

Atkinson, Marion Koogler (See: McNay)

Atwell, Julia A. Hill (1880-1930)
B. Silver City, Idaho. D. Denton, Texas, March 24. Work: private collections. AAA 1925-1929 (Denton); AAA 1930,

obit.; Mallett; Fisk, 1928, 121; Inventory of American Paintings, Smithsonian Institution.

Atwell taught drawing, painting, and art history. Before becoming dean of the School of Fine Arts at Texas State College for Women, she taught at the University of Puerto Rico. Four still life paintings by her are listed in the Smithsonian's inventory.

Aubert, Mrs. Paul (–)
Collins; Groce and Wallace.

Aubert, the wife of a jeweler, was active in San Francisco, California, about 1860. Her medium was water color.

Augsburg, D. R. (–)
AAA 1900 (Oakland, California; listed under Art Supervisors and Teachers); Olpin, 1980.

Prior to Augsburg's position in Oakland, he lived in Utah where from 1892 to 1894 he was an art instructor at the University of Utah.

Augur, Ruth Monro (–)
Mallett Supplement (Enid, Oklahoma); *El Palacio*, November 16, 1918, 115, 125–126; Museum of New Mexico library, Santa Fe; Nancy Gilson, " 'We Poke' at Saving WPA Art," Oklahoma *Journal Fun Guide*, August 15, 1976, 10–11; Oklahoma City Public Library.

Augur was living in El Paso, Texas, in 1918 when she exhibited with Louise Crow in Santa Fe. The main theme of their exhibition was New Mexico's mission churches.

By 1934 Augur was living in Oklahoma where she participated in the Federal art program. Her work which was among that stored with the local Chamber of Commerce had been ruined by dampness. The theme of that work was historical, depicting as it did the coming of plainsmen and pioneers to Oklahoma.

Aulmann/Aulman, Theodora (1882–)
B. Alton, Illinois. AAA 1917 (Des Moines, Iowa); AAA 1925 (Los Angeles, California); Ness and Orwig, 1939; California *Arts & Architecture*, December 1932.

Aulmann who had good training was identified by Ness and Orwig as an amateur. She moved to Los Angeles in 1920.

Awa Tsireh (See: Alfonso Roybal)

Ayars, Beulah Schiller (1869–1960)
 B. Eagle Lake, Texas. D. Houston, Texas, August 3.
 Work: Houston Museum of Fine Arts; family collections.
 Mallett Supplement (Houston); Houston Public Library;
 conversations with Houston artist Doris Childress, and
 Louise Ayars Stevenson, daughter of the artist; obituaries
 in the Houston *Post* and the Houston *Chronicle*, August 4,
 1960.

 In the mid-twenties when Ayars was fifty-five, she took up
painting, choosing oils as her medium. By the mid-thirties she
could view her progress with satisfaction. She had exhibited in
juried shows in Dallas and Houston, receiving good reviews, and
she had been invited to send "Scene on Buffalo Bayou" to a New
York exhibition. The painting won praise from New York critics
and is presently in the Houston Museum of Fine Arts collection.

 Ayars' teachers were Emil Bisttram in Taos, New Mexico,
an exponent of dynamic symmetry, and Frederic Browne in
Houston.

B

Back, Joe W. (1899–)
 B. Ohio. *Western Artist*, November 1935, 10; M. Barr, a
 catalogue; Leon and Betty Wiard, Kerrville, Texas.

 Western Artist reported in 1935 that Back, a former cow-
boy, was an animal artist and naturalist who had been thorough-
ly trained at the Art Institute of Chicago. Since 1916 he had been
a resident of Wyoming, living mainly in Dubois. It was the per-
fect place for a parttime artist whose earnings came largely from
guiding backpackers into the wild, beautiful mountains of the
Dubois region.

Backus, Mary Gannett (-)
AAA 1921 (Santa Fe, New Mexico); AAA 1923–1924 (Biltmore, North Carolina); McMahan (Washington, D.C.).

Backus was active in Washington, D.C., from 1910 to 1926, except for brief residences in Santa Fe and Biltmore. In Santa Fe she exhibited local subjects such as "Piñon Covered Hills" and "The Distant Range."

Baer, Martin (1890/94–1961)
B. Chicago, Illinois. D. San Francisco, California, February 14. Work: California Palace of the Legion of Honor, San Francisco; Oakland (California) Art Museum; Los Angeles County Museum of Art; Fort Worth (Texas) Art Center; Luxembourg Museum, Paris, France; Museum of Modern Art; Oskosh (Wisconsin) Public Museum, etc. Benezit; Havlice; Mallett; Sparks; Young; WWAA 1938–1941 (New York City); WWAA 1947–1959 (Carmel, California); WWAA 1962 (Los Angeles, California); University of California Special Collections Library, Davis; *Art Digest*, April 15, 1941, 18; Marjorie Warren, "An Escape into Beauty and Romance Is the Exhibit of Martin Baer Paintings," Monterey Peninsula *Herald*, July 10, 1943; Monterey (California) Public Library.

Baer moved to California in 1941. During the summers of 1955 and 1956 he vacationed in the Mount Lassen region where the Indians and the scenery "opened fresh vistas" and provided "subject matter for new paintings."

Bagg, Henry Howard (1853–1928)
B. Wauconda, Illinois. D. Lincoln, Nebraska, July 23. Work: Joslyn Art Museum, Omaha, Nebraska; churches in Omaha and Lincoln, Nebraska. AAA 1928, obit.; Mallett, obit.; Bucklin and Turner, 15; AAW v. I.

During Bagg's career as teacher of art and painter of Western scenes and religious themes, he did several hundred calendar subjects for Thomas D. Murphy Company in Iowa, and the Osborn Art Calendar Company in New York.

Bagg had worked in Kansas prior to taking a faculty position at Nebraska State Normal School in Peru. From 1902 to 1916 he taught at Cotner College in Lincoln. In 1906 he accepted

a position to teach also at Nebraska Wesleyan University, a post he held until 1919. For a number of years he had a studio in Lincoln.

Bailey, Harry L. (1879-1933)

B. St. Louis, Missouri. Work: Missouri Athletic Club. AAA 1925, 1929-1933 (Los Angeles and Beverly Hills, California); Inventory of American Paintings, Smithsonian Institution.

Although separate listings for Harry and Henry Bailey appear in the *American Art Annual,* they probably pertain to the same artist.

Bailey studied at the St. Louis School of Art. After moving to Los Angeles he joined the Printmakers Society of California and the California Art Club. He exhibited "Arch Beach Rocks" at the Art Club in 1927. The locale of this work is just south of Laguna Beach, California, a popular sketching place.

Bailey, Henry Lewis (-)

AAA 1917-1924, 1927-1929 (Los Angeles, California); Fielding.

Although Henry Lewis and Harry L. Bailey may be the same person, listings in art directories differ. Henry is listed only as an etcher; Harry is listed as painter, illustrator, and etcher.

Bailey, Roger (1897-)

B. Bradford, Pennsylvania. Work: Monterey Peninsula Museum of Art, Monterey, California; California Palace of the Legion of Honor, San Francisco; Utah Museum of Fine Arts, University of Utah; many private collections. Monterey Peninsula Museum of Art docent library; *American Architects' Directory,* 3rd ed., 1970; AIA Directory 1979 (Pebble Beach, California); "Reflections," *Utah Architect,* n.d., 19-22.

Bailey, who was on the faculty of the University of Utah for many years as professor of architecture, also achieved recognition as a painter. He works in tempera, water color, and colored crayon, and has exhibited in New York, Pennsylvania, Michigan,

Utah, and California. He began teaching at the University of Utah in 1946, and began serving as a member of the board of directors of Salt Lake City Art Center in 1963. In 1974 he moved to the Monterey Peninsula where he was still active as a painter in 1982.

Bain, Mabel A./M. A. (1880–)
B. Prince Edward Island, Canada. Havlice; Macdonald, 1967, v. I (Fort Langley, British Columbia); *Who's Who in Northwest Art* (British Columbia).

Bain studied at Chouinard Art Institute and Otis Art Institute in Los Angeles, and also in San Diego, California. Macdonald described her as a landscape painter who worked in realistic, impressionistic, and occasionally abstract styles. She exhibited water colors and oils in Toronto, Ottawa, and Vancouver. Among her teachers in California was Millard Sheets. In Vancouver she studied with Thomas W. Fripp.

Baker, Jennet M. (–)
Seattle Public Library and Salt Lake City Public Library art and artists' scrapbooks; Tacoma Daily *Ledger*, December 11, 1910; "Utah's Painter Makes Big Hit in Northwest," Salt Lake City *Herald*, October 1, 1911; Calhoun, 27.

Baker, who completed her first painting when she was fourteen, was educated at St. Mark's School in Salt Lake City. At the Alaska-Yukon Exposition in Seattle, her painting, "The Creation," won a gold medal and was thereafter widely acclaimed; in 1911 it was sent on tour.

The *Ledger* mentioned several other paintings by Baker, including "Thought at Rest" and "Summer." The *Herald* noted that she was then living in Tacoma, but was best known in Seattle.

Baker, Ora Phelps (1898–)
B. Stevens Point, Wisconsin. AAA 1933 (Stevens Point); Mallett; O'Brien, 1935.

Baker studied painting in Stevens Point before beginning a

career as art teacher and supervisor of art in West Allis, Wisconsin. She continued to study, first at Layton School of Art in Milwaukee, and then at the Art Institute of Chicago where she met William Henry Baker of Dallas, Texas [AAW v. II]. They married and settled in Dallas. During her career years she exhibited in Texas, Wisconsin, Pennsylvania, and in Canada.

Bakos, Jozef/Joseph G. (1891–1977)

B. Buffalo, New York. D. April 25, probably in Santa Fe, New Mexico. Work: Whitney Museum of American Art; Brooklyn Museum; California Palace of the Legion of Honor, San Francisco; University of Oklahoma Art Museum; Denver Art Museum; Museum of New Mexico, Santa Fe., etc. AAA 1919 (Buffalo); AAA 1921–1933 (Buffalo; Santa Fe); Benezit; Fielding; Havlice; Mallett; WWAA 1936–1959 (Santa Fe); AAW, v. I; Coke, 1963, 83–84, 127; Byron B. Jones, *Southwest Art,* June 1976, 82–87; Robertson, 1975; Robertson and Nestor, 1976; NMAA-NPG Library, Smithsonian Institution; Denver Public Library, Spalding scrapbook, 102, 193, 195; Rocky Mountain *News,* September 18, 1932, 3; *Artists of the Rockies,* Summer 1979, 66–73.

Bakos taught at the University of Denver School of Art and the University of Colorado for a number of years during the 1930s. However, his permanent address was Santa Fe.

As one of Santa Fe's first modernist painters in the early 1920s, Bakos' work was not understood by many of his contemporaries. He was dubbed one of the "Five Little Nuts" along with Willard Nash, Walter Mruk, Raymond Jonson, and B. J. O. Nordfeldt, "Los Cinco Pintores."

Ball, Katherine M. (–)

AAA 1900–1903 (San Francisco, California; listed under Art Supervisors and Teachers); University of California Special Collections Library, Davis; Martin, 1953, "The Western Art Association 1888," at Joslyn Art Museum library, Omaha, Nebraska.

In 1888 Ball was a teacher of writing in Omaha public schools who was elected secretary of the newly formed Western

Art Association. In November of that year she exhibited "Study on Birchbark," according to Association records.

Ball was probably active in Omaha a number of years as a drawing teacher as well as a writing teacher, for information at UC Davis is to the effect that she was a prominent drawing teacher in Omaha and in San Francisco. Her work in San Francisco as teacher and lecturer – especially her lectures on Japanese prints – is said to have been "exceptional."

Ballou, Bertha (1891–1978)

B. Hornby, New York. D. Spokane, Washington, January 4. Work: Grace Campbell Memorial Museum, Eastern Washington State Historical Society; Spokane Public Library; Washington State College; First Federal Savings & Loan Association, Spokane. AAA 1931–1933 (Spokane); Binheim; Havlice; Mallett; WWAA 1940–1962 (Spokane); AAW, v. I; "Work of Spokane Artist Wins Acclaim," *Spokesman Review,* March 3, 1935; Margaret Bean, "Bertha Ballou's 'Spokane House'/How Local Painter Has Recaptured Pioneer Atmosphere in New Mural," *Spokesman Review,* May 7, 1948; Gladys E. Guilbert, "Bertha Ballou's Paintings Shown," *The Art Corner, Spokesman Review,* October 20, 1963; "Spokane Artist Succumbs at 86," Spokane Daily *Chronicle,* January 5, 1978, 26; correspondence with Ballou's sister Sally Ballou, and with Assistant Librarian of Eastern Washington State Historical Society, Doug Olson.

Ballou, who lived in Spokane for fifty-four years, was the daughter of an army officer. Her first recollections of living in the West go back to the time of Geronimo when her father was active in Oklahoma. But she saw only soldiers, and her drawings were of them. Not until the mid-1940s when a Spokane banking institution commissioned her to do a historical mural did she paint any Indians.

Ballou made a study of Washington Indians for the mural, spending a month on the Colville Indian Reservation doing water color sketches. Of great help to her was Chief Jim James who posed in full dress regalia, and also arranged with other Indians to serve as models.

Ballou's specialty was portraiture. Landscape painting was

19

something she did for pleasure. Her paintings reflect her travels which were extensive. She achieved considerable recognition for she was a well-trained, competent artist who exhibited nationally.

Balmer, Clinton (–)
AAA 1909–1910 (Trenton, New Jersey); AAA 1923–1925 (Brooklyn, New York); Benezit; Mallett (Long Island City, New York); Calder and Davidson, 1966, 51.

During the early 1900s Balmer taught art in Pasadena where one of his pupils was Alexander Calder.

Bancroft, George W. (1889–1979)
D. Colorado Springs, Colorado. Colorado College Library; *Artists of the Rockies,* Spring 1976, 48.

Bancroft was a Colorado Springs doctor, art collector, and amateur artist who took up painting after his retirement in 1966.

Bangs, E. Geoffrey (1889–1977)
B. Oakland, California. D. Piedmont, California, January 1. San Francisco Public Library; San Francisco *Examiner,* January 3, 1977, 34; University of California Special Collections Library, Davis; California Historical Society, San Francisco; American Architects Directory 1962 and 1970 (Piedmont).

Bangs was an architect and a painter who was active in the San Francisco Bay area nearly all of his life. He graduated *cum laude* from the University of California in 1914, and obtained his master's degree there the following year. Immediately after the first World War he taught architecture at the AEF University in France. Then he spent a brief period in New York City before returning to San Francisco. A selection of his water color landscapes was exhibited at the California Historical Society in September 1968.

Barker, Olympia Philomena (1881–)
B. Ireland. *Who's Who in Northwest Art* (Seattle, Washington).

Barker studied with Ambrose Patterson, Edgar Forkner, Jacob Elshin, and Eustace Ziegler. She exhibited in group shows at the Seattle Art Museum, the Portland Art Museum, and at a

Provincial Exhibition of Art in Victoria, B.C., where she won first prize for a flower painting.

Barker, Selma E. Calhoun (1893–)
B. Butte, Idaho. *Idaho Encyclopedia* (Bellevue, Idaho); *Who's Who in Northwest Art* (Bellevue).

Barker was educated in Idaho public schools and studied painting briefly with Idaho artist George Eugene Schroeder [AAW v. II]. She painted cowboy life, Indians, Idaho scenery, and historical scenes. She was most active in the latter 1930s, winning prizes in 1938 and 1939, and holding a solo show in Sun Valley, Idaho.

Barnes, Matthew Rackham (1880–1951)
B. Kilmarnock, Scotland. D. San Francisco, California, April 24. Work: Oakland Art Museum; San Francisco Museum of Modern Art; California Palace of the Legion of Honor, San Francisco; Museum of Modern Art, New York; Dick Institute of Scotland. AAA 1919–1925 (San Francisco); Havlice; Mallett; WWAA 1936–1941; AAW v. I; San Francisco Museum of Art, January 18, 1952, press release; Martha Jackson, introductory remarks to "Matthew Barnes 1880–1951 Exhibition," December 5–23, 1955, Martha Jackson Gallery; Junius Cravens, "A Lone Wolf on a Lone Trail," *Argus*, February 1929; *Art Digest*, October 15, 1940, 17; "Matthew Barnes Dies in Plunge," San Francisco *Chronicle*, April 25, 1951, 15/3; NMAA-NPG Library, Smithsonian Institution; San Francisco Public Library.

Cravens' article, "A Lone Wolf on a Lone Trail," proved to be an apt and enduring description of Barnes. A stated enemy of "electicism in art," he erased by destruction any influence of others he found in his work, leaving far fewer canvases than the number he destroyed. "His integrity drove him to discover that which was his and his alone," Athol Durrell, a longtime friend of Barnes, told Martha Jackson during preparation of the Barnes exhibition.

Later Durrell gave to the Oakland Art Museum forty of Barnes' paintings and sketches, his volumes of correspondence, and his scrapbooks. Comparing Barnes' early work with that of his later years, Durrell told Jackson that the former were charac-

terized by the use of light, a multitude of people, or a distant city in his backgrounds. In later years his backgrounds "became infinity, his people a single man, overwhelmed by the Universe Matt painted for him."

Barnes had some training in Kilmarnock in 1898, in New York City in 1904, and in San Francisco in 1906; but mostly he was self-taught.

Barnett, Grace T. (1899–)
B. Omro, Wisconsin. *Who's Who in Northwest Art* (Missoula, Montana); Sternfels typescript at Butte-Silver Bowl Free Public Library, Butte, Montana.

Barnett studied at the Federal Art School in Minneapolis, Minnesota; at the San Diego (California) Academy of Fine Arts; and at the University of Montana. She exhibited locally, and wrote and illustrated (with Olive Barnett) *Beaded Buckskin, Grasshopper Gold,* and *The Mystery in Mission Valley.*

Barone, Antonio (1889–)
B. Valledulmo, Sicily. Work: Colby College. AAA 1909, 1915–1927 (New York City); Benezit; Fielding; Havlice; Mallett; Young; Weber.

Primarily a water colorist, Barone also worked in oils. He painted on the West Coast as well as in the East, and exhibited at several major museums, including the Oakland Art Museum. An oil, "California Scene," which is painted in the impressionist style, is in the Colby College collection.

Barrett, George Watson (ca 1884–)
B. Utah, probably in Salt Lake City. Olpin, 1980; Salt Lake City Public Library art and artists scrapbooks; "Barratt at Home Again/Is Now Famous Artist," Salt Lake *Tribune,* August 27, 1911.

Barrett studied with James Harwood and Mary Teasdale in Salt Lake City, and at the Chase School of Art in New York City. In 1911 he was mainly an illustrator who had received some recognition as a printmaker — he had exhibited prints in Philadelphia — and he was to spend a month in Salt Lake City sketching the Great Salt Lake region, reported the *Tribune.* Some time after this visit he turned to stage-set designing, and by the early 1920s

was active with the Schuberts, designing some thirty shows for them. In his later years he produced some of his own shows, and operated "a summer stock company theater featuring such 'stars' as Vincent Price and Imogene Coca," wrote Olpin.

Barrett, Lawrence (1897–1973)

B. near Guthrie, Oklahoma. D. Colorado Springs, Colorado. Work: Colorado Springs Fine Arts Center; Library of Congress; Brooklyn Museum; Metropolitan Museum of Art; Carnegie Institute. Havlice; Mallett Supplement; WWAA 1947–1953 (Colorado Springs); AAW v. I; Shalkop; Colorado College Library; Clinton Adams, "Lawrence Barrett: Colorado's Prophet of Stone," *Artspace,* Fall 1978, 38–43; Clinton Adams, "Rubbed Stones, Middle Tones and Hot Etches/Lawrence Barrett of Colorado," the *Tamarind Papers*, Spring 1979, 36–41; Harriet Stauss, Colorado Springs; Colorado Springs Fine Arts Center Library; NMAA-NPG Library, Smithsonian Institution.

"Attached to the school at present is Lawrence Barrett, as good a lithographer as you need ever know," said George Biddle in 1937 when he was urging that an art colony be established in Colorado Springs. A number of artists from various parts of the country had Barrett print their lithographs.

In 1940 Barrett received a Guggenheim fellowship to do further research in lithographic printing, and subsequently contributed part of the text for the book *How to Draw and Print Lithographs* by Adolf Dehn and Barrett, published in New York by American Artists Group, Inc.

Barrett's first drawings were of the animals on the Kansas farm where he grew up. Animals, especially horses, often were the subjects of his etchings and lithographs and even the relatively few paintings and sculptures he did during the course of his career.

Barrett, William Sterna (1853/54–1927)

B. Rockport, Maine. D. Rockport, August 19. Work: William A. Farnsworth Library and Art Museum, Rockland, Maine; Colby College Art Museum; Standish Museum, East Bridgewater, Massachusetts. AAA 1903–1910 (Brooklyn, New York); Benezit; Patricia Jobe Pierce, "The

Neglected American Painter," *National Antiques Review,*
November 1974, 34–35; "William S. Sterna/Rockport Art-
ist (1853–1927)," *Down East, the Magazine of Maine,* Sep-
tember 1972, 46–49; The Schenectady Museum, "Paintings
of the Sea and Shore," November 1978–February 1979 ex-
hibition; NMAA-NPG Library, Smithsonian Institution.

With the discovery in 1969 of a large cache of Barrett's
paintings, supposedly destroyed at his request, his work is again
attracting attention. A leading marine artist in his time, he also
painted a few landscapes. He made two trips to the West, one to
Utah, and another to California. "Driving Through Ogden, Utah,"
painted about 1920, was among the paintings exhibited at the
Schenectady Museum in 1978 and 1979.

Barry, John Joseph (1885–)
B. Hamilton, Canada. AAA 1919–1921 (Los Angeles, Cali-
fornia; summer, Carmel, California); AAA 1923–1929
(Waterloo, Ontario); AAA 1931 (Toronto); Benezit; Field-
ing; Havlice; Mallett; WWAA 1936–1937 (Toronto);
WWAA 1938–1941 (Toronto; summer, Rockford, Massa-
chusetts); WWAA 1947–1953 (Toronto); NMAA-NPG Li-
brary, Smithsonian Institution.

Barry studied at the Los Angeles School of Art and De-
sign, and he was active in the California Society of Etchers and
the California Print Makers. He wrote and illustrated travel ar-
ticles, lectured on the "Process of Etching," and in 1930 he pub-
lished *How to Make Etchings.*

Barse, George Randolph, Jr. (1861–1938)
B. Detroit, Michigan. D. February 24. Work: Kansas State
Historical Society, Topeka; Kansas City (Missouri) Muse-
um of History and Science; J. B. Speed Art Museum,
Louisville, Kentucky; Carnegie Institute, Pittsburgh; Kan-
sas City (Missouri) Art Institute; Minneapolis (Minnesota)
Institute of Arts. AAA 1898–1903 (New York City); AAA
1905–1933 (New York City and Katonah, New York);
Benezit; Fielding; Havlice; Mallett; WWAA 1936–1937
(New York City); WWAA 1938–1939 (Westchester Coun-
ty, New York); *Kennedy Quarterly,* June 1971, 39; Inven-
tory of American Paintings, Smithsonian Institution.

Following his return from Paris in 1885, Barse spent some time on the LX Ranch in Texas, painting cowboys. A painting of the ranch entitled "LX Ranch, Pan Handle, Texas" is in a private collection.

Bartholomew, C. B. (1898–)
B. Pingree, North Dakota. *Who's Who in Northwest Art* (Missoula, Montana); Sternfels typescript at Butte-Silver Bowl Free Public Library, Butte, Montana.

Bartholomew, who studied at Montana State Normal College, the University of Montana, the University of Washington, and the Minneapolis Institute of Art, was most active in Missoula as a high school art teacher and a lecturer.

Barton, Loren (1893–1975)
B. Oxford, Massachusetts. D. Claremont, California, May 27. Work: Art Institute of Chicago; California State Library; Library of Congress; Los Angeles Public Library; New York Public Library; Brooklyn Museum; San Diego Fine Arts Gallery; Metropolitan Museum of Art; National Museum of American Art, etc. AAA 1921–1925 (Los Angeles, California); AAA 1927–1929 (Los Angeles and New York City); AAA 1931–1933 (Rome, Italy); Benezit; Fielding; Havlice; Mallett; WWAA 1936–1941 (New York City); WWAA 1947–1962 (Los Angeles); AAW v. I; Laguna Beach Museum of Art, July-August 1979 exhibition catalogue; Selkinghaus, "Etchers of California," February 1924; University of California Special Collections Library, Davis; California State Library.

As serious about her goal as her remarkable ancestor, Clara Barton, Loren Barton began her career in Los Angeles at age sixteen. By 1921 she was well known throughout California. Many of her etchings and paintings were inspired by San Francisco's Chinatown, San Pedro's wharves, and adobe houses in the Old Town section of Los Angeles. Then she turned to other parts of the country—New York City, New England, New Orleans—and to Europe where she lived in Rome. About 1937 she returned to Los Angeles where she taught for a time at Chouinard School of Art.

Batten, (Mrs.) McLeod (-)
AAA 1915 (Mill Valley, California); AAA 1919–1921 (Mill Valley), "Mrs." is omitted from the latter listing; catalogue of Santa Cruz Art League, 2nd Annual, 1929.

Baugh, Dorothy Geraldine (1891–)
B. Bath, England. Work: Hamilton College, Clinton, New York. Havlice; WWAA 1953–1959 (Pasadena, California); WWAA 1962 (Duarte, California). Baugh was active in Los Angeles and vicinity from 1940. She exhibited in many group shows, won a number of prizes, and was given a solo show in 1945 at the Bowers Memorial Museum in Santa Ana.

Baum, Franz (1888–)
B. Wiesbaden, Germany. Work: Seattle Art Museum; Stadt Gallery, Munich; Kunsthalle, Bremen. Havlice; Mallett Supplement; WWAA 1947–1959 (Santa Cruz, California); *Who's Who in Northwest Art*, 1940 (Seattle, Washington); Seattle Public Library art and artists scrapbooks; Seattle *Times*, February 7, 1940 and March 2, 1940.

Baum was a landscape and animal painter whose career in this country spanned two decades or more. He exhibited in Seattle and in San Francisco, Sacramento, and Santa Cruz, California. A one-man exhibition at the Seattle Art Museum in February 1940 was scheduled to tour other major museums, according to the Seattle *Times*.

Known as an art teacher, as well as a painter and an etcher, Baum spent his later years teaching in the adult education department in Santa Cruz.

Baumgras, Peter (1827–1903)
B. Hamburg, Germany. D. Chicago, Illinois, October 18. Work: Oakland Art Museum; George Washington University; Brown University; New York Historical Society; Oregon Historical Society; National Park Service, Lincoln Museum. AAA 1898–1900 (Chicago); AAA 1903 (Washington, D.C.); AAA 1905, obit.; Benezit; Fielding; Groce and Wallace; Mallett; AAW v. I; NMAA-NPG and Inven-

tory of American Paintings, Smithsonian Institution; Henry Glassie, Washington, D.C.; Waldo S. Pratt, *A Forgotten American Portrait-Painter/Peter Baumgras 1827–1903*, Hartford, Connecticut: Privately printed, 1937.

Accounts differ as to the years Baumgras lived on the West Coast, mainly in San Francisco. Though he may have been there as early as 1869, he was certainly there in 1871 when, according to Pratt, he was "employed by Agassiz to make sundry drawings and paintings in connection with the latter's California trip that year."

Best known for portraits, Baumgras did paint some Yosemite landscapes and Western mining scenes. Two of the paintings, "Bridal Falls" and "Three Brothers," probably were completed in Chicago, for they are dated 1879 when he was living there.

Baumgras was a long-time resident of Washington, D.C., having first settled there in 1857. From the nature of the portrait he did of Lincoln, it is thought that Lincoln sat for it.

During the Civil War, Baumgras served as a surgical draftsman. Afterward he taught drawing at the Naval Academy and the Columbian Institution for the Deaf and Dumb, now known as Gallaudet College. In 1887 he helped found the Washington Art Club.

Baxter, Edgar (–)
Groce and Wallace; Denver Public Library; Rocky Mountain *News*, December 28, 1880, 2/2; Inventory of American Paintings, Smithsonian Institution.

Baxter, who exhibited at the American Institute in 1851, was an amateur artist living in New York City from 1858 to 1870 while working as a junior partner in his father's ship-chandlery firm. Late in 1880 the Rocky Mountain *News* reported that he was in Colorado sketching a winter scene in the Platte Canyon.

Beach, Celia May Southworth (1872–)
B. Odell, Illinois. *Idaho Encyclopedia* (Burley, Idaho); *Who's Who in Northwest Art* (Burley).

Beach was educated in East Denver and Fort Collins, Colorado. She obtained a bachelor of science degree at what is now

Colorado State University. She also worked there briefly, making botanical charts and illustrating bulletins.

In Burley, where Beach lived after her marriage in 1895, she worked in oil, pastel, charcoal, and India ink, specializing in Rocky Mountain scenes and wild flowers. She exhibited at Bonneville County fairs.

Beaman, Gamaliel Waldo (1852–1937)
B. Westminster, Massachusetts. D. Massachusetts. Work: Private collections. NMAA-NPG Library and Inventory of American Paintings, Smithsonian Institution.

Beaman studied art in Boston before going to Paris in 1878 for further study. In 1880 he settled in Northfield, Massachusetts, and later in Cambridge, Massachusetts. Some of his landscape paintings are signed W. G. Beaman instead of G. W. Beaman.

The title of Beaman's "Black Canyon, Estes, Colorado," is confusing. For those who know Estes Park the canyon that comes to mind is the Big Thompson. It may be that his painting is of the Black Canyon of the Gunnison River, now a national monument. The Inventory shows it to be an oil, 42 × 32 inches.

Beardsley, George O. (ca 1867–1938)
B. probably in New York state. D. Colorado Springs, Colorado, before February 17. Denver Public Library; "Data Hazy on This Artist," Rocky Mountain *News*, July 22, 1969, 39; "Memo to Action Line," Rocky Mountain *News*, September 30, 1969, 42; Inventory of American Paintings, Smithsonian Institution; Harriet Stauss, Colorado Springs.

Action Line obtained information on Beardsley from the Western History Department of the Denver Public Library which appeared July 22, 1969, in the Rocky Mountain *News*. The item attracted the attention of the Spearville (Kansas) *News*, which supplied the following information. The Beardsley family moved from Orlando, New York, to Spearville in 1878, and left about 1900. The family was said to have the only piano in Spearville at that time.

The family may have moved to La Junta, Colorado, where George Beardsley was living prior to settling in Colorado

Springs. Although Colorado state directories show him living in Colorado Springs in 1932, it is likely that he was there much earlier, possibly as early as 1894 when he painted "Garden of the Gods, Colorado." He worked in oils and water colors, and his paintings are said to be in homes in Spearville as well as in Colorado Springs where they are frequently seen. He was a competent painter who deserves wider recognition.

Beardsley, Nellie (–)
 AAA 1919 (Irvington, California).

Beck, Minna McL(eod) (1878–)
 B. Atlanta, Georgia. AAA 1915–1917 (Winston-Salem, North Carolina); AAA 1919–1921 (Lexington, Kentucky; summers, Green Brae, Marin County, California); AAA 1923–1927 (Harrisburg, Pennsylvania); AAA 1929–1933 (Montevallo, Alabama); Fielding; Havlice; Mallett; WWAA 1936–1941 (New York City).
 The possibility exists, despite the overlapping of entries in the *American Art Annual,* that Minna McLeod Beck and McLeod Batten are the same person. Beck was head of the art department at Alabama College in Montevallo during the early 1930s.

Becker, Florence (–)
 Denver Public Library; Denver *Times,* November 19, 1899, 17/6 and March 15, 1900.
 According to the Denver *Times,* March 15, 1900, Becker was one of the thirty most prominent and active members of the 500-member Denver Art Club at that time. However, the possibility exists that she was more active as a club member than as a producing artist.

Beckman, Jessie Mary (–1929)
 B. Upper Sandusky, Ohio. D. Los Angeles, California. AAA 1909–1913 (Kenton, Ohio); AAA 1923–1924 (Los Angeles; summer, Azusa, California); AAA 1925, 1929 (Los Angeles; summers, Laguna Beach, California); *News Notes of California Libraries,* January 1930, 74.

Beckman, who won prizes for her portraits at Tri-state fairs, was active mainly in Laguna Beach and Los Angeles during the twenties.

Beckman, John (1847–1912)
B. San Antonio, Texas. D. San Antonio. O'Brien.

Beckman, who was educated in German-English schools in Texas and in New York City, may have done a number of sketches. O'Brien mentions only his pen-and-ink sketch, "The Alamo," which was exhibited in San Antonio in 1933.

Beckmann, Max (1884–1950)
B. Leipzig, Germany, D. New York City, December 27. Work: Museum of Modern Art; Art Institute of Chicago, etc. Benezit; Havlice; Mallett; NMAA-NPG Library; Denver Public Library; Monterey (California) Public Library.

Beckmann achieved fame as an expressionist in Germany, and later in this country. During the latter years of his career he taught at Brooklyn Museum Art School, the University of Colorado in Boulder, and Mills College in Oakland. He joined the Carmel Art Association while he was in Carmel, California, during the summer of 1950.

Behn, Harry (1898–)
B. near Prescott, Arizona. Kingman, 1968, 78–79, 209; Viguers, 1958, 72; Robertson and Nestor, 137.

Behn, whose early years were spent in mining camps, sent his first drawings to *St. Nicholas* magazine in 1904. In his later years he turned to writing and illustrating books for children.

After graduating from Phoenix High School Behn obtained a job as assistant travelogue cameraman. It was the first of a number of jobs that had little to do with art, but led to experiences that gave him subjects to paint and experiences to write about. The job took him to National Parks, and at one—probably Glacier National Park—he became friendly with some Blackfoot Indians. His rapport with them was such that he was invited to become a member of the tribe.

Behn had art courses in high school and college, but it was trial and error that became his principal teachers. He was active

in Arizona where he taught at the University in Tucson; in Hollywood where he did scenario writing; and in Greenwich, Connecticut, where he moved in 1947, and specialized in children's books.

Behringer, Wilhelm (1850-1890)
B. Munich, Germany. D. San Francisco, California. Work: Society of California Pioneers, San Francisco. Society of California Pioneers' library; Inventory of American Paintings, Smithsonian Institution.

Behringer studied art with his father, a professor at the Royal Academy in Munich. He spent the last year or two of his life in San Francisco where he painted "Miner Prospecting" and "Fort Gunnybags." "Fort Gunnybags" is painted as it looked *circa* 1856-1857 when it was headquarters for a group of San Francisco vigilantes.

Bekker, David [Ben Menachem] (1897-1956)
B. Vilna, Russia. Work: State House, Boston, Massachusetts; Marshall High School, Chicago, Illinois; Oak Forest (Illinois) Hospital; National Museum, Biro-Bidjan, USSR; Tel Aviv Museum. Havlice; Mallett; WWAA 1936-1953 (Chicago); Jacobson, 1932, 139-140; Sparks.

Bekker may have been known as Menachem when he was a rabbi in Casper, Wyoming, prior to moving to Chicago. He had previously studied at the Antikolsky School of Art and the Bezalel School of Art, and had exhibited at a very young age in Jerusalem. While living in Casper in the early 1920s, he studied at the Denver Academy of Art. A painting he exhibited at the Colorado State Fair in 1923 was awarded a prize.

Bekker was also a print maker who published two titles on woodcuts and etchings, *Myths and Moods* and *Two Worlds*.

Bell, Sidney (1888-)
B. London, England. AAA 1923-1925 (Portland, Oregon); Mallett; *Who's Who in Northwest Art; Art Digest,* August 1, 1931, 8.

Formerly a professor of art at Ladies' College, Cheltenham, England, Bell later taught at the University of Oregon, and did a number of historical portraits of early Oregonians.

Bemis, Maude/Maud (–)
 Colorado College Library; *Facts,* a Colorado Springs maga-
 zine, v. 5, March 10, 1900, 9, 16; McClurg, Part VI, Decem-
 ber 21, 1924.

 In describing the development of the art department of
Colorado College at the turn of the century, Gilbert McClurg
wrote that Bemis, who had been a student in Paris from 1884 to
1886, was instructor in drawing. She had exhibited in a group
show at the College, February 7–10, 1900, and the following year,
in January, had married Reginald Hascall Parsons.

 Since McClurg did not include her in his detailed treatment
of Colorado Springs artists, it seems likely that Bemis left the city
after her marriage. The possibility exists that she is the Maude
B. Parsons listed in the *American Art Annual* in 1921.

Benak, Frank (1874–)
 B. Czechoslovakia. Bucklin and Turner, 1932 (Omaha, Ne-
 braska).

Bendixen, George (1883–)
 B. Oslo, Norway. Work: Oregon City High School; Multno-
 mah County Court House, Portland, Oregon; Milwaukie
 (Oregon) Junior High School; West Linn (Oregon) High
 School. *Who's Who in Northwest Art* (Milwaukie, Oregon).

 Bendixen, a pupil of Robert Henri in New York, specialized
in oil murals and landscapes. He exhibited at the Portland Art
Museum and the Buffalo (New York) Fine Arts Academy. Some
of his paintings were used by H. Agar to illustrate *Land of the
Free.*

Bennett, Richard (1899–1971)
 B. Ireland. D. September 16. AAA 1927 (South Bend, Indi-
 ana; summer, Seattle, Washington); AAA 1929–1931 (Rye,
 New York); Havlice; Mallett Supplement; WWAA 1936–
 1941 (New Rochelle, New York); Mahony, 1947; Viguers,
 1958; Seattle Public Library art and artists' scrapbook;
 Jean Fay, "Bennett Home to Sketch for Woodblocks,"
 Seattle *Post-Intelligencer,* August 31, 1930.

 Bennett, who wrote some of the fifty or more books he illus-
trated, was a wood engraver. He spent his childhood in the Puget

Sound country of the Northwest; graduated from the University of Washington, where Walter Isaacs and Ambrose Patterson were his principal art teachers; and attended Columbia University.

Dividing his time between Seattle and New York, Bennett saw a great deal of the West in his cross-country travels. His prints and illustrations reflect his travels. In 1930–1931 his work was among that chosen for "Fifty Prints of the Year."

Benson, Edna Grace (1887–)

B. Union, Iowa. *Who's Who in Northwest Art* (Seattle, Washington).

Benson studied at the University of Iowa, Columbia University, Chicago Academy of Fine Arts, the Paris branch of the New York School of Art, and the Fontainebleau School of Fine Arts in France. She appears to have been active in Seattle mainly as a professor of design at the University of Washington.

Benson, Tressa Emerson (1896–)

B. Bucksport, Maine. Work: Syracuse University Art Gallery. AAA 1931–1933 (Chicago, Illinois); Havlice; Mallett; WWAA 1936–1937 (Chicago); WWAA 1941–1962 (Downers Grove, Illinois); Sparks; Bucklin and Turner, 28–29.

Benson, a member of the Lincoln (Nebraska) Art Guild throughout her career, taught at the University of Nebraska School of Fine Arts from 1925 to 1930. In 1943 she had a solo exhibition at Joslyn Memorial Museum in Omaha. In the Chicago area she exhibited regularly from 1934 to 1943, and was active as a teacher through 1952.

Beran, Ann Marie Karnik (1890–)

B. Howells, Nebraska. Bucklin and Turner (Omaha, Nebraska).

Except for some instruction in public schools, Beran was self-taught. She exhibited at the Art Institute of Omaha with a group in December 1930. She did landscapes, one of which is titled "Grand Canyon."

Bergner, J./John Alfred (–)

Work: Society of California Pioneers, San Francisco; Oak-

land Art Museum. Inventory of American Paintings, Smithsonian Institution; Society of California Pioneers' library.

Although Bergner was known to be active in California from 1860–1876, only "Mission and Beale Streets," a San Francisco scene, has been listed in the Smithsonian's Inventory of American Paintings.

Berk, H. A. Gustav/Gustave (–)
Witte, 1935, 58; Joslyn Art Museum library.

Berk, a member of the Omaha Art Guild, exhibited occasionally with the Guild beginning in January 1917. He was among the artists active in the Federal government's relief program whose work attracted favorable attention at a PWAP [Public Works of Art Program] exhibition in October 1935.

BeRoth, Leon A. (ca 1895–1980)
B. Grand Rapids, Michigan. D. Edmonds, Washington, March 8. Seattle Public Library art and artists' scrapbook; Seattle *Times*, September 22, 1968; March 16, 1972; March 12, 1980; March 13, 1980.

BeRoth began his career in Chicago where he had studied illustration and figure painting at the Art Institute for four years. For two decades he drew the cartoons for "Don Winslow of the Navy."

BeRoth's Western work was done in Thompson Falls, Montana, where he lived a number of years, and in the Seattle area beginning in 1962 when he moved to Edmonds. He was a member of the West Coast Watercolor Society, but did many of his figure and landscape paintings in oils. He exhibited mainly in Chicago.

Betts, Harold Harrington (1881–)
B. New York City. Work: Santa Fe Railway collection; Chicago Historical Society; National Park Service, Hubbell Trading Post National Historic Site, Ganado, Arizona. AAA 1903–1915 (Chicago, Illinois); Benezit; Mallett; AAW, v. I; Sparks; National Archives; Inventory of American Paintings, Smithsonian Institution.

Betts probably began painting in the Southwest about 1906. Titles of paintings listed in the Smithsonian's inventory in-

dicate he worked at the Rio Grande Pueblos from Taos to Santa Domingo; in Colorado Springs, Colorado; at the Grand Canyon; on the Navajo and Hopi reservations; and in Southern California. Most of these paintings are in the Santa Fe Railway collection.

A painting in the Hubbell Trading Post Museum is titled "Hostiles in Camp Near Oraibi, Arizona" or "Hopis at Hotevilla." Betts witnessed that sad day in Hopi history, September 7, 1906, when the Hopis called "hostiles" were driven from their homes by the Hopis called "friendlies." The latter were friendly to the federal government. Betts described that scene in a letter to the Indian Service.

Exhibition records in Chicago show Betts to have been active from 1897 to 1931.

Betts, Louis (1873–1961)

B. Little Rock, Arkansas. Work: Art Institute of Chicago; Santa Fe Railway collection; Corcoran Gallery of Art; Montclair (New Jersey) Art Museum; Richmond (Virginia) Art Association; Arkansas Art Museum [probably the Arkansas Art Center in Little Rock]. AAA 1898–1910 (Chicago); AAA 1913–1933 (New York City); Fielding; Havlice; Mallett; WWAA 1936–1953 (New York City); WWAA 1962 (Bronxville, New York); WWAA 1966 obit.; Inventory of American Paintings, Smithsonian Institution.

"Coronado Beach," an oil acquired by the Santa Fe Railway in 1907, placed Betts in the San Diego, California, area. His sister Grace (AAW v. II) settled there about 1904, and like her brother Harold painted Indians in the Southwest. Louis, a portrait painter, became a National Academician in 1915, and is better known than the daughter and sons of Edwin Daniel Betts, Sr., who, like him, made art their careers. There are others of the latter's nine children who also may have done some painting.

Biddle, George (1885–1973)

B. Philadelphia, Pennsylvania. D. Croton, New York, November 6. Work: Metropolitan Museum of Art; Whitney Museum of American Art; Museum of Modern Art; Pennsylvania Academy of Fine Arts; Boston Museum of Fine Arts; San Francisco Museum of Art; San Diego Fine Arts Society; Joslyn Art Museum; Phoenix Art Museum, etc.

35

AAA 1917–1919 (Philadelphia); AAA 1921–1925 (New York City; summers 1923–1925, Paris); AAA 1927–1933 (Croton-on-Hudson, New York); Benezit; Fielding; Havlice; Mallett; WWAA 1936–1937 (Croton-on-Hudson); WWAA 1938–1939 (Colorado Springs, Colorado; summer, Croton-on-Hudson); WWAA 1941–1970 (Croton-on-Hudson); WWAA 1973 obit.; AAW, v. I; Donald J. Bear, "Biddle Paintings Reveal Strength of Personality/Exhibition of Artist's Work Showing at Chappell House [Denver] until February 22 [1937]/Character Studies and Satires on Human Race Display," unidentified, undated newspaper clipping; "Biddle Goes West," *Art Digest*, November 1, 1937, 21; "Western Twang of George Biddle's Art Exhibit Delights New York," unidentified newspaper clipping dated November 14, 1937; Colorado Springs Fine Arts Center scrapbook; Colorado College Library; George Biddle, *An American Artist's Story*, Boston: Little, Brown and Company, 1939; "Otis Features Biddle," *Art Digest*, June 1, 1941, 32; Martha Pennigar, *The Graphic Work of George Biddle with Catalogue Raisonne*, Washington: The Corcoran Gallery of Art, 1979.

When Biddle went to Colorado Springs in 1936 to teach landscape painting and painting from models at Colorado Springs Fine Arts Center, a period of printmaking was just beginning there. An accomplished lithographer, Biddle turned to the local scene and to Mexico for subject matter, and produced twenty-three lithographs known as the Colorado Springs Series. "Death on the Plains," "Fire in the Night," "Sand," and "Cripple Creek" appeared in 1936; "Bull-Dogging a Steer" and two versions of "Buffalo Dance," a New Mexico Indian Pueblo subject, appeared in 1937.

Biddle was again in the West in 1941. While spending the winter near Los Angeles he joined the Otis Art Institute faculty in June and taught until December. Biddle was especially fond of California, having spent months in 1901 and 1902 on a ranch near Santa Barbara where he had enjoyed participating in the adventures it offered. The skills he learned he later put to use in Texas when he was twenty-three. He does not mention in his autobiography that he did any sketching there; he had not yet given much thought to what career he should follow.

Biesel, Charles (1865-1945)

B. New York. D. Chicago, Illinois, August 5. AAA 1915-1917 (Newport, Rhode Island); AAA 1919 (Chicago and Newport); AAA 1921-1933 (Chicago); Fielding; Havlice; Mallett; WWAA 1940-1941 (New York City); WWAA 1947 obit.; Sparks; Jacobson, 1932, 48-49, 140.

Biesel, who exhibited mainly in Chicago until 1944, traveled extensively for subject matter and, according to Jacobson, painted in every state except those along the West Coast.

Biesel, Fred H. (1893-ca 1962)

B. Philadelphia, Pennsylvania. D. Chicago, Illinois. AAA 1919-1933 (Chicago); Fielding; Havlice; Mallett; WWAA 1936-1941 (Chicago); Sparks; Jacobson, 1932, 140; Museum of New Mexico Library, Santa Fe.

Biesel, who exhibited in Chicago from the early 1920s well into the 1940s, exhibited in the Santa Fe-Taos Annual in September 1920, and the 13th Annual Exhibition of the Artists of New Mexico in August 1926.

Biggers, Mattie (1872-)

B. Topeka, Kansas. *Idaho Encyclopedia* (Boise, Idaho).

Biggers, who was a graduate of McMinnville College in Oregon, taught several years in public schools. She worked in oil, pastel, and water color and is said to have done some "very fine" nature sketches of Idaho scenes, still lifes, and figures.

Bihlman, Carl (1898-)

B. Pittsburgh, Pennsylvania. San Antonio Public Library.

Bihlman, who lived in Waelder, Texas, probably did not start painting until about 1957 when he studied at Southwest Texas State College in San Marcos. His progress appears to have been rather extraordinary; a number of prizes followed when he exhibited at the College and at Cuero and Flatonia, Texas.

Billing, Frederick William (1835-1914)

B. Eschwege, Germany. D. Santa Cruz, California, in August. Work: Oakland Art Museum; Mackenzie Gordon collection, Washington, D.C. AAW v. II; California State

Library; Inventory of American Paintings, Smithsonian Institution; Mackenzie Gordon, "Frederick William Billing (Friederich Wilhelm Billing) 1835–1914," biographical sketch for 1976 exhibition of Billing's work at the University of California, Riverside, with introduction by George W. Neubert, curator of art, Oakland Museum; *Antiques Magazine*, November 1980.

Painting was a career Billing would have chosen had his father not insisted that he take up business. Not until the late 1850s was he able to do much painting. His subjects generally were still lifes and figures. In the mid 1860s he turned to landscapes. He worked in oils.

By the late 1870s Billing was living in Salt Lake City, and until he left for California in 1885 he painted landscapes featuring many of the West's spectacular sights in Utah, Wyoming, Colorado, and Idaho. Occasionally his painting companions were Thomas and Peter Moran.

Researchers are indebted to Mackenzie Gordon for an explanation of the initialed signatures of Billing and the Moran brothers on a painting of the Falls of the Grand Canyon of the Yellowstone River. The large tree in the left foreground of the painting is Thomas Moran's; the stag in the right foreground is Peter's.

Billing sometimes painted from photographs taken by William Henry Jackson, said Gordon, and "At least one painting, 'The Empty Cradle,' was inspired by an etching of Thomas Moran."

Billing's California paintings are of scenes at Yosemite, along the Coast, and in the Santa Cruz Mountains where he bought the Wilhelmina Ranch, now the Passatiempo Golf and Country Club. Neubert thought Billing's best work was done while living there – "he painted in a personal and humanistic scale while representing a geographical area he loved."

Binckley, Nella/Nellie Fontaine (–)
McMahan (Washington, D.C.); California State Library; AAA 1898, 391.

Binckley, who probably was born in California, lived in San Francisco, Santa Rosa, and Santa Barbara before moving to the East. In San Francisco she attended the Mark Hopkins Institute

of Art. At the Institute's 1898 winter exhibition her "Street in Chinatown" was shown.

Among Binckley's teachers was William Merritt Chase. It is likely that she studied with him at the Pennsylvania Academy of Fine Arts when she lived in Philadelphia. Her longest residence was in Washington, D.C. where she was a charter member of the Arts Club, and active as an exhibiting artist from 1916 to 1935.

Birren, Joseph P. (1864–1933)

B. Chicago, Illinois. D. Milwaukee, Wisconsin, August 4. Work: Museum of New Mexico, Santa Fe; Monterey (California) Peninsula Museum of Art; Los Angeles County Museum of Art; Washington University Gallery of Art; Pasadena (California) Art Museum; Lauren Rogers Library and Museum of Art, Laurel, Mississippi; Luxembourg Museum, Paris; Chicago Municipal Collection. AAA 1898–1931 (Chicago; summer, 1919–1924, Provincetown, Massachusetts); AAA 1933 obit.; Benezit; Fielding; Mallett; AAW, v. I; School of American Research, Santa Fe; NMAA-NPG Library, Smithsonian Institution; *Art World*, Chicago Evening *Post*, February 16, 1926, and November 23, 1926.

Birren had a home and studio in Laguna Beach, California, in the 1920s, as well as in Chicago. By 1927 he was working in Santa Fe. A tactile quality distinguished his landscapes and attracted favorable comment. In Santa Fe they were referred to as "atmospheric."

Bitterly, Lilly P. (–)

AAA 1919–1925 (Denver, Colorado); Denver Public Library, Spalding scrapbook, p. 95; *Western Artist*, October 1935, 5.

Bitterly, who was a member of the Denver Art Association, worked as a painter, sculptor, and illustrator. In 1935 she spent a summer painting in Sweden. Upon her return she exhibited in Santa Barbara and other Western cities.

Blackwell, Ruby Chapin (1876–)

B. Bridgewater, New York. *Who's Who in Northwest Art*

(Tacoma, Washington); Seattle Public Library art and artists' scrapbook.

Blackwell studied with the prominent Washington painter Alice Engley Beek. She was most active from 1935 to 1940. She exhibited landscapes and flower paintings in water color at state fairs, the College [now University] of Puget Sound, and in 1938 the Garden Club of America Show in New York.

Blackwell, Wenonah R. (1885–)
B. Seattle, Washington. AAA 1921 (Seattle); Seattle Public Library art and artists' scrapbook; "Seattle Artist To Have One-Man Painting Exhibit," Seattle *Post-Intelligencer*, March 20, 1955; Jack E. Levasseur typescript, Seattle Public Library; Dodds, Master's thesis, 71–73; University of Washington Art Library.

About 1900 Blackwell went to San Francisco to study art. She returned to Seattle in 1904. Two years later she went to New York to study under Childe Hassam at the New York Conservatory of Art. During summers she studied with Birge Harrison in Woodstock.

Blackwell returned to Seattle in 1911, but did little with her extensive training. Many years later, following a meeting with Mark Toby, she began to do some serious painting. In 1955 the Rainier Chapter of the Daughters of the American Revolution sponsored her in a solo exhibition.

Blair, Streeter (1888–1966)
B. Cadmus, Kansas. D. Beverly Hills, California, November 3. Work: San Diego Fine Arts Gallery; Los Angeles County Museum of Art. Havlice; WWAA 1956–1966 (Beverly Hills); WWAA 1970 obit.; NMAA-NPG Library, Smithsonian Institution; "Late Starter," *Time* Magazine, March 21, 1969.

Blair was sixty when he began painting scenes of Kansas and elsewhere in the primitive style, sometimes referred to as a "modern primitive style." Beginning in 1952, he exhibited nationally in one-man shows.

Blake, Edgar Leslie (1860–1949)
B. Amsterdam, New York. Work: Private collection. *Who's*

Who in Northwest Art (Edmonds, Washington); Inventory of American Paintings, Smithsonian Institution; Seattle Public Library art and artists' scrapbook; "N. W. Scenery Real Challenge for Artists," Seattle *Times,* February 1, 1937.

Blake settled in the Seattle area about 1900 and probably was active there as a commercial artist until the mid-1930s. Thereafter he frequently exhibited in group and one-man shows his landscapes in oil and water color.

Interviewed by the Seattle *Times* in 1937, Blake was asked about his training and his painting. He said he had studied nine years at the Art Institute of Chicago, and in Europe. He had painted in California, Montana, and British Columbia, as well as in Washington. He thought the real challenge for landscape painters in the Seattle area was the "constantly changing quality" of its scenery.

Blankenship, Mary Almor Perritt (1878–1955)
Wilbanks, 1959, 17.

Blankenship was one of several pioneer women, who had some art training, living in Terry or Hockley County, Texas, at the turn of the century. Very few, if any, of her charcoal sketches, prints, and oil paintings have survived.

Blaurock, Charlotta (1866–)
B. Prescott, Wisconsin. AAA 1903 (Chicago, Illinois); Dodds, Master's thesis, 119; Hanford, 1924, 641; University of Washington Art Library; University of Washington Pacific Northwest Collection; Seattle *Town Crier,* November 1, 1913, 15.

Blaurock was a charter member of the Seattle Society of Artists founded in 1904. Previously she had studied at the Art Institute of Chicago, and in Paris. Hanford referred to her as a "gifted pupil of Whistler." She was active in Seattle as a teacher and an exhibiting artist for about a decade.

Bledsoe, Alice E. Collins Matthews (1872–1915)
Wilbanks, 1959, 18 (Cleburne and Lubbock, Texas).

Bledsoe was the first wife of state senator William Harrison Bledsoe, whom she met in Cleburne in 1894 and married in

1895. At that time she had completed her art school education and was working with oils, water colors, and charcoal. She moved with her husband and family to Lubbock in 1909, continued to work in those mediums, and also did some china painting.

Blum, Jerome S. (1884–1956)
B. Chicago, Illinois. Work: Chicago Municipal Collection; Metropolitan Museum of Art; Whitney Museum of American Art; Los Angeles County Museum of Art; Santa Fe Railway collection. AAA 1913 (Chicago; summer, Paris); AAA 1915–1917 (Chicago); Benezit; Mallett; Sparks; Inventory of American Paintings, Smithsonian Institution; *Antiques* Magazine, February 1979, 268.

Blum's Southwestern landscapes are of the Grand Canyon. Two, said to have been painted before 1912, are in the Santa Fe Railway collection. Benezit lists one dated 1921.

Blum was active mainly in Chicago. He exhibited in New York in 1934.

Boeckmann, Carl Ludwig (1868–)
B. Christiana, Norway. Work: Gilcrease Institute of American History and Art; Hennepin County (Minn.) Historical Society; Minnesota State Capitol. AAA 1923–1933 (South Minneapolis, Minnesota); Mallett; Inventory of American Paintings, Smithsonian Institution.

Titles of several of Boeckmann's paintings are Montana subjects, painted about 1900.

Bohney, Jessica (1886–)
B. Holt County, Nebraska. Ness and Orwig, 1939 (Council Bluffs, Iowa).

Bohney, who studied at Pratt Institute and California School of Fine Arts, was supervisor of art at Grand Forks, North Dakota, from 1916 to 1919, and at Phoenix, Arizona, from 1919 to 1922. She exhibited mainly in Iowa and Nebraska.

Bolinger, Ethel King (1888–)
B. Garnet, Kansas. Havlice; WWAA 1947–1953 (Lodi, California).

Bolinger, a member of Stockton Art League and Northern California Artists, was most active as an exhibiting artist from 1942 to 1946.

Boone, Elmer L. (1881–1952)

B. New Cambria, Missouri. Work: McKee Foundation, El Paso, Texas. Ballinger, 1976 exhibition catalogue; El Paso Museum of Art, *The McKee Collection of Paintings,* 1968; Houston Museum of Fine Arts library; Butte-Silver Bowl Free Public Library, Butte, Montana; conversations with Phil Kovinick.

Before moving to El Paso, Texas, in the mid-twenties, Boone spent three years in Montana where he painted with Charlie Russell, and may have had some instruction from him. Boone's formal training had been obtained in Chicago at the Art Institute and the Smith School of Art.

From about 1925, Boone painted mainly in Arizona and Texas. His work was shown in exhibitions at the El Paso Museum of Art and the University of Texas in 1968, and at the Phoenix Art Museum in 1976.

Booth, James Scripps (1888–1954)

B. Detroit, Michigan. AAA 1919–1925 (Pasadena, California; summer, Birmingham, Michigan); AAA 1927–1933 (Detroit); Benezit; Fielding; Havlice; Mallett; WWAA 1936–1939 (Detroit); WWAA 1940–1953 (Grosse Pointe Park, Michigan.

Borgord, Martin (1869–1935)

B. Gausdal, Norway. D. Riverside, California, in March. Work: National Academy of Design; Washington County Museum of Fine Arts, Hagerstown, Maryland; Luxembourg Museum, Paris; Carnegie Institute, etc. AAA 1919 (Paris, France; summer, Taos, New Mexico); AAA 1921 (New York City); AAA 1933 (Riverside, California); Benezit; Fielding; Mallett; Inventory of American Paintings and NMAA-NPG Library, Smithsonian Institution; "Imaginative Pictures by Martin Borgord, American

Sculptor-Painter, Show Latest Phase of His Talent," *Art News*, May 17, 1924, 1.

Boronda, Lester David (1886–)
B. Reno, Nevada. Work: Monterey (California) Peninsula Museum of Art; Salinas (California) City Council collection; Pennsylvania Academy of Fine Arts; Mechanical Institute, Rochester, New York. AAA 1915–1933 (New York City; summers from 1927, Noank and Mystic, Connecticut); Benezit; Fielding; Havlice; Mallet; WWAA 1936–1953 (New York City, summer, Mystic); AAW v. I; Spangenberg; California State Library; Carmel (California) Public Library.

Boronda was educated in Monterey County where his parents owned a large tract of land near Salinas. Against their wishes he sought a career in art, studying first in San Francisco and then in New York City, Munich, and Paris. Many of his paintings are of life in Old California, and are based on personal knowledge and historical research of that romantic period.

With the exception of 1912–1913 when Boronda lived in Monterey and Pacific Grove, he did little painting in California. He exhibited widely and had a number of solo exhibitions in major art galleries.

Boss, Homer (1882–1956)
B. Blandford, Massachusetts. D. Santa Cruz, New Mexico, January 15. Work: Museum of New Mexico, Santa Fe. AAA 1907–1923 (New York City); AAA 1933 (Santa Cruz); Benezit; Fielding; Havlice; Mallett; WWAA 1936–1953 (Santa Cruz); AAW v. I.; "Homer Boss Shows New York the Southwest," *Art Digest*, March 1, 1933, 15; NMAA-NPG Library, Smithsonian Institution; Museum of New Mexico library.

Boss, an instructor at the Art Students League from 1922 to 1941, was a landscape and portrait painter. He was active in New Mexico from the mid-1920s, and by 1933 had a ranch at Santa Cruz.

Quoting Howard Devree of the New York *Times, Art Digest* said Boss "has succeeded in presenting some of the amazing desert formations, and has produced cloud effects, contours

of rock and brilliance of color calculated to cause the dwellers among artificial canyons of steel and stone to raise both eyebrows." Illustrating the article is a reproduction of "Sierra Alto" by Boss.

The Museum of New Mexico purchased Boss's "Pueblo Indian," a strong and dynamic painting. In 1956 the Museum featured a solo exhibition of his work.

Botke, Cornelius (1887–1954)
 B. Leeuwarden, Holland. D. Ventura or Santa Paula, California, September 16. Work: Library of Congress; New York Public Library; California State Library; Nebraska Art Association, Lincoln; Ponca City (Oklahoma) Public Library; Oak Park (Illinois) High School; Chicago Municipal Collection. AAA 1913–1919 (Chicago); AAA 1921–1927 (Carmel, California); AAA 1929–1933 (Santa Paula); Benezit; Fielding; Havlice; Mallett; WWAA 1936–1953 (Santa Paula); WWAA 1956 obit.; AAW v. I; Spangenberg; Harriet Weaver, "What Is Success? The Story of Cornelius and Jessie Arms Botke," *School Arts,* June 1940, 327–331; R. A. Lennon, "Botkes, Berninghaus at Chicago Galleries," *Art World* Magazine, Chicago Evening *Post,* October 9, 1928; NMAA-NPG Library, Smithsonian Institution; Monterey Peninsula Museum of Art docent library.

In reviewing an exhibition of Botke's etchings at the Smithsonian Institution in January 1944, the art editor of the Washington *Star* was especially enthusiastic about the artist's handling of trees and his skillful "treatment and transcriptions of local themes" such as those of Cayucos, California, a settlement lying near the Pacific in the fold of hills off Morro Bay.

Both Cornelius and his wife Jessie were well-known Chicago artists when they set out for San Francisco in the spring of 1920. At Manitou, Colorado, they stopped to do landscapes of that Rocky Mountain region, one often spelling the other in keeping their three-year-old son out of mischief.

Several months later the Botkes opened a studio in Carmel where they remained seven years, except for a lengthy visit in Europe. Their subsequent move to Los Angeles was of short duration. They preferred a rural setting and this they found in Santa Paula.

45

Botke's specialty was landscapes. Many are in oil; some are in water color; others are etchings, for which he is best known. His subjects include Death Valley, the California coast, Nevada mining towns, the Grand Tetons, and the High Sierras.

Boyd, Gilbert N. (1896–1981)
B. Belfast, North Ireland. D. Carmel, California. Monterey Peninsula Museum of Art docent library.

Boyd, a mechanical engineer by profession, had studied art in Ireland, in England, and on the continent. Following retirement he taught night classes several years at the Palo Alto (California) Art Club. He worked in water color, oil, and acrylic; and his work began bringing prizes in 1956.

Boye, Bertha Margaret (1883–)
B. Oakland, California. AAA 1909–1915 (San Francisco, California); AAA 1919 (Ukiah, California); California State Library.

By 1919, Boye appears to have been more active as a painter than as a sculptor.

Boyle, Gertrude Farquharson (See: Kanno)

Bradfield, Mrs. C. P./Miss Jeffrey (–)
AAA 1900 (Los Angeles, California; listed under Art Supervisors and Teachers); Splitter, 1959, 48.

Bradfield, whose sketches had appeared in *New York Graphic* and *Floral Cabinet*, studied and taught art in New York prior to moving to Los Angeles in 1874. Her paintings, however, were lost in a shipwreck *en route*. Whether she did many after her arrival is doubtful, but she did begin immediately to teach—first in a Methodist Church on Fort [now Hill] Street, then at Sisters of Mary School and the Misses Achelsons' school. When industrial drawing was introduced in public schools, Bradfield was hired as art supervisor and teacher, a position she held for many years.

Braley, Clarence E. (–)
AAA 1907–1913, 1917 (New Bedford, Massachusetts); San

Francisco Public Library; Inventory of American Paintings, Smithsonian Institution.

Braley, who lived in San Francisco after 1917, probably is the "C. Braley" whose pastel landscapes listed in the Smithsonian inventory are in a private collection in California.

Brandt, Henry A./Henry H. (1862–)
B. Germany. Work: Putnam Museum, Davenport, Iowa. AAA 1933 (Chicago, Illinois); Mallett; Sparks; Inventory of American Painting, Smithsonian Institution.

Brandt had studied at the Royal Academy in Berlin before moving in 1882 to the United States where he was active in Moline, Illinois, until 1907. In 1908 he returned to Germany and studied in Dresden.

By 1916 or before, Brandt was back in the United States; for Sparks shows him in Boise, Idaho, from that year until 1920, and briefly in Portland, Oregon.

Brandt worked as a painter, photographer, etcher, and scenery painter. He had at least two one-man exhibitions in the Chicago area between 1928 and 1931. He was a member of the Illinois Academy of Fine Arts, the Palette and Chisel Club, the Hoosier Salon, and the All-Illinois Society of Fine Arts.

Bransom/Branson, (John) Paul (1885–1979)
B. Washington, D.C. AAA 1913 (Fordham, New York); AAA 1915–1919 (New York City; summer, Gansevoort, New York); AAA 1921 (Green Lake, New York); AAA 1923–1924 (New York City); AAA 1925–1933 (Green Lake); Benezit; Fielding; Havlice; Mallett; WWAA 1936–1941 (Fulton County, New York); WWAA 1947–1978 (New York City); Denver *Post*, June 4, 1950, and July 5, 1950; Denver Public Library; Viguers, 1958, 79–80; personal papers in Archives of American Art, Smithsonian Institution.

With a lifelong interest in animals, Bransom early fashioned a successful career as an illustrator of animal subjects. Eventually it took him to the West for months at a time. By 1950, when he exhibited animal paintings at the Denver Museum of Natural History, he had a ranch in Wyoming's Jackson Hole country, and was devoting a major part of his time to animal

paintings and scenery. Asked by a Denver *Post* reporter which animals he liked best to paint, he said "cats," for "they are the most graceful."

By the mid-1960s Branson had illustrated forty-five books, many of them dealing with animals, and was teaching summer courses at Jackson Hole for the Teton Art Association.

Breakey, Hazel M. (1890–)
B. Garden Valley, Wisconsin. *Who's Who in Northwest Art* (Bellingham, Washington).

Breakey, who had studied at California School of Arts and Crafts in Oakland, Columbia University, Carnegie Institute on a scholarship, and the University of Oregon in Eugene, was mainly active as instructor and supervisor of art at Western Washington College of Education in Bellingham.

Brewer, Adrian Louis (1891–)
B. St. Paul, Minnesota. Work: State Capitol, Little Rock, Arkansas; Municipal Art Gallery, Little Rock; Woman's Forum, Wichita Falls, Texas; Alexandria Hotel, Chicago; Victoria (Texas) Art League. AAA 1917–1923 (St. Paul); AAA 1925–1927 (Chicago, Illinois); AAA 1929–1933 (Little Rock, Arkansas); Fielding; Havlice; Mallett; WWAA 1936–1941 (Little Rock); Lilly; Houston Public Library art and artists' scrapbook; "Artist Gets Up at 4:30 to Paint San Antonio Sky," San Antonio *Express*, April 20, 1930.

The very substantial prize money offered by Texas oil man Edgar B. Davis in the late 1920s – $50,000 for three annual exhibitions of paintings based on Texas themes – attracted many artists to the state. Brewer of Little Rock won $2500 in 1929 for an oil called "In a Blue Bonnet Year."

In 1930 Brewer was back in Texas painting what he called "sky-scapes." He was thought to be the first painter working in Texas "to make a systematic effort" to paint Texas skies.

Brewer, Nicholas Richard (1857–1949)
B. High Forest, Minnesota. D. St. Paul, Minnesota, February 14. Work: Tweed Museum of Art, University of Minnesota; Butler Institute of American Art; Bennington (Ver-

mont) Museum; Art Institute of Chicago; University of Oklahoma; Municipal Art League, Decatur, Illinois; St. Paul Art Institute; Kansas State Historical Society. AAA 1905–1913 (New York City); AAA 1915–1917 (New York City and St. Paul); AAA 1919–1927 (New York City and Chicago); AAA 1929–1933 (New York City and St. Paul); Benezit; Fielding; Havlice; Mallett; WWAA 1936–1941 (New York City and St. Paul); AAW v. I; Coen, 78; Nicholas Brewer, *Trails of a Paintbrush*, Boston: The Christopher Publishing House, 1938; Stuart; *Art News*, January 1, 1921, 6; *Art News*, August 19, 1922, showing "Aliso Cañon," painted the previous year in California; Lilly; NMAA-NPG Library, Smithsonian Institution.

Still extant is a painting by Brewer entitled "Landscape, River Scene." He was sixteen when he painted it. Coen tells about Brewer's precarious start toward an education in art and his first teacher, an unknown St. Paul painter. Later he studied in New York with Dwight William Tryon and Charles Noel Flagg.

Brewer's son Adrian also became an artist. Both won important prizes in 1929 in the Edgar B. Davis contest in Texas.

Art News in January 1921 reported that Brewer had just spent several years in the West. Throughout his career he traveled extensively, not solely for landscape subjects, for he was better known as a portrait painter. He painted many prominent persons, including the governors of twenty-seven states.

Brewster, Eugene V./Valentine (1871–1939)
B. Bay Shore, New York. D. January 1. AAA 1919–1924 (Roslyn, New York); AAA 1925 (Morristown, New Jersey); Fielding; Mallett Supplement; Richard and Mercedes Kerwin, Burlingame, California.

Brewster was a self-taught painter who exhibited from 1919 to 1924 in the New York area. After he moved to California in the mid-1920s, he was more active as a writer and a director of motion pictures, than as a painter. He returned to New York in the early 1930s and made his home in Brooklyn.

Briggs, Clare A. (1875–1930)
B. Reedsburg, Wisconsin. D. New York City, January 3. AAA 1917–1921 (New York City); AAA 1923–1929 (New

Rochelle, New York); AAA 1930 obit.; Mallett; Bucklin
and Turner, 1932, 20-21.

To Briggs, whose first published pictures were drawn for
the Lincoln (Nebraska) Evening *News*, Lincoln was home from
1888 to 1896. Then he joined the staff of the St. Louis *Globe
Democrat* and remained several years. In New York he became a
well-known syndicated cartoonist for the *Tribune*.

Brinkley, Nell (1888-1944)
B. probably in Denver, Colorado. D. New Rochelle, New
York, October 21. AAA 1923-1931 (New Rochelle); Hav-
lice; Mallett Supplement; WWAA 1936-1941 (New Ro-
chelle); WWAA 1947 obit.; Denver Public Library; Denver
Post magazine section, July 12, 1908, 20-21; Denver *Post*,
January 29, 1923, 9; October 23, 1944, 10, obit.; July 29,
1966, 25; Rocky Mountain *News*, October 23, 1944, obit.;
Washington Evening *Star*, October 23, 1944, obit.;
NMAA-NPG Library, Smithsonian Institution.

Brinkley, so far as is known, never had an art lesson. When
she was sixteen she went to work for the Rocky Mountain *News*
as an illustrator, and a few years later for the Hearst Syndicate in
New York City. Her specialty was pretty blond girls with fluffy
hair. In private life she was Mrs. Bruce MacRae, Jr.

Bristol, Olive (ca 1890-1976)
B. Piedmont, Wyoming. D. Monroe, Washington, June 10.
Work: Seattle Public Schools. Seattle *Times*, June 12,
1976, obit.; Seattle Public Library art and artists' scrap-
book.

Bristol, a charter member of the Seattle Art League, was
forty when she began painting. She exhibited in several Pacific
Coast cities and taught art classes in Seattle, Everett, Bothell,
and Yakima. She donated many of her paintings to Seattle public
schools.

Broad, Thomas D. (1893-)
B. Paris, Texas. O'Brien, 1935 (Dallas, Texas).

Broad, an architect, also did water colors and pastels. He
was first with a firm in Kansas City, Missouri, and then in Dallas
where he maintained an office from 1923 to 1934.

Brodt, Helen Tanner (1834/38-1908)

B. Elmira, New York. D. Berkeley, California. Work: Oakland Art Museum; California Historical Society, San Francisco; Bancroft Library, University of California; Society of California Pioneers, etc. AAW v. I; California State Library; Oakland Museum library; Jones, 1980, 13; San Francisco *Chronicle*, November 10, 1939; Inventory of American Paintings, Smithsonian Institution.

Brodt arrived in California in 1863, explored Mt. Lassen in 1864 — the first woman to do so reported the *Chronicle* in 1939 — and by 1867 or earlier, she was art director for Oakland Public Schools. She is said to have explored a number of Northern California mountains; certainly she was at Mt. Shasta for she painted it. She also painted several missions, including Carmel Mission and Mission San Juan Bautista, the latter ca 1870.

During her many years in California, Brodt lived in Red Bluff, Tehama, Petaluma, Pleasanton, and Berkeley. She was a competent portrait and landscape painter who merits further research.

Broemel, Carl William (1891-)

B. Cleveland, Ohio. Work: Cleveland Museum of Art; Brooklyn Museum; New Britain (Connecticut) Museum of American Art. AAA 1925-1933 (Cleveland); Havlice; Mallett; WWAA 1936-1941 (Cleveland); WWAA 1947-1962 (White Plains, New York); Clark, 355; NMAA-NPG Library, Smithsonian Institution.

Broemel traveled widely for his subject matter and did some work in the West. Clark, who said, "One feels the freedom of open air" in his landscapes, was especially impressed with his water colors.

Bromley, Valentine Walter (1848-1877)

B. London, England. D. Fallows Green, Harpenden, near London, April 30. Work: Gilcrease Institute of American History and Art, Tulsa, Oklahoma; Department of External Affairs, Ottawa, Canada; private collections of the present Earl of Dunraven and the Earl of Meuth. Benezit; Havlice; Mallett; Harper, 1970; AAW v. I; Graves, 1972; Redgrave; Hogarth; M. Barr; Richard T. York, "Valentine

Walter Bromley (1848–1877)," *Southwest Art,* August 1977, 22–27; Mallalieu.

Bromley was commissioned by the fourth Earl of Dunraven, Windham Thomas Wyndham-Quin, to paint twenty large pictures of Western and Indian life and to provide illustrations for *The Great Divide* which the Earl was writing. Bromley supplied seventeen illustrations, but was unable to complete more than five of the large paintings before his death from smallpox.

The country covered by Bromley and the Earl in 1874 is of interest. Traveling westward *via* the St. Lawrence River, Lakes Huron and Superior, the party headed for the Missouri where Bismarck is now located; then up the Missouri and Musselshell rivers; then turning south toward Denver to stay in Estes Park where the Earl owned some four thousand acres. In mid-August the party traveled, via Salt Lake City, to the land of the Crow Indians and to Yellowstone National Park.

Bromley did no landscapes of Yellowstone or elsewhere during the trip; he was a history and genre painter. Two major paintings of Indians were exhibited at the Royal Academy in 1875 and 1876: "Midday Rest—Sioux Indians," and "Pa-ha-uza-tan-ka, the Great Scalper." "The Big Chief's Toilet" and "Shifting Camp, Nebraska" were shown at the Royal Institute of Painters in Water-Colour. Bromley, who had been elected an associate member of the Royal Institute when he was nineteen, and soon afterward to the Society of British Artists, was considered a painter of great promise.

Bromwell, Henrietta Elizabeth (1859–1946)

B. Charleston, Illinois. D. Denver, Colorado, in January. Work: Denver Public Library. AAA 1898–1924 (Denver); Fielding; AAW v. I; Denver Public Library; Inventory of American Paintings, Smithsonian Institution.

In the *American Art Annual* in 1900 Bromwell is listed as a self-taught artist, and in 1903 she is also listed under art supervisors and teachers. Since some sources say she studied in Denver and in Europe, she may have done so after 1903.

Two water colors by Bromwell done in 1892 and in 1893 are at the Denver Public Library. She also did some sculpture. But her most important contributions in the field of art were her assistance to the Denver Artists' Club and her awareness that art

history was being made in Colorado. Her scrapbook of newspaper clippings from the turn of the century may be the first of its kind in the Western states.

Brook, Alexander (1898–1980)

B. Brooklyn, New York. Work: Metropolitan Museum of Art; Museum of Modern Art; Art Institute of Chicago; Corcoran Gallery of Art; San Francisco Museum of Art; University of Nebraska; Detroit Art Institute, etc. AAA 1921 (Ridgefield, Connecticut); AAA 1923–1929 (New York City; summer, Woodstock, New York); AAA 1931–1933 (New York City; summer, Cross River, New York); Benezit; Fielding; Havlice; Mallett; WWAA 1936–1939 (New York City; summer, Cross River); WWAA 1940–1947 (Savannah, Georgia; summer, Cross River); WWAA 1953–1973 (Sag Harbor, Long Island, New York); "Brook Goes to Otis," *Art Digest*, October 1, 1939, 27; "The New Alexander Brook," *Art News*, January 31, 1925, 3; Richardson, 390.

Brook, an internationally known artist, did some work in New Mexico as well as in California where he taught several years. His early work was sometimes grouped with that of regionalist painters.

Brookes, Samuel Marsden (1816–1892)

B. Newington Green, Middlesex, England. D. San Francisco, January 31. Work: Brooklyn Museum; Chicago Historical Society; State Historical Society of Wisconsin; Oakland Art Museum; E. B. Crocker Art Gallery, Sacramento, California; Society of California Pioneers, San Francisco, etc. Groce and Wallace; Mallett Supplement; AAW v. I; Barker; Joseph Armstrong Baird, Jr. (ed.), *Samuel Marsden Brookes (1816–1892)*, San Francisco: California Historical Society, 1962; Gerdts and Burke, 1971, 93, 97, 128–132, 181, 201; Inventory of American Paintings, Smithsonian Institution; *Alta California*, August 29, 1871.

"S. M. Brookes exhibited a fish study which surpasses all his former efforts in still life, and would make him fame and for-

tune anywhere but here," *Alta California* reported in August 1871.

When Brookes arrived in San Francisco in 1858, he had not yet begun doing still lifes. Portraits had been his specialty. He had done landscapes for a commercial firm in Wisconsin, and a few historical paintings; and the Wisconsin State Historical Society has some of the latter and some of the portraits. After moving to California he did some more landscapes, which are mainly in private collections. What brought him recognition, belated as it was, was still lifes of fish, fruit, and game.

Although Brookes was not widely known in his lifetime, he was one of California's more successful artists.

Brooks, Alden Finney (1840–1932)

B. West Williamsfield, Ohio. Work: Newberry Library, Chicago; Illinois State Capitol; Chicago Historical Society; Chicago Public Library; University of Chicago. AAA 1898–1933 (Chicago; summers from 1915, Fennville, Michigan); Benezit; Fielding; Groce and Wallace; Havlice; Mallett; WWAA 1936–1939 (Chicago; summer, Michigan); Sparks; Special Collections, Newberry Library; Denver Public Library; "Artist Brooks on the Trail," *Colorado* Magazine, April 1951, 143; Inventory of American Paintings, Smithsonian Institution.

Brooks was nineteen when he traveled the Oregon Trail on foot in 1859. His diary, "Grand trip across the plains, 1859; Reason for the trip," is in the Newberry Library. Brooks mentions taking two miniatures and a picture of a place then called Millersville, Wyoming. He sold the latter for five dollars to buy a pair of shoes, "having been barefoot 600 miles or so." The diary contains no sketches. Later he became known as a portrait painter.

Brotherton, Mrs. Wilber, Jr. (1894–)

B. Philadelphia, Pennsylvania. *Who's Who in Northwest Art* (Ellensburg, Washington); Seattle Public Library art and artists' scrapbook; "Exhibit of Landscapes Is Opened," Seattle *Times,* May 4, 1939.

Brotherton, who studied briefly at the Art Institute of Chicago, was mainly self-taught. Her first one-man show, May 1939,

consisted of pastel, water color, and oil landscapes of the Pacific Northwest and of Montana.

Brotze, Edward F. (ca 1868–1939)
B. San Antonio, Texas. D. Seattle, Washington, December 5. Seattle Public Library art and artists' scrapbook; Seattle *Times*, December 6, 1939, obit.

Brotze, who became a staff artist for the Seattle *Times* in 1907, learned to paint by watching his father, a commercial artist in San Antonio.

From San Antonio, Brotze went to California where he attended St. Mary's College in Moraga. Afterward he worked in Chicago before moving to Seattle.

Brown, Alfred J. (–)
AAA 1919 (Omaha, Nebraska; listed as etcher and engraver).

Brown, Eyler (1895–)
B. Waynesville, Ohio. *Who's Who in Northwest Art* (Eugene, Oregon).

Brown, an architect, etcher, and water color painter, taught architecture and etching at the University of Eugene. He had once been a student there, and he had also studied in Ghent, Belgium, and in Boston where he attended the Massachusetts Institute of Technology. He does not appear to have been active in Oregon as an exhibiting artist.

Brown, H. Harris (1864–1948)
B. Northamptonshire, England. D. August 27, probably in London. Work: Newberry Library, Chicago; Eiteljorg collection. Benezit; Mallett; Waters (Northampton and London); Inventory of American Paintings, Smithsonian Institution.

Brown painted many portraits in Canada and the United States, including portraits of Indians living in Montana. A large oil portrait of a Crow Indian is in a private collection and is dated 1917.

Brown, Howell Chambers (1880-1954)

B. Little Rock, Arkansas. D. Pasadena, California, April 15. Work: Library of Congress; Museum of History, Science and Art, Los Angeles; Smithsonian Institution. AAA 1915-1931 (Pasadena); Benezit; Fielding; Havlice; Mallett; WWAA 1936-1941 (Pasadena); AAW v. I; Edna Gearhart, "The Brothers Brown—California Painters and Etchers," *American Magazine of Art*, May 29, 1929, 283-289; Jessie A. Selkinghaus, "Etchers of California," *International Studio*, February 1924, 383-391; NMAA-NPG Library, Smithsonian Institution; California State Library.

Brown was an engineer who abandoned his profession to take up ranching in Mexico. When political developments made it necessary to leave, he returned to the states and studied art. He became locally known for his paintings, and nationally known for his etchings, drypoints, and lithographs.

An exhibition of Brown's prints at the Smithsonian in February 1924 included the following subjects: Acoma and Laguna Pueblos in New Mexico; Santa Fe; the Grand Canyon; Santa Barbara, San Francisco, and Monterey. The Library of Congress acquired "Acoma Church," "Old Houses, Santa Fe, N.M.," and "San Miguel Church, Santa Fe, N.M."

Brown, Margaretta [Maggie] Favorite (1818-1897)

B. McConnellsville, Pennsylvania. D. Boise, Idaho, November 2. Work: Idaho Historical Museum, Boise; Masonic Temple, Idaho City; Odd Fellows Hall, Idaho City. Boise Gallery of Art library; Arthur Hart, "Frontier Life Didn't Keep Artists from Seeking the Spirit of Idaho," The Idaho *Statesman*, June 5, 1978, 4A; Utahna Hall, "Idaho City Artist: Maggie Brown," Idaho *World*, July 2, 1980; LeRoy, *Northwest History in Art* catalogue, 1963.

In the 1963 exhibition catalogue for *Northwest History in Art* is an unsigned painting attributed to Mrs. Jonas W. Brown, about whom little was known. Arthur Hart and Utahna Hall have since then published the following information.

Maggie Brown probably began painting the Western scene after she left the East to join a married sister in Northern California. In 1857 she married Jonas Brown in Yreka. In 1862 he left California for the gold fields of Idaho, and she left for Portland,

Oregon, where her sister was then living. In 1864 she joined her husband in Idaho City, and in 1882 they settled permanently in Boise. "Hydraulic Mining in the Boise Basin," is the title of the painting shown in the Northwest History in Art exhibition. Painted about 1870, it is in the collection of the Idaho Historical Museum.

It seems likely that Brown's early work in California, at least some of it, was done with earth pigments which the Indians may have taught her how to mix. This possibility is supported by her murals for the Masonic Temple in Idaho City, painted in the mid-1860s. More than a century later, a Boston museum director was unable to say how Brown had achieved an "alabaster effect" that had "only slightly yellowed with age." The use of earth pigments by Brown may also explain her "somber and rather limited palette" carried over in her use of oils.

Brown, Willa M. (1868–)
B. Pittsburgh, Pennsylvania. *Who's Who in Northwest Art* (Portland, Oregon).

Brown, a member of the Oregon Society of Artists, studied art with Maude Wanker, William S. Parrott, and Nils Hagerup. She worked in oil and water color. The possibility exists that "Autumn," an oil landscape listed in the Smithsonian's Inventory of American Paintings, signed W. M. Brown, is hers.

Browne/Brown, Belmore (1880–1954)
B. Thompkinsville, Staten Island, New York. D. Rye, New York, May 3. Work: National Gallery of Art; American Museum of Natural History; Albright Art Gallery; Amherst College; Santa Barbara Museum of Natural History; California Academy of Sciences; Springville (Utah) Art Museum. AAA 1915–1917 (New York City); AAA 1921 (Tacoma, Washington; Banff, Alberta, Canada); AAA 1923–1933 (Banff); Fielding; Havlice; Mallett; WWAA 1936–1947 (Alberta, Canada); WWAA 1953 (Ross, Marin County, California; summer, Seebe, Alberta); AAW v. I; *National Cyclopaedia of American Biography,* NMAA-NPG Library, Smithsonian Institution; California State Library; Rocky Mountain *News,* May 20, 1951, 28.

Browne, whose specialty was mountain landscapes, worked mainly in the Canadian Rockies. He was in California for an extended period when he was director of the Santa Barbara School of Arts (1930–1934), and again in his later years when he made his winter home in Ross. He wrote and illustrated Alaska travel books. During 1951–1952 he illustrated U. S. Air Force manuals.

Browne, Charles Francis (1859–1920)

B. Natick, Massachusetts. D. Waltham, Massachusetts, March 29. Work: Waltham Historical Society; New Orleans Museum of Art; Topeka (Kansas) Public Library. AAA 1898–1919 (Chicago, Illinois); AAA 1920 obit.; Benezit; Fielding; Mallett; Sparks; Lonnie E. Underhill and Daniel F. Littlefield, Jr., (ed. and comp.), *Hamlin Garland's Observations on the American Indian 1898–1905.* Tucson: The University of Arizona Press, 1976.

In late summer of 1895, Browne joined sculptor Hermon Atkins MacNeil and writer Hamlin Garland for a tour of Indian reservations in the Southwest. They arrived at the Ute Agency on ration day, which Garland wrote provided "superb material" for artists. During their visit one of the Utes, Buckskin Charlie, asked Browne to paint a picture of his house. Garland did not say whether Browne complied.

The artists also visited the Navajo Reservation, the Hopis at Walpi, and the villages of Isleta and Zuni in New Mexico. Browne returned with enough material for many paintings. At least one was completed in 1895, "The Pueblo of Zuni, New Mexico," an oil.

Browne, Frederic/Frederick William (1877–1966)

B. Belfast, Ireland. D. August 13, probably in Houston, Texas. Work: Houston Museum of Fine Arts. AAA 1923–1924 (New York City); Benezit; Havlice; Mallett Supplement; WWAA 1940–1941 (Bellaire, Texas); Fisk; O'Brien; "Comprehensive Exhibit of Oils of Frederic Browne To Be Shown at Museum," Houston *Chronicle,* November 4, 1928; "Frederic Browne Captures Purchase Prize in Houston Art Show," Houston *Post,* March 6, 1938; Houston Public Library art and artists' scrapbook; Personnel files,

University of Houston and Rice University; Interview with Lowell Collins of Houston, a former pupil.

Art directories do not reflect the remarkably long career of Browne who was in his middle years when he became instructor in architectural drawing and painting at Rice University in the mid 1920s, a position he held until June 1934. In October he began teaching at the University of Houston; he died a few months before retirement.

Browne came to Houston well qualified, having studied at several schools in Paris and at the Pennsylvania Academy of Fine Arts. He was very popular with his students, but a time or two he was at odds with the administration, and was dismissed. During those lean periods his students brought him what they called CARE packages.

Browne, Harold Putnam (1894–1931)
B. Danvers, Massachusetts. AAA 1917–1919 (Danvers; summer, Provincetown, Massachusetts); AAA 1921 (Danvers and Lawrence, Kansas); AAA 1923–1927 (Danvers; Paris; Provincetown); AAA 1929 (Danvers; Paris); AAA 1931, obit.; Benezit; Fielding; Mallett.

Browne, who had studied with his father George Elmer Browne, with F. Luis Mora, and in Paris, was on the faculty of the University of Kansas School of Fine Arts during the early twenties.

Brownlee/Brownlie, Alexander (–1905)
B. Scotland. D. Cleveland, Ohio, October 24. Work: Denver Public Library; Oakland Art Museum; Society of California Pioneers, San Francisco. AAA 1898–1900 (Montclair, New Jersey); AAA 1907, obit.; Mallett; Denver Public Library; "An Artist in the Mountains," Denver *Times*, September 17, 1886; Inventory of American Paintings, Smithsonian Institution.

Following Brownlee's return from the Colorado Rockies in September 1886, the Denver *Times* wrote that he had "secured a large number of views, all sketchwork without the camera, and all of admirable accuracy, both as to peculiarity of color and as to ruggedness of outline." Brownlee had painted landscapes in Scot-

land and Switzerland before coming to Colorado. He said "the contrast between the mountain scenery there and here is very marked," and that nothing in Europe compared with the Rocky Mountains for ruggedness. His "Street in Georgetown, Colorado," a water color, is in the Denver Public Library collection.

Buck, (Charles) Claude (1890–)
B. New York City. Work: University of Chicago; Santa Cruz (California) Art Gallery; Elgin (Illinois) Art Museum; LaGrange (Illinois) Public Schools; Des Moines (Iowa) Public Library, etc. AAA 1915-1923 (New York City); AAA 1929-1933 (Chicago); Havlice; Mallett; WWAA 1936-1937 (Chicago); WWAA 1938-1941 (Midlothian, Illinois); WWAA 1947-1962 (Santa Cruz); NMAA-NPG Library, Smithsonian Institution; Ada King Wallis (ed.), "A New Force in American Art," *Western Woman,* v. 13, No. 2-3, 9 (Carmel Art Association Edition); Monterey Public Library; "Claude Buck Reveals Stylistic Extremes," *Art Digest,* December 15, 1940, 10.

Buck opened his Santa Cruz Mountains studio in 1934, exhibited at Santa Cruz County Fairs, and in general became an active part of the art world in that region, including Monterey County where Carmel is located.

Budworth, William Sylvester (1861–)
B. Brooklyn, New York. Work: Boston Museum of Fine Arts; Rochester (New York) Art Museum. AAA 1898-1933 (Mt. Vernon, New York); Benezit; Fielding; Havlice; Mallett; WWAA 1936-1939 (Mt. Vernon); Young.

Budworth worked in Denver, Chicago, and St. Louis. He won silver medals in 1902 and 1903 at American Art Society exhibitions in Philadelphia.

Buehr, Karl Albert (1866-1952)
B. Feuerbach, Stuttgart, Germany. Work: University of Chicago; Vanderpoel Collection, Chicago; Northwestern University; Des Moines History Museum; Bethany College, West Virginia. AAA 1898-1910 (Chicago); AAA 1913 (Paris); AAA 1915-1933 (Chicago; summers, 1923-1933,

Wyoming, New York); Benezit; Fielding; Havlice; Mallett; WWAA 1936-1953 (Chicago); Sparks.

Although Chicago was his home from the time he was three, Buehr did much of his work in Europe. In 1928 he was invited to Stanford University as artist-in-residence. Titles of paintings indicate he did some work in Santa Fe and Taos during one or more visits to New Mexico.

Buehr, Walter Franklin (1897-1971)
B. Chicago, Illinois. D. January 2. AAA 1925 (New York City; Viguers, 1958, 83; Kingman, 1968, 87; Contemporary Authors.

Buehr was an illustrator of children's books who did some painting in California after the First World War. He was especially interested in the sea.

Bump, Elvira (1856-)
B. Portage, Wisconsin. *Who's Who in Northwest Art* (Portland, Oregon).

Bump, a member of the Oregon Society of Artists, studied privately in New York, and worked primarily in oils and pastels.

Burbank, Addison Buswell (1895-)
B. Los Angeles, California. Work: Tulane University. AAA 1925-1927 (Forest Hills, Long Island); AAA 1929-1931 (New York City; summer, Cos Cob, Connecticut); Havlice; Mallett Supplement; WWAA 1936-1937 (New York City; summer, Cos Cob); WWAA 1938-1939 (Noank, Connecticut; summer, Cos Cob); WWAA 1940-1941 (New York City; summer, Cos Cob); WWAA 1947-1953 (New York City); Mahony; Viguers.

Burbank studied at Santa Clara University in California, the Art Institute of Chicago; Grand Central Art School in New York, and in Paris. He was known to take up residence wherever his work took him. From the West came illustrations for several published stories.

Burgdorff, Ferdinand (1883-1975)
B. Cleveland, Ohio. D. Monterey, California, May 12.

Work: Santa Fe Railway Collection; M. H. de Young Memorial Museum, San Francisco; Hubbell Trading Post Museum, Ganado, Arizona; Springville (Utah) Museum of Art; Cleveland Museum of Art; City of Monterey collection. AAA 1917–1919 (Mill Valley, California); AAA 1921 (San Francisco; summer, Pebble Beach, California); AAA 1923–1924 (Cleveland Heights; summer, Pebble Beach); AAA 1925–1929 (San Francisco and Cleveland Heights; summer, Pebble Beach); AAA 1931–1933 (Pebble Beach); Fielding; Havlice; Mallett; WWAA 1936–1962 (Pebble Beach); AAW v. I; Elizabeth H. Godfrey in *Yosemite Nature Notes,* July 1945, 74–76; Helen Clark Cranston, "Burgdorff Describes Colorful Hopi Snake Dance in Art Gallery Talk," *The Carmel Pine-Cone,* May 11, 1945; Catherine Healy, "Local Legend Keeps on Painting," *The Pine Cone,* December 21, 1972; Inventory of American Paintings, Smithsonian Institution; Monterey Public Library; Carmel Public Library.

During the early 1930s when Burgdorff was painting backgrounds for Yosemite's Museum, he told Park Service employee Elizabeth Godfrey about his early years in the Southwest. His first painting, he said, was sold to the Santa Fe Railway Company. Subsequently the Santa Fe acquired seven more, including two of Canyon De Chelly in Arizona. The years 1907–1924 were productive of many Indian paintings. For three months in 1924, James Swinnerton joined him to paint at Walpi and Oraibi on the Hopi Reservation, and at the Grand Canyon.

Historical buildings, lighthouses, and other landmarks interested Burgdorff over the years. He was among the first to paint in the old mining towns. Of twenty Pacific Coast lighthouses he painted, fourteen were phased out in 1952. These paintings are not so well known as his numerous scenes of Pebble Beach and other scenic places on the Monterey Peninsula, but like the Indian paintings, they are historically as well as esthetically important.

Burgess, William Hubert (–1893)
B. England. D. Placer County, California. Work: California Historical Society, San Francisco. Gary F. Kurutz, "Eyewitness Letters, Sketches Tell Gold Rush Violence," *Cali-*

fornia Historical Courier, November-December 1976, 3; Gary F. Kurutz, "California Is Quite a Different Place Now/the Gold Rush Letters and Sketches of William Hubert Burgess," *California Historical Quarterly,* Fall 1977, 210-229.

Burgess left London in 1848 for the United States, settling first in New York City, and then in Boston. In 1849 he sailed around the Horn to San Francisco. He did some prospecting and worked as a jeweler for miners, then went to Hawaii. He soon returned and settled in West Point, Calaveras County. When the mines gave out, he taught for twenty-five years in San Francisco schools.

Burlingame, Sheila Ellsworth (1894-)
B. Kansas. AAA 1917 (Chicago, Illinois); AAA 1923-1924 (St. Louis, Missouri; summer, Denver, Colorado); AAA 1925 (Clayton, Missouri; summer, Denver); AAA 1927-1933 (Clayton; summer, Eldora, Colorado); Havlice; Mallett; WWAA 1936-1941 (Clayton; summer, Eldora); WWAA 1947-1948 (New York City); WWAA 1953-1959 (Provincetown, Massachusetts); WWAA 1962 (Northvale, New Jersey); Colorado College Library; Denver Public Library; Reinbach.

For more than two decades, Burlingame spent her summers in Colorado, first in Denver, and later in Eldora where she had a summer home. Though she also did sculpture, she is better known for her painting and her woodcuts.

Burliuk, David/Davidovich (1882-1967)
B. Kharkov, Russia. D. January 15. Work: Phoenix Art Museum; Philadelphia Museum of Art; Whitney Museum of American Art; University of Arizona Art Museum; Montclair (New Jersey) Art Museum; Metropolitan Museum of Art, etc. Havlice; Mallett; WWAA 1936-1947 (New York City and Brooklyn); WWAA 1953-1966 (Hampton Bays, Long Island, New York); Inventory of American Paintings, Smithsonian Institution.

Burliuk was briefly in the Southwest to do some landscapes, possibly as early as 1910.

Burnett, Eva Kottinger (1859–1916)

Work: San Jose Historical Museum. Monterey Peninsula Library.

Burnett studied at the College of Notre Dame in San Jose, California. She was active in the city from 1893 to 1903, and taught drawing during 1902 and 1903.

Burnley, John Edwin (1896–)

B. Victoria, British Columbia. Work: Seattle Art Museum. Havlice; WWAA 1959–1962 (Seattle, Washington); *Who's Who in Northwest Art.*

Burnley studied at the University of Toronto and at Cornish Art School in Seattle. Among his teachers were Eustace Ziegler and F. Tadama. He exhibited annually in Seattle where he directed and taught art at Edison Vocational School, and at his own school, Burnley School of Professional Art.

Burrows, Harold [Hal] Longmore (1889–1965)

B. Salt Lake City, Utah. D. New York City. Work: Alice Art Collection, Utah Institute of Fine Arts, Salt Lake City. AAA 1923–1925 (New York City; summer, Raquette Lake, New York); Fielding; Mallett; Young; Olpin; Salt Lake City Public Library art and artists' scrapbook; Salt Lake *Telegram*, March 12, 1916; Salt Lake *Tribune*, July 27, 1965.

Burrows left Utah in 1907 to study painting in New York. Among his teachers there were Mahonri Young, Robert Henri, and Walt Kuhn. Occasionally he returned to Utah to sketch and to visit, but not to exhibit. He had several solo shows in and around New York City where he was a life member of the New York Watercolor Club.

During the First World War Burrows was in Paris as staff artist for the original *Stars and Stripes.* From 1922 to 1958 he was an art director for Metro-Goldwyn Mayer's New York studios.

Bush, Agnes Selene (–)

B. Seattle. AAA 1921–1925 (Seattle); Fielding.

Bush studied with Paul Gustin and Ella S. Bush.

Bushnell, Della Otis (1858–1964)

B. Glenwood, Iowa, or New York State. D. Seattle, Washington, May 27. AAA 1923–1924 (Aberdeen, Washington); Mallett Supplement; Pierce; *Who's Who in Northwest Art;* Seattle Public Library art and artists' scrapbook; Hazelle Watson Moritz, "Mrs. Della Bushnell, Beachcomber Artist/Aberdeen Woman 78, Finds Subjects For Many of Her Works on Waterfront," Seattle *Times,* January 3, 1954; "Woman, 96 Today, Celebrates Mother's Day," Seattle *Times,* May 9, 1954; "Artist Still Painting at 98," Seattle *Times,* May 13, 1956; Obituary, Seattle *Times,* May 28, 1964; Joslyn Art Museum library.

Bushnell, whose age varies from source to source, taught art for sixty years. She was once quoted as saying, "Anyone can paint a pussy willow, but to put fur on it is a different thing." Her specialty was portraits, but in later years she turned to waterfront scenes. "Rain or shine" she was seen painting on Seattle's docks, wrote Moritz for the Seattle *Times* in January 1954.

Bushnell studied with John Laurie Wallace in Omaha, Nebraska, early in the century. She began exhibiting with the Omaha Art Guild, of which she was a member, in 1914, and continued to be a member after she left Nebraska—exhibiting with the Guild almost every year from 1925 to 1937 when she was in Aberdeen. From Aberdeen she may have moved to Idaho before beginning a teaching stint in Pullman. In 1949 she left Pullman for Seattle. She had one-man exhibitions in Aberdeen from 1937 to 1939, and one at the Washington Athletic Club in 1938. She was a member of Women Painters of Washington.

Butler, John Davidson (1890–)

B. Mauston, Wisconsin. AAA 1913 (New York City); Havlice; Mallett Supplement; WWAA 1936–1941 (Hume, Virginia); WWAA 1947–1962 (Philadelphia, Pennsylvania; Ossipee, New Hampshire); *Who's Who in Northwest Art* (Hume; formerly Seattle); Seattle Public Library art and artists' scrapbook; Pierce; Calhoun; Seattle *Town Crier,* October 17, 1914, 17; Adele M. Ballard, "Some Seattle Artists and Their Work," Seattle *Town Crier*, December 18, 1915, 25–35; University of Washington Library.

Butler, who received his bachelor of fine arts degree at the

University of Washington, grew up in Seattle. During the summer of 1914 he studied with William Merritt Chase in Carmel, California. He had a studio in one of the Seattle Fine Arts Society rooms, and, said Calhoun, he was one of the "leading spirits of the Society."

During the 1920s, Butler was in France for further study, but returned periodically to Seattle, and exhibited there every few years. His paintings were described as "rich in color and unusual in conception."

In 1929 Butler taught for a while at the University of Washington before moving to Virginia. In his later years he turned to crafts and taught at the Philadelphia Museum School of Art.

Butler, Robert Alcius (1887–1959)
B. Dallas, Texas. D. Dallas, February 26. Wilbanks, 22 (McAdoo, Texas).

Wilbanks called Butler "one of the first painters of truly professional stature to make his home on the plains." He had received his art training at Trinity University in Waxahachie where he won a scholarship to the University of Munich for the years 1907–1909. They were interrupted by his father's illness. To support the family Butler went into dry-land farming near McAdoo. Occasionally he did a few paintings, and eventually his farm home "was literally lined with them."

In 1948 Butler returned to Dallas where he exhibited locally and at state fairs.

Butterworth, Ellen (ca 1873–1959)
B. St. Charles, Minnesota. D. Seattle Washington, October 15. Seattle Public Library art and artists' scrapbook; "Ellen Butterworth, State Pioneer, Dies," Seattle *Post-Intelligencer*, October 19, 1959.

Butterworth grew up in Washington. She lived in Centralia from 1881 until about 1890 when she moved to Seattle. She was active as a water color painter, and as a photographer.

Byers, Ruth Felt (1888–)
B. Council Bluffs, Iowa. Work: Mercy Hospital, Beck School of Music, and Council Bluffs Public Library. AAA

1933 (Council Bluffs); Havlice; Mallett; WWAA 1938–1941 (Council Bluffs); Ness and Orwig, 1939; Bucklin and Turner, 1932; Joslyn Art Museum library.

Byers, a member of the Omaha Art Guild, exhibited with the Guild nearly every year from 1912 to 1937. She was a portrait and landscape painter, and an illustrator. Her specialty was portraits.

C

Cabanis/Cabiniss/Cabaness, Ethan T. (–)
Work: Sheldon Swope Art Gallery, Terre Haute, Indiana.
Sparks; Inventory of American Paintings, Smithsonian Institution.

Cabanis was a portrait and miniature painter who sketched scenery en route to California in 1849, and remained there until 1852. Previously he had lived in Springfield, Illinois, where he had been active since the 1830s. Listed in the Smithsonian's inventory are two portraits, one dated 1811 and the other 1845, the latter at Sheldon Swope Art Gallery.

Cadwalader, Louise (1843–)
B. Cincinnati, Ohio. AAA 1929 (Berkeley, California); Mallett; Clark, 446.

Cadwalader studied at the Cincinnati Art Academy and the Art Students League. Among her teachers were William Merritt Chase, Winold Reiss, and Ralph Johonnot. She was a member of the San Francisco Society of Women Artists.

Cady, Charles Henry (1886–)
B. Kearney, Nebraska. Bucklin and Turner, 1932 (Omaha, Nebraska); Joslyn Art Museum library.

Cady studied in Omaha with J. Laurie Wallace. He exhib-

ited with the Omaha Art Guild, of which he was a member, from 1922 to 1926, and again in 1932 when the Guild had an exhibition at Joslyn Art Museum. Two of his paintings are titled "Evening on the Elkhorn" and "A Bit of Nebraska."

Cahero, Emilio G. (1897–)
B. Vera Cruz, Mexico. O'Brien, 1935 (El Paso, Texas).
Cahero, who studied in France, Spain, and Italy, was active in Europe and Mexico before moving to El Paso in the early 1930s.

Calder, Nanette Lederer (ca 1867–1960)
B. Milwaukee, Wisconsin. AAA 1905–1906, 1909–1910 (Philadelphia, Pennsylvania); AAA 1923–1924 (Spuyten Duyvil, New York); *News Notes of California Libraries,* October 1910, 537; California State Library; Alexander Calder and Jean Davidson, *Calder, an Autobiography with Pictures,* New York: Pantheon Books, a division of Random House, Inc., 1966.
Nanette Calder was the mother of Alexander. His first recollection of her at work was when he was very young and had to pose for portraits.
Although the *Art Annual* shows Calder in Philadelphia in 1905–1906, she was in Oracle, Arizona, with a sick husband. During the fall of 1906 the Calders moved to Pasadena. There she found models among some Indians living on a ranch between Pasadena and Los Angeles.
From 1910 to 1913 the Calders lived in the East, and from 1913 to 1915 in San Francisco and Berkeley. The rest of Calder's career years were spent in New York where she was active well into the twenties. She was a member of the League of American Artists.

Calkins, Loring Gary (1884/87–1960)
B. Chicago, Illinois. D. Los Angeles, California, in June. Work: Yale University; Rye Public Library; Lake Mills (Wisconsin) Public Library; Yale Club, New York. AAA 1919 (Evanston, Illinois); AAA 1921 (Boston, Massachusetts); AAA 1923–1925 (Newton, Mass.); AAA 1927–1929

(Waban, Mass.); AAA 1931 (South Hingham, Mass.); Fielding; Havlice; Mallett Supplement; WWAA 1936–1941 (Hingham, Mass.); WWAA 1947–1959 (Los Angeles); WWAA 1962 obit.

Calkins was a bookplate designer, etcher, illustrator, and teacher who began exhibiting regularly in 1902.

Call, Mary E. (ca 1874–1967)

B. Algona, Iowa. D. San Anselmo, California, December 29. Work: Scottish Rite Hall, Los Angeles, California. AAA 1917 (Old Lyme, Connecticut); Golden Gate International Exposition, 1939, exhibition catalogue; Santa Cruz Art League, 2nd and 7th Annual exhibition catalogues, 1929 and 1934, respectively; L. Mason, Pacific Grove, California.

Call studied in New York City with William Merritt Chase and others, and in Paris. She painted abroad and in the East before moving to California early this century. Her residence of many years was in San Anselmo near San Francisco Bay. Titles of paintings such as "Point Loma," "Morning Mists," and "Fishing Boats" are typical of the subjects she chose to paint. "Fishing Boats" is reproduced in the Golden Gate International Exposition catalogue of California artists.

Callcott, Frank (1891–)

B. near San Marcos, Texas. Work: Metropolitan Museum of Art; Dallas Museum of Fine Arts; West Texas Museum, Texas Technological College; Southwestern University, Georgetown, Texas; Columbia University. Havlice; Mallett; WWAA 1938–1941 (New York City; summer, Londonderry, Vermont); WWAA 1947–1956 (New York City); WWAA 1959–1962 (Georgetown, Texas); San Antonio Public Library; Houston Public Library art and artists' scrapbook; "Texas Artist Recognized," Houston *Post*, April 2, 1936.

Callcott's contribution to Texas painting and printmaking has been considerable despite his lengthy residence in New York where he taught at Columbia University. Some of his Texas work ran in series, and was historically oriented. A series during the

1930s included buildings then standing that were landmarks in the state's war for independence. Several of them were shown in the Fourth Exhibition of the Bronx Artists Guild. His lithograph of the Alamo won a place of honor.

During the 1950s Callcott worked on a series of oil paintings depicting the life and customs of Texans living in the hill country where he grew up. This series is comprised of landscapes, buildings, and portraits as well as genre scenes.

Cambuston, Henri (–ca 1861)
B. France. D. Stockton, California. Monterey Peninsula Art Museum docent library; Spangenberg, 15; Hoag, 11.

Cambuston may not have left any work to posterity. He was a very early drawing teacher in Monterey, California, who was brought there from Mexico in 1841 to teach the Spanish children topography, mathematics, French, and drawing. About 1849 he moved to San Francisco.

Camfferman, Margaret T. Gove (1881–1964)
B. Rochester, Minnesota. Work: Seattle Art Museum. AAA 1921-1933 (Langley, Washington); Havlice; Mallett; WWAA 1936-1962 (Langley); Collins; *Who's Who in Northwest Art;* Kingsbury, 1972.

Camfferman, who had extensive training in Minneapolis, New York, and Paris, began exhibiting in Pacific Coast cities in 1929. She exhibited annually with North West Artists from 1932 to 1951. In 1935 she was given a solo exhibition at the Seattle Art Museum where one of her oils is in the permanent collection. It is a landscape titled "View from Old Homestead Ranch." Her husband, Peter Camfferman, was also an artist [AAW v. I].

Candlin, Abigail [Abbie] (1885–)
B. Farmington, Wisconsin. AAA 1933 (Long Island City, New York); Havlice; Mallett; WWAA 1936-1941 (Long Island City); Denver Public Library.

Candlin was a water color artist who was active in Denver before moving to New York. She was awarded honorable mention for a work exhibited at the Denver Art Museum in 1930.

Cantabrana, Emily Edwards (See: Edwards)

Capps, Charles Merrick (1898–)
B. Jacksonville, Illinois. Work: Corcoran Gallery of Art; Joslyn Art Museum, Omaha; Swedish National Museum, Stockholm; Carnegie Institute; Library of Congress; Museum of New Mexico, Santa Fe; Philbrook Art Center, Tulsa. AAA 1931 (Wichita, Kansas); Havlice; Mallett; WWAA 1936–1962 (Wichita); AAW v. I; *American Artist*, June 1945, 25; "American Places," Corcoran Gallery of Art catalogue, December 1979; NMAA-NPG Library, Smithsonian Institution.

Capps is known for his etchings, lithographs, and aquatints of Western scenes. "Into the Hills," a New Mexico subject done in 1947, is an aquatint exhibited at the Corcoran's American Places show in 1979; it elicited the following comment: "Capps concentrates on the clear light that warms the walls of the adobe nestled in the foothills of the mountain range." "Harvest Moon," another aquatint, was used by *American Artist* to illustrate an example of successful depiction of moonlight.

Carew, Kate (Mary Williams Chambers Reed) (1869–)
B. Oakland, California. AAA 1907–1910 (New York City); Benezit (San Francisco); Monterey (California) Peninsula Museum of Art docent library; Marjorie Warren, "Kate Carew, Blessed by Great Memories Lives Happily in Her Mesa Studio," Monterey Peninsula *Herald*, July 13, 1943; Monterey Public Library; *News Notes of California Libraries*, April 1920.

Carew grew up in Placer County, California, as Mary Williams. She studied with Arthur Mathews in San Francisco; at the William Merritt Chase School in New York; and in Paris and London. Her mediums were oil, water color, and black and white which she used mainly for caricatures. She became very well known as a newspaper artist, first in San Francisco in 1895 when she went to work for the San Francisco *Examiner*, and then in New York. In 1911 the New York *World* sent her to London to interview famous people and do caricatures of them. She married in London, and after 1921 was no longer active as a newspaper artist. In 1943 she purchased a studio in Monterey.

Carew exhibited at the World Columbian Exposition in Chicago in 1893, at the Paris Salon, and at the Del Monte Hotel near Monterey.

Carlsen, (Soren) Emil (1853–1932)

B. Copenhagen, Denmark. D. New York City, January 2. Work: Metropolitan Museum of Art; Corcoran Gallery of Art; Toledo Museum of Art; National Museum of American Art; Smith College Museum of Art; Colby College; University of Oregon Museum of Art; Art Gallery of Toronto; St. Louis Art Museum; Fine Arts Gallery of San Diego; Santa Barbara Museum of Art; Art Institute of Chicago, etc. AAA 1898–1931 (New York City); Benezit; Fielding; Havlice; Mallett; AAW v. I; Earle; Gertrude Sill, "Emil Carlsen/Lyrical Impressionist," *Art & Antiques,* March–April 1980, 88–95; Gerdts and Burke, 1971; *California Art Research,* v. IV; Inventory of American Paintings, Smithsonian Institution; Weber.

During his career Carlsen commanded for his paintings prices comparable to those of his friends Chase, Hassam, and Twachtman, all early American impressionists like himself. He "did not deserve the obscurity" his work "so long endured," wrote Gertrude Sill.

Carlsen came to this country in 1872, living first in Chicago. Between 1886 and 1902 there were brief periods in San Francisco where for several years he was director of the California School of Design from which he resigned in 1889.

Carlsen's formal training was in architecture; as a painter he was mostly self-taught.

Carlson, John Fabian (1875–1945)

B. Kolsebro, Smaland, Sweden. D. March 20. Work: National Museum of American Art; Colorado Springs Fine Arts Center; Corcoran Gallery of Art; Metropolitan Museum of Art; Pasadena Art Museum; Fort Worth Art Center; Akron Art Institute; Springville (Utah) Museum of Art, etc. AAA 1907–1908 (New York City); AAA 1909–1910 (Caldwell, New Jersey); AAA 1913–1933 (Woodstock, New York); Benezit; Fielding; Havlice; Mallett; WWAA 1936–1941 (Woodstock); AAW v. I; Earle; Gary Michael, "The

Ultimate Harmonist," *Southwest Art,* December 1978, 66–75; L. Gilpin, "The Broadmoor Art Academy," Colorado Springs *Telegraph,* April 24, 1920; Colorado Springs Fine Arts Center library; NMAA-NPG Library, Smithsonian Institution.

In April 1920 Carlson made his first trip West. The occasion was to look over Julie Penrose's house and grounds at 30 West Dale, Colorado Springs, which she was making available for an art school. The Colorado Springs Fine Arts Center now stands where Carlson began teaching landscape painting in June. Named the Broadmoor Art Academy at Spencer Penrose's suggestion, though it was quite a distance from his famous hotel, it got off to a good start, and Carlson returned to teach the following summer. In 1922 he founded the John F. Carlson School of Landscape Painting in Woodstock which attracted many pupils from the West as well as the rest of the country. In 1928 he published *Elementary Principles in Landscape Painting.*

Committed to the belief that one painted best what one knew best, Carlson urged his students to specialize in painting the regions where they lived. Though Western mountains inspired a number of Carlson's paintings, scenes close to his home in Woodstock predominate. In describing Carlson in an exhibition brochure, John Pike said he was "a man who knew his hills from the deepest hair root to the topmost crag and leaf . . . plus the reasons why."

Carlson, Margaret Mitchell (1892–)
B. Deming, Washington. AAA 1921–1925 (Mill Valley, California); Fielding; Dodds, Master's thesis, 108; Calhoun, 15; Hanford, 642; Seattle *Town Crier,* December 5, 1914, 15; December 19, 1914, 31; October 23, 1915, 7; Adele M. Ballard, "Some Seattle Artists and Their Work," Seattle *Town Crier,* December 18, 1915, 25–35; University of Washington Library.

While living in Seattle where she studied with Ella Bush and Gertrude Little, Carlson [then Mitchell] showed promise as an illustrator. In 1915 she shared a studio with Little. Later she studied at the Art Students League, the National Academy of Design, and the Pennsylvania School of Design. In time she became nationally known as an illustrator.

Carpenter, Ellen M. (1831/36–ca 1909)

B. Killingly, Connecticut. Benezit; Fielding; Mallett; Groce and Wallace; Clement and Hutton, v. I, 1899, 1969; Frances E. Willard and Mary A. Livermore (eds.), *Woman of the Century/1470 Biographical Sketches...*, 1893.

Carpenter, a well-known Boston art teacher in her time, studied in England and at Lowell Institute. She traveled widely for landscape subjects, including Paris in 1867 and 1873, California, the South, and other parts of the United States.

Clement and Hutton list five of Carpenter's best paintings, of which one is "A View from Mariposa Trail of the Yosemite Valley."

Carr, J. R. (–)

B. New York. Fisk, 1928 (Waco, Texas); Smith, 1926 (Waco).

Carr began the study of art at an early age, followed by advanced study at the Beaux Arts in Paris, and in Rome, Italy. He traveled extensively, and according to Fisk, "exhibited widely and with distinction." He opened a studio in Waco where he taught art and served as president of the Waco Art Association during the 1920s. His specialty was landscapes and marines.

Carrigen/Carrigan, Thomas G. (1896–1967)

B. East Chicago, Indiana. Mallett Supplement (Casper, Wyoming); M. Barr, 46.

Carrigen, who was self-taught, opened a commercial art studio in Casper in 1920. He exhibited etchings and water colors in Wyoming during the 1920s and 1930s.

Carroll, John Wesley (1892–1959)

B. Wichita, Kansas. D. Albany, New York, November 7. Work: Whitney Museum of American Art; Detroit Institute of Arts; Pennsylvania Academy of Fine Arts; Los Angeles County Museum of Art; John Herron Museum of Art. AAA 1923–1933 (Woodstock, New York); Fielding; Havlice; Mallett; WWAA 1936–1959 (East Chatham, New York); Harry Salpeter, "John Carroll: Non-Conformist," *Esquire,* August 1938, 65–68, 157–159; Augusta Owen

Patterson, "The Art Creed of John Carroll," *International Studio,* February 1926, 75-79.

Carroll, sometimes referred to as "the boy from the West," grew up in San Francisco, and on a nearby ranch where he spent summers. He steeped himself in cowboy lore, learned cowboy songs, rode the range, and in later years he acquired a farm near East Chatham, New York, where he raised beef cattle.

Carroll's California years included three years at the Mark Hopkins Art Institute, two years at the University of California, and six months as a sketch artist for an Oakland newspaper in 1913 when he was twenty-one.

Carson, Emma C. (-)
Work: Alice Art Collection, State of Utah. AAA 1900 (Salt Lake City); Utah Art Institute, Second Annual Report, 1900, 21, 27; Salt Lake City Public Library.

Carson's painting "Road Through the Forest" was one of the first acquisitions in the art collection of the state of Utah. In return she was elected to life membership in the Utah Art Institute.

Cartwright, Isabel Branson (1885-)
B. Coatesville, Pennsylvania. Work: Museum of Northern Arizona, Flagstaff; Moore Institute of Art, Philaelphia. AAA 1915 (Coatesville); AAA 1921-1933 (Philadelphia); Fielding; Havlice; Mallett; WWAA 1936-1953 (Philadelphia); Collins; NMAA-NPG Library, Smithsonian Institution; M. S. Lilly, 1929, 345; *The Literary Digest,* February 7, 1931 and January 21, 1933; Witte Memorial Museum library, San Antonio, Texas.

Cartwright was a Philadelphia portrait painter who entered the Texas Wild Flower exhibitions of 1928 and 1929. She was awarded $1500 for "Cotton Picking Time" in 1928, and $1750 for "Wild Poppies" in 1929. The February 7, 1931, *Literary Digest* reported that she had been spending part of each year in Texas.

Case, Harriet M. (1877-)
B. Rawlins, Wyoming. *Who's Who in Northwest Art* (Seattle, Washington).

Case was a water color painter and craftsman who had

studied at the University of Washington, and was a member of Women Painters of Washington.

Casella, Alfred (1886–1971)

B. California. D. San Francisco, March 9. AAA 1919–1924 (San Francisco, California).

Casenelli/Casnelli, Victor (1867/68–1961)

B. New York City. D. about November 17, probably in Muskegon, Michigan. Work: Jackson (Michigan) Public Library; Robert F. Rockwell Foundation. Mallett Supplement (North Muskegon, Michigan); Omoto, *Early Michigan Paintings* exhibition catalogue, 36–37; Inventory of American Paintings, Smithsonian Institution; Archives of American Art, D23, 150–224, Smithsonian Institution.

Casenelli studied briefly with Henry F. Farny while living in Cincinnati. When his studio burned in 1904, he moved to Muskegon. His Western paintings appear to have been made between 1905 and 1915. Titles of record include "Yellowstone Country, Montana," a water color painted about 1910, and "Indian Encampment," an undated oil. The latter, which was exhibited at the Denver Art Museum in the early 1980s, is signed "Casnelli." Casenelli exhibited at Hackley Art Gallery in Muskegon in 1913 and 1951.

Cash, Idress (1893–)

B. Keytesville, Missouri. England, Master's thesis.

Cash, an assistant professor of art at Oklahoma State University in Stillwater, had studied at the University of Chicago, the Art Institute of Chicago, Oregon University, Ohio State University, Alfred University, and Colorado Springs Fine Arts Center.

Catherwood, Frederick (1799–1854)

B. London, England. D. September 27 when the *SS Artic* sank en route to New York City. Work: British Museum; Yale University Art Gallery. Benezit; Groce and Wallace; Havlice Supplement; AAW v. I; Houfe; Mallalieu; Cummings 1969, 246–247; Oakland Art Museum library; E. O.

C. Ord, *The City of the Angels,* edited by Neal Harlow, San Marino: The Huntington Library, 1978.

Catherwood had many attainments. He worked as an architect in New York City in 1836. In 1839 he went to Central America to record Mayan antiquities, and while he was there he worked as a railway engineer. In 1844 he published *Views of Ancient Monuments in Central America.* En route to California in 1850 he was a fellow passenger of General Ord on the steamer *California.*

While Catherwood was living in New York, he was made an honorary member of the National Academy of Design. Upon his demise, the secretary of NAD wrote that he was a man "of high attainments as an architect, and of great general information." He was also a painter, an illustrator, and an engraver.

Chabot, Mary Vanderlip (1842–1929)
B. Gonzales, Texas. D. San Antonio, Texas. O'Brien, 1935.

Chabot was a resident of San Antonio where she studied with Robert Onderdonk. She exhibited in Texas and Mexico, winning medals in both places.

Challoner, William Lindsay (1852–1901)
Work: Oakland Art Museum; Louisiana State Museum; Mariners Museum, Newport News, Virginia; private collection. Inventory of American Paintings, Smithsonian Institution.

Challoner is not listed in standard art directories, but forty-two of his paintings are listed in the Smithsonian's inventory. Among them are "San Francisco Bay" and "Harbor of Yaquina, Oregon," oils dated 1887, and "Mount of Holy Cross," an oil dated 1900. Most of Challoner's listed paintings are in the Mariners Museum.

Chamberlain/Chamberlin, Curtis (–)
Denver Public Library; *The Woman Voter,* April 25, 1895; Bromwell Scrapbook, 3, 6; Hafen (1948), v. II, 426.

Hafen lists Chamberlain as a designer and letterer active in Denver. He served on a jury of award for the Artists' Club's second annual exhibition in 1895, and may be the C. V. Chamberlin mentioned in the Rocky Mountain *News,* July 27, 1883, 6, as having exhibited some paintings in Denver. He may also be the

Chamberlain listed in the 1923-1924 *American Art Annual* as living in Laguna Beach, California.

Chamberlain, Judith (1893-)
B. San Francisco, California. AAA 1919-1921 (San Francisco); Benezit; Fielding.

Benezit, which mentions that Chamberlain exhibited at the Salon of the Independents in 1923, gives her place of birth as Portland instead of San Francisco.

Chambers, Mary Williams (See: Kate Carew)

Champ, Ada/Ida K. Farnsworth (1857-1921)
B. Illinois. D. San Diego, California, December 12. Ness and Orwig, 1939; Hoye's Directory of Lincoln City, Nebraska, 1891.

Listed as Ida Farnsworth in the Lincoln City Directory, Farnsworth lived in Iowa prior to opening a studio in Lincoln. In 1891 she married Clark Champ, moved to St. Joseph, Missouri, and then to San Diego where she was active until her death.

Champney, Edouard Frère (-)
AAA 1903-1906 (Washington, D.C.; 1905-1906 listed under Architects); Seattle *Town Crier*, October 23, 1915, 7; December 16, 1916, 26; June 16, 1917, 14; December 1, 1917, 8; December 15, 1917, 36; March 22, 1919, 6; February 7, 1920, 10; February 11, 1922, 11; University of Washington Library.

Champney, an architect, was also active as a painter. He exhibited at the Seattle Fine Arts Society, and at the Northwest Artists' Annual. He was the son of artist James Wells Champney (1843-1903) and author Elizabeth W. Champney (1850-1922) who wrote several books on European art and architecture. Champney probably was named for Edouard Frère, a teacher in France with whom his father studied. The Champney family lived in Paris at different times, and Edouard Champney entered Ecole des Beaux Arts there in 1898.

Champney, James Wells [Champ] (1843-1903)
B. Boston, Massachusetts. D. New York City, May 1. Bos-

ton Museum of Fine Arts; Smith College Museum of Art; Chicago Historical Society; New York Historical Society, etc. AAA 1898–1900 (New York City); Benezit; Fielding; Havlice; Mallett; Karolik Collection Catalogue, 98–99; Taft, 314, fn. 1; Inventory of American Paintings, Smithsonian Institution.

Champney was assigned by *Scribner's* Monthly in 1873 to portray the South as it looked ten years after the Civil War. Taft, who refers to Champney as "T. Willis" instead of James Wells, said he also visited Texas and Kansas. In Kansas he eloped with Elizabeth Williams. Two Indian paintings by Champney in the Smithsonian's Inventory bear the same title, "Portrait of Minimic (War Chief of the Southern Cheyenne Indian Tribe)."

Chancellor, H. (–)
Work: National Park Service, Yellowstone National Park; Bancroft Library, University of California. Baird, 1968, 10–11, mimeo.; Inventory of American Paintings, Smithsonian Institution.

Five water colors at Bancroft by Chancellor, bearing dates from May 9 to May 29, 1884, are of Yosemite Valley, San Francisco, and Vancouver Island. "Mammoth Hot Springs and Bunsen Peak" in the Yellowstone National Park collection is dated June 1884. All are a fraction over $4\frac{1}{2} \times 6\frac{1}{2}$ inches.

Chandor, Douglas (1897–1953)
D. Weatherford, Texas, January 13. Mallett Supplement (Weatherford); WWAA 1953 obit; Archives of American Art, Smithsonian Institution.

Chandor was a portrait painter whose home was in Weatherford. His personal papers, newspaper clippings, and photographs have been lent to the Archives of American Art where they are being filmed for distribution to the various regional centers.

Chapin, C. H. (–)
Work: First National Bank of Chicago. New York Business Directory 1872–1873; Los Angeles City Directory 1887; Art Inc./American Paintings from Corporate Collections, Montgomery Museum of Fine Arts, 1979, 74–75; Karolik

Collection Catalogue, 102; Inventory of American Paintings, Smithsonian Institution.

Business directories show Chapin active in New York in 1872 and in Los Angeles in 1887. At least one artist in this volume of *Artists of the American West* studied with him — Virginia Leslie of Texas.

A large painting by Chapin titled "Lower Falls, Grand Canyon" is owned by the First National Bank of Chicago. Dated 1886, it was painted in water color and tempera. An undated painting titled "A Mountain Lake" is mentioned in the Karolik catalogue.

Chapman, Charles Shepard (1879–1962)

B. Morristown, New York. D. Leonia, New Jersey, December 15. Work: Metropolitan Museum of Art; Cleveland Museum of Natural History; Montclair Art Museum; Mead Art Gallery, Amherst College; Library of Congress; National Museum of American Art. AAA 1905–1906, 1909–1910 (New York City); AAA 1919–1924 (Leonia); AAA 1925–1933 (Leonia and New York City; summers, Morristown); Benezit; Fielding; Havlice; Mallett; WWAA 1936–1962 (Leonia and New York City; summers, Morristown); "Charles S. Chapman, North Country Artist," Ogdensburg (New York) *Journal,* June 22, 1951; W. G. P[urcell], "Charles S. Chapman," *Northwest Architect,* v. xii, no. 4, 1948, 3–6; "Exhibition of Water-Oils," a pamphlet in vertical file, NMAA-NPG Library, Smithsonian Institution.

Chapman liked to maintain he was self-taught, and so he was when speaking of his "Water-Oils," a technique described in the pamphlet just referred to. First he floated thinned oil colors on water; then he laid his paper down upon the "floated design." The underside of the paper absorbed the oil colors, leaving an expressive work Chapman associated with music in its appeal to the senses.

Chapman did many representational illustrations and easel paintings with the conventional technique he learned in art school, polished by years of experience. He liked to get the feel of whatever he wished to paint. His forest paintings were based on experience as a "culler" in a lumber camp ninety miles north of Ot-

tawa, and a trip to the redwood forests of California, the latter made in 1923.

About 1938 Chapman headed for the North Rim of the Grand Canyon for a month of painting. He also did numerous landscapes of ranches and the Snowy Range in Wyoming.

Chapman, Kenneth Milton (1875–1968)

B. Ligonier, Indiana. D. Santa Fe, New Mexico, February 23. Work: Museum of New Mexico, Santa Fe; Santa Fe Railway Collection. AAA 1919–1931 (Santa Fe); Benezit; Fielding; Havlice; Mallett; WWAA 1936–1962 (Santa Fe); AAW v. I; Ina Sizer Cassidy, "The Man Who Revived Indian Art," *New Mexico* Magazine, October 1955, 30, 47; Robertson and Nestor; Santa Fe Public Library.

Chapman had not got beyond the use of black and white at the Art Institute of Chicago when the death of his father made it necessary for him to obtain steady work to help his family. When ill health from overwork forced him to take a rest, he began experimenting with water color. About 1899 he moved to Las Vegas, New Mexico, where he painted local scenes. When Dr. Edgar Hewett saw some of them, he offered Chapman a position in the art department of New Mexico Normal University.

Chapman's association with Hewett led to a lifelong interest in Southwest Indian pottery. Time spent writing and speaking on the subject significantly reduced his production of paintings. Such paintings as are extant depict, for the most part, life of New Mexico Indians at the turn of the century, and the remnants of New Mexico's ancient culture.

Chapman, Ottis F./Otto (–)

Work: Washington State Historical Society; Starrett House, Port Townsend, Washington. Havlice; Harper, 1970; LeRoy, 1965 exhibition catalogue; newspaper clipping from *Southender,* September 2, 1981, p. 4, n.p.

Apparently the "Otto" Chapman who painted a frescoe on a ceiling in the Starrett House in Port Townsend is the Ottis F. Chapman referred to by Havlice, Harper, and LeRoy. The fresco is "said to be the last surviving work on the West Coast by New York artist Otto Chapman," wrote the *Southender.* However, an oil painted about 1880, titled "Freeport," is in the collection of the

Washington State Historical Society. Harper, who described Chapman as "artist, frescoer, and agent for paintings," shows him active in Victoria, British Columbia, during 1891, and in 1892 when he married a Miss Emma C. Kelly.

Chase, Marion Monks (1874–)
B. Boston, Massachusetts. Work: Fogg Museum of Art, Harvard University; Museum of the City of New York. AAA 1917–1921 (Cambridge, Massachusetts); AAA 1923–1927 (Boston); Fielding; Havlice; Mallett; WWAA 1936–1941 (Beverly Farms, Massachusetts; WWAA 1947–1953 (Carmel, California).

Chase, W. Corwin (1897–)
B. Seattle, Washington. Work: Seattle Public Library; Georgia Hotel, Vancouver, British Columbia; Warden's office, McNeil Island. *Who's Who in Northwest Art* (Kirkland, Washington).
Chase, a self-taught artist whose specialty was multicolor block printing as practiced by the Japanese, had solo exhibitions in Seattle, at the Honolulu Academy of Arts in 1931, and at the Art Barn in Salt Lake City in 1936. He also worked in oil and water color.

Chase, William Merritt (1849–1916)
B. Franklin, Indiana. D. New York City, October 25. Work; Metropolitan Museum of Art; Dallas Museum of Fine Arts; Cleveland Museum of Art; Fogg Museum of Art, Harvard University, etc. AAA 1898–1915 (New York City); AAA 1917, obit.; Benezit; Fielding; Havlice; Mallett; Earle; Spangenberg; Katherine Metcalf Roof, *The Life and Art of William Merritt Chase*, New York: Hacker Art Books, 1975.
Chase, who was engaged to teach a summer class in Carmel, California, in 1914, procured a studio in nearby Monterey and painted California landscapes. Upon returning to the East he scoffed at the idea of stopping off at the Grand Canyon. Nevertheless, he did stop and is said to have found the experience a moving one.
In 1915 Chase returned to California for the Panama-

Pacific International Exposition in San Francisco where a large exhibition of his work was on view in a room reserved especially for him.

Cheetham, Mrs. E. E. (–)
Van Stone, 1924; Santa Fe Public Library; exhibition brochures at the Museum of New Mexico library, Santa Fe.

Cheetham, who lived in Taos, exhibited paintings of local scenes from 1917 to 1936.

Cheney, John (1801–1885)
B. South Manchester, Connecticut. D. South Manchester, August 20. Benezit; Fielding; Groce and Wallace; *Dictionary of American Biography.*

Cheney was best known for the fine engravings he made prior to 1857 when the demand for engravings was over. Up to that time, he had traveled extensively in this country and in Europe filling commissions for New York publishers.

From 1872 to 1874 Cheney was in California. A lithographer, as well as a portrait painter and an engraver, two of his prints were exhibited at the Panama-Pacific International Exposition in San Francisco in 1915.

Cheney, Philip (1897–)
B. Brookline, Massachusetts. Work: Boston Museum of Fine Arts; Yale University; New York Public Library; Valentine Museum, Richmond, Virginia; Library of Congress; Honolulu Academy of Art. Havlice; Mallett; WWAA 1936–1939 (Bayside, Long Island, New York); WWAA 1940–1953 (Wilmington, Vermont); WWAA 1956–1962 (Warrenton, Virginia); Park and Markowitz, 1977, 86; NMAA-NPG Library, Smithsonian Institution; "WPA Exhibition of Art Opened at D.C. Library," Washington *Post,* May 3, 1936.

Cheney was active in the West in the early 1930s. A lithograph of a Colorado scene in the Library of Congress was done during his association with the WPA program.

Cheney, Russell K. (1881–1945)
B. South Manchester, Connecticut. D. Kittery, Maine, July

12. Work: Museum of New Mexico, Santa Fe; Newark Museum; San Francisco Museum of Art; Wadsworth Atheneum, Hartford, Connecticut; National Museum of American Art, Smithsonian Institution. AAA 1913 (Paris, France); AAA 1919-1933 (South Manchester); Benezit; Fielding; Havlice; Mallett; WWAA 1936-1941 (Kittery); WWAA 1947, obit.; AAW v. I; F. O. Matthiessen, *Russell Cheney 1881-1945: A Record of His Work*, New York: Oxford University Press, 1947; "Russell Cheney Exhibit Attracts Throngs," Colorado Springs *Gazette*, February 25, 1923; *Western Artist*, June 1935, 14; Colorado College Library; Colorado Springs Fine Arts Center; Museum of New Mexico library; NMAA-NPG Library, Smithsonian Institution.

Intermittent bouts with tuberculosis forced Cheney to leave New England for warmer, drier places such as Italy, Southern California, Santa Fe, and Colorado Springs. In 1918, in Colorado Springs, he painted "Ute Pass" and "Garden of the Gods." He returned frequently to paint, exhibiting regularly from 1920 to 1928 at the Broadmoor Art Academy.

Cheney spent the winter of 1929 in Santa Fe; in 1936 he exhibited at the Southwest Annual in Santa Fe, and according to *Western Artist* he also exhibited there in 1935.

Cheney's first work in California probably dates from about 1916 when he visited his sister in Santa Barbara. Painting trips emanated from there to various parts of Southern California whenever he visited her. His first work in Texas was probably his last; in 1943 he began spending time on a ranch near San Antonio and specializing in animal paintings.

Cherry, Jeanne d'Orge (1879-1964)
B. Lancashire, England. Monterey Peninsula Museum of Art docent library; Carmel Public Library; Monterey Public Library.

Cherry was a self-taught artist who took up painting in her later years while living in Carmel, California. She has been called a nonconformist painter whose decorative "mystical" landscapes defy classification as to style. She had solo shows at the Santa Barbara Museum of Art in 1957, and at the M. H. de Young Museum in San Francisco in 1962.

Chowen, Gladys Hatch (1889–1981)

B. Springfield, Massachusetts. D. Carmel, California, October 13. Monterey Public Library; Monterey Peninsula *Herald,* October 18, 1981, 4A, obit.

Chowen, whose specialty was flowers and landscapes in water color, had studied at Pratt Institute. She lived in Chicago for forty years before moving to the Monterey Peninsula in 1964.

Christensen, LuDeen (–)

Olpin, 1980; Horne, 1914, 54.

Christensen probably was born in Gunnison, Utah. She studied with James T. Harwood in Salt Lake City, and may have studied in Paris where she went in 1901. Shortly after her return to Utah she moved to San Diego where she was supervisor of art for the public schools. She does not appear to have been active as an exhibiting artist.

Church, Elsie G. (1897–)

B. Calgary, Alberta. *Who's Who in Northwest Art* (Seattle, Washington).

Clancy, Eliza R. (–)

AAA 1919 (Fort Worth, Texas); also known as Mrs. Charles Edwin Clancy.

Clark, Arthur W. (–)

AAA 1919 (Lawrence, Kansas).

Clark was an etcher. He may be related to A. N. Clark, mentioned in Reinbach as teaching a three-year course in the art department of Kansas University in the 1890s.

Clark, Eliot Candee (1883–1979)

B. New York City. Work: Dayton Art Institute; Fort Worth Art Center; Maryland Institute, Baltimore; Woodrow Wilson House, Washington, D.C. AAA 1898–1903 (New York City); AAA 1905–1906 (Paris, France); AAA 1907–1921 (New York City); AAA 1923–1933 (Kent, Connecticut); Benezit; Fielding; Havlice; Mallett; WWAA 1936–1959 (New York City); WWAA 1962–1978 (Charlottesville, Virginia); *American Magazine of Art,* August

1928, 460 and June 1929, 346; NMAA-NPG Library, Smithsonian Institution.

During the twenties and thirties Clark made trips to Arizona, New Mexico, Texas, California, and Wyoming for landscape subjects. The *American Magazine of Art* referred to him as "another desert bewitched Easterner" when he exhibited at the Biltmore in Los Angeles in 1928. The following year he won a thousand-dollar prize for his entry in the Texas Wildflower contest. In 1936 he exhibited fifty-one paintings in Fort Worth, among which were "Grand Teton – Rocky Mountains," "Rose Cactus – Arizona." "Live Oaks – Santa Fe," and "Indian Country – Wyoming."

Clark, Lucille (1897–)
B. Boulder, Colorado. Mallett Supplement (Seattle, Washington); *Who's Who in Northwest Art.*

Clark was a water color painter who studied at the University of Washington, and exhibited at the Seattle Art Museum in 1937 and 1939.

Clarke/Clark, John Louis (1881–1970)
B. Highwood, Montana. D. Cut Bank, Montana. AAA 1919, 1923–1924 (Glacier Park, Montana); AAA 1925 (Glacier Park; Culver City, California); Fielding; *Who's Who in Northwest Art* (Glacier Park); *Art World*, Chicago Evening *Post*, November 1, 1927, and March 20, 1928; "Deaf and Dumb Native Artist 'Discovered' by U. S. at Last," Washington Daily *News*, January 27, 1934; NMAA-NPG Library, Smithsonian Institution; Sternfels typescript, Butte-Silver Bowl Free Public Library, Butte, Montana.

Clarke, who became one of the "best portrayers of western wild life in the world" in sculpture, started out as a painter. He continued during his lifetime to do a few pastels, water colors and oils of Western scenes. In 1970 the Department of the Interior exhibited carvings and a few paintings. Of three oils painted in 1960 and 1962, one was 36 × 47. A water color was painted about 1940.

Clarke studied at Indian schools in Wisconsin and Montana, with Charles Russell, and at the Art Institute of Chicago

where he exhibited two wood carvings in 1927. He was of the Blackfoot Tribe.

Clarkson, Ralph Elmer (1861-1942)

B. Amesbury, Massachusetts. D. Orlando, Florida, April 5. Work: Chicago Historical Society; Art Institute of Chicago; National Academy of Design; University of Chicago; Newberry Library; National Portrait Gallery; University of Michigan. AAA 1898-1933 (Chicago; summer, Oregon, Illinois, from 1915); Benezit; Fielding; Havlice; Mallett; WWAA 1936-1941 (University of Illinois; summer, Oregon, Illinois); WWAA 1947, obit.; Sparks; *American Magazine of Art,* February 1921, 68.

Clarkson served on the International Jury for the Panama-Pacific Exposition in San Francisco in 1915, and spent at least one winter in California. The February 1921 *American Magazine of Art* reported he was painting there until spring. His specialty was portraits.

Clausen, Alfred Bruno Leopold (1883-)

B. Hamburg, Germany. AAA 1925 (Columbus, Ohio); Mallett Supplement (Fort Worth, Texas); O'Brien, 1935.

Clausen was active in Fort Worth from about 1930. His specialty was decoration and mural painting. According to O'Brien he planned to paint scenes of early Texas history.

Clausen, Peter Gui (1830-1924)

B. Denmark. D. probably Minneapolis, Minnesota. Work: Minnesota Historical Society; private collections. Groce and Wallace; Coen; Torbert, 17-18; Inventory of American Paintings, Smithsonian Institution.

Clausen, who studied at Royal academies in Copenhagen and in Stockholm, was active in Sweden as an artist and a restorer of frescoes before moving to Chicago in 1866, and to Minneapolis in 1867. He taught art in Minneapolis for almost thirty years, and painted landscapes of the general area. In 1884 he began a panorama that contained scenes of Yellowstone National Park, North Dakota farms, Northwest gold mines, Washington lumber camps, and Mount Rainier. His route was much the same

as that of the Northern Pacific Railroad. Completed about 1884, the panorama was shown in Minneapolis, St. Louis, Chicago, Boston, and New York, and judged a great success. Unfortunately it got no farther than Brooklyn where it was destroyed by fire. The loss was a disaster for Clausen who had financed the production with a mortgage on his home. After returning to Minneapolis he painted landscapes, portraits, and frescoes and, so far as is known, made no other trips to the West.

Cleaver, Mabel (1878–)
B. Wauwatosa, Wisconsin. *Who's Who in Northwest Art* (La Grande, Oregon).
Cleaver studied at State Normal School in Milwaukee, at the California College of Arts and Crafts in Oakland, and with Maude Wanker in Portland. She was a member of American Artists' Professional League with whom she exhibited.

Cloudman, John Greenleaf (1813–1892)
B. Newburyport, Maine. D. Bethel, Maine, October 11. Work: Portland (Maine) Museum of Art. Groce and Wallace; AAA v. I; William David Barry, "The Cloudman Family: Nineteenth Century Maine Painters," typescript at Portland Museum of Art; *A Century of Portland Painters 1820–1920,* July 1970 exhibition catalogue; Oakland Art Museum library; California State Library.
Cloudman has been referred to incorrectly as "John J." and "J. D." Recent research in Maine has cleared up the confusion. Long a resident of Portland where his family settled during his childhood, Cloudman first learned the joiners' trade, and then took up painting. He went to France in 1847 for a year of study. Shortly after his return he set out for California where he did some painting in 1852 and 1853. "Pomo Indians of California," an oil painted about 1852, is perhaps his best known painting of that period.

Coates, Ida M. (–)
Work: San Jose (California) Historical Museum. *News Notes of California Libraries,* January 1909; Monterey Public Library; San Jose Historical Museum.

Coates was active in San Jose in the early 1890s. In 1893 an oil painting entitled "Ideal Head" was exhibited at the World's Columbian Exposition in Chicago. Later in the decade she moved to San Francisco.

Cochran, Fan A. (1899–)
B. Booneville, Mississippi. England, Master's thesis.

Cochran who studied privately and also at Oklahoma City University lived in Oklahoma City a number of years. During that period she had six solo exhibitions there. In a group exhibition of Oklahoma artists in 1962 she won first prize with one of her water colors. Her paintings are said to be in a number of private collections.

Coe, Ethel Louise (1880–1938)
B. Chicago, Illinois. D. March 22. Work: Santa Fe Railway Collection; Vanderpoel Art Association; Municipal Art Collection of Chicago; Sioux City (Iowa) Art Center. AAA 1905–1933 (Chicago and Evanston, Illinois); Benezit; Fielding; Havlice; Mallett; WWAA 1936–1939 (Evanston); WWAA 1940–1941, obit.; AAW v. I; Earle; Jessica Nelson North, "Ethel L. Coe: A Disciple of Light," *American Magazine of Art*, September 1922, 308–312.

When Joaquin Sorolla exhibited at the Art Institute of Chicago in 1911, he became interested in the potential of some of the junior teachers of the Institute. Among them was Ethel Coe whose "feeling for color and light" and "fresh spontaneity" in her work he found especially promising. Coe was invited to study with him in Spain. Jessica North described for *American Magazine of Art* Coe's response to Sorolla's teaching.

Although Coe's career was that of a teacher who headed University art departments, she used her summer vacations and sabbaticals to paint professionally. Of interest here are her New Mexico paintings. About 1915 she went to Taos to paint Pueblo Indians. "Water Jar of Santa Clara" and "When Day Is Done" were shown in the dedication exhibition of the Museum of New Mexico in Santa Fe late in 1917. North's article deals with Coe's remembrances of Pueblo Indian life and the similarities she found among the Moors during a more recent painting trip to Morocco.

Coffman/Cauffman, Lara Rawlins (See: Lara Rawlins)

Colbert, F. Overton (1896–1935)
B. Riverside, Oklahoma. D. Fort Lyon, Colorado, March 20. AAA 1923–1924 (Calera, Oklahoma); Benezit; AAW v. I; *Art News,* January 1, 1921, 2; *Art Digest,* January 1, 1933, 32; Oklahoma City Public Library vertical file, especially "Fantasy of Indian Legends Shown In Paintings of Chickasaw Youth," October 17, 1922, n.p.

Colbert grew up in Oklahoma near the Red River, worked as a cowpuncher, served in the First World War as a sailor, and then studied at the New York School of Fine and Applied Arts. He exhibited in New York City and in European cities. *Art News* in 1921 described him as a "good colorist and draughtsman" who "knows well the subjects he essays to portray and so presents with sympathy." His subjects dealt mainly with Southwest Indian cultures. Later they became a matter of controversy among Pueblo artists who criticized him for straying outside his tribe for inspiration.

Benezit, which lists Colbert's given names as Francois-Overton-Redfeather, notes that he exhibited at the Salon d'Automne in 1923, and with the Independents in 1926. He was a member of the League of American Artists.

Cole, George Townsend (1874–1937)
B. San Francisco, California. D. Los Angeles, California, October 4. AAA 1915, 1923–1925 (Los Angeles); Fielding; AAW v. I; Hartmann, 1934, 323; Helen Comstock, "An Artist Finds a Desert," *International Studio,* August 1922, 359–362; "An Artist's Conquest of the 'Painted Desert,' " Christian Science *Monitor,* May 5, 1922; New York *Times,* October 5, 1937, 25/4; NMAA-NPG Library, Smithsonian Institution.

Cole was not a full-time painter, but he attracted considerable attention in the early twenties with his Southwestern landscapes. He painted at the site because, as Comstock wrote, he wished to capture the geologic and atmospheric aspects of the Southwest. He used as a mainstay for his compositions the rock formations of Navajoland, wrote Hartmann; his choice of subject

matter enabled him to keep "pace with the modernistic movement."

In order to roll his on-the-spot paintings without their cracking, Cole used a technique learned from his Norwegian teacher Fritz Thaulow. The canvas was prepared to accept gouache or watercolor paint. To the pigments he added a medium containing egg white and a little glycerine. The *Times* obituary referred to the "curious" technique as "a combination of oil and water color."

Cole, Gladys (See: Gladys Cole Dawe)

Cole, Joseph Foxcroft (1837–1892)
B. Jay, Maine. D. Winchester (now part of Boston), Massachusetts, May 2. Work: Boston Museum of Fine Arts; Bowdoin College Museum of Art; William A. Farnsworth Library and Art Museum; National Museum of American Art; Detroit Institute of Arts; Robert B. Honeyman, Jr., Collection, Bancroft Library, University of California, Berkeley. Benezit; Fielding; Groce and Wallace; Mallett; Wayne Craven, "J. Foxcroft Cole (1837–1892): His Art, and the Introduction of French Painting to America," *American Art Journal,* Spring 1981, 51–71; Boston Museum of Fine Arts Memorial Exhibition of the works of J. Foxcroft Cole with introduction by Frederic P. Vinton, 1893, at NMAA-NPG Library, Smithsonian Institution.

Cole's California paintings appear to be more numerous, and his visits to the state more lengthy than previously reported. It was Cole's concern for his wife's health that took him to Southern California periodically from about 1880 to 1885 when he settled there. Not long afterward she died and he returned to Winchester.

The memorial exhibition catalogue listed 206 oils and water colors. Many were scenes, including the missions, between Santa Barbara and San Juan Capistrano, and a few were of the Sierra Nevadas. The rest were mostly European and Eastern scenes.

Cole had spent many years abroad and was not well known in this country when Vinton remarked in the introduction to the

catalogue that Cole's work showed "the quiet repose of nature" and was "of decided merit."

Cole, Sidney Herman (1865–)
B. Viola, Iowa. Bucklin and Turner, 1932 (Omaha, Nebraska); Joslyn Art Museum library.
Cole, who exhibited with the Omaha Art Guild in 1922, was a self-taught landscape painter whose principal vocation was sign painting.

Coleman, Harvey B. (–)
B. New York. Fisk, 1928 (Fort Worth, Texas); O'Brien; California *Arts & Architecture*, December 1932, (Los Angeles).
Coleman, who was mostly self-taught, married the artist Mary Darter of Fort Worth. Previously he had lived in California. Following marriage they exhibited together in Los Angeles where their landscapes found ready buyers in the Hollywood film colony, said Fisk. They also exhibited together in Arizona.

Coleman, Marion Drewe (–1925)
Work: San Jose Historical Museum, San Jose, California. *News Notes of California Libraries,* October 1908, and October 1910; Inventory of American Paintings, Smithsonian Institution.
Titles of Coleman's paintings indicate a fondness for sketching in Northern California and the San Francisco Bay region.

Coleman, Mary Sue Darter (1894–)
B. Fort Worth, Texas. AAA 1919, 1923–1924 (Fort Worth; listed as Darter); Mallett; Fisk, 1928; O'Brien, 1935; California *Arts & Architecture*, December 1932 (Los Angeles, California).
Coleman studied in New York with George Bridgeman and Luis Mora prior to teaching art at Midland College and Texas Christian University in Texas, and Phillips University in Oklahoma. She also studied landscape painting in Woodstock, New York, for three summers; there her principal teacher was John F. Carlson.

Following marriage to Harvey Coleman in 1925, Mary Coleman studied landscape painting with Roscoe Shrader, Armin Hansen, Paul Lauritz, Edgar Payne, and Jack Wilkinson Smith. She exhibited in Fort Worth and Los Angeles, and also in Arizona.

Collins, Caspar Weaver (1844–1865)
B. Hillsboro, Ohio. D. Wyoming, July 26. Work: Denver Public Library; Colorado State University. M. Barr, 10, 12, 47; Nottage, 86.

"Collins is dead—killed by Indians at Platte Bridge Station," reads Maurice Barr's chronology of artist activity in Wyoming for an exhibition catalogue.

Since 1862 Collins had been making maps and drawing forts and Indians while serving with the Eleventh Ohio Volunteer Cavalry, first as a civilian and later as a lieutenant. During that three-year period he and officer Charles Frederick Moellman produced some seventy drawings. They comprise on-the-spot views of military posts and telegraph stations on the Oregon and Overland trails between Camp Mitchell, Nebraska, and the South Pass. Though naïve in execution, they are invaluable historical records. Two watercolors, "Deer Creek Station," and "Sweetwater Station, Idaho Territory," are in the Western History Collection of the Denver Public Library.

Collins, Edna Gertrude (1885–)
B. Toronto, Canada. Mallett Supplement (Austin, Texas); Fisk, 1928; G. Smith, 1926; San Antonio Public Library; Houston Public Library art and artists' scrapbook.

Collins was sixteen when her parents moved from Toronto to Austin. She studied in New Orleans, and in New York at the Art Students League. She exhibited in Austin, Dallas (where she had a studio in 1925–1926), and Fort Worth. Her preference was oil portraits, but she also did landscapes, flowers, and figures in both oil and water color.

Collins, Mary (ca 1839–1928)
D. Denver. Work: Colorado Historical Society. Petteys; Inventory of American Paintings, Smithsonian Institution.

Collins moved from New York to Denver in 1863, and two years later married Edward H. Collins. The plant-life paintings at the Colorado Historical Society are attributed to both Mr. and Mrs. Collins. Since she apparently did not take up painting until after marriage, it seems likely that her husband, who was a botanist, encouraged her to collaborate with him. Her flower paintings apparently were quite exceptional for she was called by her Denver contemporaries "a grand artist in the world of flowers."

Colman, Samuel (1832–1920)

B. Portland, Maine. D. New York City, March 27. Work: Metropolitan Museum of Art; Art Institute of Chicago; Cooper-Hewitt Museum; Bancroft Library, University of California, Berkeley; New York Public Library; Rhode Island School of Design; St. Johnsbury Athenaeum, Vermont, etc. AAA 1898–1908 (Portland); AAA 1909–1917 (New York City); Benezit; Fielding; Groce and Wallace; Havlice; Mallett; AAW v. I; M. Barr, 17, 47; Terry Trucco, "Samuel Colman," *Art News,* January 1981, 8; *Kennedy Quarterly,* June 1970, 5; Getlein, 1973; NMAA-NPG Library, Smithsonian Institution.

Colman was eighteen when he exhibited at the National Academy of Design, twenty-three when he was made an associate member, and thirty when he became a full Academician.

The Inventory of American Paintings shows that Colman traveled widely in the West. Getlein places him there in 1870 or a little before, and returning "for most of his life."

Colorado, Utah, and California titles predominate in Colman's Western paintings. Some titles escape classification such as "Indian Encampment on the Plains," thought to have been painted about 1865.

Barr places Colman in the Green River country of Wyoming in 1871. He also traveled to Mexico and to British Columbia.

Comins, Alice R. (–)

AAA 1917–1921 (Boston, Massachusetts); AAA 1923–1924 (Boston; Cape Neddick, Maine); AAA 1925–1931 (Boston; Cape Neddick; Carmel, California); Fielding; Mallett (Carmel); California *Arts & Architecture,* Decem-

ber 1932 (Carmel); " 'Art' and 'Carmel' Synonymous . . . ,"
Monterey Peninsula *Herald,* October 18, 1966, A4/c3.

Comins was a member of the Carmel Art Colony by 1925
and, according to Mallett, was still active there in 1934.

Comins, Eben Farrington (1875-1949)

B. Boston, Massachusetts. D. Falls Church, Virginia.
Work: Parrish Art Museum, Southampton, Long Island,
New York; Connecticut State Library and Supreme Court
Building; Yale University. AAA 1903 (Paris, France);
AAA 1905-1919 (Boston; summer, East Gloucester,
Massachusetts); AAA 1923-1933 (Washington, D.C.; sum-
mer, East Gloucester); Benezit; Havlice; WWAA 1936-
1953 (Washington, D.C.; summer, Gloucester); McMahan;
Michael Harrison, Fair Oaks, California; "90 Drawings of
Indian Types by District on View Here," Washington *Post,*
March 17, 1940; *Indians at Work,* April 1940, an Interior
Department publication; NMAA-NPG Library, Smithsoni-
an Institution.

Although the *American Art Annual* does not give a Cali-
fornia address for the years 1917 until about 1920, it is that
period that Comins was most active in the Los Angeles area, ex-
hibiting portraits and landscapes, and teaching art at a state nor-
mal college.

Comins' Southwest Indian drawings were done during the
winter of 1939-1940, and exhibited in the Interior Department's
art museum in March during which he lectured on the Hopi snake
dance. However, he is better known for his paintings of promi-
nent persons in politics and in the arts, and for his drawings and
paintings of Indians of remote tribes south of the border.

Comstock, Anna Botsford (1854-1930)

B. Otto, New York. D. August 24, probably in Ithaca, New
York. AAA 1903-1915 (Ithaca); Benezit; Mallett; *News
Notes of California Libraries,* January 1908, 12.

Comstock was a natural history artist who later became a
professor of nature study at Cornell University. She was active in
California during the early 1900s as an illustrator and engraver.
Her specialty was wood engravings.

In 1893 Comstock exhibited at the World's Columbian Ex-

position in Chicago; in 1900, the International Exposition in Paris; and in 1901, the Pan-American Exposition in Buffalo at which she was awarded a bronze medal. During 1899–1900 she lectured at Stanford University.

Comstock, John Adams (1882–1970)

B. Illinois. D. Del Mar, California. AAA 1919 (Los Angeles); Castor typescript, San Francisco Public Library.

Comstock was active in Los Angeles and Carmel, California, as a physician and as an etcher. For five years he served as director of the Southwest Museum, an institution specializing in Indian cultures. In 1923 he was appointed to the Advisory Committee on Indian Affairs.

Comstock's directorship of Southwest Museum spanned the years 1921–1926. The following year he published *Butterflies of California*, based on his entomological studies. It is unlikely that he did much art work after 1920.

Conant, Lucy Scarborough (1867–1920)

B. Brooklyn, Connecticut. D. Boston, Massachusetts, December 31. Work: Boston Museum of Fine Arts. AAA 1898–1919 (Boston); AAA 1921, obit.; Benezit; Mallett; Thornton Oakley, "Lucy Scarborough Conant – Artist," *American Magazine of Art*, August 1921, 269–273; Henry Hunt Clark, "Lucy Scarborough Conant," *American Magazine of Art*, August 1921, 274–276; Inventory of American Paintings, Smithsonian Institution.

Although articles in *American Magazine of Art* mention only that Conant was on the faculty of the University of California, it is likely that she did some painting in California, and perhaps elsewhere in the West. Her publicized landscapes were mainly done in Italy. None of the six paintings she exhibited at the Panama-Pacific International Exposition in San Francisco in 1915 had a Western title.

Condon, Stella C. (1889–)

B. St. Paul, Minnesota. *Who's Who in Northwest Art* (Seattle, Washington).

Condon, who studied with Mark Tobey and others in Wash-

ington, was mainly active as director of the Children's Free Creative Art School in Seattle.

Cone, Florence M. Curtis (–)
Calhoun, 20 (Seattle, Washington); Seattle *Town Crier,* November 23, 1912, 6; November 1, 1913, 15; and November 8, 1913, 14; University of Washington Library.

Cone was Florence Curtis when she became a charter member of the Seattle Fine Arts Association and exhibited at its first show in November 1908.

Following marriage Cone continued to exhibit in Seattle at least through 1913. Helen Ross in her art column in the *Town Crier* mentioned Cone several times. On November 8, 1913, Ross called attention to some oils of local scenes, "including an admirable picture of a scene amid the mountain tops near Ketchikan, and some delightful studies of the rose garden on the University of Washington campus."

Cone, Martella Lydia (See: Martella Cone Lane)

Cook-Smith, Jean Beman (1865/66–)
B. Waterloo, New York. Work: San Diego Museum [of Man?]. AAA 1898–1906 (Chicago, Illinois); AAA 1907–1913 (Waterloo, New York); AAA 1919–1921 (Jamaica, Long Island, New York); AAA 1923–1929 (Jamaica; Chula Vista, California); AAA 1931–1933 (San Diego, California); Benezit; Fielding; Mallett; Young; AAA 1898, 322.

The last reference refers to Cook-Smith's two entries, "Sundown" and "Along the Lake" in the Trans-Mississippi International Exhibition in Omaha in 1898. The work listed at the San Diego Museum in Fielding is "The Maya Frieze."

Cooper, Elizabeth Ann (1877–1936)
B. Nottingham, England. D. Seattle, Washington, September 4. AAA 1921–1924 (Seattle); Mallett Supplement; WWAA 1938–1939, obit.; *Who's Who in Northwest Art;* Pierce.

Cooper was one of Washington's "Group of Twelve." She exhibited in Seattle where she had studied at the University of Washington; in Oakland, California; and in San Francisco where

she had studied at Mark Hopkins Art School. She specialized in marines and flowers in water color, but also did oils, lithographs, and woodblock prints. In 1936 a memorial exhibition of her work was held at the Seattle Art Museum.

Cooper, Emma Lampert (1855-1920)
B. Nunda, New York. D. Pittsfield, New York, July 30. Work: Wells College, Aurora, New York. AAA 1898-1900 (London, England); AAA 1903-1906 (Philadelphia, Pennsylvania); AAA 1907-1908 (Philadelphia; New York City); AAA 1909-1919 (New York City); Benezit; Fielding; Havlice; Mallett; Inventory of American Paintings, Smithsonian Institution.

Cooper, who married the artist Colin Campbell Cooper in 1897, traveled extensively with him, including in the West. Among the six paintings listed in the Smithsonian's inventory are two with Western titles—"At Colorado Springs, Colorado," and "Adobe House," which was painted about 1900.

Cooper, (William) Leonard (1899-)
B. Salinas, California. Work: Atlanta University. Havlice; Mallett Supplement (Salinas); WWAA 1947-1953 (Salinas); Cederholm.

Cooper, who studied at the College of the Pacific, began exhibiting regularly in 1936 at the Oakland Art Gallery and the Santa Cruz (California) Art League. In 1946 he exhibited at the San Francisco Museum of Art and at Atlanta University.

Coppedge, Fern Isabel (1883-1951)
B. Decatur, Illinois. Work: Pennsylvania Academy of the Fine Arts; Witte Memorial Museum, San Antonio, Texas; Detroit Institute of Arts; Thayer Museum, Kansas [not listed in *Museums Directory*]; Reading (Pennsylvania) Museum of Art, etc. AAA 1915 (Topeka, Kansas; listed as Mrs. Robert Coppedge); AAA 1917-1933 (Philadelphia, Pennsylvania; summer 1917-1921, Gloucester, Massachusetts; summer 1923-1929, Lumbersville, Pennsylvania; summer 1931-1933, New Hope, Pennsylvania); Benezit; Fielding; Havlice; Mallett; WWAA 1936-1941 (Philadelphia; summer, New Hope); WWAA 1947-1953

(New Hope); Reinbach; *American Magazine of Art*, May 1924, 242.

While attending art classes at Topeka High School Coppedge was encouraged to seek further training. Study at leading art schools, following marriage, led to a long and successful career, especially as a landscape painter.

Coppini, Pompeo Luigi (1870-1957)
B. Moglia, Italy. D. San Antonio, Texas, September 26. Work: Many portrait busts and public memorials. AAA 1905-1915 (San Antonio); AAA 1917-1921 (Chicago); AAA 1923-1933 (New York City; Pelham Manor, New York); Fielding; Havlice; Mallett; WWAA 1936-1937 (Pelham Manor); WWAA 1938-1941 (Pelham Manor; San Antonio); WWAA 1947-1953 (San Antonio; New York City); WWAA 1956 (San Antonio); WWAA 1959, obit.

Coppini is listed as a painter as well as a sculptor, but his principal works are sculptures. He was also an educator, lecturer, and writer.

Cormack, Claire D. Sutherland (1883-)
B. Harvard, Nebraska. *Who's Who in Northwest Art* (CX Ranch, Decker, Montana).

Cormack studied with Winold Reiss in New York and in Glacier National Park, and with Goerge Biddle, Ernest Fiene, and Boardman Robinson at the Colorado Springs Fine Arts Center. She exhibited in group shows in New York, Denver, Sheridan (Wyoming), and in Montana.

Cotton, Leo/R. Leo (1880-)
B. San Antonio, Texas. AAA 1923-1924 (Fort Worth); AAA 1925-1927 (Los Angeles, California); California *Arts & Architecture*, December 1932 (Los Angeles); Fisk, 1928.

Cotton studied with Robert Onderdonk in San Antonio, and at the Holmes School of Illustration in St. Louis. He is known in Fort Worth for his colorful paintings of scenic places on the outskirts of town. As a charter member of the Texas Artists' Camp at Christoval, Texas, he undoubtedly found much of scenic interest there as well. In 1920 he was awarded a gold medal by the Dallas Art Association, and in 1922 he received two blue rib-

bons at the West Texas Fair in San Angelo. His memberships include the Fort Worth Painters Club, the Fort Worth Art Association, and the Southern States Art League. In the mid-twenties he began working in the art department of the Los Angeles *Examiner.*

Couch, Maude C. (-)

B. Hollywood, Arkansas. Fisk, 1928 (Abilene, Texas).

Couch was a child when her family moved to Texas in 1890. She obtained her art education at Trinity University when it was at Waxahachie, and at McMurry College where she studied with Lois Hogue who became better known as Lois Hogue Shaw. Fisk considered Couch especially good in her oil landscapes which included mountain scenes around Buffalo Gap and "Old Fort Phantom Hill." Her paintings were given a number of awards at West Texas fairs.

Coughlan, A. T. (-)

Work: Dr. and Mrs. Franz Stenzel collection. Inventory of American Paintings, Smithsonian Institution; Stenzel, Portland Art Museum exhibition catalogue, September 1959, 13–14.

"View of Newport, Oregon" listed in the Smithsonian inventory, is a 24 × 45-inch oil on canvas that probably is the earliest painting of Newport ever made. Stenzel traced its origin to Sam Case who plotted the town and built the Ocean House Hotel. Case had commissioned the painting for the hotel lobby. He paid Coughlan forty dollars. The painting, dated 1883, hung in the lobby for many years. It was one of several that Coughlan did in Oregon, and it almost met the same fate as the others no doubt did. In the mid 1900s or earlier, a Newport newspaper man rescued it from a trash pile. Stenzel obtained it for his collection and had it restored.

Coulter, Mary J. (1880–1966)

B. Newport, Kentucky. D. Northampton, Massachusetts, October 19. Work: Art Institute of Chicago; British Museum, London; Metropolitan Museum of Art; Huntington Library and Art Gallery, San Marino, California; California State Library; Fogg Museum, Harvard University; Chal-

cographic du Louvre, Paris; Museum of New Mexico, Santa Fe; Boston Museum of Fine Arts; Library of Congress; New York Public Library; Los Angeles Public Library; Oakland Art Museum, etc. AAA 1909–1910 (Chicago); AAA 1915–1925 (San Francisco); AAA 1927 (San Diego); AAA 1929–1933 (Santa Barbara); Fielding; Havlice; Mallett; WWAA 1936–1956 (Santa Barbara); WWAA 1959–1962 (Amherst, Massachusetts); AAW v. I; "Art Career of Mary J. Coulter," San Francisco *Chronicle*, January 29, 1939, S4/1; "Mary J. Coulter," *American Magazine of Art*, April 1920, 196–198; Henry Noyes Pratt in *Art News*, January 1, 1921, 7; Monterey Peninsula Museum of Art docent library; California State Library; NMAA-NPG Library, Smithsonian Institution.

Coulter "is one whose art is not at a standstill," wrote Pratt in his review of her paintings, etchings, monotypes, color block-prints, and batiks. Of the six etchings in the Library of Congress collection, four are California landscapes; the two others are Hawaiian. She spent much of 1917 in Hawaii and may have made later trips.

Coutts, Gordon (1868–1937)

B. Aberdeen, Scotland. D. Palm Springs, California, February 21. Work: Oakland Art Museum; M. H. De Young Memorial Museum, San Francisco; Henry Gallery, University of Washington; Adelaid National Gallery, National Art Gallery, and Melbourne Art Gallery, Australia. AAA 1909–1910, 1917 (Piedmont, California); AAA 1919 (Pasadena, California); AAA 1921 (Piedmont); Benezit; Fielding; Havlice; Mallett; WWAA 1936–1937 (Palm Springs, California); AAW v. I; Ann Sullivan, "Here's A Real Castle In the Desert," *Desert Sun*, May 12, 1978; "London Notes," *American Magazine of Art*, January 1922, 26–27; Palm Springs Public Library; Inventory of American Paintings, Smithsonian Institution.

Although Coutts' art directory listings do not show him in California until 1909, some of his Marin County subjects are dated as early as 1890. He was often out of the state for extended periods—exhibiting abroad; serving as government art instructor in New South Wales, Australia; painting in Tangier, Morocco. So

influenced was he by the architecture in Tangier that he built a French-Moroccan style castle in Palm Springs where he spent his last years. Characteristic of an artist's needs is the huge north-facing window of the castle.

Covey, Arthur Sinclair (1877–1960)

B. Bloomington, Illinois. D. Tarpon Springs, Florida, February 5. Work: Library of Congress; murals, Wichita (Kansas) Public Library; Norton Hall, Worcester, Massachusetts; La Guardia Field, New York, etc. AAA 1910–1913 (Leonia, New Jersey); AAA 1915 (Coytesville, New Jersey); AAA 1917–1933 (New York City; Pelham Manor, New York; summer 1921–1925, Rockport, Massachusetts); Fielding; Havlice; Mallett; WWAA 1936–1956 (Torrington, Connecticut); WWAA 1959 (Tarpon Springs, Florida); Reinbach; NMAA-NPG Library, Smithsonian Institution.

Covey grew up in El Dorado, Kansas, and began the study of art at Southwestern College in Winfield, Kansas. Then he studied in Chicago, Paris, Munich, and London. In Kansas, where he was commissioned to paint a mural for the Wichita Public Library, he is thought of as a native son. Though he never returned there to live, he created a memorable mural called "The Spirit of the Prairies" which pictures Kansas history and life. It brought him wide recognition throughout the state.

Covey's murals are in various public buildings from coast to coast. He also did easel paintings and prints. A solo exhibition of landscapes at Clearwater (Florida) Art Museum in 1948 featured work done in several Western and Southern states.

Covington, (Isaac) Loren (1885–1970)

B. Orderville, Utah. D. St. George, Utah, May 27. Work: Private collections; church murals. Biographical data, courtesy of Professor Robert Olpin, University of Utah.

Covington studied at Brigham Young University where E. A. Eastmond, then head of the art department, took an interest in his work. He never became a fulltime painter because of financial obligations, but he was among those chosen by BYU to sketch historical sites along the Mormon trail from Nauvoo, Illinois, to Utah. The sketching party left Salt Lake City by bus in

mid June 1936, and returned late in July. He was again among those selected the following year for a visit to Indian communities in Arizona, New Mexico, and California.

Covington's principal residence was Hurricane, Utah, but he also lived for a while in Provo; Short Creek on the Arizona border; Harbor City, California, about 1917 when he worked in the shipyards; Los Angeles and Hollywood where he painted signs and movie sets and at times worked as a plasterer.

Cowles, Russell (1887–1979)

B. Algona, Iowa. Work: Denver Art Museum; Terre Haute Museum [Sheldon Swope Art Gallery, Terre Haute?]; University of Wichita; Dartmouth College; Minneapolis Institute of Art; Pennsylvania Academy of Fine Arts; Des Moines Art Center; Addison Gallery of American Art; Museum of New Mexico, Santa Fe; Santa Barbara Museum of Art, etc. AAA 1915–1917 (New York City; Rome, Italy); AAA 1919 (Rome); AAA 1921–1933 (New York City); Fielding; Havlice; Mallett; WWAA 1936–1037 (New York City); WWAA 1938–1941 (Santa Fe); WWAA 1947–1976 (New York City; New Milford, Connecticut); AAW v. I; "Russell Cowles Tempers the Southwest Sun," *Art Digest,* February 15, 1935, 13; Alice Graeme, "Corcoran Gallery Shows Work by Russell Cowles . . . ," Washington *Post,* November 26, 1939; Samuel Sachs, "Russell Cowles/A Superb Exhibition by a Distinguished American Artist," Minneapolis Institute of Art catalogue, 1975; NMAA-NPG Library, Smithsonian Institution; Museum of New Mexico library, Santa Fe.

Cowles worked in Santa Fe for twenty years or more, off and on. He had a studio at Bishop's Lodge that goes back to Willa Cather days when it was the archbishop's barn.

In comparing Cowles' paintings with those of other Southwestern artists, *Art Digest* wrote in 1935: "Unlike other Southwestern painters whose canvases are impregnated with brilliant sunlight and extreme shadows, Cowles' landscapes are softened interpretations of this arid West."

Cowles did not limit himself to the Western scene, however. As he told Samuel Sachs, curator of the Minneapolis Institute of Art, he liked "to paint everything." His long career and

periodic residences in other places enabled him to accomplish much of what he set out to do.

Cox, Lyda Morgan (1881–)
B. Depere, Wisconsin. AAA 1923–1933 (Seattle, Washington; summer, Cleveland, Ohio); Mallett.

Cox was a painter, craftsman, and teacher who was active in the Seattle Fine Arts Society.

Craig, Alice (–1961)
B. Colorado Springs, Colorado. D. Colorado Springs, November 2. Colorado Springs Fine Arts Center library and registrar's office; "72 Paintings by Springs Artists in Exhibition . . . ," Colorado Springs *Gazette,* June 13, 1915, 5/4; Grove typescript; Colorado College Library.

Craig, the daughter of artist Charles Craig, never achieved recognition outside of her state, but she was well known in Colorado Springs for her teaching in the city's public schools, and at the Broadmoor Art Academy where she was a faculty member from 1921 to 1925 and from 1936 to 1939. In 1915 she began exhibiting her landscape and still life paintings locally.

Craig's art education included study in New York City with William Merritt Chase and Robert Henri, and with Robert Reid, probably when he was teaching in Colorado Springs.

Craig, Della Vernon (See: Della Vernon)

Cram, "LD" (1898–)
B. Albany, Oregon. Mallett Supplement (Caldwell, Idaho); *Idaho Encyclopedia* (Atlanta, Georgia); Viguers, 1958.

LD grew up on a cattle ranch in Central Oregon. His formal art training was brief – two years in Kalamazoo, Michigan, and a correspondence course with Famous Artists Schools, Inc., of Westport, Connecticut. His main teachers were the animals he worked with during summer months, and put on paper at night or whenever time permitted.

Between 1936 and 1941 LD illustrated six children's books in pen and ink, including *Wild Animals of the Southwest* by Franklin George Cory (Houghton, 1950). In 1953 he did free-lance illustrating while living in Warren, Idaho. Much of this work was

based on his familiarity with Idaho's remote and primitive mountain regions.

Crandall, Harrison (1887–1970)

B. Newton, Kansas. Work: National Park Service, Grand Teton National Park; First Security Bank, Boise, Idaho. M. Barr; Laurene Smith, "Crandalls To Make Boise Their Home," Capitol *News,* April 17, 1933; Laurene T. Cork, Capitol *News,* November 19, 1935; Boise Public Library.

In 1921, Crandall—a former student of the Los Angeles School of Art—began homesteading some land in Wyoming near Jenny Lake. When Grand Teton National Park was established in 1929, he was granted the photography and art concession at Jenny Lake in return for selling his land to the government. He operated that concession until 1959.

During the early thirties Crandall built a winter studio near Boise, and within two years, a residence. He spent his summers in the Park, painting portraits of persons frequenting the area, especially dudes, and sketching and photographing his main interest, the Tetons. Cork wrote that he "studied them from sunup until sundown . . . by moonlight and in the dead of winter," and "dared death" to get a particular view.

Craton, Bertha Alene Tatum (1885–)

B. Newtonia, Missouri. Bucklin and Turner, 1932 (La Grange, Wyoming; Hull, Nebraska).

Craton studied locally, and with Robert Graham in Denver.

Crawford, Brenetta Hermann (1876–)

B. Toledo, Ohio. Work: Museum of Monte Carlo, Monaco. AAA 1900 (New York City; listed as Hermann); AAA 1907–1910 (New York); AAA 1913–1921 (Nutley, New Jersey; summer 1919, Roque Bluffs, Maine); AAA 1923–1933 (France); Fielding; Havlice; Mallett; WWAA 1936–1941 (Menton, France; Nutley); WWAA 1947–1953 (South Pasadena, California).

Crawford, Dorsey Gibbs (–)

AAA 1919–1921 (Dallas, Texas).

Crawford, Ethelbert Baldwin (1872–1921)

B. New York City. D. Monticello, New York. Work: Crawford Memorial Library, Monticello; private collection. Inventory of American Paintings, Smithsonian Institution; NMAA-NPG Library, Smithsonian Institution; interview with Lucy McKay, Chevy Chase, Maryland; Colorado College Library.

Crawford who studied briefly with Robert Henri, and probably with some of the impressionists he knew in France, was an engineer and amateur painter who particularly enjoyed painting in Colorado Springs, Colorado. He began visiting there about 1910, usually staying at the Broadmoor Hotel. In 1911 he exhibited 117 paintings in the ballroom of the hotel, and sold a few. His titles often were Western such as "Utes on War Path," "Sage Brush," and "Rocky Mountains."

Crawford, Mrs. W. L. (–)

Fisk, 1928 (Dallas, Texas).

Fisk described Crawford as an "outstanding Dallas artist" who had spent "a number of years in European art centers." She was also a collector and art patron. It seems likely she was the wife of Dallas attorney W. L. Crawford who is listed in *Who Was Who in America*. Her specialties were still life paintings of flowers, and portraits. Among her sitters were a number of prominent Texans.

Cresswell, William Nichol (1822–1888)

B. England. D. Seaforth, Ontario. Work: London (Ontario) Art Gallery; National Gallery of Canada; Ottawa Government Collection; Royal Ontario Museum; Art Gallery of Ontario. Havlice; Mallett; Harper, 1966 and 1970.

Cresswell, who is said to have been a remittance man, left England for Canada in 1855 and settled at Harperhaye near Seaforth. He divided his time between fishing and painting. Working in oil and water color, he did marines; historical, genre and animal subjects; and landscapes. When railroad transportation opened up to Colorado he went there for a while, and on another occasion he went to the White Mountains of New England. In Canada he painted mainly in the Lake Huron and Georgia Bay region.

From 1856 Cresswell exhibited regularly in Canada and at least once in Philadelphia.

Crews, Seth Floyd (ca 1885–)
B. Mount Vernon, Illinois. AAA 1923–1924 (New York City); Mallett Supplement (El Paso, Texas); Fisk, 1928; O'Brien, 1935.

O'Brien described Crews as a theatrical painter who took up portrait painting in 1917, and Southwest landscape painting in 1918. A New Mexico desert landscape was accepted by the National Academy for its 1921 winter exhibition. In 1927 he won a prize at Edgar B. Davis' Texas Wildflower show in San Antonio. He was later given a one-man exhibition at the Witte Memorial Museum in San Antonio.

Critcher, Catharine Carter (1868–1964)
B. Westmoreland County, Virginia. D. Blackstone, Virginia. Work: University of Virginia; Witte Memorial Museum, San Antonio; National Academy of Design; Corcoran Gallery of Art; Boston Arts Club. AAA 1898–1903 (Washington, D.C.); AAA 1905–1908 (Paris, France); AAA 1909–1933 (Washington, D.C.); Benezit; Fielding; Havlice; Mallett; WWAA 1936–1941 (Washington, D.C.); AAW v. I; McMahan; Washington *Star*, December 16, 1923; Washington *Post*, October 12, 1924; November 14, 1926; May 13, 1928; February 17, 1929; Washington *Star*, April 7, 1929; Leila Mechlin's column in the Washington *Star*, January 12, 1930; Washington *Post*, May 31, 1942; NMAA-NPG Library, Smithsonian Institution; Corcoran Gallery of Art.

Critcher was considered one of the best painters working in Taos, New Mexico, in the 1920s. As such she was invited to become a member of the Taos Society of Artists although she was not a resident in the same sense the others were. In Washington her portraits of Taos Indians, Mexicans, and Indians of other Southwest tribes made headlines in the art sections of the *Star* and the *Post* for over a decade.

Crocker, Charles Mathew/Matthew (1877–1950/51)
B. near Chicago, Illinois. Work: Santa Fe Railway Collec-

tion. AAA 1900–1903 (Chicago); AAA 1923–1924 (Los Angeles, California); AAW v. I; *California Design*, 1910, and exhibition catalogue.

Crocker grew up in Decatur, Illinois, where at age nineteen he studied with Jean Mannheim, and thereafter in Chicago. Inasmuch as he was born in a log cabin to very poor parents and dropped out of school after the third grade, one surmises that by age nineteen he was supporting himself and for the first time was able to finance his art instruction. Not only did he progress rapidly in art, but he began writing poetry. When he went to California in 1910 where he obtained a job as a reporter for the Berkeley *Gazette,* he became friends with some of the leading writers and philosophers. And when he went to Los Angeles about 1919, his studio became a meeting place for artists and writers.

In 1938 Crocker returned to Chicago where he is said to have been active as a painter until his death.

Cronenwett, Clare (–)
AAA 1919 (Gold Hill, Monrovia, California); AAA 1921–1925 (San Francisco, California); Fielding.

Cronenwett, an etcher, was a member of Printmakers of Los Angeles and California Print Makers.

Cronyn, George W. (–)
AAA 1915 (Portland, Oregon).

Crouch, Mary Crete (–1931)
B. Virginia City, Nevada. D. Sacramento, California, December 26. AAA 1932, obit.; Mallett Supplement; *News Notes of California Libraries,* January 1913, 121.

Crouch, Penelope Thomas (–)
Work: The Alamo, San Antonio, Texas. O'Brien, 1935.

O'Brien states that Crouch painted portraits of a number of well-known Texas pioneers. Her portrait of Sam Houston's wife hangs in the Alamo.

Crowell, Annie (ca 1862–1949)
D. Santa Cruz, California, October 3. San Francisco Public Library art and artists' scrapbook; San Francisco *Examiner,* October 7, 1949, 19/5 obit.

Cromwell grew up in San Francisco where she was known as a "skilled water colorist" and a photographer. She lived many years in Spain prior to 1941 when she returned to the United States.

Crowther, Mollie L. Vining (1867–1927)

B. Baton Rouge, Louisiana. D. August 13, probably in San Angelo, Texas. AAA 1923–1925 (San Angelo); Fisk, 1928; O'Brien, 1935.

Crowther began the study of art in 1908. Among her teachers were Frank Phoenix, Edward Timmins, Kathryn Cherry, and several Texas painters. In 1920 she organized a summer art camp at Christoval, a scenic place on the Concho River south of San Angelo. It attracted a number of well-known artists who were competent teachers.

Cunningham, Florence (1888–1980)

B. Gloucester, Massachusetts. D. Carmel Valley, California, January 10. Work: School of Design, New York. Monterey Peninsula Museum of Art docent library; Monterey Public Library; John Woolfenden, "Years Have Failed to Dim the Palettes of Carmel Valley Nonagenarian Artists," Monterey Peninsula *Herald,* December 9, 1979, 15, 19; Monterey Peninsula *Herald,* January 11, 1980, 4, obit.

Cunningham had exhibited in Los Angeles and Monterey County cities for a number of years, but until retirement in 1971 her principal profession was that of a drama and speech teacher.

Curran, Mary Eleanor (–1930)

AAA 1919 (Los Angeles, California); Sheldon Cheney, "Book Plates . . . ," 189; Clare Ryan Talbot, *Historic California in Bookplates,* Los Angeles: Graphic Press, 1936, 43.

Curran, an etcher specializing in book plates, is said to have been the first *ex libris* artist in Los Angeles.

Curtis, Elizabeth L. (1892–)

B. Seattle, Washington. Work: murals, Women's Gymnasium, and Oceanographic Building, University of Washington. *Who's Who in Northwest Art* (Seattle).

Curtis, who studied at the University of Washington and the Seattle Art School, worked mainly in oils. She also taught art.

Curtis, Leland S. (1897–)

B. Denver, Colorado. Work: Springville (Utah) Art Museum; City of Los Angeles Municipal Collection; John Muir National Historic Site, Martinez, California. AAA 1925–1933 (Los Angeles); Havlice; Mallett; WWAA 1936–1959 (Los Angeles; summers from 1956, Moose, Wyoming); WWAA 1962 (Twenty-Nine Palms, California); AAW v. I; *Western Artist,* November 1935, 14; "His Fillings Fell Out," *Art Digest,* June 1, 1941, 26; "Leland Curtis Returns," *Art Digest,* April 15, 1941, 11; *American Magazine of Art,* September 1929, 533; Walter Nelson-Rees, Oakland, California; M. Barr, 47.

Curtis is best known in California for his Sierra Nevada scenes which he began painting about 1920. In 1929 the City of Los Angeles purchased "High Sierras" for the Mayor's office. About 1950 he opened a summer studio in Grand Teton National Park, and in his late years, a winter studio in Carson City, Nevada. In 1980 he was active principally in those two areas.

The *Art Digest* references cited above refer to Curtis' experiences from 1939 to 1940 when he was official artist with the U. S. Antartic Expedition. In 1957 he again served as official artist in the Antartic; that time it was for the U. S. Navy Operation Deepfreeze, III.

D

Dabelstein, William F. (–ca 1971)

B. St. Paul, Minnesota. D. Oakland, California. Work: Oakland Art Museum; Burlington Northern Railway Company. AAA 1915 (New York City); California *Arts & Architecture,* December 1932 (San Francisco); NMAA-NPG Library,

Smithsonian Institution; Minnesota Museum of Art, *Iron Horse West,* 45; California State Library; Oakland Museum's Archives of California Art; Walter Nelson-Rees, Oakland; Inventory of American Paintings, Smithsonian Institution.

Dabelstein was active in the Minneapolis-St. Paul area before moving to California in the 1920s. His "Trappers Peak" mural at the Minneapolis railway station is a Bitter Root Mountains scene painted in 1914.

In California Dabelstein lived in Contra Costa County, and then in Oakland. He painted many landscapes of the High Sierras and the Monterey County Coast. In 1941 he exhibited three paintings at the California Palace of the Legion of Honor in San Francisco in a show given by the Society for Sanity in Art of which he was a member.

Daggett, Vivian Sloan (1895–)
B. Whitesboro, Texas. Fisk, 1928.

Daggett studied in Fort Worth, New York City, and at the Broadmoor Art Academy in Colorado Springs. Among her teachers were Sallie B. Mummert of Fort Worth, Randall Davey, Robert Reid, and John Sloan. She was a member of the Society of Independent Artists with which she exhibited in New York City, and the Fort Worth Painters Club with which she exhibited in Texas. Her specialty was oil landscapes.

D'Agostino, Vincent (1896/98–)
B. Chicago, Illinois. Work: Whitney Museum of American Art; Tilden High School, Brooklyn; murals, Mount Loretto Institute, Staten Island. AAA 1933 (Chicago); Havlice; Mallett; WWAA 1936–1941 (Chicago); WWAA 1947–1970 (Los Angeles and Beverly Hills, California).

D'Agostino began exhibiting in major Western cities in the early 1930s.

Dahl, Bertha (1891–)
B. Voss, Norway. *Who's Who in Northwest Art* (Seattle, Washington).

Dahl, a public school art teacher, studied at Iowa State Teachers College, the University of Washington, and with Peter Camfferman of Langley, Washington.

Dahlgreen, Charles William (1864–1955)

B. Chicago, Illinois. D. Oak Park, Illinois. Work: Library of Congress; National Museum of American Art; Art Institute of Chicago; New York Public Library; Los Angeles Museum of Art, etc. AAA 1907–1933 (Chicago and Oak Park); Benezit; Fielding; Havlice; Mallett; WWAA 1936–1953 (Oak Park); Sparks; Smithsonian Institution, *Edition of Etchings & Drypoints by Charles W. Dahlgreen,* Washington, D.C.: The Smithsonian Institution, 1946; NMAA-NPG Library, Smithsonian Institution; Art Institute of Chicago Index.

Dahlgreen left school at age twelve to help support his family. Years of sign painting, decorating, etching swords, working in foundries, and a bit of prospecting in the Klondike (1898) intervened before he could give full time to a career. His study background up to that time consisted of three years in Germany in the 1880s, followed in 1906 by painting and etching lessons at the Art Institute of Chicago. Although he became a painter as well as an etcher, it was his etchings and drypoints that attracted the most attention. The Smithsonian publication commented upon their "fine sense of pattern and design" which gave them "carrying power as wall decorations," and credited Dahlgreen with a "fresh point of view" and a "genuine feeling for nature."

Dahlgreen probably was first in the West in the early 1920s when he painted the Grand Canyon. His Yosemite scenes came much later. The Library of Congress purchased nine of his etchings, drypoints, and aquatints of which three are from the Yosemite series.

Dake, Carel L., Jr. (–)

Benezit; Inventory of American Paintings, Smithsonian Institution; Panama-Pacific International Exposition catalogue, 100.

Dake was a resident of Holland when he exhibited "The Trail" and "On the Slopes: Mt. Tamalpais" at the Panama-Pacific Exposition in San Francisco in 1915.

Dake, Zahad (–)

Work: Society of California Pioneers. Evans catalogue, Society of California Pioneers' library.

According to Evans, Dake was an etcher who was active in San Francisco from 1915 to 1930. He may have been a brother of Carel Dake who also appears in this volume.

Dalziel, John Sanderson (1839-1937)
B. Edinburgh, Scotland. D. Denver, Colorado, August 19. Work: said to be in American and British museums. AAA 1900 (Carson City, Colorado); Havlice; Harper, 1970; Mallett Supplement, obit.; Denver *Times,* March 15, 1900; Denver Public Library; "J. S. Dalziel, Engraver," *Art Digest,* September 1, 1937, 25; Washington *Star,* August 20, 1937, obit.; NMAA-NPG Library, Smithsonian Institution.

Dalziel was a wood engraver and illustrator who illustrated many famous writings, including those of Dickens, a lifelong friend. He also illustrated Bryant's *History of America.*

The study of birds brought Dalziel renown in this country to which he had come as a young man of thirty. By 1900 he was living in Colorado where he was considered one of the most prominent of the thirty most active members of the Denver Artists' Club. He remained a resident of the state for the rest of his life.

Danziger, Abraham (ca 1867-)
B. California. San Francisco Public Library art and artists' scrapbook; San Francisco *Chronicle,* June 16, 1947.

At age eighty Danziger, who had taken up water color and oil painting in 1930, was still active.

D'Arc, A. Jerome (-)
Work: San Jose Museum of Art. San Francisco City and County Directory, 1886; Oakland Art Museum library; Inventory of American Paintings, Smithsonian Institution.

D'Arc is said to have lived in California from 1857 to 1886. The painting in the San Jose Museum of Art is a seascape in oil dated 1886.

Darling, William S. (1882-1963)
B. Sandorhaji, Hungary. D. Laguna Beach, California, December 15. Laguna Beach Museum of Art exhibition catalogue, July-August 1979.

Born Wilmos Bila Sandorhaji, Darling assumed his wife's family name during the period of hysteria in this country following World War I.

Darling had studied at the Royal Academy of Budapest, and at the Academy of Fine Arts and L'Ecole des Beaux Arts in Paris before moving here in the early 1900s. His specialty was portraits.

About 1920 Darling moved to Los Angeles where he worked as an artist in the motion picture industry. Upon retirement in the early 1950s he turned to Western scenes of cowboys and Indians. In October 1967 his work was given a memorial exhibition at the Palm Springs Desert Museum in Palm Springs, California.

Darlington, Mabel Kratz [M.R.K.D.] (1871–)
B. Hilltown, Pennsylvania. Work: Women's Club, Jerome, Idaho. *Who's Who in Northwest Art* (Santa Monica, California); *Idaho Encyclopedia.*

Darlington attended Pennsylvania Academy of Fine Arts and graduated from Philadelphia School of Design before moving to Idaho in 1899. She worked in oils and water colors and exhibited mainly at Idaho State Fairs in Boise. Her paintings won prizes regularly, and she was selected to represent the state one year in an exhibition held in Salt Lake City. Her specialty was landscapes, often signed with her initials.

Prior to 1940 Darlington moved from Idaho to California.

Darter, Mary Sue (See: Mary Darter Coleman)

Daudis, Jose (–)
B. Barcelona, Spain. Work: Pasadena Museum of Art; Los Angeles County Museum of Art. Colorado Springs Fine Arts Center library.

Daudis was a Spanish-American impressionist who was mainly active as a Los Angeles businessman. He exhibited at Dalzell Hatfield Galleries from 1918 to 1958. Two Yosemite scenes were among the paintings listed in a catalogue on file at the Colorado Springs Fine Arts Center.

Davey, Clara (–)
AAA 1917–1919 (New York City); AAA 1921 (Santa Fe,

New Mexico); Colorado Springs Fine Arts Center student files.

Davey was a student at the Colorado Springs Fine Arts Center in 1929.

Davidson, Duncan (1876-)
B. Aberdeen Shire, Scotland. Work: Laurier House, Arthabaska, Quebec. *Who's Who in Northwest Art* (Seattle, Washington).

Davidson, who worked in oil and water color, had obtained his training in Grays School of Art in Aberdeen, Colarossi Academy in Paris, and with a private teacher in England.

Davidson, Ola McNeill/McNeil (1884-)
B. Brazoria, Texas. AAA 1931-1933 (Houston; summer, Brazoria); Benezit; Havlice; Mallett; WWAA 1936-1941 (Houston; summer, Brazoria); Fisk; Houston Museum of Fine Arts Bulletin, December 1930, No. 9; Houston Museum of Fine Arts library; Houston Public Library art and artists' scrapbook; Lowell Collins, Houston.

Davidson grew up on the S. R. Ranch where she worked as a cowboy and learned to paint pictures on shingles with paints ordered from Montgomery Ward. Though she later studied with two prominent Texas artists, she continued to think of herself as self-taught. In Houston she was far ahead of her time, but her experimental painting and teaching had considerable influence on her pupils, some of whom became successful artists.

Davies, Ernest R. (1898-)
B. Great Britain. Bucklin and Turner, 1932 (Oakland, California; summer, Ben Lomond, California).

Davies studied art in British schools before moving to Nebraska where he attended high school and college. He was active in Omaha during the early 1920s.

Davies, Gay Williams (-)
Benezit; Havlice; Mallett Supplement; WWAA 1940-1941 (Omaha, Nebraska); Joslyn Art Museum library.

Davies was a portrait painter who exhibited with the Omaha Art Guild nearly every year from 1912 to 1937, and perhaps later.

Davis, Miss A. (-)
Bucklin and Turner, 1932.
Davis taught drawing and painting at the University of Nebraska during 1883-1884.

Davis, Donna F. (-)
AAA 1919 (San Francisco, California); Harbick, v. II, a directory of Monterey Peninsula artists; Carmel Public Library.
Davis attended Mark Hopkins Art School during 1905-1906, taught for many years at San Mateo Junior College, and retired to Carmel where she was a member of the Carmel Art Association.

Davis, Gerald Vivian (1899-)
B. Brooklyn, New York. Work: University of Kansas; Tiffany Foundation; private collections. Havlice; WWAA 1947 (Summit, New Jersey); WWAA 1953 (Lawrence, Kansas); WWAA 1956-1970 (Summit).

Davis, Helen Cruikshank (1889-)
B. Elizabeth, New Jersey. Work: National Academy of Design; Grand Central Galleries; private collections. AAA 1915 (New York City); AAA 1917-1921 (Plainfield, New Jersey); AAA 1923-1924 (Orange, New Jersey); AAA 1925 (New York City); AAA 1931 (Houston, Texas); Benezit; Havlice; Mallett; WWAA 1936-1947 (Houston); Fisk, 1928; O'Brien, 1935; Houston Public Library art and artists' scrapbook; Cora Bryan McRae, "National Honors Achieved by Helen Cruikshank Davis with Lifelike Miniatures," Houston *Chronicle*, February 25, 1940; Lowell Collins, Houston.
Davis, whose specialty was miniatures on ivory, studied all phases of art. In 1931 she was invited to join the American Society of Miniature Painters.

Davis, Stuart (1894-1964)
B. Philadelphia, Pennsylvania. D. June 24. Work: Metropolitan Museum of Art; Pennsylvania Academy of Fine Arts; Milwaukee Art Institute; Newark Art Museum; Ros-

well (New Mexico) Museum and Art Center, etc. AAA 1913 (New York City); AAA 1915 (East Orange, New Jersey); AAA 1919-1933 (New York City; summer, East Gloucester, Massachusetts); Benezit; Fielding; Havlice; Mallett; WWAA 1936-1962 (New York City); Diane Kelder, *Stuart Davis*, New York. . .: Praeger Publishers, 1971; Coke, 1963, 64-65; Roberta Smith, "Stuart Davis, Picture-Builder," *Art in America*, September-October 1976, 80-87; Hassrick, 1977, 228-229.

At John Sloan's urging, Davis spent the summer of 1923 in Santa Fe. Davis found the region most interesting, but better suited to ethnologists than to artists. Nevertheless he did some abstract landscapes there that seemed to mark a new direction in his work over the next ten years.

Davison, Edward L. (–)
AAA 1919-1925 (Wichita, Kansas); Mallett Supplement; Reinbach.

Dawe, Gladys Cole (1898–)
B. Black Hawk, Wisconsin. AAA 1921-1924 (Seattle, Washington; listed as Gladys Cole); *Who's Who in Northwest Art* (Bellingham, Washington).

Dawe studied in Chicago, and in Seattle at the University of Washington. Among her teachers was Edgar Forkner. During 1938 she had two solo shows in Seattle. However, she was mainly active as an art teacher.

Dawes, Edwin Munott (1872-1945)
B. Boone, Iowa. D. Los Angeles, California, March 26. Work: Minneapolis Institute of Arts; Minnesota State Art Society, St. Paul; Owatonna (Minnesota) Public Library; Santa Fe Railway Collection; Los Angeles Public Library. AAA 1913-1919 (Minneapolis); AAA 1921-1924 (Reno, Nevada); AAA 1925-1933 (Fallon, Nevada); Benezit; Fielding; Havlice; Mallett; WWAA 1936-1941 (Fallon); AAW v. I; Ness and Orwig; James G. Scrugham (ed.), *Nevada/A Narrative of the Conquest of a Frontier Land*, v. II, Chicago and New York: The American Historical Society, Inc., 1935, 486-488.

Dawes was active in Minnesota from 1891 well into the twentieth century, first as a commercial artist and then as a landscape painter. His landscapes brought him local recognition. However, his career as a painter was interrupted by business ventures in Denver and Los Angeles, and later in Nevada. Most of his Southwestern landscapes were painted during the years 1915–1921. Thereafter he was active as a silver mine operator for eight years; then as a gold mine operator.

Day, Oriana (–)
Work: Society of California Pioneers. California State Library; San Francisco *Bulletin*, April 15, 1882, 2/4; Boston City Directory, 1876.

A letter to the Editor of the *Bulletin* reported that Day, a Boston artist, had been painting California missions under the supervision of General Mariano G. Vallejo, and that the series was nearing completion, some twenty-one in all.

From a historical standpoint, even the knowledge Day was painting them is important.

Deane, Granville M. (–)
O'Brien, 1935.

O'Brien characterized Deane's early work as having an "almost primitive" ingenuousness, and his later work as having a "cameo" appearance attributed to very fine brush strokes. Deane began painting in 1892.

Deane, Lionel (1861–)
B. Canada. AAA 1921–1925 (New York City and Brooklyn, New York).

Deane, who studied in San Francisco at the School of Design, and with Ernest Narjot (1826–1898), was also an architect.

Deaver, Iva S. McDonald (1893–)
B. Tekamah, Nebraska. Bucklin and Turner, 1932 (Tekamah).

Deaver, who studied at Federal Art Schools in Minneapolis, exhibited at local fairs and in 1929 at the Art Institute of Omaha.

118

De Beukelaer/Benkelear, Laura Halliday (1885–)

B. Cincinnati, Ohio. Work: Washburn College, Topeka, Kansas; State Normal School, Geneseo, New York; YWCA, Newark. AAA 1913 (College Hill, Ohio; listed as Laura Halliday); AAA 1915–1924 (Topeka); Fielding; Clark, 453.

Inasmuch as De Beaukelaer worked mainly in sculpture, the collections listed here may not have examples of her painting.

DeCamp, Ralph Earl (1858–1936)

B. Attica, New York. D. Chicago, Illinois, May 27. Work: C. M. Russell Gallery, Great Falls, Montana; State Capitol and Law Library, Helena, Montana. AAW v. I (Helena); *Who's Who in Northwest Art;* Federal Writers' Project, *Montana*; The Editors, "Ralph E. DeCamp: Artist as Photographer," *Montana, a Magazine of Western History*, July 1979, 50–55; Butte-Silver Bowl Free Public Library; Sternfels, typescript, 4, 15, 111; Inventory of American Paintings, Smithsonian Institution.

Sternfels said that the "Northern Pacific did for Ralph DeCamp what the Great Northern did for [John] Fery," and that offices and stations of those two railroads could "rightfully be called Montana's first art galleries."

DeCamp studied art in Wisconsin and Minnesota, and during 1881–1882 at the Pennsylvania School of Art in Philadelphia. In 1885 he went to Yellowstone to paint. He returned to his home in Moorhead, Minnesota, by way of Prickly Pear Valley in Montana. The scenic possibilities of the region prompted him to move to Helena the following year.

In Helena, De Camp worked as a draftsman for the Interior Department, and with Charlie Russell he organized the Helena Sketch Club. Much of his sketching and photography was done on the Hilger Ranch; the glass plates have since been donated by Dan Hilger to the Montana Historical Society. Of thirteen paintings listed in the Smithsonian's inventory most are oils, including "Prickly Pear River with Two Bends," and "Rosebud Lake Near Red Lodge, Montana."

In 1912 DeCamp was commissioned by the State to paint six panels for the law library. During the twenties he painted four panels for the State Capitol.

Decker, John (1895–)

B. San Francisco, California. Work: Los Angeles County Art Museum. Havlice; WWAA 1947 (Los Angeles, California); WWAA 1953, obit.; San Francisco Public Library art and artists' scrapbook; California State Library; NMAA-NPG Library, Smithsonian Institution; Ben Hecht, "John Decker's Hollywood," *Esquire,* December 1945, 132.

Ben Hecht found an "unvarying exuberance" in Decker's work. Well known as a Los Angeles and Hollywood painter since the 1930s, Decker painted many prominent motion picture people as well as a variety of other subjects. He had solo shows in San Francisco and Beverly Hills, the latter featuring Mexican subjects inspired by a trip to Mexico in 1946.

Decoto, Sarah Horner (1863–)

Work: Lyman House Memorial Museum, Hilo Hawaii; Museum of New Mexico. AAA 1919–1925 (Irvington, California); Benezit; Inventory of American Paintings, Smithsonian Institution.

Decoto studied in Paris with Henri Morriset. It is assumed that the paintings attributed to Mrs. Decota in the Smithsonian's Inventory are those of this artist. One is of California redwoods.

Deem, Mary Goodrich (1868–)

B. Indiana. AAA 1900 (Winona, Minnesota; listed under Art Supervisors and Teachers); Barr, 1954, 20; Robinson, 1966, 519.

Deem graduated from Hillsborough Female College in Ohio in 1886, taught for a number of years, and then went to Columbia University for her master of arts degree. From all accounts she was a pioneer in the field of fine art in North Dakota, and an inspiring teacher. She taught at Valley City Normal School for twenty-eight years prior to retiring in Williamsville, New York.

DeGhize, Eleanor (1896–)

B. New York City. Work: Baltimore Museum of Art; Museum of New Mexico, Santa Fe. Havlice; Mallett Supplement; WWAA 1947 (Cockneysville, Maryland); WWAA1953–1962 (Santa Fe); Museum of New Mexico library.

DeGhize was an expressionist painter who exhibited annu-

ally at the Baltimore Museum of Art, and had a solo exhibition there in 1945. From 1952 she was active in Santa Fe.

De Gissac, F. (-)
B. France. Work: Texas State Library, Austin. O'Brien, 1935; Inventory of American Paintings, Smithsonian Institution.

De Gissac taught art in Waco, Texas, in the 1890s. His portrait of Judge Robert M. Williamson, painted in 1891, is in the Texas State Library.

Delavan/Delevan, William (-)
Gibson; Opal M. Harber, "A Few Early Photographers of Colorado," *Colorado Magazine,* October 1956, 291; Denver Public Library; Rocky Mountain *News,* November 14, 1868, 4/3.

Gibson lists Delavan as a sculptor active in Detroit from 1868 to 1889. He had come directly from the West with "Indian artifacts and other memorabilia" to aid him in painting a panorama. The panorama apparently was not completed.

Harber describes Delavan as an itinerant artist-photographer who spent the summer of 1868 along the Union Pacific railroad line, making sketches and taking veiws for a panorama of the rail route and its branches from Omaha to San Francisco. It was to be called "Across the Continent" and was designed to cover six thousand square feet of canvas. Each scene was to be six by ten feet. Denver citizens feared the footage for the Denver scenes might include the hanging of a man named Sanford S. C. Duggan.

The Denver connection was not completed by Union Pacific until 1870; the transcontinental connection in Utah was completed in May, 1869. Delavan may have been engaged by one of the Union Pacific builders to do the panorama, just as Thomas Hill had been engaged by Leland Stanford to paint the commemorative scene at Promontory Point, Utah, on May 10, when the last spike was driven.

De Lemos, Pedro J./Lemos, Pedro J. (1882-)
B. Austin, Nevada. Work: California State Library; Monterey Public Library; Oakland Art Museum. AAA 1915-

1917 (Oakland, California); AAA 1919-1933 (Palo Alto, California); Fielding; Havlice; Mallett; WWAA 1936-1956 (Palo Alto); AAW v. I; Porter, and others; Mary Van Court, "A Visit to the Workshop of Pedro J. Lemos, Artist-Craftsman," *American Magazine of Art*, August 1922, 254-257; California State Library; Inventory of American Paintings, Smithsonian Institution.

Van Court felt the skill in etching and lithography of De Lemos had gone "unproclaimed." His prints and paintings were overshadowed by his roles as professor of design at the University of California; director of the San Francisco Institute of Art; organizer of the California Society of Etchers; editor of *School Arts* Magazine; director of the Stanford University Museum of Fine Art; designer of the Allied Arts complex in Menlo Park and by other civic contributions. His name is often heard in the San Francisco Bay region, but his work is seldom seen. His etchings of Northern California subjects are now as important for their historical attributes as for their esthetic and technical ones.

Denison, Lucy Dunbar (-)
AAA 1900-1903 (Denver, Colorado; listed under Art Supervisors and Teachers); Denver Public Library; Bromwell Scrapbook, 23, 28; Denver *Times*, March 15, 1900.

Denison, who taught at East Denver High School, was one of the thirty most active members of the Denver Artists' Club. She exhibited with Club members in 1899 and 1900, and perhaps in other years.

Denning, Estella L. (1888-)
B. Canyon City, Oregon. *Who's Who in Northwest Art* (Boise, Idaho).

Denning, who taught art at Whittier School in Boise, had studied at Saint Francis Academy in Baker, Oregon; the University of Idaho; and with Ethel Fowler in Boise. She worked in oils, pastels, and water colors.

Denny, Emily Inez (1853-1918)
B. Seattle, Washington. D. Seattle, August 23. Work: Museum of History and Industry, Seattle. Dodds, Master's thesis, University of Washington Art Library.

Denny studied with several local artists, and with Thomas Alexander Harrison when he was briefly in Seattle while painting landscapes of the Northwest. In 1909 she published *Blazing the Way* (Rainier Printing Company Inc.) which probably contains some of her observations of a budding art movement in Seattle. A typescript of her reminiscences about the development of art in Seattle is in the archives of the Seattle Historical Society.

Denny, Madge Decatur (-)
Dodds, Master's thesis, 90, University of Washington Art Library.

Denny had some water color instruction, but was mainly self-taught. Her specialty was wild flowers.

Denny, Milo B. (1887-)
B. Waubeek, Iowa. AAA 1919-1921 (Cedar Rapids, Iowa; summer, Waubeek); AAA 1923-1924 (Grand Rapids, Michigan); AAA 1925-1927 (Cedar Rapids); AAA 1929 (Cincinnati, Ohio; summer, Taos, New Mexico); AAA 1931 (Saugatuck, Michigan); Fielding; Clark.

Denslow, William Wallace (1856-1915)
B. Philadelphia, Pennsylvania. AAA 1905-1913 (New York City and Bermuda); Benezit; Denver Public Library; "Denver Artist, originator of Scarecrow & Tin Man," Denver *Republican*, September 4, 1904, 13; *American Artist*, May 1978, 23.

Denslow traveled widely during his career as illustrator for some of this country's leading newspapers.

De Ribcowsky, Dey/Ribcowsky, Dey De (1880-)
B. Rustchuk, Bulgaria. Work: museums in foreign countries. AAA 1927-1933 (Los Angeles, California); Fielding; Havlice; Mallett; WWAA 1936-1941 (Miami Beach, Florida); Weber, Colby College exhibition catalogue; Inventory of American Paintings, Smithsonian Institution.

De Ribcowsky, who studied in Paris, Florence, and Petrograd, traveled extensively and painted in many places. He was quite popular as a teacher in Texas, probably during the early 1930s when his main residence was in Los Angeles. Paintings en-

titled "Monterey at Moonlight" and "Grand Canyon" may be in a Manchester, Vermont, gallery once known as the Manchester Memorial Museum.

Dermody, Grace (1889–)
B. Flora, Illinois. San Antonio Public Library art and artists file.

Dermody, who lived in San Antonio, Texas, had once studied commercial art, but was mainly active as a landscape painter.

DeRome, Albert (1885–1959)
B. Santa Barbara County. *California/Albert DeRome 1885–1959/Oil Paintings and Biography,* 1976, n.p.; NMAA-NPG Library, Smithsonian Institution.

It is said that DeRome probably traveled more extensively for his subject matter from 1918 to 1931 than any other California artist. The year he did water colors in Indian country along the upper Klamath River, 1918, was the beginning of his travels to remote places in the state where few other artists went. After a crippling automobile accident in 1931 he had to confine himself to scenes in Santa Clara, Santa Cruz, and Monterey counties near his Monterey studio. Later he moved to Carmel.

Among DeRome's artist friends were William Keith, Carlos Hittell, and Will Sparks. It was Keith who noticed DeRome's ability to achieve a luminous effect in his water colors, and it was Sparks who encouraged him to do small oils after the accident. Both Keith and Hittell supplemented DeRome's early but limited training at the Mark Hopkins Institute of Art in San Francisco where DeRome was a successful business man.

De Steiguer, Ida (–)
Hafen, *History of Colorado,* v. III, 1268; Denver Public Library; Bromwell Scrapbook.

De Steiguer was on the first faculty of Denver School of Fine Arts, University of Denver. The 1892–1893 Prospectus lists her for "drawing, life and casts." She was one of the most active members in the Denver Artists' Club in 1900 and is often mentioned in Bromwell's scrapbook, pages 1–18.

Detreville/De Triville, Richard (1854–1929)
Work: Oakland Art Museum. Inventory of American Paintings, Smithsonian.

Dickson, Henry (1843–1926)
B. Iowa. D. Dixon, California. Castor typescript, San Francisco Public Library.

Dickson, who was active in San Francisco after 1861, was a protégé of the artist Thaddeus Welch. He was also a photographer.

Dickson, Lillian Ruth Durham (–)
B. Atlanta, Georgia. Mallett Supplement (Fort Worth, Texas); O'Brien, 1935; Houston Public Library art and artists' scrapbook.

Dickson, who studied at Washington University's School of Fine Arts in St. Louis, moved to Texas in 1914. Her first paintings were often of Indians and the desert. She maintained a studio in Fort Worth, exhibited locally, and was still active in 1938.

Dismukes, Mrs. E. (–)
McMechen, 1947, 103.

Little known painter working in Denver, Colorado, about 1906.

Dobos/Do Bos, Andrew (1897–)
B. Galicia, Poland. Work: State Museum, Springfield, Illinois; Amalgamated Lithographers of America, Chicago. AAA 1931–1933 (Oak Park, Illinois); Havlice; Mallett; WWAA 1936–1939 (Oak Park); WWAA 1940–1941 (River Forest, Illinois); WWAA 1947–1953 (San Rafael, California).

Dodge, Regina Lunt (–)
McClurg, 1924, pt. VI; Colorado College Library.

Dodge may have been a daughter of Judge Horace G. Lunt of Colorado Springs. She exhibited frescoes at the dedication of Perkins Fine Arts Hall at Colorado College in 1900. As Regina

Lunt Dodge she exhibited two California landscapes at the Broadmoor Art Academy in Colorado Springs in 1927 and 1928.

Dolan, Elizabeth Honor (1884–1948)

B. Fort Dodge, Iowa. D. Lincoln, Nebraska, May 26. Work: University of Nebraska; Nebraska State Capitol; Museum of Natural History, New York City; Masonic Temple, Lincoln; All Souls Unitarian Church, Lincoln. AAA 1929–1933 (Lincoln); Havlice; Mallett; WWAA 1936–1953 (Lincoln); AAW v. I; Bucklin and Turner, 1932; Leila Mechlin, "Regional Conference at Lincoln," *American Magazine of Art*, January 1928, 17; Holmes Smith, "Elizabeth Dolan's Habitat Backgrounds for the University of Nebraska," *American Magazine of Art*, August 1929, 460–462; Ann Reinert, librarian, Nebraska State Historical Society.

Dolan's murals for the University of Nebraska's Morrill Hall attracted national attention. Mechlin wrote that they compared "in quality with the best of the kind that have been done in our eastern museums," and "in some respects are superior." Heroic in scale—they were 70' × 16'—they necessitated Dolan's conquering her fear of heights to do them.

While Dolan was studying at the Art Institute of Chicago, she was considered by the director the most talented student there. She was awarded two scholarships, one of life tenure. They enabled her to study at the Art Students League and later in France and Italy.

Before going to Europe, Dolan earned a living in New York painting portraits, landscapes, miniatures, birds, and animals, and designing stained-glass windows for Louis Tiffany. In Europe she turned to frescoes and murals. While studying at Fontainbleau, she was one of three who received a diploma in painting, and the only one in a class of twenty-five to receive a diploma in fresco.

Dolmith, Rex (1896–)

B. Canton, Ohio. Havlice; Mallett Supplement; WWAA 1936–1941 (Wilmington, Delaware); WWAA 1953–1962 (Taos, New Mexico).

Dolmith appears to have lived in the West much earlier

than is indicated in art directories. He studied with Robert Graham and Sidney Bell in Denver, and at Chouinard Art Institute, Otis Art Institute, and California College of Arts and Crafts, in addition to the Art Institute of Chicago. He exhibited in New York, Connecticut, Arizona, New Mexico, and Colorado.

Dolph, M. D. (Mrs. R. J.) (1884–)
B. Baraboo, Wisconsin. Work: State Capitol, Cheyenne, Wyoming. Mallett Supplement (Casper, Wyoming); *Who's Who in Northwest Art* (Hood River, Oregon; Casper); M. Barr, 40, 48–49; *Western Artist,* May 1936, 18.

Dolph studied at the Milwaukee Art League, the Art Institute of Chicago, and the University of Minnesota. She settled in Wyoming at the invitation of her uncle Captain Henry Palmer.

During the 1930s Dolph exhibited regularly in group shows at the University of Wyoming, at several WPA-sponsored exhibitions, at John Herron Art Institute in Indianapolis, and at Rockefeller Center in New York. By 1940 she had a studio at Hood River and was active in the Oregon Society of Artists.

Dominique, John Augustus (1893–)
B. Sweden. Work: University of Virginia Art Gallery. Havlice; WWAA 1947 (Los Angeles, California); WWAA 1956 (Santa Barbara, California); WWAA 1959–1976 (Ojai, California); *Who's Who in Northwest Art* (Canby, Oregon); *News Notes of California Libraries,* April 1931, 175.

Dominique studied at Portland Art Museum School, San Francisco Museum of Art, Otis Art Institute, and Santa Barbara School of Art. His principal teachers in California were Frank Van Sloun, Carl Oscar Borg, Armin Hansen, and Colin Campbell Cooper. He had solo shows in Los Angeles in 1933, Santa Barbara in 1934, and Salem, Oregon, in 1938.

Donaldson, Olive (–)
Fisk, 1928; O'Brien, 1935; *Texas Painting and Sculpture,* 6.

Donaldson had seven years of art study and art research, and was the first Ph.D. to teach in the Dallas area where she was director of the art department of Southern Methodist University from 1915 well into the 1930s, and perhaps later.

127

Dondo, Mathurin M. (1884–)
AAA 1921 (Columbia University, New York); AAA 1923–1933 (University of California, Berkeley); Mallett.

Donovan, John Ambrose (1871–1941)
B. Hamilton, Ontario. D. Los Angeles, January 9. *National Cyclopedia of American Biography,* v. 30, 449; *News Notes of California Libraries,* October 1910, 537.

Donovan studied in Detroit, London, Paris (where his work was well enough known to attract newspaper art critics), and Ireland. He married the daughter of a San Bernardino (California) rancher, settled in Los Angeles, and specialized in marines.

d'Orge, Jeanne (See: Jeanne d'Orge Cherry)

Dorn, Marion V. (–)
AAA 1919 (San Francisco, California).

Dougherty, Paul (1877–1947)
B. Brooklyn, New York. D. Palm Springs, California, January 9. Work: Metropolitan Museum of Art; Brooklyn Museum; National Museum of American Art; St. Louis Art Museum; Monterey Peninsula Museum of Art; Fort Worth Art Center; Toledo Museum of Art, etc. AAA 1900–1903 (Brooklyn); AAA 1905–1929 (New York City); AAA 1931–1933 (Carmel Highlands, California); Benezit; Fielding; Havlice; Mallett; WWAA 1936–1941 (Carmel Highlands); WWAA 1947 (Palm Springs, California); AAW v. I; *National Cyclopedia of American Biography;* Earle; Spangenberg; Jean Kellogg, "Paul Dougherty/A Painter in the Classic Sense," Monterey Peninsula *Herald,* October 29, 1960, A15; NMAA-NPG Library, Smithsonian Institution.

Highly acclaimed as a marine painter, Dougherty is said to have left no field of subject matter untouched. His Southwestern desert scenes of Arizona and California coincided with his need to live in a drier climate. His last four years were inactive ones because of arthritis.

Success came early to Dougherty. He exhibited at the National Academy of Design when he was eighteen, and was made a member of the Academy at age thirty.

The artist Abel Warshawsky called Dougherty "one of the

greatest marine painters of our time." And Jean Kellogg Dickie who had studied with him called him "a rare teacher who taught her to paint with 'anything that would stick' and to push all media to their fullest expression."

Douglass, Emma Simpson (-)
Fisk, 1928 (San Angelo, Texas).

After 1909, Douglass was more active as a lecturer in art history than as a landscape painter.

Dovey, Ione/Ione Dovey Betts (-)
Bucklin and Turner, 1932 (Omaha, Nebraska); Joslyn Art Museum library.

Dovey grew up in Plattsmouth, Nebraska. She studied at the Art Institute of Chicago, the New York Fashion Academy, and with various private teachers in New York and France. She exhibited with the Omaha Art Guild, of which she was a member, from 1913 until 1931 or later. According to Bucklin and Turner she painted "along the Missouri River, in France, in California, and along the Canadian border."

Dowd, A. W. (-)
Olpin, 1980 (Sunnyside, Utah); *Art News,* January 3, 1925, 9; Salt Lake City Public Library art and artists' scrapbook.

Dowd, formerly of Carbon County, Utah, was a doctor whose "admirable" mountain landscape attracted the attention of Deseret *News* in March of 1925, according to a news item in the art and artists' scrapbook. Several months earlier he had exhibited with a group at the Chamber of Commerce in Salt Lake City.

Downie, Janet (-)
B. Detroit, Michigan. Mallett (Austin, Texas); Fisk, 1928; O'Brien, 1935; Colorado Springs Fine Arts Center Registrar's office, Colorado Springs, Colorado.

Downie, whose parents were natives of Scotland, was sent to a government school in London where she got some art training, and then to South Kensington Institute. About 1906 she became art supervisor for Austin public schools, a position she held for ten years. During summers she continued her art studies in

New York and Pennsylvania, the Art Institute of Chicago, and the Broadmoor Art Academy in Colorado Springs.

Downie's specialty was Texas floral landscapes in oils and water colors. She was active in the San Antonio Art League, the Texas Fine Arts Association, and the Southern States Art League. Her work was known mainly in Texas and Oklahoma.

Downie, Mary (-)
B. Detroit, Michigan. O'Brien, 1935; Colorado Springs Fine Arts Center Registrar's office.

Like her sister Janet, Mary Downie studied art in England, New York, Chicago, Pennsylvania, and Colorado Springs. Both were residents of Austin, Texas, for many years.

Downing, Alfred (-)
Work: Washington State Historical Society, Tacoma. Denver Public Library; Bruce LeRoy, "Mosquitoes, Mules, and Men," *American Heritage*, April 1965, 102–107; Inventory of American Paintings, Smithsonian Institution.

While Downing was engaged in surveying trails in the territories of Washington, Idaho, Montana, and the Dakotas, he sketched his observations. A sketchbook at the Washington State Historical Society contains 144 sketches and water colors done during four major expeditions. Many of them are in a humorous vein. A pair of small oils of the Olympic Range, painted by him in 1870, are listed in the Smithsonian's Inventory of American Paintings.

Doyle, Florence Watkins (-)
Wilbanks, 1959.

Doyle was a very early teacher of art and elocution in the public schools of Lubbock, Texas. Her paintings are in family collections.

Drake, Florence Bonn (1885–1958)
B. Winona, Minnesota. D. Ogden, Utah, May 9. Olpin, 1980; Salt Lake City Public Library art and artists' scrapbook; Salt Lake *Tribune*, May 11, 1958, obituary; George Dibble, "Art," Salt Lake *Tribune*, May 22, 1958.

Drake was active in Ogden as artist and teacher from 1919 until she retired in 1954. Dibble described her work as "strong,

dynamic, and forceful," and called her one of Utah's "ablest water colorists."

Dressler, Edward James (1859–1907)
B. Centerville, Michigan. D. Chicago, Illinois. AAA 1900–1903 (Chicago); Mallett; Richard E. Lynch, Scottsdale, Arizona; Santa Fe Railway catalogue, 1981.

About 1903 Winfield Scott, for whom Scottsdale is named, arranged with Dressler and his wife to make sketches on the Indian Reservation in Northern Arizona. Bertha Menzler Dressler (later Bertha Menzler-Peyton) became well known as a landscape painter specializing in Western scenery – her "Evening in the Arizona Desert" was the Santa Fe Railway's first acquisition – but whether any of Dressler's Western work is extant has not been determined.

Drewes, Werner (1899–)
B. Canig, Germany. Work: Pennsylvania Academy of Fine Arts; Museum of Modern Art; Honolulu Academy of Arts; Henry Gallery, University of Washington; National Museum of American Art, etc. AAA 1933 (New York City); Havlice; Mallett; WWAA 1936–1939 (New York City); WWAA 1940–1953 (Catskill, New York); WWAA 1956–1966 (St. Louis, Missouri); WWAA 1970 (Point Pleasant, Pennsylvania); WWAA 1970–1978 (Reston, Virginia); NMAA-NPG Library, Smithsonian Institution.

Drewes, a German-American expressionist, came to the United States in 1930. His Western subjects include the Grand Canyon, Yosemite National Park, the California Redwoods, and the Ely (Nevada) area. Most of this work was done between 1956 and 1966, and much of it consists of woodcut prints, Drewes' preferred medium.

Drummond, Mrs. A. A. (1856–)
B. Ohio. Ness and Orwig.

Drummond taught herself to paint while living in a sod house in Smith County, Kansas. She made her brushes from a mule's tail and her daughter's hair. House paint was her medium.

Later Drummond moved to Iowa. She painted portraits of several prominent persons, probably from photographs or repro-

ductions. Her portrait of General Drake may be at Drake University in Des Moines. At an Iowa Federation of Women's Clubs exhibit held in the Des Moines Public Library in 1932, she exhibited a self-portrait.

Ducker, Clara Estelle (1886–)
B. Lawrence, Kansas. *Who's Who in Northwest Art* (Washington Hotel, Weiser, Idaho); *Idaho Encyclopedia* (Caldwell, Idaho).

Ducker studied at Lewis Academy in Wichita, Kansas; Emporia College, Emporia, Kansas; and Pratt Institute. During the years she lived in Indian Territory she did many portrait and genre paintings of Cherokee, Creek, Choctaw, Kiowa, and Comanche Indians.

In Idaho, where Ducker taught at a vocational school in Weiser, she specialized in mountain landscapes and sunsets. She also painted murals for the Rebecca and Grand lodges of the Eastern Star.

Duer, Ben F./Benjamin Franklin (1888–)
Havlice; WWAA 1953–1959 (Los Angeles, California).
Duer was active in California from 1949.

Duff, Pernot Stewart (1898–)
B. Corvallis, Oregon. *Who's Who in Northwest Art* (Wakonda Beach, Waldport, Oregon).

Duff studied at the Portland Art Museum School, Oregon State College, and with private teachers in Southern California. He exhibited in group shows in New York, Los Angeles, Portland, and Salem (Oregon), and won several prizes.

Du Mond, Frederic Melville (1867–1927)
B. Rochester, New York. D. Monrovia, California, May 25. Work: Hubbell Trading Post National Historic Site, Ganado, Arizona; Santa Fe Railway. AAA 1900–1917 (Paris, France); AAA 1927 obit.; Benezit; Mallett; AAW v. I; *National Cyclopedia of American Biography*, v. 27, 58; NMAA-NPG Library, Smithsonian Institution.

During the early years of his career Du Mond was mainly active in France where, with his brother Frank, he established a summer art school at Crecy in 1894. He taught there until 1900.

From 1909 to 1912 Du Mond worked in Colorado, Arizona, and New Mexico, making paintings of the Grand Canyon, Pueblo cliff dwellings, and other southwestern scenes. In 1913 he moved to Monrovia, but continued to work abroad where he was well known as an animal and desert painter.

Duncan, Dorothy J. (1896-)
B. Sausalito, California. Work: San Francisco Museum of Art. Havlice; Mallett Supplement; WWAA 1940-1941 (San Francisco); WWAA 1947-1953 (Sausalito); California *Arts & Architecture,* December 1932 (San Francisco.

Duncan, W. M. (-)
AAA 1919 (Los Angeles, California).

Duval, Ella Moss (1843-1911)
B. Pass Christian, Mississippi. D. St. Louis, Missouri. Work: District Court, Austin, Texas; portraits in private collections. AAW v. I; Pinckney, 1967, 172-174; Inventory of American Paintings, Smithsonian Institution.
Duval studied art at the Dusseldorf School where her principal teacher was August Wilhelm Sohn (1829-1899). During her last year there she was awarded a year's study in Rome. She accepted instead a cash award, for her father's business in Philadelphia was failing and she was needed at home. She opened a studio in New York and became a successful portrait painter. Among her patrons were the musician Louis Gottschalk and the second wife of Commodore Vanderbilt. In 1877 she began exhibiting at the National Academy of Design.
Following marriage to Burr Duval, Ella Duval moved to Austin, Texas, and later to San Antonio where she continued to paint portraits and to teach. A portrait reproduced in Pinckney's book is of a Texas doctor, and is listed in the Inventory of American Paintings.

Dwight, Mabel (1876-1955)
B. Cincinnati, Ohio. D. Sellersville, Pennsylvania, September 4. Work: Metropolitan Museum of Art; Boston Museum of Fine Arts; Cleveland Museum of Art; Art Institute of Chicago; Bibliotheque Nationale, Paris; Whitney Museum of American Art, etc. AAA 1921-1933 (New York

City); Fielding; Havlice; Mallett; WWAA 1936–1941 (New York City); Park and Markowitz, 1977, 87; Clark, 456; NMAA-NPG Library; "Gallery Shows Group of Prints," Washington *Post,* November 1, 1936.

Dwight attended high school in San Francisco and studied art in 1896–1897 at the Mark Hopkins Institute. Among her teachers was Arthur Mathews.

Because of her international recognition as a print maker, her work was seen in every "notable print show of the country," said the Washington *Post.* Her approach to her subjects, both figures and landscapes, was "full of intuition and subtle characterization."

Dwyer, James (ca 1880–)
Mallett (Dayton, Ohio); California *Arts & Architecture,* December 1932 (Oakland, California).

Dye, Olive Leland Bagg (1889–)
B. Lincoln, Nebraska. D. Lincoln. AAA 1933 (Lincoln); Havlice; Mallett; WWAA 1936–1939 (Lincoln); WWAA 1940–1941 (Los Angeles, California); AAW v. I; Bucklin and Turner, 1932.

Dye studied with her father Henry Howard Bagg, and at the Chicago Fine Arts Academy. She did several landscapes for the Thomas D. Murphy Company, a calendar company in Red Oak, Iowa, and several of her paintings are listed in WWAA 1940–1941.

E

Eaton, Charles Warren (1857–1937)
B. Albany, New York. D. Leonia, New Jersey, August 4. Work: Butler Institute of American Art; Montclair Art Museum; National Museum of American Art; Dallas Museum of Fine Arts; Bennington (Vermont) Museum;

Hackley Art Gallery; Detroit Art Institute, etc. AAA 1898-1933 (New York City; Bloomfield, New Jersey); Benezit; Fielding; Havlice; Mallett; WWAA 1936-1937 (New York City; Bloomfield); Earle; Gibson; Charles Teaze Clark, "Charles Warren Eaton," *Antiques* Magazine, December 1980, 1242-1250.

Clark's biographical article on Eaton includes Eaton's work in Montana at Glacier National Park in 1921. At least twenty-two canvases from the summer's work were exhibited at Macbeth Gallery in New York, and in various other galleries over a two-year period. A black-and-white reproduction of "Mt. Rockwell, Glacier Park" is shown on page 1250 of *Antiques*. Eaton was one of several artists commissioned by a railroad company to paint scenes of the park for promotional purposes.

Eberhardt, Eugenia McCorkle (–)
B. Alabama. AAA 1923-1924 (Fort Worth, Texas); Mallett Supplement; O'Brien, 1935.

Eberhardt grew up in Texas, studied with Vivian Aunspaugh in Dallas, Samuel Ziegler in Fort Worth, and at the Art Institute of Chicago. She exhibited annually in Fort Worth from 1920, won numerous awards, and held solo exhibitions there.

Edgren, Robert W. (1874-1939)
D. Del Monte, California. Mallett Supplement, obit.; Castor typescript, San Francisco Public Library; California *Arts & Architecture*, December 1932 (Del Monte).

Edgren was active in San Francisco in 1895 as a sports reporter and sketch artist. Later he turned to cartooning and illustrating in black and white.

Edmiston, Henry (1897–)
B. Kansas City, Missouri. Havlice; WWAA 1947-1953 (Los Angeles, California).

Edmiston, who began exhibiting in California in 1943, is listed as a painter, cartoonist, illustrator, and writer. During 1944 and 1945 he exhibited nationally in major museum group shows.

Edmondson, Edward, Jr. (1830-1884)
B. Dayton, Ohio. D. California. Work: Dayton Art Insti-

tute; Santa Barbara Historical Society; Odd Fellows Hall, Dayton. Groce and Wallace; Young; Clark; Peat; Dayton Art Institute library; Gerdts, 1971, 72–73; Inventory of American Paintings, Smithsonian Institution.

Although best known for his still life paintings, Edmondson also did portraits and landscapes. About 1870 he moved to California for his health. "California Snow Plant" was painted about 1870, and three "Mission Santa Barbara" titles were painted in 1872. The latter are at the Santa Barbara Historical Society. The Dayton Art Institute has the largest collection of his work.

Edmondson, Elizabeth (1874–)
B. Indiana. *Who's Who in Northwest Art* (Medford, Oregon).

Edmondson, who studied at Pratt Institute, worked in all media, and exhibited in group shows at the Corcoran Gallery of Art, Cincinnati Art Museum, Denver Art Museum, and others.

Edmondson, William John (1868–1966)
B. Norwalk, Ohio. D. Pasadena, California, July 17. Work: Monterey Peninsula Museum of Art; Cleveland Museum of Art; Western Reserve University; Isaac Delgado Museum of Art, New Orleans; State House, Columbus, Ohio, etc. AAA 1898–1933 (Cleveland and Cleveland Heights); Benezit; Fielding; Havlice; Mallett; WWAA 1936–1941 (Cleveland and Cleveland Heights); Clark, 348; Monterey Peninsula Museum of Art docent library; Inventory of American Paintings, Smithsonian Institution.

Edmondson painted in the West long before he moved to Monrovia, California, in 1950. He was especially well known as a portrait painter, but his landscapes also were popular. Clark was impressed with his Western mountains "rising from a misty plain, white adobe houses with red tile roofs, swaying trees in a raging storm," done with a "gorgeous colorful breadth of landscape in beautifully composed subtle patterns."

Edwards, Emily (–)
B. San Antonio, Texas. AAA 1915 (Chicago, Illinois);

Mallett (San Antonio); Fisk, 1928; O'Brien, 1935; Witte Memorial Museum library, San Antonio.

Known also as Emily Cantabrana, Edwards studied at the Art Institute of Chicago, and in the late twenties with Diego Rivera in Mexico City. Then she moved on to a little Mexican village where she could observe, sketch, and transmit to wood blocks her impressions. When color prints from these blocks were exhibited, they "attracted much attention," said O'Brien.

Edwards exhibited mainly in Texas, and in New York City on one or more occasions. She is known in Texas for her landscape paintings as well as for her prints.

Edwards, H. Arden (1884–1953)
B. Frankfurt, Indiana. D. Lancaster, California. AAA 1925 (Los Angeles); Sparks; California *Arts & Architecture,* December 1932 (Eagle Rock, California).

Edwards was a portrait painter, lecturer, teacher, and an authority on American Indians. After moving to Los Angeles he taught at Lincoln High School for twenty years. In 1928 he founded the Yato Kya Indian Museum in nearby Antelope Valley. He exhibited with the California Art Club of which he was a member.

Eggers, Theodore (1856–)
B. Schleswig-Holstein, Germany. *Who's Who in Northwest Art* (Seattle, Washington).

Eggers studied with Edgar Forkner in Seattle, and exhibited with the Painters and Sculptors' Guild of Northwest Men Painters.

Elliott, Henry Wood (1846–1930)
B. Cleveland, Ohio. D. Washington, D.C. Work: National Museum of American Art; Cleveland Museum of Natural History; Lowie Museum of Anthropology, University of California. AAW v. I; M. Barr; NMAA-NPG Library, Smithsonian Institution; Aubrey L. Haines, *Yellowstone National Park/Its Exploration and Establishment,* Washington: U. S. Department of the Interior, 1974, 104, 122; Samuels.

Although Elliott produced enough water colors from his

Alaska trips to enable the Smithsonian Institution to circulate them in a traveling exhibition, only one water color from his F. V. Hayden Survey years has been listed in the Smithsonian's Inventory of American Paintings. Elliott was artist/naturalist with Hayden's Survey from 1869 through the field season of 1871. His water color "Yellowstone Lake" is dated 1871, the year Hayden's U. S. Geological Survey of the Territories convened in Ogden, Utah, to complete work there and then moved into the region that became Yellowstone National Park. Hayden played a major role in influencing favorable legislation creating the Park; Elliott played a minor role as field correspondent for *Frank Leslie's Illustrated Newspaper* with articles that appeared in September 1871 and January 1872. (Samuels and others credit the oil paintings of Thomas Moran, guest artist in 1871, with leading to the legislation, but those paintings did not appear until after the Park legislation passed; pictorially the credit belongs to the photographer William Henry Jackson.)

Elliott covered a great deal of the Rocky Mountain West during his years with Hayden, especially in 1869 when the party worked as far south as Northern New Mexico. There should be more work by him around — somewhere.

Ellis, Harvey (1852–1904)
B. Rochester, New York. D. Syracuse, New York, January 2. AAA 1898–1903 (Rochester); AAA 1905 obit.; Benezit; Mallett; Young; Barry Sanders, "Harvey Ellis: Architect, Painter, Furniture Designer," *Art and Antiques,* January-February 1981, 58–67.

Ellis studied at the National Academy of Design, exhibited at the New York Water Color Club, and at the Paris Exposition of 1900, and was president of the Rochester Society of Arts and Crafts. About 1890 he disappeared for a year and apparently toured the Southwest. If so, it is likely that paintings made during that year, or soon thereafter, are extant.

Ellsworth, Edyth Glover (1879–)
B. Portland, Oregon. Work: Portland Woman's Club. *Who's Who in Northwest Art* (Portland).

Ellsworth who worked in oils, water colors, and pastels, studied at the University of Minnesota, the Art Institute of

Chicago, the Chicago Art Academy, Portland Art Museum School, and Thorpe Institute in Pasadena.

Elmendorf, Stella T. (See: Stella Tylor/Tyler)

Elvidge, Anita Miller (1895–)
B. Oakland, California. *Who's Who in Northwest Art* (Seattle, Washington); Pierce, 1926.
Elvidge, whose specialty was landscapes, studied at California College of Arts and Crafts, New York School of Fine and Applied Art, Cornish School of Art in Seattle, and the University of Washington. She worked in water color and exhibited widely in group shows.

Emerson, Sybil Davis (1892/95–)
B. Worcester, Massachusetts. Benezit; Havlice; Mallett; WWAA 1936–1941 (New York City); WWAA 1947–1956 (State College, Pennsylvania); WWAA 1959–1962 (McMinnville, Oregon); Young; Mahony, 1947.
Emerson was in the West much earlier than her art directory entries indicate, at least as early as 1924 when she was studying in San Francisco. In the 1930s she wrote and illustrated two books for children; in 1942 she became associate professor of Art Education at Penn State; from 1943 to 1951 she exhibited nationally in art museums and clubs.

Emerson, William Otto (–)
News Notes of California Libraries, January 1908, 12, and October 1910, 537; Inventory of American Paintings, Smithsonian Institution.
Research on this artist was not very productive. Emerson's Dutch and French oils and water colors, listed in the Smithsonian's Inventory, bear dates from 1890 to 1892. A reproduction of a painting entitled "Western Meadow Lark" is at the California State Library.

Emert/Emmert, Paul (1826–1867)
B. near Berne, Switzerland. D. Honolulu, Hawaii, March 13. Work: Bancroft Library, University of California,

Berkeley. Groce and Wallace (New York City, 1845–1849); Young (New York City, 1845–1859); Bancroft Library.

Emert began his career in New York City. He visited California in 1849 to gather material for a panorama on life in the gold mining region. Completed in 1850 it was shown in New York City in March of that year, and in Saint Louis the following December. While Emert was in California in 1850, he began another panorama which he completed in 1852 and showed in San Francisco in May of that year. In February 1853 he went to Hawaii. He visited California again in 1854, and in 1858 when he worked as artist for Professor C. A. Shelton, a biologist. Twelve drawings of California and Mexico, ca 1850–1858, are at Bancroft Library.

Emery, Nellie Augusta (–1934)
B. Hartford, Maine. Work: St. Paul (Minnesota) Art Gallery. AAA 1909–1915 (St. Paul); AAA 1923–1925 (Dallas, Texas); Fisk, 1928; O'Brien, 1935.

Emery was active in applied arts as well as fine art. Her training for the latter was extensive. Among her teachers were John Enneking of Boston, William Merritt Chase of New York, and James Whistler in Paris. She is said to have been the first American woman to receive permission to sketch in Westminster Abbey.

Although some of Emery's major paintings were done in Minnesota, she seems to have been active in Dallas as early as 1909. She painted several landmark buildings in Texas, including the first capitol, and a number of landscapes with Texas and Minnesota settings. Undoubtedly there are European subjects among her works, for she studied in Paris and traveled in a number of countries.

Engledow, Charles O. (1898–)
B. Denver, Colorado. *Who's Who in Northwest Art* (Seattle, Washington).

Engledow, who was an advertising artist for Pacific Telephone and Telegraph, worked mainly with oils.

Englehardt/Englehart, Joseph/John/J. (–)
Work: Oakland Art Museum; College of Notre Dame, Belmont, California; Washington State Historical Society.

AAW v. I; LeRoy, exhibition catalogue, 1965; Society of California Pioneers library; Inventory of American Paintings, Smithsonian Institution.

The Inventory of American Paintings lists thirty oil landscapes that appear to be by the same artist, although given names and/or initials vary. Most are signed Joseph or J. Englehardt. Dates on the paintings range from about 1880 to about 1911. All are of Northern California and the Pacific Northwest.

The results of efforts to obtain data on Englehardt or Englehart are in the general information files of the Society of California Pioneers. The San Francisco directory for 1889 shows Englehardt with a studio on Clay Street. During his California years he also had a home in Alameda. It is thought that Leland Stanford may have met him during one of his visits to Germany, and encouraged him to come to the United States.

Whether Englehardt was the Josef/Joseph Englehardt (1859–) listed in Benezit, Thieme, and Mallett Supplement has not been determined.

Erdmann, Richard Frederick (1894–)
B. Chillicothe, Ohio. AAA 1929 (Albuquerque, New Mexico); AAA 1931–1933 (Chillicothe); Benezit; Havlice; Mallett; WWAA 1936–1941 (Chillicothe); WWAA 1947–1962 (Dedham, Massachusetts); Clark.

Erickson, Eric (1878–)
B. Plattsmouth, Nebraska. *Idaho Encyclopedia* (Rupert, Idaho); *Western Artist*, March 1936, 17.
Erickson studied with Idaho painter George Eugene Schroeder, and exhibited locally.

Eriksen, Jens (–1920)
D. Denver, Colorado, November 18. Denver Public Library; Denver *Post*, November 20, 1920, obit.
Eriksen was a portrait and mural painter who did murals for El Jebel Temple, the old Broadway Theater, and other Denver establishments.

Ernesti, Ethel H. (1880–)
B. Huntington, Indiana. Mallett Supplement (Seattle,

Washington); *Who's Who in Northwest Art;* Colorado
Springs Fine Arts Center library.

Ernesti studied at Penn State College, Colorado State College, Broadmoor Art Academy in Colorado Springs, in Chicago, and with Charles Partridge Adams, Henry L. Richter, and Edgar Forkner. She had at least two solo exhibitions in Seattle.

Ernesti, Richard (1856–)

B. Chemnitz, Germany. Work: Hubbell Trading Post Museum, Ganado, Arizona. *Who's Who in Northwest Art* (Seattle, Washington); Ness and Orwig; Inventory of American Paintings, Smithsonian Institution.

Ernesti obtained much of his art training in Chemnitz and at the Chicago Academy of Design. He taught at Penn State College, Drake University in Iowa, and Colorado State Teachers College. Many of his paintings, which he is said to have exhibited widely, are landscapes of the Colorado Rockies; a few are Indian studies such as "Comanche Dancer" at Hubbell Trading Post Museum. His wife, Ethel, also was a painter.

Erwin, Margaret D. (–)

O'Brien, 1935 (McKinney, Texas).

Erwin attended Peace College in Raleigh, North Carolina, and the Art Students League where she studied with Twachtman and Dumond. Among other teachers with whom she studied were Rhoda Holmes Nichols and William Merritt Chase. She had a studio in McKinney, but usually spent her summers in art colonies.

Eskridge, Robert Lee (1891–)

B. Philipsburg, Pennsylvania. Work: Illinois Athletic Club, Chicago. AAA 1915–1933 (Chicago; Coronado Beach, California); Benezit; Fielding; Havlice; Mallett; WWAA 1936–1939 (Philipsburg); WWAA 1940–1941 (Honolulu, Hawaii); Sparks; "Honolulu," *Art Digest,* October 15, 1940, 32.

Eskridge studied at Los Angeles College of Fine Arts, the Art Institute and the Academy of Fine Arts in Chicago, and in Paris. By 1915 he was exhibiting in California, for he received a

medal for a water color at the Panama-California Exposition in San Deigo.

Espoy, Angel de Sarna (–)
Work: Oakland Art Museum. California *Arts & Architecture,* December 1932 (Los Angeles, California); Inventory of American Paintings, Smithsonian Institution; Richard and Mercedes Kerwin, Burlingame, California.

Espoy painted California scenes as early as 1915 and was still active in the thirties. "Hay Barge" is at the Oakland Museum; "Monterey Seascape" and "California Hills" are in private collections.

Evans, Ethel Wisner (1888–)
B. Stayton, Oregon. AAA 1919–1925 (New York City); Havlice; Mallett Supplement; WWAA 1940–1941 (Las Vegas, Nevada); *Who's Who in Northwest Art* (Hollywood, California).

Evans studied with Helen Neilson Rhodes, Lorser Feitelson, and Stanton MacDonald-Wright. She belonged to the post-surrealist group in Los Angeles, and exhibited in west coast cities.

F

Farley, Bethel Morris (1895–)
B. Clifton, Kansas. Work: Idaho State University; Union Pacific Station, Pocatello, Idaho. *Who's Who in Northwest Art* (Pocatello); Leedice Kissane, Pocatello.

Farley, whose sense of history distinguishes many of her paintings, was official artist for the Fort Hall Centennial in Pocatello in 1934. Largely self-taught, she works in oil, water color, and pen and ink. (She was still painting in 1982.)

From Kissane comes the information that Farley's painting, "Pocatello Junction, 1878," now at the UP Station, was done during the Second World War. It then hung in the hospitality "hut" of the USO that was operated for troops passing through Pocatello.

In reflecting on Farley's work, Kissane said she especially likes her "feeling for the hazy blue color that bathes the plains and mountains" in that part of the West.

Farlow, May Jennings (-)
 Olpin, 1980.

 Farlow was a Utah artist who spent some time in Paris about 1899, and probably studied there.

Farnham, Ammi Merchant (1846-1922)
 B. Silver Creek, New York. D. San Diego, California. Work: Buffalo & Erie County Historical Society. Petersen, 1970; Inventory of American Paintings, Smithsonian Institution.

 Farnham began the study of art in Munich when he was eighteen. Then he studied with Frank Duveneck at the Royal Academy of Bavaria. Before moving to San Diego where he spent the last thirty-four years of his life, he was curator at Buffalo Academy of Fine Arts. He exhibited in a number of large cities, including New York, Philadelphia, Chicago, and San Francisco.

Farnsworth, Ada (See: Ada/Ida K. Farsnworth Champ)

Farnsworth, Alfred Villiers (ca 1858-1908)
 B. Lancastershire or Yorkshire, England. D. San Francisco, California, September 17. Work: Oakland Art Museum; Marin County (California) Historical Society; Civic Art Gallery of San Jose; Society of California Pioneers; California Historical Society; San Jose Museum of Art. AAW v. I; Society of California Pioneers' library; California State Library; Joseph A. Baird, *From Frontier to Fire...*, University of California, Davis, mimeo., 1964, 8-9; Inventory of American Paintings, Smithsonian Institution.

 Farnsworth was studying civil engineering in Paris when

he became interested in art. Subsequently he became a member of the British Royal Engineers, went to Canada where he worked as a railroad surveyor, and then moved to Spokane. He left Spokane about 1892 and went to work as an artist for a San Francisco newspaper.

In the San Francisco Bay area he painted hunting scenes, landscapes, and seascapes, usually in water color. A favorite subject was Mount Tamalpais. At least one sketching trip was made to Southern California, for a water color titled "Monks Leaving San Luis Rey Mission" is dated 1893.

Farnsworth was friendly with a number of local artists such as Thad Welch; like Welch, he had a contract with Gumps Gallery in San Francisco.

Farnsworth, Ethel Newcomb (1873–)
B. Orange, New Jersey. AAA 1913–1917, 1923–1924 (Minneapolis, Minnesota); AAA 1925 (Pasadena, California); California *Arts & Architecture*, December 1932 (Los Angeles).

Farnsworth, who studied with a number of well-known New York artists, was active in Minneapolis as an illustrator, and in Southern California where art directories list her as a painter. She was a member of the Minneapolis Society of Fine Arts and the Pasadena Society of Artists.

Farnsworth, Louise Richards (–)
B. Salt Lake City, Utah. Work: Private collections. Mallett; Olpin, 1980 (listed as Richards); *Art Digest,* March 15, 1934, 19; Horne, 1914, 54; Utah Art Institute, First Annual Report, 1899, 5; Salt Lake City Public Library; NMAA-NPG Library, Smithsonian Institution; Donna Anderson, Salt Lake City.

Farnsworth was the daughter of Dr. Joseph S. Richards. She studied with James T. Harwood in Salt Lake City, the Art Students League in New York, and in Paris where she won a place in the Paris Salon of 1904 with a portrait. Her specialty was landscapes in oil and pastel. A number of her Rocky Mountain paintings were exhibited in New York at Montross Gallery in 1934, and again in 1938. The latter exhibit included Canadian and Alaskan landscapes.

Farr, Ellen Frances Burpee (1840–1907)

Work: Littleton (New Hampshire) Public Library; Washington County (Pennsylvania) Historical Society. *News Notes of California Libraries,* January 1908, 12; Inventory of American Paintings, Smithsonian Institution.

Farr was living in Pasadena, California, by 1893, for she exhibited at the World's Columbia Exposition that year as a California artist. Twenty-three oils by Farr have been listed in the Smithsonian's inventory.

Farrell, Margaret C. Taylor (1883–1972)

D. Sacramento, California, September 7. California State Library; Sacramento *Bee,* September 9, 1972, p. C2/1–2; *News Notes of California Libraries,* April 1931, 175; Inventory of American Paintings, Smithsonian Institution.

Fassett, Elisha S. (–1903)

D. Denver, Colorado, in late September. Denver Public Library; Denver *Times,* September 29, 1903, 4/1.

Faul, Henry (See: J. Y. Glendinen)

Fee, Chester Anders (1893–1951)

B. Pendleton, Oregon. D. Portland, Oregon, May 24. *Who's Who in Northwest Art* (Pendleton); *Who Was Who in America* (Portland).

Fee taught himself to paint with oils and water colors. He began exhibiting in 1938, and in 1945 won a prize for work exhibited. He is best known as an author and editor. Among his published books are *Chief Joseph: The Biography of a Great Indian* and *Wilderness Patriot: A Drama of Marcus Whitman.*

Fehmel, Herbert (1898–1975)

B. Germany. D. Salt Lake City, May 26. Salt Lake City Public Library art and artists' scrapbook; "Noted Artist For State Dies at 76," Salt Lake *Tribune,* May 27, 1975.

Fenderich, Charles (1805–ca 1887)

B. Baden, Germany, or Lausenburg, Switzerland. D. probably in San Francisco. Work: National Portrait Gallery,

Smithsonian Institution; Bancroft Library, Universiy of California. Benezit; Groce and Wallace; AAW v. I; McMahan; Baird, mimeo., 1968; *Overland Monthly,* July 1968, 115; Oakland Museum library; San Francisco Public Library art and artists' scrapbook; NMAA-NPG Library, Smithsonian Institution.

In Washginton, D.C., where Fenderich lived from 1837 to 1843, he was active as a lithographer. His portraits of John Calhoun, James Buchanan, Henry Clay, and William Henry Harrison are in the National Portrait Gallery.

Perhaps as early as 1849 Fenderich settled in San Francisco where he became known as a portrait painter. *Overland Monthly* referred to his crayon portraits as being "of great excellence."

Ferris, Bernice Marie Bransom (1882–1936)
B. Astoria, Illinois. AAA 1921 (New York City); AAA 1923–1924 (Washington, D.C.); AAA 1925–1933 (Alexandria, Virginia); Benezit; Fielding; Havlice; Mallett; WWAA 1936–1937 (Alexandria); McMahan; Bucklin and Turner.

Ferris, who for many years was an artist with the Department of Agriculture, began her art studies under Sara Hayden at the University of Nebraska, and continued them at the Art Institute of Chicago. She was mainly active as an illustrator.

Feurer, Karl (–)
B. Germany. Work: Timberline Lodge, Oregon, near Portland. AAA 1921–1925 (Seattle, Washington); Griffin and Munro, 87; Pierce.

Feuer, who painted many of the water colors of wild flowers at Timberline Lodge, exhibited a number of genre subjects in oil in Seattle. He was a member of the Seattle Fine Arts Society.

Ficht, Otto C. (–)
Groce and Wallace; Inventory of American Paintings, Smithsonian Institution.

Ficht was active in New York City from 1844 until some time after 1860. His Western paintings are undated, but the titles

are of interest: "Near Fort Logan, Colorado," and "From North Denver" are water colors; "Grande Ronde Valley, Eastern Oregon" is a restored oil listed in the Smithsonian's inventory. Ficht also did a water color with the title "Grande Ronde Valley." In New York he was active as a fresco painter as well as an easel painter.

Field, M./Mrs. Heman H. (1864–1931)

B. Stoughton, Massachusetts. D. Chicago, Illinois, May 21. AAA 1919–1929 (Chicago); AAA 1931, obit.; Fielding; Mallett; Calhoun, 15, 17; Dodds, Master's thesis, University of Washington Art Library; Seattle *Town Crier*, March 27, 1911, 11; University of Washington Library.

Field graduated with honors from the Art Institute of Chicago. She lived in Seattle from about 1904 to 1912 when she returned to Chicago. Calhoun described her as "an artist of ability" and an activist on behalf of art. She exhibited at the annuals of the Seattle Society of Artists from 1904, and with the Seattle Fine Arts Association of which she was a charter member. Of four paintings she exhibited in March 1911, two were California landscapes.

Field, Marian (1885–)

B. North Dakota. Work: dioramas, Museum of Natural History, University of Oregon. *Who's Who in Northwest Art* (Salem, Oregon).

Field's dioramas at the University of Oregon are of Klamath Indian life. Much of her other work is of botanical subjects, including some 200 drawings of native Oregon trees and shrubs in graphite, and various other works in oil and water color.

During the mid-thirties Field was involved with the government's WPA program as manager of the Salem Art Center. Her study background included work in Cincinnati at the School of Fine Arts, and in Oregon at the University in Eugene.

Filippone, John C. (1882–)

B. Brackettville, Texas. Mallett Supplement (San Antonio, Texas); O'Brien, 1935.

Filippone is best known in San Antonio for his still lifes

148

and portraits, and as one of the founders of the Artists' Guild. Although primarily an etcher he is said to have painted several murals.

During a three-year period away from Texas Filippone lived for a while in St. Louis, then New York. Prior to his return he traveled in Italy, France, Cuba, South America, and Mexico.

Fisher, Flora Davis (1892–)
 Olpin, 1980 (Provo, Utah).
 Fisher was mainly active in Southern Utah where she was considered an artist "of some note."

Fisher, Vaudrey (1889–)
 B. Staffordshire, England. AAA 1921 (Denver, Colorado; studio in New York City); AAA 1923–1924 (Denver); Fielding.
 Fisher, who studied with Brangwyn, von Herkomer, and others, was active as a craftsman and teacher as well as a painter.

Fishwood, Hazel C. (1889–)
 B. Swanton, Nebraska. *Who's Who in Northwest Art* (Creswell, Oregon).
 Fishwood studied at the University of Nebraska, University of Oregon, and California School of Arts and Crafts in Oakland. She won a number of prizes, and a scholarship. In Oregon she worked as art supervisor of Eugene's public schools.

Fitz Gerald, J. Maurice (1899–)
 B. Oregon. Mallett Supplement (Seattle, Washington); *Who's Who in Northwest Art* (Seattle); Santa Cruz Art League, Seventh Annual Exhibition Catalogue.
 J. Maurice Fitz Gerald should not be confused with James Fitzgerald (1899–1971). The latter was born in Milton, Massachusetts, and lived for a number of years in Monterey, California.
 J. Maurice studied at the Mark Hopkins Art Institute in San Francisco. He did oils, water colors, and prints, and exhibited in California and at the Seattle Art Museum. He also held a full-time position as art director for Bon Marche Department Store in Seattle.

Fitzgerald, May Eastman (1894–)

B. Vancouver Barracks, Washington. *Who's Who in Northwest Art* (Seattle).

Fitzgerald was a sculptor and craftsman who also did oils and pastels. She studied at a number of schools, including the Art Institute and the Academy of Fine Arts in Chicago, the University of Washington summer school, and the Portland Art Museum School. She had several solo exhibitions in Portland and Seattle.

Fitzgibbon, James L. (–)

Work: Kansas City Museum of History and Science. AAA 1917, 1921 (Kansas City, Missouri); Inventory of American Paintings, Smithsonian Institution.

The Smithsonian inventory lists twenty-eight works by Fitzgibbon painted in the period from 1883 to 1912. Two portraits and an 1883 painting called "The Junction" are at the Kansas City Museum of History and Science. Titles of other listed works denote mountain landscapes, historical sites, portraits, and ranch scenes. Inasmuch as the address of Fitzgibbon in AAA 1917 appears to be in a commercial building, it is likely that he was a businessman.

Fleming, Alice (1898–)

B. Montague County, Texas. Work: University of Oklahoma; Oklahoma City University; Christian Church, Norman, Oklahoma. England, Master's thesis.

Fleming obtained her bachelor of fine arts and bachelor of science degrees at the University of Oklahoma. She also studied at Castlehill Art School in Ipswich, Massachusetts, and the Art Museum School [Fine Arts Center School?] in Colorado Springs, Colorado. She had at least three solo exhibitions in Oklahoma, two at the University in Norman, and one at the Art Center in Oklahoma City.

Fletcher, Annie C. (–)

Denver Public Library; Denver *Times,* April 9, 1899, 6/2; Bromwell scrapbook, 21; *American Art Annual,* 1898, 188.

Fletcher exhibited at the Denver Artists' Club in 1898 and

150

1899, and perhaps later. The *Times* reported that she gave "great promise in the artistic world."

Benezit, Mallett, and WWAA show an Anne Fletcher born in Chicago in 1876 or 1878, but it could not be ascertained whether these painters were the same person.

Flynn, Ruby M. (1895–)
B. Sumas, Washington. *Who's Who in Northwest Art* (Seattle).

Flynn who studied with Eustace Ziegler and Ambrose Patterson in Seattle worked in oils and water colors.

Forbush, Marie R. (–)
AAA 1900 (Manitou, Colorado; listed under Art Supervisors and Teachers); Grove typescript, Colorado College Library; "Colorado Springs Art Studio," an ad in *Facts,* September 22, 1900, 9; "Academy of Fine Arts Opens Exhibit . . .," Colorado Springs *Gazette,* June 3, 1914, 5/5–6; Wray, "Exhibit by Springs Artists . . . ," 1916.

Forbush, a graduate of the Art Institute of Chicago, taught drawing, painting, and china decorating in Colorado Springs during the first two decades of this century. She exhibited locally in 1914, 1916, and 1921. Henry Russell Wray credited her in 1916 with having "developed great firmness in her oils."

Force, Anne (1884–)
B. Boston, Massachusetts. *Who's Who in Northwest Art* (Seattle).

Force who studied in Boston at the Museum of Fine Arts School and in Seattle with Mark Tobey exhibited at the Seattle Art Museum with Women Painters of Washington, of which she was a member.

Ford, Arva (1890–)
Mallett Supplement (Dallas, Texas); Dallas Museum of Fine Arts 1936 Exposition brochure.

Forsberg, Elmer A. (1883–)
B. Gamalakarleby, Finland. Work: Art Institute of Chi-

cago; Chicago Municipal Collection. AAA 1929–1933 (Chicago; summer, Covington, Michigan); Benezit; Havlice; Mallett; WWAA 1936–1941 (Chicago; summer, Covington); *Art Digest,* May 15, 1941, 29.

According to the *Art Digest* in May 1941, Forsberg was with Edward Grigware "in the Cow Country" teaching at the Cody (Wyoming) Summer School of Art. Usually he spent his summers in Covington. The school year was spent in Chicago where he headed the Fine Arts department of the Art Institute, a position he had held since the late 1920s.

Forslund, A./Mrs. Victor Forslund (1891–)
 B. Roanoke, Virginia. *Who's Who in Northwest Art* (Everett, Washington).
 Forslund, who taught art in Everett, worked in oils and pastels.

Foster, Arthur Turner (1877–)
 B. Brooklyn, New York. AAA 1925–1933 (Los Angeles, California); Benezit; Mallett; *News Notes of California Libraries,* April 1924, 146; "Los Angeles," *Art News,* May 24, 1924, 9.
 Foster, who was self-taught, was a member of the Artland Club, the Painters and Sculptors Club of Los Angeles, and the California Water Color Society. *Art News* noted that he was among those exhibiting at the "new home" of The Potboiler in Los Angeles.

Foster, Ben (1852–1926)
 B. North Anson, Maine. D. New York City, January 28. Work: Corcoran Gallery of Art; Pennsylvania Academy of Fine Arts; Toledo Art Museum; Luxembourg Museum, Paris; National Museum of American Art; Metropolitan Museum of Art; Omaha Society of Fine Arts; Oakland Art Museum; Santa Fe Railway Collection; Henry Gallery, University of Washington, etc. AAA 1898–1915 (New York City); AAA 1917–1925 (New York City; summer, West Cornwall, Connecticut); Benezit; Fielding; Havlice; Mallett; AAW v. I; Earle; Inventory of American Paint-

ings, Smithsonian Institution; *Art and Decoration*, January 1916, 137; AAA 1913, 154; AAA 1915, 171; AAA 1919, 154; AAA 1921, 158; Oakland Museum library.

Although Foster maintained a New York address throughout his career, he was in the West for extended periods from 1880 to about 1920, principally in California. In 1912 he began serving on the executive committee of the newly formed Society of Men Who Paint in the Far West which was active until 1921.

Foster was about thirty when he began to study. By 1887 he was exhibiting regularly in New York and other cities. According to information in Earle, he gave "much attention to the painting of landscapes and sheep." His favorite subjects were "night effects and woodland scenes."

Fournier, Alexis Jean (1865-1948)

B. St. Paul, Minnesota. D. East Aurora, New York, January 20. Work: Minnesota Historical Society; Vanderbilt University; Detroit Art Institute; East Aurora Public Library, etc. AAA 1898-1903 (Minneapolis, Minnesota); AAA 1905-1923 (East Aurora); AAA 1925-1933 (East Aurora; South Bend, Indiana); Benezit; Fielding; Havlice; Mallett; WWAA 1936-1947 (East Aurora); Earle; Minnesota Historical Society; "Catalogue of Works of Art," Minneapolis Industrial Exposition, 1892; Torbert; Ruth Thompson, "Minnesota Memories/Fournier – Early Minnesota Artist," Minneapolis Morning *Tribune*, February 16, 1948; Mary E., "Fournier Family Has an Unusual Interest in Art," in her column "Between You & Me," St. Paul *Pioneer Press*, March 16, 1970, 12-13; Alissa Wiener, Minnesota Historical Society.

At the art gallery of the Minneapolis Industrial Exposition in 1892, Fournier exhibited 193 oils and 34 water colors. Of the former, at least fifteen were Utah and Colorado landscapes; of the latter, seven were of Mesa Verde and bore such titles as "Section of Long House (showing manner of joining walls to rock arch above)," "A Balcony House in the Cliff Cañon," and "Our Camp in the Estufa during the Snow-storm on the First Morning."

During the winter of 1891-1892 Fournier was staff artist for the H. Jay Smith party that explored Mancos River and tributary canyons in Southwestern Colorado. The purpose of the expe-

dition was to acquire scientific knowledge and artistic renderings of Mesa Verde from which Richard Wetherill and his brothers had excavated artifacts previously exhibited at a Minneapolis exposition. Fourneir's paintings were an integral part of the Seventh Annual Exposition in 1892.

During his assignment Fournier accumulated a number of Indian artifacts which he kept at his Aurora studio. His interest in the area was such that he is said to have written a monograph entitled "Among the Cliff Dwellings in San Juan County," but it is not listed in the bibliographic references consulted.

According to Earle, Fournier was widely recognized as a leading painter of nature. He also painted the homes of the Barbizon artists when he was in France in 1907 for a lengthy visit. These paintings were reproduced in his *Haunts and Homes of the Barbizon Masters*, a published work.

Fowler, Ethel Lucile (–)
B. Nebraska. Work: Boise Gallery of Art; U. S. Veterans Hospital, Boise. *Idaho Encyclopedia; Who's Who in Northwest Art* (Boise); Cornelia Hart Farrer, Boise artist; New York City Municipal Art Committee, Second Annual Exhibition brochure, 1937.

Fowler attended the Art Institute of Chicago, Pennsylvania School of Industrial Art in Philadelphia, and Chouinard Art Institute in Los Angeles. She began receiving awards in 1905, before she had completed her art education.

At a New York City exhibition in 1937 featuring selected works by artists throughout the United States, Fowler's work was among those chosen. She was especially active during the 1930s, wrote Mrs. Farrer. Many of her paintings of local scenery, flowers, and still lifes are in water color. She also worked with oils.

Frame, Stateira Elizabeth (1870–1935)
B. Waterloo, Quebec. *Who's Who in Northwest Art* (Vancouver, B.C.).

Frame studied with Robert Henri in New York and with Armin Hansen in Monterey, California. She exhibited nationally in Canada and at the Seattle Art Museum, Seattle, Washington.

Francis, Gene (See: Gene Baker McComas)

Francis, Robert Talcott (1873–)
B. Pittsfield, Massachusetts. Mallett Supplement (New York); Inventory of American Paintings, Smithsonian Institution.
Two oil landscapes of record are Southwestern scenes, probably painted in the mid-thirties.

Frang, Emil L. (1885–)
B. Hale, Trempealeau County, Wisconsin. *Who's Who in Northwest Art* (Big Timber, Montana).
Frang was self-taught. He worked in oils and pen-and-ink, and exhibited in Billings, Great Falls, and in state and regional fairs.

Frankl, Paul Theodore (1886–1958)
B. Vienna, Austria. D. Palos Verdes Estates, California, March 21. AAA 1933 (New York City; summer, Woodstock, New York); Havlice; Mallett; WWAA 1936–1937 (Los Angeles, California; summer, Woodstock); WWAA 1938–1941 (Los Angeles and Hollywood); WWAA 1947–1956 (Palos Verdes Estates).
Frankl, who taught art at the University of Southern California, began his career as an architect.

Franklin, (Mrs.) Arla (1897–)
B. Florence, Wisconsin. Havlice; WWAA 1956–1962 (Los Angeles and Lennox, California).

Frantz, (Samuel) Marshall (1890–)
B. Kiev, Russia. AAA 1921–1933 (New York City); Fielding; Havlice; Mallett; WWAA 1936–1941 (New York City); WWAA 1947–1953 (Van Nuys, California).

Frederick, George (1889–)
Mallett Supplement (San Antonio, Texas); Dallas Museum of Fine Arts 1936 Exposition catalogue.

Freedman, Ruth (1899–)

B. Chicago, Illinois. AAA 1921–1927 (Seattle, Washington); Fielding.

Freedman studied at the Chicago Academy of Fine Arts. She was awarded a first prize in 1921 by the Seattle Society of Fine Arts.

Fretelliere, Louise Andree (1856–1940)

Work: Witte Museum, San Antonio. Utterback; Pinckney.

Fretellier and her sister Marie studied with their uncle, Theodore Gentilz [AAW v. I]. Their work is said to be so much like his that collectors are sometimes confused. Utterback's Witte Museum publication shows an oil titled "Watercart" and a pencil and charcoal drawing of "First Presbyterian Church."

Presumably the Fretelliere sisters lived in San Antonio where Gentilz (1819–1906) had settled in 1846.

Fries, Charles Arthur (1854–1940)

B. Hillsboro, Ohio. D. San Diego, California, December 15. Work: Fine Arts Gallery of San Diego; Corcoran Gallery of Art. AAA 1903–1933 (San Diego); Benezit; Fielding; Havlice; Mallett; WWAA 1936–1941 (San Diego); WWAA 1947, obit.; AAW v. I; Peterson, 1970; Lytle, 1978, 168–169; *Art News,* January 24, 1920, 4; *Art Digest,* July 1929, 12; NMAA-NPG Library and Inventory of American Paintings, Smithsonian Institution.

Fries lived briefly in San Juan Capistrano, California, prior to building an adobe house and studio in San Diego in 1897.

Reviews of Fries' work are most favorable. The art critic for *Art News* wrote that his paintings, though not large, suggested "vast spaces"; Fries had "mastered that point in Western landscape painting imposed by a clear air which makes details visible at a distance." His landscapes "focused on the desert, the mountains, and eucalyptus trees," wrote Petersen, who also mentioned their "atmospheric light" and "sound craftsmanship."

Froelich, Maren Margrethe (1868–1921)

B. Fresno, California. D. San Francisco, June 27. Work: Oakland Art Museum. AAA 1903 (San Francisco; listed

under Art Supervisors and Teachers); AAA 1915–1917 (San Francisco); AAW v. I; Porter, and others, *Art in California*, 169; Castor typescript, San Francisco Public Library; Spangenberg, 46, citing San Francisco *Call*, January 14, 1906; California State Library; Inventory of American Paintings, Smithsonian Institution.

Froelich studied at the San Francisco School of Design, and in Paris with various teachers, including Richard Miller. In Paris she exhibited at l'Union Internationale and Salon des Artistes Francais; in San Francisco she exhibited at the Art Institute, Golden Gate Park Memorial Museum, and Panama-Pacific International Exposition. She received several awards, including two gold medals.

Titles of paintings listed in the Smithsonian's Inventory indicate that Froelich painted mainly in Northern California as far south as Monterey where she was a familiar figure in the Carmel Art Colony. She taught art from 1887, principally at the San Francisco School of Design. Castor stated that Froelich's best-known work is "The Chinese Robe," a self portrait, but that it has disappeared. A reproduction, identified as Plate 11, is in *Art in California*.

Fuller, Ruth B. (1893–)

B. Norway, Maine. *Who's Who in Northwest Art* (Spokane, Washington).

Fuller, an author and illustrator as well as a painter, studied in Chicago at the Academy of Fine Arts and at the Art Institute. She exhibited in 1928 with Michigan and Wisconsin artists in group shows, and in group shows at the Seattle Art Museum and the Art Institute of Chicago.

Fuller, William (–)

Work: Amon Carter Museum of Western Art, Fort Worth. Hassrick, 1975, 76–77; Hassrick, 1977, 188–189; Catalogue of the Collection, Amon Carter Museum of Western Art, 30.

Fuller worked on the Union Pacific Railroad while it was being built through Nebraska. Then he took a job as carpenter at the Crow Creek Agency in Dakota Territory. He took two months off every other year to paint. His painting of Crow Creek Agency,

which once hung on Agency office walls, is in the Amon Carter Museum. Measuring 25⅝ × 51¾ inches, this oil is dated 1884. Its historical value is enhanced by notations on the back identifying Indians in the foreground, and buildings in the background.

Fullerton, Alice V. (1854–1950)
Work: Laguna Beach Museum of Art, Laguna Beach, California. AAA 1923–1925 (Laguna Beach); Mallett Supplement (Laguna Beach); Inventory of American Paintings, Smithsonian Institution.

Fursman, Frederick Frary (1874–1943)
B. El Paso, Illinois. D. Saugatuck, Michigan, June 12. Work: Art Institute of Chicago; Toledo Museum of Art. AAA 1903, 1909–1921 (Chicago); AAA 1923–1933 (Saugatuck); Benezit; Fielding; Havlice; Mallett; WWAA 1936–1941 (Saugatuck); WWAA 1947, obit.; Young; Sparks; "In Denver," *American Magazine of Art*, November 1925, 614; Chicago Evening *Post*, August 16, 1927; Donald Key, "Allea Library Surveys Work by Impressionist," Milwaukee *Journal*, September 28, 1969; NMAA-NPG Library, Smithsonian Institution.
Fursman who was on the staff of the Art Institute of Chicago from 1910 to 1938 took time off in 1925 to direct the Chappell School of Art in Denver, and to teach drawing, painting, and composition there. During the winter of 1926–1927 he painted in New Mexico. During August 1927 he exhibited a number of New Mexico landscapes in Chicago.

Fursman, Mary O'Farrell (–)
Work: Colorado Historical Society, Denver. McClurg typescript, 9; Petteys; Colorado College Library, Colorado Springs.
Fursman who studied portrait and figure painting in Philadelphia exhibited at the Colorado Springs Second Annual in 1915. Her portrait of Mary M. McCook, wife of a territorial governor, is in the Colorado Historical Society's collection.

Furuya, Kinzo/Kiuzo (–1929)
Work: Portland (Oregon) Art Museum. AAA 1923–1924 (Portland); Pierce, 1926.

Furuya was active in Washington by 1926, but little else is known about him. He exhibited in 1925 with Pacific Northwest artists. Two of his paintings are at the Portland Art Museum—"Still Life," an oil on canvas, and "Mountains," a water color.

G

Gaastra, Bonney Royal/Bonnie Royla (–)
AAA 1909–1910 (Chicago); Van Stone, 1924; Museum of New Mexico library, Santa Fe.

Gaastra exhibited with Southwestern artists in Santa Fe in 1921, 1922, and 1924. Her paintings were of Northern New Mexico scenes and subjects.

Galloway, Gene (1897–)
B. Kansas. Work: Lewiston (Montana) High School; Canajoharie Museum, Canajoharie, New York. *Who's Who in Northwest Art* (Roy, Montana).

Galloway, who studied with George Luks, attended the Art Students League. His portrait of George Luks is in the Canajoharie Museum. Two of his oil landscapes are in the high school at Lewiston. In 1933 he held a one-man exhibition at Anderson Galleries in New York. He was also a sculptor.

Gammon, Estella M. (1895–)
B. Pasadena, California. Havlice; WWAA 1953–1962 (Altadena, California).

Gannett, Ruth Chrisman Arens (1896–)
B. Santa Ana, California. Work: Library of Congress. Havlice; Mallett; WWAA 1947–1953 (New York City); WWAA 1956–1962 (New York City; Cornwall, Connecticut); Viguers, 1958.

159

Gannett, who grew up in Southern California, began drawing at an early age. She attended the University of California and the Art Students League. Among the books she illustrated is Steinbeck's *Tortilla Flat*. She wrote four of the books she illustrated.

Gardner, Gertrude Gazelle (1878–1975)
B. Fort Dodge, Iowa. D. Laguna Beach, California. Work: Laguna Beach Museum of Art. AAA 1919–1933 (Flushing, New York; summer 1919–1921, Gloucester, Massachusetts; summer 1927–1929, Booth Bay Harbor, Maine); Benezit; Fielding; Havlice; Mallett; WWAA 1936–1941 (Flushing); WWAA 1959–1962 (Laguna Beach); Laguna Beach Museum of Art exhibition catalogue, July-August 1979.

Gardner was a frequent exhibitor of water colors from 1919 to the mid-1920s. From about 1943, when she became active in Laguna Beach, she worked mainly in oils. Her principal subjects were still lifes, gardens, and landscapes.

Gaw, Eleanor D'Arcy (–)
Denver Public Library; Bromwell scrapbook, p. 28.

Gaw was a Leadville, Colorado, painter who exhibited a water color at the Denver Artists' Club's annual in 1900.

Gay, Auguste F./Gus (1891–1949)
B. Gap, France. D. Carmel, California, March 9. Work: Oakland Art Museum. Mallett Supplement (Monterey, California); Spangenberg, 67; St. John, 11, 24–25, 32; Monterey Peninsula Museum of Art docent library; Monterey Public Library; Inventory of American Paintings, Smithsonian Institution.

About 1905 Gay settled with his family in Alameda, California. There he contracted tuberculosis, and was sent to live with an uncle on a ranch in Imperial Valley. While recovering his health he began to draw. When he left the ranch three years later, he took with him a collection of drawings that demonstrated unmistakable talent. Despite his family's precarious financial condition he was able to study art in Oakland and San Francisco.

Gay became one of Oakland's "Society of Six," that early group of modernists who disdained the painting of "gorgeous pot boilers" to survive. He exhibited regularly as one of "The Six" until about 1928.

Gay moved to Monterey in 1922, and later to Carmel. To survive he turned to designing and making furniture, picture frames, decorator items, woodcarvings, and altar pieces. Spangenberg wrote that he could do "such perfect gold leaf work that no seam ever showed." He also did some murals for commercial establishments. With Bruce Ariss he did a 150-foot painting of the Monterey coastline for Monterey High School. They worked three years on the mural that later was destroyed in a fire. He is remembered in Monterey by Ariss and the Bruton sisters [AAW v. I] as a "fine artist."

Geary, Fred (1894–1955?)
B. Clarence, Missouri. Work: Library of Congress; Kansas City Public Library; New York Public Library; Denver Art Museum; Texas Technological College Museum; Princeton University, etc. AAA 1933 (Kansas City, Missouri); Havlice; Mallett; WWAA 1936–1953 (Carrollton, Missouri).

Although art directories differ as to Geary's residence, his studio was in the Union Station in Kansas City; therefore his residence was more likely Carrollton, Missouri, than Carrollton, Ohio.

Fifty of Geary's wood engravings are at the Library of Congress. Several are of New Mexico subjects such as San Felipe Church, Old Albuquerque; Mission Laguna, New Mexico; and Ranchos de Taos. He also did several decorations for places in New Mexico and Arizona such as pictographs for The Watchtower at Desert View in Grand Canyon National Park, and Navajo sand paintings for a hotel in New Mexico. His illustrations have appeared in *Navajo Medicine Man*, published in 1939, and Fred Harvey's promotional brochures. It is likely that he was in the West at least as early as the mid-thirties.

Geiger, Marie J. (1887–)
B. Tacoma, Washington. *Who's Who in Northwest Art* (McMillin, Pierce County, Washington).

Geiger, who attended the College of Puget Sound and also

a Lutheran Academy in Parkland, Washington, worked in oils and water colors, and exhibited at Western Washington fairs.

Gellert, S. M. (1884–)
B. California. *Who's Who in Northwest Art* (Portland, Oregon).
Dr. Gellert, who worked in oils, received a medal from the San Francisco Museum of Art in 1938.

Gerten, John (1888–)
B. Chicago, Illinois. *Who's Who in Northwest Art* (Raymond, Washington); Mallett Supplement.
Gerten, who exhibited at the Seattle Art Museum in 1936, did oils, water colors, etchings, and woodblock prints.

Gervasi, Frank (1895–)
B. Palermo, Italy. Work: Texas Technological College Museum; Oklahoma Museum of Art. Havlice; Mallett; WWAA 1936-1941 (Brooklyn, New York; summer, Cornwallville, New York); WWAA 1947-1959 (New York City); WWAA 1962 (New York City; Alpine, Texas); WWAA 1966 (Marfa, Texas); Robby Vestal, Lubbock, Texas.
Mountains have long been a favorite subject with Gervasi who began sketching those near his home in Italy before he left in 1908. In New York he turned to the Catskills. Not until 1960 did he settle in Southwest Texas to capture the beauty of the Davis Mountains and the Big Bend country. It is thought by some that these paintings "may well be the definitive record of this area."
Service in the First World War, and the loss of his right arm delayed Gervasi's recognition. That he succeeded in making the difficult adjustment to painting with his left hand is evidenced by his election to full membership in the National Academy of Design.

Gibbs, Ralston Snow (–)
Olpin, 1980; Salt Lake City Public Library art and artists' scrapbook; Deseret *News,* April 20, 1912; Salt Lake *Herald,* May 13, 1912; May 3, 1914.
Other than that Gibbs was working in Paris, France, in 1912, and that he exhibited at the Paris Salon, little is known

about this Utah artist who did illustrations and specialized at one time in humorous subjects.

Gideon, Sadie Cavitt (-)
B. Bryan, Texas. Fisk, 1928; O'Brien, 1935; Smith, 1926; Houston Public Library; Houston Museum of Fine Arts library.

Gideon attended Hollins College in Virginia and then studied painting at Massachusetts Normal Art School under Ross Turner.

From the early 1920s until about 1927 Gideon and her husband, Samuel Edward Gideon (1875–1945), spent several summers in France studying at the American School of Fine Arts in Fontainebleau. During that period they also spent several summers in Laguna Beach, California, where she studied with Anna Hills (1882–1930).

Gideon exhibited landscapes and portraits in Texas cities and taught art in Austin. Her husband was professor of architectural design at the University.

Gifford, Robert Swain (1840–1905)
B. Nonamesset Island. D. New York City, January 15. Work: National Museum of American Art; Metropolitan Museum of Art; Corcoran Gallery of Art; Columbus Gallery of Fine Arts; Fogg Museum, Harvard University; New Bedford (Mass.) Free Library, etc. AAA 1898–1903 (New York City; Bedford); Benezit; Fielding; Groce and Wallace; Havlice; Mallett; AAW v. I; Earle; Elton W. Hall, "R. Swain Gifford," *American Art Review,* May-June 1974, 51–67; Inventory of American Paintings, Smithsonian Institution.

Hall clarifies in his article conflicting information in several published accounts of Gifford's life. Born on Nonamesset Island – not Naushon – Gifford was named Robert Swain for the deceased son of the Island's owner as a gesture of regard for the bereaved Swains. Later Mrs. Swain encouraged Gifford to follow his inclination to become an artist and helped him financially by purchasing some of his paintings. Gifford's letters to Mrs. Swain are used by Hall to trace the artist's development and his early success as a landscape painter.

Gifford illustrated three articles for *Picturesque America* based on his travels to the West where he spent part of 1869. Arriving in San Francisco in August, he sketched along the Pacific Coast and inland at the quicksilver mines near San Jose. In September he left by steamer for Portland where he sketched along the Columbia River as far as The Dalles and Castle Rock. He returned overland to San Francisco by private carriage, boarded a train for the East, and *en route* stopped at Salt Lake City. Such titles as "Fish Rock, Coast of Mendocino County," "Covered Wagon on Prairie," "Indians Crossing the Columbia River in a Canoe," and "Italian Fishing Boats, San Francisco" are of particular interest. He also produced a major painting of Mount Hood.

Gifford, Sanford Robinson (1823-1880)
B. Greenfield, New York. D. New York City, August 29. Work: Metropolitan Museum of Art; Seattle Art Museum; Brooklyn Museum; Wadsworth Atheneum; Cleveland Museum of Art; Phoenix Art Museum; National Museum of American Art, etc. Benezit; Fielding; Groce and Wallace; Havlice; Mallett; AAW v. I; Nicolai Cikovsky, Jr., *Sanford Robinson Gifford,* Austin: University of Texas Art Museum, 1970, 11; Ila Weiss, *Sanford Robinson Gifford (1823-1880),* New York: Garland Publishing, Inc., 1977, 331-340; Eugene Ostroff, *Western Views and Eastern Visions,* Smithsonian Institution Traveling Exhibition catalogue, 1981, 28-29.

Gifford was guest artist with the F. V. Hayden Survey in 1870 — one year before Thomas Moran. Weiss's carefully documented book traces Gifford's travels through Wyoming and discusses where sketches for several major paintings were made.

A reproduction of Gifford's painting "Valley of the Chug Water Wyoming Ter.," and a photograph made by William Henry Jackson (Hayden's photographer) of Gifford painting it are on pages 28 and 29 of *Western Views and Eastern Visions.*

Gifford made his second trip West in 1874. After visiting friends in San Francisco he traveled by boat up the Sacramento River and then by stage to Portland, Oregon. An avid fisherman, he seems to have spent more time trying for the big fish than for the big picture.

From Portland Gifford went to Washington, British Co-

lumbia, and Alaska. After returning to Portland he joined a survey party bound for The Dalles on the Columbia River. He returned to San Francisco by boat.

Some 270 paintings by Gifford are listed in the Smithsonian Institution's Inventory of American Paintings. At least six bear Western titles. Associated with his 1870 trip are "Wyoming Territory," "Valley of the Crying Water, Wyoming Territory," and "Rocky Mountains, Autumn." Associated with the 1874 trip are "Mt. Rainier," "Site of Tacoma," and "High Banks of the American, Near Colfax, California.

Gilbert, Ralph (1884–)

B. Salem, Oregon. *Who's Who in Northwest Art* (Salem).

Gilbert studied with Datus Myers, exhibited in group shows in West Coast cities, and won several prizes. He worked in oils.

Gill, Minna Partridge (1897–1964)

B. Washington, D.C. D. Boulder, Colorado. McMahan; NMAA-NPG Library, Smithsonian Institution.

Gill, Miriam Fort (–1917)

B. Paris, Texas. D. Battle Creek, Michigan. Work: Confederate Museum, Richmond, Virginia. Fisk, 1928.

Gill studied art in New York City and Washington, D.C. Prior to opening her own studio she taught in Paris, Texas, and at Witherspoon School for Girls.

She painted portraits, miniatures, and landscapes.

Gill, Ross R. (–)

B. Kansas. Mallett Supplement (Bothell, Washington); *Who's Who in Northwest Art* (Bothell); "Art in Seattle," *American Magazine of Art,* March 1927, 157; Richard and Mercedes Kerwin, Burlingame, California.

Gill, who worked in water colors, tempera, and oils, studied at the Art Institute of Chicago and the Art Students League. He had one-man exhibitions at Boise (Idaho) Art Gallery; Western Washington College of Education, Bellingham; the University of Montana; and Seattle Art Museum.

Gill, Sue May Wescott (1890- •)

B. Sabinal, Texas. AAA 1923-1925 (Denver, Colorado; listed as Wescott); AAA 1929-1933 (Wynnewood, Pennsylvania; studio in Philadelphia); Benezit; Havlice; Mallett; WWAA 1936-1978 (Wynnewood); Denver Public Library; "Denver Artist Attains Fame," Denver *Post*, July 21, 1936; "Sue May Gill Exhibits," *Art Digest*, January 15, 1941, 19.

Gill was a member of the Denver Art Museum and the Pennsylvania Academy of Fine Arts. Her specialty was portraits and flowers.

Gillette, Lester A. (1855-)

B. Columbus, Ohio. Work: Mulvane Art Center, Washburn University. AAA 1925-1929 (Topeka, Kansas); AAA 1931 (Gloucester, Massachusetts); Havlice; Mallett; WWAA 1936-1939 (Gloucester); WWAA 1940-1941 (Topeka); Clark; Reinbach; Whittmore, 1927, 19; *American Magazine of Art*, April 1924, 210; July 1924, 355; January 1925, 54.

After many years in the lumber business, Gillette studied art, ultimately achieving his boyhood wish to become a painter. He worked mainly in Colorado, New Mexico, Florida, and along the New England Coast, spending several seasons in Colorado and New Mexico. He was among the Kansas artists whose work was shown at the opening of Mulvane Art Center in 1924, and his "Taos Country" is in the Mulvane collection.

Gilley, Samantha Vallient (ca 1869-1938)

Houston Public Library art and artists' scrapbook; Houston *Press*, March 1, 1938, obit.; Houston *Post*, March 2, 1938, obit.

The *Post* captioned its obituary "Services Held for Prominent Texas Artist," and the *Press* referred to Gilley as a painter of Texas bluebonnets; neither supplied details of her career.

Gilstrap, W. H. (1840-1914)

B. Beecher City, Effingham County, Illinois. D. Tacoma, Washington, August 2. Work: Washington State Histori-

cal Museum. AAA 1905-1913 (Tacoma, Washington); AAA 1915, obit.; Groce and Wallace; AAW v. I; LeRoy, *Northwest History in Art* catalogue; Inventory of American Paintings, Smithsonian Institution.

Gilstrap, who exhibited in the Midwest before moving to Tacoma, was a painter of landscapes and portraits. Among extant paintings are "Cows in Meadow" (1889) and "The Cobbler's Shop," *circa* 1890. Both are oils.

It is likely that Gilstrap's various interests limited his artistic production. He taught art, served as secretary of the Washington State Historical Society from 1907 to 1914, and was the first curator of the state historical museum erected in 1911, then known as the Ferry Museum.

Girard, Joseph Basil (1846-1918)
B. Courpiere, Puy-de-Dome, France. D. August 25, probably in San Antonio, Texas. Work: Private collection in San Marino, California. M. Barr, 16, 51; Nottage, 87; *Who Was Who in America;* Inventory of American Paintings, Smithsonian Institution.

M. Barr's chronological appearance of artists in Wyoming contains the following news item: "Joseph Basil Girard — Colonel born in France — is drawing many military forts. He's at Fort Steele now." The year was 1870. During that decade Girard did pencil sketches of forts Russell, Fetterman, Sanders, and Steele, all in Wyoming Territory.

Girard was an army surgeon who may have made sketches wherever he was stationed. Later he used some of his sketches to make water color paintings. However, his water color "Tucson in 1850," listed in the Smithsonian's inventory, was copied from another person's sketch, or perhaps a daguerreotype. His last years were spent in San Antonio where he was chief surgeon of the military's Department of Texas from 1907 until retirement in 1910.

Glendinen, J. Y. (–)
Hafen, 1948, v. II, chap. XVI; Denver Public Library; Maturano, Master's thesis, University of Denver.

Glendinen worked mainly as a photographer. Maturano de-

scribes him as "a colorful but insignificant character who happened to be one of the first artists during the 1859-1863 [gold rush] period" in Colorado where he painted a few landscapes. In 1862 he formed a partnership with Henry Faul, also a photographer who did a few sketches and paintings.

McMechen in Hafen's *Colorado and Its People* cited the Rocky Mountain *Herald* of June 23, 1860, with reference to Glendinen's having sketched the town of Auraria [Aurora], and noted the existence of Glendinen's portrait of George Washington, done with house paint, which hung for years in the Masonic Temple in Central City, Colorado.

Glover, Edwin S. (1845-1919)

B. Michigan. D. Tacoma, Washington. Work: Amon Carter Museum of Western Art; John Ross Robertson Historical writings and collections in the Public Reference Library, Toronto, Canada. Havlice; Harper, 1970; M. Barr; Amon Carter Museum of Western Art, Catalogue of the Collection, 1972; Society of California Pioneers' library, San Francisco; Denver Public Library; Public Reference Library of Toronto; Splitter, 1959, 47; Warren R. Howell, "Pictorial California," *Antiques* Magazine, January 1954, 40, 63-64; Colorado Springs *Gazette,* November 29, 1873, 2/4, and February 7, 1874 , 3/2; Pueblo (Colorado) Daily *Chieftain,* December 13, 1873, 4/3; Denver *Times,* March 23, 1874, 3/1.

In Barr's chronology of artists working in Wyoming is a reference to E. S. Glover's drawing in Green River City in 1868, and another reference in 1869 to his hand-colored lithographs of the town then being produced in Chicago. For more than a decade Glover supplied drawings to several lithographic firms, among them A. L. Bancroft Company of San Francisco. Views of Los Angeles, Santa Barbara, and San Luis Obispo in California are in the Amon Carter collection, along with views of Central City, Black Hawk, Georgetown, Colorado Springs, and Manitou in Colorado, and Olympia in Washington.

Gluckmann, Grigory (1898-)

B. Russia. Work: Luxembourg Museum, Paris; Art Insti-

tute of Chicago; San Diego Fine Arts Gallery; Encyclopaedia Britannica Collection; Charles & Emma Frye Museum, Seattle, etc. Havlice; Mallett; WWAA 1947-1956 (Los Angeles and Beverly Hills, California).

Goddard, George Henry (1817-1906)
B. Bristol, England. D. Berkeley, California, December 27. Work: California State Library. Groce and Wallace (Sacramento, San Francisco, and Berkeley); AAW v. I; Peters; Albert Shumate, *The Life of George Henry Goddard: Artist, Architect, Surveyor, and Map Maker,* Berkeley: The Friends of the Bancroft Library, University of California, 1969, especially p. 8-9.

Although Goddard, a member of the San Francisco Art Association, exhibited several times during the 1870s and 1880s and offered his paintings for sale, few have survived. Those that have, deserve careful preservation, for he was a competent painter and his work is historically important.

Goddard took seriously his role as an artist, maintaining a studio at the Mercantile Library at least as late as 1900. In the 1889 San Francisco Directory he is listed as a landscape painter. His landscapes were of the San Francisco and Monterey Bay regions, the Walker River area, Carson Valley, Donner Lake, and numerous mining towns. He had several hundred lithographs ready for publication when the fire following the 1906 earthquake destroyed his home.

Golden, Charles O. (1899-)
B. Newlon, West Virginia. Work: Phoenix Art Museum. Havlice; Mallett; WWAA 1936-1941 (Bushkill, Pennsylvania); WWAA 1947-1962 (Tucson, Arizona); AAW v. I; George W. Riedell, Tucson; interview with Golden in 1972.

Golden began painting in the Tucson area in 1937. In 1939 he built his Tucson home and studio far out on East Pima Avenue. Primarily a portrait painter, he did landscapes only when he got an idea for one.

Golden's portraits include famous local cowboys, teen-age girls from a school at San Xavier Mission, and Indians he met on the reservations.

Goldworthy, Philoma (ca 1895-)

Monterey (California) Public Library; Monterey Peninsula *Herald*, February 21, 1982, 9B.

The *Herald* art critic identified Goldworthy as an eighty-seven-year-old retired San Jose public school art supervisor living in Pacific Grove and still active in 1982. The occasion was a showing of seventeen of her paintings in a local exhibition. Her Carmel Mission scene "Call to Worship" was described as almost expressionist, and the "undisputed star" of the exhibit.

Goodloe, Nellie Sterns/Mrs. Paul (-)

AAA 1909-1910 (San Francisco, California); *News Notes of California Libraries*, January 1908, 12.

Gordon-Cumming, Constance Frederica (1837-1924)

B. Altyre, Morayshire, Scotland. D. Crieff, Scotland, September 4. Work: National Park Service, Yosemite National Park; California Historical Society; Oakland Art Museum. AAW v. I; Kovinick; Sargent; Constance Frederica Gordon-Cumming, *Granite Crags of California*, Edinburgh and London: William Blackwood and Sons, 1886; Oakland Museum library; Inventory of American Paintings, Smithsonian Institution.

When Gordon-Cumming arrived in Yosemite Valley in April 1878, she expected to spend a few days looking at the scenery before going on to Honolulu. Instead she remained three months, painted a variety of scenes in water color, and gave an impromptu exhibition of her work before she left. Among her Park scenes are Barnard's Hotel, Mirror Lake, Nevada Falls, and Indian camp life. Thirteen of her water colors, including one each of New Zealand and England, are listed in the Smithsonian's inventory.

Gordon-Cumming left not only a rare pictorial record of Park scenes, but, according to Sargent, a "most literary and authentically drawn book about Yosemite."

Gore, John Christopher (1806-1867)

B. Boston, Massachusetts. Groce and Wallace (Boston); Spangenberg, 16.

Gore was a portrait and landscape painter who exhibited at

the Boston Atheneum in 1828 and then went to Italy for further study. Upon his return in 1834 he was made an honorary member of the National Academy of Design.

In order to provide a more healthful climate for his son Arthur, Gore purchased Rancho El Pescadero, a 4448-acre ranch near Monterey, California. He lived there from 1852 to 1861 when he returned to Boston.

Gould, Carl Frelinghuysen (1873–1939)
B. New York City. D. Seattle, Washington, January 4. Work: Museum of the City of New York; University of Washington; Seattle *Times* Building. AAA 1921–1929 (Seattle; summer, Bainbridge Island, Washington); Fielding; Mallett Supplement; *Who's Who in Northwest Art; Who's Who on the Pacific Coast;* Pierce; Calhoun; Inventory of American Paintings, Smithsonian Institution.

Gould was an architect and a painter who established the Department of Architecture at the University of Washington in 1914, and was active in the Seattle Fine Arts Society.

Gourley, Bess E. (–)
B. American Fork, Utah. Work: Springville (Utah) Museum of Art. AAW v. I; Olpin, 1980; Springville Museum of Art, Permanent Collection Catalogue.

Gourley studied under Aretta Young at Brigham Young University, graduating from its School of Arts in 1907. She returned in 1908 to teach there for four years.

Following the death of her artist brother, E. H. Eastmond, Gourley went to California for further study at the Los Angeles Art Center. Her specialty was flowers. The Springville Museum of Art purchased her water color "Sego Lilies" in 1947.

Gove, Eban Frank (1885–1938)
B. Madelia, Minnesota. *Idaho Encyclopedia; Who's Who in Northwest Art* (Payette, Idaho).

Gove, who had a studio in West Yellowstone, Montana, for a number of years, lived briefly in Boise (1904–1905), and later moved to Payette. His specialty was rugged mountain landscapes for which he became well known locally. He had some pri-

vate instruction and worked in all media. He exhibited in Boise and in Minneapolis, Minnesota.

Grabill, Nora Kain Nichols (1882–)

B. Plainfield, Indiana. California State Library; Monterey (California) Public Library; Spangenberg, 54.

Grabill lived in Carmel, California, and was active in the Carmel Art Association from 1930 to 1950. Previously she lived in Texas. She was considered an "accomplished" painter and carver of figurines.

Grafström, Olaf/Olof Jonas (1855–1933)

B. Attmar Medeload, Sweden. D. Stockholm, Sweden. Work: M. H. De Young Memorial Museum, San Francisco; Augustana College, Rock Island, Illinois; Swedish Royal Family collection. Benezit; AAW v. I; Sparks; Inventory of American Paintings, Smithsonian Institution.

Grafström settled in Portland, Oregon, in 1886; Spokane, Washington, in 1889; and Lindsborg, Kansas, in 1893. His painting "View of Portland, Oregon" is in the De Young Museum.

Following four years of teaching at Bethany College in Lindsborg, Grafström moved to Rock Island and taught at Augustana College until 1920.

Graham, Robert Alexander (1873–1946)

B. Iowa. D. August 19, probably in Denver. Work: Private collections. AAA 1913–1919 (Haworth, New Jersey); AAA 1921–1933 (Denver, Colorado); Benezit; Fielding; Havlice; Mallett; WWAA 1938–1941 (Denver); WWAA 1947, obit.; AAW v. I; Inventory of American Paintings, Smithsonian Institution; Denver Public Library.

Graham, who exhibited mainly in Colorado Springs and Denver, was a charter member of the Denver Art Guild, formed in 1928. His specialty was figure painting and landscapes. The titles of some of his paintings, listed in the Smithsonian's inventory as having been done about 1917 or 1918, show the extent of his early Western travels: "Lumber Yard, Olympia, Washington," "Alcatraz," "Topsy's Roost at Ocean Beach, San Francisco," and "Farmlands in Colorado." His address at that time was Haworth, New Jersey.

Graner, Luis (1867-1929)

B. Barcelona, Spain. D. Barcelona. Work: New Orleans Museum of Art; Sheffield City Art Galleries, Sheffield, England. AAA 1925 (New York City); AAA 1930, obit.; Benezit; Fielding; Havlice; Mallett; Inventory of American Paintings, Smithsonian Institution.

Graner, a Spanish-Brazilian painter, lived in New Orleans at intervals from 1914 to 1922, and then opened a studio in New York. He was internationally known as a painter of portraits, genre subjects, and landscapes. Two oils indicate his presence in the West sometime after 1910 – "Surf, California" and "Fisherman, La Jolla, California."

Grant, Frederic/Frederick Milton (1886-1959)

B. Sibley, Iowa. D. Oakland, California. Work: Lafayette (Indiana) Art Association; Metropolitan Museum of Art; Illinois State Museum, Springfield; Union League Club, Chicago; Rockford (Illinois) Art Association. AAA 1917-1933 (Chicago); Benezit; Fielding; Havlice; Mallett; WWAA 1936-1941 (Chicago); Ness and Orwig; Sparks; Inventory of American Paintings, Smithsonian Institution.

Grant, who studied in Venice, Paris, Chicago, San Francisco, and New York City, received many awards during his career as a painter.

Grant, Gordon Hope (1875-1962)

B. San Francisco, California. D. May 6. Work: Whitney Museum of American Art; Metropolitan Museum of Art; Joslyn Art Museum, Omaha; Library of Congress; Museum of New Mexico, Santa Fe; Brooks Memorial Art Gallery, Memphis; U. S. Naval Academy Museum, Annapolis. AAA 1905-1933 (New York City; summer, Port Jefferson, Long Island, 1925-1933); Benezit; Fielding; Havlice; Mallett; WWAA 1936-1939 (New York City); WWAA 1940-1941 (Gloucester, Massachusetts); WWAA 1947-1962 (New York City); NMAA-NPG Library, Smithsonian Institution; *Art News*, June 20, 1925; San Francisco Public Library art and artists' scrapbook; Viguers, 1958; Castor typescript at San Francisco Public Library.

Grant grew up in San Francisco, worked as an illustrator

173

for the San Francisco *Examiner,* and then went to New York where he was an illustrator for one or more newspapers. In 1925 he was briefly in California to exhibit, and to spend three months sketching at sea between San Francisco and Alaska. *Art News* reported his return to New York in June. His specialty was clipper ships in port and at sea.

Graves, Helen D. (1899–)
B. St. Helena, California. Mallett Supplement (Seattle, Washington); *Who's Who in Northwest Art.*

Graves studied at the San Francisco School of Fine Arts, the University of California, and the University of Washington. She exhibited in group shows at the Seattle Art Museum in 1932 and 1936.

Gray/Grey, William Vallance (–)
Pacific Coast Business Directory, 1871–1873 (San Francisco, California); California State Library; Oakland Art Museum library.

Gray was active in California from 1863 to 1889, mainly as a portrait painter.

Grayson, Andrew Jackson (1818–1869)
B. Louisiana. D. Mazatlan, Mexico, August 17. Work: Bancroft Library, University of California. Lois C. Stone, "Andrew Jackson Grayson, Artist-naturalist of the Pacific Slope," *The American West,* Summer 1965, 19–31; Castor typescript; California State Library.

It was John J. Audubon's Elephant Folio of birds Grayson saw in 1853 that inspired him to learn to draw and color as well as Audubon did.

Grayson had studied birds for many years. His interest in them had lengthened his trip to California in 1846 by months because he spent so much time off the trail looking for them.

That Grayson succeeded in his drawing and coloring is apparent from prizes he won at Sacramento Fairs and elsewhere during his later years in California. He was a resident of San Francisco before moving to a ranch in Marin County; in 1853 he moved to San Jose, and in 1859 to Mazatlan.

174

Greathouse, Mrs. G. W. (-)

B. Allenton, Colorado County, Texas. AAA 1923–1924 (Fort Worth, Texas); Fisk, 1928.

Greathouse studied at the Art Institute of Chicago; the Broadmoor Art Academy in Colorado Springs; in California; and in New York, St. Louis, and Dallas. Her principal teacher in Dallas was Frank Reaugh. During the 1920s she spent summers in Manitou, Colorado. She had a studio in Fort Worth and a teaching position at Texas Christian University.

Green, Jay S. (1892–1984)

B. Santa Cruz, California. Work: Presidio Museum, San Francisco. Interviews with Green and Dr. Mary Shepardson in Palo Alto, California.

Green studied at the California School of Fine Arts in San Francisco and the California College of Arts and Crafts when it was in Berkeley. In 1919 he established the firm of Nelson and Green to design and build industrial displays. His credits include the architectural model of the Golden Gate World's Fair, which was exhibited in Chicago, New York, Los Angeles, and San Francisco, and ten dioramas for the Fair depicting the history of San Francisco. The dioramas were later placed in the Presidio Museum.

Green's easel paintings include oil landscapes of Utah, Arizona, Nevada, Idaho, Vermont, and California scenery. He exhibited mainly at the Bohemian Club in San Francisco.

Green's memberships include the Society of Western Artists, Palace of Fine Arts League, Santa Cruz Art League, and the Oakland Art Association of which he was president from 1961 to 1963. Following retirement from commercial art work he opened a studio in Palo Alto.

Greenbaum, Joseph (1864–1940)

B. New York City. D. Los Angeles, California, April 16. Work: M. H. De Young Memorial Museum, San Francisco; Santa Cruz (California) Art Museum; California Historical Society; Mechanics Institute of San Francisco; Society of California Pioneers. AAA 1915–1917 (Los Angeles); AAW v. I; *Who's Who in the Pacific Southwest*, 1913; California *Arts & Architecture*, December 1932 (Los Angeles); Cali-

fornia State Library; California Historical Society library; "The Creative Frontier/A Joint Exhibition of Five California Jewish Artists 1850–1928," Judah L. Magnes Museum exhibition catalogue, Berkeley, January–February 1975; Spangenberg, 25.

Except for Greenbaum's early years in New York City and art student years in Germany and France, he lived in California. Prior to the earthquake of 1906 he lived in San Francisco. In 1900 he spent some time in Monterey studying and painting life among Monterey's Chinese fisherfolk.

After 1906 Greenbaum worked in Santa Barbara and in Los Angeles. Known mainly as a portrait painter, he did a number of Southwestern landscapes during his Southern California years. The Judah Magnes Museum catalogue refers to his work as "a school of muted colors, landscape, sea, simple portraits or animal studies" showing "extreme refinement in color tones and technical refinement."

Greenbury, George C. (–)

Denver Public Library; Denver *Times*, April 9, 1899, 6/2; Bromwell scrapbook, p. 19.

A painting entitled "Mission," depicting early mission days in Santa Fe, New Mexico, was exhibited by Greenbury at the Denver Artists' Club in 1899.

Greenbury, William (–)

Work: Pioneers' Museum, Colorado Springs, Colorado. Ormes and Ormes, 338; Denver Public Library; Bromwell scrapbook, 15; "An Art Exhibition . . . ," Colorado Springs *Gazette*, September 18, 1897, 5/1; Colorado Springs Fine Arts Center library; Colorado College Library.

The *Gazette* calls Greenbury an "impressionistic colorist" whose exhibition was an impressive one. Among the paintings were two from Greenbury's recent California travels—"Gumbo Slough," a view of San Diego Bay, and "Sunrise on San Diego Bay." The Gazette reported that Greenbury had studied in Europe under "most able masters," and had opened his Colorado Springs studio to paint Colorado scenery for European exhibitions.

In 1898 Greenbury exhibited eight oils and water colors in

Denver. Several of the paintings were marines done in Northern and Southern California.

Greene/Green, E. (ca 1830–)
Work: Idaho Historical Society; Amon Carter Museum of Western Art. Boise Gallery of Art library; Arthur Hart, "Early Artist Drew Mining Camps," Idaho *Statesman,* June 12, 1978, 4A.

Hart substantiates Green's presence in Idaho by citing the Tri-Weekly *Statesman* of September 2, 1879, and the January 1884 issue. The former referred to a "beautiful lithographed view of the Gold Hill mill and works, taken from a crayon sketch made by an Idaho artist, Mr. Green [sic]" The 1880 census lists an Edmond Greene, a draftsman fifty years of age, born in England, who, Hart feels, is the same artist.

The January 1884 *Statesman* tells how Greene went about getting his view of Boise City published. First he put the original drawing in a local store where it could easily be seen. Then he toured the area in search of customers; he needed a hundred subscribers at three dollars each to make it profitable for Britton and Rey of San Francisco to lithograph it. Such a view exists in the Amon Carter collection. It is a toned lithograph entitled "View of Boise City, Idaho, from the Court House C. 1850." As with several other of Greene's Idaho lithographs, the year is incorrect. A courthouse in Boise did not then exist, nor had mining begun. To protect miners Fort Boise was established in 1863 and the town subsequently laid out.

Gremke, Henry Deidrich [Dick] (1860/69–1939)
B. San Francisco, California. D. Oakland, California. Work: Oakland Art Museum. AAW v. I; California *Arts & Architecture,* December 1932 (Oakland); Arkelian; Oakland Museum library.

Gremke exhibited regularly at the Oakland Art Museum, at California state fairs, and at the Mark Hopkins Institute of Art in San Francisco. His contribution to the California scene from the early 1890s until well after the turn of the century is considerable. For his subjects he traveled along the Coast Range, to the Panamint Mountains, and many times to Yosemite Valley. His historic "Camp Teller," an oil painted in 1892, is of a narrow

gauge train that served the Santa Cruz Mountain area. He did some murals for the Santa Fe and Southern Pacific railroads. Eighteen of his easel paintings are listed in the Smithsonian Institution's Inventory of American Paintings.

Gremke studied at San Francisco's California School of Design, later known as the Mark Hopkins Institute. His principal teacher was Raymond Yelland, a well-known marine painter from London.

Grier, Auda Fay (1898–)
B. Geary, Michigan. *Who's Who in Northwest Art* (Portland, Oregon).

Grier studied at the University of Oregon and with Maude Wanker in Portland. She worked in oils.

Griffen, (William) Davenport (1894–)
B. Millbrook, New York. Work: Art Institute of Chicago; murals in postoffices in Flora and Carmi, Illinois. AAA 1929–1933 (Chicago); Benezit; Havlice; Mallett; WWAA 1936–1941 (Algonquin, Illinois); WWAA 1947–1953 (Rock Island, Illinois); Sparks; Jacobson, 70–71, 142–143.

Griffen, an early exponent of abstract realism, painted in a number of states, including South Dakota. He exhibited widely from 1927 to 1943.

Griffin, James Martin (1850–)
B. Cork, Ireland. Work: Private collections. AAA 1915–1931 (Oakland and Berkeley, California); Benezit; AAW v. I; Oakland Museum library; Inventory of American paintings, Smithsonian Institution.

Griffin, who studied at the School of Art in Cork, was active in California from 1885 to 1931 as etcher, painter, and art teacher. He exhibited one print at the Panama-Pacific International Exposition in San Francisco in 1915. "California Landscape" is one of the six paintings by him listed in the Smithsonian's inventory.

Griffin, Walter (1861–1935)
B. Portland, Maine. D. Stroudswater, Maine, May 18. Work: Wadsworth Atheneum; National Academy of De-

sign; Corcoran Gallery of Art; University of Nebraska; Wellesley College; Brooklyn Museum; Luxembourg Museum, Paris; Buffalo Fine Arts Academy, Albright-Knox Art Gallery; Washington County Museum of Fine Arts, Hagerstown, Maryland. AAA 1898–1900 (Boston, Massachusetts); AAA 1905–1908 (Hartford, Connecticut); AAA 1909–1910 (Old Lyme, Connecticut); AAA 1913–1915 (Old Lyme and Paris); AAA 1917 (Portland and Paris); AAA 1919 (Portland and New York City); AAA 1921–1925 (Portland); AAA 1927–1933 (Nice, France; summer 1933, Portland); Benezit; Fielding; Mallett; Rupert Loveyon, "The Life and Work of Walter Griffin, 1861–1935," *American Art Review* (September–October 1975), 92–107; NMAA-NPG Library, Smithsonian Institution; Inventory of American Paintings, Smithsonian Institution.

Griffin was in California in 1915 to receive a gold medal at the Panama-Pacific Exposition, and again in 1916. Rupert Loveyon wrote that he painted in Yosemite Valley and in Southern California "several outstanding works" with an original dry brush watercolor technique that "gave a vibration of color" similar to that of his oils.

Another informative account of Griffin's work can be found in the introductory remarks of Marius B. Péladeau for an exhibition catalogue, "Walter Griffin/1861–1935/Maine Impressionist." The exhibit was held at the William A. Farnsworth Library and Art Museum in Rockland, Maine, in 1978.

Griffith, Armand Harold (1860–1930)

B. Kingston, Indiana. D. Santa Barbara, California, September 24. Work: Detroit Institute of Arts. Gibson, 1975.

Griffith was a Michigan painter and sculptor who was mainly active as director of the Detroit Museum of Art (1891–1913), and as art critic and lecturer. "Santa Barbara Mission," an oil reproduced on page 120 of Gibson indicates he did some painting in the West.

Griffith, William Alexander (1866–1940)

B. Lawrence, Kansas. D. Laguna Beach, California, May 25. Work; Laguna Beach Museum of Art; Thayer Memorial Museum, Lawrence; Mulvane Art Gallery, Topeka, Kan-

sas; State Historical Society, Topeka; University Club, San Diego; Springville (Utah) Museum of Art. AAA 1909-1919 (Lawrence); AAA 1921-1933 (Laguna Beach); Fielding; Havlice; Mallett; WWAA 1936-1941 (Laguna Beach); AAW v. I; Reinbach; "William Alexander Griffith" by Sarah Jane Griffith Stevens, typescript dated March 1916 at NMAA-NPG Library, Smithsonian Institution.

A sabbatical in 1918-1919 in Southern California introduced Griffith to the mountains, the desert, and the sea. In July 1920 he moved his family to Laguna Beach, joining them in November when a replacement teacher took over his position at the University of Kansas.

Griffith exhibited his work at leading galleries in cities along the West Coast, and won a number of awards. He "sold his canvases in good times and bad," said Sarah Stevens, and during depression years he sometimes bartered them.

Grigg, Joanna S. (-)
B. Prince Edward Island, Canada. AAA 1905-1906 (Butte, Montana); AAW v. II; Sternfels typescript, Butte-Silver Bowl Free Public Library.

Most of Grigg's art education was acquired in Pennsylvania. She married young and settled in Montana in 1892. Some time later she studied with E. S. Paxson, one of the state's best-known early painters. Grigg worked in oils and water colors and exhibited locally as late as 1933.

Grigware, Edward Thomas (1889-1960)
B. Caseville, Michigan. D. Cody, Wyoming, in January. Work: University of Wyoming education building; Kalif Temple, Sheridan, Wyoming; Chicago Municipal Collection; University of Chicago; Illinois State Museum. AAA 1917-1933 (Chicago and Oak Park, Illinois); Benezit; Fielding; Havlice; Mallett; WWAA 1936-1937 (Oak Park); WWAA 1938-1941 (Oak Park; summer, Cody); AAW v. I; Sparks; Lawson; M. Barr; "In the Cow Country," *Art Digest,* May 15, 1941, 29; NMAA-NPG Library, Smithsonian Institution.

Western landscapes were exhibited in Chicago by Grigware in the 1920s. In 1937 he established with photographer Stanley

Kershaw the Cody Summer School of Art which enabled him to spend a great deal of time in Wyoming. He absorbed the state's history and utilized it in easel paintings and murals.

Grimm, Paul (1892–1974)

B. South Africa. D. Palm Springs, California, December 30. Work: Palm Springs Post Office; Bank of America, Palm Springs. *Desert Sun,* January 2, 1975; Palm Springs Public Library; California State Library.

From 1919 to 1932 Grimm worked as an artist for the motion picture industry. Then he moved to Palm Springs where he became known as a desert painter. He developed a great fondness for the dazzling sunsets; but when a friend asked him to paint one, he said, "A Master artist has made that picture and no human can do justice to it."

Dwight Eisenhower was one of Grimm's admirers, and liked to watch him paint. Some say Eisenhower took lessons from him.

Grist, F. R./Franklin[?] (–)

Work: Amon Carter Museum of Western Art. Groce and Wallace; Young; M. Barr, 7; Hassrick, 1977, 90–91; Amon Carter Museum of Western Art Catalogue of the Collection, 358–360; Olpin, 1980.

Apparently F. R. Grist is Franklin Grist who appears in Groce and Wallace and Young. He was a genre painter who worked in New Haven, Connecticut. He exhibited at the National Academy of Design in 1848. If, as it appears, Franklin Grist accompanied Captain Howard Stansbury, U. S. Army Topographical Engineers, in 1849, and made sketches along a route from Independence, Missouri, to Utah and Wyoming, he may have produced some paintings in addition to the illustrations for Stansbury's report. The items in the Amon Carter Museum are toned lithographs, dated 1852.

Maurice Barr noted Grist's presence in Wyoming in 1849: "F. R. Grist is with Stansbury—he's drawing at Fort Laramie," wrote Barr in his chronology.

Griswold, J. C. (1879–)

B. Jersey City, New Jersey. Fisk, 1928 (San Antonio, Texas).

Griswold, who studied architecture at Pratt Institute, painted as an avocation. He settled in Texas in 1905, set up a studio in his home, and painted in his spare time. He worked mostly in pastels, and he liked to paint marines. Fisk noted Griswold's "very fine technique" in his "Rocks at La Jolla." He exhibited in New York City, in San Antonio, and in Abilene at the West Texas Fair.

Grosz, George (1893–1959)

B. Berlin, Germany. D. Berlin ?, July 6. Work: Museum of Modern Art; Art Institute of Chicago; Minneapolis Institute of Arts; Wichita Art Museum; Los Angeles Museum of History, Science, and Art, etc. Benezit; Havlice; Mallett (New York City); WWAA 1938–1956 (Douglaston and Huntington, Long Island, New York); Young; Dallas Museum of Fine Arts, "Impressions of Dallas by George Grosz," October 4–November 9, 1952.

Grosz, who taught for many years at the Art Students League and at Columbia University, was commissioned by A. Harris and Co. to paint various Texas subjects. Grosz did a series of water colors, drawings, and an oil titled "The Skyline of Dallas." Other titles include "Study of a Texas Saddle," "Cowboy in Town," and "Old Negro Shacks."

Gruder, Carl (–)

B. Rostoch, Germany. Bucklin and Turner, 1932.

Gruder was a landscape painter, decorator, and cabinet maker who moved to Omaha, Nebraska, in 1923. According to an October 5, 1930, Omaha newspaper Gruder had learned to paint in an Austrian prison camp where he was confined as a civilian prisoner for five years during World War I.

Guerin, Jules (1866–1946)

B. St. Louis, Missouri. Work: San Francisco Public Library; Lincoln Memorial, Washington, D.C.; Pennsylvania Railroad Station, New York City. AAA 1900–1908, 1913–1933 (New York City); Benezit; Fielding; Havlice; Mallett; WWAA 1936–1941 (New York City); WWAA 1947, obit.;

Earle; NMAA-NPG Library, Smithsonian Institution; Inventory of American Paintings, Smithsonian Institution.

Guerin's principal medium was water color, and his specialty was architectural subjects. He became the first director of color "ever appointed for an international exposition" when he supervised the color treatment for the Panama-Pacific Exposition in San Francisco. His "Court of Four Seasons" series was one of the attractions of the Exposition when it opened in 1915.

It is likely that Guerin's painting "Carmel Sand Dunes" was done during his San Francisco assignment.

Guerin's murals for the Pennsylvania Railroad include six enormous "topographical landscapes" depicting the region served by the railroad.

Guislain/Guislane, J. M. (1882–)
B. Louvain, Belgium. Work: Private collections. AAA 1919–1925 (New York City; Brussels, Belgium); AAA 1927 (Belgium); Fielding; AAW v. I; McClurg, pt. VI; Colorado College Library.

Guislain was active in Colorado Springs, Colorado, during 1908 and 1909. He did portraits and landscapes in the impressionist style which were described in local newspaper accounts as "charming."

Guptill, Thomas Henry (1868–)
B. North Cutler, Maine. *Who's Who in Northwest Art* (Port Angeles, Washington).

Guptill studied illustration and painting in San Francisco, and exhibited with the San Francisco Art Association. Later he studied at the Olympic Sketch Club in Seattle. He worked in all media.

Gustavson, Henry (1864–1912)
Work: Fairfax (California) City Hall. San Francisco Public Library art and artists' scrapbook; Inventory of American Paintings, Smithsonian Institution.

Gustavson was a portrait and landscape painter who lived in San Francisco and Marin County many years. Seven of his oils

of the San Francisco Bay region are listed in the Smithsonian's Inventory.

Gustin, Paul Morgan (1886–1974)

B. Fort Vancouver, Washington. D. Seattle, Washington, August 16. Work: Henry Gallery, University of Washington; Seattle Art Museum; Washington State University; murals, Roosevelt High School, Seattle; Northwest History Room, University of Washington Library. AAA 1913–1933 (Seattle; Paris in 1925); Benezit; Havlice; Mallett; WWAA 1936–1941 (Seattle; summer 1938–1941, Normandy Park, Washington); AAW v. I; *Who's Who in Northwest Art;* Vickie Ross, "Paul Morgan Gustin 1886–1974," ms. at Henry Gallery; Madge Bailey, "Paul Morgan Gustin," *American Magazine of Art,* February 1922, 82–86; "With the Fine Art Folk," Seattle *Town Crier,* October 9, 1915, 7: "Art in Seattle," *American Magazine of Art,* March 1927, 157.

Gustin showed nineteen paintings when he first exhibited in Seattle in May 1913. They attracted immediate attention. In 1914 he was asked to serve as a juror for the Panama-Pacific Exposition, held in San Francisco in 1915. He also served as a juror for the Chicago Art Institute's 28th annual exhibition of American oil paintings and sculpture in 1915.

"A California Hilltop" shown by Gustin in Seattle in October 1915 was lauded for its delicacy and charm, albeit with the observation that its coloring was reminiscent of Washington. Nor did California scenery lure Gustin back to California. Throughout his long career of landscape painting, the mountains of the Northwest, Deerfield Valley and the coast of Massachusetts, and the wild northern part of British Columbia among the fiords and Indian villages attracted him most often. In an interview with Madge Bailey he related his conviction that the Northwest was "endowed by nature with the possibilities of a great landscape school."

When Gustin showed some seventy-five works at the Society of Fine Arts gallery in Seattle in February 1927, the *American Magazine of Art* called him one of the "ablest painters of the Northwest." His work is "vigorous and free, confident in its execution and full of feeling."

H

Hackwood, Harriet Chapin McKinlay (1874–)

B. Osborn, Missouri. Work: Soquel (California) Public Schools. *Who's Who in Northwest Art* (Hoquiam, Washington); Santa Cruz Art League Exhibition catalogue, 1934.

Hackwood, who signed some of her work H. McK. Hackwood, was active in California as well as Washington and lived in Santa Cruz during the mid-1930s.

Haffer, Virna/Mrs. Norman B. Randall (1899–)

B. Aurora, Illinois. *Who's Who in Northwest Art* (Tacoma, Washington).

Haffer, a printmaker, sculptor, and photographer, had a number of solo exhibitions in Washington and Alaska during the 1930s.

Hagerman, Percy (1869–1950)

Work: Colorado Springs Fine Arts Center. AAW v. I; Denver Public Library; McClurg, Colorado Springs *Gazette*, December 21, 1924.

Hagerman studied lithography during 1938–1939, and exhibited a number of prints featuring mines, sheep ranches, forests, and mountains.

Haig, Emily (1890–)

B. Petaluma, California. *Who's Who in Northwest Art* (Seattle, Washington).

Haig, who worked in oils and pastels, studied at the San Francisco Institute of Art and exhibited at a private gallery in Burlingame, California.

Hale, Ellen Day (1855–1940)

B. Worcester, Massachusetts. D. Brookline, Massachusetts, February 10. Work: Library of Congress; Iowa State University; U. S. Capitol; Connecticut State Library and Supreme Court; Yale University; National Museum of

American Art. AAA 1898 (Boston); AAA 1905-1933 (Washington, D.C.; summer, 1917-1933, Gloucester, Massachusetts); Benezit; Fielding; Havlice; WWAA 1936-1939 (Baltimore, Maryland; summer, Gloucester); WWAA 1940-1941, obit.; NMAA-NPG Library, Smithsonian Institution.

Hale, a well-known portrait painter, did a number of etchings from her travels in this country and abroad. Her Western subjects include San Gabriel, San Diego, San Luis Rey, and Santa Barbara missions. The Santa Barbara and San Diego etchings are dated 1892 and 1893, respectively.

Hale, Florence Keffer (1887-)
B. Des Moines, Iowa. Ness and Orwig, 1939 (Pacific Beach, California).

Hale, Girard Van Barkaloo (1886-1958)
B. Denver, Colorado. D. New York City, October 29. Work: Utah State Capitol. AAA 1913-1915 (Paris, France); Mallett; California *Arts & Architecture*, December 1932 (Santa Barbara, California); Olpin, 1980; Salt Lake City Public Library art and artists' scrapbook; San Francisco Public Library art and artists' scrapbook, v. IV, p. 5; obituaries in San Francisco *Chronicle*, October 31, 1958, and Salt Lake City papers; Castor typescript, San Francisco Public Library.

Hale who began his career as a portrait painter turned to landscapes in Paris. His specialty was nocturnes, created from careful observation of night light.

By 1914 Hale had had solo exhibitions in Paris and in the United States. Subsequently he opened a studio in San Francisco. He continued to spend much time in France where, after the Second World War, he adopted the devastated village of Maille. His other homes and studios were in Santa Barbara and Atascadero, California.

Hall, Arthur William (1889-)
B. Bowie, Texas. Work: Smithsonian Institution; Library of Congress; California State Library; Bibliotheque Nationale, Paris; Honolulu Academy of Art. AAA 1917 (Chi-

cago, Illinois); AAA 1925-1929 (Edinburgh, Scotland); AAA 1931 (Howard, Kansas); Benezit; Havlice; Mallett; WWAA 1936-1939 (Howard); WWAA 1940-1941 (Howard; summer, Bluemont, Virginia); WWAA 1947-1953 (Santa Fe, New Mexico); WWAA 1956-1962 (Alcalde, New Mexico); AAW v. I; Howell C. Brown, "The Halls," *American Magazine of Art,* March 1929, 153-154; Santa Fe *New Mexican,* October 18, 1944; Museum of New Mexico library.

Hall was a painter and a printmaker. When he submitted some etchings to the Jury of Selection for the Exhibition of Contemporary American Prints at the Bibliothèque Nationale in Paris in 1928, all of them were accepted. Five of the six jurors requested duplicate copies of one or more of the prints – "A phenomenal occurrence," said the editor of *American Magazine of Art* in 1929.

Much of Hall's work deals with the Southwestern scene. Among seven dry points and aquatints at the Library of Congress are "Night in the Apache Desert," "Pecos," and "Walpi Window."

When the headquarters of the Prairie Print Makers was moved from Wichita, Kansas, to Santa Fe in the early 1940s, Secretary-treasurer Hall moved into the studio Gerald Cassidy (1879-1934) had occupied. Later he moved to Alcalde where he operated a summer school with his wife, Norma Bassett Hall.

Hall, Howard H. (-)
Denver Public Library; *The Tepee Book,* v. 2, no. 4 (April 1916), 36.

Hall was a resident of Sidney, Nebraska, who did at least two covers for *The Tepee Book.* According to *The Tepee* he was to leave for Italy about May 1, 1916. His plan was to spend three years in Europe studying art and then return to the Big Horn country to paint.

Such paintings by Hall as have been seen by this writer are reminiscent of Charlie Russell's work and differ markedly from the fishing and forest scenes he did for *The Tepee* covers.

Hall, Norma Bassett (1889-1957)
B. Halsey, Oregon. D. Santa Fe, New Mexico. Work: Brooklyn Public Library; Smithsonian Institution; Honolulu Academy of Art; California State Library; Uni-

versity of Tulsa; Wichita Art Association; University of Wichita; Currier Gallery of Art, Manchester, New Hampshire. AAA 1925-1929 (Edinburgh, Scotland); AAA 1931 (Howard, Kansas); Havlice; Mallett; WWAA 1936-1939 (Howard); WWAA 1940-1941 (Howard; summer, Bluemont, Virginia); WWAA 1948-1953 (Santa Fe, New Mexico); WWAA 1956 (Alcalde, New Mexico); AAW v. I; Howell C. Brown, "The Halls," *American Magazine of Art,* March 1929, 153-154; Museum of New Mexico library.

Following her marriage to Arthur Hall in 1922 the couple vacationed at Cannon Beach on the Oregon coast. Desiring a pictorial record of their visit, they printed by hand two copies of a book containing thirty blockprints. For the first time, Hall said later, she saw the "real possibilities" of block printmaking and decided to make it her principal medium.

Hall's experiments led to the use of the oriental method of printmaking, mixing dry color with water and rice-flour paste. She printed by hand, "using a small disk covered with a bamboo leaf" to press the paper over the carved blocks. Many of her prints are of New Mexico subjects.

Hall, Robert H. (1895-)
B. Indiana. *Who's Who in Northwest Art* (Butte, Montana); Butte-Silver Bowl Free Public Library; Sternfels, typescript, 7, 108-109, 149-151.

Sternfels described Hall as a miner, an adventurer, and an artist who "attracted much attention by his unusual work." In Montana he is especially well-known for his pencil and pen-and-ink sketches of the "underground workings" of Butte's mines. Some of this work has appeared in mining journals.

Hall, who studied at the Cleveland School of Art, taught at Butte Art Center, and illustrated for Caxton Printers of Caldwell, Idaho.

Halsey, Anna Mary McKee (1865-)
Bucklin and Turner, 1932 (Omaha, Nebraska).

Halsey studied at the University of Omaha, exhibited locally, and taught art in the public schools. Her medium was water color.

Hamilton, Doris W. (–)

Olpin, 1980; Salt Lake Public Library art and artists' scrapbook; Salt Lake *Tribune*, May 28, 1961.

Hamilton studied at various art schools over a period of many years: Tullie House Art School, Carlisle, England, about 1911; University of Utah, 1922-1923; Rudolph Schaeffer School of Design, 1936. She was active in San Francisco, Salt Lake City, and Farmington, Utah, where she may have grown up. By 1961 she was again living there, engaged principally, according to the *Tribune*, in demonstrating china painting.

Hammarstrom/Hammerstrom, H. C. (–)

AAA 1909-1910, 1917 (Life Saving Station, Golden Gate Park, San Francisco); Porter, and others, 120, article by Robert B. Harshe.

Hammarstrom was a painter and an etcher who specialized in marines. He was not well-known, but his monotypes deserved "especial mention" said Harshe in his article for *Art in California*, published in 1916.

Hammerstad, John Olson (1842-1925)

B. Christiansund, Norway. D. February 10. Work: Norwegian-American Museum, Decorah, Iowa. Denver Public Library; Colorado *Miner*, July 4, 1872, 4/2; Rolf Erickson, Evansville, Illinois. Hammerstad was a landscape painter who settled in Chicago in 1869.

Hammond, Leon W. (1869–)

B. Attica, New York. *Who's Who in Northwest Art* (Everett, Washington).

Hammond studied with Eustace Ziegler, Edgar Forkner, and Myra Wiggins, and worked in most media.

Hamp, Margaret (ca 1830-1921)

B. England. D. Colorado Springs, Colorado, April 16. Work: Private collections. Ormes and Ormes, 343; AAW v. I; Colorado College Library; Colorado Springs Public Library; McClurg, pt. V; *Facts*, a Colorado Springs publication, March 10, 1900; *Pioneers' Museum Cookbook*, 1980, published in Colorado Springs.

Madam Hamp, as she was known, settled with her four

children in Colorado Springs in June 1877. She had studied art in England, and continued to study whenever she was there for a visit. She worked in water color.

Hamp's favorite subjects were Pikes Peak and Cheyenne Mountain scenes. As to the latter McClurg wrote that "its pinks and purples found in her a loving and skilled interpreter." She also painted in Monterey, California, where cypresses were a favorite subject.

Hamp exhibited infrequently from 1900 to 1915. McClurg wrote that her work "commanded good prices," and that she donated much of the money she received to her "numerous and wisely directed charities."

Handforth, Thomas Schofield (1897–1948)

B. Tacoma, Washington. D. Los Angeles, California, October 19. Work: Metropolitan Museum of Art; New York Public Library; Fogg Museum of Art, Harvard University; Philadelphia Museum of Art; Library of Congress; Seattle Art Museum; Tacoma Public Library; Art Institute of Chicago; Bibliotheque Nationale, Paris; Los Angeles County Museum of Art, etc. AAA 1919–1921 (Washington, D.C.); AAA 1927–1931 (Tacoma; summer, Hingham Center, Massachusetts); AAA 1933 (Peking, China); Benezit; Havlice; Mallett; WWAA 1936–1939 (Peking); WWAA 1940–1947 (Wilmington, Delaware); AAW v. I; *Who's Who in Northwest Art;* NMAA-NPG Library, Smithsonian Institution; Mahoney, 1947; Viguers, 1958; Elizabeth Whitmore, "The Etchings and Drawings of Thomas Handforth," *American Magazine of Art,* May 1926, 185–190.

Handforth, who grew up in Tacoma, studied art there and in Seattle before going to New York and Paris for further study. Upon returning to Tacoma about 1926 he specialized in painting Siwash Indians, Northwest Coast landscapes, and portraits of children.

Handforth's world travels and a year in Mexico during which he was awarded a Guggenheim Fellowship occupied him a good part of the 1930s. Then he went to the Southwest to study and draw Indians. By 1939 he was back in Tacoma making sketching trips to the Cascades and specializing in landscapes. His last years were spent mainly in California.

Hankins, Vina S. (1878–)
 B. Chicago, Illinois. Havlice; WWAA 1953–1962 (Carlsbad, California).
 Hankins, who studied at the Art Institute of Chicago, began exhibiting in Southern California in the late 1940s.

Hannis, Geneva Grippen (1868–)
 B. Winnebago, Illinois. Bucklin and Turner, 1932 (York, Nebraska).
 Hannis studied art in York and Lincoln, Nebraska.

Haradynsky, E./Frank Stadter (–)
 B. Poland[?]. Bucklin and Turner, 1932, 14–15, 23.
 Haradynsky used the name of Stadter while teaching drawing and painting at the University of Nebraska in 1877 and 1878. He was said to have returned to Poland.

Hardman, Maud R. (–)
 B. Laramie, Wyoming. Olpin, 1980; Salt Lake City Public Library art and artists' scrapbook; "Veteran Art Teacher to End S.L. Career," Deseret *News*, May 25, 1959.
 Hardman graduated from Salt Lake City High School in 1913 and then studied art and art education. In 1922 she joined the art department of the University of Utah where she remained until 1937 when she became Supervisor of Art for Salt Lake City schools.

Harlan, Thomas (–)
 Pierce, 1926; Calhoun, 19, 30, 103.
 Harlan was an architect and a water color artist who was active in Seattle from about 1908 until the late twenties, and possibly thereafter.

Harle, Annie L. (–1922)
 B. Paris, Texas. D. Abilene, Texas, March 28. Work: Private collections in Texas, New Mexico, Oklahoma, and Colorado. Fisk, 1928, 150–151.
 Harle's career began in Thorpe Springs, Texas, where she taught drawing and water color at Clark College. Failing health

prompted her to move to Abilene in 1882 where she taught periodically. She spent two years in Mexico City studying oil landscape and still life painting; a year in St. Louis studying oil tapestry; a year in El Paso, Texas, teaching and painting; and an unstated period in Detroit studying with Franz Bischoff.

Harman, Jean C. (1897–)
 B. Dayton, Ohio. *Who's Who in Northwest Art* (Los Angeles, California).
 Harman studied with Martella Cone Lane, Clyde Keller, and H. Raymond Henry. She exhibited with the Oregon Society of Artists, and in Los Angeles. Her specialty was landscapes in oil.

Harmon, Charles Henry (–1936)
 B. Ohio. D. San Jose, California, October 14. Work: Clarke Memorial Museum, Eureka, California. See AAW v. I for biographical sketch; Denver *Republic,* September 3, 1905, 17; Denver *Post,* August 25, 1906, 9; San Francisco *Chronicle,* April 30, 1923, 9/2; Minnesota Museum of Art, *Iron Horse West,* 1976, 51; Inventory of American Paintings, Smithsonian Institution.

Harms, Alfred (–)
 AAA 1917 (San Francisco).

Harn, Alice Moores (1855–1931)
 Work: Oklahoma Art Center, Oklahoma City. AAA 1923–1925; England, 21.
 Harn studied in Cincinnati, Ohio, and at the National Academy of Design in New York. She is believed to have been the first person to teach art in Oklahoma City.

Harpe, Sophie Elaine (1895–1981)
 B. Quebec, Canada. D. November 7, probably in Monterey. California State Library; Monterey Public Library; Monterey Peninsula *Herald,* November 9, 1981; *Herald* art critic Irene Lagorio, "Artist Identified with Paintings," Monterey Peninsula *Herald,* May 18, 1980, 8–B; *Herald*

special writer Jean Milne, "The Many Interests of a 'Fantastic' Teacher," Monterey Peninsula *Herald Weekend Magazine,* March 19, 1978, 3–5; California *Arts & Architecture,* December 1932 (Los Angeles, California).

Harpe studied music in New York City, and then began the serious study of art. She attended the National Academy of Design and Columbia University, graduating from the latter with a degree in architecture. By 1918 she was living in California. She obtained her bachelor's and master's degrees at Stanford University, and subsequently joined the faculty. At various times she studied in Paris and in Los Angeles.

In Monterey, Harpe is remembered for her many years as instructor and art department chairman at Monterey Union High School. She retired in 1960.

Harpe exhibited in New York City, Carmel, California, and in Los Angeles. She was a member of the Carmel Art Association for fifty years and was in her eighty-fifth year when she last exhibited at the Association's galleries.

Harris, Lawren Stewart (1885–1970)
B. Brantford, Ontario. D. Vancouver, British Columbia, January 29. Work: Detroit Institute of Arts; National Gallery of Canada; Art Gallery of Toronto; Art Association of Montreal; William Art Gallery, London, Ontario, etc. Havlice; Mallett; WWAA 1947–1970 (Vancouver); Wallace and McKay, 1978; Harper, 1966; Hubbard and Ostiguy, 1967; Murray, 1973; School of American Research, 1940; Coke, 1963; Washington *Post,* February 1, 1970, obit.; New York *Times,* January 31, 1970, obit.

In Santa Fe, New Mexico, Harris was associated with the transcendental movement organized in June 1938. He was active there much of 1940. In 1941 he moved to Vancouver where he did non-objective paintings until 1950, and then turned to abstract expressionism.

Harrison, (Lowell) Birge (1854–1929)
B. Philadelphia, Pennsylvania. D. Woodstock, New York, May 11. Work: Pennsylvania Academy of Fine Arts; Luxembourg Museum, Paris; Corcoran Gallery of Art, etc.

193

AAA 1898–1906 (Plymouth, Massachusetts); AAA 1907–1908 (Woodstock); AAA 1909–1917 (Bearsville, New York); AAA 1919–1921 (New Hope, Pennsylvania); AAA 1923–1927 (Woodstock); Benezit; Fielding; Havlice; Mallett; AAW v. I; Earle; Birge Harrison, *Espanola and Its Environs,* Espanola, New Mexico: Las Trampas, 1966 (reprinted by Las Trampas from "An Artist's Impressions," *Harper's* Monthly Magazine, May 1885); Colorado College Library; Boyle, 1974, 79; California State Library; Oakland Museum library.

In 1883 Harrison lived for some time in Espanola, New Mexico, in a two-room shack that let lots of blowing sand through its board framework. He described Espanola as a tent city that had grown up with the recent arrival of the Denver and Rio Grande Western Railroad, known in New Mexico as the "Chili Line."

Santa Fe had been Harrison's destination. In retrospect he could not recall why he and his wife had instead spent so much time in Espanola sketching. His account of their experiences and the subjects they sketched, especially the nearby Indian Pueblos, is most informative. His sketches bear titles such as "Indian Foot Race," "Old Mexican Chapel by Moonlight," "The Penitentes," and "Dear Old Adobe Church at Santa Cruz" [Santa Cruz de la Canada].

"Each adobe, each stray figure, frames itself into a brilliant little 'genre' picture," wrote Harrison regarding a trip to Puye in the land of the Santa Clara Pueblo Indians. Everything about the region was "flashing, scintillating, iridescent with color."

Harrison began working in the West about 1880. A number of his important paintings were done at Santa Barbara, California. Earle has written that his work "is marked by a love of evanescent effects,—moonrise over a majestic shadowy landscape, winter twilight after snow, the harbor ice in moonlight."

Hart, Alfred A. (1816–)
B. Norwich, Connecticut. Work: Kansas City Museum of History and Science. Fielding; Groce and Wallace; Mallett Supplement; AAW v. I; French; Denver Public Library; Rocky Mountain *News,* September 8, 1869, 4/2; Inventory of American Paintings, Smithsonian Institution.

Hart was a portrait painter and panoramist who was in the West, perhaps as early as the mid-1850s. He probably made his home in California. Extant paintings listed in the Smithsonian inventory include "In the Olympic Range, Washington," and two Yosemite scenes, one painted about 1883. French, whose book was published in 1879, felt that Hart's attention to his inventions had interfered with his career as an artist, but acknowledged that during the almost twenty-five years he had lived in the West he had invented "several useful machines."

Hart, Lantz/Lance Wood (-1941)
D. Eugene, Oregon, May 26. Work: U. S. Post Office, Snohomish, Washington; Elks Club Building, Aberdeen, Washington. AAA 1915 (Chicago, Illinois); AAA 1921–1924 (Aberdeen); Havlice; Mallett Supplement; WWAA 1940-1941 (Eugene); WWAA 1947, obit.; *Who's Who in Northwest Art;* Pierce.

Hart, who studied at the Art Institute of Chicago, in New York City, and in Stockholm, Sweden, was assistant professor of drawing and painting at the School of Architecture and Allied Arts, University of Oregon. His specialty was oil landscapes.

Hart, Sally (1891–)
B. Portland, Oregon. *Who's Who in Northwest Art* (Portland).

Hart, who studied at the Portland Art Museum School, Columbia University Teachers College, and in Paris, exhibited at least once in New York, but mostly in Portland. She worked mainly in water color and tempera.

Hartley, Marsden (1877-1943)
B. Lewiston, Maine. D. Ellsworth, Maine, September 2. Work: Art Institute of Chicago; Museum of New Mexico, Santa Fe; Roswell (New Mexico) Museum and Art Center; Columbus Gallery of Fine Arts; Whitney Museum of American Art; Amherst College; Denver Art Museum, etc. AAA 1913-1924 (New York City); AAA 1927-1931 (Aix en Provence, France); Benezit; Fielding; Havlice; Mallett; WWAA 1936-1941 (New York City); AAW v. I; *Encyclo-*

pedia of Painting, Myers ed.; Elizabeth McCausland, *Marsden Hartley,* Minneapolis: University of Minnesota Press, 1952; Coke, 1963; NMAA-NPG Library, Smithsonian Institution.

Hartley went to New Mexico in June 1918. He spent the summer and early fall in Taos, drawing and working with pastels. He spent the winter in Santa Fe and the spring of 1919 in California, returning to Santa Fe in the summer to do a number of oils inspired by the *santos* of the Spanish-speaking people of Northern New Mexico. In May 1920 his work was exhibited in Santa Fe. While living in Berlin in 1922–1923 he painted numerous New Mexico landscapes from recollection.

When Hartley returned to the United States in 1930, he traveled extensively, doing landscapes, marines, genre paintings, and still lifes in an expressionistic style. Some of his most memorable works were produced in Maine, the state he considered home.

Hartshorne, Harold (–)
McClurg, Colorado Springs *Gazette,* Part VI, December 21, 1924; Colorado College Library.

Almost nothing is known about Hartshorne who is said to have had a studio in Paris prior to the First World War. His "studies of the red rocks of the Colorado land," its peaks and plains, were exhibited with scenes of Fountainebleau forest and the Normandy coast at the home of Judge Horace G. Lunt in Colorado Springs in the early 1900s. His wife was the daughter of Judge Lunt.

Hartwell, Emily S. (–)
Work: State Historical Society of North Dakota. Inventory of American Paintings, Smithsonian Institution.

Hartwell, who does not appear in any art directories, painted a number of water colors of Indian subjects of historical importance, some dated 1894, and others dated 1913.

Harwood, Harriet/Hattie Richards (–1922)
B. Utah. D. California. Work: Family collections. Olpin, 1980; Heaton, and others, 74; Utah Art Institute, Second Annual Report, 26; Salt Lake City Public Library.

While studying still life painting in Paris about 1899, Harriet Richards of Lehi, Utah, married the painter James T. Harwood [AAW v. I]. In 1900 Mrs. Harwood was awarded honorable mention by the Utah Art Institute for a still life in oil. Family responsibilities brought her career to a close.

The Harwoods lived in Salt Lake City until 1920 and then moved to California.

Hashimoto, Michi Yosida/Mrs. Masahiko Hashimoto (1890–)
B. Japan. AAA 1929 (Sawtelle, California); AAA 1931–1933 (Los Angeles, California); Benezit; Mallett; California *Arts & Architecture,* December 1932.

Haslehurst, Minette Tucker (–)
News Notes of California Libraries, January 1908, 12; October 1910, 537.

Haslehurst was active in California as a painter of miniatures during the first decade of the century.

Hassam, (Frederick) Childe (1859–1935)
B. Dorchester (Boston), Massachusetts. D. East Hampton, Long Island, New York, August 27. Work: Corcoran Gallery of Art; Oakland Art Museum; Denver Art Museum; Library of Congress; Metropolitan Museum of Art; Pennsylvania Academy of Fine Arts, etc. AAA 1898–1933 (New York City); Benezit; Fielding; Havlice; Mallett; Earle; Gerdts, 1980, 59; Boyle, 1974, 154, 157; Charles E. Buckley, *Childe Hassam; a retrospective exhibition,* Washington: Corcoran Gallery of Art, 1965; Wybro, 521; NMAA-NPG Library, Smithsonian Institution.

There is confusion as to the year Hassam first painted in Oregon. Most sources place him there in 1908 when he was the guest of Colonel C.E.S. Wood in Portland. At that time he painted murals in Wood's home and did "panoramic views" of Oregon scenery in the Harney Desert, wrote Gerdts. However, "Mount Hood, Oregon," a small sketch at the Corcoran Gallery, bears the date August 17, 1904.

Hassam probably visited California in 1908, and may have returned in 1914 when he painted "Hill of the Sun, California."

Wybro described that painting in *Overland* Monthly the following year.

Hassam's best work as an early American impressionist is said to have been done in the 1890s, and for a brief period thereafter. His later work, wrote Boyle, contains "hints of a post-impressionist style."

Hatlo, James [Jimmy] (1897–1963)
B. Providence, Rhode Island. D. Carmel, California, November 30. Havlice; WWAA 1947–1953 (Lobos Lodge, Carmel); WWAA 1956–1962 (Pebble Beach, California); WWAA 1966, obit.; "Famed Cartoonist Jimmy Hatlo Dies of Heart Attack," Monterey Peninsula *Herald,* December 2, 1963, obit.; Monterey Public Library; *Who Was Who in America.*

Hatlo, who studied at the California School of Fine Arts, was active as an illustrator as well as a cartoonist.

Hauge, Marie Gjellstad (–)
Inventory of American Paintings, Smithsonian Institution; North Dakota Retired Teachers Association.

The Inventory of American Paintings lists fourteen oils by Hauge painted between 1905 and 1913. Most appear to be genre scenes.

Haugseth/Hougseth, Andrew/Anders John (1884–)
B. Norway. Havlice; Mallett (Chicago, Illinois); WWAA 1938–1941 (Chicago; Hollywood, Illinois); Sparks; Bucklin and Turner, 1932.

Haugseth taught drawing and painting at the University of Nebraska (1922–1924), and later in Chicago. He was also active as an illustrator and a decorator. His wife Gladys Browning Haugseth, who studied art at the University of Nebraska, was especially interested in Indian design. They collaborated in illustrating a book by Hartley Burr Alexander, and possibly worked together at other times.

Haverstick, R. E./Jake (1898–1961)
B. Newman, Illinois. D. August 17, probably in Albuquer-

que, New Mexico. Work: New Mexico State Fair collection; Midwestern University, Wichita Falls, Texas. Catalogue of the *New Mexico State Fair Permanent Art Collection, 1954-1965,* published by State Fair Commission.

Haverstick studied at the Federal School of Art in Minneapolis, Minnesota, and with W. Herbert Dunton (1878-1936) of Taos, New Mexico.

Although Haverstick is known mainly in New Mexico where he lived for twenty-five years, he also exhibited in other states, including California and Texas. His studio and his home were in Albuquerque.

Hay, Jean M. (**-1942)**
B. Kansas. Barr, 1954, 27; Robinson, 1966, 519.

Hay studied at the Art Institute of Chicago, the Ecole des Beaux Arts in Paris, and in Italy. Her career as a teacher and director of art at North Dakota State Teachers College in Mayville spanned the years 1916-1935.

Hayden, Sara Shewell (- **)**
B. Chicago, Illinois. AAA 1900-1915 (Lincoln, Nebraska, and Chicago); AAA 1917-1931 (Chicago); Mallett; AAW v. I; Sparks; Bucklin and Turner; Denver Public Library; Bromwell scrapbook, 23, 28.

Hayden was a prominent Chicago artist who taught at the University of Nebraska School of Fine Arts from 1899-1916, becoming director in 1900. She had studied with several well-known teachers in this country, and in Paris, France. Among the former were Frank Duveneck and William Merritt Chase. Working mainly in water color and pastel, she exhibited at the Art Institute of Chicago, the American Water Color Society in New York, the Pennsylvania Academy of Fine Arts in Philadelphia, and in 1898 at the Paris salon.

Hays/Hayes, Ethel (1892- **)**
B. Billings, Montana. *Who's Who in Northwest Art* (Kansas City, Missouri); Sternfels typescript, 7.

Hays studied at the Los Angeles School of Art and Design, and the Art Students League where she was awarded a scholar-

ship. She illustrated a number of children's books and worked for twelve years as a feature artist for a Scripps-Howard syndicate.

Hayward, Alfred (1893–)
B. Camden, New Jersey. AAA 1915–1933 (Philadelphia); Benezit; Fielding; Mallett; New Mexico, "The Artists of . . . ," mimeo. at Santa Fe Public Library.

Hayward was a painter and cartoonist who spent so much time in Santa Fe, New Mexico, in the mid-1930s that he has been listed as a Santa Fe artist.

Heaney, Charles Edward (1897–)
B. Oconto Falls, Wisconsin. Work: Portland Art Museum; Library of Congress; Seattle Art Museum; Henry Gallery, University of Washington; Bucknell University; Western Washington College of Education. AAA 1932–1933 (Portland, Oregon); Havlice; Mallett; WWAA 1936–1941 (Portland); AAW v. I; *Who's Who in Northwest Art; Portland Painter and Printmaker Charles Heaney/A Retrospective Exhibition*, March 11–April 17, 1952, Portland Art Museum brochure; Portland Art Museum, *Paintings and Sculptures of the Pacific Northwest, Oregon, Washington, British Columbia*, Portland, Oregon: 1959, an exhibition catalogue; NMAA-NPG Library, Smithsonian Institution.

In the introduction to Heaney's 1952 one-man show at the Portland Art Museum, Dean Givler of the Museum's Art School traced Heaney's transition from one medium to another from the time of his enrollment in 1917. By the time Heaney returned to the Museum School in 1937 to study etching, he was well-known in the Northwest for his woodcuts, linoleum prints, and paintings.

Much of Heaney's subject matter was drawn from local scenery and the John Day country badlands of Eastern Oregon. His discoveries of ancient fossil beds led to his use of fish and bird imprints as motifs in much of his late work.

While studying etching with Givler, Heaney discovered that "the expressive range of the aquatint etching [was] especially suited to his aesthetic needs." Givler said that a "particular type of resin ground afforded the working surface from which [Heaney] was able to achieve extraordinary prints of great textural range

and vitality." It was these experiments that led to Heaney's innovative fossil paintings with their encrusted, raised, half relief surfaces.

Heath, Carroll D. (1880–)
B. Shawano, Wisconsin. *Who's Who in Northwest Art* (Coeur d'Alene, Idaho).

Heath, Frank L. (1857–1921)
B. near Salem, Oregon. D. Santa Cruz, California, April 21. Work: Society of California Pioneers; Yosemite National Park Museum; First Methodist Church, Santa Cruz. AAW v. I; California State Library; Oakland Museum library; San Francisco Public Library art and artists' scrapbook; Koch, 200–201; Wallis, ed., *Western Woman,* v. 13, no. 4, 30; Santa Cruz *News*, April 21, 1921, 4/3, and April 23, 1/2; San Francisco *Chronicle*, April 22, 1921; Lytle, 1978, 162; Inventory of American Paintings, Smithsonian Institution.

Heath's family moved to Santa Cruz in 1866 and established a home on Beacon Hill. Following Heath's three years at California School of Design in San Francisco (it became the Mark Hopkins Institute while he was there) he opened a studio in the family home.

An outdoor enthusiast, Heath often took his students to nearby places to paint. For his own work he traveled extensively in California and occasionally to scenic areas outside the state. He spent the winter of 1887 in San Diego.

Heath helped found the Society of Decorative Art of Santa Cruz in 1885, and later he organized the Jolly Daubers. The latter was the forerunner of the Santa Cruz Art League which he and his wife Lillian, also an artist, helped organize in 1919. He served as the League's first president.

Heath, William Albert (1840–1911)
B. Hebron, Vermont. M. Barr, 18, 54.
Heath moved to Laramie, Wyoming, in 1873. He worked for the Union Pacific Railroad, did some gold mining and fur trapping, and ran a gunsmith shop and a bicycle shop. He painted

wild life subjects and "simple landscapes." Some of his landscapes were painted on locomotive cabs and coal cars. "Elk in High Timber," an oil, is in a private collection.

Hedrick, Mary S. (1869–)
Who's Who in Northwest Art (Portland, Oregon).

Hedrick, who worked in water color and oil, studied at the Art Institute of Chicago. She was a member of the Oregon Society of Artists and the American Artists' Professional League.

Heerman/Heermann, Norbert Leo (1891–)
B. Frankfort-on-Main, Germany. Work: Cincinnati Museum Association; Wellesley Art Museum; Cleveland Museum of Art; Northeastern University Library; State House, Frankfort, Kentucky; murals, Evanston and Hughes high schools in Cincinnati. AAA 1919 (Cincinnati); AAA 1921–1933 (New York City; summer, Woodstock and Zena, New York); Benezit; Fielding; Havlice; Mallett; WWAA 1936–1937 (Woodstock and New York City); WWAA 1938–1939 (Woodstock; summer, Zena); WWAA 1940–1962 (Woodstock); Norbert Heerman, "Artistic Exhibition of Paintings and Photographs by Springs Art Society," Colorado Springs *Gazette,* August 5, 1917, 2/1–2; "The Art Exhibit," Colorado Springs *Gazette,* August 12, 1917, Sec. 2:2/1.

Prior to 1918 Heerman made at least two visits to Colorado, sketching in Estes Park and at Pikes Peak. On one occasion, as art critic for the Cincinnati *Enquirer*, he reviewed an exhibition in Colorado Springs. Two of his paintings were on exhibit at the August 1917 show – "Pikes Peak from Woodland Park" and "Cameron's Cove, Colorado." The latter was the subject of the mural at Hughes High School in Cincinnati.

Heerman had studied for a time with Frank Duveneck who considered him too lazy to be a painter. Later, the story goes, Duveneck saw a painting at an exhibition that he was judging, and he very much wanted to own it. "Who did that?" asked Duveneck. Someone answered, "A young chap named Heerman – Norbert Heerman." "How much does he want for it?" "Four Hundred Dollars," someone replied. "It's mine," said Duveneck.

Heisser, Margareth/Margarethe E. (1871-)
B. Minneapolis, Minnesota. Work: State Historical Society of North Dakota. AAA 1907-1910 (Minneapolis); Benezit; Barr, 33; Inventory of American Paintings, Smithsonian Institution.

Artist Paul Barr described Heisser as "thoroughly schooled and splendidly equipped to make a fine contribution to the field of painting." She grew up in Minneapolis, studied in New York City at the Art Students League, and after teaching at Moorhead State Normal School (now Moorhead State College) she studied for three years in Paris and in Madrid.

Heisser had a studio in Fargo, North Dakota, where she specialized in portraits. Several of her portraits are of Indians, dated about 1906 and 1907. She signed her work with a painted scarab.

Heitmann, Charles G. (-)
AAA 1909-1910 (Brooklyn, New York).

The *Art Annual* lists Heitmann as a painter, illustrator, and worker in applied arts. He may be C. Heitmann whose oil painting "Yosemite Falls," dated 1910, is in the M. H. De Young Memorial Museum in San Francisco. The painting is listed in the Smithsonian's Inventory of American Paintings.

Heizer, Dell (1877-1964/1965)
B. Great Bend, Kansas. D. Colorado Springs, Colorado. Work: Private collection. AAW v. I; Colorado College Library; Shalkop; Groves typescript; Ormes and Ormes, 339; Henry Russell Wray, Colorado Springs *Gazette*, April 2, 1916, 7/1; Jean Armstrong Jones and Harriet Stauss, Colorado Springs; Colorado Springs *Gazette*, May 18, 1906, 5/3; May 30, 1906, 3/4.

Heizer studied at Colorado College with Louis Soutter, at the Art Students League, and at the New York School of Art. Among her teachers in New York were William Merritt Chase and Robert Henri; a scholarship enabled her to study with the latter.

Heitzer's specialty was flowers and landscapes. She "sees big and paints with freedom," said artist Henry Russell Wray in his April 2, 1916, article for the *Gazette*.

In 1915 Heizer exhibited some paintings of La Jolla, California, using her married name, Mrs. Willis R. Armstrong.

Held, John, Jr. [Cari] (1889-1958)
B. Salt Lake City, Utah. D. Belmar, New Jersey, March 2.
AAA 1915 (New York City); AAA 1917-1919 (Bronxville, New York; summer, Merida, Yucatan); AAA 1921-1927 (Westport, Connecticut); AAA 1929-1933 (Palm Beach, Florida; Westport); Havlice; Mallett; WWAA 1936-1941 (Palm Beach; Westport); WWAA 1959 obit.; Olpin, 120-124; NMAA-NPG Library, Smithsonian Institution; John Held, Jr., *The Most of John Held Jr.*, with foreword by Marc Connelly and introduction by Carl J. Weinhardt, Brattleboro, Vermont: The Stephen Greene Press, 1972; Catherine Beach Ely, "John Held, Jr.," *Art in America*, February 1922, 86-92.

Held was nine when he sold his first woodcut for nine dollars. In 1904 he sold his first cartoon to *Life* magazine. In 1905 he became sports cartoonist for the Salt Lake *Tribune*.

In 1910 Held went to New York City. He moved in with his friend Mahonri Young, the only art teacher he ever had. Occasionally he returned to Salt Lake City for a visit. His usual inquiry was where the best fishing holes were. Olpin, who teaches art history at the University of Utah, has written an informative biographical sketch for Held in *Dictionary of Utah Art*.

Heller, Leonard G. (1893-1966)
B. San Francisco, California. Monterey Peninsula Museum of Art docent library; Carmel (California) Art Association; Monterey Peninsula *Herald*, October 27, 1961, A12.

Heller studied with Gene Baker McComas and at the California School of Fine Arts. Following retirement in 1955 from an import trade business in San Francisco he traveled extensively in Europe and in Mexico. In 1957 he settled in Carmel. He was a landscape and marine painter who worked in oils.

Helwig, Arthur Louis (1899-)
B. Cincinnati, Ohio. Work: Denver Art Museum; Cincinnati Museum; Western Hills High School and East End Public School, Cincinnati; murals in several Kentucky and

Ohio cities. Fielding; Havlice; Mallett; WWAA 1938–1956, 1962 (Cincinnati); WWAA 1959 (Hebron, Kentucky).

Helwig, who was instructor of drawing and painting at the Cincinnati Art Academy from 1930 to 1946, was in the West, probably in the ealy 1920s. His "Black Canyon, Colorado" was exhibited at the Cincinnati Museum in 1925.

Hemstegger, L. G. (–)

Work: Santa Fe Railway Collection. Inventory of American Paintings, Smithsonian Institution.

Only one painting by Hemstegger was listed in the Smithsonian's inventory when a search was made in 1979. That was "Hopi Pottery Maker," an oil in the Santa Fe Railway Collection, supposedly painted before 1910.

Henderson, John R. (–)

Denver Public Library; Bromwell scrapbook, 5, 15, 28, 86; Denver *Republican,* February 3, 1910, 2; Baker and Hafen, 1927, v. III, 1268.

Henderson served on a jury award committee in Denver in 1895, taught design and wood carving, and exhibited at the Denver Artists' Club at least as early as 1900. Examples of his bookmark designs were exhibited on another occasion, and sketches and a photograph appeared in the Denver *Republican* in 1910. He was on the first faculty (1892–1893) of the University of Denver's School of Fine Arts.

Hendrickson, David (1896–)

B. St. Paul, Minnesota. AAA 1921 (San Francisco, California); AAA 1931 (New York City; New Hope, Pennsylvania); Havlice; Mallett; WWAA 1936–1941 (New Hope); WWAA 1947–1953 (Palo Alto, California); WWAA 1956–1962 (San Diego County, California).

Hendrickson was an illustrator and etcher who exhibited regularly from 1926 to 1943. He illustrated a number of books published during the 1940s and early 1950s.

Hendrie, Marion G. (–)

AAA 1923–1925 (Denver, Colorado); Mallett (Denver);

Baker and Hafen, 1927, v. III, 1269; Colorado College Library.

Hendrie is best remembered as one of the three painters who helped keep the Denver Art Museum alive for "many years." She exhibited in Colorado Springs at the Broadmoor Art Academy during the years 1926–1928.

Henke/Henka/Hencke, Bernard Albert (1888–1949)
B. Cologne, Germany. Work: Blackburn College, Carlinville, Illinois. AAA 1919–1924 (Manasquan, New Jersey); AAA 1925–1933 (Pasadena, California); Benezit; Mallett; Young.

Henke was an illustrator and painter. He was a pupil of Guy Rose and a member of the California Art Club in Los Angeles. The Inventory of American Paintings, Smithsonian Institution, lists an oil called "Dutch Interior" located at Blackburn College. It is signed B. Henke and may well be the work of this artist.

Henkel, Estella M. (1889–)
Mallett Supplement (Dallas, Texas).

Henkel exhibited an oil painting at a 1936 exposition held at the Dallas Museum of Fine Arts.

Hennessy, Stephen (1893–)
B. Cincinnati, Ohio. Carmel Art Association directory of artists at the Gallery in Carmel, California.

Hennessy studied at the Cincinnati Art Academy and at the California College of Arts and Crafts in Oakland. He exhibited regularly in the San Francisco Bay Area and on the Monterey Peninsula where he lived.

Henry, Harry Raymond (1882–1975)
B. Woodson, Illinois. D. Costa Mesa, California. Work: Laguna Beach Museum of Art. Havlice; WWAA 1959–1962 (Laguna Beach, California); *News Notes of California Libraries*, April 1931, 175; California *Arts & Architecture*, December 1932 (Beverly Hills, California); Laguna Beach Museum of Art exhibition catalogue, July–August 1979.

Henry exhibited in California from 1915. He was living in

Los Angeles by 1918, and San Juan Capistrano by 1920. In 1929 he opened a studio in Hollywood.

During the depression years and the early forties Henry was occupied mainly with murals for restaurants, backdrops for motion pictures, and as art critic for the Hollywood *Citizen News*. After the war he settled in Three Arch Bay near Laguna Beach and painted "poetic landscapes" that brought him "local renown." Many of these paintings were printed for framing.

Hensley, Mercedes H. (1893–)
B. Oberlin, Kansas. Work: Seattle Art Museum; Henry Gallery, University of Washington. *Who's Who in Northwest Art* (Bothell, Washington); Kingsbury, 1972, 19.

Hensley studied at the University of Washington School of Art. Kingsbury noted the expressionist origin of Hensley's interpretation of Seattle's "raw urban environment" in her block prints. Hensley also worked in oils and water colors.

Herminghaus, Ernst (1890–)
B. Lincoln, Nebraska. Bucklin and Turner, 1932 (Lincoln).

Herminghaus worked as a painter, illustrator, and landscape architect. He obtained his schooling at the University of Nebraska and Harvard University.

Herold, J. J. (1866–)
B. Frederick, Maryland. Bucklin and Turner, 1932 (Omaha, Nebraska).

Herold studied at the Cincinnati Academy of Fine Arts from 1899 to 1902, and later in Omaha. Among his teachers were J. Laurie Wallace, Albert Rothery, Joseph Sharp, and others. He exhibited in Cincinnati, Buffalo (New York), and in most of Omaha's early shows.

Herring, Fern Lord (1895–1975)
B. Excelsior Springs, Missouri. Work: Private collection. M. Barr, 39, 54; New York Municipal Art Committee catalogue, June–July 1937.

Herring was active in Wyoming for over forty years. Her interest in Wyoming history is reflected in some of the subjects she chose to paint. She exhibited regularly in Laramie, and she

was among the several Wyoming artists whose work was selectd for exhibition in New York City in 1937.

Herter, Adele (1869–1946)
B. New York City. D. East Hampton, Long Island, New York, October 1. Work: University of Pennsylvania Museum. AAA 1898–1921 (New York City); AAA 1923–1929 (Santa Barbara, California); AAA 1931–1933 (East Hampton; Santa Barbara); Benezit; Fielding; Havlice; WWAA 1936–1941 (East Hampton); WWAA 1947, obit.; Inventory of American Paintings, Smithsonian Institution.

Herzog, Herman (1832–1932)
B. Bremen, Germany. D. West Philadelphia, Pennsylvania, February 6. Work: Metropolitan Museum of Art; Oakland Art Museum; Bancroft Library, University of California; Bowdoin College Museum of Art; Heckscher Museum, Huntington, New York; Philadelphia Museum of Art, etc. AAA 1903 (Lake Worth, Florida); AAA 1909–1910 (Philadelphia); AAA 1932, obit.; Benezit; AAW v. I; Philadelphia *Ledger*, February 6, 1932, obit.; "Herman Herzog 1832–1932," Chapellier Galleries catalogue, New York City, n.p., n.d. (probably prepared for the June 1973 exhibition); *Art News*, October 1973, 95; Donald S. Lewis, Jr., "Herman Herzog (1832–1932), German Landscapist in America," *American Art Review*, July–August 1976, 52–66; NMAA-NPG Library, Smithsonian Institution.

Herzog, who settled permanently in the United States in 1876, painted in many parts of the world. A sketchbook of Western scenes done in 1874 shows him in Wyoming, Utah, California, and the Coronado Islands, Mexico. He probably visited Yosemite that year, for he received the 1876 Philadelphia Centennial award for "Sentinel Rock, Yosemite." His favorite subjects were coastal scenes, lakes, fjords, and rugged mountains. The Smithsonian's inventory lists well over four hundred titles; a number are of Yosemite.

Hess, Sara M. (1880–)
B. Troy Grove, Illinois. Work: Oshkosh Museum of Art; Gary Memorial Gallery, Gary, Indiana; Ridgewood (New

Jersey) Women's Club. AAA 1909-1910 (Paris, France); AAA 1919 (Gary, Indiana); AAA 1921-1933 (Hillsdale, New Jersey); Havlice; Mallett; WWAA 1936-1941 (Hillsdale); WWAA 1947-1962 (San Diego, California).

Hetrovo, Nicolai/Nicholas (1896-ca 1959)
B. Petrograd, Russia. D. Agnew State Hospital, California. *Who's Who in Northwest Art* (Portland, Oregon; San Francisco, California); Virginia McGrath, "Nick Hetrova," *Game & Gossip*, a Monterey Peninsula publication, March 12, 1952, 11, 32; Monterey Public Library.

Hetrovo was a painter and architectural designer who lived intermittently on the Monterey Peninsula. He exhibited landscapes at the Lucien Labaudt Gallery in San Francisco. In 1949 he exhibited early and late work, including recent abstract paintings, at the M. H. De Young Museum.

Heynemann/Heyneman, Julia/Julie H. (1871-1943)
B. San Francisco, California. D. San Francisco. Work: St. Mary's College, Moraga, California; Bancroft Library, University of California; Bancroft Library, University of California. Castor typescript, San Francisco Public Library; California State Library; Panama-Pacific International Exposition catalogue; Inventory of American Paintings, Smithsonian Institution.

Heynemann who painted portraits and landscapes was awarded a bronze medal for one of her entries in the Panama-Pacific International Exposition in 1915.

Heywood, Herbert (1893-)
B. Portland, Oregon. Work: University of Portland; Peninsula Park, Portland; University of Oregon Art Museum. *Who's Who in Northwest Art* (Portland).

Heywood studied at Oregon State College, University of Oregon, and Portland Art Museum School. Later he became Director of Art at the University of Portland.

Hildebrandt, Edouard (1817-1868/69)
B. Danzig, Germany. D. Berlin, Germany, October 25. Work: Bancroft Library, University of California; Metro-

politan Museum of Art; Corcoran Gallery of Art; National Gallery, Berlin. Benezit; Havlice; Mallett; Baird, mimeo., 1968; California State Library.

Hildebrandt was in San Francisco from April 20 to May 4, 1863 or 1864, during his two-year trip around the world. In 1867 he published *Reise un die Erde,* a three-volume work based on his travels.

The subjects of Hildebrandt's around-the-world paintings are landscapes and genre scenes, many of ethnological interest. The water color in the Bancroft Library is a view of Yerba Buena Island with Mount Diablo in the background.

Hill, Lavina Baker (–)
Work: California State Capitol collection.

Hill was the wife of artist Edward Hill, and the daughter-in-law of artist Thomas Hill.

Hill, Raymond Leroy (1891–1980)
B. Uxbridge, Massachusetts. D. in February, probably in Seattle, Washington. Work: Seattle Art Museum; Henry Gallery, University of Washington. Mallett (Seattle); *Who's Who in Northwest Art;* Wesley Wehr, "Ray Hill, 1891–1980," ms. dated February 10, 1980, at Henry Gallery; University of Washington Faculty Exhibition catalogue, March 1966; LeRoy, 1965, 652.

Hill studied at Rhode Island School of Design, California School of Fine Arts, New York University, and Dante Sicci in Rome. He joined the faculty of the University of Washington in 1927 and retired in 1961.

Hill did many Western landscapes in water color, especially at Chelan, Washington. In connection with his teaching he established a small "Art Vacation" program there. Another place Hill liked to paint was the Teton Mountains. Solo exhibitions of his work include Denver Art Museum, Providence (Rhode Island) Art Club, Seattle Art Museum, and Gumps in San Francisco.

Hird, Herbert Shaw (1886–)
B. Gainsborough, England. Bucklin and Turner, 1932 (Seneca, Nebraska).

Hird was a painter and teacher who studied in England at

the Gainsborough School of Art, the Nottingham School of Art, and with Miss Davis, an associate member of the Royal Academy. He exhibited in England at the South Kensington Museum in 1903, and at Litchfield City Museum in 1918.

Hirst, Sue (-1928)
D. in July, probably in Dallas, Texas. Work: Dallas Museum of Fine Arts. Fisk, 1928; O'Brien, 1935.

Hirst studied at the St. Louis Art School and in Chicago before moving to Texas. In Dallas, where she lived for twenty years, she studied with Martha Simkins and Frank Reaugh. Following a summer in New Mexico's art colonies in 1926, she returned with several colorful canvases of Northern New Mexico scenes.

Hodges, Frederick (1858-1926)
D. Denver, Colorado, July 25. Denver Public Library; Denver *Times*, July 26 or 27, 1926, 15; Denver *Post*, July 26, 1926, 12/5.

Hodges, whose work is infrequently seen in Denver art galleries, may be the F. Hodges whose "Stag at Bay" is listed in the Smithsonian Institution's Inventory of American Paintings. It is an oil dated 1900.

Hohnstedt, Peter Lanz (See: Peter Lanz Holmstedt)

Holcomb, Maurice S. (1896-)
B. Ritzville, Washington. *Who's Who in Northwest Art* (Seattle, Washington).

Holcomb studied at the Otis Art Institute in Los Angeles, at the University of Washington, and with Yasushi Tanaka in Seattle. He was director of advertising for the North Pacific Bank Note Company in Seattle and Tacoma.

Hollier, Harold S. (1886-)
B. Birmingham, England. *Who's Who in Northwest Art* (Monroe, Washington).

Hollier studied at Handsworth College in England. He worked in oil and pastel, and served as art instructor for WPA [Works Progress Administration] for Snohomish County, Washington.

Hollingshead, Mary/M. Mary (1897–)

B. Antelope, Oregon. *Idaho Encyclopedia* (Boise, Idaho);
Who's Who in Northwest Art (Boise).

Hollingshead, an artist-educator who specialized in Idaho
flower and landscape paintings, published for junior and senior
high schools an art course that was ranked by Columbia University in 1936 as one of the two best in the United States. Prior to
and during the course of her career she attended Smith College,
University of California (Berkeley), University of Washington
(Seattle), the School of Art in Ashland (Oregon), and the Art Institute of Chicago. She worked in pastel, oil, and water color, and
taught art at Boise Senior High School.

Holmberg, Samuel (1885–1911)

B. Sweden, D. Kansas. Jacobson and d'Ucel, 266–267;
England, Master's thesis, 11.

Holmberg left Paris in 1908 to head the newly formed art
department at the University of Oklahoma. Jacobson who followed him in that position and Jeanne d'Ucel, Jacobson's wife,
called him a "splendid draughtsman, painter, and sculptor"
His work was "very good," but he destroyed most of it not given
to his friends. Jacobson and d'Ucel mentioned in particular the
landscapes Holmberg did in the Wichita Mountains during a
summer's vacation.

Holmes, Mildred M. (1897–)

B. Oakland, California. Work: Private collections in Oregon. *Who's Who in Northwest Art* (Corvallis and Portland,
Oregon).

Holmes studied at the California College of Arts and
Crafts, Oregon State College, and the University of Oregon. Her
Oregon landscapes were purchased by several local doctors and
businessmen for their offices. She worked in oils and pastels.

Holmes, Ralph William (1876–1963)

B. La Grange, Illinois. D. San Luis Obispo County, in February. AAA 1915–1917 (Pittsburgh, Pennsylvania); AAA
1919–1921 (Atascadero, California); AAA 1923–1924 (Los
Angeles and Atascadero); AAA 1929–1933 (Los Angeles);
Benezit; Havlice; Mallett; WWAA 1936–1947 (Los Ange-

les); WWAA 1953-1962 (Chatsworth, California; Atasca-
dero); AAW v. I; James M. Hansen, *Ralph Holmes,* Santa
Barbara: James M. Hansen, 1981; National Archives, In-
dian Service Moqui File No. 113.1.

Holmes was forty-one, with five years' experience as head
of the department of painting and decorating at Carnegie Insti-
tute when he accepted a position in Atascadero as head advertis-
ing artist for E. G. Lewis. Concurrently he served as art editor
and writer for Lewis's *Illustrated Review.* Atascadero was not
Holmes' introduction to the West, however; he spent the summer
of 1916 on the Hopi Reservation.

In 1923 Holmes left Atascadero to teach drawing, composi-
tion, and painting at Otis Art Institute. He left twenty-five years
later to retire in Chatsworth and to have more time to paint.

Holmes was a muralist of note whose easel paintings re-
flect a muralist's technique. Hansen quotes one critic as saying
that Holmes "thinks of a picture as a mural, preserving its flat
plane on the wall."

The Southwestern states are well represented in Hansen's
exhibition catalogue; thirty-three of the landscapes have been re-
produced in color.

Holmstedt/Hohnstedt, Peter Lanz (ca 1872-1957)
B. Cincinnati, Ohio. Work: Washington State University,
Pullman; Witte Memorial Museum, San Antonio. Mallett
(San Antonio); O'Brien, 1935; Pierce, 1926; Houston Public
Library; Witte Memorial Museum library; "Peter L. Hohn-
stedt Paintings of Western Texas May Be Seen on First
Floor of Witte Museum," San Antonio *Express,* October
15, 1933; "Museum Acquires Big Bend Oils," San Antonio
Express, July 22, 1939; *American Magazine of Art,* June
1929, 346.

Holmstedt studied with Frank Duveneck in Cincinnati,
and began his career there. He was active in a number of cities:
Memphis; New Orleans where he was commissioned to paint his-
torical landmarks; Comfort, Texas, about 1912 or soon there-
after; Seattle in the mid-twenties; Los Angeles; San Antonio for
at least a decade beginning in 1929.

In Seattle Holmstedt was a member of the Fine Arts So-
ciety. He exhibited with Painters of the Pacific Northwest, and

he donated paintings to the Washington State Federation of Women's Clubs to be exhibited elsewhere in the state.

Holmstedt moved to San Antonio in 1929 to paint pictures for the Texas Wild Flower contest. They brought him two important prizes, one for $1500. In 1933 he was commissioned by the Southwest Texas Archaeology Society to paint scenes in the Big Bend Country where the Society had conducted its expeditions. Late that year Holmstedt exhibited sixteen large oils of Big Bend scenes at the Witte Memorial Museum. In 1939 eleven of these canvases were purchased for the collection of the Museum.

Besides membership in the Seattle Fine Arts Society, Holmstedt belonged to the San Antonio Art League, the Southern States Art League, the New Orleans Art League, and the Little Rock (Arkansas) Art Association.

Holsman, Elizabeth A. Tuttle (1873–)
B. Brownville, Nebraska. Work: University of Nebraska; Omaha Society of Fine Arts; Tarkio College, Tarkio, Missouri. AAA 1898–1915 (Chicago, Illinois); AAA 1917–1933 (Chicago; summer, Lotus Island, Lauderdale Lakes, Wisconsin); Benezit; Fielding; Havlice; Mallett; WWAA 1936–1941 (Chicago; summer, Lauderdale Lakes); Collins, Sparks; Bucklin and Turner; Inventory of American Paintings, Smithsonian Institution.

Holsman taught at the University of Nebraska during the early years of her career. An oil entitled "Indian Encampment near Rushville, Nebraska," ca 1888, is listed in the Smithsonian's Inventory of American Paintings.

Holt, Geoffrey (–)
Work: Society of California Pioneers; Santa Fe Railway Company. AAA 1915–1917 (Minneapolis, Minnesota); California *Arts & Architecture,* December 1932 (Los Angeles, California); Richard and Mercedes Kerwin, Burlingame, California; Inventory of American Paintings, Smithsonian Institution.

Two of Holt's California mission paintings ca 1910 are in the collection of the Society of California Pioneers, and a Grand Canyon landscape is in the Santa Fe Railway Collection. All three are oils.

Hondius, Gerrit/Gerritt (1891–1970)

B. Kampen, Holland. D. Hyannis, Massachusetts, July 22. Work: San Francisco Museum of Art; Provincial Museum, Kampen; Whitney Museum of American Art. Havlice; Mallett; WWAA 1938–1953 (New York City); Denver Public Library; Washington *Post*, July 27, 1970, obit.; NMAA-NPG Library, Smithsonian Institution; "Mattson and Hondius Exhibit," *Art News*, January 10, 1925, 3; Philadelphia Art Alliance Bulletin, May 1950.

Sources differ as to the year Hondius came to the United States, but it was probably in 1916 or earlier. According to a clipping in the Spaulding scrapbook at the Denver Public Library he exhibited at Joslin's Department store in June. After spending some time on a Colorado ranch, Hondius settled in New York City. His work began attracting attention there in 1925 when he exhibited at the Whitney Studio Club. The reviewer for *Art News* referred to him as a young painter who was "rapidly approaching a very personal way of painting."

Hooper, Floy (1898–)

Mallett Supplement (Lubbock, Texas); Wilbanks, 35, 38.

Floy Hooper and Mrs. C. E. Hooper appear to be the same person. Under the latter name, Hooper exhibited an oil portrait titled "Flo" at the Centennial Show in Dallas in 1936. She was also a teacher.

Hopkin, Robert (1832–1909)

B. Glasgow, Scotland. D. Detroit, Michigan, March 21. Work: Detroit Institute of Arts; Detroit Historical Museum; Lake County (Ohio) Historical Museum; University of Michigan Museum of Art. AAA 1898–1908 (Detroit); AAA 1909–1910, obit.; Benezit; Fielding; Groce and Wallace; Havlice; Earle; Denver Public Library; Baker and Hafen, 1927, v. III, 1261; Rocky Mountain *News*, December 27, 1919, 18A; Arthur Hopkin Gibson, *Robert Hopkin/Master Marine and Landscape Painter*, Ann Arbor: Edwards Bros., 1962; Inventory of American Paintings, Smithsonian.

Hopkin who lived in Detroit from 1843 learned to paint

while mixing colors for local decorators. He earned his living mainly by painting drop curtains in various cities, including Denver, where he painted a scene for the Tabor Opera House. But he was also a competent easel painter whose work favorably impressed the English art critic C. Lewis Hind.

Hopkins, George Edward (1855-)
B. Covington, Kentucky. AAA 1898-1903 (Chicago, Illinois); AAA 1905-1910 (Baltimore, Maryland); AAA 1913-1915 (Raleigh, North Carolina); Mallett (Raleigh); Reinbach.
Hopkins studied in Cincinnati, Ohio; Munich, Germany; Florence and Venice, Italy. His principal teacher was Frank Duveneck. From 1886 to 1891 Hopkins directed the Kansas State Art Association school in Topeka, and then moved on to the University of Kansas art department for two years.

Horne, Alice Merrill (1868-1948)
B. Fillmore, Utah. D. probably in Salt Lake City, Utah. Work: Utah State Collection; South Cache High School, Hyrum, Utah. Olpin, 1980; Heaton, 1968, 128-129; Utah Art Institute, 2nd annual report, 1900, 27; Salt Lake City Public Library.
Horne, who was born in a log cabin, became one of Utah's most influential residents. She studied briefly with Mary Teasdel and Jame T. Harwood, both prominent Utah painters and teachers. Her endeavors on behalf of others left little time to paint.

Hosoda, Kuraju (1885-)
B. Japan. *Who's Who in Northwest Art* (Seattle, Washington).
Hosoda was a self-taught painter who worked in oil and water color, and exhibited at Seattle Art Museum.

Hough, Walter (1859-1935)
B. Morgantown, West Virginia. D. Washington, D.C., September 20. Work: Museum of Northern Arizona, Flagstaff; private collection. AAA 1919-1933 (Washington, D.C.); Benezit; Mallett; McMahan; NMAA-NPG Library and In-

ventory of American Paintings, Smithsonian Institution.

Hough was an archaeologist and anthropologist who studied art in Washington with William Henry Holmes and E. F. Andrews. Like Holmes, Hough early developed an interest in the Southwest. From that interest came such paintings as "Painted Desert" and "Desert Landscape." He exhibited at the Washington Water Color Club and the Cosmos Club in Washington.

Houghton, Arthur Boyd (1836–1875)

B. Bombay, India. D. Hampstead, London, November 23. Work: Boston Museum of Fine Arts; British Art Museum; Victoria and Albert Museum. Benezit; Havlice; Mallett (England); AAW v. I; Redgrave; M. Barr; Paul Hogarth; Nottage; Graves, 1970, 1972.

A. B. Houghton, special artist for the London *Graphic,* arrived in New York, October 24, 1869, to report on the American scene. After depicting Easterners in a satiric vein, he left in January to sketch buffalo hunts, Mormons, and Indians. According to *Graphic* he was to go as far West as San Francisco, but he may have gone no farther than Salt Lake City.

Traveling on the Union Pacific line, Houghton stopped off in Nebraska at an Army camp—later named Fort Hartsoff—to obtain papers to visit the Pawnees. As their guest he participated in gambling sessions and friendly smokes in the chief's lodge. His notes and sketches give a detailed and objective account of what he saw and experienced.

Paul Hogarth, in *Artists on Horseback,* said it was Houghton's technique of working directly on wood instead of on paper that gave his work the etching-like quality that impressed Van Gogh. Van Gogh, who had acquired a copy of the entire series of illustrations by Houghton, found in them "something rather mysterious like Goya, with a wonderful soberness" that was reminiscent of Charles Meryon, the Famous French etcher.

Houghton was also an accomplished painter in water color and in oil, who exhibited regularly at the Royal Academy from 1861 to 1872.

Houghton, Merritt Dana (1846–1919)

B. Otsego, Michigan. D. Spokane, Washington. Work:

217

Amon Carter Museum of Western Art; Wyoming State Gallery, Cheyenne. M. Barr, 19, 29, 58; Lawson, 603; Nottage, 94; Inventory of American Paintings, Smithsonian Institution.

Barr's chronological commentary of artists working in Wyoming announced the presence of Houghton there in 1875. "Houghton has moved to Laramie from Michigan. His drawings are of mining operations, ranching, logging, and towns."

Houghton's pictures were based on personal experiences, wrote Nottage, who said that Houghton lived for a while in Saratoga and Encampment, Wyoming, as well as in Laramie.

Houghton counted among his customers a number of ranchers and urban businessmen who wanted pictures of their properties. He was also an illustrator whose work appears in Coutant's *The History of Wyoming* and other publications.

House, Dorothy (1899–)
Work: Museum of New Mexico, Santa Fe. Mallett Supplement (Houston, Texas).

Howard, Eloise (1889–)
B. Pine Valley, Oregon. Work: San Francisco Art Association. AAA 1921–1929 (New York City, c/o Tiffany Foundation); AAA 1932–1933 (Woodstock, New York); Fielding; Havlice; Mallett; WWAA 1936–1937 (Woodstock); WWAA 1938–1941 (Milton, New York); *Who's Who in Northwest Art* (San Francisco, California; Milton).

Howard had a number of solo exhibitions, including some at galleries in Woodstock (New York) and Boothbay Harbor (Maine), and at Portland Art Museum where she had once studied at the Museum's Art School. She was a printmaker whose specialty was wood engravings, and she also worked in oil and water color.

Howard, John Galen (1864–1931)
B. Chelmsford, Massachusetts. D. July 18, probably in San Francisco. Work: Bancroft Library, University of California, Berkeley. AAA 1900–1903 (Montclair, New Jersey; listed under architects); AAA 1905–1910 (San Francisco);

California State Library; Museum of New Mexico library, Santa Fe. Barclay's East Bay Banter, "The Howards Are a Creative Clan," San Francisco *Chronicle*, July 26, 1953; Withey; *California Art Research*, mimeo.

Howard was a practicing architect who directed the School of Architecture at the University of California, and did some painting in water color.

Howard, Lillian A. (-)
Koch, 5, 12, 195, 200 (Santa Cruz, California).

Howard taught at Santa Cruz High School, and gave private lessons. Some of her early pen and ink sketches done in the 1890s and early 1900s were used to illustrate history books on Santa Cruz County.

Howard, Rose/Rosine (See: Rose Howard Salisbury)

Hoyer, F. M. (1863-)
B. Reading, Pennsylvania. Bucklin and Turner, 1932 (Omaha).

Hoyer, who studied art in Reading, exhibited for thirty years in western Iowa, Nebraska, and Wyoming. He worked in pastels and oils and painted mostly wild game subjects.

Hubbell, Henry Salem (1870-1949)
B. Paola, Kansas. D. Miami, Florida, January 9. Work: Luxembourg Museum, Paris; Museum of Lille, France; Art Institute of Chicago; Mulvane Art Museum, Topeka; Kansas State Historical Society; Union League Club, Philadelphia; Grand Rapids Art Museum, etc. AAA 1898-1900 (Chicago, Illinois); AAA 1903-1910 (New York City; Paris); AAA 1913-1917 (New York City); AAA 1919-1921 (Pittsburgh, Pennsylvania; Norwalk, Connecticut); AAA 1923-1927 (New York City; Norwalk); AAA 1929-1933 (Miami Beach; New York City); Benezit; Fielding; Havlice; Mallett; WWAA 1936-1937 (Miami Beach; New York City); WWAA 1938-1947 (Miami Beach); WWAA 1953, obit.; Reinbach.

Hubbell graduated from high school in Lawrence, Kansas,

and began his career as a sign painter in Garden City before attending the Art Institute of Chicago. A brief period as illustrator for *Woman's Home Companion* at a salary of $50 per week followed in 1897; then Hubbell studied in New York and Paris.

Hubbell's attachment to Kansas was lifelong. He did much to further the development of art there.

Hubbert, Lily Saxon (1878–　)
B. Mississippi. Wilbanks, 1959, 26.

Hubbert studied at Southern Female College in Westport, Mississippi, in 1901 and later at Texas Tech in Lubbock. She taught in Texas public schools for twenty-eight years.

Huffsmith, Dolly (1896–　)
B. Marshalltown, Iowa. Ness and Orwig, 1939 (La Mesa, California).

Huffsmith studied at the San Diego Academy of Fine Arts.

Hufstedler, Mrs. E. Virgil (　–　)
B. Greenville, Texas. Fisk, 1928, 138–139 (Gorman, Texas).

Hufstedler, a graduate of a teacher's college in Commerce, Texas, in 1912, taught art. She was locally known as a landscape and nature study painter.

Hughes, Marie Gorlinski (　–　)
AAA 1900–1903, 1915 (Salt Lake City, Utah); Olpin, 1980.

Hukari, Oscar (1878–　)
B. Finland. Work: Tofthagen Musem Library, Lakota, North Dakota. *Who's Who in Northwest Art* (Hood River, Oregon).

Hukari studied at the University of North Dakota. He worked in oils and pastels and exhibited at the Portland Art Museum in 1934.

Hulme, Harold Emluh (1882–　)
B. Birmingham, England. Work: F. D. Roosevelt collec-

tion; Ex-Governor Charles H. Martin collection. *Who's Who in Northwest Art* (Portland, Oregon).

Hulme studied at the Birmingham Academy of Art, and in Paris. He exhibited in Birmingham and Portland, and had a solo exhibition in 1926 in Seattle, Washington.

Hunnius, Carl Julius Adolph/Ado (1842–)
B. Leipzig, Germany. Harmon Mothershead, "The Journal of Ado Hunnius, Indian Territory, 1876," *Chronicles of Oklahoma*, Winter 1973–1974, 451–472.

Hunnius is said to have arrived in New York City about 1861. From 1866 to 1876 he traveled in Colorado, New Mexico, Oklahoma, North Texas, Missouri, and especially Kansas where he made a sketch of Caldwell. Most of his sketches were made in pencil in small notebooks while he was on the trail. Mothershead wrote that Hunnius' maps were a work of art.

Just before his travels came to a close in 1876 Hunnius spent some time among the Kiowa and Comanche Indians near Fort Sill.

Huntington, Charles S. (–)
Bucklin and Turner, 1932, 16; Savage and Bell, 450.

Huntington, the son of a pioneer merchant in Omaha, Nebraska, took up drawing and painting, and illustrated the *Story of Omaha* by Alfred Sorenson. About 1881 he supervised a sketching class of The Social Art Club of Omaha.

Huntsman, S. Ralph (1896–)
B. St. Joseph, Nevada. Biographical data, courtesy of Professor Robert S. Olpin, University of Utah.

Huntsman spent his early years in southeastern Nevada. By 1936 he was living in St. George, Utah, and teaching at Woodward Junior High School and Dixie College. According to his own estimate, he did between 300 and 350 oils and water colors, mostly desert scenes in southeastern Nevada and southern Utah.

Hutchings, Augusta Ladd Sweetland (–1881)
D. Yosemite National Park, November 6. Work: National Park Service, Yosemite National Park Museum. Sargent,

13; Inventory of American Paintings, Smithsonian Institution.

About 1877 Augusta Sweetland, whose husband had just died, opened a studio in San Francisco. She painted landscapes and marines in oil and water color. About 1879 she married James Mason Hutchings, publisher of *California* Magazine. In 1880 they moved to Yosemite Valley where Hutchings had a log-cabin house.

Two paintings by Augusta Hutchings are listed in the Smithsonian inventory, "Yosemite Indian Scene" and "Hutchings Sawmill."

Hutchings, Elvira Sproat (1842–ca 1917)

B. probably at La Pointe, Wisconsin. D. Vermont. Work: National Park Service, Yosemite Park Museum. Sargent, 34, 36.

Sargent described Hutchings as "a fragile, dreamy seventeen-year-old" when she married 39-year-old James Mason Hutchings in San Francisco in 1860. She was a gifted water color artist who painted a number of Yosemite Valley scenes during the summers she spent there with Hutchings before she left him about 1875. Such paintings as she preserved were destroyed in the San Francisco earthquake and fire of 1906.

Hutchins, Sheldon F. (1886–)

B. Norwalk, Ohio. *Who's Who in Northwest Art* (Kirkland, Washington).

Hutchins studied at Federal Art School in Minneapolis, Minnesota, and in Seattle, Washington, with Eustace Ziegler, Fokko Tadama, and others. He worked in oils and water colors, and exhibited locally.

Hutton, William Rich (1826–1901)

B. Washington, D.C. D. Montgomery County, Maryland. December 11. Work: Huntington Library Art Gallery. Groce and Wallace; AAW v. I; Webb, 1952, 131, 157; Splitter, 1959, 39; Monterey Public Library; Huntington Library, *California 1847–1852, Drawings by William Rich Hutton, Reproduced from the Originals in the Huntington*

Library with introduction by Willard O. Waters, San Marino, 1942.

Hutton, a civil engineer, worked in California as a paymaster's clerk from Januay 1847 to August 31, 1849. He is said to have made the first drawing of Los Angeles in 1847.

Of the ninety-five drawings at the Huntington Library, twenty-seven are in water color or tinted. (The one of Benecia City was done by his brother James.)

Hutton's drawings depict mainly the Monterey and Los Angeles regions, including the California missions. Seventy-nine are of California subjects. The rest are of the Isthmus of Panama, Peru, and Mexico.

Hutton returned to Washington in March of 1853, and thereafter pursued a career as civil engineer.

Hyde, Josephine E. (1885–)
B. Columbus, Ohio. Havlice; WWAA 1953–1962 (Long Beach, California); California *Arts & Architecture*, December 1932 (Long Beach).

Hyde studied at Stanford University, and privately. From 1923 to 1950 she taught art at Long Beach High School. She exhibited in Southern California.

Hyer, Florine (1868–)
B. Iowa Falls, Iowa. Ness and Orwig, 1939 (Los Angeles, California); Inventory of American Paintings, Smithsonian Institution.

Hyer who worked in oil and water color, and whose still life paintings of flowers are listed in the Smithsonian inventory, was associated with Luther Burbank in recording flower development.

Hyer, Robert Stewart (1860–1929)
B. Oxford, Georgia. D. Dallas, Texas, May 29. O'Brien.

Hyer was a professor of sciences who taught at Southwestern University in Georgetown, Texas, and in 1911 became president of Southern Methodist University in Dallas. O'Brien describes him as a "painter of ability" whose special interest was wood carving.

I

Ikard, Virginia (1871–)

B. Tennessee. *Idaho Encyclopedia; Who's Who in Northwest Art* (Jerome, Idaho).

Ikard obtained most of her art training at Oklahoma A&M College where one of her teachers was Ada Hahn of Grenoble, France. In 1924 she moved to Idaho where she taught art at a school in Gooding before moving to Jerome. She worked in oil and pastel and specialized in landscapes of Idaho's Sawtooth Mountains.

Ilyin, Gleb A. (1889–1968)

B. Russia. D. San Francisco, California. Work: portraits in private collections. Mallett Supplement (San Francisco); California State Library; Denver Public Library; California *Arts & Architecture,* December 1932; Castor typescript, San Francisco Public Library; Hafen (1948) v. III, 378–379; "Oakland Annual," *Art Digest,* April 1, 1937, 15; *California Art Research,* mimeo.

Ilyin who arrived in San Francisco in 1923 was active there until 1946 when he moved to Lakewood, Colorado. A portrait he exhibited at the Oakland Museum's Annual in 1937 was declared "outstanding" by the Oakland *Tribune* art critic.

Ireland, Leroy (1889–1970)

B. Philadelphia, Pennsylvania. D. February 2. Work: Dallas (Texas) Art Association; San Antonio Art Museum [Witte?]. AAA 1921–1933 (New York City); Benezit; Fielding; Havlice; Mallett; WWAA 1936–1941 (New York City); NMAA-NPG Library, Smithsonian Institution.

Ireland was a still-life painter who did some Southwestern subjects in the early 1920s, and perhaps later. He was also active as an art dealer, and as a consultant on American paintings. He returned to Philadelphia in 1958.

Irvin/Irwin, Marie Isabella Duffield (1863–1932)

B. Nashville, Tennessee. D. Boise, Idaho, ca March 2. Work: College of Idaho Art Department, Caldwell. Bin-

heim, 1928; Boise City and Ada County Directory, 1908–1910, 1921; Idaho State Gazeteer and Business Directory, 1912–1913 (Boise); Dale Walden, Boise; Cornelia Hart Farrer, Boise artist; Sandy Harthorn, registrar, Boise Gallery of Art; Sylvia Wood, "Pioneering in Avant Garde Art," an undated, unidentified clipping at Idaho Historical Society Library.

In the Art Department of the College of Idaho in Caldwell are the Walden-Irvin collection of Irvin's work and her collection of the work of other artists, mostly etchers and engravers.

Irvin appears to have been quite extraordinary. Idaho artist Cornelia Hart feels that Irvin "contributed more to beauty and art in Boise than any person before or since." Following her death caused by a speeding auto, Irvin's friends had inscribed on her tombstone, "She brought Art to Idaho."

Irvin, a graduate of the Woman's School of Art at Cooper Union in 1887, had studied with Robert Reid and Willard Metcalf. She was ahead of her time in Boise and did not exhibit any work that would have been considered avant garde. Instead she emphasized art forms more appropriate to basic home beautification, such as interior decorating in which she made an enviable reputation. Before moving to Boise in 1898 to become the first art instructor at St. Margaret's School, she was active in Chicago.

Ishii, Kowhoo (1897–)
 Havlice; Pierce, 1926 (Seattle, Washington).
 During the years Ishii lived in Seattle he was known as a Japanese artist who painted oil landscapes.

Ivanoff, Eugene Samson (ca 1898–1954)
 D. Stanford University Hospital, January 31. Havlice; Mallett; WWAA 1940–1941 (San Francisco, California); California *Arts & Architecture,* December 1932; San Francisco Public Library art and artists' scrapbook; San Francisco Art Association *Bulletin,* August 1940, 1.
 Ivanoff, a resident of San Francisco since 1922, was best known for oil paintings and wood carvings. His "After Grapes of Wrath" is shown in the August 1940 San Francisco Art Association *Bulletin.* It won third prize at the Golden Gate International Exposition in 1939.

J

Jack, Gavin Hamilton (1859–1938)

 B. Scotland. D. Utah, in August. Work: Church of Latter Day Saints collection, Manti, Utah. Olpin, 1980; additional data, courtesy of Professor Robert S. Olpin, University of Utah.

 Jack had been living in Manti ten years when he went to Connecticut in 1881 to study painting. Later he studied with William Merritt Chase in New York, and at the Art Students League. Then he went to Europe. At some point in his studies in Germany or in France he turned to sculpture.

 Following Jack's return to the United States, he lived in the Northeast for a number of years and then went to Latin America. About 1914 he returned to Utah, living at various times in Manti, Orderville, and Salt Lake City. Two of his oil paintings are in the LDS collection in Manti. He is best remembered in Utah for his lion sculptures at the State Capitol.

Jackson, David E. (1874–)

 B. Kirkland, New Brunswick, Canada. *Who's Who in Northwest Art* (Olympia, Washington).

 Jackson was a self-taught painter who worked in oils.

Jackson, Jessie/Jesse Short (–)

 AAA 1919 (San Francisco, California; listed as Jessie Francis Short); California *Arts & Architecture,* December 1932 (Berkeley, California); Anon., " 'Art' and 'Carmel' Synonymous. . . ," Monterey Peninsula *Herald,* October 18, 1966, A3; Monterey Public Library.

 By 1925 Jackson was active in the Carmel Art Colony.

Jackson, Roy (1892–)

 B. Washington State. AAA 1921–1924 (Seattle and Earlington Heights, Washington); Pierce, 1926.

 Jackson, who studied abroad, was active in Seattle during the 1920s. He was a landscape painter.

Jacobsen, Norman (1884–1944)

B. Cokeville, Wyoming. Fielding; Mallett; M. Barr, 59; Olpin, 1980; *Art Digest,* February 1, 1929, 17; "Jacobson's Paintings on Linen," *Art News,* October 12, 1940, 9–10.

Jacobsen was the son of a Norwegian-American rancher. His student years were spent in Chicago at the Art Institute and Lewis Institute (1905–1907) and the New York School of Art (1908). The *Art Digest* referred to him in 1929 as a "Wyoming Expatriate in Paris." Upon his return to the United States he taught art for a short time in Utah at the Salt Lake Art Center. However, his livelihood was mainly that of a successful illustrator.

One of Jacobsen's paintings on linen, exhibited in 1940, was called "Camouflaged American Indian Woman." It is shown on page 9 of *Art News.*

Jacobson, Julia C. (1879–)

B. Omaha, Nebraska. Bucklin and Turner, 1932 (Omaha).

Jacobson, who studied locally, was a member of the Omaha Art Guild. She exhibited landscapes, still lifes, and textile designs at the Art Institute of Omaha and at the Omaha Art Studio.

Jacobson, Oscar Brousse (1882–1966)

B. Westervik, Sweden. D. Norman, Oklahoma, September 18. Work: Bethany College Art Gallery, Lindsborg, Kansas; McPherson (Kansas) Art Gallery; State Capitol, Oklahoma City; University of Oklahoma; Oklahoma Art Center, Oklahoma City. AAA 1903 (Lindsborg; listed under Art Teachers and Supervisors); AAA 1917–1933 (Norman); Benezit; Fielding; Havlice; Mallett; WWAA 1936–1941 (Norman; summer, Allenspark, Colorado); AAW v. I; Mary Goodard, "Building Marked By Artist," *Daily Oklahoman,* February 19, 1953, 14; Nan Sheets, "Jacobson's Paintings Go on Display," *Daily Oklahoman,* March 6, 1938; Nan Sheets, "Oscar Jacobson Opens Art Exhibit Here Today," *Daily Oklahoman,* January 6, 1946; Nan Sheets, "Art," *Daily Oklahoman,* October 10, 1954; Oklahoma City Public Library; Oscar Brousse Jacobson, "The Meaning of Modernism in Art," *American Magazine*

of Art, January 1924, 697–705; *Daily Oklahoman,* September 20, 1966, obit.

Jacobson was director of the School of Art at the University of Oklahoma from 1915 to 1945. He used his considerable knowledge of art history, and his lectures and teaching, to imbue his students with courage to break with the provincialism in art that dominated much of the country during the first thirty years of this century. In 1924 he was joined in this effort by Doel Reed who taught at A & M College in Stillwater, Oklahoma. Together they built an art movement that brought Oklahoma artists to the attention of Eastern art critics.

Jacobson's dedication to teaching left little time for painting. Yet Goodard was able to report in 1953 that he had done some 400 Western landscapes in "30 years of summer roaming" that were in collections from Stockholm to Melbourne. He had by then covered virtually all of the West, except Death Valley and Southern Oklahoma.

At age thirteen Jacobson had run away from his family's Kansas farm to work on Western ranches, apparently with a view to financing his education. Ultimately he worked his way through Yale and through Bethany College where he taught while obtaining his doctorate. From there he went to Washington state to teach from 1911 to 1915. During that period he met and married Jeanne D'Ucel, an exchange teacher from France. Later they collaborated on articles about American Indian artists as well as Oklahoma artists.

During sabbaticals Jacobson painted in various countries including Morocco and France. But much of his work was done at his summer headquarters in the Rocky Mountains near Allenspark, often at altitudes as high as 13,000 feet.

James, Bess B. (1897–)
B. Big Springs, Texas. AAA 1933 (Monroe, Louisiana); Havlice; Mallett; WWAA 1936–1962 (Monroe); Collins.

James, who studied art in Texas, was active mainly in Texas, Louisiana, and Mississippi.

James, Jimmie (1894–)
B. Kansas. *Who's Who in Northwest Art* (Portland, Oregon).

James studied in Chicago, worked in oils and did etchings, and was a member of the American Artists' Professional League.

Janin, Louise (1892–)
AAA 1923–1925 (New York City); Benezit; Mallett; California State Library; San Francisco Public Library art and artists' scrapbook; Louise Weick, "Local Girl who turned Back on Society Wins Art Laurels in Paris," San Francisco *News,* December 20, 1933; San Francisco *Chronicle,* March 8, 1948, 14; New York *Times* Book Review Magazine, July 23, 1922, 18/5; New York *Times,* May 26, 1929 (exhibition review).

By 1948 Janin had spent a quarter of the century in Europe, mainly in Paris and in Corsica—the latter from 1938 to 1946. She seldom returned to San Francisco where she had grown up, and her work reflects an interest in ancient cultures rather than the contemporary scene.

Jaques, Francis Lee (1887–1969)
B. Genesco, Illinois. D. July 24. Work: American Museum of Natural History; Welder Wildlife Research Station, Sinton, Texas. AAA 1929–1933 (New York City); Benezit; Havlice; Mallett; WWAA 1938–1941 (New York City); Young; Viguers, 1958; Florence P. Jaques, *Francis Lee Jaques/Artist of the Wilderness World,* Garden City: Doubleday & Company, Inc., 1973.

Jaques, who grew up in Illinois and Kansas, was active as a wild life and habitat painter from 1920. During the years he was with the American Museum of National History he specialized in bird paintings. In 1958 he announced that he was going off "the bird standard." He turned to landscapes featuring the scenes of his travels. In the West he sketched and painted in the Dakotas, Nebraska, Kansas, and on the Olympic Peninsula in Washington. His favorite painting, and his last, was "The Passing of the Old West."

Jarvis, W. Frederick (1868–)
B. Clearington, Ohio. AAA 1923–1924 (San Antonio, Texas); AAA 1925 (Dallas, Texas); AAA 1929–1931 (San

Antonio); AAA 1933 (Dallas); Mallett; Fisk, 1928; O'Brien, 1935.

Jarvis studied at the Art Students League, and in Munich, Germany. He taught painting in New York and exhibited nationally before moving to Texas. From San Antonio and Dallas he made sketching trips to New Mexico and the Grand Canyon. He was a member of the Society of Independent Artists.

Jeffreys, Arthur Bishop (1892–)
 B. Hillsboro, Texas. Work: La Grange College, La Grange, Georgia; Hilton Hotel, Waco, Texas. Fisk, 1928; O'Brien, 1935 (Dallas, Texas).

Jeffreys studied briefly in New York with Frederick Jarvis, but was mainly self-taught. Outside of Texas he was little known. The July 10, 1926, issue of *Literary Digest* used his "A Texas Bluebonnet Field" on its cover. The attention it attracted brought him an invitation to exhibit his landscapes at La Grange College. According to Fisk "his refined color sense" made "his every canvas wholly pleasing." He was a member of the Dallas Art Association, the Chicago Art League, and the Society of Independent Artists.

Jemne, Elsa Lauback (1888–)
 B. St. Paul, Minnesota. AAA 1917–1933 (St. Paul); Fielding; Havlice; Mallett; WWAA 1936–1941, 1959–1962 (St. Paul); Mahony, 1947.

Known as an illustrator during the early years of her career, Jemne later specialized in mural painting. The regions in which she worked included the Rocky Mountains.

Jenkins, Marian Brooks (1885–1944)
 B. Utah. D. Costa Mesa, California, May 6. Work: South Cache High School, Hyrum, Utah. Olpin, 1980; Heaton, 1968, 128, 131; Salt Lake City Public Library art and artists' scrapbook; Salt Lake *Tribune*, May 8, 1944, obit.

Jenkins studied with James T. Harwood in Utah and was active there a number of years before moving to California. Olpin has described her as a "significant Utah artist."

Jenks, Dea S. (-)
AAA 1900 (Denver, Colorado); Denver Public Library; Bromwell scrapbook, page 12.

Jenks exhibited flower paintings at the Denver Artists' Club in 1898.

Jenson, Edgar M. (1888-1958)
B. Ephraim, Utah. Biographical data, courtesy of Professor Robert Olpin, University of Utah.

Except for a year at Stanford University studying school administration, Jenson studied in Utah. He taught art in Ephraim and St. George schools and later at Brigham Young University. Most of his paintings are landscapes in oils of Southwestern desert and mountain scenes; he also did water colors.

Jewell, Wynn R. (-)
AAA 1917 (Oklahoma City, Oklahoma).

Johanson, Erik (1874-)
B. Lund, Sweden. Mallett Supplement (Seattle); *Who's Who in Northwest Art* (Seattle); Inventory of American Paintings, Smithsonian Institution.

Johanson, who studied in Sweden, was a member of the Painters' and Sculptors' Guild of Northwest Men Painters. He worked in oil and water color and also did wood carvings.

Johnson, Arthur Monrad (1878-1943)
B. Fredrikstad, Norway. D. Los Angeles, California, July 19. *Who Was Who in America*; California *Arts & Architecture,* December 1932 (Westwood Village, Los Angeles); Castor, typescript.

Johnson studied art at the University of Minnesota and the San Francisco Art Institute. He exhibited paintings in Minneapolis, Chicago, Brooklyn, Los Angeles, San Francisco, and Sacramento. From 1927 he taught at the University of California, Los Angeles, and in 1931 he wrote *Taxonomy of Flowering Plants.*

Johnson, Catherine C. (1883-)
B. Nova Scotia, Canada. AAA 1933 (Seattle, Washington);

Who's Who in Northwest Art (Seattle).

Johnson studied in San Francisco and Seattle. She worked in oil, water color, and Chinese black and white.

Johnson, George/G. A. (–)

Inventory of American Paintings, Smithsonian Institution; Los Angeles City Directory, various years, 1897–1928.

The approximate dates on four small water colors listed in the Smithsonian inventory indicate that Johnson may have begun working in the Los Angeles area as early as 1895. Titles of the listed paintings are "Indian Chief," "Indian in Blanket," "Landscape," and "San Gabriel Mission Bells."

Johnson, Herbert (1878–1946)

B. Sutton, Nebraska. Work: Hall Collection, University of Nebraska. AAA 1915–1927 (Philadelphia; summer, Huntingdon Valley, Pennsylvania); AAA 1929–1931 (Huntingdon Valley); Fielding; Havlice; Mallett; WWAA 1936–1941 (Huntingdon Valley); Bucklin and Turner, 1932.

Johnson was an illustrator and cartoonist who worked on the Denver *Republican,* Kansas City *Journal,* and Philadelphia *North American.* He did illustrations and cartoons for various magazines, including *Saturday Evening Post.* His education was obtained in Lincoln, Nebraska.

Johnson, Ida (ca 1852–1931)

B. Duchess County, New York. *News Notes of California Libraries* January, 1930, 74; California State Library; Spangenberg, 53–54; Polk's Salinas, Monterey, Pacific Grove, and Carmel City Directory, 1930 (Carmel); Carmel Public Library.

Johnson, who was educated at Parker School in Brooklyn, was a china painter who moved to Carmel in 1905. In 1919 she created a series of wildflower paintings that were judged "botanically perfect." She exhibited them locally, and in recent years the paintings have been shown at the Carmel Library, a fitting tribute to a person who did much to develop an art movement in Carmel, and also served as president of the board of the first Carmel Free Library in 1905.

Johnson, June Greevy (1890–)

B. Omaha, Nebraska. Bucklin and Turner, 1932 (Omaha).

Johnson studied at the Art Institute of Chicago from 1909 to 1912, and with J. Laurie Wallace and others in Omaha. She exhibited at the Art Institute in 1913 and 1914, at the Omaha Art Guild, and with Nebraska Artists in Omaha.

Johnson, Mamie (C. Irwin) (1879–)

B. Saline County, Kansas. AAA 1933 (Tescott, Kansas); Mallett.

Johnson was a member of the Salina Art Association.

Johnson, Mary Totten (1885–)

Mallett Supplement (Sherman, Texas).

Johnson exhibited an oil portrait at the 1936 Exposition held at the Dallas Museum of Fine Arts.

Johnson, Minnie Wolaver/Walaver (–)

B. Diana, Tennessee. Havlice; Mallett Supplement; WWAA 1936–1941 (Dallas, Texas); Fisk, 1928; O'Brien, 1935; Wilbanks, 1959.

Johnson taught art in Wichita Falls, Texas, for five years, and San Angelo, Texas, for another five years before moving to Lubbock in the mid-twenties and Dallas a few years later. Although most of her landscapes and flower paintings were of Texas subjects, she did some work in California during the brief period she studied with William Griffith in Laguna Beach. She exhibited mainly in Texas.

Johnson, Thomas Berger (1890–1968)

B. Omaha, Nebraska. D. Seward, Nebraska. Dolores Gunnerson, "Thomas Berger Johnson, Nebraska Artist, 1890–1968," *Nebraska History*, Winter 1978, 539–548.

In 1969 an exhibition of Johnson's drawings, paintings, and sculptures was held at Concordia College in Seward, and reviewed in the Sunday Omaha *World-Herald* Magazine, November 23.

Johnson's formal training included courses at Bethany College from 1921 to 1925 following which he was awarded an

artist's certificate. During 1923 and 1924 he studied with Robert Reid at the Broadmoor Academy of Art in Colorado Springs. During 1926 and 1927 he studied at the Minneapolis School of Art. Painting became a fulltime pursuit only after he retired.

Johnson, Wayne (1872-1950)

B. Springville, Utah. D. Springville, October 5. Work: Springville Museum of Art. AAW v. I; Olpin, 1980; Springville Museum of Art *Permanent Collection Catalogue.*

Johnson was an educator and a parttime painter who was a moving force in the advancement of the arts in Utah. Periodically he returned to Brigham Young University, University of Utah, and University of California for further study. Two oils, "Hobble Creek Canyon" and "Provo Canyon," were purchased by the Springville Museum of Art, an institution that grew into a leading art center largely as a result of Johnson's capable performance as curator and head of the art department.

Johnston, Edith Constance Farrington (1890-)

B. Waucoma, Iowa. Mallett Supplement (New York); Mahony, 1947; Viguers, 1958.

Johnston, who received her bachelor's degree at the University of Colorado, is best known for her wild flower illustrations.

Johnston, Eliza Griffin (-)

Eliza Griffin Johnston, *Texas Wild Flowers,* Austin, 1972; Sandra L. Myers, "Romance and Reality on the American Frontier: Views of Army Wives," *Western Historical Quarterly,* October 1982, 423-424.

Johnston took up painting to counter the boredom of army life on the Texas frontier, and made a significant contribution with her wild flower studies.

Johnston, Margaret Isabelle (1884-)

B. Chicago, Illinois. Havlice; WWAA 1947-1953 (Hollywood, California).

Johnston began exhibiting at San Francisco and Los Angeles museums in the early forties.

Johonnot, Ralph H. (　　　　 -1940)

D. Los Gatos, California, in November. AAA 1898-1900 (Syracuse, New York); AAA 1909-1913 (Brooklyn; summer 1913, Pacific Grove, California); AAA 1915-1917 (Pacific Grove); WWAA 1947 obituary; California *Arts & Architecture,* December 1932 (Pacific Grove); Polk's Salinas, Monterey, Pacific Grove, and Carmel City Directory, 1930.

Johonnot, who had a long career as a painter, teacher, and designer, had an artists' materials and supplies business in Carmel in 1930.

Jones, Mary Elizabeth (See: Mary Elizabeth Jones Kast)

Jones, D. Paul (　　 - 　　)

B. Maryland. Colorado College Library; Colorado Springs Fine Arts Center library; Alfred Morang, "Some Artists of New Mexico," undated article at Santa Fe Public Library; School of American Research, 1940.

Jones studied in Maryland, served in the First World War, and upon his return to the United States he went West to live several years among the Indians, "learning their language," studying their "stoical character," and their art. The information is from the School of American Research publication *Representative Art and Artists of New Mexico.*

In 1921 Jones enrolled at the Broadmoor Art Academy in Colorado Springs, occasionally returning to the Southwest desert to paint. An unidentified clipping at the Colorado Springs Fine Arts Center mentions that he had "a flair for the hazes and distances and subtle color qualities of the vast reaches of our deserts. . . ."

Perhaps the most definitive statement on Jones' work comes from Santa Fe painter Alfred Morang (1901-1958) who called Jones a "painter of significant externals." Jones paints "with an eye on his subject matter," he said. "He observes the play of light and shadow, and the movement of figures across a landscape with the utmost care. . . ."

During Jones' career years he lived in Phoenix, Arizona, Colorado Springs, and in the Santa Fe area. In 1933 he was living in Espanola, New Mexico, and in 1940 at nearby Alcalde. He ex-

hibited at Santa Fe's Southwest Annuals during the 1930s, and at the Broadmoor Art Academy during the 1920s.

Jones, Mary Elizabeth (See: Mary E. Jones Kast)

Jones, Seth C. (1853-1930)
B. Rochester, New York. D. Rochester. Work: Robert B. Honeyman, Jr. Collection, Bancroft Library, University of California. AAA 1907-1908 (Rochester); AAA 1909-1929 (New York City; summers from 1913, Linden, New York); AAA 1931, obit.; Fielding; Mallett; Baird, 1968, mimeo., 50-55; Inventory of American Paintings, Smithsonian Institution.

Jones studied with Thomas Moran and William Henry Holmes. His detailed drawings of California missions at Bancroft Library were made in January and February 1889. Holmes who was curator of the National Museum also served as archeologist for the Bureau of Ethnology and may have suggested that Jones do the drawings. Because Jones was an illustrator as well as a painter, further research is needed to determine whether he actually worked in the West.

Jorgensen, Ejler Andreas Christoffer (1838-1876)
B. Roskilde, Denmark. D. Oakland, California, December 17. Work: Bernice P. Bishop Museum, Honolulu, Hawaii; Eiteljorg Collection. Benezit; Indianapolis Museum of Art, Eiteljorg Collection catalogue; Ellie Schaeffer, Littleton, Colorado; Inventory of American Paintings, Smithsonian Institution.

Jorgensen who signed at least some of his paintings Chris Jorgensen should not be confused with another Chris Jorgensen (1859-1935). Two of his paintings are listed in the Smithsonian inventory: a portrait dated 1875 in the Bishop Museum, and "Bright Angel Trail, Canyon of the Colorado, Arizona" in the Eiteljorg collection.

Joslyn, Florence Brown (ca 1881-1954)
B. Michigan. D. February 25, probably in Oklahoma City, Oklahoma. AAA 1909-1910 (New York City; listed as Florence Bradshaw Brown); AAA 1913-1915 (Chicago, Il-

linois); AAA 1917–1921 (Indianapolis, Indiana); AAA 1925–1933 (Oklahoma City); Havlice; Mallett; WWAA 1938–1956 (Oklahoma City); Will May in the *Daily Oklahoman*, November 21, 1926; Oklahoma City Public Library.

Commenting on Joslyn's canvas "Paola," exhibited in 1926, Will May wrote that she had caught the spirit of the Southwest country.

Jourdan, Alda (1889–)

B. Salem, Oregon. *Who's Who in Northwest Art* (Portland, Oregon); Inventory of American Paintings, Smithsonian Institution.

Jourdan, who was mainly self-taught, studied briefly at the Art Institute of Chicago.

Judd, Frank Willson (–)

Inventory of American Paintings, Smithsonian Institution; Herbert Dengler, Palo Alto, California; Paul Emerson, "Stepping back in time to view flora and fauna of our foothills a century or so ago," Palo Alto *Times*, September 15, 1978, 14–15.

Titles of several oil paintings by Judd indicate that he worked in the Sierras and the Searsville Lake area of California. One of the paintings is dated 1917.

Juleen, Lee D. (1891–)

B. Minneapolis, Minnesota. *Who's Who in Northwest Art* (Everett, Washington).

Juleen studied at the Chicago Academy of Fine Arts, Chouinard Art School in Los Angeles, and University of Washington summer school.

Junge, Carl Stephen (1880–)

B. Stockton, California. Work: Boston Museum of Fine Arts; Library of Congress; British Museum, London; Metropolitan Museum of Art, etc. AAA 1913–1933 (Oak Park, Illinois); Fielding; Havlice; Mallett; WWAA 1936–1941 (Oak Park; summer, Long Beach, Indiana);

WWAA 1947-1953 (New York City); WWAA 1956-1962 (Oak Park); Sparks; Mark Hoffman, San Francisco.

Junge, who studied in San Francisco at the Mark Hopkins Art Institute and in Paris at Julian Academy, occasionally painted in California.

Justice, Martin (-)
B. Wyoming, Iowa. AAA 1905-1921 (New York City); AAA 1923-1933 (Los Angeles and Hollywood, California); Mallett; Ness and Orwig, 1939.

K

Kahler, Carl/Karl (1855-)
B. Linz, Austria. AAA 1921-1924 (New York City); Benezit; Fielding; California State Library; Inventory of American Paintings and NMAA-NPG Library, Smithsonian Institution.

Kahler was a genre painter who traveled widely. He exhibited in New York City in 1899, but appears to have been in the United States by 1880 or earlier. The Detroit *Free Press*, April 9, 1961, 6-D, showed a picture of the famous cat painting of Kate Birdsall's forty-two San Francisco cats. Birdsall supposedly paid $30,000 for it in 1880. Kahler was the leading cat portrait painter of his day, said the *Free Press*.

Kahler, Joseph A. (-)
Inventory of American Paintings, Smithsonian Institution; California State Library; Herbert Dengler, Palo Alto, California; San Francisco City Directories.

Kahler, who did some painting in the Monterey and San Francisco Bay regions, was photo engraver, artist, and art director of Hearst newspapers in Chicago and San Francisco from

1887 to 1928. "Indian Camp at Night," an oil painted about 1900, is listed in the Smithsonian inventory.

Kaltschmidt, Oscar (–)
Pacific Coast Business Directory, 1871–1873 (San Francisco); California State Library.

Kaltschmidt was active in San Francisco at least as early as April 28, 1870, when Calaban of the Daily *Alta California* mentioned him in passing as a portrait painter. Two references in the California State Library indicate he may have been active in California as late as 1890.

Kann, Frederick I. (1886–)
B. Gablonz, Czechoslovakia. Havlice; Mallett Supplement (Kansas City, Missouri); WWAA 1947–1953 (Hollywood, California).

Kanno/Kenno, Gertrude Farquharson Boyle (1876–1937)
B. San Francisco, California. D. San Francisco, August 14. AAA 1915 (San Francisco); AAA 1921–1924 (New York City); Mallett Supplement; Castor typescript, San Francisco Public Library; San Francisco Public Library art and artists' scrapbook; NMAA-NPG Library, Smithsonian Institution; Marion Taylor, "A California Sculptress," *Overland* Monthly, May 1916, 365–369.

Although best known as a sculptor, Kanno also exhibited drawings and water colors. "With a few strokes, her figures breathe," wrote Taylor in 1916.

Kast, Mary Elizabeth Jones (1857–1942)
B. California. Work: Oakland Art Museum. Oakland Museum library; *News Notes of California Libraries,* January 1908, 12.

Kauffer, Edward McKnight (1890–1954)
B. United States. Mallett (London, England); *Who's Who in Art,* v. 9, obit.: Porter and others, 1916, 42.

Kauffer was briefly active in California before settling in England, probably about 1916. Gannett in an article for *Art in California* called him the "most pronounced modernist" among

California's painters, and predicted he would become an important artist.

Kayser, Louise Darmstaedter (1899–)
B. Mannheim, Germany. Havlice; WWAA 1947–1953 (San Jose, California).
Kayser began exhibiting in California in 1942 when she had a solo show at the M. H. de Young Memorial Museum.

Keane, Theodore J. (1880–)
B. San Francisco, California. AAA 1921–1933 (Chicago, Illinois); Fielding; Mallett.
Keane studied at the California School of Design and the Art Institute of Chicago. He specialized in animal paintings and etchings in conjunction with carrying out administrative duties as director of the Minneapolis Society of Fine Arts and serving as dean at the Art Institute of Chicago and director of his own school in Toledo, Ohio.

Kearfott, Robert (1890–)
B. Martinsville, Virginia. AAA 1921 (San Francisco, California); Havlice; Mallett; WWAA 1936–1953 (Mamaroneck, New York).

Keatinge, Elizabeth (1885–)
B. Corvalis, Oregon. "Elizabeth Keatinge, Noted Watercolorist," Big Sur *Gazette,* September 1980, 15; Everett Messick, "Elizabeth Keatinge/Busy Artist Finds Days Too Short," Monterey Peninsula *Herald,* March 15, 1982, 13; Terri Lee Robbe, "Elizabeth Keatinge, 97, Is an Optimist," Carmel *Pine Cone*/Carmel Valley *Outlook,* March 18 1982, A-12; Monterey Public Library.
Keatinge did some painting in Portland, Oregon, before moving to California in 1907. She lived for a number of years in Berkeley where she studied at the California College of Arts and Crafts. She also studied with Eliot O'Hara whenever he was on the West Coast.
Long before Keatinge moved to Carmel in 1967 she began painting in the Big Sur country and also in Nevada. She likes to paint on location, and prefers trees and flowers as subjects. Her

water colors have been exhibited at the San Francisco Museum of Art, the M. H. de Young Museum, the Oakland Museum, and the Carmel Art Association gallery where she has served on the Association's board.

Keck, Josephine Frances/Francis (1860–)
B. St. Mary's, Elk County, Pennsylvania. AAA 1925 (Santa Cruz, California); Mallett Supplement; California *Arts & Architecture,* December 1932 (Santa Cruz).
Keck studied with several California painters, including Frank Heath and Lorenzo Latimer.

Keffer, Frances (1881–1954)
B. Des Moines, Iowa. Work: Des Moines Public Schools. AAA 1919 (Des Moines); AAA 1921–1933 (Hillsdale, New Jersey); Fielding; Havlice; Mallett; WWAA 1938–1941 (Hillsdale); WWAA 1947–1953 (San Diego, California).

Keihl, Mabel C. (1899–)
B. Milwaukee, Wisconsin. Harbick (Monterey, California, area).
Keihl, who worked in water color and ink, was a member of Pacific Grove and Carmel art associations.

Keith, Elizabeth/Lizzie Emerson (1838–1882)
B. Maine. D. San Francisco, California, March 9. Work: Oakland Art Museum; St. Mary's College, Moraga, California. Hart, 1937, pt. II, 39; Eugen Neuhaus, *William Keith, The Man and the Artist,* Berkeley: University of California Press, 1938, 17; Inventory of American Paintings, Smithsonian Institution.
The Smithsonian inventory lists eight oils, some painted in 1870, by Keith who is credited with encouraging her husband to become a painter.

Keller, Henry George (1869–1949)
B. Cleveland, Ohio. D. San Diego, California, August 2. Work: Art Institute of Chicago; Metropolitan Museum of Art; Whitney Museum of American Art; Brooklyn Museum; Cleveland Museum of Art; Boston Museum of Fine

Arts; Library of Congress, etc. AAA 1903-1933 (Cleveland); Benezit; Fielding; Havlice; Mallett; WWAA 1936-1947 (Cleveland); AAW v. I (Cleveland and San Diego); William M. Milliken, introduction to *The Henry G. Keller Memorial*, Cleveland: Cleveland Museum of Art, 1950; Charles Burchfield, "Henry G. Keller," *American Magazine of Art*, September 1936, 586-593.

Of interest here are the periods the well-known Keller spent in the West. In 1915 he went to California. In 1920 he visited Taos, New Mexico, and again in 1931 when he combined the trip with Aspen, Colorado. In 1925 he combined a trip to Texas with a summer in San Diego. In 1927 he went to the Pacific Northwest where he did a "brilliant" series of watercolors of Mount Rainier and Puget Sound.

Keller loved the forms of mountains and clouds and "the wheeling flight of birds." From the early thirties, coastal California was a particular favorite, especially San Diego and La Jolla. In 1941 he spent the winter in Palm Springs.

Rhythmic subjects attracted Keller. At La Jolla, during the later years, he turned to circus themes.

Keller was a great admirer of Cezanne, and credited his influence with helping Keller learn how to convey rhythm in his own work.

Kelly, Louise Minert (1879–)

B. Waukon, Iowa. Work: Foster County (North Dakota) Historical Museum. AAA 1929-1933 (Minneapolis, Minnesota; summer, Provincetown, Massachusetts); Benezit; Havlice; Mallett; WWAA 1936-1941 (Minneapolis; summer, Provincetown); Ness and Orwig, 1939; Barr, 1954; Robinson, 1966; Agnes Olson, North Dakota Retired Teachers' Association; NMAA-NPG Library, Smithsonian Institution.

Kelly was active in Carrington, North Dakota, from 1905 to 1918, with time out for travel to Europe. A water color called "Scene in Holland" is dated 1914. She continued her travels for two more decades—England in 1934, and various trips to Carmel and Laguna Beach, California.

By the late twenties Kelly was a recognized landscape painter. "The Valley of the Lot—Espalion France" hung in the

Spring Salon in Paris in 1928, and is reproduced in the June issue of *American Magazine of Art,* page 344. Artist Paul Barr wrote that her oils and water colors "are notable for their excellent composition, their brilliant coloring, and their fidelity to nature."

Kelly, Myrle E. (1891–)
B. Hays Center, Nebraska. England, Master's thesis, University of Oklahoma; Oklahoma City Public Library.

Kelly, who studied at Pratt Institute and Colorado State College, was professor of art at Southwestern State College in Weatherford, Oklahoma. She exhibited in Brooklyn, New York; in Greeley, Colorado; and at the University of Oklahoma.

Kempf, F. P. [Tud] (1886–)
B. Jasper, Indiana. AAA 1925, 1933 (Chicago, Illinois); Havlice; Mallett; WWAA 1936–1941 (Chicago); Jacobson, 1932, 145.

According to Jacobson, Kempf sketched and carved in almost every state, and all over the world. He was influenced by the work of American Indians and blacks.

Kempf is best known as a woodcarver and sculptor, but he also wrote and illustrated numerous articles for popular magazines.

Kempf, Thomas M. (1895–)
B. Jasper, Indiana. AAA 1925 (Chicago, Illinos); Sparks; Jacobson, 1932, 145.

Kempf exhibited in Denver, Chicago, Indianapolis, and New York City. He painted in Colorado, probably in the twenties or early thirties.

Kempster, Frances Saunders (–)
Olpin, 1980.

Kempster was instructor of art at the University of Utah from 1915 to 1917 while the department head, Edwin Evans, was studying in Paris and New York City.

Kende, Geza (1889–)
B. Budapest, Hungary. Havlice; WWAA 1947–1953

(Hollywood, California); California *Arts & Architecture*, December 1932 (Los Angeles).

Kennedy, Samuel James (1877–)
B. Mt. Pleasant, Michigan. Work: Santa Fe Railway Collection; Mt. Pleasant Public Library; Michigan Agricultural College Library. AAA 1915–1919 (Chicago, Illinois); AAA 1921–1925 (Chicago; summer, Laguna Beach, California); Benezit; Sparks; *Art World*, Chicago Evening *Post*, November 10, 1925; NMAA-NPG Library, Smithsonian Institution.

Kennedy, who studied with Henri Martin, probably was in the West before 1907. An oil, "Pikes Peak Near Colorado Springs," is in the Santa Fe Railway Collection.

Kensett, John Frederick (1816–1872)
B. Cheshire, Connecticut. D. New York City, December 14. Work: Boston Museum of Fine Arts; National Gallery of Art; Pennsylvania Academy of Fine Arts; Los Angeles County Museum of Art; Toledo Museum of Art, etc. Benezit; Fielding; Groce and Wallace; Mallett; AAW v. I (New York City); Richardson, 1956; Stuart; John K. Howat, *John Frederick Kensett 1816–1872*, New York: Museum of Modern Art, 1968; Joan C. Siegfried, *John Frederick Kensett: a retrospective exhibition*, New York: Saratoga Springs, 1967; Ellen Johnson, "Kensett Revisited," *Art Quarterly*, v. 20, no. 2, 1957, 71–92; Inventory of American Paintings, Smithsonian Institution.

In 1853 Kensett was one of fifty painters and writers traveling West as far as trains would take them. In 1857 he traveled up the Missouri River to its headwaters. Although there is conjecture as to whether he was in Colorado in 1866, a painting called "Western Colorado" and dated that year is listed in the Smithsonian inventory.

Kensett was in Colorado with Worthington Whittredge and Sanford Robinson Gifford in 1870. Gifford left the party to work in Wyoming with the F. V. Hayden Survey. Kensett and Whittredge worked mainly in the Denver area and around Loveland Pass. For those who wish to research further the places

where Kensett sketched, there is the Edwin D. Morgan collection of over 600 letters, notes, etc., at the New York State Library.

Kensett's work was very popular during his lifetime. The paintings in his estate were sold for $136,312 when he died at age fifty-six.

Kent, Celia Burnham Seymour (See: Celia Seymour)

Kent, Dorothy (1892–)
B. Pittsburgh, Pennsylvania. AAA 1919–1921 (Tarrytown, New York); AAA 1925 (Springfield, Pennsylvania); Mallett Supplement (Chamita, New Mexico); School of American Research, 1940; Houston Public Library; Houston Museum of Fine Arts library; Robertson and Nestor.

Kent's work was described as "strong, forcible and vibrant" when it was exhibited at the Houston Museum of Fine Arts in 1927.

By 1930 Kent was living in New Mexico, perhaps at Chamita. Later she moved to Alcalde. She was a member of the New York Society of Women Artists and the Philadelphia Art Alliance. Her brother is the artist Rockwell Kent.

Kenyon, Zula (–)
Work: Santa Fe Railway Collection. AAA 1907–1908 (Chicago, Illinois); Inventory of American Paintings, Smithsonian Institution.

Kernodle, Ruth (–)
AAA 1917 (Lawrence, Kansas).

Kerr, Adam Green (–)
Mallett Supplement (Estes Park, Colorado); McMahan; Baker and Hafen, v. III, 1271; *Western Artist*, May 1936, 22; "Local Art in Denver," *American Magazine of Art*, December 1928, 695; Denver *Post*, May 17, 1936; Denver Public Library.

Kerr probably moved to Colorado soon after she left Washington, D.C., where she had been active as an exhibiting member of the Society of Washington Artists in 1916 and 1917. McMechin in his chapter for Baker and Hafen's *History of Colo-*

rado said that she had a "spiritual understanding of the mountains" and called her one of the leading artists of the region.

In 1928 Kerr served on the jury of award at the Colorado State Fair. In May 1936 she exhibited a series of mountain landscapes painted in Estes Park. These "recent oils" received notice in the Denver *Post* and *Western Artist.*

Kersey, Pliny Earle (1850–1873)
B. Northern California. D. San Diego, California. Peat, 1954, 96.
Kersey was active in California from 1869 to 1873.

Key, John Ross (1832/37–1920)
B. Hagerstown, Maryland. D. Baltimore, Maryland, March 24. Work: Joslyn Art Museum; Bancroft Library, University of California, Berkeley; Washington County (Maryland) Museum of Fine Arts; University of Michigan Museum of Art; Oakland Art Museum; Amon Carter Museum of Western Art, Fort Worth; Corcoran Gallery of Art; Arizona Historical Society, Tucson. AAA 1909–1915 (Washington, D.C.); AAA 1917 (Boston, Massachusetts); Benezit; Fielding; Groce and Wallace; Mallett; AAW v. I; California State Library; Inventory of American Paintings and NMAA-NPG Library, Smithsonian Institution; McMahan; "Baltimore," *American Art News,* February 26, 1910, 5; Oakland Museum library.

Key, the grandson of Francis Scott Key and the great grandson of John Ross Key, was active in California in 1870, and perhaps later. Yosemite, Lake Tahoe, Santa Cruz, Monterey, and San Francisco areas inspired many of his landscapes. In 1870 his activities were frequently noted in *Alta California.*

In 1853 Key had obtained employment with the U. S. Coast and Geodetic Survey where Whistler also was employed. While experience on the job may account for his accurate draftsmanship, it was his friends Whistler, Inness, and Duveneck who helped him learn to paint. The need to help support his widowed mother when he was fourteen had ruled out formal study.

Kimball, Ranch S. (1894–1980)
B. Salt Lake City, Utah. Olpin, 1980; Haseltine, 1965.

Kimball studied at Brigham Young University (1912–1913), and had three years at the Art Institute of Chicago and further study at the Art Students League. Back in Utah by 1920 he exhibited for the next three years at Utah state fairs.

The year 1931 marked the beginning of the Salt Lake City Art Center, often called the Art Barn, where Kimball exhibited for five seasons. His landscapes of that period have been described as "stylized."

From 1934 to 1944 Kimball was more active in administration than in painting, and thereafter he worked in commercial fields. Upon retiring he went into business.

Kimbrough, Frank Richmond (–1902)
B. Tennessee. D. England. AAA 1903, obit.; Benezit; Mallett; Denver Public Library.

Kimbrough was a young American illustrator who made sketches in Colorado to be used in London.

King, Minnie Clark (1877–)
B. Caldwell, Texas. Work: Texas National Bank, Guaranty State Bank, City Auditorium, and City Federation Club House collections, San Antonio, Texas. AAA 1925 (San Antonio; summer, Camp Arpa, Waring, Texas); Smith, 1926, 153.

King studied with William Merritt Chase, Charles Hudson Cox, Jose Arpa, and others. Her specialty was flower paintings which she exhibited widely in Texas.

Kirby, C. Valentine (1875–)
B. Carnajoharie, New York. AAA 1915–1919 (Pittsburgh, Pennsylvania); AAA 1921–1931 (Harrisburg, Pennsylvania); Denver Public Library; Denver *Times*, March 15, 1900; Sheldon Cheney, 1908, "Book-Plates . . . ," 186–190.

Cheney wrote in *Overland Monthly* that Kirby had made nearly one hundred bookplate designs during the few years he worked in that field.

From 1900 to 1910 Kirby was instructor of fine and industrial art in Denver, and active as an exhibiting artist in the Denver Artists' Club. The Denver *Times* referred to him as one of

the most prominent of the thirty most active members of the Club which then had five hundred members.

Kirkham, Richard A. (ca 1850–1930)
B. England. Havlice; Harper, 1970; Omoto, 1976, exhibition catalogue; NMAA-NPG Library and Inventory of American Paintings, Smithsonian Institution.

Kirkham was a landscape painter and photographer who was active in London, Ontario, by 1883 and Menominee, Michigan, by 1888. About 1908 he moved to California where he is said to have painted with Thomas Moran.

Omoto has shown Kirkham's "Sacramento Valley" in the exhibition catalogue. It is signed R. A. Kirkam, 1913. Three oils listed in the Smithsonian inventory as painted in 1914 by Richard *R.* Kirkham may also be his. They are titled "Big Santa Anita (View of San Gabriel Valley)," "Big Santa Anita Canyon," and "Griffith Park in Los Angeles."

Kirsch, (Frederick) Dwight, Jr. (1899–)
B. Pawnee County, Nebraska. Work: Wichita Art Museum; Philadelphia Museum of Art; Sioux City Art Center; Joslyn Art Museum; Des Moines Art Center; Nebraska Art Association, Lincoln. AAA 1931–1933 (Lincoln); Havlice; Mallett; WWAA 1936–1953 (Lincoln); WWAA 1956–1970 (Des Moines, Iowa); AAW v. I; Bucklin and Turner, 1932; NMAA-NPG Library, Smithsonian Institution.

Kirsch, a graduate of the University of Nebraska, began teaching there in 1924. In 1931 he became chairman of the art department, a position he held until 1947. Among his paintings are still lifes, abstractions, landscapes—especially of the sandhill country of Nebraska—and backyard scenes. He was also active as an illustrator.

In 1974 Kirsch was honored with testimonial exhibitions at the University of Nebraska Art Galleries which he had directed from 1936 to 1950, and the Des Moines Art Center which he had directed from 1950 to 1958. Shown also were the works of art by leading artists which these institutions had acquired during "the Kirsch Years."

Kleinschmidt, Florian Arthur (1897–)

B. Mankato, Minnesota. WWAA 1953–1962 (Lubbock, Texas); O'Brien, 1935.

Kleinschmidt, an architect and landscape painter, opened an office in Mankato in 1923, but soon afterward accepted a position at Kansas State Agricultural College. In 1928 he left Kansas State to head the department of Architecture and Allied Arts at Texas Tech in Lubbock. According to O'Brien he gave much time to landscape painting in the 1930s.

Kleitch/Kleitsch, Edith/Edna (1890–1950)

B. Michigan. D. Laguna Beach, California, August 5. Mallett Supplement (Laguna Beach); WWAA 1940–1941 (Laguna Beach); *Who's Who on the Pacific Coast*, 1947; California State Library; New York *Times*, obit., August 6, 1950, 72/2.

Kleitch married the painter Joseph Kleitch in Chicago in 1914. She taught at Laguna Beach High School, and painted landscapes, marines, and still lifes.

Kleitch/Kleitsch, Joseph (1885–1931)

B. Banad, Hungary. D. Santa Ana, California, November 16. Work: Laguna Beach Museum of Art. AAA 1915–1917 (Chicago, Illinois); AAA 1923–1931 (Laguna Beach); Mallett; AAW v. I; Berry, "California and some California Painters"; Eva Marie Stewart, "Chicago," *American Art News*, December 25, 1920, 5; *American Magazine of Art*, June 1924, 291; "Kleitsch and His California," *Art Digest*, April 15, 1931, 20; Inventory of American Paintings, Smithsonian Institution.

Kleitch was a portrait painter prior to his Laguna Beach years, whereupon landscapes became a major endeavor. Stewart wrote in December 1920 that he had departed for the Far West where he expected to do "the most serious work he has ever attempted in landscape and outdoor figure painting."

Kleitch apparently returned to Laguna Beach the following winter. During 1922 he worked in San Francisco and Carmel, California. Thereafter, except for the years 1926–1928 when he was in France and Hungary, he worked mainly in Laguna Beach.

Klepper, Frank Earl (1890–1952)

B. Plano, Texas. D. Dallas, Texas, June 4. Work: Dallas Museum of Fine Arts; Prairie View State Normal School; Arkansas State Art Association; West Texas Art Association; Federal Building, McKinney, Texas; Plano High School. AAA 1915 (Plano); AAA 1917–1933 (McKinney); Fielding; Havlice; Mallett; WWAA 1936–1953 (Dallas); WWAA 1956, obit.; AAW v. I; Fisk, 1928; O'Brien, 1935; B. G. Eades, "Frank Klepper 1890–1952," *The Southern Artist*, June 1956, 12–13, Houston Public Library.

Except for studying at the Art Institute of Chicago, and at the American Art Center in Bellevue, France, after the First World War, Klepper lived in Texas. Specializing in landscapes he began exhibiting locally in 1915, and winning important prizes beginning in the early twenties. In the late twenties he was in Belgium and France for a short painting trip.

Fisk describes Klepper as "an impressionist in the best sense," and quotes authorities, including Richard Miller who praised Klepper's handling of light. "The poetry of light, direct or reflected," Miller said, "is one of the finest things of his art."

In 1943 Klepper turned to figure and portrait painting. A number of his still life and figure paintings were inspired by his collection of Chinese porcelain art objects.

Kley, Alfred Julius (1895–1957)

B. Chicago, Illinois. D. Los Angeles, California, June 26. Havlice; WWAA 1947–1956 (Los Angeles and Hollywood); WWAA 1959, obit.

Kley was a member of the California Water Color Society. He began exhibiting in the West in 1940.

Klinge, Nellie Killgore (–)

B. Marshall, Illinois. Work: Kimberly, Preston, and Heyburn, Idaho, high schools. *Idaho Encyclopedia; Who's Who in Northwest Art* (Preston, Idaho); Inventory of American Paintings, Smithsonian Institution.

Klinge, who worked in oils, studied at the Art Institute of Chicago and Pratt Institute in Brooklyn. Her paintings include "Farmhouse in Southern Idaho," *circa* 1910, in a private collection, and "Portneuf Valley" and "Idaho Rainbow" at Heyburn and

Kimberly high schools, respectively. She exhibited in Idaho, Utah, and Colorado, and held a solo show at Colorado State College in Fort Collins in 1933. Sources differ as to whether she graduated from Colorado State or Utah State in Logan.

Knight, Frederic (1855–1930)
Work: Joslyn Art Museum, Omaha, Nebraska. Joslyn Art Museum library.

Knight was a member of the Omaha Art Guild who exhibited with the Guild in 1917, 1919, and 1921. Among his watercolor paintings at Joslyn Art Museum are "Old Town, California," "Cheyenne Canyon," and "House and Barn, Ipswich."

Knight, Louis Aston (1873–1948)
B. Paris, France. D. New York City, May 8. Work: Newark Museum; Toledo Museum of Art; Luxembourg Museum, Paris; Rochester Memorial Art Gallery; Delgado Museum, New Orleans; Society of Liberal Arts, Omaha, Nebraska, etc. AAA 1900 (Poissy, France); AAA 1903 (Paris); AAA 1905–1910 (Paris and New York City); AAA 1913–1933 (Paris); Benezit; Fielding; Havlice; Mallett; WWAA 1936–1941 (Paris); "N. Y. Criticism," *Art Digest,* December 1, 1934, 14; Mark Hoffman, San Francisco; NMAA-NPG Library and Inventory of American Paintings, Smithsonian Institution.

Knight did little work in the West. However, some of his titles are of interest–"Santa Monica Sunset," "The Alamo," "Pacific Cave," and "Carmel." "Carmel" is presumed to have been painted during the first decade of this century. He painted a number of Monterey Peninsula scenes.

Knight, S. Dubois (–)
Gibson.

Knight was an artist and illustrator working in Detroit from 1880 to 1887. He later lived in New York (1893), and in Los Angeles, California.

Koch, George Joseph (1885–1951)
B. Newark, New Jersey. D. Monterey, California, September 13. AAA 1909–1915 (Mystic, Connecticut; New York

City and Brooklyn); Spangenberg, 54; Monterey Public Library.

Koch visited California in 1914 and decided to make his home in Carmel Highlands. He later lived in Carmel and Pebble Beach. In 1929 he moved to Robles del Rio. He specialized in landscapes and seascapes in oil.

Koch, Karl F. (1888–)

B. Sandusky, Ohio. *Who's Who in Northwest Art* (Portland, Oregon).

Koch studied at the Minneapolis School of Art and the New York School of Art. He worked in oil, tempera, and water color and exhibited at the Portland Art Museum from 1934 to 1936 and at the Seattle Art Museum in 1938.

Koen/Kohn/Koehn, Irma René (–)

B. Rock Island, Illinois. Work: Toledo Art Museum; Pennsylvania Academy of Fine Arts; Davenport (Iowa) Municipal Gallery; Illinois State Museum; Rock Island Public Library; Chicago Municipal Collection. AAA 1913–1919 (Rock Island); AAA 1921–1927 (Chicago; studio, 1921, East Gloucester, Massachusetts); AAA 1929 (Rock Island; summer, Boothbay Harbor, Maine); AAA 1931–1933 (Rock Island; summer, Gloucester); Fielding; Havlice; Mallett; WWAA 1936–1941 (Rock Island); Sparks.

Koen did some work in California early in her career. In 1916 she exhibited at the Art Institute of Chicago a number of water colors of landmark buildings and streets in Monterey, and of the Mission in nearby Carmel.

Koriansky, Alexander (1884–)

B. Moscow, Russia. AAA 1933 (Seattle, Washington); Mallett.

Koogler, Jessie Marion (See: Marion Koogler McNay)

Koopman, Augustus B. (1867–1914)

B. Charlotte, North Carolina. D. Etaples, France, January 30. Work: Santa Fe Railway Collection; Library of Con-

gress; New York Public Library; St. Louis Museum; Cosmos Club, Washington, D.C.; Brooklyn Museum. AAA 1898-1900 (Paris); AAA 1900-1906 (New York City; Chelsea, England); AAA 1907-1913 (New York City); Benezit; Fielding; Havlice; Mallett; Earle; NMAA-NPG Library and Inventory of American Paintings, Smithsonian Institution.

While Koopman was exhibiting in the United States in 1913, he visited the Grand Canyon. His oil painting "Vision of the Grand Canyon" is in the Santa Fe Railway Collection.

Korda, Augustyne/Augustine/Augustyn (1894–)

B. Buffalo, New York. AAA 1919-1924 (Denver, Colorado; Buffalo); AAA 1925 (Buffalo).

Korda was a member of the Denver Art Association.

Kremser, Harry Edward (1890–)

B. York, Nebraska. Bucklin and Turner, 1932.

Kremser was a landscape painter who chose to coordinate the weather and his work. July to October was spent in Estes Park, Colorado; October in Fremont, Nebraska; and November to June in Cocoanut Grove, Florida. He exhibited in Miami.

Kress, Frederick B. (1888-1970)

B. Pittsburgh, Pennsylvania. D. Santa Rosa, California, August 10. Work: Private collections. AAA 1919 (San Francisco, California); Daniel C. Lienau, Santa Rosa; Richard and Mercedes Kerwin, Burlingame, California.

Kress, who moved to California in 1906, studied at the Mark Hopkins Institute of Art and the San Francisco Institute of Art. One of his teachers was Maynard Dixon.

From 1912 to 1917 Kress went regularly to the Big Sur area to sketch, and from 1920 to 1960 to Yosemite, Lake Tahoe, and Fallen Leaf Lake. Much of his painting was done on weekends and during vacations, for he was employed as a sign painter and subsequently as the superintendent of Foster & Kleiser's paint department. Therefore many of his paintings are of scenes in San Francisco and Marin counties. His medium was oil.

About 1962 Kress moved to Santa Rosa.

Kristoffersen, J. K. (1877–)

B. Denmark. O'Brien, 1935 (Dallas, Texas).

Kristoffersen was a carpenter who moved to Texas early this century and took up painting when he was in his early fifties. He lived in Dallas from 1910, and in 1932 he won third prize at a Dallas Allied Art Exhibition.

Kroupa, Bohuslav (–)

B. Austro-Hungary. Havlice; Harper, 1970; California State Library; B. Kroupa, *An Artist's Tour/Gleanings and Impressions of Travels in North and Central America and the Sandwich Islands*, London: Ward and Downey, 1890.

Kroupa was an engraver and illustrator who worked in England before moving to Canada where he was active in 1872 and 1873. He traveled extensively and later wrote and illustrated the book just mentioned. Among his American subjects are the Sierra Nevadas, Yosemite Valley, Calaveras Grove in the Sierras, a Chinese joss house, Utah's Uintah Mountains, San Francisco's seal rocks, and an opium den in Chinatown.

Krueger/Kruger, Richard (–)

Work: Santa Fe Railway Collection. Inventory of American Paintings, Smithsonian Institution; (American) *Art News*, November 16, 1909; Los Angeles City Directory, 1906–1918; San Francisco City Directory, 1920–1924.

Krueger, who was active in California for a number of years, has two paintings listed in the Smithsonian inventory: "Grand Canyon," a 60 × 96-inch oil in the Santa Fe Railway Collection, and "Santa Cruz Sand Dunes," an oil in a private collection. When he exhibited with Southern California artists in Chicago in 1909, the *American Art News*, as it was then known, mentioned his participation.

Kruse, Max H. (–)

Work: California Historical Society. Inventory of American Paintings, Smithsonian Institution.

Listed in the Smithsonian inventory are two oil paintings by Kruse: "Marin County, Richardson's Bay" in the California

Historical Society's collection, and "Hunters in Mountains" dated 1912 and in a private collection.

Kuntz-Meyer/Kunz-Meyer, "Professor" (–)
Fisk, 1928, 70; Bywaters, 1978, 2; *Texas Painting and Sculpture:* 20th Century, 5, n.d.

Bywaters places Kuntz-Meyer in Texas about 1900. According to Fisk, he had been a professor at Munich Academy. A number of Texas residents studied with him, including the prominent Dallas artist Robert Jerome Hill. Another pupil, Mrs. W. L. Crawford, had ten of his canvases, including the portrait he did of her.

L

Lackey, Vinson (1889–1959)
B. Paris, Texas. Work: Thomas Gilcrease Institute of American History and Art. Oklahoma City Public Library; *American Scene,* 1958, v. 1, no. 2, p. 3, 5; v. 1, no. 4, p. 9.

Lackey was a parttime painter who received his bachelor of fine arts degree in 1920. His principal teachers at the University of Oklahoma were O. B. Jacobson and Patricio Gimeno. He was active in the fine arts from 1916 and exhibited mainly in Tulsa where he lived.

After 1940 Lackey devoted much of his time to doing historical paintings and drawings of Oklahoma subjects, including many of the state's first buildings. These are at the Gilcrease Institute in Tulsa. One of the paintings is pictured on page 9 of *American Scene,* v. 1, no. 4.

Ladd, Laura D. Stroud (1836–1943)
B. Philadelphia, Pennsylvania. D. Philadelphia, May 21.
AAA 1900 (Philadelphia; listed as Stroud); AAA 1905–

1913 (Overbrook, Pennsylvania); AAA 1915–1933 (Philadelphia); Fielding; Havlice; Mallett; WWAA 1940–1941 (Philadelphia); WWAA 1947, obit.; *American Magazine of Art,* January 1927, 44–45; NMAA-NPG Library, Smithsonian Institution.

The *American Magazine of Art* in 1927 referred to Ladd as a Southwest artist who had exhibited at the Arizona State Fair the previous November. In 1928 she won a prize for a painting that was judged "the best" by a Philadelphia woman. The painting was shown in the New York *Times,* February 5.

Laidlaw, Cora M. (1863–)

B. Gouverneur, New York. *Who's Who in Northwest Art* (San Diego, California); California *Arts & Architecture,* December 1932 (Coronado, California).

Apparently Laidlaw was once active in the Northwest where she was a member of the Oregon Society of Artists. In San Diego she studied with Leslie Lee, Alfred Mitchell, and Otto Schneider, and was active in the Art Guild of San Diego. She was a painter and an etcher.

Lakes, Arthur (1844–)

Work: Peabody Museum of Natural History, Yale University. Inventory of American Paintings, Smithsonian Institution. Lakes, "A Trip Through Arizona," *Mines and Minerals,* v. 24, p. 356–358, 1904.

Other than that Lakes accompanied one or more expeditions to Wyoming led by Yale professor of paleontology Othniel C. Marsh, beginning in 1870, and appears to have been active as a geologist, little is known, except what appears in the Smithsonian Inventory. Listed is a water color entitled "Marsh Expedition: Lunch at Como Bluff, Wyoming."

Lamb, Frederick Stymetz (1863–1928)

B. New York. D. Berkeley, California, July 9. Work: City of New York Public School No. 5; Church of the Messiah, New York; Plymouth Church, Brooklyn. AAA 1900–1927 (New York City; summer 1913–1925, Cresskill, New Jersey; summer 1927, Berkeley); AAA 1928, obit.; Benezit;

Fielding; Havlice; Mallett; Earle; *American Magazine of Art*, June 1924, 317; *Art Digest*, July 1928, 4.

Lamb spent most of his last years in Berkeley where he established a second home about 1922. In 1924 the *American Magazine of Art* reported that he was painting in the East San Francisco Bay region, exhibiting in the area, and making sales. He is best known for murals and stained glass.

Lambdin, Victor B. (-)
Denver Public Library; Bromwell scrapbook, 15; Denver *Times*, March 15, 1900.

Aside from a reference to Lamdin's exhibiting with the Denver Artists' Club in November 1898, and mention in the *Times* of his prominence, nothing was found on this painter-illustrator who was then an active member in the club.

Lamson, James (-)
Work: California Historical Society. Groce and Wallace (Sebec, Maine); AAW v. I; California Historical Society; California State Library; "Sells Sketch of Yosemite Falls and Environs," Sacramento *Bee* One Hundred Years Ago column, July 22, 1959, D 8/6; *California on Canvas/a Portfolio of Paintings of Early California Scenes by Contemporary Artists*, San Francisco: The Book Club of California, 1941.

Lamson joined the gold rush to California, arriving by ship in 1852. After trying his luck at mining and storekeeping he worked as an itinerant artist. His best customers were mine owners and ranchers.

Principal California counties in which Lamson worked as an artist from 1858 to 1860 are Butte, Yuba, Nevada, Amador, and Mariposa. Dated ca 1858 are a water color called "Col. Fremont's Mills, Bear Valley, Mariposa County," and another of Fremont's residence. An 1859 water color is of "Mount Broderick and the Nevada Falls, Yosemite Valley, Cal." A June 1858 water color is called "Emery's Crossing, Middle Yuba, Yuba Co." Lamson estimated as 175 feet the height of the flume in "High Flume, Tunnel Hill," painted in 1857. It is shown in the *Portfolio of Paintings*. Fifteen of these water colors are in the collection of the California Historical Society.

Landaker, Harold (ca 1892–1966)

B. Chicago, Illinois. D. Pacific Grove, California, November 6. AAA 1925 (Chicago; listed as H. C. Landaker); Monterey and Carmel public libraries; Virginia McGrath in *Game and Gossip*, March 12, 1952, at the Monterey Public Library.

Landaker, whose specialty was circus life, animals, and birds, depicted with "whimsical humor," moved to Pacific Grove about 1946. During his later years he turned to landscape painting. He was a member of the Carmel Art Association. His wife Mabel also was a painter.

Lane, Loubeth King (–)

O'Brien, 1935 (Canyon, Texas).

Lane studied at the University of Chicago, the Art Institute of Chicago, Pennsylvania Academy of Fine Arts, and Southern Methodist University in Dallas where she received her master's degrees in 1920. She taught drawing, water color painting, and design at SMU until 1923 when she moved to Canyon to take charge of the art department of West Texas State College.

Lane, Martella Lydia Cone (1897–1962)

Work: Eureka (California) High School; Clarke Memorial Museum, Eureka; Los Angeles General Hospital; California State Collection. AAA 1925 (Fortuna, California); California *Arts & Architecture*, December 1932 (Los Angeles); *News Notes of California Libraries*, January 1913, 21; Ada Wallis, "Save the Redwoods," *The Western Woman*, January-March 1938, 5–8; NMAA-NPG Library and Inventory of American Paintings, Smithsonian Institution.

"Yosemite Scene," a water color listed in the Smithsonian inventory is signed "Cone," but most of her work is signed "Lane." She is best known for paintings of redwoods which are said to be in many private collections here and abroad.

Each summer Lane painted in the heart of redwood forests in Humboldt County, and each year she showed her work, usually in San Francisco, Los Angeles, Lincoln (Nebraska), St. Paul, and Philadelphia.

Lane, who maintained a studio in Fortuna, had a doctor's

degree in fine arts and taught at Chapman College in Los Angeles.

Lanham, Alpha Johnson (-)
B. Johnson County, Texas. Fisk, 1928; O'Brien, 1935.
Lanham studied at the School of Art in Lubbock, Texas, and with Will Stevens and Xavier Gonzalez. She specialized in landscapes and still-life subjects. She won awards and, according to Fisk, was "prominently identified" as an artist in the Panhandle region in the mid-twenties. She was active in Cleburne until she married in 1903, then Slaton, and probably in Midland, Texas, in the thirties.

Lanman, Charles (1819–1895)
B. Monroe, Michigan. D. Washington, D.C., March 4.
Work: Corcoran Gallery of Art; Japanese Government.
Benezit; Fielding; Groce and Wallace; Mallett; Young; Harper, 1970; French; Gibson; McMahan.
Lanman began studying art in 1835 while working as a clerk for an East-Indian business in New York City. Among his teachers was A. B. Durand. In 1847 he was elected an associate member of the National Academy of Design.
In 1845 Lanman started writing for various publications, including the London *Illustrated News.* According to French, sketching trips to illustrate his articles took Lanman to every state east of the Rockies. Harper describes him as a "painter, traveller, and sportsman" who was active in Canada and Central and Western United States from 1846 to 1856, and cites several published works illustrated with Lanman's water-color sketches.
Lanman was active mainly in New York, Ohio, and Michigan until 1850 when he settled permanently in Washington, D.C. In 1871 he was appointed American secretary of the Japanese Legation. He was active in Washington art associations.

La Rosa, Vincenzo (ca 1871–1925)
D. San Francisco, California, April 26. California State Library.
La Rosa, whose painting, "Stella," brought him fame, died in poverty. The California State Library has a number of references on this now forgotten painter.

Larsen, Ben (1892–)

B. Cedar Falls, Iowa. *Who's Who in Northwest Art* (Portland, Oregon).

Larsen studied at Iowa State College and Chicago Academy of Fine Arts. He worked in oil, pastel, and water color; did decorating and print making; and held a one-man exhibition at Meier & Frank Department Store in Portland in 1931 and 1933.

Larsen, Bessie (1889–)

Mallett Supplement (Dallas, Texas); Dallas Museum of Fine Arts 1936 exposition catalogue.

Larsen, Mae Sybil (–1953)

B. Chicago, Illinois. D. February 18, probably in Chicago. AAA 1921–1933 (Chicago); Havlice; Mallett; WWAA 1936–1953 (Chicago); WWAA 1956, obit.; Sparks; Jacobson, 1932.

Larsen studied at the Art Institute of Chicago, and may also have studied in Santa Fe, New Mexico. Among her teachers were John Sloan and Randall Davey. In September 1920 she exhibited "From the Arroyo" at the Museum of New Mexico during an exhibition of Santa Fe and Taos artists.

Larsen, Morten (1858–1930)

Work: Oakland Art Museum. Inventory of American Paintings, Smithsonian Institution.

According to the Smithsonian inventory, the Oakland Museum has fifty-five oil landscapes by Larsen. They include scenes of Yosemite, Bolinas Bay, and the San Bruno mud flats.

Lash, Lee (1864–)

B. San Francisco. AAA 1923–1927 (New Rochelle, New York); Mallett; *California at the World's Columbian Exposition 1893.*

Lash who exhibited "Old Sailor's Home" at the Columbian Exposition in Chicago was active in New York as a scenic designer. He was a member of the New Rochelle Art Association.

Lauderdale, Ursula (1879–)

B. Moberly, Missouri. AAA 1919-1933 (Dallas, Texas); Benezit; Mallett; AAW v. II; Fisk, 1928, 74-76.

Lauderdale studied with Robert Henri and others at the Art Students League, and with Maurice Braun whose influence is said to show in her work.

During the middle 1920s Lauderdale was in New Mexico for extended periods, spending time in Joseph Sharp's studio in Taos, living with the Moya family in Santa Fe, teaching landscape painting while dean of the Southwest Chautauqua in Las Vegas, New Mexico. During the latter period she spent several weeks painting at a ranch near Hermit Mountain. She exhibited her first painting of that region, "New Mexico Wild Flowers," at Santa Fe's Thirteenth Annual.

Other New Mexico subjects painted by Lauderdale are the mountains and the early mission churches of the Santa Fe-Taos region. Most of her work was done in Texas where she was art director of Trinity University in Waxahachie.

Lawford, Charles (–)

AAA 1917 (Minneapolis, Minnesota); AAA 1919 (Santa Barbara, California); AAA 1921-1929 (Los Angeles); Fielding.

Lawford won a number of awards for his work while living in Minneapolis where he was a member of the Attic Club and the Minneapolis Art League.

Lawrence, David Herbert (1885-1930)

B. Eastwood, Nottinghamshire, England. D. Zence, near Antibes, France, March 2. Mallett Supplement; *Paintings of D. H. Lawrence,* edited by Mervyn Levy with essays by Harry T. Moore, Jack Lindsay, and Herbert Read, New York: Viking Press, 1964.

Some of Lawrence's paintings are of New Mexico subjects, including the ranch northeast of Taos where he lived during 1922 and part of 1923.

Lawrence, Herbert Myron (1852-1937)

B. San Francisco, California. D. Sharon, Massachusetts,

September 4. California State Library; San Francisco Public Library art and artists' scrapbook; Castor typescript.

Lawrence was a painter and designer who was active in San Francisco from the 1880s until the turn of the century. He returned to San Francisco in 1915.

Lazarus, Edgar M. (1868–1939)
B. Baltimore, Maryland. D. Portland, Oregon, October 2.
Who's Who in Northwest Art (Portland).

Lazarus, who studied at the Maryland Institute of Arts, was an architect and an etcher. He was the designer of Vista House on the Columbia River Highway in Oregon. In 1929 he exhibited at the Tenth International Printmakers' show in Los Angeles.

Leadbetter, Noble (1875–)
B. Wardsville, Ontario. *Who's Who in Northwest Art* (Portland, Oregon).

Leadbetter, who was mainly self-taught, had studied briefly at Oregon State College at Corvallis in 1897. He exhibited at the Portland Art Museum in 1938.

Lee, Arthur T. (–)
American Art Review, May–June 1976, 27; W. Stephen Thomas, *Fort Davis and the Texas Frontier—Paintings by Arthur T. Lee, Eighth U. S. Infantry,* an Amon Carter Museum Project, College Station: Texas A&M, ca 1975.

Captain Lee, an Easterner, was stationed in Texas in 1848. While there he did forty water color sketches of his impressions. He traversed the state from San Antonio to the Big Bend Country and from the Rio Grande to the Brazos River, and described the Davis Mountains as "beautiful beyond description."

Lee, Ida Fursman/Furzman (–)
McClurg, 1924, pt. V; Wray, Colorado Springs *Gazette,* April 2, 1916, 7/1; Grove typescript; Colorado College Library.

Lee, whose parents were prominent Colorado pioneers,

studied at the New York School of Art, the Cleveland School of Art, and under Charles Woodbury. She exhibited in Colorado Springs in 1915, 1916, 1926, and 1928. Her entries in 1915 were "Quiet Valley," "Scene from Stratton Park," and "Old Fisherman." She later turned to portrait painting.

Leeper, Vera (1899-)

B. Denver, Colorado. Work: Denver Art Museum; murals in New Jersey and New York public schools. AAA 1923 (New York City); AAA 1925 (East Orange, New Jersey); AAA 1927-1933 (Yorktown Heights, New York); Fielding; Havlice; Mallett; WWAA 1936-1941 (Yorktown Heights); WWAA 1947-1953 (Los Angeles); WWAA 1956-1962 (Montrose, California).

Leggett, Mabel E. (1878-)

B. Eleva, Wisconsin. *Who's Who in Northwest Art* (Portland, Oregon).

Leggett studied at the Art Institute of Chicago and the Metropolitan Art School in New York. She worked in oil and water color and exhibited locally.

Leich, Chester (1889-)

B. Evansville, Indiana. Work: Museum of New Mexico, Santa Fe; Museum of Fine Arts and History, Evansville; Society of American Ethers; Roerich Museum, New York City; Central High School, Evansville; Library of Congress; Newark (New Jersey) Public Library; Metropolitan Museum of Art; National Museum of American Art, etc. AAA 1917-1919 (Chicago); AAA 1921 (Evansville); AAA 1923-1924 (Evansville and New York City); AAA 1925-1929 (Evansville; Leonia, New Jersey); AAA 1931-1933 (Leonia); Fielding; Havlice; Mallett; WWAA 1936-1941 (Leonia); WWAA 1947-1962 (Arlington, Virginia); Museum of New Mexico catalogue of the collection.

Leich did a number of drypoints and other etchings of Southwestern subjects such as "Comanche Dance," "Crossing the Desert," "Indian Rodeo," "Mountains in Arizona," and "San Francisco Peaks" (near Flagstaff, Arizona).

Leith-Ross, Harry (1886–)

B. Mauritius. Work: Pennsylvania Academy of Fine Arts; mural, USPO, Masontown, Pennsylvania. AAA 1915 (Rowley, Massachusetts); AAA 1917–1933 (Woodstock, New York); Benezit; Fielding; Havlice; Mallett; WWAA 1936–1937 (Litchfield, Connecticut; summer, Woodstock); WWAA 1938–1970 (New Hope, Pennsylvania).

Leith-Ross, who was active in the Southwest in the late 1920s, exhibited with Painters of the Southwest at their Sixteenth Annual in Santa Fe, New Mexico, in 1929.

LeMaster, Harriet (1883–)

B. West Farmington, Ohio. *Who's Who in Northwest Art* (Seattle, Washington).

LeMaster, who studied at Western Reserve University, exhibited in Idaho state fairs and in Portland in 1927. She specialized in landscapes and Western life subjects featuring Indians and Mexicans.

Lemos, Pedro J. (See: Pedro J. DeLemos)

Lenders, Emil W. (ca 1865–1934)

B. England or Germany. D. Oklahoma City, Oklahoma, April 5. Work: Buffalo Bill Memorial Museum, Golden, Colorado; Smithsonian Institution. AAA 1915 (Philadelphia); Havlice; Mallett Supplement; WWAA 1936, obit.; AAW v. I; Denver Public Library; "Col. Emil Lenders, Noted Painter of Western Life, Dies," Denver *Post*, ca April 6, 1934.

Lenders who is listed in the *American Art Annual* as a sculptor was also a painter who is said to have been recognized internationally for his paintings of the buffalo. Five oils, three dated 1908 and two dated 1912, are listed in the Smithsonian Institution's Inventory of American Paintings; three are of buffalo. In Oklahoma he was regarded by his contemporaries as "one of the five leading portrayers of Indian life." What had attracted him to the West where he spent most of his adult life was Indians, cowboys, fauna, and sun-drenched prairies.

Sources differ as to Lender's place of birth. According to the *Post* he was born in London of German and English parents,

and educated in Munich. His home was in Oklahoma City where he was active until his death.

Lent, Frank T. (–)

AAW v. I; Colorado College Library; Colorado Springs Fine Arts Center library; Colorado Springs *Gazette*, December 5, 1885, 4/1; January 6, 1886, 4/1; January 19, 1889, 7/4; Ormes and Ormes, 337–338; McClurg, 1924, pt. I; Baker and Hafen, v. III, 1266; National Academy of Design catalogue 1882; Newark Museum library.

Lent, an accomplished painter and an architect, was active in New Jersey and New York before moving to Colorado Springs in the mid-1880s. While living in Jersey City in 1881 and 1882 he exhibited at the National Academy of Design and the Pennsylvania Academy of Fine Arts. Previously he had studied with Bruce Crane, and also in Paris where he had exhibited at the Paris Salon. He worked mainly in water color.

The *Gazette* announced, December 5, 1885, that Lent would "take pupils in drawing and painting at his studio on Pikes Peak Avenue."

Leslie, Virginia (–)

O'Brien, 1935 (Waco and Mineral Wells, Texas).

Leslie studied in Cincinnati, New Orleans, and in New York City where her teacher was C. H. Chapin. She taught for many years in Waco schools and probably retired to Mineral Springs. The Waco Public Library may have additional information on this artist who was known for "accuracy of drawing and coloring."

Levitt, Joel J. (1875–)

B. Kiev, Russia. Work: National Gallery of Canada; Petrograd Museum, Russia; Wilna Museum, Russia; Colorado Springs Fine Arts Center, Colorado. AAA 1915–1933 (New York City); Benezit; Fielding; Havlice; Mallett; WWAA 1936–1937 (New York City); Colorado Springs Evening *Telegraph*, June 17, 1920; Colorado Springs Fine Arts Center library.

Levitt spent several summers in Colorado Springs. By 1920 his enthusiasm for an art center there was noted in the Evening *Telegraph* whose reporter had visited Levitt's studio.

Referring to the "exquisite studies" found there, the *Telegraph* said that "the observer immediately feels himself transplanted into the atmosphere" Levitt depicted.

Levy, Beatrice S. (1892–)

B. Chicago, Illinois. Work: Library of Congress; Art Institute of Chicago; Smithsonian Institution; Los Angeles County Museum of Art; Bibliotheque Nationale, Paris; University of New Mexico; Long Beach (California) Museum of Art. AAA 1915–1933 (Chicago); Benezit; Fielding; Havlice; Mallett; WWAA 1936–1953 (Chicago); WWAA 1956–1973 (La Jolla, California); Sparks; Jacobson, 1932; NMAA-NPG Library, Smithsonian Institution.

Levy's subjects have been drawn from extensive travels here and abroad. An early etching dated 1922 is a San Francisco scene. The states in which she was most active are California, New Mexico, Massachusetts, Louisiana, Kentucky, and, of course, Illinois.

Levy also exhibited widely. Among the cities where she had solo exhibitions are Boston, New York, San Francisco, Washington, D.C., and Philadelphia. Her color process for aquatints was discussed in connection with the 1932 exhibition at the Smithsonian Institution of etchings, drypoints, and prints in color, and can be read at the Smithsonian's NMAA-NPG Library.

Lewis, Herbert Taylor (1893–1962)

B. Chicago, Illinois. D. Madison, Wisconsin, December 29. Work: Rockford (Illinois) Art Association. AAA 1925 (Rockford; summer, Desbarat, Ontario); AAA 1927–1933 (Rockford); Havlice; Mallett; WWAA 1936–1937 (Oak Park, Illinois; summer, Neebish, Michigan); WWAA 1938–1941 (Oak Park; summer, Ontario); Sparks; "Houston," *Art News,* January 3, 1920, 9; California State Library; NMAA-NPG Library, Smithsonian Institution; Monterey (California) Public Library; Carmel (California) Public Library.

Lewis taught painting in Chicago, Rockford, New York City, Booth Bay Harbor in Maine, and in Tucson where he moved in 1943. He began exhibiting in the West in 1920 when he showed water colors in Houston, Texas. In 1925 he exhibited in Santa Fe,

New Mexico. He was active in Tucson until 1954 when he moved to the Monterey Peninsula and began exhibiting with the Carmel Art Association.

Lewis, (L.) Howell (ca 1853-1935)
Work: Oklahoma State Capitol. Havlice; Mallett; WWAA 1936, obit.; Dale and Wardell, 524.
Dale and Wardell refer to Lewis as a painter of the Oklahoma scene.

Lewis, Jeannette/Jeanette Maxfield (1894-1982)
B. Oakland, California. D. Monterey, California, April 22. Work: Metropolitan Museum of Art; New York Public Library; Brooks Memorial Art Gallery, Memphis, Tennessee; California State Library; Library of Congress; Cincinnati Art Museum; Monterey Peninsula Art Museum; Oakland Art Museum. AAA 1929-1933 (Fresno, California; summer 1929, Monterey); Benezit; Havlice; Mallett; WWAA 1936-1956 (Fresno; summer 1936, Carmel, California); WWAA 1959-1976 (Pebble Beach, California); AAW v. I; Monterey Public Library; San Francisco Public Library art and artists' scrapbook; Irene Alexander, "Pebble Beach Art Gallery Opens Fine Show of Jeannette Lewis Drawings," Monterey Peninsula *Herald*, April 14, 1955; Janice Lovoos, "The Prints and Drawings of Jeanette Maxfield Lewis," *American Artist*, April 1962, 34, 39, 60; "Internationally Known Artist Jeannette Maxfield Lewis Dies," Monterey Peninsula *Herald*, April 25, 1982, 4A.
Lewis attended Castilleja School in Palo Alto, California, and studied art in San Francisco at the Mark Hopkins Institute and the California School of Fine Art. She worked as a commercial artist for a while in New York City, but later became known as an etcher and painter of landscapes.

Lewis, Mary Amanda (1872-1953)
B. San Francisco, California. D. Sacramento, California, September 25. Work: Society of California Pioneers, San Francisco; Crocker Art Gallery, Sacramento. *Impression-*

ism/The California View 1890-1930, The Oakland Museum, 1981, exhibition catalogue.

Lewis was not an impressionist painter; rather, as the subtitle of the catalogue implies, the Oakland Museum was showing work of California painters that showed the impact of impressionism.

Leyden, Louise Hannon (1898–)
B. Fresno, California. Havlice; WWAA 1853–1962 (Capistrano Beach, California).

Leyden won awards for work exhibited in San Francisco and Southern California in 1939.

Lichnovsky, Jennie M. (–)
B. Everest, Kansas. Havlice; Mallett Supplement; WWAA 1936–1941 (Omaha, Nebraska); *Western Artist,* July–August 1936, 11; Joslyn Art Museum library.

Lichnovsky, a member of the Omaha Art Guild, exhibited with the Guild regularly from 1913 to 1937, and perhaps later.

Lichtner, Charles S. (1871–)
B. Leavenworth, Kansas. Bucklin and Turner, 1932 (Omaha, Nebraska).

Lichtner studied with Richard Tallant, probably in Estes Park or Denver, Colorado, and with J. Laurie Wallace in Omaha. He exhibited mainly in Colorado and in Omaha.

Lie, Jonas (1880–1940)
B. Norway. D. January 10, probably in New York City. Work: Metropolitan Museum of Art; Boston Museum of Fine Arts; Detroit Institute of Arts; Dallas Art Association, etc. AAA 1905–1913 (Plainfield, New Jersey); AAA 1915–1921 (New York City); AAA 1923–1924 (New York City and Saranac Lake, New York); AAA 1925–1933 (New York City); Benezit; Fielding; Havlice; Mallett; WWAA 1936–1939 (New York City); Earle; Monterey Peninsula *Herald,* October 18, 1966, A3/3.

The Monterey Peninsula *Herald* article tells about the noted painters who joined the Carmel Art Colony for a season's

work, among them Jonas Lie who spent a summer there painting landscapes and marines.

Lightfoot, Mary L. (1898–)
Mallett Supplement (Dallas, Texas). Dallas Fine Arts Museum brochure for the Exposition of 1936 in which Lightfoot is listed as having exhibited a still-life oil on canvas.

Liljestrom, Gus/Gustav F. (1882–1958)
B. Stockholm, Sweden. D. San Francisco, California, August 26. Work: Museum of New Mexico, Santa Fe; Bohemian Club, San Francisco; California Historical Society. California *Arts & Architecture,* December 1932 (San Francisco); Panama-Pacific International Exposition catalogue, 1915.
Liljestrom, who studied at the Art Institute of Chicago, painted at Canyon de Chelly, the Grand Canyon, the San Francisco Bay region, and other scenic areas.

Lind, Edward G. (1884–)
AAA 1933 (Kansas City, Kansas); Mallett (Kansas City, Missouri).

Lindberg, Thorsten Harold Frederick (1878–)
B. Stockholm, Sweden. Work: Milwaukee (Wisconsin) Public Museum. AAA 1917–1919 (Minneapolis, Minnesota); AAA 1923–1924 (Milwaukee); AAA 1925–1933 (Omaha, Nebraska); Benezit; Havlice; Mallett; WWAA 1936–1953 (Milwaukee); Bucklin and Turner, 1932; Joslyn Art Museum library.
Lindberg studied art in Sweden. He exhibited regularly at the Milwaukee Art Institute from 1914 to 1922. About 1917 he began several years of teaching at the University of Minnesota. By 1924 he was living in Omaha where he exhibited occasionally. In 1928 and 1929 he exhibited at the Brooklyn Museum in New York.

Lindsay, Lilah Denton (–1943)
England, master's thesis; Oklahoma City Public Library.
Lindsay was educated in Ohio. She taught at Wealaka Indi-

an Boarding School near Bixby, Oklahoma, in 1884, and in Tulsa in 1893. She was considered a pioneer in the teaching of art in Oklahoma.

Linnell, Lilian B. (1894–)
B. Fredericton, New Brunswick. *Who's Who in Northwest Art* (Medina, Washington).
Linnell, who studied art in Seattle, Washington, worked in water color and in oil.

Linnen, Virginia Mitchell Hoskins (1848–)
B. Madison, Indiana. Houston Public Library art and artists' scrapbook; Witte Memorial Museum library, San Antonio, Texas.
Linnen studied at the Conservatory of Art in St. Louis, Missouri. By the late 1860s she was teaching in Sulphur Springs, Texas. Other Texas teaching positions included eight years in Cleburne, and an undisclosed number of years at the old Polytechnic College in Fort Worth where she had been the first art teacher hired. She was still active when she celebrated her ninety-first birthday on January 15, 1939, at her home near San Antonio.

Lockwood, Florence (1896–1963)
B. Santa Cruz, California. D. Carmel, California, November 22. California *Arts & Architecture,* December 1932 (Burlingame, California); Monterey Public Library; Monterey Peninsula *Herald,* November 23, 1963; Wallis, ed., *Western Woman,* v. 13, no. 2–3, 80; Carmel Art Association; Polk's City Directory 1941 (Carmel).
Lockwood studied in San Francisco at the Mark Hopkins Art Institute. She was a member of the Society of Western Artists for thrity-five years, and also a member of the Carmel Art Association. She specialized in pastel portraits of children.

Lockwood, (John) Ward (1894–1963)
B. Atchison, Kansas. D. Rancho de Taos, New Mexico, July 6. Work: Whitney Museum of American Art; Denver Art Museum; California Palace of the Legion of Honor, San Francisco; Pennsylvania Academy of Fine Arts; Colorado

Springs Fine Arts Center; Harwood Foundation, Taos; Museum of New Mexico, Santa Fe; Addison Gallery of American Art, Andover, Massachusetts; Dallas Museum of Fine Arts, etc. AAA 1923-1925 (Atchison); AAA 1927-1933 (Taos); Havlice; Mallett; WWAA 1936-1939 (Taos); WWAA 1941-1947 (Austin, Texas; summer, Taos); WWAA 1953-1959 (Berkeley, California); WWAA 1962 (Taos); AAW v. I; Loren Mozley, *Ward Lockwood/A Retrospective Exhibition of Paintings, Prints and Drawings,* Austin: University of Texas Art Department and Art Museum, 1967; "An Artist's Roots," *The Arts,* May 1940, 268-273; Charles C. Eldredge, *Ward Lockwood 1894-1963,* Lawrence, Kansas: University of Kansas Museum of Art, 1974; Coke, 1963.

"The Southwest is reflected in whatever he did, in obvious and ineffable ways," wrote Mozley for the catalogue of a traveling exhibit to places Lockwood had lived and taught art.

Lockwood's Taos paintings date from about 1926 when he first had a studio in Taos. From then on his home was there or in the general vicinity, when he wasn't away teaching.

Lockwood's teaching years began in Colorado Springs about 1932. From 1938 to 1948 he was chairman of the Art Department of the University of Texas; from 1949 to 1961 he was professor of art at the University of California in Berkeley. A sabbatical in 1957-1958 enabled him to return to his alma mater, the University of Kansas, as artist-in-residence.

Lockwood developed several mixed media innovations during his later years. "The compositions," wrote Mozley, were "more geometric and arbitrary." Forms derived from American Indian motifs were "combined with simplifications or distillations of Southwest landscape." An abstract treatment of familiar themes characterizes these paintings.

Lombard, Warren Plimpton (1855-1939)

B. West Newton, Massachusetts. D. July 13. Work: Library of Congress. AAA 1929-1931 (Ann Arbor, Michigan; summer, Monhegan, Maine); Havlice; Mallett Supplement; WWAA 1936-1939 (Ann Arbor; summer, Monhegan); WWAA 1940, obit.

Lombard was an etcher who did some work in California.

Lombardo, Emilio Vincent (1890-)

B. Italy. AAA 1921-1924 (Cambridge and Boston, Massachusetts); AAA 1925-1927 (Dorchester, Massachusetts); Mallett.

Lombardo studied at the San Francisco Institute of Art, and later pursued a career in Massachusetts.

Loomis, Manchus C. (-)

B. Fairview, Pennsylvania. AAA 1913 (Evanston, Illinois); AAA 1921 (Chicago, Illinois); AAA 1923-1924 (Villa Park, Illinois); AAA 1925-1933 (Chicago); Mallett.

Loomis studied at the San Francisco School of Design under Virgil Williams, and at the Art Institute of Chicago from which he graduated. He was sometimes referred to as Marcus instead of Manchus.

Lorenz, Richard (1858-1915)

B. Voigstadt, Germany. D. Milwaukee, Wisconsin, August 3. Work: Milwaukee Art Center; University Club of Milwaukee; Joslyn Art Museum; Amon Carter Museum of Western Art. AAA 1898-1913 (Milwaukee); AAA 1915, obit.; Benezit; Fielding; Mallett; AAW v. I; Margaret Fish, *Richard Lorenz/February 9, 1858, to August 3, 1915*, Milwaukee: Milwaukee Art Center, 1966; Stuart; NMAA-NPG Library, Smithsonian Institution.

Lorenz was twenty-eight when he arrived in Milwaukee where he spent about a year working on panoramas. A trip to San Francisco in 1887 to install one of these introduced him to the West. He remained for almost two years. Upon his return to Milwaukee to teach at the Milwaukee School of Art, he began making finished paintings from the hundreds of sketches he had done in California, Arizona, Texas, and Colorado.

During summer vacations he made other trips to the West. They included Nebraska, Wyoming, Montana, and the Dakotas. He painted his first Indians at the Crow Reservation in 1898.

When Lorenz's work was shown in Milwaukee in 1912, a newspaper critic termed it "the most important by a Wisconsin artist ever held in the city."

Influenced by the impressionists, Lorenz "made light part of his imagery, capturing exactly its quality and making viewers

conscious of it, in every possible condition," said Margaret Fish. His storm scenes on the Great Plains were painted as "convincingly" as Winslow Homer's storms at sea.

Lotave, Carl G. (1872-1924)

B. Jonkoping, Sweden. D. New York City, December 27. Work: Museum of New Mexico; Denver Public Library; Colorado Springs Fine Arts Center; Pioneers' Museum, Colorado Springs; Colorado Historical Society. AAA 1898-1900 (Lindsborg, Kansas); AAA 1925, obit.; Benezit; Fielding; Mallett; AAW v. I; Edna Robertson, "Museum Notes," *El Palacio*, Winter, 1974; "Carl Lotave," *Art News*, January 3, 1925, 4; McClurg, 1924, p. 52 in typescript at Denver Public Library; Colorado College Library; Inventory of American Paintings, Smithsonian Institution.

On the summit of Pikes Peak is a bronze tablet, placed there July 4, 1925, by friends of Lotave to honor a death pledge made in 1910.

Lotave lived in the West from 1897 to 1910, first in Kansas as dean of the art department of Bethany College; then in Colorado as a painter of Indian life for the Smithsonian's Bureau of Ethnology. He also painted portraits of Colorado Springs, Denver, and Santa Fe residents, and murals for the New Mexico State House.

Lotave had studied with Anders Zorn and in Paris. He is known for his portraits of Generals Joffre and Pershing, King Albert, Von Hindenburg, and other prominent persons.

Love, Charles Waldo (1881-1967)

B. Washington, D.C. Work: Santa Fe Railway Collection; Colorado Museum of Natural History; Colorado State Historical Museum; Stapleton Airport, Denver. AAA 1913 (Denver); AAA 1921-1927 (New York City); AAW v. I; Santa Fe Railway exhibition catalogue, *Standing Rainbows: Railroad Promotion of Art..*, May 1981; Hafen, 1948, v. II, 434; Denver Public Library.

Edgar McMechen in Hafen's *Colorado and Its People* called Love one of the few excellent miniature painters left in the America of the late forties. Love is also known for the back-

grounds he created for the habitat exhibits at the Museum of Natural History in Denver where he was a staff member.

Love studied in Denver with Henry Read. He won a scholarship to the Art Students League and later went to Paris for further study. His easel paintings are of Southwest subjects, the Rocky Mountains, and, while on the staff of the Colorado State Historical Society, a number of historical portraits.

Lowrie/Lowry, Eleanor (1875–)

B. Minnesota. Mallett Supplement (Seattle, Washington); *Who's Who in Northwest Art* (Seattle); New York City Municipal Art Committee brochure, 1937.

Lowrie studied at the Minneapolis Art Institute. She worked in oil and water color and exhibited at the Portland and Seattle art museums. Her work was selected for exhibition in New York City in 1937, along with that of several other Washington artists.

Lozowick, Louis (1892–1973)

B. Ludvinovka, Ukraine. D. South Orange, New Jersey, September 9. Work: Museum of Modern Art; Metropolitan Museum of Art; Boston Museum of Fine Arts; Cincinnati Art Museum; Honolulu Academy of Art; Los Angeles County Museum of Art; Houston Museum of Fine Arts; Library of Congress; Henry Gallery, University of Washington, etc. AAA 1929–1933 (New York City); Havlice; Mallett; WWAA 1936–1941 (New York City); WWAA 1947–1973 (South Orange, New Jersey); NMAA-NPG Library, Smithsonian Institution; Barbara Zabel, "Louis Lozowick and Urban Optimism of the 1920s," Archives of American Art *Journal*, v. IV, no. 2, 1974, 17–21; National Collection of Fine Arts [now NMAA], *Louis Lozowick: Drawings and Lithographs,* Washington, D.C.: Smithsonian Institution Press, 1975; Brown, 1955, 121–123.

In 1919, five years after his arrival in the United States, Lozowick toured our cities from coast to coast. While he was in Berlin the following year, his work during the tour began to take shape in a series of paintings and lithographs called "Cities." Lozowick's work has been described as "representational cubist,"

and by Milton Brown as "cubist realist." Over the years it "became progressively more realistic," said Brown.

Among the fourteen lithographs at the Library of Congress is "Grand Canyon," dated 1932.

Lum, Bertha Boynton (1897-1954)

B. Iowa. D. Genoa, Italy, in February. Work: Library of Congress. AAA 1913-1917 (Minneapolis, Minnesota); AAA 1919-1921 (San Francisco, California); AAA 1923-1933 (San Francisco; Peking, China); Fielding; Havlice; Mallett; WWAA 1936-1939 (San Francisco; Peking); WWAA 1940-1941 (Peking); Helen R. Rich, "Los Angeles (Calif.)," (American) Art News, December 4, 1920, 7.

Lum, who specialized in Oriental subjects, is widely known for her woodblock prints. A very large collection of them is in the Library of Congress, including "Point Lobos," a Monterey Peninsula scene dated 1920. She was also a painter.

Lundborg, Florence (1871-1949)

B. San Francisco, California. D. New York City, January 18. Work: Metropolitan Museum of Art; high schools in New York and Staten Island. AAA 1913-1915 (San Francisco); AAA 1917-1919 (New York City); AAA 1921-1924 (Paris); AAA 1925-1933 (New York City); Fielding; Havlice; Mallett; WWAA 1936-1947 (New York City); WWAA 1953, obit.; AAW v. I; Porter, and others, Art in America.

Although Lundborg painted landscapes that were well received, her ability as a mural painter was noted early in her career, and brought her more recognition. The decorations she did for the Panama-Pacific International Exposition were so "successful in execution as to make them worthy of the highest praise." She was also an illustrator.

Lundin, Emelia A. (1884-)

B. Stockholm, Sweden. AAA 1921-1929 (Seattle, Washington; summer 1923-1935, North Bend, Washington).

Lundin studied in Seattle with Paul Gustin and Fokko Tadema, and was active in the Seattle Fine Arts Society.

Lyle, Jeannette E. (1883–)
Who's Who in Northwest Art (Seattle, Washington).
Lyle studied with Peter Camfferman and worked in water color, oil, and pen-and-ink.

Lyser, Edna Potwin (1880–)
Work: Oakland Art Museum. Inventory of American Paintings, Smithsonian Institution.
Fourteen San Francisco Bay area landscapes and marines by Lyser are listed in the Smithsonian inventory as having been done between 1893 and 1916. All are in the Oakland Museum collection.

M

McAfee, Ila (1897–)
B. near Gunnison, Colorado. Work: Stark Museum, Orange, Texas; Greeley (Colorado) Public Library; Koshare Indian Kiva Museum, La Junta, Colorado; Thomas Gilcrease Institute of American History and Art, Tulsa, Oklahoma; murals at Gunnison; Clifton, Texas; Cordell and Edmund, Oklahoma post offices. Havlice; Mallett Supplement; WWAA 1940–1962 (Taos, New Mexico); Mary Carroll Nelson, "Ila McAfee of the White Horse Studio," *American Artist,* January 1981, 64–69; NMAA-NPG Library, Smithsonian Institution.
On a ranch near Crested Butte in Colorado high country McAfee spent her early years and made her first drawings. Following graduation from Western State College in Gunnison when it was a two-year normal school she studied art in Chicago and New York. She works largely from imagination, often featuring horses and other subjects associated with the West. She has lived in Taos since 1928. Her husband Elmer Page Turner also was an artist.

McArthur, Betty/Bettie (1865–)
B. Mississippi. AAA 1898–1903 (Tuskegee, Alabama); AAA 1907–1908 (Madison Station, Mississippi); AAA 1917–1927 (Columbus, Mississippi); Mallett (McHenry, Mississippi); *El Palacio,* November 11, 1931, 304.
McArthur was referred to as a Santa Fe (New Mexico) area artist in November 1931.

McCaig, Flora Thomas (1856–1933)
B. Royalton, New York. D. Flintridge, California, March 28. AAA 1898–1900 (Beverly, West Virginia); AAA 1905–1913 (Buffalo, New York); AAA 1915–1924 (Chicago); AAA 1925–1927 (Pasadena, California); AAA 1929–1931 (La Canada and Flintridge, California); AAA 1933, obit.; Fielding; Mallett.

McCall, Alice Howe (1882–)
B. Exeter, Devonshire, England. *Who's Who in Northwest Art* (Portland, Oregon).
McCall studied in London, Canada; Ashland, Oregon; and at the University of Oregon in Eugene. She exhibited locally.

MacCannell, Earl E. (1885–)
B. Boston, Massachusetts. Work: City Hall, Kentfield, California; Sacajawea State Park Museum, Pasco, Washington. *Who's Who in Northwest Art* (Olympia, Washington).
MacCannell, who worked in oils and pastels, studied in Boston and in Paris. He exhibited in Boston and in Mill Valley, California. "Marin County" is the title of the oil mural he did for the Kentfield City Hall, and "Fiesta Days" is the title of an oil mural he did for a private residence in Carmel, California.

McCarter, Henry Bainbridge (1864–1942)
B. Norristown, Pennsylvania. D. Philadelphia, November 20. Work: Pennsylvania Museum of Art; Pennsylvania Academy of Fine Arts; Whitney Museum of American Art; Corcoran Gallery of Art; Butler Institute of American Art. AAA 1903–1906 (New York City); AAA 1907–1919 (Bethayres, Pennsylvania); AAA 1923–1927 (Philadel-

phia); AAA 1929-1933 (Cedar Springs, Pennsylvania);
Benezit; Fielding; Havlice; Mallett; WWAA 1936-1941
(Philadelphia); WWAA 1947, obit.; Earle; NMAA-NPG Library, Smithsonian Institution; Denver Public Library,
Denver Artists' Club files.

McCarter spent a summer in Colorado teaching at the Denver Art Academy and exhibiting with Colorado's leading artists.

McCaslin, Louise (1896-)
B. Fresno, California. Work: City of Monterey collection.
Harbick; Colton Hall records, Monterey, California; Chase
Weaver, Monterey.

McCaslin was a graduate of the California School of Fine
Arts. From 1919 to 1921 she was art department head at Santa
Ana High School and Junior College in Southern California.
From 1942-1957 she taught at Fresno (California) High School.
She was a member of the Carmel Art Association and often
painted on the Monterey Peninsula. A water color in the City of
Monterey collection bears the following historical inscription:
"San Carlos Ranch, Carmel Valley; building where Jonathan
Wright found Robert Louis Stevenson."

McClain, George M. (1877-)
Mallett Supplement (Dallas, Texas).

McClain exhibited "Magnolia Blossom," an aquatint, at the
Dallas Museum of Fine Arts in 1936.

McClaire, Gerald Armstrong (1897-)
B. Seattle, Washington. AAA 1923-1925 (Seattle); Pierce,
1926.

McClaire was a landscape painter active in the mid-twenties.

McCloskey, Alberta Binford (1863-1911)
Work: Bowers Museum, Santa Ana, California. AAA 1903
(San Francisco, California); National Academy of Design,
1886 catalogue; Inventory of American Paintings, Smithsonian Institution; Los Angeles City Directory, 1894.

In 1886 McCloskey exhibited the following Western subjects at the National Academy of Design: "Colorado Poppies,"

"Snowballs from Colorado," and "California Blossoms." At that time she was living in New York City. She sometimes worked jointly with her husband William J. McCloskey. Two such joint efforts are listed under his name in the Smithsonian inventory.

Apparently the McCloskeys separated soon after 1900 for she is listed in the *Art Annual* as living in San Francisco; he, in Philadelphia.

McCloskey, William J./John/Joseph (1859–1941)
B. Philadelphia, Pennsylvania. Work: Society of California Pioneers; California Historical Society; Hudson River Museum, Yonkers, New York; Syracuse University. AAA 1903 (Philadelphia); *Who's Who in Northwest Art* (Ashland, Oregon); Gerdts and Burke, 1971, 163, 166–168; Gerdts, 1970, 28, exhibition catalogue; Inventory of American Paintings, Smithsonian Institution; Los Angeles City Directory, 1894.

Gerdts and Burke did extensive research on McCloskey and published the following information: McCloskey studied with Thomas Eakins and Christian Schussell at the Pennsylvania Academy of Fine Arts where he exhibited a crayon portrait in 1879. His specialty became still-life painting; his forte was fruit wrapped in tissue paper, "the treatment of which is a marvel of illusionistic painting," wrote Gerdts and Burke.

During the early years of McCloskey's career he was married to Alberta Binford, also a still-life and portrait painter. Two oils dated 1891–1896 are listed as joint efforts in the Smithsonian's inventory. About twenty others, mostly still lifes, are McCloskey's. McCloskey painted in various cities from coast to coast, and in England and France. He exhibited at the Paris Salon and with the Royal Academy of British Artists.

McClung, Florence White (1896–)
B. St. Louis, Missouri. Work: Metropolitan Museum of Art; Dallas Museum of Fine Arts; High Museum of Art, Atlanta; Delgado Museum, New Orleans; Library of Congress; University of Kansas; University of Texas, etc. AAA 1933 (Waxahachie, Texas); Fielding; Havlice; Mallett; WWAA 1936–1962 (Dallas); AAW v. I; O'Brien, 1935.

McClung, who taught at Trinity University in Waxahachie from 1928 to 1942, was especially active as an exhibiting artist

during the early 1940s. In addition to group shows, she had solo shows in Texas, Louisiana, Alabama, and London, England.

McClure, Lillie Delphine (1864–)
Ness and Orwig, 1939.
McClure was an Iowa artist who studied for two years in California.

McComas, Gene Baker/Gene Frances (1886–1982)
B. San Francisco, California. Work: Oakland Art Museum; Mills College; mural, Del Monte Lodge, Monterey Peninsula; Monterey Peninsula Museum of Art. Mallett (Pebble Beach, California); Havlice; WWAA 1940–1962 (Monterey, California; listed variously under McComas, Francis, and Frances); Spangenberg, 39–40; Irene Alexander, "Gene McComas Exhibit Powerful and Exciting," Monterey Peninsula *Herald*, November 18, 1955; John Woolfenden, "Bohemian Life Recalled by Gene McComas," Monterey Peninsula *Herald*, February 13, 1968, part 1; February 14, part 2; Monterey Public Library.
Gene Baker married the landscape painter Francis McComas late in 1917 when she was a journalist for the *Oakland Tribune*. She had had some formal art training. Following marriage she took up painting, and specialized in murals. Gertrude Stein thought the mural at Del Monte Lodge "the best thing she had seen in America," reported Woolfenden in recapping McComas's career.

McDade, Ira (1873–)
B. Pittsburgh, Pennsylvania. Work: Keystone Club, Pittsburgh. AAA 1917–1925 (Pittsburgh); Mallett Supplement (Fort Worth, Texas); O'Brien, 1935.

McDermott, Cecelia (–)
AAA 1923–1924 (Dallas, Texas); Fisk, 1928.
McDermott began her career as an illustrator for *Holland's Magazine*, a Texas publication. In 1916 she won first prize for figure composition at the Beaumont (Texas) fair. By the mid-twenties she was an assistant instructor at the Aunspaugh Art School in Dallas.

McEwen, Alexandrine (-)

B. Nottingham, England. AAA 1915-1921 (Detroit, Michigan); AAA 1923-1927 (Seven Dash Ranch, Johnson, Arizona).

McEwen was active mainly as an illustrator. She was the sister of the painter Katherine McEwen (1875-) whose biographical sketch appears in v. II of *Artists of the American West.*

McFee, Henry Lee (1886-1953)

B. St. Louis, Missouri. D. Altadena, California, March 19. Work: Metropolitan Museum of Art; Corcoran Gallery of Art; Pennsylvania Academy of Fine Arts; Cleveland Museum of Art; Dayton Art Institute; Kansas City Art Institute; Los Angeles County Fair collection; etc. AAA 1913-1933 (Woodstock, New York); Benezit; Fielding; Havlice; Mallett; WWAA 1936-1941 (Woodstock); WWAA 1947-1953 (Claremont, California); Gerdts and Burke, 1971, 227; Howald Collection catalogue, Columbus Gallery of Fine Arts, 80, 87; "Chouinard Classes," *Art Digest,* June 1, 1941, 32; Los Angeles *Times,* June 30, 1940; Castor typescript, San Francisco Public Library.

McFee was active in California from 1940.

McGlynn, Thomas A. (1878-1966)

B. San Francisco, California. D. Pebble Beach, California, June 21. Work: Oakland Art Museum; Monterey Peninsula Museum of Art. AAA 1917 (San Francisco); Havlice; Mallett Supplement; WWAA 1938-1941 (San Francisco; summers, Pebble Beach); AAW v. I; Betty Hoag McGlynn, *Thomas A. McGlynn,* 1979; Spangenberg; Irene Alexander, "Highlights Association March Program,"Monterey Peninsula *Herald,* March 8, 1949; Alexander, "Serene McGlynn Oils," *Herald,* November 16, 1962; Monterey Public Library.

By profession an art instructor, McGlynn taught at Girls' High School in San Francisco for twenty-seven years. He also carried on an interior decorating and furniture business. Much of his painting was done after 1938 when he began spending summers at Pebble Beach. In 1945, he moved there.

McGlynn combed the coastal area between Santa Barbara

and Mendocino for many of his landscapes. In reviewing a solo exhibition in March 1949, Irene Alexander called him "one of the most lyrical" of the California luminists. His daughter-in-law Betty Hoag McGlynn of San Mateo has published a detailed account of his life.

McGregor, Charles Malcolm (1868 – 1941)
Work: Private collection. Wilbanks, 1959, 55.

McGregor studied art at Baylor University where he won two medals of achievement, and then in Munich (1893–1894). Soon afterward he gave up painting to go into ranching in Haskell County, Texas. When he later returned to painting, he exhibited some of his work at West Texas Museum in Lubbock.

McGuire, Myrtle (1897–)
B. Portland, Oregon. *Who's Who in Northwest Art* (Portland).

McGuire studied with Maude Wanker and exhibited locally. She worked in oil.

Mack, Alexander Watson (1896–)
B. Scotland. Work: Private collections in Lubbock. Mallett Supplement (San Antonio, Texas); Fisk, 1928; O'Brien, 1935; Wilbanks, 1959.

Mack studied in Glasgow, Edinburgh, where he received a diploma from the Edinburgh School of Art; in London; and in Paris. He worked in all media. Although he specialized in portrait painting, he was skilled in landscape, still life, and mural painting. He left Scotland in 1925 to exhibit in the United States.

From 1926 to 1929 Mack was active in Lubbock where he taught free-hand drawing at Texas Tech and painting at Lubbock's School of Art. Thereafter he maintained studios in San Antonio and Amarillo until 1939 when he joined the British armed forces to serve in World War II. He returned to Texas in 1946 and made his home in Canyon.

McKay, Fawn Brimhall (1889–1960)
B. Spanish Fork, Utah. D. Huntsville, Utah. Work: Utah Institute of Fine Art and Utah State Fair collections. Olpin, 1980; Salt Lake City Public Library art and artists'

scrapbook; "Reflecting Atmosphere of Utah," Salt Lake *Tribune,* March 3, 1929; George Dibble, "Art," Salt Lake *Tribune,* October 16, 1960.

McKay studied at Brigham Young University. She was active in Associated Artists of Utah with which she exhibited throughout the state. To her contemporaries she was a water colorist's water colorist. Professor Dibble in his art column for the Salt Lake *Tribune* called her one of Utah's most gifted artists.

McKechnie, Mary (1887–)
B. Girard, Kansas. Mallett Supplement (Spokane, Washington); *Who's Who in Northwest Art* (Spokane).

McKechnie, who studied at the Pennsylvania Academy of Fine Arts, was best known for miniatures in oil and in water color. She had a solo exhibition at Grace Campbell Memorial Museum in Spokane in 1929.

McKenna, Helen (–)
Houston Museum of Fine Arts; Jack Flanagan, Houston, Texas.

McKenna exhibited two oils and three drawings at the Houston Museum of Fine Arts in 1934. Her husband William McKenna was also a Houston artist.

McKenna, William (ca 1866–)
Houston Museum of Fine Arts; Jack Flanagan and Doris Childress, both Houston artists, in interviews with the author.

McKenna, a commercial artist, was also known in Houston for his easel paintings. He exhibited an oil portrait of his wife Helen at the Houston Museum of Fine Arts in 1934.

Mackenzie, Catherine (1896–)
Work: Portland (Oregon) Art Museum. Mallett (Portland).

Five oils and water colors of Western subjects are at the Portland Art Museum. "Landscape with Rainbow," a water color, is dated 1935.

McKim, C. C. (–)
Who's Who in Northwest Art; Polk's Oregon and Washington Business Directory, 1919-20 (Portland, Oregon).

McKim, who studied with Winslow Homer, painted and taught art in Oregon. He is listed in WWNA as deceased.

Macklin, Lida Allen (1872–)

B. Marion, Ohio. *Who's Who in Northwest Art* (Portland, Oregon).

Macklin studied at the Portland Museum Art School, at University of Oregon extension, and with Clyde Keller and C. C. McKim. She worked in oil and in water color and exhibited locally.

MacLaren, T./Thomas (–1928)

B. Scotland. D. Colorado Springs, Colorado, December 4, 1928. Work: Victoria and Albert Museum, London. Withey; Grove typescript; McClurg, 1924, pt. IV; Wray, Colorado Springs *Gazette*, April 2, 1916, 7/1; Colorado Springs *Gazette*, May 15, 1921; Colorado College Library; Colorado Springs Fine Arts Center library.

MacLaren studied at South Kensington School of Art and at the Royal Academy of Arts, London. A gold medal and traveling scholarship from the latter enabled him to sketch for a year on the European continent, "making architectural sketches that appealed to him," said McClurg. Two hundred of these were exhibited in Colorado Springs in May 1921, according to the *Gazette*.

MacLaren moved to Colorado Springs in 1894 to regain his health, and remained to contribute significantly to its "beautification" through his ability as an architect. He exhibited various ones of his designs and architectural drawings at the Broadmoor Art Academy from 1920 to 1928.

McLellan, Ralph D. (1884–)

B. McLellan Ranch, near San Marcos, Texas. Work: Reading (Pennsylvania) Public Museum and Art Gallery; Philadelphia Public Schools collection; Southwest State College, San Marcos. AAA 1917–1919 (Boston, Massachusetts); AAA 1921–1933 (Philadelphia, Pennsylvania); Fielding; Havlice; Mallett; WWAA 1936–1941 (Philadelphia); WWAA 1947–1953 (New York City); WWAA 1956–1962 (Lime Rock, Connecticut); O'Brien, 1935; Houston Public

Library art and artists' scrapbook; L. N. Burleson, "Texas Artist Now Prominent As a Teacher," n.p., April 18, 1926, at Houston Public Library.

McLellan, who first studied art in San Marcos, grew up on a ranch. He was a painter and printmaker as well as a teacher. Some of his landscapes and portraits were done in the Southwest. He exhibited nationally.

McLoughlin, Gregory (1889–)
B. Santa Monica, California. Work: Westport (Connecticut) Public Library. AAA 1923-1924 (Rye and Mt. Kisco, New York); AAA 1925-1927 (Mt. Kisco); Havlice; Mallett Supplement; WWAA 1938-1941 (Washington, D.C.); Colorado College Library; Wray, Colorado Springs *Gazette*, April 2, 1916, 7/1.

McLoughlin was active in Colorado Springs at least as early as 1915, and as late as 1925. Among the paintings he exhibited at the Second Annual Exhibition at the Colorado Springs Academy of Fine Arts in June 1915, were "Colorado Pines," "Cottonwoods, Early April," and "Roadway and Plains After April Showers."

Wray referred to McLoughlin in 1916 as a self-taught painter who had been at work just two years, yet did not "need to stand in the reflected glory of his two famous uncles, George Townsend Cole and Robert Van Vorst Sewell."

McMahon, Emily Mahon (1882-1974)
B. James Mahon ranch near Stockton, California. D. Washington, D.C., June 30. Work: Private collections. Interview with Lucy McKay, Chevy Chase, Maryland.

McMahon, who studied with Mrs. I. S. Chambers in Omaha, Nebraska, was a resident of Omaha for many years.

McMahon, Harolde A. (1889–)
B. Dubuque, Iowa. *Who's Who in Northwest Art* (Portland, Oregon).

McMahon studied with Clyde Keller and others in Portland, and at the University of Oregon extension. He exhibited locally.

McNay, Marion Koogler (1883-1950)

B. Logan County, Ohio. D. San Antonio, Texas, ca April 13. Work: McNay Art Institute, San Antonio. Lois Wood Burkhalter, *Marion Koogler McNay: A Biography, 1883-1950*, San Antonio: Marion Koogler McNay Art Institute, 1968; McNay (Marion Koogler) Art Institute, a selective catalog printed by William S. Henson, Inc., Dallas, n.d.

McNay, who lived in Kansas from about 1884 to 1912, showed talent by the time she was nine. Known then as Jessie Koogler she attended the University of Kansas for two years and later studied at the Art Institute of Chicago where she was known as Marion Koogler.

Prior to marrying Don McNay in December 1917 she did some teaching in public schools. Ten months after the marriage her husband died in a Florida army camp. Thereafter, until marriage to Donald Atkinson in 1926 she signed her paintings Marion Koogler McNay. About 1936 McNay divorced Atkinson. In July 1937 she married the artist Victor Higgins; a divorce followed in 1940.

None of McNay's work bears the name Higgins, but her use of the other names at various times meant less recognition than she might otherwise have achieved.

McNay worked in water color and exhibited occasionally. From 1929 she painted many New Mexico Indian studies. Her interest in the welfare of Indians and her efforts on their behalf when proposed dams on the Rio Grande threatened their homes made her a welcome guest in their pueblos. She also painted in Navajo country.

McNulty, William Charles (1884-1963)

B. Ogden, Utah. D. Gloucester, Massachusetts, September 26. Work: Metropolitan Museum of Art; Boston Museum of Fine Arts; Whitney Museum of American Art; Library of Congress; Detroit Institute of Art; Newark Museum, etc. AAA 1925-1931 (New York City; summer, Rockport, Massachusetts); Benezit; Fielding; Havlice; Mallett; WWAA 1936-1959 (New York City; summer, Rockport); WWAA 1962 (Rockport); Bucklin and Turner, 1932.

McNulty grew up in Omaha, Nebraska, where he held a

position on the *World-Herald* under Guy Spencer, followed by positions on newspapers in Montana (*Anaconda Standard*), Portland, Seattle, St. Louis, and New York City. He exhibited mainly in New York where he taught at the Art Students League.

McVeigh, Blanche (1895–1970)

B. St. Charles, Missouri. Work: Library of Congress; Carnegie Institute; Oklahoma A&M; Princeton University; Pennsylvania Academy of Fine Arts; University of Texas; Fort Worth Art Center; Dallas Museum of Fine Arts; Amon Carter Museum of Western Art. Havlice; Mallett Supplement (Fort Worth, Texas); WWAA 1936–1962 (Fort Worth); *Texas Painting and Sculpture: 20th Century;* Houston Museum of Fine Arts library.

McVeigh was nationally known as an etcher specializing in aquatints. In 1931, with the help of two other artists, she founded the Fort Worth School of Fine Arts, where she taught figure drawing and etching.

Landscape, genre, and architectural subjects characterize much of McVeigh's work. In the late forties she turned to Taos, New Mexico, for new material.

MacWhirter, John A. (1839–1911)

B. Slateford, Scotland. D. London, England. Benezit; Havlice; Mallett; Waters; Graves, 1970; World's Columbian Exposition, v. 5.

MacWhirter worked abroad and in the United States. He arrived in America in 1877 and spent several years in California. His reputation as an etcher is international. He exhibited frequently at the Royal Academy where he was a member.

Maack, George J. (–)

B. New York City. Salt Lake City Public Library art and artists' scrapbook; "Mighty Marvel of the Winds," Salt Lake *Tribune,* October 26, 1924.

From age sixteen to nineteen Maack studied art during his free time. About 1889 he moved to Salt Lake City. His paintings of Utah scenery date from about 1904 and cover almost every part of the state, reported the *Tribune* which noted that his "appreciation of color, balance, perspective and mass [was] highly de-

veloped." Shown with the news article is a reproduction of Maack's painting "The Chinese Temple," a formation in Bryce Canyon.

Macy, William Starbuck (1853-1945)
B. New Bedford, Massachusetts. D. Santa Barbara, California, July 29. Benezit; Fielding; Havlice; Mallett; WWAA 1947 obituary; NMAA-NPG Library, Smithsonian Institution; "American Painters – William Starbuck Macy," *Art Journal*, August 1880, 225-226.
In 1880 Macy spent two months sketching in the Red River region of Dakota Territory and Minnesota. *Art Journal* illustrated its article with Macy's "A Forest Scene."

Madsen, Otto (1882-)
B. Germany of Danish parents. AAA 1923 (Kansas City, Missouri; summer, Point Loma, California); AAA 1925-1929 (Kansas City); Fielding; Mallett.
Madsen studied with Charles Wilimovsky, Oscar Berninghaus, and others. He did decorative panels for the California State Building at the Panama-Pacific International Exposition in 1915, and murals for a number of churches and office buildings. He was also an illustrator.

Maher, Kate Heath (-)
Work: California Historical Society. Inventory of American Paintings, Smithsonian Institution; California *Arts & Architecture*, December 1932 (San Francisco, California).

Mahier, Edith (1892-)
B. Baton Rouge, Louisiana. Work: mural, Watonga, Oklahoma, Post Office. AAA 1919 (Norman, Oklahoma); AAA 1923-1927 (Norman; summer, Nachitoches, Louisiana); AAA 1933 (Norman; summer, Baton Rouge, Louisiana); Fielding; Mallett; AAW v. I; Oklahoma City Public Library; Will May, "Oklahoma Artists' Exhibition Is Best Association Has Offered," *Daily Oklahoman*, November 21, 1926; "University Dress Designer Lauded/Edith Mahier Holds Fashion Spotlight," *Daily Oklahoman*, March 14, 1941; "Watonga's New Post Office Mural

'Stinks,' the Indians Say/Cheyennes Picketing In Protest,"
Oklahoma City *Times,* June 14, 1941; " 'He Stink' Says
Chief," *Art Digest,* July 1, 1941, 16.

Mahier, who taught at the University of Oklahoma for
many years, had a particular interest in Indians and their art. She
had great respect for the paintings of the Kiowas and other
tribes, and helped a number of Indians further their careers as
artists. She drew from their native ceremonial attire for fashion
designing, and from their culture for easel and mural paintings.
She certainly did not anticipate the unfriendly reception the
Cheyennes accorded her Watonga Post Office mural.

In defense Mahier said that she had read every book she
could find about the Cheyennes. She had entered the competition
"mainly because few Oklahoma artists were participating and
they were sending out this way eastern artists who were putting
English saddles on Indian ponies." She added, "At least I didn't
do that."

Maiben, Henry (–)
Olpin, 1980.

Maiben worked with George Ottinger in Salt Lake City
during the early 1860s, painting scenery for the Salt Lake
Theatre. Then he moved to Provo, Utah, where he became known
as a prominent painter and decorator.

Malm, Gustav, N. (1869–1928)
B. Svarttorp, Sweden. D. Lindsborg, Kansas. AAA 1919–
1929 (Lindsborg); Fielding; Reinbach, 1928.

Malm, who studied art in Sweden, was a painter, illustra-
tor, craftsman, and writer. He illustrated "Charlie Johnson," a
study of a Swedish emigrant. Since he was a member of the
Smoky Hill Art Club, it is likely that he exhibited locally. His
work may be in collections of Lindsborg residents.

Malone, Blondelle Octavia Edwards (1879–1951)
B. Athens, Georgia. D. Columbia, South Carolina, June 25.
AAA 1905–1913 (Columbia); AAA 1915 (Paris and Colum-
bia); AAA 1917 (Paris; Aiken, South Carolina); AAA 1925
(New York City); AAA 1927–1929 (Washington, D.C.);
Louise Jones DuBose, *Enigma/The Career of Blondelle*

Malone in Art and Society 1879–1951, Columbia: University of South Carolina Press, 1963.

Malone was a landscape and garden painter who was active in California, and exhibited at a number of public museums in the state. She was a pupil of Twachtman.

Manon, Estelle Ream (1884–)

B. Lincoln, Illinois. AAA 1917–1924 (St. Joseph, Missouri); AAA 1925–1927 (Nutley, New Jersey); Fielding; Young.

Manon studied with William Merritt Chase and Charles W. Hawthorne. She was active in Oklahoma as head of the art department of Oklahoma City High School, and as a member of the Oklahoma Art League.

Manser, Percy L. (1886–)

B. Tunbridge Wells, Kent, England. Work: Portland Art Museum; University of Oregon; University of Idaho; Hood River High School. *Who's Who in Northwest Art* (Hood River, Oregon); New York City Municipal Art Committee catalogue for its Second Annual, 1937; Portland Art Museum library.

Manser studied in England and in Ashland, Oregon, during a summer session taught by Pratt Institute faculty. He was one of three Oregon artists selected to exhibit oils in New York City in 1937. He also exhibited in Oregon and Idaho. Two mountain landscapes are at the Portland Art Museum.

Manuel, Donaldo (1890–)

B. Buenos Aires, Argentina. Work: Grumbacher Collection; Rollins College. Havlice; WWAA 1953–1962 (Pasadena, California).

Marlow, Lucy Clare Drake (–)

B. Erie, Pennsylvania. Work: University of Arizona; Board of Education, Pittsburgh, Pennsylvania. Havlice; Mallett Supplement; WWAA 1940–1941 (Tucson, Arizona; summer, Erie); Bermingham, 1980, exhibition catalogue, p. 7.

Marlow, who exhibited at Hoosier Salon, Carnegie Insti-

tute, and in Arizona, was well known in Tucson as a portrait painter.

Marple, William Lewis (1827-1910)

B. Philadelphia, Pennsylvania. D. Aspen, Colorado, February 23. Work: Oakland Art Museum; E. B. Crocker Art Gallery, Sacramento; Society of California Pioneers; California Historical Society. AAW v. I; San Francisco Public Library art and artists' scrapbook; typescript by Charles L. Marple, the artists' son, at San Francisco Public Library; Inventory of American Paintings, Smithsonian Institution; California State Library.

Marple, who painted many California scenes, especially of Northern California, arrived in San Francisco by ship in 1849. He worked for a while as a miner, then settled in San Francisco. During the 1870s he was a partner in the firm of Marple and Gump Art Gallery and on the board of directors of the first Art Association of San Francisco.

In 1878 Marple moved to St. Louis where he completed hundreds of paintings, including rural scenes of California. He sold many of them in San Francisco, and lost many during the 1906 earthquake and fire. He also sold paintings in St. Louis and in New York City.

Marsh, Lucile Patterson (1890-)

B. Rapid City, South Dakota. AAA 1925 (New York City); AAA 1927-1931 (New York City; summer, Torresdale, Pennsylvania); Havlice; Mallett; WWAA 1936-1962 (New York City); Bucklin and Turner, 1932.

Marsh lived in Omaha, Nebraska, from 1895 to 1909, and is thought of as a Nebraska artist. She studied at the Art Institute of Chicago and specialized in illustrations for national magazines that featured children.

Marshall, Mary (-)

B. Greenville, Texas. Fisk, 1928; O'Brien, 1935.

Marshall studied in colleges in Dallas, Texas, and Lexington, Kentucky; at Pratt Institute in Brooklyn; and privately in Provincetown, Massachusetts and Taos, New Mexico. She ob-

tained her bachelor's and master's degrees at Columbia University.

In 1922 Marshall joined the faculty at Texas State College for Women in Denton, a college Fisk said was considered by many to be the finest in the South. Several years later Marshall became assistant dean of fine arts, and in the mid-thirties, director of the Fine Arts Department. She exhibited in New York City and in various Texas cities, winning numerous awards, said O'Brien.

Martin, Jo G. (1886–)

B. Idaho Falls, Idaho. *Idaho Encyclopedia* (Pioche, Nevada); *Who's Who in Northwest Art* (Pioche).

Martin, who studied at the Art Institute of Chicago, illustrated several Western books for Caxton Printers in Caldwell, Idaho. She specialized in landscapes with equestrian themes, and in 1937 was given a solo exhibition at the Art Barn in Salt Lake City.

Martinez, Crescencio [Ta'e] (–1918)

B. San Ildefonso Pueblo, New Mexico. D. San Ildefonso, June 20. Work: Museum of New Mexico, Santa Fe. Dunn, 1968; Edgar L. Hewett, "Crescencio Martinez — Artist," *El Palacio*, August 3, 1918, 67–69; Bertha P. Dutton (ed.), *Indians of the Southwest*, Santa Fe: Southwestern Association on Indian Affairs, 1961; Edgar Lee Hewett, "Native American Artists," *Art and Archaeology*, March 1922, 107–108; NMAA-NPG Library and Inventory of American Paintings, Smithsonian Institution.

During May and June of 1929, paintings by Indian artists from the collection of Anne Evans, a Denver artist, were exhibited at the Boston Museum. The Washington *Post*, May 26, 1929, discussed the merit of the paintings on its art page, singling out Martinez for special praise: "The work he left shows a mature technique, perfect assurance of brush stroke, a remarkable sense of composition, arrangement, and color sense."

The twenty-four water colors by Martinez in the Museum of New Mexico are the gift of Dr. Hewett who knew Martinez well and had commissioned them in 1918 before the artist died. Mar-

tinez "will stand as the first [Indian] artist of record," said Hewett in his article for *El Palacio.*

Martinez, Julian (1897–1943)
 B. San Ildefonso Pueblo, New Mexico. D. San Ildefonso. Work: Museum of New Mexico; Museum of Northern Arizona; William A. Farnsworth Library and Art Museum. AAA 1933 (Santa Fe, New Mexico); Havlice; Mallett; WWAA 1936–1941 (Santa Fe); Ina Sizer Cassidy, "Tonita Peña Quah Ah)/Julian Martinez," *New Mexico* Magazine, November 1933, 28, 46; Dunn, 1968.
 The presence of Anglo artists in Santa Fe early in this century encouraged a number of Pueblo Indians to take up painting. Martinez had already developed his painting skills by doing designs on the pottery made by his wife Maria, now internationally known. When he began painting on paper in water color and tempera, he found them similar to the earth paints he used on Maria's pottery. Cassidy described his draftsmanship as perfect, his colors as radiant, and "his hand the obediant servant of his master mind."

Marulis/Marusis, Athan (1889–)
 B. Athens, Greece. AAA 1921–1925 (Seattle, Washington); Fielding; Calhoun, 35; Pierce, 1926.
 Marulis studied in Seattle with Paul Gustin, Yasushi Tanaka, and others. He was a member of the Seattle Fine Arts Society and contributed work to the first Annual Traveling Exhibition of the Western Association of Art Museum Directors.

Mason, Doris/Dora Belle Eaton (1896–)
 B. Green River, Wyoming. Work: Spokane Art Association. Havlice; WWAA 1947–1962 (Iowa City, Iowa); *Who's Who in Northwest Art* (Iowa City).
 Mason was active in Idaho while studying at the State Normal School in Lewiston in 1917, and the University of Idaho in Moscow. Later she studied at the University of Iowa in Iowa City. She exhibited in New York City, Brussels, Belgium, and Davenport, Iowa. She worked in oils, water colors, pastels, and charcoal, but specialized in sculpture and pottery.

Massenburg/Massenburgh, Eugenia C. (1869–)
B. Boston, Texas. Fisk, 1928; O'Brien, 1935.

Massenburg studied in Chicago, St. Louis, New York City at the Art Students League, and at several summer schools in New York and other eastern states. Among her teachers was Arthur Dow. She began her career in Paris, Texas, her home from 1882 to 1926. She exhibited locally and taught portrait painting, mural painting, and decorative art to large classes. Her own work included landscapes, portraits, miniatures, and mural decorations said to be in many private collections in the state. In 1926 she moved to Navasota, Texas.

Mast, Clara Glenn (1880–1947)
B. Delaware, Ohio. Fisk, 1928, 180; Wilbanks, 1959, 28, 34, 38, 40, 46, 49, 50, 51, 52, 54, 55.

Mast studied in Ohio prior to living in Lubbock, Texas, where she continued to study. She exhibited locally, in circuit shows, and at the Century of Progress exhibition in Chicago in 1933. Her oil painting entitled "Old Baldy" is reproduced in Wilbanks, page 28. She was a member of Texas Fine Arts Association, West Texas Museum Association, and a charter member of Texas Tech Art Institute.

Matheson, Johanna (See: Mathieson)

Mathews, Arthur Frank (1860–1945)
B. Markesan, Wisconsin. D. San Francisco, California, February 19. Work: Metropolitan Museum of Art; Oakland Public Library; University of California Library, Berkeley; California State Capitol. AAA 1909–1933 (San Francisco); Benezit; Fielding; Havlice; Mallett; WWAA 1936–1941 (San Francisco); AAW v. I; Jones, 1980; Neuhaus, 1931, 386; California State Library; *California Art Research,* mimeo.

The work of Mathews and his wife Lucia is again frequently seen. He set high standards in everything he undertook. Much of his painting is decorative; some of it is historical; but always it is "individual in treatment," said the *Argonaut* in November 1905. Somewhat ahead of his time in the California of his day,

Mathews nevertheless enjoyed a responsive reception to his exhibited works, especially his landscapes.

Mathews directed the California School of Design from 1890 to 1906. Following the earthquake and fire he advanced ideas in city planning in his publication *Philopolis*, and discussed art with a view to creating a beautiful city. He also opened a craft shop to supply furniture, art objects, and picture frames that would enhance the homes of San Francisco residents.

Mathews, Lucia Kleinhaus/Kleinhans (1872–1955)
B. San Francisco, California. D. Los Angeles, California, July 14. Work: Oakland Art Museum. AAA 1909–1931 (San Francisco); Fielding; Mallett; AAW v. I; Collins; Porter, and others, 1916; Jones, 1980; California State Library.

Mathews studied with Whistler, and with Arthur Mathews whom she later married. In 1915 she exhibited two paintings at the Panama-Pacific International Exposition and received a silver medal for the one titled "Monterey Oak."

Although Mathews' talent was unmistakable and her work exceptional, she chose to assume the role of collaborator with her husband in whatever he undertook, whether it was publishing *Philopolis* or running a craft shop. The latter led Mathews into designing art objects, some quite extraordinary. Jones discusses this phase of her production in detail.

Mathieson/Matheson, Johanna (–)
B. Tromso, Norway. AAA 1921–1925 (Seattle, Washington); Binheim (Hollywood, California); California State Library.

Mathieson, also known as Mrs. Elmer Newton Woolf, resided in Seattle prior to moving to California about 1925. She exhibited water colors and decorative pen and ink sketches in Seattle for five consecutive years. Thereafter she was employed as a costume designer at Universal Pictures Corporation in Hollywood.

Mathieu, Hubert/Herbert (1897–)
B. Brookings, South Dakota. AAA 1921 (South Dakota State College, Brookings); AAA 1925–1933 (New York

City; summer, Westport, Connecticut); Benezit; Havlice; Mallett; WWAA 1936–1941 (New York City; summer, Westport).

Mathieu, Mrs. Julien (–)
California State Library; *Overland Monthly,* August 1868, 115; *Alta California,* July 10, 1870, 1/1.

Caliban reviewed Mathieu's work in *Alta California.* He descirbed it as deficient in warmth, but said Mathieu had "much ability in water color art" and the "power to represent nature with a feeling far above the average."

Matthews, Harold J. (1897–)
Mallett Supplement (Houston, Texas).

Matthews was an engraver who exhibited a woodcut at the 1936 Exposition held at the Dallas Museum of Fine Arts.

Mauzey, Merritt (1898–1973)
B. Clifton, Texas. D. Dallas, Texas, November 14. Work: Whitney Museum of American Art; Houston Museum of Fine Arts; Art Institute of Chicago; Museum of the Southwest, Midland, Texas; Witte Memorial Museum, San Antonio; Library of Congress; Corcoran Gallery of Art; Metropolitan Museum of Art; Pennsylvania Academy of Fine Arts, etc. Havlice; Mallett; WWAA 1941–1970 (Dallas); AAW v. I; *Gaceta de Tejas,* August 1969, published by Museum of the Southwest, Midland; Houston Public Library art and artists' scrapbook; Viguers, 1958; Gordon Weaver, ed., *An Artist's Notebook/The Life and Art of Merritt Mauzey,* Memphis: Memphis State University Press, 1979.

Mauzey's career grew out of a desire "to make a graphic record of Southwestern rural life during the first portion of the century," reported *Gaceta de Tejas.* Mauzey knew especially well the life of a sharecropper on a cotton farm; for that had been his life at Sweetwater, Texas, until he moved to Dallas in 1934.

Mauzey is best known as a print maker. By 1938 he began exhibiting, and by 1969 he had done twenty-four solo shows and was internationally known. He was also a painter and an author of children's books depicting life in Texas.

Maverick, Lucy Madison (　–　)

B. probably in Sedalia, Missouri. AAA 1923-1924 (San Antonio, Texas); Mallett Supplement (San Antonio); O'Brien, 1935.

According to O'Brien, Maverick was a sister of Rena Maverick Green (1874-　) [AAW v. I]. Maverick worked in oils and exhibited in Philadelphia, New York City, and Texas.

May, Beulah (1883-1959)

B. Hiawatha, Kansas. D. Los Angeles, California. Work: Bowers Historical Museum, Santa Ana, California. AAA 1917-1933 (Santa Ana); Fielding; Havlice; Mallett; WWAA 1936-1947 (Santa Ana); California *Arts & Architecture,* December 1932.

May studied painting with William Merritt Chase but is better known as a sculptor. She exhibited in Southern California and wrote and illustrated two books: *Buccanner's Gold,* published in 1935, and *Cuentes de California,* in which she is co-author, published in 1937.

Mayer, Evelyn S. (　–　)

California *Arts & Architecture,* December 1932 (San Francisco); Olpin, 1980.

Mayer was a student assistant in the Department of Art of the University of Utah, 1913-1915, and instructor of art, 1915-1922. She was later active in San Francisco.

Mayo, Mrs. S. I. (　–　)

Splitter, 1959, 49; Los Angeles City Directory, 1887.

Mayo opened a studio in Los Angeles, California, in 1877. She exhibited several figure paintings at the Los Angeles County fair; painted landscapes and portraits to order, working from photographs; and taught drawing and painting.

Megargee, Lon (1883-1960)

B. Philadelphia, Pennsylvania. D. Cottonwood, Arizona, January 24. Work: Museum of New Mexico, Santa Fe; Museum of Northern Arizona, Flagstaff; Hubbell Trading Post Museum, Ganado, Arizona; Arizona Historical Society, Tucson; Santa Fe Railway Collection. AAA 1917-

1919 (Mesa, Arizona); Havlice; Mallett; WWAA 1940-1941 (Phoenix, Arizona); AAW v. I; "Lon Megargee," *Arizona Highways,* February 1974, 6-9, 38-41; Inventory of American Paintings, Smithsonian Institution.

Megargee, who wanted to be a cowboy, moved to Arizona while still a teenager and acquired a small ranch. A severe drought put him out of business soon afterward, but another ambition emerged – the desire to portray the Southwest. He studied at the Pennsylvania Academy of Fine Arts, the National Academy of Design, the Art Students League, Pratt Institute, and Cooper Union.

The Santa Fe Railway acquired its large collection of Megargee's work between 1911 and 1953. Many other paintings by Megargee have been reproduced in *Arizona Highways,* and as illustrations for commercial firms.

Megargee's career included a period in Los Angeles where he worked for several newspapers and later at the old Lasky (Paramount) Studio where he was head of the art department.

Melton, Mrs. Jesse J. (-)
AAA 1913 (Fort Worth, Texas).

Mendenhall, Emma (1873-)
B. Cincinnati, Ohio. AAA 1900-1933 (Cincinnati); Fielding; Havlice; Mallett; WWAA 1936-1962 except 1953, (Cincinnati).

Mendenhall was active in New Mexico about 1920 when she exhibited a number of local scenes in Santa Fe.

Menton, Mary Theresa (Murphy) (-)
Inventory of American Paintings, Smithsonian Institution; *News Notes of California Libraries,* January 1908, 13; *American Art Annual* 1898, 392.

Menton probably was a student at Mark Hopkins Institute of Art in San Francisco when she exhibited eight paintings at the Institute's Winter Exhibition, 1897-1898. Among them were "Sand Dunes, Monterey," "Old Military Headquarters, Monterey," and "Old House at Monterey." Four California Mission scenes, dated 1909-1911, are listed in the Smithsonian inventory.

Mermillod, A. (-1900)

D. Colorado Springs, Colorado, in May. Denver Public Library; Bromwell scrapbook, 28; Colorado Springs *Gazette,* June 28, 1898, 3/4, and May 23, 1900, 5/5.

The following watercolors, "When Clouds and Mountains Meet," "Early Winter Morn," and "Lingering Lights," and one oil by Mermillod were shown in the Denver Artists' Club exhibition. However, Mermillod was mainly a Colorado Springs art dealer who sold Copley prints of works by famous artists.

Merriam, Irma S. (-ca 1924)

AAA 1921-1925 (Seattle, Washington); Pierce, 1926; Calhoun 35.

Merriam was a landscape artist who contributed paintings to the first Annual Traveling Exhibition of the Western Association of Art Museum Directors, *circa* 1921.

Merriam, James Arthur (ca 1878-1951)

D. Los Angeles, California, in September. Gibson; California State Library; California *Arts & Architecture,* December 1932 (Los Angeles).

Gibson lists a James A. Merriam working in Detroit from 1897 until the early 1900s. He appears to have been active in Los Angeles from the mid-1920s.

Meuttman, William (-)

AAA 1913 (Cincinnati, Ohio); Inventory of American Paintings, Smithsonian Institution; *Antiques* Magazine, December 1978, 1206.

Three paintings by Meuttman are listed in the Smithsonian Inventory: "Apaches at River Bank," probably painted between 1910 and 1920, "Indian Burial," and "Vermillion Cliffs, Arizona."

Meyer, Elizabeth Barbara (1862-)

B. Winterthur, Switzerland. Bucklin and Turner, 1932 (Grand Island, Nebraska).

Meyer studied in Switzerland art schools; with Augustus Dunbier of Omaha, Nebraska; and with Mrs. D. L. Skiff of Boul-

der, Colorado. She exhibited locally. For many years she was chairman of the art department of Omaha Woman's Club.

Meyer, Myrtle (1889–)

B. Minneapolis, Minnesota. *Who's Who in Northwest Art* (Portland, Oregon).

Meyer studied in Minneapolis, Chicago, and Portland. Among her teachers was Maude Wanker. She exhibited locally.

Meysenburg/Meysenberg, Virginia C. (–)

Houston Public Library art and artists' scrapbook; Houston Museum of Fine Arts library; Chester G. Snowden, Houston, Texas.

Meysenburg, who retired to Houston, had been a professor at the University of Chicago and the University of Washington. She began doing woodblock prints during her spare time from teaching. Later she turned to oils. She exhibited in the 1930s at the Houston Museum of Fine Arts and the Dallas Museum of Fine Arts.

Midgley, Waldo (1888–)

B. Salt Lake City, Utah. Work: Library of Congress; Springville (Utah) Museum of Art. Mallett (New York City); Olpin, 1980; Salt Lake City Public Library art and artists' scrapbook; "Arresting Item in 'U' Exhibition," Salt Lake *Tribune*, December 5, 1937.

Midgley studied briefly in Chicago, 1915–1916, but mainly in New York City where his teachers were Mahonri Young, Robert Henri, John Sloan, and George Bellows. In 1924 he studied in Paris.

Intermittently Midgley returned West, and occasionally he exhibited there. An exhibition at the University of Utah in December 1937 elicited the following tribute: "Midgley's impressive beach scene, 'Santa Monica,' or the vigorous portrayal of 'Little Cottonwood,' have [sic] a quality to grace any metropolitan show."

Midgley retired in Salt Lake City where he completed an autobiography that, as Olpin says, "should prove interesting not only in regard to his life story but in connection with the lives of close friends including such interesting characters as M. M. Young."

Milam, Annie Nelson (1870–1934)

B. Homer, Louisiana. D. January 9. AAA 1919 (Fort Worth, Texas; summer, El Paso, Texas); AAA 1921–1925 (El Paso); AAA 1927–1929 (Canutillo, Texas); AAA 1931–1933 (Ennis, Texas); Benezit; Havlice; Mallett; WWAA 1936, obit.; AAW v. II; Fisk, 1928, 189.

Milan began teaching art in Louisiana before she was out of college. After moving to Texas she lived in Dallas, Kauffman, Fort Worth, and in 1920, El Paso. She exhibited mostly in Texas, except in 1913 when she was in New York studying with John F. Carlson at the Art Students League.

While regaining her health in the early 1920s, Milam lived for several years at Canutillo, a small town on the Rio Grande north of El Paso. There she did hundreds of small water colors and pastels of desert scenes. By 1928 more than 1200 of them were scattered throughout the United States, wrote Fisk.

Miles, Elsie Ziese (–)

B. Bellingham, Washington. Bucklin and Turner, 1932 (Lincoln, Nebraska).

Miles studied with Arthur Dow and later with Robert Reid when he was at the Broadmoor Art Academy in Colorado Springs. She taught at the University of Washington, the University of Idaho, and the University of Nebraska, the last from 1922 to 1925. She exhibited in Lincoln, and in New York City.

Millar, Clara L. (1893–)

B. Bowmanville, Ontario. Work: Collection of the Sultan of Johore, Federated Malay States. *Who's Who in Northwest Art* (Vancouver, British Columbia).

Millar studied at the Ontario School of Art in Toronto, the University of Washington in Seattle, in New York City, and in Paris. She exhibited locally.

Miller, Edith Luella (1889–)

B. Ogden, Iowa. Ness and Orwig, 1939 (Perry, Iowa).
Miller was active in Southern California.

Miller, Lilian May (1895–1943)

B. American Legation in Tokyo, Japan. D. San Francisco,

California, January 13. Work: British Museum; Smithsonian Institution; Baltimore Museum of Art; Denver Public Library; Art Institute of Chicago; Library of Congress. AAA 1932 (Kyoto, Japan); Havlice; Mallett; WWAA 1936–1937 (Kyoto); WWAA 1938–1941 (Honolulu, Hawaii); California State Library; San Francisco Public Library art and artists' scrapbook; NMAA-NPG Library, Smithsonian Institution.

Miller did mainly wood-block color prints of Japanese subjects. Her color prints of redwoods, exhibited in San Francisco, were reviewed favorably.

Miller, (T.) Oxley (1855–1909)

B. Columbia, California. D. Stockton, California, November 6. Work: Haggin Museum, Stockton; St. Mary's College, Moraga, California. Inventory of American Paintings, Smithsonian Institution; press release dated January 11, 1967, and fact sheet prepared by Miller's daughter for Haggin Museum.

Miller attended school in Stockton before entering the California School of Fine Arts in San Francisco where he studied with Virgil Williams and William Keith. The latter became a lifelong friend with whom Miller went on sketching trips.

About 1871 Miller went by horseback from Columbia to Yosemite Valley with George and Charles Crocker. Later Yosemite became a favorite place to paint. "Indians Camped in Yosemite Valley" is listed in the Smithsonian inventory along with eighteen other paintings.

In 1877 Miller opened a studio in the Hook's Building in Stockton and began teaching. He did many genre scenes and landscapes of Northern California, some dated as late as 1908.

Miller, Ralph Davison (1858–1945)

B. Cincinnati, Ohio. D. Los Angeles, California, December 14. Work: Santa Fe Railway collection; California Historical Society. WWAA 1947, obit.; AAW v. I; *National Cyclopaedia of American Biography*, v. 36, 240–241; Neeta Marquis, "The Paintings of Ralph Davison Miller," *International Studio*, July 1918, 3–7; Inventory of American Paintings, Smithsonian Institution; Castor typescript at

San Francisco Public Library; New York *Times,* obit., December 17, 1945, 21/5; Polk's Salinas, Monterey and Pacific Grove Directory, 1926 (Carmel, California).

Miller specialized in still life painting for a decade or more during the years he lived in Kansas City, Missouri. George Caleb Bingham also was there and helped the self-taught Miller improve his technique. During the 1890s Miller moved to Southern California where he painted landscapes and sometimes marines. He covered the coastal areas at least as far north as Mendocino County.

From other states came such paintings as "Black Lake, Colorado," dated 1903; "On the Colorful Arizona Desert"; "In a Hopi Village"; and "Indian Pueblo Scene," the last-named dated 1905.

Miller, Rose Kellogg (1890–)
B. Isle St. George, Ohio. *Who's Who in Northwest Art* (Missoula, Montana); Sternfels typescript at Butte-Silver Bowl Free Public Library, Butte, Montana.

Miller studied at Dayton (Ohio) Teachers' College; Federal Art School, Minneapolis; California School of Arts and Crafts, Oakland; and the University of Montana. She worked in oil, water color, and tempera, and had several solo exhibitions during the 1930s. She also exhibited at the Century of Progress Exposition in Chicago in 1933.

Miller, William Rickarby (1818–1893)
B. Staindrop, County Durham, England. D. New York City, in July. Work: Boston Museum of Fine Arts; New York Historical Society. Groce and Wallace; Havlice; Harper, 1970; Gerdts, 1964, 75; Gerdts and Burke, 1971; Karolik Collection catalogue; Inventory of American Paintings, Smithsonian Institution.

Miller studied art in Newcastle, England, in 1840, and probably had some lessons from his artist father. He arrived in the United States in 1844 or 1845 and settled first in Buffalo and later in New York City. Gerdts refers to him as an oil painter of note, but is especially complimentary about his water colors.

One of Miller's most ambitious projects was his "1000 Gems of American Landscape," in pen and ink which he did not

complete. For these he worked chiefly from nature, but occasionally copied the designs of other artists. His extensive travels apparently took him to San Francisco about 1869.

Between 1853 and 1876 Miller submitted work to fourteen of the National Academy of Design exhibitions. He also did a great deal of illustrating.

Milleson, Royal Hill (1849–)

B. Batavia, Ohio. Work: Herron Museum of Art, Indianapolis, Indiana; private collections. AAA 1905–1921 (Chicago, Illinois); Benezit; Fielding; Mallett; Sparks; Clark; Inventory of American Paintings, Smithsonian Institution.

Milleson was a landscape painter who exhibited annually in Chicago from 1903 to 1915 and wrote a book called *The Artist's Point of View*. His "Mt. Hood, Oregon" is at the Herron Museum.

Milligan, Gladys (1892–)

B. LaRue, Ohio. Work: Museum of New Mexico, Santa Fe. Havlice; Mallett; WWAA 1938–1962 (Washington, D.C.); McMahan; NMAA-NPG Library, Smithsonian Institution.

Milligan did a number of Southwest landscapes in oil and water color. A water color of Pikes Peak in Colorado is at the Museum of New Mexico. She taught at the National Cathedral School in Washington, D.C., from 1931 to 1962 and was active as an exhibiting artist from 1930 to 1955.

Mitchell, Mabel Kriebel (1897–)

B. Eau Claire, Wisconsin. *Who's Who in Northwest Art* (Seattle, Washington).

Mitchell studied at Federal Art School in Minneapolis, and with Eustace Ziegler and Leon Derbyshire in Seattle. She exhibited in Washington and in Minnesota.

Moellman, Charles Frederick (1844–1902)

B. Prussia. Work: University of Wyoming Archives. M. Barr, 11, 66; Nottage, 86.

Moellman was a farmer in Hillsboro, Ohio, when he enlisted in 1863. He remained in the Service until 1866, serving as a bugler in Company G of the 11th Ohio Volunteer Cavalry. During

that period he produced many pencil, crayon, and watercolor drawings while active in Nebraska and Wyoming. These naïve renderings are important historical documents, depicting as they do the life of the Indians, and the landmarks along the Oregon and Overland trails.

According to James Nottage, Moellman and Lieutenant Casper Collins, also in this volume of AAW, did at least seventy drawings along those trails, depicting "almost every military post and telegraph station" between Camp Mitchell, Nebraska, and the South Pass.

Moellman later settled in Cincinnati where he worked as a zinc etcher.

Montoya, Alfredo [Wen'Tsireh/Wen-Tsireh] (-1913)
B. San Ildefonso Pueblo, New Mexico. D. May 21. Work: Museum of New Mexico, Santa Fe; Museum of the American Indian, New York City. Bertha Pauline Dutton, "Alfredo Montoya – Pioneer Artist," *El Palacio,* July 1942, 143–144; Dunn, 1968; Herbert Joseph Spinden, "Artists of the Southwest," *International Studio,* February 1930, 51; Inventory of American Paintings, Smithsonian Institution.

Montoya first dabbled with paints when he was about ten. Spinden credits him and Crescencio Martinez with beginning the movement in San Ildefonso that inspired other Pueblo Indians to paint on paper. Montoya worked in water color and tempera.

Moore, Percy Caruthers (1888-)
B. Texas. Fisk, 1928 (Blossom, Texas).

Moore studied at the Art Institute of Chicago and with Howard Pyle and others. He exhibited portraits in Dallas and Fort Worth prior to abandoning the art field for farming and cotton buying.

Moore, Sarah Wool (-)
Bucklin and Turner, 1932, 23–24; *Nebraska Art Today,* A Centennial Invitational Exhibition, 1967, 9, Joslyn Art Museum catalogue.

In 1884, Moore, who had studied at the Vienna Academy of Fine Arts, began teaching drawing and painting at the University of Nebraska. Largely at her suggestion, art history was

added to her teaching schedule in 1885, and the study of anatomy in 1886. Her paper "History and Art" is quoted in *Nebraska Art Today*. She is credited with organizing the Haydon Art Club in 1888. Its purpose was to acquire a collection of art and a museum in which to display it. The club was renamed the Nebraska Art Association in 1900. Moore left the University in 1891.

Mopope, Steven (1898–1974)
B. Oklahoma. Work: Southwest Oklahoma State University, Weatherford; University of Oklahoma; Museum of New Mexico, Santa Fe. Havlice; Mallett Supplement; WWAA 1938–1941 (Fort Cobb, Oklahoma); Arthur Silberman, Guest Curator, the Oklahoma Museum of Art, Oklahoma City, 1978 exhibition catalogue, 2, 16, 56, 57.

Mopope credits two grand uncles with being his first teachers whose teaching was followed by instruction at St. Patrick's Mission School and the University of Oklahoma.

Moran, Earl (Steffa) (1893–)
B. Belle Plain, Iowa. Havlice; WWAA 1947–1953 (Los Angeles, California).

Morgan, Jean Scrimgeour (1868–1938)
B. Galveston, Texas. D. Galveston, December 2. Work: Rosenberg Library, Galveston. Witte Memorial Museum library, San Antonio; Lise Darst, curator, Rosenberg Library.

From 1886 to 1887 Morgan studied with Kenyon Cox, William Merritt Chase, J. Carroll Beckwith, and Thomas Eakins. About one hundred of her oil paintings, water colors, and drawings, made between 1880 and 1910, were exhibited in 1973.

Morgan was a prolific painter who specialized in hometown scenes, many of them of historical as well as aesthetic value. Sixty-five of her works are at the Rosenberg Library.

Morgan, Mary A. (1880–)
B. Philadelphia, Pennsylvania. *Who's Who in Northwest Art* (Burton, Vashon Island, Washington).

Morgan studied at Smith College, the Art Institute of Chi-

cago, and the University of Washington. She worked in oil, water color, and crayon, and exhibited mainly in Western Washington.

Morgan, Theophilus/Theodore/Theo J. (1872-1947)
B. Cincinnati, Ohio. D. March 14. Work: University of Indiana, Bloomington; Aurora (Illinois) Art Association; Houston Museum of Fine Arts; New Orleans Museum of Art; Witte Memorial Museum, San Antonio; Women's Building, Harlingen, Texas; Springville (Utah) Art Museum, etc. AAA 1907-1908 (New York City); AAA 1913-1919 (Washington, D.C.); AAA 1921-1931 (Washington, D.C. and Provincetown, Massachusetts); AAA 1933 (Washington, D.C.); Fielding; Havlice; Mallett; WWAA 1936-1941 (Atlantic City, New Jersey; summer, Forest Glen, Maryland); WWAA 1947 (Silver Spring, Maryland); Clark, 1932, reprinted 1975; Lilly, "The Texas Wild Flower Painting Competition," *American Magazine of Art*, June 1929, 345; Washington *Star*, obit., March 15, 1947; NMAA-NPG Library, Smithsonian Institution; Inventory of American Paintings, SI.
Morgan, who resided in Castroville, Texas, in 1929, was accustomed to living wherever he found subjects for his monotypes and oil landscapes. He spent months in California and Arizona.

Morris, Elizabeth H. (1887-)
Mallett Supplement (Houston, Texas).

Morrison, Louise Gertrude (1873-)
B. Boston, Massachusetts. AAA 1909-1910 (Paris, France); AAA 1915 (Bryn Mawr, Pennsylvania); AAA 1921-1924 (Seattle, Washington); *Who's Who in Northwest Art* (Seattle).
Morrison studied at Massachusetts Normal Art School, Cowles Art School of Boston, and the Academy de la Grande Chaumiere in Paris. She exhibited in Paris, Baltimore, Philadelphia, and Seattle. In 1939 she had a solo exhibition in Seattle.

Morrison, May (-)
B. Fort Concho, Texas. California State Library; *Who's Who Among the Women of California*, San Francisco and

Los Angeles: Security Publishing Company, 1922, 249 (Berkeley, California).

Morrison, who graduated from Berkeley High School in 1895, was active in Berkeley for a number of years as a teacher as well as an artist.

Morrow, Marie Catherine Rusche (1892–)
B. Columbus, Nebraska. Bucklin and Turner, 1932 (Columbus).

Following study with private teachers in Columbus, Omaha, and Chicago, and attendance at the Art Institute of Chicago, Morrow taught in Columbus schools and exhibited locally.

Morse, Samuel F. B. (1885–1969)
B. Newtonville, Massachusetts. Monterey and Carmel, California, public libraries; Carmel Art Association.

Morse, who was related to the famous artist and scientist by that name, took up painting in his late years and sold some of his work at Monterey Peninsula art exhibitions. He had lived on the Peninsula since 1915.

Morton, Charlotte A. (1885–)
B. Tescott, Kansas. Monterey and Carmel (California) public libraries; "The Artist Who Never Stayed Put," Peninsula *Spectator,* January 23, 1959; Carmel Art Association.

Following graduation from Kansas State College, Morton taught art. Later she studied at the Art Institute of Chicago, Pratt Institute, and the Art Students League.

Before moving to Carmel in 1947, she taught briefly at San Jose State College. In Carmel she developed a postcard industry featuring scenes of interest. It has been estimated that more than 200,000 cards depicting sixteen Carmel scenes were sold in twelve years. Later she turned to painting water color studies of Monterey Peninsula wild flowers.

Moser, (John) Henri (1876–1951)
B. Wabern, Switzerland. D. Logan, Utah, September 1. Work: University of Utah; Utah State Institute of Fine Arts; 9th and 21st Ward Latter Day Saints chapels. AAW v. I (Malad, Idaho; Payson and Logan, Utah); Haseltine;

Heaton, 95–98; Olpin, 163–166; Salt Lake City Public Library art and artists' scrapbook; "Lone Star State Calls Artist," Salt Lake *Tribune*, September 23, 1928; "Henri Moser's Work Hangs in Art Center," Salt Lake *Tribune*, February 17, 1963.

Moser was an engineering student at Utah State Agricultural College in Logan when one of his professors urged him to study art. Thereafter he studied with Utah artist Alma B. Wright, 1906–1908, and in Paris until 1910. In Paris he was befriended by Picasso.

Moser is known in Utah for his landscapes of the Teton Mountains, Zion National Park, Logan Canyon, and other scenic areas, and for his pioneer scenes. Early in his career he taught a year at Utah State and two years in Cedar City, Utah, at a branch of the State Agricultural College. While living in Idaho he was engaged in farming. In 1928 he went to Texas for a year.

Moses, Thomas G. (1856–1934)

B. Liverpool, England. D. Oak Park, Illinois. AAA 1909–1933 (Oak Park, Illinois; studio in Los Angeles from 1931); Benezit; Fielding; Mallett.

Moses was a landscape painter who occasionally painted marines. His affiliations in Southern California included the Laguna Beach Art Association and the California Art Club.

Muehlenbeck, Herbert P. (1886–)

B. Peoria, Illinois. Work: Washington State Capitol, Olympia. *Who's Who in Northwest Art* (Seattle, Washington).

Muehlenbeck studied at the Art Institute of Chicago and later exhibited there and at the Seattle Art Museum. He did portraits and landscapes, working in oil and in water color.

Mulroney, Regina Winifred (1895–)

B. New York City. AAA 1925–1931 (New York City; summer, San Francisco, California); AAA 1933 (San Francisco); Havlice; Mallett; WWAA 1936–1953 (San Francisco).

During the early years of her career Mulroney was active as a printmaker and a sculptor. Later she directed her own art school.

Multner, Ardis (1899–)

B. Spokane, Washington. *Who's Who in Northwest Art* (Des Moines, Washington).

Multner, who studied at the Denver Art Institute, was active mainly as a commercial artist. In 1927 she won two prizes for oil landscapes at the Montana state fair.

Mummert, Sallie Blyth (1888–)

B. Cisco, Texas. AAA 1917–1933 (Fort Worth, Texas); Benezit; Mallett; Fisk; *Texas Painting and Sculpture: 20th Century*, 20.

Mummert studied with Vivian Aunspaugh at the Aunspaugh Art School in Dallas, at the Art Institute of Chicago, and with William Merritt Chase in Florence, Italy, where he conducted classes in his later years. In Texas she is best known for her landscapes of local scenes, often featuring early landmarks, and for her years of activity on behalf of the arts in Fort Worth. She organized exhibitions, designed sets for Fort Worth's Little Theater, served as art critic, lectured, and taught art.

Muncy, Milton A. (–)

Pierce, 1926 (Seattle, Washington); Seattle *Town Crier*, March 25, 1911, 11.

Muncy was one of twenty artists whose work was in a traveling exhibition arranged by Washington State Federated Clubs in 1911. He was also a Seattle art dealer.

Munger, Gilbert Davis (1836/37–1903)

B. Madison, Connecticut. D. Washington, D.C., January 27. Work: Tweed Museum of Art, University of Minnesota; Miami University Art Gallery; Oakland Art Museum; Utah Museum of Fine Arts, etc. AAA 1903, obit.; Benezit; Groce and Wallace; Mallett; AAW v. I (Paris, France; Washington, D.C.); California State Library; Caliban in *Alta California*, March 27, 1870, 2/3, and June 5, 1870, 2/3; M. Barr; Donald R. Torbert, 13–14; Thurman Wilkins, *Clarence King*, New York: The Macmillan Company, 1958, 128, 135, 137, 215, 294; Pacific Coast Business Directory, 1871–73 (San Francisco, California); Inventory of American Paintings, Smithsonian Institution.

"They're crossing Laramie Plains" wrote Barr in his chronology to the exhibition catalogue *One Hundred Years of Artist Activity in Wyoming*. In 1867 Clarence King began his Fortieth Parallel survey for the War Department; Munger served intermittently as his "staff artist." During a side trip Munger painted an Indian encampment called "Indian Camp in the Tetons." It is listed in the Smithsonian inventory along with other Western titles.

Munger was with King in Utah in 1869. From this trip came "Great Salt Lake, Mormon City, and Wahsatch Mountains," exhibited at the Royal Academy in London in 1879. Several years later he joined King to work in Northern California.

Munger called St. Paul, Minnesota, home. He had a studio there from 1867 to 1874, overlapping another studio in San Francisco. Neither place offered much of a living for artists, and by 1875 Munger was in New York painting views from his Yosemite sketches for a wealthy British patron. In 1878 he opened a studio in London which overlapped a studio of longer duration in Paris. He spent the last years of his life in Washington, D.C.

Munn, Marguerite Campbell (-)
B. Washington, D.C. AAA 1921–1931 (Washington, D.C.); AAA 1933 (Crozet, Virginia; summer, Saltville, Virginia); Fielding; Havlice; Mallett; WWAA 1936–1941 (Washington, D.C.); McMahan; NMAA-NPG Library, Smithsonian Institution.

Munn, who was active in Washington, D.C., from 1917 to 1958, exhibited a number of mountain and desert subjects in 1929. February 17, 1929, the Washington *Star* called them a "strong and fine rendition of Western landscape."

Munroe, Marian (-)
AAA 1919 (Muskogee, Oklahoma).

Munson, Linley (See: Linley Munson Tonkin)

Murray, Ralph V. (1897-)
B. Boston, Massachusetts. Carmel Art Association, Carmel, California.

Murray studied locally with Burton Boundey and A. G.

Warshawsky, and exhibited oil paintings in Monterey Peninsula shows.

Musgrave, Arthur Franklin (1878–1969)
B. Brighton, England. Work: Museum of New Mexico, Santa Fe. AAA 1919–1921 (Santa Fe); AAA 1923–1925 (Washington, D.C.); AAA 1927 (Truro, Cape Cod, Massachusetts); AAA 1929–1933 (Cambridge, Massachusetts); Fielding; Havlice; Mallett; WWAA 1936–1941 (Cambridge; summer, Cape Cod); WWAA 1947–1959 (Cape Cod); AAW v. I; Santa Fe Public Library; Inventory of American Paintings, Smithsonian Institution.

Musgrave went to Santa Fe in 1916. The Museum of Fine Arts was then under construction, and he was the first to paint it. His "Patio and Tower of New Museum," "Sunlit Wall," "Patio Interior," "North Wall," and "Door of the Inner Court" were on display at the dedication exhibition in November 1917. Later he gave the Museum several of these oil paintings.

About 1920 Musgrave left Santa Fe to live in Washington, D.C. He lived in Santa Fe briefly in 1943, and it is said that he returned for the Museum's Fiftieth Anniversary Exhibition.

Mutton, Hilda (–)
AAA 1919–1925 (Hollywood, California).

Mutton, an etcher, was a member of the Printmakers of Los Angeles and the California Art Club.

Myers, Frank Harmon (1899–1956)
B. Cleves, Ohio. D. San Francisco, California, March 7. Work: Museum of New Mexico, Santa Fe; Oakland Art Museum; National Museum of American Art. AAA 1919–1931 (Cincinnati, Ohio); AAA 1933 (Silverton, Ohio); Benezit; Havlice; Mallett; WWAA 1936–1941 (Cincinnati); WWAA 1947–1956 (Pacific Grove, California); AAW v. I; Coke, 1963; Spangenberg; Carmel (California) Public Library; Albuquerque Public Library.

Myers, who taught many years in Cincinnati at the Art Academy and also at the University of Cincinnati, did a great deal of painting in New Mexico during the sixteen months he lived there in 1932 and 1933. It is said that Myers' concentrated work

of that period, in a land of shifting light and shadows, brought about a new direction in his painting.

When Myers left New Mexico in June 1933, it was to travel through the Chama River Valley, the Reservation of the Jicarilla Apaches, and across the New Mexico border to Mesa Verde in Colorado. Then Myers turned southwest, passing through the Navajo Reservation en route to California, and ultimately Cincinnati. Titles of his paintings and drawings indicate a considerable interest in nearly every phase of New Mexican and Indian life.

Later, seascapes predominated in Myers' work. That period began in 1940 in Pacific Grove. Spangenberg wrote that from then on he "painted the Pacific in storm and calm, in the dawn and at dusk."

Myers, O. Irwin (1888–)

B. Humphrey, Nebraska. AAA 1913–1927 (Chicago, Illinois); Fielding; Sparks.

Myers studied at the Art Institute of Chicago, the Chicago Academy of Fine Arts, and the University of Nebraska. He illustrated Indian stories for *Mother's Magazine, Home Life, Woman's World*, etc. He exhibited in Chicago for several years beginning in 1910.

Myers/Meyers, William H. (1815–)

Work: Bancroft Library, University of California, Berkeley; Franklin D. Roosevelt Library. Groce and Wallace; AAW v. I, under Meyers; NMAA-NPG Library, Smithsonian Institution; John Haskell Kemble, ed., *William H. Meyers/Journal of a Cruise to California and the Sandwich Islands in the United States Sloop-of-War CYANE 1841–1844*, San Francisco: Grabhorn Press for San Francisco Book Club of California, 1955; John Haskell Kemble, "The West Through Salt Spray," *Amercan West*, Fall 1964, 65–75; Taft, 253, note 3a.

According to Groce and Wallace, Myers' service in the Pacific spanned a period of sixteen years. His California sketches of San Pedro, Angel Island, Santa Barbara, and Hide Houses at San Diego, made in 1842 and 1843, are shown in Kemble's article for *American West*.

About 1931 a newly discovered diary with 105 full-page water color sketches was advertised at $2500, according to an undated item from the Washington Daily *News* found in a vertical file in the Smithsonian's NMAA-NPG Library. In the article Myers' colors are described as "good and his handling of the brush, excellent."

Myrick, Margaret Wilson (-)
Wilbanks, 1959, 24.

Myrick grew up in Corsicana and Beaumont, Texas. In 1912 she enrolled in the Chicago Academy of Fine Arts, and she also received some instruction at the Art Institute of Chicago. In 1915 she married and moved to Lubbock, Texas. A pastel dated 1912 is in a private collection in Sweetwater, Texas.

Myrick, Roberta Neal Miller (1866–1947)
Wilbanks, 1959, 24.

Myrick lived in San Antonio, Texas, prior to settling in Lubbock in 1915. For a time she taught water color, oil, and china painting. About 1944 she returned to teaching. An oil by her dated *circa* 1880 is in a private collection in Sweetwater, Texas.

N

Nahl, Virgil Theodore (1876–1930)
B. Alameda, California. D. San Francisco, California, February 9. Work: Oakland Art Museum; Society of California Pioneers. AAA 1930, obit.; AAW v. I (San Francisco); Mallett Supplement; *California Art Research,* mimeo.; Inventory of American Paintings, Smithsonian Institution.

Nahl was thirty-two years with the San Francisco *Examiner.* He did portraits, landscapes of California scenes and illustrations of pioneer types. He declined to sell his easel paintings, preferring to give them to his friends.

Nash, Louisa (–)
Work: Oregon Historical Society. Oregon Historical Society library.

Nash and her husband Wallis Nash were residents of London when they visited Oregon in 1877. The Oregon Historical Society has twenty-five of her oil paintings.

Nash, Wallis (1837–1926)
Oregon Historical Society library.

Nash was a London attorney who visited Oregon in 1877 and illustrated *There and Back in 1877* with pen-and-ink sketches. Oregon State University Press has published the book in paperback.

Nash, Willard Ayer (1898–1943)
B. Philadelphia, Pennsylvania. D. Los Angeles, California. Work: Museum of New Mexico, Santa Fe; Colorado Springs Fine Arts Center, Colorado; Denver Art Museum; Los Angeles County Art Museum; University of New Mexico. AAA 1921–1933 (Santa Fe); Fielding; Havlice; Mallett; WWAA 1936–1939 (Santa Fe); WWAA 1940–1941 (Hollywood, California); AAW v. I; Robertson and Nestor; Robertson, 1975; Coke; NMAA-NPG Library, Smithsonian Institution; Colorado Springs Fine Arts Center library.

Nash studied in Detroit and began his career there. In 1920 he went to Santa Fe to research material for a mural. When he showed some of the work he had just done, it was received with reservations by his Santa Fe colleagues; apparently he had yet to master the light and colors peculiar to the region. When he returned the following year to make his home there, *El Palacio* reported in its September issue a "greater brilliance" in his canvases and a "greater feeling for the luminous colors of the Southwest." Nash had "brought more light into his landscapes."

Though not yet a modernist, Nash found himself quite at home with Santa Fe's vanguard group of five, "Los Cinco Pintores," of which he was a member during its years of activity, 1921–1925. Other members were Fremont Ellis, Will Shuster, Walter Mruk, and Jozef Bakos.

During the late twenties Nash's work began attracting at-

tention in other cities. In 1931 he was engaged to teach a session on landscape painting at the Broadmoor Art Academy in Colorado Springs. In 1936 he began teaching in California, first in San Francisco, and then in Los Angeles. By that time he had demonstrated his competence in painting portraits and nudes as well as landscapes. A representative collection of his oils, water colors, and lithographs is at the Museum of New Mexico.

Neebe, Minnie Harms (1873–)
 B. Chicago, Illinois. Work: Chicago Municipal Collection; Chicago public schools. AAA 1915-1925 (Chicago); Fielding; Mallett Supplement; Sparks; Jacobson, 1932.
 Neebe, a regular exhibitor in Chicago from 1914 to 1932, painted in the Southwest and along the Pacific Coast. Her oil "The Black Mesa" is reproduced in Jacobson's *Art of Today.*

Needham, Charles Austin (1844-1923)
 B. Buffalo, New York. AAA 1898-1924 (New York City); Benezit; Fielding; Mallett; Hartmann, 1934, 110-111; Mark Hoffman, San Francisco.
 Hartmann, who called Needham an "expert watercolourist" with "something to say," has described Needham's work in detail. Needham's specialty was landscapes and street scenes.

Neilson, Thomas Raymond (1886–)
 B. Sunbury, Ohio. D. California. Work: Transition Gallery, Idaho State University Student Union. *Idaho Encyclopaedia* (Pocatello); *Western Artist,* March 1936, 17, 19; Leedice Kissane, Pocatello.
 Neilson taught music in Nampa, Idaho, public schools prior to the early twenties when he moved to Pocatello to teach art and music at Idaho Technical Institute (now Idaho State University). He soon became head of the Department of Music and Art. When the departments were separated in the early 1930s he headed the Art Department.
 "Neilson's work," wrote Kissane, "comprises numerous landscapes, representative of the Rocky Mountain country, particularly in its garb of autumn color." He also painted a number of snow scenes. While on a year's leave he painted seascapes at

Boothbay Harbor, Maine. He was given a one-man exhibition upon his return.

"Besides being a productive painter," wrote Kissane, "Mr. Neilson was a prominent member of the community, and was known for his tireless efforts to promote appreciation of art." By donating paintings from his personal collection he provided the nucleus for what became the Neilson Art Gallery. To enlarge the collection he persuaded citizens and civic organizations to purchase additional paintings. Ultimately this enlarged collection became the Transition Gallery at Idaho State University.

Neubauer, Margaret Barnett (ca 1899-)
Fisk, 1928, 139-140.

Neubauer studied with Eva Woodall in Taylor, Texas, for six years prior to attending the Art Institute of Chicago and the University of Chicago. She began exhibiting and selling paintings in Texas in 1925. In 1926 she was invited to spend the summer with Frank Reaugh and his other personally selected painters of exceptional talent to sketch in the Big Bend and Davis Mountain region of Texas.

Neubauer's palette knife paintings attracted the attention of a firm in San Antonio who gave her a solo exhibition.

Newell, George Glenn (1870-1947)

B. Berrien County, Michigan. D. Sharon, Connecticut, May 7. Work: Dallas Museum of Fine Arts; Detroit Institute of Art; Henry Gallery, University of Washington; Corcoran Gallery of Art; National Museum of American Art. AAA 1898-1910 (New York City); AAA 1913-1919 (Dover Plains, New York); AAA 1921-1933 (New York City); Fielding; Havlice; Mallett; WWAA 1936-1937 (New York City); WWAA 1938-1941 (Dover Plains); WWAA 1947, obit.; AAW v. I; Gibson; *Art Digest*, March 1, 1929; *American Magazine of Art*, June 1929, 345-346.

Newell, the well-known cattle and landscape painter, won the $2,000 first prize in the Texas ranch life class at the Texas Wild Flower Show in 1929. His prize-winning painting is pictured in the March 1 *Art Digest*. One hundred thirty-nine paintings were accepted that year, and $36,500 in prizes was given away. There were residence requirements for at least one category of

paintings. The show, though short-lived, attracted artists from all over the country.

Nichols, Harley De Witt (1859–1939)

B. Barton, Wisconsin. D. Orange County, California. Work: Laguna Beach Museum of Art. AAA 1898–1933 (New York City and Brooklyn; summer, 1915–1917, Montreal, Canada); Fielding, Havlice, Mallett; WWAA 1936–1940 (San Juan Capistrano, California); AAW v. I; California *Arts & Architecture,* December 1932 (San Juan Capistrano); Inventory of American Paintings, Smithsonian Institution.

Nichols, a landscape painter, etcher, and illustrator, was first in California in 1894. By 1932 he was living in San Juan Capistrano.

Nicholson, Jennie M. (1885–)

B. Dayton, Ohio. *Idaho Encyclopedia; Who's Who in Northwest Art* (Filer, Idaho).

Nicholson studied privately in Chicago. During her years in Filer where she taught art she exhibited at the University of Idaho, at Southern Idaho Art Center in Heyburn, and at Twin Falls. Some of her paintings have been reproduced on calendars. An oil, "Trinity Lake–Sawtooth Mts., Idaho," is in a private collection in Filer. She also worked in water color and pastel.

Nicholson, Lillie May (1884–1964)

B. near Aromas, California. D. Oakland, California, November 28. Work: Oakland Art Museum; Monterey Peninsula Museum of Art; Walter A. Nelson-Rees collection. Walter A. Nelson-Rees, *Lillie May Nicholson/1884–1964/ An Artist Rediscovered,* Oakland: WIM, 1981; Walter A. Nelson-Rees and James L. Coran, *Lillie May Nicholson . . .,* exhibition catalogue, Monterey Peninsula Museum of Art, April-May 1981; Charles Shere, "A Major Discovery in California Art," Oakland *Tribune, Today* Magazine, April 12, 1981, I–27; Joy Berry [a review], *California History/The Magazine of the California Historical Society,* Summer 1981, 196, 198.

The recently rediscovered paintings by Nicholson, an

American impressionist, are making their appearance in group and solo exhibitions in California. ". . . they are, at best," wrote Shere, "really quite wonderful, taking a place among much of the work done by such contemporaries as Seldon Gile and Oakland's 'Society of Six.'"

The discoverer of the work of Nicholson (not destroyed by her in 1947) is Walter Nelson-Rees who has written and published a book about her.

Nicholson, a school teacher by profession, began studying water color in 1910 with L. Minnie Pardee in Watsonville, California. Late in 1911 she went to Japan where she taught at Kyoto for two years and studied with one J. Taguchi. In July 1916 she began studying at the San Francisco Institute of Art during summer months. Gottardo Piazzoni appears to have been her favorite teacher there.

Nelson-Rees lists 335 of Nicholson's paintings with details as to media, size, subject titles, and ownership. Most are oils, and most were painted while Nicholson had a studio in Pacific Grove, California, 1923–1933. Nicholson painted mainly landscapes, genre scenes, and marines. Her subjects include San Francisco Bay, Lake Tahoe, Venice (Italy), Paris and Etaples, France and Monterey Bay.

In 1934 when Nicholson moved to Oakland, she may have intended to do portrait and figure painting. Many pencil sketches of persons observed at various downtown places such as Lake Merritt, the stock exchange, court rooms, and the library are extant, but apparently no paintings. Perhaps she destroyed them along with others in 1947.

Many beautiful color reproductions accompany the text of Nelson-Rees' book, along with an introduction by Joseph Armstrong Baird, Jr., and a photograph of the artist taken in 1918 by Dorothea Lange.

Nicoll, James Craig (1846–1918)
B. New York City. D. Norwalk, Connecticut, July 25. Work: Library of Congress; National Academy of Design; National Museum of American Art; Joslyn Art Museum, Omaha; Metropolitan Museum of Art. AAA 1898–1917 (New York City; summers from 1909, Olgunquit, Maine); AAA 1918, obit.; Benezit; Fielding; Havlice; Mallett; Na-

tional Academy of Design exhibition catalogue; Inventory of American Paintings, Smithsonian Institution.

Nicoll was a marine painter and etcher who did some work in California in 1897, including the island of Santa Catalina.

Nielsen, Holger (1883–)
B. Denmark. Bucklin and Turner, 1932 (Omaha, Nebraska).

Nielsen was a self-taught painter who exhibited with Nebraska Artists at the Art Institute of Omaha in 1929 and 1930.

Nielson, Harry A. (1881–)
B. Slagelse, Denmark. AAA 1919–1924 (Pasadena, California); AAA 1925 (Los Angeles, California); Fielding; California *Arts & Architecture,* December 1932 (Pasadena).

Nielson studied at the Art Institute of Chicago, and with Jean Mannheim. He was a member of the California Art Club in Los Angeles.

Nishii, K. (–)
Pierce, 1926 (Seattle, Washington).

This Japanese painter of still life may be Keigaku Nishii (1880–1937) listed in Roberts, 1976.

Nordfeldt/Nordfelt, Bror Julius Olsson (1878–1955)
B. Tulstorg, Sweden. D. Henderson, Texas, April 21. Work: Library of Congress; Museum of New Mexico, Santa Fe; University of North Carolina; Art Institute of Chicago; Montclair (New Jersey) Art Museum; University of Georgia; University of Minnesota; Wichita (Kansas) Art Museum; San Diego Fine Arts Gallery, etc. AAA 1903–1913 (Chicago, Illinois); AAA 1915–1917 (New York City; summer, Provincetown, Massachusetts); AAA 1919–1933 (Santa Fe); Benezit; Fielding; Havlice; Mallett; WWAA 1936–1941 (Santa Fe); WWAA 1947–1953 (Lambertsville, New Jersey); WWAA 1956, obit.; AAW v. I; Sparks; Earle; Van Deren Coke, *Nordfeldt the Painter,* Albuquerque: University of New Mexico Press, 1972; El Paso (Texas) Museum of Art, *B. J. O. Nordfeldt In Retrospect,* February-April 1963 exhibition catalogue; "Nordfeldt's Graphics at Princeton," *Art News,* December 1976, 90;

Robertson and Nestor; Robertson, Curator, *Handbook of the Collections, 1917–1974, Museum of Fine Arts,* Museum of New Mexico, 113, 115–116.

Nordfeldt was in California by 1913, and in New Mexico by late 1918 when his friend William Penhallow Henderson took him to Santa Fe. He felt "happy and energetic" there, wrote Robertson and Nestor, and made it his home for the next twenty years. There were, of course, teaching commitments and extensive travels elsewhere. But he did a large number of Southwestern subjects during those years.

Russell Cowles is credited with much of Nordfeldt's production. Previously Nordfeldt had destroyed many of his landscapes. With Cowles along on sketching trips, Nordfeldt made hundreds of charcoal studies which he used in his studio to make paintings and prints.

In Utah where Nordfeldt went in 1931 to teach at the State University, he often worked in the vicinity of Moab. He also did some work at Bear Lake, Idaho. Upon his return to Santa Fe, he and Cowles went to France.

Late in 1937 Nordfeldt decided to make Lambertville his permanent residence. During the early forties he was in Austin much of the time, teaching at the University of Texas.

Norskov, Hedvig (1889–1931)
D. Omaha, Nebraska. Bucklin and Turner, 1932; Joslyn Art Museum library.

Norskov was a member of the Omaha Art Guild. She exhibited water color paintings annually in Guild shows from 1925 to 1929.

Northington, Clara Beard (1882–)
Mallett Supplement (Egypt, Texas); O'Brien, 1935.

Northington was a self-taught artist who painted landscapes featuring windswept trees and shadows at dusk. She exhibited in group shows at the Houston Museum of Fine Arts and the Ney Museum in Austin.

Nuhn, Marjorie Ann (1898–)
B. Cedar Falls, Iowa. Mallett Supplement (Santa Fe, New Mexico); School of American Research, 1940.

Nuhn studied at the Chicago Academy of Fine Arts, the Art Institute of Chicago, and at Grant Wood's Art Colony in Iowa. She painted and exhibited in Iowa, New Mexico, California, and in Chicago, Illinois.

Nutting, Myron Chester (1890–)

B. Panaca, Nevada. Work: Library of Congress; murals, Museum of Natural History, Milwaukee, Wisconsin; High School, Beaver Dam, Wisconsin; Chateau Baradieu, France. AAA 1923–1925 (Paris, France); Havlice; Mallett; WWAA 1936–1941 (Milwaukee); WWAA 1947 (Hollywood, California); WWAA 1953 (Dallas, Texas); WWAA 1956–1966 (Los Angeles); "Composition," *Art News,* March 21, 1925; NMAA-NPG Library, Smithsonian Institution.

Nutting attracted favorable attention in France when he studied and exhibited there in the mid-twenties. *Art News* reported that his painting "Composition" had "won much praise from Paris critics" for its "mastery of form."

During Nutting's California years he taught at Chouinard Art Institute and the Los Angeles Art Center, and, in the mid-forties, wrote reviews for *Script* magazine.

O

Oakes, Mrs. A. T. (–)

Work: California Historical Society; Wells Fargo Bank History Room, San Francisco. Groce and Wallace; California State Library; *Alta California,* February 10, 1859, 2/2, and December 23, 1858, 2/2; National Academy of Design exhibition catalogue, 1874; NMAA-NPG Library and Inventory of American Paintings, Smithsonian Institution; Van Nostrand, 1980.

Sources disagree, and none are certain when Oakes arrived in California, or whether there were two Mrs. Oakeses. Mrs. A. T. Oakes resided in New York City in 1852, Boston in 1854, and probably arrived in San Francisco about 1855. The Smithsonian inventory lists "View of Mission Dolores" dated 1857, and "Ocean Beach, San Francisco" dated 1859.

Oakes exhibited at the National Academy of Design from 1865 to 1888. Subjects of her paintings indicate she also worked in Switzerland and in France.

Obata, Chiura (1885–)

B. Japan. Work: Oakland Art Museum. Mallett Supplement (Berkeley, California); AAW v. I; California *Arts & Architecture,* December 1932 (San Francisco); Oakland Museum exhibition catalogue, *A California Journey,* 1977; "Among the Print Makers, Old and Modern/Obata Wins Imperial Honor," *Art Digest,* February 1, 1931, 21; California State Library; San Francisco Public Library art and artists' scrapbook; Interview with Obata, ca 1953; *California Art Research,* mimeo.

Obata arrived in Seattle, Washington, in 1903, and subsequently settled in San Francisco where he sketched Bay area scenes and studied English. He subscribed to the old Japanese maxim, "An artist has nothing to say until he has painted a thousand paintings."

Obata's paintings reflect his love of California scenery, especially Yosemite. His "Lake Basin in High Sierra" won first prize at the eighty-seventh exhibition in Uyeno Park, Tokyo. He exhibited mainly in San Francisco Bay area museums after achieving his preliminary goal of a thousand paintings. He has also put in many years of teaching art.

O'Brien, Michael Edward (1854–1936)

D. Denver, Colorado, May 12. Mallett Supplement; *Western Artist,* June 1936, 5; "Hod Carrier Turns Artist," Washington Sunday *Star,* February 17, 1935; NMAA-NPG Library, Smithsonian Institution; Denver Public Library.

O'Brien was a construction worker who began painting late

in life and attracted favorable attention. "Rest by the Roadside" is pictured along with his photograph in the Sunday *Star.* He was interested in both abstract and representational painting. Following his death the Denver Art Museum held a memorial exhibition at Chappell House.

Oehler, Helen Bower/Helen Gapen (1893–1979)
B. Ottawa, Illinois. D. Monterey, California, February 17. Work: City of Monterey collection; Monterey Public Library. Havlice; Mallett; WWAA 1938–1939 (Ridgewood, New Jersey); WWAA 1940–1941 (Saddle River, New Jersey); WWAA 1947 (Westwood, New Jersey); WWAA 1953–1962 (Mill Valley, California); WWAA 1969–1978 (Carmel, California); "Helen Bower Oehler, Noted Carmel Valley Landscape Artist, Dies at 85," Monterey Peninsula *Herald,* February 19, 1979, 4; Monterey Public Library; Carmel Art Association.

Oehler graduated with honors at the Art Institute of Chicago, and at one time she taught there. Her work has been shown in over 200 museums and other galleries here and abroad, reported the *Herald.*

Ogilby, Robert E. (–1884)
D. ca March 9, probably in Oakland, California. Work: California State Library; Society of California Pioneers. Groce and Wallace; AAW v. I; Evans, Society of California Pioneers library; California State Library; Oakland and Alameda County Directory, 1870; Oakland City Directory 1873; San Francisco *Call,* March 9, 1884, 6/4, obit.

Ogilby was a professor of drawing at Durant University School and after it became the University of California in 1868. A portfolio of his miniature water colors at the California State Library shows Pescadero; Missions San Miguel and San Diego, dated 1864; San Fernando and Carmel Missions and Mt. Shasta, all dated 1873; Tahoe, 1874; San Juan Capistrano, 1875; and others that are not dated. The portfolio also contains pressed flowers and grasses.

According to Evans, Ogilby was active in California from 1852 to 1880, first as a topographer.

O'Keeffe, Ida Ten Eyck (1889-1961)

B. Sun Prairie, Wisconsin. D. Whittier, California. Havlice; Mallett Supplement (New York); WWAA 1938-1939 (Cortland, New York); WWAA 1940-1941 (New York City); Laurie Lisle, *Portrait of an Artist: A Biography of Georgia O'Keeffe,* New York: Seaview Books, 1980, 340, *et passim.*

O'Keeffe studied art at the University of Oregon and at Columbia University from which she graduated. She was an instructor and a supervisor of art at Cortland State Normal School before moving to Southern California. Occasionally she visited her famous sister in New Mexico. In 1974 her paintings were shown in Santa Fe.

Oldfield, Otis William (1890-1969)

B. Sacramento, California. D. San Francisco, California, May 18. Work: Library of Congress; Brooklyn Museum; Oakland Art Musuem; San Francisco Museum of Art; Palace of the Legion of Honor, San Francisco. Havlice; Mallett; WWAA 1938-1962 (San Francisco); AAW v. I; *California Art Research,* mimeo; California State Library; "The New York Season," *Art Digest,* February 1, 1931, 14; Thiel, 146-162.

Oldfield worked at many jobs to earn his way through art schools, including milking cows on a ranch near Battle Mountain, Nevada; sweeping floors and peeling potatoes in a Missoula, Montana, cafe; serving as mess boy on a Coeur d'Alene-Wallace, Idaho, branch railroad; but always taking time to sketch. After a few months at Arthur Best's art school in San Francisco and several more odd jobs he enrolled at Julian Academy in Paris, probably about 1909.

About 1924 Oldfield returned to San Francisco. From 1925 to 1942 he taught at the California School of Fine Arts, and from 1946 to 1952 at the California College of Arts and Crafts in Oakland. He exhibited in Paris from 1912 to 1924, and in the United States from 1925 to 1947. He won several important prizes, and was given some very favorable reviews such as the one appearing in *Art Digest* for a New York exhibition in 1931:

> Mr. Oldfield's paintings have been much in evidence this winter, but it is pleasant to come upon them

again. His ships, steamers and tugs, his figures of the water front have the vividness of personal contact and sympathetic interpretation. His increasing power of selection tells more and more in his work, placing the emphasis on design rather than mere factual statement, while his color grows richer and more varied.

Olds, Elizabeth (1897–)

B. Minneapolis, Minnesota. Work: Metropolitan Museum of Art; Brooklyn Museum; Seattle Art Museum; San Francisco Museum of Art; Hirshhorn Museum; Nebraska State Historical Society; Library of Congress, etc. AAA 1923–1924 (Minneapolis); AAA 1925 (New York City); AAA 1933 (Omaha, Nebraska); Havlice; Mallett; WWAA 1936–1937 (New York City; summer, Clinton, New York); WWAA 1938–1962 (New York City); WWAA 1966–1973 (Tamworth, New Hampshire); AAW v. I; Kingman, 1968; NMAA-NPG Library, Smithsonian Institution; Witte, 60.

In 1926 Olds received a Guggenheim fellowship in painting, the first woman to receive the award. She is probably best known today as a lithographer although she excelled in silkscreen and woodblock printing as well. As a painter she worked in oil, water color, and casein.

During the early thirties while living in Omaha she depicted the unemployed and dispossessed. Titles of these works include "Miss Manchester's Musical Program for Homeless Men," "The Preacher's Message to the Homeless Men," and "Black Jack at the Transient Shelter."

Olds traveled extensively in Mexico and Guatamala and throughout the United States. She wrote and illustrated several books, referring to this phase of her career as her "doublelife." She exhibited regularly until about 1952, often in one-person shows.

Oleson, Julie Haskell (1870–)

B. Fort Dodge, Iowa. Mallett Supplement (Fort Dodge); California *Arts & Architecture*, December 1932 (San Diego, California); Ness and Orwig, 1939.

Oliver, Joseph Kurtz (–)

Spangenberg, 34; Hoag, "Chronicle of Monterey Peninsula

Art"; Monterey Peninsula *Herald,* March 22, 1951; Monterey Public Library.

Oliver began his long residence in Pacific Grove in 1893 when he moved there from Kansas to teach art at a branch of the College of the Pacific (now University of the Pacific). He exhibited locally and had a significant impact on the development of art in Pacific Grove along with his colleagues William Adam and John Ivey. His son Myron Oliver also was an artist.

Olsen, Teckla (1889–)
B. Cedar Bluffs, Nebraska. Bucklin and Turner, 1932 (Omaha, Nebraska).

Olsen studied at the University of Nebraska and the Chicago Academy of Fine Arts.

Olson, Albert Byron (1885–1940)
B. Montrose, Colorado. D. March 9, probably in Denver, Colorado. Work: Denver Art Museum; mural, Illyria Branch Library, Denver; altar painting, St. Mark's Church, Denver. AAA 1915–1933 (Denver); Fielding; Havlice; Mallett; WWAA 1936–1941 (Denver); WWAA 1947, obit.; AAW v. I; Baker and Hafen, *History of Colorado,* v. III, 1270.

Olson studied at the Pennsylvania Academy of Fine Arts where he won the Henry Thouron prize, and in Paris and Madrid. He "developed an excellent technique in still life," and handled color "with precision and rare talent," said Edgar McMechen in a chapter for *History of Colorado.* Four of his paintings were exhibited at the Panama-Pacific International Exposition in San Francisco in 1915.

Olson, Joseph Oliver (–)
AAA 1915 (Seattle, Washington).

Onderdonk, Eleanor (1886–1964)
B. San Antonio, Texas. D. San Antonio, November 11. AAA 1923–1929 (San Antonio); Fisk, 1928; O'Brien, 1935; G. Smith, 1926; *Texas Painting and Sculpture: 20th Century,* p. 10; Witte Memorial Museum library, San Antonio.

Onderdonk grew up in a family in which her father and

brother were landscape painters. Occasionally she also painted landscapes, but her specialty was portraiture. After her father's death in 1917 she studied in New York where her principal teachers were Frank Vincent DuMond, Lucia Fairchild Fuller, and Alice Beckington.

Upon Onderdonk's return to San Antonio, the miniature painting she had learned from Fuller and Beckington was put to use when she found a ready market for ivory miniatures of women and children. From prominent women in Texas Onderdonk received many commissions for these miniatures, described by Fisk as "lovely."

In 1927, after teaching art for a number of years at Bon Avon School and St. Mary's Hall, Onderdonk embarked on a new career – that of curator of art for Witte Memorial Museum.

O'Neil/O'Neill, James Knox (1847–1922)

D. Omaha, Nebraska, June 6. Work: Joslyn Art Museum; Buffalo Bill Memorial Museum, Golden, Colorado. AAW v. I (Omaha); Bucklin and Turner, 1932, 19; Joslyn Art Museum library; Elizabeth Flynn, "Californian Reports on Artist-Father," Omaha Evening *World-Herald,* March 6, 1963, 14; Inventory of American Paintings, Smithsonian Institution.

O'Neil who taught art in Omaha from about 1880, exhibited frequently and won over forty awards. He is said to have grown up in the East and to have graduated from the Cincinnati School of Art. He is best known in Nebraska for portraits. However, Bucklin and Turner have called attention to his "The Battle of Wounded Knee" as especially noteworthy.

The *World-Herald* article describes O'Neil as "popular, handsome and debonair in the dashing manner of his friend, Buffalo Bill Cody, whom he closely resembled." A reproduction of a self-portrait wherein O'Neil is attired in Cody's clothing accompanies the article.

Ord, Edward O. C. (1818–1883)

B. Cumberland, Maryland. D. Havana, Cuba. Work: Catholic University, Washington, D. C. Ord, *The City of the Angels . . . in 1856,* (Neal Harlow, ed.), San Marino: Huntington Library, 1978.

General Ord, who was stationed in California for a number of years, was an amateur painter.

Ord, Edward O. C., Jr. (1858–1923)
B. Benicia Barracks, California. D. Eagle Rock, California, April 4. San Mateo, California, Public Library; *National Cyclopaedia of American Biography.*
Ord is said to have "possessed exceptional artistic ability." Following retirement from the military in 1918, he spent the rest of his life in California where he devoted his leisure time to marine and landscape painting.

Ormes, Eleanor R. (ca 1865–1938)
D. September 25, 1938, probably in Colorado Springs, Colorado. Colorado College Library; Colorado Springs Public Library; *Colorado Springs Gazette Index;* Wray, Colorado Springs *Gazette,* April 2, 1916, 7/1; McClurg, 1924, typescript p. 20.
Ormes studied painting two years in Philadelphia, including a course in drawing from life at the Pennsylvania Academy of Fine Arts. She became one of the most prolific amateur artists of Colorado Springs. Specializing in landscapes, she began exhibiting water colors a decade after her arrival in 1890. Later she worked with oils.
Ormes showed two California subjects – "Carmel Mission" and "Monterey Coast" – when she exhibited at the Broadmoor Art Academy in 1928, but most of her landscapes were scenes sketched in Cheyenne and Red Rock Canyons, Monument Valley Park, and the Rampart Range. She also did some still life painting.

Ostrom, Cora Chambers (1871–)
B. Harrison, Arkansas. AAA 1927–1933 (Eagle Pass, Texas); Mallett (Eagle Pass).

Ostrom, George (1888–)
B. Spencer, Iowa. M. Barr (Sheridan, Wyoming).
Ostrom was a Wyoming rancher who homesteaded in the state in 1913 after working briefly in a Minneapolis art studio. He designed the bucking bronco insignia for the 148th F. A. Battery of Artillery, World War I, that later became the symbol on

Wyoming license plates. His work consists of drawings and pen-and-ink sketches.

Otis, Minnie V. (–)
Reinbach, 571.
Washburn College in Topeka, Kansas, offered its first art class in 1865 with Otis as instructor, but had to abandon it a year or two later.

Owen, Narcissa Chisholm (1831–1911)
B. Webber Falls, Indian Territory (Oklahoma). D. Lynchburg, Virginia. Work: University of Virginia, Charlottesville; Oklahoma State Historical Society. McMahan (Washington, D.C.); England, Master's thesis; Jacobson and d'Ucel, 1954, 265–266; NMAA-NPG Library and Inventory of American Paintings, Smithsonian Institution.

Owen, who was part Cherokee, majored in art and music at the College of Evansville, Indiana. Her paintings consist mainly of portraits, including a self-portrait done in 1896. A portrait she did of Thomas Jefferson and several of his descendants won a medal at the St. Louis Exposition in 1904.

Jacobson and d'Ucel called Owen "a painter of more than average talent and competence." From 1895 to 1900 she was active in Washington, D.C. (Following her husband's death in 1873, Owen was sufficiently successful as a music teacher to educate her two children. Her son Robert Latham Owen was elected to the United States Senate when Oklahoma was admitted to the Union.)

P

Paca, Lillian Grace (1883–1978)
B. Jamaica, British West Indies. Mayo Hayes O'Donnell,

"An Exhibit in Santa Ana," Monterey Peninsula *Herald,* November 16, 1960; "Lillian Paca Takes Up Whales," Monterey Peninsula *Herald,* October 30, 1975, 32; "Lillian Grace Paca, Foremost Bird Artist, Writer, Dies at 94," Monterey Peninsula *Herald,* January 15, 1978; Carmel Art Association (Pacific Grove, California); Monterey Public Library.

Paca studied art in England, France, and Germany. Soon after the First World War during which she did intelligence work, she moved with her husband to the United States. She wrote and illustrated a number books, including *Our Great Gray Whales* which was based on her observations while living in Pacific Grove.

As an exhibiting artist Paca did not become active until the late 1950s. She exhibited at the Smithsonian Institution, Bowers Memorial Museum in Santa Ana, and in Monterey Peninsula cities. She was a member of the Carmel Art Association. Her principal medium was hard pastels.

Packer, Fred L./Frederick Little (1886–1956)
B. Hollywood, California. D. Brightwaters, New York, December 8. AAA 1925–1927 (New York City); *Who Was Who in America;* San Francisco art and artists' scrapbook; San Francisco *Examiner,* December 9, 1956, obit.; Inventory of American Paintings, Smithsonian Institution.

Packer was staff artist for the San Francisco Morning *Call* from 1907 to 1913, and art director of the San Francisco *Call-Post* from 1913 to 1918. Then he worked on Los Angeles papers until 1933 when he went to New York to work on the Daily *Mirror.* An oil landscape by Packer is listed in the Smithsonian Inventory of American Paintings.

Page, Harvey L. (1859–1934)
B. Washington, D.C. D. probably in San Antonio, Texas. O'Brien, 1935 (Washington, D.C. and San Antonio).

Page was an architect who lived in San Antonio from about 1900. The artist Robert Onderdonk encouraged him to take up painting and took him along on sketching trips. Many of his landscapes feature Texas bluebonnets and old missions. He used the

latter as "focal points of interest in most of his canvases," said O'Brien.

Pages, J. F. (1833-1910)

B. France. D. San Francisco, California, May 16. AAW v. I; California State Library; San Francisco *Examiner,* May 17, 1910, 6/6; L. Mason, Pacific Grove, California.

Pages came to California during the Gold Rush period, probably about 1857. He was an amateur painter and the father of the professional painter Jules, Jr. At the latter's request, the story goes, Jules, Sr. became J. F. to avoid confusing the two Juleses. The reference in AAW v. I to J. F.'s listing in Mallett is incorrect. He does not appear in either Mallett or Mallett Supplement.

Pages, Jules (1867-1946)

B. San Francisco, California. D. San Francisco, May 22. Work: M. H. de Young Museum and Palace of the Legion of Honor, San Francisco; Oakland Art Museum; California Historical Society; Detroit Institute of Arts; Springville (Utah) Museum of Art. AAA 1903-1919 (Paris, France, and San Francisco); AAA 1921-1933 (Paris); Benezit; Fielding; Havlice; Mallett; WWAA 1936-1941 (Paris); WWAA 1947, obit.; AAW v. I; San Francisco Public Library art and artists' scrapbook; "Jules Pages Dies at 79," San Francisco *Examiner,* May 23, 1946, 7/1; Donovan, 1908, 32; Inventory of American Paintings, Smithsonian Institution.

Pages achieved recognition on two continents by 1908 when the French Government purchased his popular Belgium cabaret scene "Les Convives." At that time he was spending more time in Paris where he was teaching, than in San Francisco where he was also well known. His San Francisco paintings, listed in the Smithsonian inventory, include "Street in Chinatown," painted before 1906; "Reconstruction in San Francisco After Fire and Earthquake of 1906," a very large canvas at the Oakland Museum; "View of Downtown San Francisco" and "View of Twin Peaks," painted in 1910. In 1915 he served on the International Jury of Awards at the Panama-Pacific Exposition in San Francisco.

Palansky, Abraham (1890–)
B. Lodz, Poland. Havlice; WWAA 1947–1962 (Los Angeles, California).

Palmer, Hattie Virginia Young (–)
B. Ripley, Ohio. AAA 1923-1933 (Houston, Texas); Mallett; Fisk, 1928; G. Smith, 1926; Clark, 1932, 1975.

Palmer moved to Houston with her husband in 1907. Previously she had lived in Indiana, and before that in Ohio where she had studied privately and at the Cincinnati Art Academy.

In 1924 Palmer exhibited Texas bay shore scenes showing Seabrook, Mud Island, and Goose Creek derricks; a fishing fleet at Kemah; and flower studies. Her bluebonnet paintings were sketched in the vicinity of Austin, La Grange, Tehuacana, and San Antonio. Sketching trips to West Texas were annual affairs.

In 1926 Palmer worked at Taos, New Mexico. The paintings from that trip created much interest when they were shown at the Museum of Fine Arts in Houston the following year, said Fisk.

Palmer exhibited at the Cincinnati Art Museum, Herron Art Institute, and an art museum in Nashville, Tennessee, as well as in Texas. Her work is said to be in many private collections from New York to California.

Palmer, Herman (1894–)
B. Farmington, Utah. AAA 1921-1929 (New York City); Benezit; Mallett (New York); Olpin, 1980.

Palmer, who illustrated *Hidden Heroes of the Rockies,* studied first at the University of Utah before joining Mahonri Young in New York City. He was a water color painter and an etcher. His goal was to become the "greatest painter of animals in the country," and he achieved some "well-deserved fame for very competent zoologically-inspired studies," said Olpin.

Paris, Walter (1842-1906)
B. London, England. D. Washington, D.C., November 26. Work: Boston Museum of Fine Arts (Karolik Collection); National Museum of American Art; Pioneers' Museum, Colorado Springs. AAA 1900-1903 (Washington, D.C.); AAA 1907, obit.; Benezit; Fielding; Mallett; AAW v. I;

Ormes and Ormes, 337; McClurg, 1924, pt. I; Colorado Springs *Gazette,* December 5, 1875, 2/4; March 6, 1875, 2/4; April 3, 1875, 2/7; April 19, 1892, 4/1; April 26, 1892, 4/1; June 24, 1892, 4/1; Colorado College Library; Colorado Springs Fine Arts Center library; Colorado Springs Public Library; Karolik Collection catalogue.

Paris was an architect and a water color painter. As architect he was with the British government in India from 1886 to 1890. In 1894 he became a citizen of the United States.

According to McClurg, Paris was first in Colorado Springs in 1871. He returned in 1874, probably after visiting California. When he exhibited at the Corcoran Gallery of Art in 1875, his paintings were seen by U. S. Geologist Ferdinand Vandeveer Hayden who was familiar with Colorado and commented on their "remarkable . . . fidelity to nature" and their importance as "excellent studies for the geologist."

December 5, 1874, a reporter for the Colorado Springs *Gazette* "had the pleasure" of visiting Paris in his studio and looking over his latest water colors. Paris also showed the reporter a chromo of "The Gate of the Garden of the Gods" executed the previous year in England from one of his drawings.

April 19, 1892, the *Gazette* reported that Paris had just returned from Cripple Creek, Colorado, bringing with him some "excellent sketches" of the town from various points, and two water colors of mountain scenery. Paris also had shown the *Gazette* reporter a sketch of Cripple Creek's main street while "the fire was in progress Wednesday night." June 24, 1892, the *Gazette* reported that Paris had just completed a "fine water color" painting of Gold Hill in Cripple Creek showing the Anaconda Mine.

Parke, Sara/Sarah Cornelia (1861–1937)

B. Houghton, Michigan. D. Palo Alto, California, January 23. Work: Monterey Public Library; Stevenson Museum, Scotland. *American Art Annual* 1898, 392; Spangenberg, 42, 44; Monterey Public Library; Josephine Blanch, "The Barbazon of California," *Del Monte Weekly,* May 13, 1911, previously published in *Overland Monthly.*

Sara Parke was the daughter of Hervey Parke of pharmaceutical renown. Her desire to paint materialized during childhood, and early efforts showed promise. She began studying in

New York in 1880 and later exhibited there and in San Francisco, California. However, she did not pursue painting as a career, preferring to paint for her own pleasure.

Places where Parke may have painted in the West include a family ranch near Santa Fe, New Mexico, and a family ranch in El Cajon Valley near San Diego. Many of her paintings are of the Pacific Grove area where she moved in 1906. Her favorite subjects were the windswept cypress trees so characteristic of the Monterey Peninsula. She also painted Carmel Mission and Monterey's old adobe buildings. Her interest in preserving the latter led to the purchase and restoration of the Barreto adobe.

Nine of Parke's Monterey Peninsula paintings have been used on post cards. A painting she called "Cliffs at La Jolla" was shown at the 1897–1898 Winter Exhibition at the Mark Hopkins Institute of Art. As to her paintings of the Monterey cypress, Blanch wrote that she painted them "with great strength and directness."

Parrish, Anne Lodge (–ca 1904)
B. Delaware or Pennsylvania. D. probably at Claymont, Delaware. Work: Pioneers' Museum, Colorado Springs, Colorado; El Paso Club, Colorado Springs; Wadsworth Atheneum, Hartford, Connecticut; Wheaton College, Norton, Massachusetts; Yale University. Groce and Wallace; AAW v. I; Inventory of American Paintings, Smithsonian Institution; *Facts*, a Colorado Springs weekly, February 19, 1898, 13; April 22, 1899, 14; February 3, 1900, 16; March 10, 1900, 6; November 10, 1900, 17; January 31, 1902, 12; Grove, typescript; McClurg, 1924, typescript, 11; Ormes and Ormes; Shalkop exhibition catalogue; Colorado College Library; Colorado Springs Public Library.

Parrish's family lived in Claymont, Delaware. She may have been born there. She studied in Paris and at the Pennsylvania Academy of Fine Arts. It was at PAFA that she met her husband Thomas (1837–1899), brother of Stephen Parrish and uncle of Maxfield Parrish.

Parrish moved to Colorado Springs with her husband, probably about 1880. They opened a studio and a few years later were joined by the New Jersey artist Frank T. Lent. Her work was the most extraordinary of the three. She had established a

reputation as a portrait painter "of high excellence" before she came to Colorado Springs, and "her talent more than equaled that of her husband," said McClurg. When she exhibited miniatures in April 1899, *Facts* weekly wrote that, "In point of detail and execution they show the most skillful and artistic touches and are equal to work seen anywhere." She was also an etcher. In 1888 she sent four prints to New York City for exhibition. She had painted a number of prominent persons in the East. Among those she painted in Colorado Springs was Helen Hunt Jackson.

Parrish, Thomas Clark/Clarkson (1837–1899)
B. Philadelphia, Pennsylvania. D. Colorado Springs, Colorado, November 7. AAW v. I; McClurg, 1924, typescript, 10; Grove, typescript; Ormes and Ormes, 337; Hafen, 1948, v. II, 436; *Facts,* a Colorado Springs weekly, February 19, 1898, 13; September 3, 1898, 20; December 3, 1898, 7; November 11, 1899, obit.; Colorado College Library; Colorado Springs Public Library.

Parrish studied at Pennsylvania Academy of Fine Arts. In Colorado Springs where he moved about 1872 he was known as a business man who dealt in real estate, a civic leader, and a painter and etcher. Regarding his etchings, McClurg said they "evinced sincere study and fine feeling" and showed his travels from Scandinavia to California.

Following the death of his first wife Parrish returned to Philadelphia, married portrait painter Anne Parrish, and returned to Colorado Springs about 1880. He illustrated *Colorado Springs, Its Climate, Scenery and Society,* published in 1889, and *Legends of the Pikes Peak Region* by Ernest Whitney, published in 1892. He was an uncle of Maxfield Parrish, and the brother of Stephen Parrish, a lesser known artist.

Parry, Caroline Keturah (1885–)
Olpin, 1980.

During the second decade of this century Parry studied with Edwin Evans at the University of Utah. Several sessions at the University of California, Berkeley, and four years of further study in New York, 1924–1927, followed. She returned to Utah where she managed to have a career in painting and sculpture as

well as in teaching. In 1935 she was in New York for another year's study at the Art Students' League.

Parsons, Ernestine (1884-1967)

B. Booneville, Missouri. D. Colorado Springs, Colorado, July 30. Work: Colorado Springs Fine Arts Center; Colorado Springs High School; Fort Carson. Havlice; Mallett Supplement; WWAA 1940-1966 (Colorado Springs); WWAA 1970, obit.; AAW v. I; Colorado Springs Fine Arts Center library; Paul Parker, "Parsons Landscapes on Exhibit," Colorado Springs *Telegraph*, October 22, 1944; Shalkop, exhibition catalogue.

Parsons was a Colorado Springs high school teacher who taught social and cultural history and painted on weekends, bank holidays, and after school, said Parker on the occasion of a solo exhibition in 1944. Her subjects were drawn from the Colorado scene—mining towns, mountains, plains, and Victorian buildings. The forties and fifties were especially busy years for Parsons who had several solo shows and exhibited in many group shows as well. She received several prizes.

Parsons, Laura B. (-)

Denver Public Library; *American Art Annual* 1898, 188.

Parsons exhibited an oil still life at the Fifth Annual of the Denver Artists' Club in 1898, and probably exhibited in 1900 when she was referred to in the Denver *Times* on March 15 as an active and prominent member of the DAC.

Parsons, Marian Randall (1878-1953)

B. San Francisco, California. D. July 17. Work: E. B. Crocker Art Gallery, Sacramento, California. *Who's Who in California*, 1942 (Berkeley); California State Library; Marian Randall Parsons, "Mono Vignette," Sierra Club *Bulletin*, December 1952, 68-74; B. H. Lehman, "Marian Randall Parsons," Sierra Club *Bulletin*, October 1953, 35-39.

Best known as a writer and a mountain climber, Parsons took up painting in the thirties and began exhibiting in 1941. Her paintings, mainly of old houses of historical importance, led to publication of her book, *California Houses*. Other paintings

337

reflect her interest in the Mono Lake region. The Crocker Art Gallery has a large collection of her work.

Parsons, Maude B. (–)
AAA 1921 (Seattle, Washington).
This may be Maude Bemis who was active in Colorado Springs, Colorado, in 1900, and married Reginald Hascall Parsons in January 1901. If so, further information can be obtained at Colorado College Library. *Facts* weekly, March 10, 1900, mentions water colors by Bemis and reproduces one on page 9.

Partridge, Esther E. (1875–)
B. Union City, Pennsylvania. *Who's Who in Northwest Art* (Spokane, Washington).
Partridge studied privately in San Francisco; at the Art Center School in Los Angeles; and at the Art Institute of Chicago summer school in Saugatuck, Michigan. She was active locally, with one solo exhibition in 1928. She worked in oil, pastel, and water color.

Patten, Katharine (1866–)
B. Bangor, Maine. *Who's Who in Northwest Art* (Portland, Oregon).
Patten was a water color painter who studied at the Museum of Fine Arts in Boston, the University of Minnesota, and privately with William Lester Stevens. She was given a solo exhibition at the Minneapolis Public Library.

Patterson, Viola (1898–)
B. Seattle, Washington. Work: Seattle Art Museum; Henry Gallery, University of Washington; Phoenix Art Museum. AAA 1929–1933 (Seattle); Havlice; Mallett; WWAA 1936–1966 (Seattle); AAW v. I; Collins; Kingsbury, 1972, 26; "Seattle Art Notes," *American Magazine of Art*, June 1928, 339; *Who's Who in Northwest Art*.
From 1928, when Patterson received a prize for the "outstanding picture" of the Northwest Artists' Annual in Seattle, she exhibited regularly in group and solo shows. Her husband Ambrose also was an artist. Both taught at the University of Washington.

Patty, William Arthur (1884–1961)

B. New Hartford, Connecticut. D. Laguna Beach, California. AAA 1919–1933 (New York City and Brooklyn): Fielding; Havlice; Mallett; WWAA 1936–1941 (New York City); WWAA 1947–1959 (Hollywood and Laguna Beach, California); WWAA 1962, obit.

Paulsen, Esther Erika (1896–)

B. Skamania, Washington. Work: Cache County Public Library, Utah. Mallett Supplement (Logan, Utah); *Who's Who in Northwest Art* (Logan); Olpin, 1980; *Western Artist*, June 1936, 10.

Paulsen studied art at Washington State College, Pullman; Utah State Agricultural College, Logan; and privately with Birger Sandzen, Ralph Stackpole, and Otis Oldfield. She achieved recognition in Washington before moving to Logan, but she is better known in Utah. During her career which spanned the years 1930–1959 she traveled extensively in foreign countries, including China, Japan, Hawaii, and the Phillipine Islands. She exhibited often in the United States where she is known for lithographs, sculptures in stone, and paintings in oil and water color.

Paxson, Stella (–)

Wilbanks, 1959, 16.

The November 28, 1887, Crosby County *News* reported that Paxson, an artist from Bristol, Indiana, was visiting a school teacher friend in Estacado, Texas, and sketching some of the local Quakers and their adobe houses.

Paxton, William A. (–)

AAA 1919–1925 (Los Angeles, California); Fielding; California *Arts & Architecture*, December 1932 (Los Angeles).

Paxton was a painter and an etcher, and a member of the California Art Club in Los Angeles.

Payne, Lura Masterson (–)

B. Chenango, Brazoria County, Texas. Fisk, 1928 (Houston, Texas); G. Smith, 1926; Houston Public Library art and artists' scrapbook; Ellen Douglas MacCorquodale, "Houston Woman's Portfolio Shows Mastery of Applied

Design Technic," Houston *Post-Dispatch*, November 28, 1926.

Payne attended public schools in Beaumont, Texas, and studied art with local teachers before attending Newcomb College in New Orleans for three years. At the Art Institute of Chicago she studied five years and specialized in decorative design. Her principal teacher there was Antonio Serba.

Following marriage to Chicago newspaperman John H. Payne, Payne moved to New York, and later to Cincinnati where she became a decorator for Rookwood Pottery. When her husband accepted a position with the Houston *Press* in 1919, she began specializing in portraiture. During her career she exhibited in New Orleans, Cincinnati, Houston, and Beaumont.

Peabody, Lucy L. (–)

AAA 1913 (Cambridge, Massachusetts); AAA 1915–1917 (Toledo, Ohio); AAA 1919 (Quincy, Massachusetts); Polk's City Directory, 1930 (Carmel, California); "'Art' and 'Carmel' Synonymous," Monterey Peninsula *Herald*, October 18, 1966, A4/3; *American Magazine of Art*, April 1927, 220; April 1929, 236.

It is likely that Peabody moved to Carmel in the early 1920s, for she was a member of the Carmel Art Colony by 1925. In 1927 she won a prize at the California Society of Miniature Painters' Tenth Annual Exhibition, and an honorable mention at the Society's Twelfth Annual in 1929. She is listed in the *Art Annual* as Mrs. L. L. Peabody.

Pearce, Edgar Lewis (1885–)

B. Philadelphia. Work: Pennsylvania Academy of Fine Arts; National Academy of Design; Carnegie Institute, Pittsburgh. AAA 1913–1917 (Philadelphia); AAA 1919 (Tulsa, Oklahoma; Manasquan, New Jersey); AAA 1921 (St. Louis, Missouri); AAA 1923–1925 (Manasquan); Benezit; Fielding; Havlice; Mallett Supplement; WWAA 1938–1953 (Manasquan).

Pearce, Mary Blake (1890–)

B. Cuero, Texas. Mallett Supplement (Dallas, Texas); Fisk, 1928, 103.

After graduating from college Pearce studied in Europe for three years, specializing in portraiture. Later she studied at the Art Students' League. She did some college level teaching prior to becoming active in Dallas as a designer and an illustrator.

Pease, Lucius Curtis [Lute] (1869–1963)
B. Winnemucca, Nevada. D. Maplewood, New Jersey, August 16. Havlice; Mallett (Newark, New Jersey); WWAA 1936–1941, 1959–1962 (Maplewood, New Jersey); AAW v. I; New York *Times,* obit., August 17, 1963, 19/2; Stenzel, *Early Days in the Northwest,* 19, a Portland Art Museum exhibition catalogue; Inventory of American Paintings, Smithsonian Institution.

Pease grew up without money to study painting. Following marriage in 1905 to Nell McMillan he learned from her the fundamentals. Notwithstanding his early deprivation, he began his career as a newspaper artist in 1895. From 1897 to 1901 he was the Yukon-Nome correspondent for Portland and Seattle papers; from 1902 to 1906 he was staff artist for the Portland *Oregonian;* from 1906 to 1914 he was editor of *Pacific Monthly* Magazine. The next thirty years he worked as a cartoonist with the Newark *Evening News.*

The Inventory of American Paintings lists a number of oils, mostly of Alaska gold strike scenes. It is likely that these were done later from sketches made during the years he was active in Alaska.

Pease, Nell Christmas McMillan/McMullin (1873–1958)
B. Steubenville, Ohio. Havlice; Mallett Supplement (Maplewood, New Jersey); WWAA 1938–1951 (Maplewood); Stenzel, *Early Days in the Northwest,* 19, a Portland Art Museum exhibition catalogue; Inventory of American Paintings, Smithsonian Institution.

Pease lived in Portland, Oregon, from 1905 to 1914, and did some of the cover illustrations for *Pacific Monthly* magazine of which her husband Lute Pease was editor.

Peck, Anne Merriman (1884–)
B. Piermont, New York. Work: Newark Museum. AAA 1909–1927 (New York City; summer 1913–1917, Washing-

ton, Connecticut); AAA 1929-1932 (Croton-on-Hudson, New York); Benezit; Fielding; Mallett; Havlice; WWAA 1936-1953 (New York City); Mahony, 1947; Viguers, 1958.

Peck was an illustrator who specialized in woodcuts and lithographs, but painted in her leisure time. She traveled widely, and lived for extended periods in Tucson, where she found inspiration in the "beautiful Arizona desert country." She was active in Tucson art organizations, taught in the extension division of the University of Arizona, and wrote and illustrated *Southwest Roundup*.

Peck, Charles (1827-1900)

B. Burlington, Vermont. D. Chicago, Illinois, December 10. Work: Wadsworth Atheneum. Mallett; Sparks; Inventory of American Paintings and NMAA-NPG Library, Smithsonian Institution.

Peck's interest in the West grew out of a trip to California in 1849. Unsuccessful as a gold miner, he painted houses in San Francisco until he could book passage back by ship. Whatever caught his attention he sketched and later used in easel paintings and a panorama. The latter was described in 1850 as 2400 yards of canvas, nine feet in width, representing thirty-eight cities and towns in California, and 5,000 miles of country, including the Pacific Isthmus and the Gulf of Mexico. Identified as "Chambers & Co's ODEOCAMEO," it was shown in Europe and in several American cities before it was destroyed by fire in Chattanooga.

Peck's easel paintings include such titles as "California Marsh Scene" and "Crossing the Plains in 1849."

Pedersen, Conrad Georg (1887-)

B. Denmark. Work: University of Oregon; Oregon State University, Corvallis; U.S. District Court, Portland; Coos County Court House, Marshfield, Oregon; Oregon State Hospital, Pendleton. *Who's Who in Northwest Art* (Portland).

Pedersen studied privately in Denmark and in Portland, where his teacher was C. C. McKim. He worked in oil, water color, and pastel, and exhibited mainly in Oregon. Titles of his paintings indicate a preference for landscapes. Among these are "Co-

lumbia River near Bonneville," "Portland Landscape," and "Columbia River, Morning Sun."

Pedrose, Margaret Bjornson (1893 –)
B. Seattle, Washington. *Who's Who in Northwest Art* (Seattle).

Pedrose, who worked in oil, exhibited at the Art Institute of Seattle and the fair at Puyallup.

Pegram, Marjorie (–)
B. New York City. Monterey Peninsula *Herald*, October 31, 1949, 14; *Game and Gossip*, v. 5, no. 11, 15, at Monterey Public Library; Carmel (California) Public Library.

Pegram, who studied with Twachtman at Cooper Union and with Emil Carlsen in New York City, settled in Carmel in 1935. She continued her studies at the University of California in Berkeley, and with Lee Randolph and John Cunningham in Carmel. She did landscapes, portraits, and decorative painting.

Pelenc, Siméon (1873–1935)
B. Cannes, France. D. San Francisco, California. Work: Berkeley (California) Public Library; San Francisco State University. California State Library; San Francisco Public Library; California *Arts & Architecture*, December 1932 (San Francisco).

Pelenc studied in Paris, Aix en Provence, and Marseilles. In 1915 he came to California to do murals, frescoes, and scene painting. He also taught for a number of years at San Francisco State University.

Pelton, Agnes (1881–1961)
B. Stuttgart, Germany, of American parents. Work: San Diego Fine Arts Society; Santa Barbara Museum of Art. AAA 1915–1919 (New York City; summers, Madison, Connecticut); AAA 1921 (New York City; summer, Southampton, Long Island, New York); AAA 1923–1931 (Water Mill, Long Island); AAA 1933 (Cathedral City, California); Fielding; Havlice; Mallett; WWAA 1936–1962 (Cathedral City); AAW v. I; California State Library; San Francisco Public Library.

Pelton, whose exhibition record begins with the Armory Show in 1913, had her first one-person showing in New York City in 1929. By the early thirties she was living in California and exhibiting almost annually in one-person shows until 1955. Much of her painting reflects an interest in the Southwestern desert, especially around Palm Springs.

Peña, Tonita [Quah Ah] (1895–1949)

B. San Ildefonson Pueblo, New Mexico. Work: Whitney Museum of American Art; Museum of New Mexico, Santa Fe; Oklahoma University Museum; Southwest Museum, Los Angeles; Denver Art Museum; St. Louis Art Museum, etc. Havlice; Mallett; WWAA 1947 ([Indian School], Santa Fe); WWAA 1953, obit.; Fisher directory (Cochiti, Star Route, Bernalillo, New Mexico); Alice Corbin Henderson, "Indian Artists of the Southwest," *The American Indian,* Spring 1945, 25; Dunn, 1968; Ina Sizer Cassidy, "Tonita Peña (Quah Ah) . . .," *New Mexico* Magazine, November 1933, 28, 45; Lila Nol Liggett, "Artist on the Warpath," *Independent Woman,* February 1944, 46–47, 71; Inventory of American Paintings, Smithsonian Institution.

Peña began very early to take an interest in painting. Years later she recalled for Alice Corbin Henderson how her first teacher at San Ildefonso Day School told her to "think how the people danced in the plaza, and how they felt when they danced, and to paint that." She has since become one of the most famous of the early Indian artists.

For a brief period after her marriage to a Cochiti Indian, Peña was forbidden by the elders at Cochiti to do ceremonial paintings. Her husband intervened on her behalf; later such paintings brought prestige to Cochiti Pueblo.

Peña was active well into the 1940s, and her success encouraged other Indians to excel as artists.

Pennell, Joseph (1857–1926)

B. Philadelphia, Pennsylvania. D. Brooklyn, New York, April 23. Work: Library of Congress; Mead Art Gallery, Amherst College; University of Michigan Museum of Art; Marion Koogler McNay Art Institute, San Antonio; Akron (Ohio) Art Institute; Museum of New Mexico, Santa Fe,

etc. AAA 1900-1910 (London); AAA 1913-1915 (London and New York City); AAA 1917-1925 (New York City and Brooklyn); Benezit; Fielding; Havlice; Mallett; Mahonri Sharp Young, "The Remarkable Joseph Pennell," *American Art Journal*, Spring 1970, 81-91; "A Series of Sketches by Joseph Pennell," *American Magazine of Art*, January 1920, 94-97; Joseph Pennell, *Etchers and Etching*, 4th ed., New York: MacMillan Company, 1936; Tolerton, 124-125.

Pennell traveled extensively to fulfill assignments for illustrations. Some of his travels can be traced through his 1,885 lithographs and etchings at the Library of Congress. His San Francisco, Yosemite, and Grand Canyon scenes were printed in 1912. Another group of Western subjects materialized from his trip to San Francisco in 1915 to serve on the International Jury of Awards for the Panama-Pacific Exposition. That year he included Montana in his travels.

Print collectors will find Young's assessment of Pennell's art of interest. When Pennell was twenty-two, his etchings were among the best he ever made. He had a "remarkable talent for drawing," said Young, and he was "every bit as good as he thought he was."

Tolerton in *Art in California* dwelt on Pennell's Western subjects, especially the Grand Canyon and Yosemite Valley, wherein he noted the "wonderful effects which may be produced by a master, when inspired by the landscapes and mountains of California and the great West."

Percival, Olive (-)
AAA 1919 (Los Angeles, California); California *Arts & Architecture*, December 1932 (Los Angeles).

Percy, Isabel/Isabelle Clark (1882-1976)
B. Alameda, California. D. Greenbrae, California, August 15. Work: Oakland Art Museum; California Historical Society. AAA 1909-1910, 1915 (Oakland, California); AAA 1917-1921 (Brooklyn, New York); AAA 1923-1933 (Sausalito, California); Fielding; Havlice; Mallett; WWAA 1936-1953 (Sausalito); AAW v. I; Society of California Pioneers library; San Francisco *Chronicle*, August 17, 1976, obit.; *California Design 1910*, exhibition catalogue,

1974, 63; Porter, and others, *Art in California,* 1916, 119; Inventory of American Paintings, Smithsonian Institution.

Robert Harshe in *Art in California* called Percy "one of the half-dozen artists in this country who have done notable work in color lithography." She also worked in water color and pastel. She exhibited in Europe, New York, Boston, Cleveland, and San Francisco.

When the California College of Arts and Crafts opened in 1907, she was one of its three art teachers. She left at the end of the school year, but returned in 1920 to teach until 1943. A gallery at the College bears her name.

Percy is also known as Isabel Percy West. After marriage to George West, a San Francisco newspaper editor, she lived in Sausalito.

Perry, Clara Fairfield (–1941)
B. Brooklyn, New York. D. Stoneham, Massachusetts, September 28. AAA 1903 (Brooklyn, New York; listed as Clara L. Fairfield); AAA 1915–1933 (Brooklyn; summer, Stoneham, Massachusetts); Benezit; Fielding; Havlice; Mallett; WWAA 1936–1941 (Stoneham); WWAA 1947, obit.; *American Magazine of Art,* August 1918, 405.

In Seattle in August 1918 Perry exhibited paintings of Yosemite.

Perry, Winifred Annette (–)
B. Wasepi, Michigan. AAA 1919–1925 (Oakland, California); Fielding.

Perry studied at the San Francisco School of Art.

Pescheret, Leon Rene (1892–1961)
B. Chiswick, England. Work: Library of Congress; British Museum; New York Public Library; Art Institute of Chicago, etc. AAA 1921–1931 (Chicago, Illinois); Fielding; Havlice; Mallett Supplement; WWAA 1936–1937 (New London, Iowa); WWAA 1938–1941 (Whitewater, Wisconsin); WWAA 1956–1962 (Whitewater); Ness and Orwig.

Pescheret's Western work is of his late years. According to the November 15, 1936, Milwaukee *Journal,* cited by Ness and

Orwig, Pescheret learned the art of one-plate color etchings in Belgium. At that time he was believed to be the only etcher using that technique in this country. His color etchings have appeared in *American Artist* and *Arizona Highways*.

Petersen, Einar C./Einer (1885–)
B. Denmark. Work: University Club, Hotel Rosslyn, and Boos Bros. Cafeteria, Los Angeles, California. California State Library; *News Notes of California Libraries,* October 1922; California *Arts & Architecture,* December 1932 (Los Angeles).

With a scholarship from the Danish Government, Petersen studied for a career that included several years as a decorator in Copenhagen, Munich, Paris, and Florence, before coming to the United States. Prior to settling in Los Angeles about 1911 he did decorative painting in Nebraska, Oregon, and Washington.

Peticolas, Arthur Brown (–)
Pinckney, 1967, 212; Inventory of American Paintings, Smithsonian Institution.

Pinckney wrote that Peticolas lived in Victoria, Texas, for a period from about 1858 when he joined Judge S. A. White's law firm. His pencil sketches include "The Court House Square," "The Wheeler Home," and "Victoria Hotel," dated 1862. An oil painting by Peticolas titled "El Paso, Texas" is listed in the Inventory of American Paintings. He may be the Sgt. A. B. Peticolas whose diary and drawings are at the Arizona Historical Society in Tucson.

Petit, Dale (1898–)
B. Billings, Montana. *Who's Who in Northwest Art* (Billings).

Petit was a self-taught artist who did oils and graphics, and exhibited in Billings.

Petrovits, N. Paul (–)
B. Hungary. D. Australia. California State Library; San Francisco Public Library; Splitter, 1959, 49.

Petrovits was a portrait painter who lived briefly in Los Angeles in 1876, and later in Virginia City, Nevada. He had been

a successful artist in New York prior to moving West for his health, first to San Francisco, where he lived two years, ca 1874-1876.

Pettingill, Lillian Annin (1871-)
B. LeRoy, New York. AAA 1919-1933 (LaCrosse, Wisconsin); Mallett; Calhoun; Dodds; University of Washington Art Library; University of Washington Library, Pacific Northwest Collection; Helen Ross, "Seattle Artists to Exhibit," Seattle *Town Crier*, November 23, 1912, 6; "Exhibit of Seattle Artists," Seattle *Town Crier*, November 1, 1913, 15; Helen Ross, "Seattle Is Growing Artistic," Seattle *Town Crier*, November 8, 1913, 14; Hanford, 631.

Not only was Pettingill one of the first artists of Seattle, but she taught art there, and urged publicly that Seattle should become the artistic center of the Pacific Coast. In 1904 she was listed in the city directory. She exhibited that year in the first annual of the Society of Seattle Artists of which she was president. In 1908 she became a charter member of the Seattle Fine Arts Association, soon to be called the Seattle Fine Arts Society, and she exhibited later in the year in its first annual showing.

In 1912 Ross wrote that Pettingill was one of the Seattle artists who had "exhibited successfully in Eastern cities," and reported that she would be "adequately represented by landscapes in oils and water colors," at a forthcoming exhibition of the Society of Seattle Artists.

In reviewing the Society's ninth annual exhibition held in 1915, the year Pettingill departed for La Crosse, Ross called her oil landscape "Where Trout Lurk in the Shadows," a picture of "delightful coloring and feeling."

Peyraud, Frank Charles (1858-1948)
B. Bulle, Switzerland. Work: Santa Fe Railway Collection; Museum of Bulle; Union League Club, Chicago; Art Institute of Chicago; Peoria Public Library. AAA 1898-1903 (Chicago); AAA 1905-1906 (New York City); AAA 1907-1919 (Chicago); AAA 1921-1925 (Highland Park, Illinois); AAA 1927-1933 (Ravenia, Illinois); Benezit; Fielding; Havlice; WWAA 1936-1941 (Highland Park); Inventory of American Paintings, Smithsonian Institution.

An oil by Peyraud titled "Spring–Painted Desert" in the Santa Fe Collection indicates at least one trip to the West.

Phair, Ruth (1898–)
Who's Who in Northwest Art (Spokane, Washington).
Phair studied in Spokane, and exhibited oil paintings in Seattle, Spokane, and Portland, Oregon.

Philipp, Werner (1897–1982)
B. Breslau, Iowa. California State Library; San Francisco Public Library art and artists' scrapbook; San Francisco *Chronicle*, May 18, 1982, 6, obit.
Philipp moved to San Francisco in 1939.

Phillips, Walter Shelley [El Comancho] (1867–1940)
Work: University of Washington Library, special collections. J. F. Dykes, *American Book Collectors*, December 1967, 27.
Known mainly as a writer, Phillips contributed drawings to *Pacific Sportsman* while he was editor of that Washington State Game and Fish Protective Association publication. He also wrote and illustrated several books about outdoor life and Indians, using the pen name "El Comancho." Among them was *Indian Fairy Tales* ... (1902), a reissue of *Totem Tales* (1896).

Phipps, W. F./William (–)
Work: Denver Public Library; Boston Museum of Fine Arts, Karolik Collection. Inventory of American Paintings, Smithsonian Institution; Denver Public Library; Karolik Collection catalogue, 261, 262.
W. F. Phipps appears to be William Phipps whose paintings are in the Denver Public Library collection. Between 1867 and 1869 William Phipps, a Georgetown, Colorado, minister, painted many water colors of the region.

Picknell, William L. (1853 – 1897)
B. Hinesburg, Vermont. D. Marblehead, Massachusetts, August 8. Work: Corcoran Gallery of Art; Boston Museum of Fine Arts; Luxembourg Museum, Paris; Houston

Museum of Fine Arts; Pennsylvania Academy of Fine Arts; Metropolitan Museum of Art; Carnegie Institute, etc. Benezit; Fielding; Havlice; Mallett; Earle; *Dictionary of American Biography;* Gerdts, 1980 exhibition catalogue, 18–19; Michael Quick, *American Expatriate Painters of the Late Nineteenth Century,* Dayton: Dayton Art Institute, 1976, 124, 155; Graves, 1970, 1972; Hartmann, 85–86.

During the late 1880s Picknell spent a season in California from which came a major painting "In California," exhibited at the National Academy of Design in 1894. Although Picknell is probably better known in Europe than here, some of his most important works are in American museums. Michael Quick called him "one of the strongest and most original" of the American nineteenth century landscape painters.

Picknell began serious study of painting with Inness in Rome in 1874. Two years later he went to Paris to study with Gerome and then to Brittany where he studied with Robert Wylie.

Following a decade in Europe Picknell spent several years in Annisquam, Massachusetts. During winter months he sought warmer climates, usually the Mediterranean. In 1890 he returned to France where he lived until shortly before his death.

Pierce, B. W. (　－　)
Work: Society of California Pioneers; Sherman Library, Newport Beach, California. Evans, Society of California Pioneers.

Pierce was active in Sacramento, California, from 1880 to 1890, and apparently in Southern California in the early 1890s, mostly as a maker of illustrated maps.

Pietierre, P. (　－　)
M. Barr, 6, 68, exhibition catalogue.

Pietierre was an artist from Paris engaged by Sir William Drummond Stewart of Alfred Jacob Miller fame, to serve as artist for Stewart's ninth trip west since Miller had declined to go. He is also said to have accompanied John Charles Fremont's second party which was at Fort Platte (or Bissonette's Fort) in 1843. His Western work may not be extant.

Pissis, Emile M. (1854–)

B. Guaymas, Mexico. Work: Society of California Pioneers; California Palace of the Legion of Honor, San Francisco. *News Notes of California Libraries,* April 1920; California State Library; Inventory of American Paintings, Smithsonian Institution.

In 1920 Pissis could claim that he had lived in San Francisco for over sixty-three years. His paintings consist of landscapes and portraits in private collections, and historical paintings in public collections. He chose not to exhibit, nor did he try to sell his work. A considerable part of it was destroyed in the earthquake and fire of 1906.

Pittwood, Ann (1895–)

B. Spokane, Washington. *Who's Who in Northwest Art* (Seattle, Washington).

Pittwood was a graphic artist who did some painting. Her training included attendance at the National Academy of Design, the Art Students League, Otis Art Institute in Los Angeles, and Cornish School in Seattle. She had several solo shows in Los Angeles, California, and Aberdeen, Washington, between 1927 and 1936.

Pixley, Emma Catharine O'Reilly (1836–)

B. Rochester, New York. California State Library; *News Notes of California Libraries,* January 1908, 13; October 1910, 538.

Pixley studied at Cooper Institute in New York and at Mark Hopkins Institute in San Francisco. Among her teachers at the latter were Binoni Irwin, Arthur Mathews, and Will Sparks.

In response to a query from the California State Library in 1907 Pixley advised that she had exhibited several landscape paintings at the state fair in Sacramento, and that since April she had been "boating on the Hood Canal, sketching some of its water scenery and also making studies among the Olympic range" of mountains. During the previous forty-three years she had lived mainly in San Francisco and Marin County, and briefly in Seattle. Some of her paintings were in Seattle and San Francisco collections, she said, and some were lost in the 1906 fire.

The Inventory of American Paintings, Smithsonian Insti-

tution, lists two oils by Mrs. De Witt Clinton Pixley – one titled "Wood's Cove, Laguna, California" – which may be Emma Pixley's.

Plaw/Plau, Eleanor Walls (1878–)
B. San Francisco, California. California State Library; *News Notes of California Libraries,* January 1908, 13; California *Arts & Architecture,* December 1932 (Long Beach, California).
Plaw, who studied with Arthur Mathews and others at the California School of Design, taught art in San Francisco and Los Angeles schools. The paintings she exhibited in San Francisco received favorable attention, but were later destroyed in the fire following the 1906 earthquake.

Plein, Charles M. (–1920)
B. Alsace-Lorraine. D. Omaha, Nebraska, in January.
AAA 1920, obit.; Joslyn Art Museum library.
Plein, a member of the Omaha Art Guild, exhibited with Guild members in 1917. He was an authority on Indian history and had a rare collection of Indian art objects.

Plotkin, Peter (–)
Fisk, 1928, 173-175 (Dallas and Abilene, Texas); *The Texas Artist,* February 1955, 42, n.p.
Fisk wrote that Plotkin's School of Portraiture would have a lasting influence on the art of West Texas. Apparently he had started this school while in Abilene in 1927. Previously he had lived for about ten years in Dallas. He specialized in paintings based on religious themes and also did some historical scenes such as Sam Houston on his horse. According to an article in *The Texas Artist* Plotkin was a doctor of philosophy whose education had been directed by Count Leo Tolstoy. He had been banished from Russia by the Soviet Government, the author said.

Podchernikoff, Alexis M. (1886-ca 1933)
B. Russia. AAW v. I; San Francisco City Directory, 1919; California State Library; Anna Cora Winchell, "Artists and Their Work," San Francisco *Chronicle,* December 24,

1916, 23/4; *The Literary Digest,* March 10, 1928 cover, with descriptive text on page 29; Walter Nelson-Rees, Oakland, California.

Podchernikoff had a studio in San Francisco by 1916. By 1928 he was living in Santa Barbara, California, but appears to have moved to Pasadena soon afterward. A file card at the California State Library indicates he was divorced in 1933; therefore the year of death shown in AAW v. I as 1931 is incorrect.

Pollock, A. M. (–)
Work: Supreme Court, Austin, Texas. O'Brien, 1935.

Pollock was in Waco, Texas, in 1896. His painting of Judge George F. Moore was in the Texas Supreme Court building in the mid-1930s, and perhaps still is.

Pool, Eugenia Pope (–)
B. Cameron, Texas. Fisk, 1928; O'Brien, 1935.

Pool, who married in 1899 and settled on a ranch near Big Springs, Texas, did not take up painting until she was thirty-five. She credited Olive Rush with teaching her to paint during the summer of 1923, in Santa Fe. She also studied with other well-known artists.

By 1928 Pool was exhibiting her work in Santa Fe and various Texas cities. She won a number of awards at West Texas fairs for landscape and still life oils.

Porter, Frederic Hutchinson [Bunk] (1890–1976)
B. Salem, Massachusetts. Work: University of Wyoming Art Museum. M. Barr, 68–69; H. R. Dieterich and Jacqueline Petravage, "New Deal Art in Wyoming," *Annals of Wyoming,* Spring 1973, 55.

Porter's introduction to the West was Denver, Colorado, in 1903. After serving as an apprentice to an architect for several years he worked as an architectural draftsman in Cheyenne, Wyoming, from 1910 to 1912, and in Salt Lake City, Utah, for two more years. He returned east in 1914, attended Wentworth Institute, and in 1920 went back to Cheyenne. He had his own architectural firm from 1922 to 1965. His interest in painting developed early in his career. Water color was his principal medium.

Porter, W. F. (–)
Hafen, 1948, v. II, 423.
Porter was a landscape painter who taught art in Colorado in 1877.

Porter, William Solon (–)
B. Tennessee. "Sagebrush Artist," *Daily Oklahoman,* January 5, 1947; Oklahoma City Public Library.
Porter, who began painting local scenes early in this century, was a farmer who staked a claim in Indian Territory. He appears to have been living in Woodward, Oklahoma, in 1947 when the *Daily Oklahoman* reported that he was writing a book about his life over the past seventy-two years. He was known locally as a "sagebrush artist" because of the scenes he chose to paint.

Postle, (Katherine) Joy (1896–)
B. Chicago, Illinois. Work: Murals for Hotel Beaumont and City National Bank, Beaumont, Texas; Hotel San Carlos, Pensacola, Florida; Hotel Majestic, Lake Charles, Louisiana. *Idaho Encyclopedia* (Boise, Idaho); Binheim, 1928, 126; *American Magazine of Art,* May 1927, 270; *Art Digest,* August 1930, 18; "Boise Artist Successful," Idaho *Statesman,* February 1, 1931; "Joy Postle Holds Painting Exhibit at Pensacola, Florida," Idaho *Statesman,* December 14, 1931; Boise Gallery of Art library.
Postle studied at the Art Institute of Chicago. While teaching in Boise, she exhibited a number of landscapes of the Snake River country that brought her recognition in 1927. She also painted portraits and murals. Following marriage to Robert Blackstone she moved to the South.

Potter, A. L. (–)
Work: Denver Public Library. Shalkop exhibition catalogue, 26; Denver Public Library; Colorado College Library; Inventory of American Paintings, Smithsonian Institution.
As Shalkop remarked in *100 Years of Painting in the Pike's Peak Region,* nothing is known about Potter "except his signature." The four oils listed in the Smithsonian inventory are "Altman Colorado," "View of Altman, Colorado," "Mine and Cabins at

Cripple Creek," and "Portland Mine." The Denver Public Library estimates the approximate year of the two Altman views it has as 1905. Altman was a goldmining town in the Rockies that claimed to be "the highest city in the world," said Marshall Sprague who is quoted by Shalkop. By November 1893 it had six saloons, six groceries, four restaurants, several boarding houses, and 1200 inhabitants.

Information at Colorado College Library indicates that Potter probably was active in Colorado and Wyoming by 1885.

Potthast, Edward Henry (1857–1927)

B. Cincinnati, Ohio. D. New York City, March 9. Work: Cincinnati Art Museum; Art Institute of Chicago; Brooklyn Museum; Hackley Art Gallery, Muskegon, Michigan. AAA 1898–1925 (New York City); Benezit; Fielding; Havlice; Mallett; AAW v. I; Donelson Hoopes, *The American Impressionists,* New York: Watson-Guptill, 1972, 118, 151; Boyle, 1974, 139; *Art News,* October 1968, 15; January 1969, 25.

Potthast's early years were spent in Cincinnati where he worked first as a lithographer's apprentice and later as an illustrator. He studied at McMicken School of Design before it was taken into the Art Academy of Cincinnati, and later in Munich.

In 1892 Potthast opened a studio in New York City, but continued to work also as an illustrator, mainly for *Harpers.* Assignments in the West enabled him to paint a number of Grand Canyon and Rocky Mountain landscapes.

About 1900 Potthast began painting in an impressionist style, and specialized in small, intimate beach scenes.

Potvin, Lora Remington (1880–)

B. Silverton, Oregon. *Who's Who in Northwest Art* (Lewiston, Idaho).

Potvin studied at the Art Students League, the [William Merritt] Chase Art School, and with A. Phimister Proctor. She did pastels, oils, and clay sculptures, which she exhibited in Idaho.

Powell, Caroline Amelia (1852–1934)

B. Dublin, Ireland. AAA 1903–1919 (Boston, Cambridge,

and Lynnfield Centre, Massachusetts); AAA 1921–1925 (Santa Barbara, California); AAA 1927–1931 (Santa Monica, California); Benezit; Fielding; Havlice; WWAA 1936, obit.

Powell was a wood engraver who began winning awards in 1893.

Powell, Doane (1881–1951)
B. Omaha, Nebraska. D. August 27. Work: Joslyn Art Museum. AAA 1921–1924 (Omaha); AAA 1925–1927 (Chicago); Havlice; Mallett; WWAA 1940–1947 (New York City); Bucklin and Turner, 1932; "Masks Are Latest Fad in Portraiture," Washington *Post* Magazine, September 1, 1935, VIII/1; Joslyn Art Museum library; NMAA-NPG Library, Smithsonian Institution.

Powell was a cartoonist for the Omaha *Bee* during the early years of his career. He exhibited regularly with the Omaha Art Guild, which he helped organize, even after he moved to Chicago in 1923. During a decade there he taught at the Chicago Academy of Fine Arts and directed art and layout work for advertising agencies. Then he moved to New York City where his experimental mask portraits created a stir, especially the ones he did of highly visible public figures.

Powell, Myra Grout (1895–)
B. San Diego, California. Olpin, 1980 (Ogden, Utah).

Powell studied art one year at the University of Utah when she was nineteen and then took private instruction from Joseph Everett of Salt Lake City. Later she studied at Utah State University.

Powers, Helen (–)
Denver Public Library; Bromwell scrapbook, 48; Rocky Mountain *News*, April 18, 1894, 5.

Powers, who had her own ranch near Denver, Colorado, painted the life associated with it, especially the animals. She exhibited oils, pastels, and water colors at the Brown Palace Hotel in Denver, November 13–14, 1892. In 1894 she exhibited an oil at the Denver Artists' Club.

Powers, Jane Gallatin (-1944)
 B. Sacramento, California. Spangenberg, 46, 47, 48, 49.
 Powers was the daughter of Albert Gallatin, a prosperous
Sacramento merchant. Before marriage she had traveled and
lived abroad "where her interest and talent in painting flour-
ished," wrote Spangenberg. She was very much a part of the Car-
mel Art Colony and is thought to have had the first studio in the
area. Spangenberg cites the January 14, 1906, San Francisco *Call*
which reported that Powers was then revamping a "log barn into
a studio." It was located near the gate to Seventeen-Mile-Drive.

Prather, Ralph Carlyle (1889-)
 B. Franklin, Pennsylvania. AAA 1921 (Denver, Colorado;
 summer, Estes Park); AAA 1923–1924 (La Crescenta, Cali-
 fornia; Denver; summer, Estes Park); AAA 1925 (Philadel-
 phia); AAA 1927 (West Chester, Pennsylvania); AAA
 1929–1931 (Drexel Hill, Pennsylvania); Havlice; Mallett;
 WWAA 1936–1941 (Drexel Hill).

Pratt, Irwin (1891–1955)
 B. England. Olpin, 1980 (Salt Lake City, Utah).
 Pratt studied in England. He became a citizen of the
United States shortly before the First World War and served
with American forces. In Salt Lake City he taught in the exten-
sion division of the University of Utah, painted scenes for the Old
Salt Lake Theatre, and specialized in water color paintings.

Pratt, Lorus, Jr. (1894–1964)
 Olpin, 1980.
 Pratt was the son of well-known Utah artist Lorus Pratt,
Sr. (1855–1923). Little else is known about him, except that he
created an eleven-foot mural for the Utah centennial of 1947.

Prentice, Sydney C. (–)
 AAA 1903 (Lawrence, Kansas; listed under art supervisors
 and teachers); Reinbach.
 Prentice graduated from the University of Kansas, studied
at the Art Institute of Chicago, and returned to the University to
teach at the School of Fine Arts. Later he illustrated publications
of the Carnegie Museum in Pittsburgh.

Preuss, Charles (1803–1854)

B. Germany. D. near Blandensburg, Maryland, September 2. Groce and Wallace; AAW v. I; Michael Harrison, Fair Oaks, California; William H. Goetzmann, *Exploration and Empire,* New York: Knopf, 1966, 242; M. Barr, 69.

Goetzmann described Preuss as an "excellent cartographer" who "hated the West and the outdoors." He saw plenty of both when he joined John Fremont's expedition in the early 1840s. Some of the sketches he made are in Fremont's official report published in 1845.

In 1958 the University of Oklahoma Press published Preuss' diaries, translated and edited by Edwin G. and Elisabeth K. Gudde, under the title *Exploring with Fremont.*

Price, Eugenia (1865–1923)

B. Beaumont, Texas. D. Los Angeles, California, in August. AAA 1907–1910 (Chicago, Illinois); AAA 1917–1921 (San Antonio, Texas; summer, 1917–1919, Chicago); AAA 1924, obit.; Benezit; Fielding; Mallett; AAW v. I; O'Brien.

Price studied at the St. Louis School of Fine Arts; the Art Institute of Chicago, from which she graduated; and Julien Academy in Paris. She exhibited nationally, and many times in Texas where she was known as a landscape and miniature painter.

Price, Garret/Garrett (1896–)

B. Bucyrus, Kansas. Havlice; Mallett (Mystic, Connecticut); WWAA 1947–1970 (Westport, Connecticut); Kingman, 1966; M. Barr, 33, 34, 69.

Price was fifteen when he began doing cartoons and drawings for the Saratoga, Wyoming, *Sun.* While attending the University of Wyoming for three years he illustrated the University's *Annual.* After that he studied a year at the Art Institute of Chicago. In 1916 he went to work for the Chicago *Tribune,* and in 1925, the *New Yorker* magazine. He also illustrated a number of books.

Price, Lida Sarah (–)

AAA 1905–1908 (Paris, France); California *Arts & Archi-*

tecture, December 1932 (Los Angeles, California); *News Notes of California Libraries,* October 1910, 538.

Prideaux, Mado M. (-)
Fisk, 1928; Wilbanks, 1959, 26, *et passim.*
Prideaux appears throughout Wilbank's *Art on the Texas Plains.* She taught in Brownsville, Texas, where she lived during the years 1917–1923. Then she moved to Lubbock where she was active for many years, exhibiting in a number of cities in the West and Midwest. She generally painted Western subjects, including Indians. She sketched in New Mexico and California, as well as Texas. Her principal teachers were Jose Arpa, Eric Gibberd, and Carl Redin.

Pritchard, George Thompson (1878-)
B. New Zealand. Work: Springville (Utah) Museum of Art; Gardena (California) High School collection. Springville Museum of Art permanent collection catalogue; Richard and Mercedes Kerwin, Burlingame, California.
Pritchard studied in New Zealand, Holland, London, and in Paris at Julian Academy. "Street at Amsterdam, Holland," is one of the two oils at Springville Museum of Art. The catalogue describes his themes as "poetic, simple in composition, but strong in execution." That Pritchard traveled widely for his subjects is indicated by the further comment that "he brings to his canvas the moods of many lands and of many people." His frequent changes of residence may account for his absence from art directories. While painting in California he is said to have lived in Glendale.

Q

Quesenburg/Quesenberg, William (1822-1888)
Fielding 1974, addendum; California State Library; Eugene Ostroff, *Western Views and Eastern Visions,* Smith-

sonian Institution Traveling Exhibition catalogue, 1981, 10-11.

Quesenburg was editor of the Sacramento *Union* when he joined J. Wesley Jones and other artists in 1851 to sketch in California, Nevada, and Utah. Jones, a daguerreotypist, is portrayed in John Ross Dix's *Amusing and Thrilling Adventures of a California Artist,* Boston, 1854.

Quinlan, Will J. (1877–)
B. Brooklyn, New York. Work: Oakland Art Museum; New York Public Library. AAA 1907-1933 (Yonkers, New York); Benezit; Fielding; Havlice; Mallett; WWAA 1936-1941 (Yonkers); Panama-Pacific International Exposition catalogue.

Quinlan, who was a member of the Chicago Society of Etchers, the New York Society of Etchers, and the California Society of Etchers, exhibited thirty-six prints at the Panama-Pacific Exposition in San Francisco in 1915. Among them were "Eleventh Street Bridge, Tacoma" and "The Smith Building, Seattle." He also exhibited an oil titled "Mt. Rainier From Pinnacle Peak."

R

Radford, Zilpha (1885–)
B. Auburn, California. AAA 1923-1924 (Seattle, Washington; listed as Mrs. Colin Radford); Mallett Supplement (Seattle); *Who's Who in Northwest Art* (Seattle).

Radford studied at the University of Washington, and exhibited oil paintings at the Seattle Art Museum from 1934 to 1938, and perhaps later.

Raleigh, Henry Patrick (1880–)
B. Portland, Oregon. AAA 1913 (New York City); AAA

1915–1927 (Westport, Connecticut); AAA 1929–1931 (New York City); Benezit; Fielding; Havlice; Mallett; WWAA 1936–1941 (New York City); *American Art Annual*, 1898, 392.

Raleigh studied at the Mark Hopkins Art Institute in San Francisco. He exhibited "Chinatown Sketch" at the Institute's 1897–1898 Winter Exhibition. He was an etcher and lithographer who was mainly active as an illustrator.

Randall, Ida A. (–)
Denver Public Library; Bromwell scrapbook, p. 28.

Randall exhibited a water color landscape at the Denver Artists' Club in 1900.

Randlett, Mamie Randall (–)
Fisk, 1928 (Lancaster, Texas).

Randlett studied with William Merritt Chase. She exhibited in the East, the South, and in Texas, and won a gold medal at the Nashville Centennial Exhibition. Fisk described her as a Dallas artist of "high merit and great versatility."

Raphael, Joseph M./Joe (1869–1950)
B. San Francisco, California. D. San Francisco, December 11. Work: San Francisco Museum of Modern Art; Oakland Art Museum; Mills College Art Gallery; Stanford University Museum and Art Gallery; M. H. de Young Memorial Museum. AAA 1905–1910 (Paris, France); AAA 1915–1925 (San Francisco); AAA 1927–1933 (San Francisco; Belgium); Benezit; Fielding; Havlice; Mallett; WWAA 1936–1941 (San Francisco; Uccle, Belgium); AAW v. I; Boyle, 1974, 215–216; Porter and others, 1916; Inventory of American Paintings, Smithsonian Institution; San Francisco *Chronicle*, December 12, 1950, 19/5, obit.; Johanna Raphael Sibbett, Swarthmore, Pennsylvania; Singer Museum, Laren, North Holland, "Joseph Raphael, 1869–1950," December 1981–January 1982 exhibition catalogue; Anita Ventura Mozley, curator, Stanford University Museum of Art, "Joseph Raphael: Impressionist

Paintings and Drawings/An exhibition," June 10–August 17, 1980.

The *American Art Annual* does not reflect the places Raphael actually worked and lived during the years 1905–1933. They are Paris, France, and Laren, North Holland, through 1911; Belgium through 1929; Holland through part of February 1939 when Raphael returned to San Francisco.

Raphael grew up in Amador County, California, and when he was thirteen, began working to help support the family. Two years later he spent some time in Arizona Territory working in a trading post. It was at that time he began drawing for pleasure. In 1887 he returned to San Francisco where he studied art – often at night so that he could work days to finance his training – until he went to Paris for advanced study in 1903. The paintings he sent home for exhibition and sale kept his name alive in California despite his lengthy residence in Europe.

When painting supplies were hard to obtain during and immediately after the First World War, Raphael turned to printmaking, first specializing in etchings and then woodblock prints. Recognizing that in this country there was less interest in black-and-white Raphael began about 1940 to apply "color to [the woodblocks] before each unique print [was] drawn off," said his daughter Johanna Raphael Sibbett.

Raphael and his California contemporary E. Charlton Fortune have been called the most important "exponents of a California impressionism" by Boyle who feels their use of "the bright palette and broken brushwork" was more for "expressive than for impressionist purposes." Boyle considered them two of the best artists exhibiting at the Panama-Pacific International Exposition in San Francisco in 1915 at which Raphael won a silver medal.

Rawles, Charles S. (–)
> Work: Museum of New Mexico, Santa Fe. Museum of New Mexico library; Santa Fe Public Library; Inventory of American Paintings, Smithsonian Institution.

Rawles exhibited "Gathering of the Clans" at the Musuem of New Mexico in 1921, "Cundiyo Dawn" and other titles in 1923, and "La Ramuda" in 1926. He does not appear to have been active after 1927.

Rawlins, Lara/Lara Cauffman/Coffman (-)
Olpin, 1980; Horne, 1914.

Little is known about Rawlins, the daughter of U.S. Senator Joseph L. Rawlins of Utah. She was in Paris with the well-known artist Mary Teasdel in 1899. In 1914 Horne called her an "adequate portraitist." She was then living in California, said Olpin.

Raymond, Kate Cordon (1888-)
B. Cuero, Texas. *Who's Who in Northwest Art* (Portland, Oregon).

Raymond studied with C. C. McKim in Portland, worked in oil and water color, and won several prizes at Oregon state fairs.

Read, Frank E. (1862-)
B. Austinburg, Ohio. AAA 1921–1925 (Seattle, Washington); Benezit; Fielding.

Read was a painter, an etcher, an architect, and a writer who was active in the Seattle Fine Arts Society.

Red, Harold Doak (-)
B. Abilene, Texas. Fisk, 1928, 166–167.

Red began the study of art in Texas at an early age, and in 1912 went to Chicago for advanced study at the Academy of Fine Arts. Following service in the First World War he studied with Leon Kroll. Though mainly active in Chicago, he exhibited in Texas and filled some commissions in Dallas.

Redd, Lura (1891 –)
B. New Harmony, Utah. Olpin, 1980; "Item of Note in Art Barn Exhibition," Salt Lake *Tribune,* February 27, 1938; Salt Lake City Public Library art and artists' scrapbook.

Redd studied at the University of Utah under Mabel Frazer and sketched with her at Zion Canyon in Utah and the Grand Canyon in Arizona. She also studied at Chouinard Art School in Los Angeles, California, for two years and at a landscape school in Canada during one summer. "Her mountain pictures have architectural strength," said the reviewer of her exhibition at the Art Barn in Salt Lake City in 1938.

Redd was head of the art department of Box Elder High

School in Brigham City for twenty years. She belonged to several art societies and was active as an exhibiting artist well into the 1950s.

Redin, Carl (1892–1944)

B. Sweden. D. Los Gatos, California, June 19. Work: McKee Foundation, El Paso, Texas; Department of Labor, Washington, D.C.; Royal Academy, Stockholm. Havlice; Mallett Supplement; WWAA 1940–1941 (Palomar Mountain, California); Wilbanks, 1959; School of American Research, 1940; *Western Artist*, June 1935, 15; *El Palacio*, November 11, 1931, 303, and February 3, 1932, 71; Santa Fe (New Mexico) Public Library; Van Stone, 239.

Redin had some art training in Sweden before moving to Chicago in 1913 to work in the building industry. In 1916 he moved to Albuquerque, New Mexico, where he spent five years in a sanitarium. He had always wanted to be a landscape painter, and such painting was more compatible with his precarious health. Despite a late start, he achieved regional recognition in the Southwest in the later 1920s, and some national recognition in the 1930s. He was highly respected as a teacher at the University of New Mexico, and wherever he taught summer courses, especially in Lubbock, Texas. His last years were spent in Palomar, Las Manzanitas, and Los Gatos, California.

Wilbanks considered Redin a perfectionist and said he would exhibit only his best work. Following his death some of the paintings he had relegated to the basement have been exhibited, she said.

Reed, Doel (1894–)

B. Logansport, Indiana. Work: Museum of New Mexico, Santa Fe; Library of Congress; Metropolitan Museum of Art; Bibliotheque Nationale, Paris; Victoria and Albert Museum, London; Notre Dame University Art Museum. AAA 1923-1924 (Cincinnati; summer, Nashville, Indiana); AAA 1925-1927 (Stillwater, Oklahoma; summer, Nashville); AAA 1929-1931 (Stillwater; summer, Nashville; Siloam Springs, Arkansas); AAA 1933 (Stillwater); Benezit; Havlice; Mallett; WWAA 1936-1959 (Stillwater); WWAA 1962-1978 (Taos, New Mexico); AAW v. I; Will

May, 1926; Mary Carroll Nelson, "Doel Reed: Taos Maverick," *American Artist,* May 1979, 66–71, 102–103; James T. Forrest, "Doel Reed, NA/A Gentle Man of True Artistic Spirit," *Southwest Art,* September 1975, 69–72.

Reed's career in the West began in 1924 when he joined the faculty of Oklahoma A & M, now Oklahoma State University. When he exhibited with Oklahoma artists two years later, Will May, of the Daily *Oklahoman,* found his work "totally unlike the other things in the exhibit," and praised the "quality and refinement in his canvasses."

Reed remained with Oklahoma A & M thirty-five years, building an impressive art department and helping many a student to a promising career with the excellence of his teaching.

Following retirement Reed moved to Talpa, a village outside of Taos. He had long been fascinated with the atmospheric conditions and distinctive scenery of Northern New Mexico, having begun work there in the early 1940s. The area was remarkably well suited to the technique he had developed for his aquatints. Though he is also known for his oils and caseins, it is his aquatints that brought him international recognition, and in 1952, membership in the National Academy.

Reed, Peter Fishe (1817–1887)
B. Boston, Massachusetts. D. Burlington, Iowa. Fielding, 1974 addendum; Groce and Wallace; Peat, 1954; Sparks.

Reed was a portrait, landscape, and figure painter who lived in various parts of the country, often for extended periods. He was in Chicago from 1865 to 1874, and in San Francisco in 1878.

Reeder, Walter Edwin (1893–)
B. Mount Eagle, Pennsylvania. Bucklin and Turner, 1932 (Omaha, Nebraska).

Reeder was a self-taught artist who exhibited at the John Wanamaker Exhibition in Philadelphia in 1913, winning an honorable mention, and at Joslyn Museum of Art in December 1931.

Reedy, Leonard Howard (1899–1956)
B. Chicago, Illinois. D. December 8. Work: Santa Fe Railway Collection. AAW v. I (Chicago; various ranches in

the West); Santa Fe Railway exhibition catalogues; Phil Kovinick, Los Angeles.

Reedy was a great admirer of Remington and Russell and spent a lifetime depicting the Old West and the New in water color and in oil. More a later-day Russell than a Remington, he had lived with the Indians, and he had worked as a ranch hand.

Paintings by Reedy in the Santa Fe Railway Collection were purchased during the depression years. One painting was used in the "annual calendar series" put out by the Santa Fe. Many other paintings by Reedy are in private collections.

Reese, Walter Oswald (1889–)

B. Pana, Illinois. AAA 1909–1910 (Chicago, Illinois); AAA 1919 (New York City); Havlice; Mallett Supplement; WWAA 1940–1941 (Seattle, Washington); *Who's Who in Northwest Art;* Pierce, 1926 (Seattle).

Reese studied at the Chicago Academy of Fine Arts, and at the University of Washington. He exhibited at the Seattle Art Museum and with Northwest Printmakers. He worked in water color. As an illustrator he did many cover designs and drawings for ads for national magazines.

Reichmann, Josephine Lemos (1864–1938/39)

B. Louisville, Kentucky. AAA 1913–1933 (Chicago, Illinois); Fielding; Havlice; Mallett; WWAA 1936–1939 (Chicago); Sparks; Lena M. McCauley, "Three Women Artists at Chicago Galleries," Chicago Evening *Post* Magazine of the *Art World,* April 12, 1927; "Chicago," *Art News,* February 28, 1925; NMAA-NPG Library, Smithsonian Institution.

Reichmann's exhibition of forty-six paintings in Chicago in 1927 included landscapes and townscapes from Gloucester, Massachusetts, to Carmel, California. She drove her car wherever "the picturesque lured her," wrote McCauley. "Her color schemes are radiant." Among the water colors mentioned by McCauley was "Midwinter in the Copper Country." Reichmann exhibited in Chicago from 1909 to 1932.

Reid, Robert (1862–1929)

B. Stockbridge, Massachusetts. D. Clifton Springs, New

York, December 2. Work: Metropolitan Museum of Art; National Museum of American Art; Corcoran Gallery of Art; Cincinnati Art Museum; Penrose [Colorado Springs] Public Library, Colorado Springs, Colorado; Herron Museum of Art, Indianapolis, etc. AAA 1898–1921 (New York City); AAA 1923–1927 (New York City and Colorado Springs); Benezit; Fielding; Havlice; Mallett; AAW v. I; Earle; Colorado Springs *Gazette,* April 22, 1920; "Reid's Garden of the Gods Phantom Is a Reality, Says Lloyd Shaw," Colorado Springs *Telegraph,* March 17, 1921; *Art Digest,* April 15, 1927, 14; "Robert Reid Dies/Foremont Painter," Colorado Springs *Gazette,* December 3, 1929; Colorado Springs Fine Arts Center library; Colorado College Library.

According to the April 22, 1920 *Gazette,* Reid had been painting in Colorado Springs about six months when he was invited to teach figure painting at the Broadmoor Art Academy. Reid accepted the invitation and spent a good part of the next six years there.

The remarkable mountain scenery, together with atmospheric conditions that bewitched the Garden of the Gods at moonlight, inspired a new trend in Reid's painting. When Reid exhibited these paintings at Milch galleries, Henry Tyrrell of the New York *World* said that Reid's Colorado experience had given "a new and finer spirit" to his work.

Reimers, Johannes (–)
Work: Oakland Art Museum. AAA 1919 (San Francisco, California); Inventory of American Paintings, Smithsonian Institution.

Of Reimers' four pastels at the Oakland Museum there are two landscapes titled "The Arroyo" and "Eucalyptus Trees," the latter dated 1914.

Reimers, Marie Arentz (1859–)
B. Bergen, Norway. California State Library; California *Arts & Architecture,* December 1932 (Berkeley); Mary McPhail, "Woman, Past 69, Succeeds in Art Career/Work of Berkeley Artist Who Learned Painting in Year Will Be Placed on Exhibition," San Francisco *Examiner* (Oakland

edition), January 6, 1929; "Berkeley Woman Wins Art Honors At Sixty-nine," San Diego *Union*, November 24, 1929; *News Notes of California Libraries*, January 1930, 74.

Reimers came to California in 1880, and two years later she married Johannes Reimers in Oakland. In her sixty-ninth year she taught herself to paint with the assistance of a professor of art who recognized her talent. She became rather a sensation in 1929 when she exhibited locally. In 1930 fourteen of her water colors were sent to Paris for exhibition.

"Among her creations, abounding in modernism but offering excellent studies in lines and color," wrote the *Union*, was "A Master's Sculptor," an oil painting of a "beautiful mountain lake nestled at the foot of lofty snow-covered Sierra peaks."

Reynard, Grant Tyson (1887–1968)

B. Grand Island, Nebraska. D. Leonia, New Jersey, August 13. Work: Metropolitan Museum of Art; Library of Congress; M. H. De Young Museum, San Francisco; Fogg Museum, Harvard University; Addison Gallery of American Art, Andover; Newark Museum; South Dakota Memorial Art Center, Brookings. AAA 1921–1933 (Leonia); Benezit; Havlice, Mallett; WWAA 1936–1966 (Leonia); AAW v. I; Stuart, v. II; *Western Artist*, July-August 1936, 3; Norman Kent, "The Several Careers of Grant Reynard," *American Artist*, November 1961, 48–55, 80–84; "Grant Reynard/An Exhibition of Oil Paintings, Watercolors, Drawings and Prints," May 1–29, 1966, Montclair Art Museum, Montclair, New Jersey; NMAA-NPG Library, Smithsonian Institution.

When Reynard was asked to comment on his career for the Montclair Art Museum's exhibition catalogue, he recalled his eighth grade efforts to draw (or rather to copy) Gibson girls. His next subjects were Grand Island's merchants and town characters which he drew on the sly from behind whatever shielded him from view. While in art schools he discovered how really difficult it is to draw, and "how much there was to learn." In retrospect, however, he admitted that those early efforts had something that brought that "little prairie town to life."

Reynard taught and lectured in addition to painting and

etching. During the summers of 1938 and 1939 he taught in West Texas at the Palo Duro School of Art. The years 1952, 1954–1957 were spent in Brookings where he was Artist-in-Residence at South Dakota State University. His attachment to the West was lifelong, and his interest in Western artists inspired such lectures as "Painters of the Old West."

Reynolds, Clara P. (–)
AAA 1903 (Utica, New York; listed with art supervisors and teachers); Binheim, 1928; Calhoun, 1942, 89; Pierce, 1926; Seattle *Town Crier,* October 3, 1914, 16.
Reynolds was director of art for the Seattle Public Schools. She also maintained a studio in Seattle.

Rhodes, Helen Neilson (1875–1938)
B. Milwaukee, Wisconsin. D. Seattle, Washington, June 16. AAA 1923–1933 (Seattle); Havlice; Mallett; WWAA 1936–1938 (Seattle; summer, Ellisport, Washington); WWAA 1940, obit.; AAW v. I; *Who's Who is Northwest Art;* Binheim, 1928; Pierce, 1926; Kingsbury.
Rhodes studied at the National Academy of Design, Columbia University, Cowles Art School in Boston, and the University of Washington where she also taught. During the early years of her career she lived in New York City. She exhibited nationally.
Aside from teaching at the University of Oregon and the University of Washington, Rhodes made a most significant contribution to the art of the Northwest by promoting linoleum and woodblock print making. According to Binheim, she edited and published *Northwest History in Block Print.*
A memorial exhibition of Rhodes' water colors was held at the Seattle Art Museum.

Ribcowsky, Dey de (See: De Ribcowsky, Dey)

Richards, F. De Berg (1822–1903)
B. Wilmington, Delaware. D. Philadelphia, Pennsylvania. Work: Santa Barbara Museum of Art; Museum of Northern Arizona, Flagstaff; Siena College, Londonville, New York; Library of Congress. AAA 1898–1900 (Philadelphia);

Fielding; Groce and Wallace; Young; *American Prints in the Library of Congress,* a catalogue; Inventory of American Paintings, Smithsonian Institution.

Richards lived briefly in New York City before moving to Philadelphia in 1846. He exhibited in several New York museums and at the Pennsylvania Academy of Fine Arts. The Smithsonian inventory lists twelve works by him, several with Western titles. The Library of Congress lists seven etchings dated from 1877 to 1888, including "Bear Creek Canyon, Colorado" dated 1888.

Richards, Samuel G. (1853–1893)

B. Spencer, Indiana. D. Denver, Colorado, November 30. Work: Dayton Art Institute; Detroit Institute of Arts; National Academy of Design; Indianapolis Museum of Art. Mallett; Peat; Baker and Hafen, v. III, 1268; Virginia Ballance Bush, "The Denver of To-Day," *Colorado* Magazine, v. 1, no. 4, 302; Gerdts, 1980 exhibition catalogue, 103; chapter by McMechen in Hafen, v. II, 1948, 429; Denver Public Library; Bromwell scrapbook.

Richards showed up in Colorado a few months before the Denver Art League opened its School of Fine Arts in September 1892. He was offered and he accepted the directorship of the school. Previously, it is said, he was offered the directorship of the Boston School of Fine Arts. Tuberculosis determined the choice this well-trained artist made.

Richards, William Trost (1833–1905)

B. Philadelphia, Pennsylvania. D. Newport, Rhode Island, November 8. Work: Pennsylvania Academy of Fine Arts; Corcoran Gallery of Art; Downtown Club, Birmingham, Alabama; Newark Museum; Metropolitan Museum of Art, etc. AAA 1898–1904 (Newport, Rhode Island); AAA 1905, obit.; Benezit; Fielding; Groce and Wallace; Havlice; Mallett; Linda S. Ferber, *William Trost Richards/American Landscape & Marine Painter 1833–1905,* New York: The Brooklyn Museum, 1973; Ferber, "William Trost Richards at the Brooklyn Museum" *American Art Review,* September-October 1973, 103–107; Gerdts, 1964, 173; Inventory of American Paintings, Smithsonian Institution; *Dictionary of American Biography.*

Richards, a landscape and marine painter of note, traveled by rail to the West Coast in 1885. Titles of paintings from that trip include "The Summit of Mount Tacoma [Rainier], Washington Territory" which he exhibited at the National Academy of Design in 1886, "Mt. Tacoma from Crater Lake," "Summit of Mount Tacoma," and "Colorado Rocks." His desire to return to the West did not materialize.

Richardson, Edward M./Ed (-)

B. England. Work: British Columbia Provincial Archives, Victoria; Public Archives of Canada, Ottawa. Havlice; Harper, 1966, 1970; Caliban [S. T. Stuart], "Art in San Francisco," *Alta California*, March 27, 1870, 2/3; April 28, 1870, 4/1; June 5, 1870, 2/3; California State Library; San Francisco Business Directories, 1868–1872; Pacific Coast Business Directory, 1871–1873 (San Francisco); National Archives.

Richardson, the son of a London sculptor, worked at sculpture and painting in British Columbia during 1863 and 1864, and in California, 1868–1871.

In 1871 Richardson was engaged as artist and assistant surveyor by Lt. George M. Wheeler to accompany his geographical survey of Southeastern California, Nevada, and Northwestern Arizona. Official orders show that he was to return to California early in November, but evidence of his return was not found notwithstanding his listing in 1872 and 1873 directories. His survey sketches may have been destroyed when Wheeler's boat capsized in the Colorado River.

Harper (1966, p. 159) saw an "almost oriental touch" in Richardson's Cariboo country scenes. Caliban, on the other hand, found a "too rigid representation of objects, natural and artificial," in his San Francisco Bay region scenes done in March 1870, but noted improvement in April. At that time Caliban said Richardson was planning to go into oils.

Richmond, Leonard (-1965)

B. England. Benezit; Mallett (London); Waters; Inventory of American Paintings, Smithsonian Institution.

Richmond exhibited at the Panama-Pacific International Exposition in San Francisco in 1915. "Pidgeon Point Lighthouse,

Pescadero, California" and the two Western landscapes listed in the Smithsonian inventory may have been painted at that time. After the First World War he was active briefly in Canada. He exhibited internationally and in London's principal art galleries.

Richter, Henry Leopold (1870–1960)
B. Plumenau, Austria. D. Rolling Hills, California, March 11. Work: Laguna Beach Museum of Art; Children's Museum, Colorado Springs, Colorado; murals, Western State College of Colorado, Gunnison. AAA 1898–1910 (Chicago, Illinois); AAA 1919 (La Veta Hotel, Gunnison); AAA 1921 (Long Beach, California); AAW v. I; Ness and Orwig, 1939; California *Arts & Architecture,* December 1932 (Long Beach); Laguna Beach Museum of Art exhibition catalogue, 1979; Inventory of American Paintings, Smithsonian Institution.

Richter was active as an exhibiting artist in Chicago before moving to Gunnison in 1911 to teach at Western State College. Except for a leave of absence in 1913 to study in Munich, he was in Gunnison until 1919 when he went to Des Moines to teach at Drake University. In 1920 he moved to Southern California. He is said to have painted in Estes Park, Colorado, from 1890.

Riddlesbarger, Sara K. (1869–)
B. near Dubuque, Iowa. Bucklin and Turner, 1932 (Blair, Nebraska).

Among Riddlesbarger's teachers was Charlie Russell of Montana.

Ridelstein, Maria Von (1885–1970)
California State Library; Castor typescript, San Francisco Public Library.

Ridelstein was a baroness who painted portraits, and taught art in San Francisco and Oakland for forty-four years.

Rippeteau, Hallie Crane (–)
B. Independence, Texas. Fisk, 1928; O'Brien, 1935.

Except for a period of study on the West Coast, and seven years of teaching art at Checotah and Eufaula, Oklahoma, Rip-

peteau studied and worked in Texas. Among her teachers were Henry A. McArdle, Janet Downie, Eva Fowler, and Robert Onderdonk. By 1928 she had exhibited so frequently in state fairs in Texas, Oklahoma, and California, that she had won sixteen prizes, twelve of them firsts. She worked in oil, water color, pastel, and French tapestry, and painted landscapes, flowers, figures, portraits, and miniatures. She resided in Dallas where she was a member of the Highland Park Art Association.

Ritschel, William (1864–1949)

B. Nuremberg, Bavaria, Germany. D. Carmel Highlands, California, March 11. Work: National Museum of American Art; Pennsylvania Academy of Fine Arts; Monterey Peninsula Museum of Art; St. Louis Art Museum; Dayton Art Institute; Art Institute of Chicago; Fort Worth Art Center; Santa Fe Railway Collection; Charles W. Bowers Memorial Museum, Santa Ana, California. AAA 1903–1933 (New York City); Benezit; Fielding; Havlice; Mallet; WWAA 1936–1941 (New York City); WWAA 1947 (Carmel, California); AAW v. I; Neuhaus, 1931; Spangenberg; *American Magazine of Art,* March 1921, 109; September 1921, 322; June 1922, 207; Carmel Public Library.

Ritschel probably made his first trip West in 1911, stopping long enough en route to sketch the Grand Canyon, the desert, and the Navajo. Then he discovered the rugged Pacific coast near Monterey and subsequently did much of his painting there. Beginning in 1911, Carmel Highlands was his second home.

Ritter, Anne Lawrence Gregory (1868–1929)

B. Plattsburg, New York. D. Denver, Colorado, November 15. Work: Denver Art Museum; Colorado Springs Fine Arts Center; Pioneers' Museum, Colorado Springs. AAA 1898–1900 (Shamokin, Pennsylvania); AAA 1903, 1907–1908 (Colorado Springs; listed as Van Briggle); AAA 1909–1910 (Colorado Springs; listed as Ritter); AAA 1915–1917 (c/o a New York art gallery); AAA 1925–1931 (Denver); Benezit; Mallett; AAW v. I; Binheim, 1928; Barbara M. Arnest (ed.), "Van Briggle Pottery/The Early Years," Colo-

rado Springs Fine Arts Center exhibition catalogue, January-March 1975; McClurg, 1924, typescript p. 52; Ormes and Ormes, 344–345; Shalkop exhibition catalogue.

Perhaps the best account of Ritter's career is given in Arnest's introduction to the Van Briggle pottery exhibition in 1975. Ritter's first husband was Artus Van Briggle, the painter and potter who started Van Briggle Pottery Company in 1902, the year they married. Following his death in 1904, she reorganized the company and took over its direction. In 1908 she married the Swiss-born engineer Etienne Ritter.

Ritter was a competent artist who deserves to be better known. She first studied landscape painting with Charles Melville Dewey in New York City. In 1893 she went to Paris for further study and remained there several years, studying also in Berlin. Upon her return she taught French, German, and art in high school at Shamokin, Pennsylvania. She taught art at Colorado Springs High School from 1900 to 1902, and at Chappell School of Art in Denver after moving there in 1923. From 1915 to 1928 she exhibited in Colorado Springs and Denver.

Robbins, Leona (–)
Ormes and Ormes, 339; Wray, Colorado Springs *Gazette,* April 2, 1916, 7/1; Colorado Springs *Gazette,* June 3, 1914, 5/5–6; June 13, 1915, 5/4; Grove, typescript; Colorado Springs Library.

The Colorado Springs *Gazette,* June 3, 1914, called the painting Robbins entered in a local exhibition a "delightful portrait." She had studied at the New York School of Art before moving to the Springs. The artist Henry Russell Wray reviewed an annual exhibition in 1916 and referred to her as a "psychological impressionist." That her work was respected is indicated by her role as a juror in the 1915 annual of the Academy of Fine Arts in Colorado Springs.

Robbins, Vesta O. (1891–)
B. Baxter, Iowa. Mallett Supplement (Bozeman, Montana); *Who's Who in Northwest Art* (Bozeman); Sternfels, typescript, 7, 11, 47, 97, 111, at Butte-Silver Bowl Free Public Library.

Robbins studied privately and at Montana State College. She exhibited often in Montana, including a one-person show at the University of Montana in Missoula. Her work was among that exhibited at the Golden Gate International Exposition in San Francisco in 1939. Her preferred medium was opaque water color.

Inasmuch as Robbins had married a forest ranger, she was able to work in some of the most scenic areas, such as Glacier National Park where she lived for months at a time. In the early 1930s she lived in Belt, Montana.

Roberts, Georgina Wootan (1891–)
B. Auburn, Indiana. AAA 1923–1925 (Hays, Kansas); Reinbach, 1928 (Pittsburg, Kansas).

Roberts studied at the Art Institute of Chicago, and taught art at Kansas State College in Pittsburg.

Robinson, Adah Matilda (1882–1962)
B. Richmond, Indiana. Work: Oklahoma Art Center, Oklahoma City. AAA 1905–1910 (Richmond); AAA 1917–1925 (Oklahoma City); AAA 1927–1933 (Tulsa, Oklahoma); Benezit; Fielding; Havlice; Mallett; WWAA 1936–1941 (Tulsa); WWAA 1947–1962 (San Antonio, Texas); AAW v. I; Nan Sheets, "Adah Robinson Exhibit Opens," *Daily Oklahoman,* December 13, 1942; "A Woman Designs a Church/Adah Robinson Gives American Expression in Her Tulsa Edifice," New York *Times,* March 10, 1929; Oklahoma City Public Library.

Robinson began her career in Richmond, Indiana, but soon moved to Oklahoma where she taught until 1945. Then she took a position at Trinity University in San Antonio.

Nan Sheets described Robinson as a "sincere, thoughtful, soft spoken" person who "truly pioneered for art in Oklahoma. Her strength, her vision, her ability and understanding, have inspired many of her students to become nationally recognized as sculptors, painters, craftsmen, Hollywood art directors, commercial artists and last but not least, simply lovers of good art."

Robinson's great achievement was the design for a church in Tulsa that attracted a most favorable review in the New York

Times. She was called upon to undertake the project when an earlier design by an architect failed to satisfy the building committee.

Robinson, Boardman Michael (1876–1952)
B. Somerset, Nova Scotia. D. Noroton, Connecticut, September 5. Work: Art Institute of Chicago; Metropolitan Museum of Art; Butler Institute of American Art; Denver Art Museum; Colorado Springs Fine Arts Center; University of Arizona Museum of Art; Museum of New Mexico; Dallas Museum of Fine Arts; Los Angeles County Museum of Art; Library of Congress, etc. AAA 1913–1915, 1919–1921 (New York City); AAA 1923 (Croton-on-Hudson, New York); AAA 1925–1927 (New York City; summer, Chilmark, Massachusetts); AAA 1933 (Colorado Springs, Colorado); Benezit; Fielding; Havlice; Mallett; WWAA 1936–1948 (Colorado Springs); WWAA 1953, obit.; AAW v. I; Earle; Albert Christ-Janer, *Boardman Robinson,* Chicago: University of Chicago Press, 1946; Paul Parker, "Boardman Robinson – Master of Conflict," *Pacific Review,* v. III, 1944, 40–42; Colorado College Library; Colorado Springs Fine Arts Center library.

Parker in an article for *Pacific Review* compared Robinson with Daumier, "not through imitation but because Robinson is the same sort of person." Robinson's preoccupation with conflict has been noted in his mountain landscapes as well as in his political cartoons. From his twenty years in Colorado Springs, 1930–1950, have come many unusual landscapes.

In introducing an extensive exhibition of 180 works by Robinson, including twenty-six landscapes, Parker wrote that landscapes interested Robinson because "mountains and clouds and trees can be invested with animistic significance. His mountains have sorrow; conversely, his human figures have the terror of mountains."

Robinson was invited to teach in Colorado Springs because Mrs. Meredith Hare believed the town needed "a top-flight artist." He taught first at Fountain Valley School for Boys of which he was director; then at the Broadmoor Art Academy, and finally at Colorado Springs Fine Arts Center of which he was made director upon its completion in 1936. The school subse-

quently attracted well-known artists and many students from all over the country.

Robinson, Delia Mary (-)
B. Waterloo, Nebraska. Work: Kearney (Nebraska) Junior High School; Masonic Home, Plattsmouth, Nebraska. AAA 1931–1933 (Waterloo); Havlice; Mallett; WWAA 1938-1941 (Waterloo); Bucklin and Turner, 1932; Joslyn Art Museum library.

Robinson studied at the University of Nebraska under Sara Hayden and Augusta Knight. Then she studied at the Chicago School of Normal and Applied Art, from which she graduated in 1917, and with several Chicago and New York City artists. In 1919 she began exhibiting regularly in Nebraska and California, and later with Midwestern Artists at the Kansas City Art Institute. From 1920 to 1922 she taught art at the University of Southern California. As a member of the Omaha Art Guild she exhibited regularly in Omaha from 1913. Many of her paintings are flower studies, usually done in water color.

Roca, Stella McLennan (-1955?)
B. Nebraska City, Nebraska. Havlice; Mallett Supplement; WWAA 1936-1941 (Tucson, Arizona); Bucklin and Turner, 1932; Bernice Cosulich, "Tucson's Palette and Brush Club Is Arizona's Oldest, Most Unusual Art Society," October 26, 1947, n.p. at University of Arizona Special Collections Library; Arizona Historical Society library.

Roca was a charter member of the Palette and Brush Club. She exhibited regularly at Southwest Artists' exhibitions in Santa Fe, New Mexico, and in Arizona. She painted portraits and landscapes. Among the latter are such titles as "Enchanted Mesa" and "Wheatfields."

Rockwell, Elizabeth A. (-)
B. New York. Work: Society of California Pioneers. Monterey (California) Public Library; Society of California Pioneers' library.

Rockwell, who lived in San Francisco from 1873 to 1895,

377

had a studio on Montgomery Street from 1879 to 1883. (She had studied in New York, and in Brussels where she went in 1868 to study at Flemish School.) She was a portrait and figure painter who also did some landscape work. Her paintings received favorable comment when exhibited at the San Francisco Art Association.

Rockwell, Etta Maia Reubell (1874–)
B. Kentucky. Bucklin and Turner, 1932 (Valentine, Nebraska).

Rockwell studied with Henry Howard Bagg in Lincoln, worked in oil and water color, and exhibited at Nebraska fairs.

Rode, Cora (1898–)
B. Chicago, Illinois. *Who's Who in Northwest Art* (Seattle, Washington).

Roeder, John (1877–1964)
B. Luxembourg, Belgium. Work: Oakland Art Museum. Inventory of American Paintings, Smithsonian Institution; Oakland Museum library.

Roeder moved to California in 1909.

Rogers, Charles A. (1848–)
B. New Haven, Connecticut. Work: California Historical Society. AAW v. I; Lewis Publishing Company, 1892, *Bay of San Francisco*, v. 2, 15–16; *American Art Annual*, 1898, 392; California State Library; San Francisco Public Library.

Rogers studied art in New York, Germany, Italy, and France. He had studios first in New York City, then Chicago, and in 1877, San Francisco. He had a "passion for brilliant effects of color, which he [rendered] with rare skill," said the compilers of *Bay of San Francisco*. He was known for landscapes, portraits, and China Town studies. He exhibited "Sunset at Pt. Reyes" at the winter 1897–98 exhibition of the Mark Hopkins Institute of Art.

Following the earthquake of 1906 when many of his paintings were destroyed, Rogers moved to Southern California.

378

Rohland, Caroline Speare (1885-1965)

B. Boston, Massachusetts. Work: Whitney Museum of American Art; Museum of New Mexico; Library of Congress; Honolulu Academy of Art; murals, USPO Bunkie, Louisiana; Sylvania, Georgia; and Fulton, New York. AAA 1931-1933 (Woodstock, New York; summer, Sierra Madre, California); Havlice; Mallett; WWAA 1936-1939 (Woodstock; summer, Sierra Madre); WWAA 1940-1941 (Brooklyn, New York); WWAA 1947-1953 (Sierra Madre).

Rohland, H. Paul (1884-1949)

B. Richmond, Virginia. Work: Whitney Museum of American Art. AAA 1915 (Brooklyn, New York); AAA 1919, 1925, 1933 (Woodstock, New York); Havlice; Mallett Supplement; WWAA 1936-1939 (Woodstock); WWAA 1940-1941 (Brooklyn); WWAA 1947 (Sierra Madre, California).

Root, Anna/Annie Stewart (-)

Work: California Historical Society. *American Art Annual,* 1898, 392; Walter Nelson-Rees, Oakland, California.

At the Mark Hopkins Institute of Art 1897-98 winter exhibition, Root showed "Across the Bay." Titles of other paintings in private collections indicate that she painted scenes of the Sacramento Valley, the Sierras, and Richardson Bay. She signed her paintings A. S. Root.

Rorphuro, Julius J. (1861/62-1928)

D. Fresno, California, May 20. Work: Oakland Art Museum. AAW v. I; California State Library; San Francisco city directories, 1894-1925; Inventory of American Paintings, Smithsonian Institution; San Francisco *Chronicle,* May 21, 1928, 7/5; Fresno *Bee,* May 21, 1928, 6/6.

The Smithsonian Institution Inventory of American Paintings lists five paintings by Rorphuro, three of which are thought to have been painted ca 1902. The titles are indicative of the subjects he chose to paint: "Herd of Buffalo Drinking from Stream," "Herd of Deer," "Indian Village," "Path Through a Wood," and "Shepherd and Sheep." Persons who are qualified to judge consider Rorphuro a competent painter; therefore it is surprising

that information about him is so limited in San Francisco where he was active from 1894, and perhaps earlier.

Ross, Gordon (1873-1946)
B. Scotland. D. New York City, December 26. AAA 1915 (New York City); AAA 1921 (Montclair, New Jersey); Mallett; WWAA 1947, obit.; Cheney, 1908, 189; Castor typescript at San Francisco Public Library.

Ross was active in San Francisco as an illustrator during the early years of his career.

Ross, Harry Dick/Harrydick (1899-)
B. Idaho. Carmel Art Association, Carmel, California; Monterey Public Library; Elayne Wareing Fitzpatrick, "Harry Dick Ross – A Remarkable Life," Monterey Peninsula *Herald* Weekend Magazine, February 7, 1982, 3-7; Irene Alexander, "Harrydick Ross Featured in New Group Gallery Show," Montery Peninsula *Herald,* February 13, 1952.

Although Ross was primarily a sculptor, his paintings featured at the New Group Gallery elicited the following comment from Alexander: "The dozen or so water color paintings included in the exhibition are uniformly lovely, having something of the quality of etchings." Ross had once studied painting with Lee Randolph at the California School of Fine Arts, and had sketched in France, Belgium, and Western United States.

Ross, Sue Robertson (-)
AAA 1919 (Fort Worth, Texas).

Rost, Miles Ernest (1891-1961)
Havlice; WWAA 1956-1959 (Carlsbad, California).

Rothery, Albert (1851-1915)
B. Matteawan, New York. Work: Joslyn Art Museum. AAA 1903-1915 (Omaha); Mallett; Bucklin and Turner, 1932, 19; Joslyn Art Museum library; Inventory of American Paintings, Smithsonian Institution.

Bucklin and Turner describe Rothery as "a portrait and

landscape painter of ability." He was active in Omaha from 1888 when he opened a studio in the Paxton Block, the location of several other art studios. In 1889 he received a first prize for "Old Hunter" and a third prize for a still life. In 1890 the two-year-old Western Art Association of Omaha awarded him a gold medal for the best oil painting in the exhibit.

Rothery grew up in Poughkeepsie where he studied at Vassar College.

Rothstein, Theresa (1893–)
B. Richmond, Minnesota. Work: Portland (Oregon) Woman's Club. Havlice; Mallett Supplement; WWAA 1938–1941 (Vancouver, Washington); AAW v. II; *Who's Who in Northwest Art.*

Rothstein studied at St. Catherine's Conservatory in St. Paul, Minnesota, before moving to Washington where she studied with Clyde Keller of Portland, at the Portland Museum of Art School, and by extension at the University of Oregon. She exhibited in the Portland-Vancouver area and won several prizes for oils.

Roybal, Alfonso [Awa Tsireh] (1895–1955)
B. San Ildefonso Pueblo, New Mexico. Work: Museum of New Mexico, Santa Fe: Denver Art Museum; Corcoran Gallery of Art; Philbrook Art Center, Tulsa, Oklahoma; Museum of Modern Art, etc. Dunn, 1968; Dorothy Dunn, "Awa Tsireh: Painter of San Ildefonso," *El Palacio,* April 1956, 107–115; Elizabeth Shepley Sergeant, "An American-Indian Artist," The *Freeman,* August 8, 1923, 514–515; "The Tribal Arts Show," *Art Digest,* December 1, 1931, 11.

Several Southwestern Indian artists are better known by their Indian names, such as Awa Tsireh. In 1920 the artist John Sloan showed some of his work at an exhibition of the Society of Independent Artists in New York. Alice Corbin Henderson arranged for an exhibition of his work that same year at the Arts Club in Chicago. A one-man exhibition at the Newberry Library followed in 1925. Further recognition came in 1931 when Awa Tsireh won first prize at the exhibition of the Grand Central Galleries. Such critics as Walter Pach and Edward Alden Jewel "lauded his art." "Awa Tsireh is a stylist, a maker of exact, order-

ly patterns . . .," they said in reviews quoted by Dunn in her article for *El Palacio.*

Awa Tsireh, whose father was Navajo, credited his mother and aunts, both exceptional potters, with his artistic talent. But Sergeant saw another influence in his art which she described as "a wide variant from the Pueblo norm. . . ."

Rush, Olive (1873-1966)

B. Fairmount, Indiana. D. Santa Fe, New Mexico, August 20. Work: Brooklyn Museum; Worcester Museum of Art; Witte Memorial Museum, San Antonio; Philadelphia Museum of Art; Museum of New Mexico, Santa Fe; Houston Museum of Fine Arts; Herron Museum of Art; Mills College, etc. AAA 1900 (New York City); AAA 1907-1908 (Wilmington, Delaware); AAA 1909-1910 (Philadelphia); AAA 1913 (Wilmington); AAA 1915-1917 (New York City); AAA 1919 (Fairmount); AAA 1921-1933 (Santa Fe); Benezit; Fielding; Havlice; Mallett; WWAA 1936-1962 (Santa Fe); AAW v. I; Coke, 1963, 63-64; Ina Sizer Cassidy, "Olive Rush," *New Mexico* Magazine, May 1957, 29, 48; "Olive Rush – Quaker Artist," *The Santa Fe Scene,* February 22, 1958, 6-8, at Santa Fe Public Library; Grace Dunham Guest, "Olive Rush Didn't Mind Being Called a Humanist," *Pasatiempo, New Mexican* Sunday Magazine, September 25, 1966, 6-7, at Santa Fe Public Library.

Rush's career as an illustrator was highly successful when she turned to easel painting – studying in Paris in 1911 and again in 1913. In June 1914 she exhibited in Santa Fe. At a retrospective exhibition of her work at the Museum of New Mexico in 1957, Rush said: "Painting out of doors everywhere finally brought me to the Southwest, and one of my first exhibitions of paintings was in June 1914 in the old Palace of the Governors."

Six years later Rush purchased a studio-home on Canyon Road, one of the first Santa Fe artists to do so, and she was active there until age ninety-one.

Perhaps the most definitive analysis of Rush's work is that of Grace Dunham Guest, curator of art at Freer Gallery in Washington, D.C. "I am amazed by its range of subject matter and of techniques, by its versatility and its consistent qualities," Guest wrote. "It is plainly to be seen that Miss Rush cannot by 'typed.'

All her life her work has borne the imprint of fresh impulse, a creative vitality."

Russell, Shirley Marie Hopper (1886-)
B. Fresno, California. Work: Honolulu Academy of Arts; Royal Hawaiian Hotel; Tripler Hospital; Moana Hotel; Supreme Court of Hawaii; Imperial Museum, Tokyo, etc. Havlice; Mallett Supplement; WWAA 1936-1970 (Honolulu, Hawaii); *Artists of Hawaii,* v. I, Honolulu: The State Foundation on Culture and the Arts and the University Press of Hawaii, 1974, 104-111.

Russell's California work was done primarily while she was studying at Stanford University, San Francisco School of Fine Arts, and California School of Arts and Crafts. She married in 1909 in Los Angeles and settled in Honolulu. She is best known for paintings of tropical flowers, seascapes, and portraits. She exhibited widely, including a number of times in Oakland, San Francisco, and Los Angeles.

Russon, Joseph F. (1874-1958)
B. Lehi, Utah. D. Salt Lake City, Utah, August 12. Work: murals, Salt Lake Temple. "Father and Son Create Joint Attraction," Salt Lake *Tribune,* January 20, 1929; "Utah Artist, Educator, 84, Succumbs After Illness," Salt Lake *Tribune,* August 14, 1958; Salt Lake City Public Library art and artists' scrapbook; Robert Olpin, Salt Lake City.

Russon was a landscape painter who was active mainly as an educator. He had studied at Brigham Young University, Pratt Institute, and the Art Students League. At Laguna Beach, California, during the summer of 1928 he painted a series of landscapes and seascapes which he exhibited in Salt Lake City in January. A water color "Dancing Rocks" was described by the *Tribune's* art critic as "vibrant and in good key." Also mentioned were an oil landscape of California poppies and two still lifes in which he had combined water color and charcoal. Many of his other paintings are of Utah scenes.

Rutland, Emily (1892/94-)
B. Lee County, Texas. Work: Witte Memorial Museum,

San Antonio; Dallas Museum of Fine Arts; Texas Tech University, Lubbock; Corpus Christi Museum of Fine Arts. Havlice; Mallett; WWAA 1936–1970 (Robstown, Texas); AAW v. I; O'Brien, 1935; Houston Public Library art and artists' scrapbook; "Texas Artist Preserves Characteristics of Horse, Mule," Houston *Chronicle,* March 19, 1938.

A lifelong interest in horses and mules led Rutland to the serious study of their anatomy and the way they communicate. "They speak to me as plainly with two ears and a tail as many a human can talk with his tongue," she said. Her lithographs of cotton plantation life, especially those featuring horses and mules, have attracted national attention. Rutland had been a school book illustrator prior to taking up painting and print making.

Ryan, Charles James (1865–1949)
B. Halifax, England. D. Covina, California, December 24. Benezit; Mallett; California State Library; *News Notes of California Libraries,* January 1908, 13; Kamerling, 1980, 248.

Ryan studied painting and architecture in England and exhibited at the Royal Academy in London from 1885 to 1892. He settled at Point Loma, California, in December 1900. He appears to have been more active there as an author than as an artist.

Ryland, C. J. (1892–)
B. San Jose, California. Carmel Art Association, Carmel, California.

Ryland studied at the University of Toulouse in France, the California School of Arts and Crafts in Oakland, and with E. Charlton Fortune and Arthur Hill Gilbert. He worked in water color.

Rymer, William C. (–)
Work: Boston Museum of Fine Arts. M. Barr, 71; *Kennedy Quarterly,* June 1967, 126; Inventory of American Paintings, Smithsonian Institution.

As Maurice Barr has said in *One Hundred Years of Artist Activity in Wyoming 1837–1937,* details of Rymer's life "remain

unavailable." However, titles of his paintings listed in the Smithsonian inventory indicate where he was: "Bear River Valley," and "In the Laramie Canyon Twenty Miles Down" are water colors dated 1871; "Bluffs of East Bank of the Missouri" is a water color dated 1872; "Indians in a Pine Forest" is dated 1876; a seascape is dated 1881. Four others also bear descriptive titles. Sizes vary from 12 × 21 to 20 × 30 inches.

S

Sacks/Sachs, Joseph (1887–)
B. Shavli, Russia. Work: Pennsylvania Academy of Fine Arts. AAA 1913 (Philadelphia, Pennsylvania); AAA 1915 (Washington, D.C.); AAA 1917–1921 (Philadelphia); AAA 1923–1929 (Philadelphia; Altadena, California); AAA 1933 (Philadelphia); Fielding; Havlice; Mallett; WWAA 1936–1941 (Philadelphia); Colorado Springs Fine Arts Center scrapbook.
Sacks visited Colorado Springs, Colorado, in July 1922, perhaps while en route to California.

Saint John, J. Allen (1872–)
B. Chicago, Illinois. Work: New York Historical Society; Santa Fe Railway Collection. AAA 1898–1900 (New York City); AAA 1905–1933 (Chicago); Benezit; Mallett; Sparks; Inventory of American Paintings, Smithsonian Institution; Huckel, 1934.
Saint John exhibited regularly in Chicago from 1909 to 1931, and at the Panama-Pacific International Exposition in San Francisco in 1915. "Indians on Horseback" and "Pueblo Mother and Child," presumably painted before 1914, are in the Santa Fe Railway Collection. Some of his Western illustrations were painted from photographs.

Salisbury, Cornelius (1882–1970)

B. Richfield, Utah. D. Salt Lake City, Utah. Work: Springville (Utah) Museum of Art. Olpin, 1980; Haseltine, 1965; Springville Museum of Art catalogue of the collection.

Following a year of study with John F. Carlson in 1904 Salisbury prepared for a teaching career at the University of Utah and Brigham Young University. Throughout many years of teaching, 1907–1943, he attended at various times the Art Students League, Pratt Institute, Corcoran Gallery of Art, and the Broadmoor Art Academy. His specialty was winter scenes and pioneer homes in Utah. He exhibited mainly at the Utah Art Institute and at Utah state fairs, and often won awards.

Salisbury, Rose/Rosine Howard (1887–1975)

B. New Brunswick, Canada. D. Salt Lake City, Utah. Work: Public collections in Utah. Olpin, 1980; Haseltine, 1965.

Like her husband Cornelius, Rose Salisbury taught art in Salt Lake City for many years. In 1928 she took a year off to study in San Francisco. In 1952 she retired from teaching to pursue "full-time a somewhat broader approach in painting than that of her husband's landscape and figure work." She exhibited at the Utah Art Institute and at state fairs, often winning awards, and she had three solo exhibitions at the Salt Lake City Art Center.

Sampson, S. Andrea (1891–)

B. New Brighton, Minnesota. Mallett Supplement (Auburn, Washington); *Who's Who in Northwest Art.*

Sampson studied privately with a number of teachers, including Eustace Ziegler and Ambrose Patterson of Seattle. She had two solo exhibitions in 1938, one at the Washington Athletic Club in Seattle, and the other at the Women's Club of Auburn. One of her paintings, "N. P. Round House," was included in a Seattle Art Museum traveling exhibit. She did linoleum and wood block prints as well as oil and water color paintings.

Sandefer, Lucile Gilbert (–)

Fisk, 1928 (Abilene, Texas).

Sandefer studied in Alabama and in Tennessee at the Nashville Conservatory of Music and Art. She moved to Abilene in

1909 with her husband who had just become president of Simmons College. She worked in all media and exhibited at West Texas fairs.

Sanden, Arthur G. (1893–)
B. Colorado Springs, Colorado. *Who's Who in Northwest Art* (Bellingham, Washington).

Sanden who worked in all media, including sculpture, obtained his training at the University of Oregon, the University of Washington, Western Washington College of Education, and Cornish School in Seattle. He taught art at Bellingham High School, wrote "How to Draw the Human Head" for *School Arts* magazine, and supplied pen-and-ink portraits of Hoover and his wife for the National Republican Campaign Committee in New York.

Sanders, Helen Fitzgerald (–)
AAA 1913 (Butte, Montana).

Sanders, Mrs. A. H. (1892–)
Mallett Supplement (Fort Worth, Texas).

Sanders exhibited "Amaryllis" at the 1936 Exposition held at the Dallas Museum of Fine Arts.

Sandor, Mathias (1857–1920)
B. Hungary, D. New York City, November 3. Work: Arizona Historical Society; Santa Fe Railway Collection. AAA 1903–1919 (New York City); AAA 1920, obit.; Benezit; Fielding; Mallett; AAW v. I; *American Art News,* later known as *The Art News,* November 20, 1920.

Sandor, who came to this country in 1881, studied at the Art Students League, 1885–1886, and at Julian Academy in Paris, 1889–1890. He did commercial work for a number of years before becoming a portrait, landscape, and miniature painter of note. *American Art News* reported that "his paintings of the Indians and their homes in New Mexico brought him deserved reputation." His paintings of the Hopi Indians of Arizona and their homes also enhanced his reputation.

Sargent, John Singer (1856–1925)
B. Florence, Italy. D. London, England, April 15. Work:

major art museums here and abroad. AAA 1898–1923 (London); Benezit; Fielding; Havlice; Mallett; Earle; Waters; James T. Forrest, "Some Went Abroad," *The American Scene*, v. 2, no. 3 (Fall 1959), 5, 9, published in Tulsa by Gilcrease Institute; Mrs. Frank B. Hoffman in an introduction to an exhibition of her husband's work at Gallery of the Southwest, Taos, New Mexico.

In 1916 Sargent went on a two-month camping trip to the Rocky Mountains of Canada during which he visited Glacier National Park. There he met Frank Hoffman, then directing public relations at the Park. Hoffman observed Sargent painting portraits of Blackfoot Indians, and "learned much about portrait painting" from him, said Mrs. Hoffman.

Two oils of Canadian scenes, said to have captured the light and color of the West, are in the Isabella Steward Gardner Museum in Boston.

Sargent, Lloyd L. (1881–1934)

B. Lyndon, Kansas. D. Dallas, Texas, October 28. O'Brien, 1935 (Dallas).

Sargent studied at the Academy of Fine Arts in Chicago, specializing in advertising art. He was with an advertising agency in Dallas from 1914 to 1924, and after 1927. In the interim he was director of a Pacific Coast advertising agency in California.

Sargent's avocation was landscape and portrait painting. Prior to his Dallas position he had done some teaching in Topeka, Kansas.

Savage, Marguerite Downing (1879–)

B. Bay Ridge, Long Island, New York. Work: Hobart College, Geneva, New York; Stanford University; Union Seminary, New York; Worcester (Massachusetts) Polytechnic Institute. AAA 1923–1933 (Worcester; summer, Prouts Neck, Maine); Fielding; Havlice; Mallett; WWAA 1936–1941 (Worcester; summer, Prouts Neck); WWAA 1947–1953 (Encino, California; summer, Prouts Neck).

Sawyer, Philip Ayer (1877–1949)

B. Chicago, Illinois. D. March 7. Work: Smithsonian Institution; Library of Congress; New York Public Library;

Hubbell Trading Post Museum, Ganado, Arizona; Santa Fe Railway Collection. AAA 1913–1919 (Chicago; summer 1917–1919, Conover, Wisconsin); AAA 1923–1927 (Paris, France); AAA 1929 (Detroit, Michigan); AAA 1931–1933 (Tiskilwa, Illinois); Benezit; Fielding; Havlice; WWAA 1936–1941 (New York City); WWAA 1947 (Clearwater, Florida); WWAA 1953, obit.; AAW v. I; *International Studio,* v. 75 (1922), 509–513; Inventory of American Paintings, Smithsonian Institution.

Among Sawyer's Western paintings are "Indian Ceremony and Landscape," dated 1904; "Hopi Girl," dated 1909; and "Navajo Indian Weaver," thought to have been painted before 1907.

Saxod, Elsa Florence Ericksen (1892–)
Olpin, 1980 (Salt Lake City, Utah).

Saxod began studying with J. T. Harwood, one of Utah's most influential teachers, in 1908. Later she studied at the University of Utah. She exhibited locally.

Schaefer, Harry (1875–1944)
B. Lockhaven, Pennsylvania. D. Multnomah County Farm, Portland, Oregon. Work: Dr. and Mrs. Franz Stenzel Collection. Stenzel, Introduction, Portland Art Museum exhibition catalogue, September 1959, 21.

Schaefer is believed to have studied in Chicago. In 1895 he made woodcuts for a Great Falls (Montana) newspaper. He worked six years in Spokane, Washington, some time prior to settling in Portland where he was a commercial artist from 1918 to the mid-thirties. His avocation was painting western subjects. A portrait of Mayor George L. Baker hung in the Portland City Hall, and a number of western subjects hung in the Old Northwest National Bank. Among the paintings exhibited at the Portland Art Museum in 1959 was "Turning Aside the Stampede," an oil dated ca 1922.

Schafer/Schaeffer, Frederick Ferdinand (1839/41–ca 1917)
B. Germany. D. Alameda or Oakland, California. Work: Seattle Art Museum; Oakland Art Museum; Shasta State Historical Monument; Bancroft Library, University of

California; California Historical Society; Society of California Pioneers. AAW v. I; California State Library; Society of California Pioneers library; Inventory of American Paintings, Smithsonian Institution; Stenzel catalogue, 1963; Baird, mimeo., 1968; San Francisco directories 1880, 1885, 1886 (Oakland and Alameda).

Recent research shows Schafer painting periodically in California from 1880 to 1917. He is said to have also painted in Oregon, British Columbia, Colorado, Montana, Idaho, Wyoming, Washington, Utah, and probably in the Southwest. "Indian Summer, Northwest" is dated 1875; "Mount Shasta, from the Meadow" is dated 1881; "Truckee River, Sierra Nevada Mountains, California" is dated 1892. About sixty of his paintings are listed in the Smithsonian inventory.

Sources differ as to Schafer's life span. It may have been 1839-1927.

Schaldach, William Joseph (1896-)
B. Elkhart, Indiana. Work: Metropolitan Museum of Art; Library of Congress; New York Public Library; Society of American Graphic Artists; Dartmouth College; Salmagundi Club. AAA 1931 (Westport, Connecticut; summer, Roscoe, New York); Havlice; Mallett; WWAA 1936-1937 (Westport); WWAA 1938-1956 (West Hartford, Vermont); WWAA 1959 (Sasabe, Arizona); WWAA 1962 (Tubac, Arizona).

Many of Schaldach's paintings and etchings reflect an interest in hunting and fishing, and in the characteristics of birds and fish. Exposure to southern Arizona prompted him to take up the study of Southwestern Indian archaeology in his later years. He first visited Arizona in the 1930s; then he began spending winters there and finally moved there. In 1963 MacMillan published his *Path to Enchantment; An Artist in the Sonora Desert.*

Schechert, Dorothea (1888-)
B. New York City. *Who's Who in Northwest Art* (Poulsbo, Washington).

Schechert, who studied in Seattle, exhibited at Kitsap County fairs and at the Seattle Art Museum. She worked in all media.

Schildhauer, Mrs. Henry (–before 1927)
Wilkinson, *American Magazine of Art,* May 1927, 271.
Mrs. Schildhauer's paintings "showed exceptional talent," said Wilkinson in her review of an exhibition by Idaho artists.

Schille, Alice O. (1869–1955)
B. Columbus, Ohio. Work: Pennsylvania Academy of Fine Arts; Columbus Gallery of Fine Arts; California Palace of the Legion of Honor, San Francisco; Herron Art Institute; Colby College collection. AAA 1905–1933 (Columbus); Fielding; Havlice; Mallett; Young; WWAA 1936–1941 (Columbus); Earle; Clark, 319–320; Edna Owings, "The Art of Alice Schille," *International Studio,* August 1913, xxxi–xxxiii; Weber, Colby College catalogue of the collection.
Schille, who taught at Columbus Art School, was a prominent Ohio painter. She traveled extensively for new subjects, including to New Mexico. In 1920 four of her New Mexico paintings were exhibited in Santa Fe.
Although Schille was skilled in oil painting as well as in water colors, most of her important awards were for the latter. In 1915 she received a gold medal at the Panama-Pacific International Exposition in San Francisco. Clark identified her "brilliant water-color pictures of many countries" as "splendid bits of impressionism."

Schlueter, Lydia Bicky (1890–)
B. Seward, Nebraska. Bucklin and Turner, 1932 (Seward).
Schlueter, who exhibited mainly in Nebraska state and county fairs, had been a pupil of H. H. Baggs of Lincoln.

Schmedtgen, William Herman (1862–1936)
B. Chicago, Illinois. Work: Chicago Union League Club; Santa Fe Railway Collection; C. M. Russell Gallery, Great Falls, Montana. AAA 1898–1904 (Chicago); AAA 1907–1908 (Evanston, Illinois); AAA 1913–1917 (Chicago); Benezit; Fielding; Mallet; Sparks; Inventory of American Paintings, Smithsonian Institution.
Schmedtgen who began his career as a newspaper artist in 1883 and became head of the Chicago *Record's* art department in 1886, traveled widely to do sketches for the newspaper and for

magazines featuring outdoor subjects. Most of his paintings in the Smithsonian inventory are portraits.

Schmidt, Theodor B. W. (1869–)
B. Niendorf Province, Schleswig Holstein, Germany. *Who's Who in Northwest Art* (Monroe, Washington).

Schmidt studied in Germany, in St. Louis, and at the Art Institute of Chicago. He did oil paintings and woodblock prints.

Schofield/Schoenfeldt/Schoenfeld, Flora Itwin (1879–)
B. Lanark, Illinois. Work: Detroit Institute of Arts. AAA 1898–1923 (Chicago; summer 1919, Provincetown, Massachusetts); AAA 1925–1933 (Chicago; Paris, France); Fielding; Havlice; Mallett; WWAA 1936–1953 (Chicago); Sparks; Jacobson, 1932, 150; Santa Fe, New Mexico, Public Library.

Schofield's career spanned many years. That she did some work in the West is evident from titles of paintings she exhibited in Santa Fe in 1920.

Schonborn, Anton (–1871)
B. Germany. D. Omaha, Nebraska, October 14. Work: Amon Carter Museum of Western Art; Beinecke Library, Yale University. AAW v. I; M. Barr, 10, 71; Franz Stenzel, *Anton Schonborn: Western Forts*, a portfolio, Amon Carter Museum of Western Art; Inventory of American Paintings, Smithsonian Institution; Aubrey L. Haines, *Yellowstone National Park/Its Exploration and Establishment*, Washington: U.S. Department of the Interior, National Park Service, 1974, 100, 103, 197, 202, 203; Michael Harrison, Fair Oaks, California.

Inasmuch as dates on Schonborn's sketches are sometimes at variance with government documents, the Haines book with its thorough documentation will be helpful to researchers.

Between the time Topographer Schonborn worked for Captain William F. Raynolds in 1859–1860 on an exploration trip to Yellowstone which failed to reach the area, and 1871 when he was with the Ferdinand Vandeveer Hayden party that did reach it, little is known of Schonborn's activities. As Hayden's chief topog-

rapher, Schonborn was in the process of making a detailed map of the season's work when he committed suicide in Omaha. His field notes were so comprehensive that others were able to complete the map. He is now best known for his sketches of early forts.

Schultz, F. W. (–)
Albuquerque Public Library; Ellen O'Connor article in the Denver *Post*, July 31, 1960.
According to O'Connor, some of the earlier dealers in Santa Fe and Taos, New Mexico, remembered Schultz as an artist who wandered through the Southwest doing numerous paintings. Six huge canvases painted for the old Congress Hotel in Pueblo, Colorado, in 1910 were discovered in 1960. The series began with a scene of Franciscan padres and conquistadores meeting with the Indians, and was followed by scenes of commerce on the plains, the laying of the railroad with Pikes Peak looming in the background, an old Bessemer converter, a pastoral subject set in the front range country of the Rockies, and a harvest.
Persons who have seen the paintings call them "first rate." At the time O'Connor wrote the article, they were being restored by George Bartlett of Colorado Springs, Colorado.

Schupback, Hedwig Julia (1889–)
B. Columbus, Nebraska. Bucklin and Turner (Columbus).
Schupbach studied with Martha Turner and others. She exhibited at Nebraska fairs and at the World's Fair in St. Louis in 1904.

Schwartz, Mrs. Morris (–)
B. Bryan County, Oklahoma. O'Brien, 1935 (Austin, Texas).
Schwartz, who was born in Indian Territory, was a great granddaughter of Chief Colbert of the Chickasaw Tribe. She attended Bloomfield Seminary, an Indian boarding school for girls; the Presbyterian College for Girls in Durant, Oklahoma; and the College of Industrial Arts in Denton, Texas, from which she received her bachelor of science degree in 1918.
Following marriage, Schwartz studied with Frank Klepper in McKinney, Texas. By the late twenties she was living in

Austin where she received her master's degree from the University of Texas in 1929. She studied art with Professor Samuel and Sadie Cavitt Gideon, and exhibited at Texas state fairs, the Cotton Palace in Waco, the Texas Fine Arts exhibition at the Century of Progress in Chicago, and the circuit exhibitions of the Texas Fine Arts Association.

Schwartz, William Samuel (1896–)

B. Smorgon, Russia. Work: Pennsylvania Academy of Fine Arts; Joslyn Art Museum, Omaha; Oklahoma City Art Center; University of Nebraska; Chicago Public Schools collection; University of Missouri; University of Wisconsin; Art Institute of Chicago; Detroit Institute of Arts; Dallas Museum of Fine Arts; San Francisco Museum of Art; Santa Barbara Museum of Art, etc. AAA 1925–1931 (Chicago, Illinois); Benezit; Havlice; Mallett; WWAA 1936–1970 (Chicago); Sparks; Bucklin and Turner, 1932; *Nebraska Art Today,* exhibition catalogue, Joslyn Art Museum; Jacobson, 1932, 151.

Schwartz moved from New York City to Omaha where he studied with J. Laurie Wallace before entering the Art Institute of Chicago. In 1967 he exhibited "The Ex-Trapper" at the Nebraska Centennial Invitational Exhibition in Omaha. Bucklin and Turner cite a monograph by Manuel Chapman, "William S. Schwartz, A Study," published in 1930, which may be of interest to researchers.

Seabury, Roxoli (1874–)

AAA 1923–1925 (Colorado Springs, Colorado); Fielding; Mallett Supplement (Laguna Beach, California); Young; Reinbach, 1928 (Lawrence, Kansas); California *Arts & Architecture,* December 1932 (San Francisco); *American Magazine of Art,* January 1925, 54.

Seabury studied in Munich, the Boston Museum of Fine Arts School, and at the Broadmoor Art Academy with Robert Reid. She exhibited at Washburn University in Topeka in 1925, the Kansas City Art Institute in 1930, and the Southwest Annual in Santa Fe, New Mexico, in 1932 when she showed a painting called "Shiprock." Before moving to California she was with the art department at the University of Kansas.

Seaman, Ada (-)

Bucklin and Turner, 1932, 23.

Seaman taught painting and drawing at the University of Nebraska in Lincoln, 1882-1883.

Seaquest, Charles L. (1864-1938)

B. Wisby, Island of Gotland, Sweden. *Who's Who in Northwest Art* (Portland, Oregon).

Seaquest was a student of Clyde Keller in Portland and a member of the Oregon Society of Artists.

Sears, John Septimus/Jack (1875-1969)

D. June 6. Work: South Cache High School, Hyrum, Utah. AAA 1915 (Rochester, New York); Olpin, 1980; Heaton, 1968.

Nationally known for his cat pictures – he also published a book called *Cat Drawings* – Sears had a long career in the East and in Salt Lake City where he taught drafting, printmaking, and graphic designing at the University of Utah from 1919 to 1943. He began as a newspaper artist in Salt Lake City in 1897, continuing in that field in New York City, Rochester, and Chattanooga. From 1907 to 1917 he worked as a free-lance artist. In 1948 he estimated that he had "completed some 25,000 drawings and sketches." He also had painted many landscapes and portraits.

Sears' years of study began in Salt Lake City, continued at the Mark Hopkins Art Institute in San Francisco, and were carried on intermittently in New York with such well-known artists as William Merritt Chase, George De Forest Brush, and Robert Henri with whom he began a year's study in 1907.

Segesman, John F. (1899-)

B. Spokane, Washington. *Who's Who in Northwest Art* (Seattle, Washington).

Segesman, an illustrator for Scripps newspapers, studied in Chicago, at Cornish School in Seattle, and at the University of Washington. He worked in water color, tempera, and oil.

Seideneck, Catherine Comstock (1885-1967)

B. Evanston, Illinois. D. Carmel, California, February 13. Work: City of Monterey Collection. Spangenberg, 1976;

Betty Hoag McGlynn article in Monterey Peninsula *Herald* Weekend Magazine, September 17, 1978, 4/7; Monterey, Carmel, and San Francisco public libraries; California *Arts & Architecture,* December 1932 (Carmel).

Seideneck studied at the Art Institute of Chicago prior to settling in California in 1915. Then she studied at the University of California and the California School of Arts and Crafts.

In Carmel Seideneck met the artist George Seideneck whom she married in 1920, after which they went to Europe for three years. In 1927 she began working with oils on paper instead of on canvas, and attracted favorable attention.

Seielstad, Benjamin Goodwin (1886–)
 B. Lake Wilson, Minnesota. Havlice; WWAA 1947–1953 (Inglewood, California).

Setterberg, Carl (1897–)
 B. Las Animas, Colorado. Work: Columbus (Georgia) Museum of Art; McChord Air Force Base; Air Force Academy, Colorado Springs, Colorado. Havlice; WWAA 1970 (New York City); Phoenix Art Museum exhibition catalogue, March-May 1972.

 Setterberg, a United States Air Force artist, studied at the Art Institute of Chicago, Chicago Academy of Fine Arts, and the Grand Central School of Art in New York. He has painted and exhibited in the West. In 1962 he was elected to associate membership in the National Academy of Design.

Severance, Julia Gridley (1877–)
 B. Oberlin, Ohio. Work: Library of Congress; Oberlin College; St. Mary's School, Knoxville, Illinois; San Diego Fine Arts Gallery. AAA 1917–1933 (Oberlin); Fielding; Havlice; Mallett; WWAA 1936–1941 (Oberlin); WWAA 1947–1959 (San Diego, California); WWAA 1962 (Chula Vista, California); Clark, 1932, 1975; *Art News,* January 12, 1924.

 Clark called Severance, better known as a sculptor, "another good etcher whose work deserves special mention." An etching accompanies the statement, and another etching by Severance appears in *Art News.*

Seymour, Celia Burnham (1869–1958)

B. Buffalo, New York. D. Salinas Valley Hospital, Salinas, California, June 27. AAA 1905–1913 (Brooklyn and New York City); AAA 1915 (Oakland, California); Mallett; Monterey Public Library; Polk's Salinas, Monterey, Pacific Grove, and Carmel City Directory, 1930 (Carmel); California *Arts & Architecture,* December 1932 (Oakland); Santa Cruz Art League exhibition catalogue, 1929.

Seymour gave her address as Oakland when she exhibited "Jolly Spaniards" and "Point Lobos" at the Santa Cruz Art League Annual in 1929. In Carmel she was known as Celia Seymour Kent.

Shattuck, (William) Ross (1895–)

B. Enderlin, North Dakota. Barr, 1954, 54; California *Arts & Architecture,* December 1932 (Hollywood, California); "Ross Shattuck Painting Older Homes in S.F.," San Francisco *Examiner,* February 29, 1948, A7; San Francisco Public Library art and artists' scrapbook.

Shattuck grew up in various parts of the West and Middle West. While working in Chicago he studied at the night classes of the Chicago Academy of Fine Arts. During summers he studied at the Pennsylvania Academy of Fine Arts. His professional life included working for the Container Corporation of America in North Dakota and the motion picture industry in Hollywood, and doing enough painting to merit a place in the arts.

Shaw, Horatio W. (1847–1918)

B. Dover Township near Adrian, Michigan. D. Cadmus, Michigan, June 28. Work: Detroit Institute of Arts; University of Michigan; Adrian College Library. Mallet Supplement (Detroit); Gibson, 1975; Omoto, 1977, 104, 107–113; Inventory of American Paintings, Smithsonian Institution; "Shaw Exhibition Reviewed," *American Art Review,* July-October 1974, 48.

Sixty-two paintings by Shaw, a White Cloud, Kansas, hardware store proprietor, are listed in the Smithsonian inventory. He studied two years with Eakins at the Pennsylvania Academy, but abandoned newly learned techniques in favor of a somewhat primitive style. By the mid-1880s he was back in

Michigan, farming and painting animals and landscapes. His residence in White Cloud may precede his period of painting. His work was exhibited in Detroit in 1940.

Shaw, Jack (1898–)
B. Kansas. Work: murals, Press Club and Elks Club, Seattle, Washington. Mallett Supplement (Kirkland, Washington); *Who's Who in Northwest Art.*

Shaw, who considered himself self-taught, studied briefly at the Chicago Academy of Fine Arts, and with Mark Tobey. He worked in all mediums, exhibited in the Seattle area, and occasionally wrote articles for *School Arts* magazine.

Shaw, Lois Hogue (1897–)
B. Merkel, Texas. Work: Sweetwater (Texas) High School. Havlice; WWAA 1959–1962 (Sweetwater); AAW v. II; Collins; Fisk, 1928, 163, 175; Van Stone, 239.

Shaw was also known as Hogue, for she was well along with her career when she married Elmer Shaw in 1927. She had graduated from Baylor College in 1919; taken a year of advanced study at the Art Institute of Chicago; taught two years at Baylor during which she had a summer of study at the Art Students League; and taught several years at Abilene Christian College and McMurry College in Abilene.

During the summer of 1924 Shaw sketched in New Mexico. From that summer's work came several paintings she exhibited in September at the Museum of New Mexico during the Santa Fe Fiesta. Other landscapes of this period were mainly inspired by sketching trips to the Buffalo Gap Mountains while she was living in Abilene.

During Shaw's years in Sweetwater, she specialized in portrait painting.

Shawhan, Ada Romer (1865–1947)
Work: Historical Society of the Tarrytowns, Tarrytown, New York. San Francisco Public Library art and artists' scrapbook; San Francisco *Examiner,* September 18, 1947, 10; Inventory of American Paintings, Smithsonian Institution.

The San Francisco *Examiner* referred to Shawhan as a

noted San Francisco portrait painter when she died in Oakland at age eighty-two.

Sheckels, Glenn (-1939)
D. Seattle, Washington, December 3. *Who's Who in Northwest Art* (Seattle).

Sheckels was a commercial artist who exhibited water color paintings at the Seattle Art Museum in 1939.

Sheets, Nan (1885-1976)
B. Albany, Illinois. D. Oklahoma City, Oklahoma, September 27. Work: Kansas City Art Institute; Illinois State Museum of Natural History and Art; Dallas Museum of Fine Arts; University of Oklahoma. AAA 1923-1933 (Oklahoma City); Benezit; Fielding; Havlice; Mallet; WWAA 1936-1976 (Oklahoma City); AAW v. I; Rex F. Harlow, "Oklahoma's Nationally Famous Artist," *Harlow's Weekly,* March 21, 1931, 4-6; Nancy Gilson, "The Legacy of Nan Sheets," Oklahoma *Journal,* March 13, 1977; Oklahoma City Public Library; Albuquerque Public Library.

Sheets studied pharmacy at Valparaiso University, and art at the University of Utah while working as a pharmacist in Salt Lake City, a position not usually open to women at that time. That she obtained it is indicative of her ability to accomplish whatever she set out to do.

After two years in Salt Lake City Sheets married a doctor who had been her classmate at Valparaiso, and moved to Bartlesville, Oklahoma, then to Muskogee, and finally to Oklahoma City about 1910.

In 1919 Sheets learned that John Carlson would teach summer classes at the Broadmoor Art Academy in Colorado Springs. She enrolled and continued to study there for several summers. Among her other teachers were Robert Reid, Everett Warner, Birger Sandzen, and Nellie Knopf. By 1930 Sheets had become one of Oklahoma's best-known artists.

Through the years Sheets traveled widely for landscape subjects: Nova Scotia, the New England coast, the Canadian Rockies, and throughout the West. She often painted in New Mexico where she had a summer studio on the highway between Taos and Santa Fe. In addition she was columnist for the Daily

Oklahoman, 1934–1962, and director of the Oklahoma Art Center, 1935–1965.

Shephard, Minnie (–)
AAA 1919 (San Francisco, California).

Shepherd, J. Clinton (1888–)
B. Des Moines, Iowa. Work: Harrison Eiteljorg Collection. AAA 1921 (Leonia, New Jersey); AAA 1923–1924 (New York City; summer, Sheridan, Wyoming); AAA 1925–1933 (New York City; summer, Westport, Connecticut); Benezit; Fielding; Havlice; Mallett; WWAA 1936–1941 (New York City; summer, Westport); WWAA 1947–1953 (Palm Beach, Florida); WWAA 1956 (New York City); WWAA 1959–1962 (Palm Beach); *Kennedy Quarterly,* June 1969, 11; Indianapolis Museum of Art Eiteljorg Collection catalogue.

Shinn, Alice (–)
Mallett (New York in 1934); "The New Instructor at the High School," *Facts,* a Colorado Springs publication, March 10, 1900, 16; "Much Interest in Art Exhibit/Impressionistic Style in Public Eye Now/Miss Shinn, Supervisor of Drawing, Gives Sketch of the New School," Colorado Springs *Gazette,* February 22, 1913, 5/3; "Pictures of Real Merit at Exhibit at Academy," *Gazette,* June 11, 1914, 5/2; "Artists' Paintings on Exhibit at Art Academy," *Gazette and Telegraph,* June 6, 1926, sec. 3, 2/2; "Many New Artists in Spring Exhibit at New Gallery/Much Variety in Pictures Shown at Broadmoor Art Academy," *Gazette and Telegraph,* May 23, 1926, 13/1–2; Colorado College Library.

Shinn, a New York City still-life painter, was an influential teacher in Colorado Springs and a defender of the "impressionistic style" before it was accepted in the West, or by more than a few in the East. She had studied with Merson and others in Paris and at the Pennsylvania Academy of Fine Arts. During her several years in Colorado Springs she was supervisor of drawing for the public schools.

About 1914 Shinn came into a private fortune. She then opened a studio in New York City and occasionally returned to

Colorado Springs during summers when she wasn't painting at her Provincetown (Massachusetts) studio. She also exhibited occasionally at the Broadmoor Art Academy.

Shorey, Maude Kennish (1882–)
B. near Rutland, North Dakota. *Who's Who in Northwest Art* (Puyallup, Washington).

Shorey studied at Federal Art School in Minneaspolis, Central Washington State College, and privately in Bellingham, Washington.

Shumate, Frances Louise (1889–)
B. Macomb, Illinois. Bucklin and Turner, 1932 (Omaha, Nebraska).

Shumate studied at the American Academy of Art in Chicago, and exhibited with Midwestern Artists at Kansas City Art Institute, 1930–1932, and with Nebraska Artists at the Art Institute of Omaha in 1930.

Shuttleworth, J. D. (–)
B. England. Denver Public Library; Bromwell scrapbook, p. 4; Rocky Mountain *News*, April 18, 1894, 5.

When Shuttleworth exhibited some of his work in Denver in 1894, the Rocky Mountain *News* reported that it showed the tradition of the English School of water color.

Siegfried, Edwin (1889–1955)
Work: Athenian Nile Club, Oakland. Walter Nelson-Rees, Oakland, California.

Siegfried, a largely self-taught artist from a pioneer family, lived mainly in Alameda, California, where he had a studio. His preferred medium was pastel, and his preferred subjects were landscapes of the San Francisco Bay Area. He also did mission and Yosemite scenes in California, and desert scenes in Arizona.

Sill, Robert A. (1895–)
B. Spencer, South Dakota. Bucklin and Turner, 1932 (Lincoln, Nebraska).

Sill studied at the Minneapolis School of Art and at the Art Institute of Chicago. He was a member of the Lincoln Art Guild

and the Art Institute of Chicago Alumni Association. He exhibited with the Guild in 1929 and 1930, and perhaps later.

Silva, William Posey (1859-1948)

B. Savannah, Georgia. D. Carmel, California, February 10. Work: Fort Worth Art Center; Isaac Delgado Museum of Art, New Orleans; Montgomery (Alabama) Museum of Fine Arts; Milwaukee Art Institute; Houston Museum of Fine Arts; Boise Art Association; Springville (Utah) High School Art Association. AAA 1909-1910 (Paris, France); AAA 1913 (Washington, D.C.); AAA 1915-1933 (Carmel); Benezit; Fielding; Havlice; Mallett; WWAA 1936-1947 (Carmel); WWAA 1953, obit.; AAW v. I; Spangenberg; Leila Mechlin, "William P. Silva – An Appreciation," *American Magazine of Art*, January 1923, 26-28; Irene Alexander, "William Silva, Business Man Turned Artist, Came to Carmel in Sand Dune Days, Stayed to Paint Forever," Carmel *Pine Cone*, November 12, 1943; Carmel Public Library.

Notwithstanding Silva's obvious ability to draw and paint, he was sent to the University of Virginia to study engineering. A reversal in his father's business necessitated his return to Savannah, and to a career in business.

In January 1907 Silva and his wife, who had encouraged him to try for a career in painting, set out for Paris. "I was as green as a gourd," he told Alexander in 1943, "but I hunted up the best men I could find, and followed their advice."

Silva progressed remarkably well, in 1908 exhibited two paintings that received acclaim, and had a solo exhibition in 1909. In 1911 the Silvas returned and made their headquarters in Washington, D.C., and later in Carmel. From 1913 on, much of Silva's painting was done on the Monterey Peninsula.

Simmons, Edward Emerson (1852-1931)

B. Concord or Cambridge, Massachusetts. D. Baltimore, Maryland, November 17. Work: State Capitol, Pierre, South Dakota; Massachusetts State House, Boston; Library of Congress; Harvard University. AAA 1898-1929 (New York City); AAA 1931, obit.; Benezit; Fielding; Havlice; Mallett; Stuart, 1974, v. II.

Simmons is said to have traveled all over the United States

to do paintings and murals, one of which is in the South Dakota State Capitol in Pierre.

Simpson, Roberta (1897–)
B. Salt Lake City, Utah. *Who's Who in Northwest Art* (Portland, Oregon).

Simpson studied at the California School of Fine Arts in San Francisco, and at the Portland Art Museum School. Her specialty was wood block prints.

Slack, Erle B. (1892–)
B. Nashville, Tennessee. Work: Library of Congress; Oklahoma State Archives; University of Oklahoma; Claremore Roundup Club, Claremore, Oklahoma. Havlice; WWAA 1953–1962 (Tulsa, Oklahoma).

Slaughter, Mrs. John B. (1858–1947)
Fisk, 1928, 180 (Post, Texas); Wilbanks, 1959, 17.

Slaughter lived on the U-Lazy-Ranch near Post from 1901. Fisk referred to her as still active in 1928 and said she painted "with considerable ability." Wilbanks called her an "accomplished artist." Many of her paintings were destroyed when her house burned in 1936.

Sloan, Lydia May/Mary (1890–)
B. Clarendon, Michigan. *Idaho Encyclopedia* (Lewiston, Idaho); *Who's Who in Northwest Art.*

Sloan studied at a normal school in Mt. Pleasant, Michigan, the Art Institute of Chicago, the University of California in Berkeley, and the University of Washington. Her work brought prizes at local exhibitions.

Small, Mrs. Robert E. (–1912)
B. probably in Chicago, Illinois. D. probably in Seattle, Washington. University of Washington Library; Mrs. Robert E. Small, "The Beginnings of an Art Institute," Seattle *Town Crier,* November 12, 1912, 6, 15; *Town Crier* art columns, March 25, 1911, 11; November 23, 1912, 6; December 7, 1912, 7.

Small had the distinction of being the first child taken into

the old Academy of Design out of which grew the Art Institute of Chicago, incorporated in 1879. She did not long remain at the Academy, but upon graduation from grammar school in 1884, she returned when it was the Art Institute. Later she wrote a paper about those early days. Following her death it was read before the Society of Seattle Artists.

Small's work "consisted of portraits in oils and figure compositions, forcefully constructed, harmonious in color, strong in technique," reported the *Town Crier* when it published her paper, November 12, 1912. She also did some landscape work.

Smeraldi, John D. (ca 1868–1947)
B. Palermo, Sicily. D. Bayside, Queens, New York, May 14. WWAA 1947, obit.; California *Arts & Architecture* (Pasadena, California).

Smeraldi was a mural painter and designer who came to this country in 1889. At the time of his death his home was in Los Angeles, California.

Smith, Clemie C. (–)
B. Tiskilwa, Illinois. AAA (Omaha, Nebraska); Mallett; Bucklin and Turner, 1932.

Smith periodically studied painting from 1907 to 1931 at: Fremont, Nebraska, 1907–1909; Nebraska State Teachers College, Wayne, 1913; Omaha, 1915; Providence and Boston, 1917; Chicago, 1926; Omaha, 1931, with Augustus Dunbier. During that lengthy period she exhibited in 1923 at the County Fair in Sidney, winning a first prize, and at the Art Institute of Omaha in 1930.

Smith, Eugene Leslie (See: Eugene Leslie Smyth)

Smith, Francis Drexel (1874–1956)
B. Chicago, Illinois. D. Colorado Springs, Colorado. Work: Colorado Springs Fine Arts Center; Denver Art Museum; Dubuque (Iowa) Art Association; Kansas City Art Institute; Municipal Art Club, Jackson, Mississippi; Montgomery (Alabama) Museum of Fine Arts; Grinnell College; Pioneer Museum, Colorado Springs. AAA 1919–1933 (Colorado Springs); Fielding; Havlice; Mallett; WWAA 1936–

1956 (Colorado Springs); AAW v. I; Denver Public Library; Colorado College Library; McClurg, 1924, typescript, 42–44.

Smith, a landscape painter, began exhibiting regularly in Colorado Springs in 1920. Many of his subjects are now historical such as "Road to Cripple Creek" and "Mine at Wagon Wheel Gap," exhibited at Broadmoor Art Academy in 1924 – the year he also began exhibiting at Carnegie Institute.

In 1938 the painter Peppino Mangravite wrote an introduction for the catalogue of Smith's solo exhibition at the Colorado Springs Fine Arts Center. Smith's art is "without frills and without dogmas," said Mangravite. "It is earthy and human and expresses consciously and conscientiously native aspects of suburban and rural scenes."

Smith, George N. (–)
AAA 1919 (Oakland, California).

Smith, Gladys Nelson (1888–)
B. near El Dorado, Kansas. Work: Warren Hall Coutts III Memorial Art Gallery, El Dorado. Havlice; Mallett Supplement; WWAA 1938-1941 (Washington, D.C.); Reinbach; El Dorado *Times*, September 17, 1979, at NMAA-NPG Library, Smithsonian Institution.

Smith was living in Minneapolis, Kansas, when she sent some of her work to Topeka to be entered in the 1921 state fair. When Marie Witwer, head of the art department of the fair, saw it, she said: "[It is] absolutely different from anything we have ever had sent in before." And Carl Bolmar, art critic for the Topeka State *Journal*, wrote: "Smith's paintings present power, vitality, color appreciation and draughtsmanship." Smith won seven first prizes that year, and also won the sweepstakes.

During 1923 and 1924 Smith continued her studies at the Chicago Art Institute. Later she studied in Washington, D.C. She exhibited in Washington for many years, including at the Corcoran Gallery of Art, and became well-known for her portraits and studies of child life.

Smith, Holmes (1863–1943)
B. Keighley, England. Work: University of Nebraska Art

Galleries; Joslyn Art Museum, Omaha. AAA 1898-1933 (St. Louis, Missouri; summer 1933, Magog, Quebec); Benezit; Fielding; Mallett; Inventory of American Paintings, Smithsonian Institution.

Smith was professor of drawing and art history at Washington University. He painted a number of Western scenes, mostly in water color. "Red Canyon, Wolf, Wyoming," dated 1912, is at the University of Nebraska; an oil of the Sangre De Cristo Mountains is at Joslyn Art Museum.

Smith, Houghton Cranford (1887–)

B. Arlington, New Jersey. Work: Wichita Art Museum. AAA 1923-1924 (Lawrence, Kansas); AAA 1925 (Taos, New Mexico; New York City); Benezit; Young; Marlene Schiller, "Houghton Cranford Smith Creates His Own World," *American Artist,* June 1976, 18-25, 64-67.

In 1922 Smith became interested in Taos, especially the Indians. His method of painting them was to watch carefully from a discrete distance and paint them from memory in his studio. Then he would return to the scene to verify his sketches. He exhibited two Taos scenes at the Santa Fe Fiesta in 1923. As for his landscapes of the New Mexico mountains, they are noted for their "gorgeous" colors, said one critic.

Prior to moving to New York City, Smith taught advertising design and drawing from cast at the University of Kansas for about five years.

Smith, Jack Wilkinson (1873-1949)

B. Paterson, New Jersey. D. Monterey Park, California, January 8. Work: Laguna Beach (California) Museum of Art; Phoenix (Arizona) Municipal Collection; Springville (Utah) Museum of Art. AAA 1917-1925 (Los Angeles, California); AAA 1927-1933 (Alhambra, California); Benezit; Fielding; Havlice; Mallett; WWAA 1936-1941 (Alhambra); AAW v. I; "Painters of the West," *American Magazine of Art,* February 1930, 112-113; Neeta Marquis, "Jack Wilkinson Smith, Colourist," *International Studio,* December 1919, 74-76; *California Design 1910,* exhibition catalogue, 47; Laguna Beach Museum of Art, July-August 1979 exhi-

bition catalogue; Inventory of American Paintings, Smithsonian Institution.

Smith's Spanish-American War sketches brought him early recognition, and a number of his Western landscapes and marines brought him prizes. In the "Painters of the West" exhibition, reviewed in the *American Magazine of Art*, Smith won a gold medal for "Fog-Veiled Headlands," and the thousand dollar de Brabant purchase prize for "Shadow Lake—High Sierras," a sizable sum in 1930.

Smith, Katharine Conley (1895–)

B. Mount Vernon, Washington. *Who's Who in Northwest Art* (Mount Vernon).

Smith studied at the School of Applied Art in Chicago, but was mainly self-taught. She worked in water color and pen-and-ink, did linoleum block prints, and exhibited locally.

Smith, Marie Vaughan (1892–)

B. Tacoma, Washington. Havlice; WWAA 1953–1962 (South Pasadena, California).

Smith, M. Lavina Olin (1878–)

B. Platte County, Nebraska. Bucklin and Turner, 1932 (Omaha, Nebraska).

Smith studied at the Minneapolis School of Art. She exhibited at Joslyn Art Museum in 1931, Kansas City Art Institute in 1932, and in Chicago.

Smyth/Smith, Eugene Leslie (1857–1932)

B. New York. D. Townshend, Vermont, In May. Work: Santa Fe Railway Collection. AAA 1919–1924 (Providence, Rhode Island); Mallett; Inventory of American Paintings, Smithsonian Institution.

Oil paintings by Smyth listed in the Smithsonian inventory bear dates from 1889 to "before" 1907, and indicate his presence in Southern California at least as early as 1892 when he painted "Sierra Madre Mountains from Pasadena."

Snider, Louise Bohl (1893–1955?)

B. Kansas City, Kansas. Work: William Rockhill Nelson

Gallery; Joslyn Art Museum. Havlice; Mallett Supplement; WWAA 1940-1941 (St. Joseph, Missouri); WWAA 1947-1953 (Albany, Missouri); Federal Writers Project, *Santa Barbara*, 96.

Snider who exhibited as a California artist at the Golden Gate International Exposition in 1939 then lived in Santa Barbara. From 1935 to 1942 she exhibited mainly in Nebraska and Missouri.

Snyder, Amanda (1894–)

Work: Portland (Oregon) Art Museum. Mallett Supplement (Portland); Portland Art Museum library.

Four oils, a linoleum print, and a woodcut print by Snyder are in the Portland Art Museum. The woodcut print is dated 1951. One of the oils is called "C. S. Price's Worktable." She may have studied with Price.

Sondag, Alphonse (1873–)

Work: Oakland Art Museum; Society of California Pioneers; San Rafael Mission, San Rafael, California. San Rafael Mission Sesquicentennial, 1967; California *Arts & Architecture*, December 1932 (San Francisco, California); *News Notes of California Libraries*, July 1934, 106.

When Sondag was staff artist for the National Park Service, he did the painting of San Rafael Mission that qualified it for state landmark status in 1934. The painting is based on a sketch said to have been made by General Vallejo, but may be Oriana Day's. See: Day, Oriana. Another historical painting by Sondag is "San Francisco Ferry Building 1877." Both are oils.

Soutter, Louis Jeanneret (1871-1942)

B. Morgues, Switzerland. D. Ballaigues, Switzerland, February 20. Work: Colorado Springs Fine Arts Center, Colorado Springs, Colorado; Cantonal Museum of Fine Arts, Lausanne, Switzerland. Benezit; AAW v. I; Barbara M. Arnest, "'These Eyes,'" *The Colorado College* Magazine, Summer 1972, 18-22; Thevos Michel, *The Complete Life and Works of Louis Soutter 1871-1942*, Zurich, MB & Cie/Josef Muller-Brookman, 1974, chapter by Elsa Reich, Colorado Springs; Ormes and Ormes, 338-339; "Expo of

Swiss Artist's Work Slated at FAC," Colorado Springs *Sun*, April 5, 1971, 5; "Soutter Works on Display at FAC," *Sun*, April 12, 1971, 10; Colorado College Library; Colorado Springs Fine Arts Center library; Denver Public Library.

The search for Soutter's paintings continues on two continents. His years in the United States were few. In Brussels he met a young violinist from Colorado Springs. They married in Colorado Springs in 1897, and were divorced in 1903 or 1904.

Soutter was a violinist as well as a painter; and when he settled in Colorado Springs in 1899 after two years in Paris with his wife, he made quite a stir. In 1900 he opened studios in the newly finished Perkins Fine Arts Hall at Colorado College. Seventeen of his portraits, flower studies, seascapes, and landscapes were exhibited at the dedication.

Ormes and Ormes wrote that Soutter had "excellent classes," and pupils that "won scholarships to the Art Students League in New York."

Soutter returned to Switzerland in 1904, divorced and ill. Ultimately he became very innovative in his painting, doing much of it with his fingers. The lovely paintings of his early years, described by Reich as "quite traditional," were only a passing phase. It is his innovative work that today brings him fame.

Spang, Frederick A. (1834–1891)

B. Norristown, Pennsylvania. D. Reading, Pennsylvania. Mallett; California State Library; Pacific Coast Business Directory, 1871–73 (San Francisco); Caliban, "Art in San Francisco," *Alta California,* April 28, 1870, 4/1, and June 5, 2/3.

Caliban referred to Spang as a "disciple of the pictorial school whose merits are of a superior order." An "able portrait painter," Spang also showed a particular interest in birds when he was in San Francisco.

Sprinchorn, Carl (1887–1971)

B. Broby, Sweden. Work: Metropolitan Museum of Art; High Museum of Art, Atlanta; Brooklyn Museum; Philadelphia Museum of Art; Fogg Museum, Harvard University; Dayton Art Institute, etc. AAA 1917–1933 (New

York City); Benezit; Fielding; Havlice; Mallett; WWAA 1936-1941 (New York City); WWAA 1947 (Mount Vernon, New York); WWAA 1953 (Shin Pond, Maine); WWAA 1956 (New York City); WWAA 1959-1970 (Selkirk, New York); "Carl Sprinchorn Exhibits," *Art News*, May 17, 1924, 2; Inventory of American Paintings, Smithsonian Institution.

When a retrospective exhibition of Sprinchorn's work was held in New York in May 1924, it included his recent California pastels. They were called "the most personal in expression of all his work" by the art critic for *Art News*.

Squires, (Charles) Clyde/C. Clyde (1883-1970)

B. Salt Lake City, Utah. AAA 1907-1908, 1913-1933 (New York City; summer, Little Neck, Long Island, New York); Mallett; Olpin, 1980.

Squires studied with James T. Harwood in Salt Lake City before going East to study illustration with Howard Pyle. Then he studied drawing and painting with William Merritt Chase, Robert Henri, Frank DuMond, Francis Luis Mora, and Kenneth Hays Miller. Although he was successful as an exhibiting artist, he is better known as an illustrator for leading magazines and book publishing companies. He was a charter member of the Society of Illustrators.

Sroufe, Susan E. (-)

B. California. California State Library; World's Columbian Exposition catalogue, 1893.

Sroufe studied abroad for three years, and exhibited at the Paris Salon. Then she opened a studio in San Francisco and painted landscapes, one of which she exhibited in 1893 at the World's Columbian Exposition in Chicago.

Stadter, Frank (See: E. Haradyniski)

Stafford, Cora Elder (-)

B. Vineland, New Jersey. O'Brien, 1935 (Denton, Texas).

Stafford studied at the University of Puerto Rico, and at Columbia University where she obtained her bachelor's and

master's degrees. Later she studied in Europe and the Near East. In 1921 she began teaching at North Texas State Teachers College, later known as Texas Woman's University, and became director of the art department in 1923. She also wrote textbooks on art appreciation.

Stahl, Marie Louise (-)

B. Cincinnati, Ohio. Work: Ohio University; Athens (Ohio) Country Club; Athens High School. AAA 1898-1900 (Avondale, Ohio); AAA 1905-1910, 1915-1931 (Athens); Benezit; Havlice; Mallett; WWAA 1936-1941 (Cincinnati); WWAA 1947-1956 (Middleton, Ohio); Clark, 1932, 1975, 493.

Stahl, who was head of the art department at Ohio University for twenty-five years, exhibited nationally. Among her teachers were William Merritt Chase, Charles Hawthorne, and Leon Gaspard with whom she studied in Taos, New Mexico. Her specialty was portraiture.

Stanton, John Aloysius (1857-1929)

B. Grass Valley, California. D. Palo Alto, California, August 25. AAA 1903 (San Francisco; listed under Art Supervisors and Teachers); AAA 1917 (San Francisco, c/o San Francisco Art Institute); AAW v. I; Porter, and others, *Art in California*, 1916; L. Mason, Pacific Grove, California; "Paintings by J. A. Stanton Adorn Theaters, Churches," Palo Alto *Times*, July 7, 1922, 8.

Stanton studied at the San Francisco School of Design. About 1888 he went to Paris where he studied under Laurens and de Chavannes. He exhibited in Paris and in Munich. By 1893 he was back in San Francisco. In 1894 he opened a studio which he maintained until the earthquake of 1906 when much of his work was destroyed. His home, however, was in Palo Alto where he had been living since 1904.

From about 1900, Stanton painted marines from sketches made during summer vacations on the Monterey Peninsula. He also traveled in the Southwest to sketch Indians and desert scenes. He exhibited mainly in San Francisco and taught there at the San Francisco School of Design for fifteen years. His por-

traits of prominent persons are in private collections, but his murals for theaters may not have survived.

Stark, Jack Gage (1882–1950)
B. Jackson County, Missouri. D. Santa Barbara, California, December 2. Work: Santa Barbara Museum of Art; Art Institute of Chicago. Havlice; Mallett Supplement (Silver City, New Mexico); WWAA 1947 (Santa Barbara); WWAA 1953, obit.; AAW v. I; California State Library; "San Francisco, Cal.," *American Art News,* February 26, 1910, 2; Maxwell, 1910, 152, 154; Art Institute of Chicago Index to Art Periodicals.

Stark's "brilliant effects of desert light and shadow lent themselves well" to the modern French school of impressionism, wrote Maxwell in 1910. In the same year *American Art News* commented favorably on Stark's work then being shown in California. In 1952 a memorial exhibition of his paintings was held in Kansas City, Missouri.

Starr, Nellie S. (1869–)
B. Illinois. *Who's Who in Northwest Art* (Glenwood and Portland, Oregon).

Starr, who worked in water color, pastel, and oil, exhibited at Oregon state fairs, Portland Art Museum, and Meier and Frank Department Store.

States, Mignon Trickey (1883–)
B. New Orleans, Louisiana. M. Barr, 73.

States was mainly self-taught when she began teaching art to elementary school children at age sixteen. Later she studied two years at the University of Nebraska. She was twenty-one when whe married and moved to a ranch near Lander, Wyoming. She exhibited at Lander, Saratoga, and Laramie where she was living by 1933. While there she studied at the University of Wyoming. By 1939 she was living in Saratoga, Wyoming. "The States' Ranch, Sinks Canyon, Lander, Wyoming," a water color in a private collection, was painted about 1910.

Stedman, Esther (–)
AAA 1919 (Santa Barbara, California); Santa Barbara City Directory, 1906.

Steele, Bess (–)

B. Meadville, Pennsylvania. Bucklin and Turner, 1932 (Lincoln, Nebraska; Washington, Pennsylvania).

Steele studied at Pratt Institute, Columbia University, University of Pittsburgh, University of California, and privately with Ralph Johonnot and Birger Sandzen. She was an etcher, a craftsman, and a teacher who began teaching at the University of Nebraska in 1921. She exhibited with the Lincoln Art Guild of which she was a member.

Stell, Thomas M., Jr. (1898–)

B. Cuero, Texas. Work: Dallas Museum of Fine Arts. O'Brien, 1935 (Dallas); *Texas Painting and Sculpture,* page 6.

Stell studied at Rice University, Columbia University, and the Art Students League. He exhibited at the Grand Central Galleries in New York, and in Texas; in December 1932 he had a one-man show at the Dallas Public Art Gallery.

During the thirties Stell taught at the Dallas Art Institute, designed stage sets, painted portraits and murals, and worked as a motion picture technician. Later he moved to San Antonio where he was living about 1971. An example of his work is shown in *Texas Painting and Sculpture.*

Stellar, Hermine Josephine (–1969)

B. Austria. AAA 1917–1933 (Chicago, Illinois); Fielding; Havlice; Mallett; WWAA 1940–1941 (Chicago); Sparks, Bucklin and Turner, 1932; Santa Fe (New Mexico) Public Library.

Stellar headed the department of drawing and painting at the University of Nebraska for a number of years beginning in 1920, and she also taught briefly at Washington State Normal School. She probably spent the summer of 1921 in Santa Fe, for she exhibited in Santa Fe's Eighth Annual. Her specialty was portrait painting.

Stephen, Jessie (1891–)

B. Delaware, Ohio. Mallett (Wayne, Nebraska); Bucklin and Turner, 1932.

Stephen, a portrait painter and teacher, studied at Ohio

State University, exhibited in Columbus, Ohio, in 1931, and taught art at Nebraska State Teachers College.

Stephens, Richard (1892-)
 B. Oakland, California. Havlice; WWAA 1953-1970 (San Mateo, California); California *Arts & Architecture,* December 1932 (San Francisco).

Stephenson, Estelle J. (ca 1885-)
 B. Danville, Illinois. Work: Elk's Club, Burley, Idaho; Burley Public Library. *Idaho Encyclopedia* (Burley); Lorena E. Warnke, Librarian, Burley Public Library; Wilkinson, 1927, 271.
 Stephenson was a graduate of Northwestern University whose career began as a registered nurse. She studied art in Chicago and in New York City.
 In reviewing an exhibition of paintings by Idaho artists, Wilkinson commented favorably on Stephenson's handling of her subjects, especially her animal pictures. At the time of the exhibition Stephenson was making an "exhaustive study" of the life and customs of Indians in order to record their vanishing way of life through her paintings.

Stephenson, Lee Robert (1895-)
 B. San Bernardino, California. Carmel Art Association, Carmel, California.
 Stephenson, who specialized in etchings and lithographs, studied principally with Armin Hansen in Monterey, California.

Sterling, Lew/Lewis Milton (1879-)
 B. Sterling, Illinois. *Who's Who in Northwest Art* (Cashmere, Washington); Calhoun, 20.
 Sterling, who worked in oils, first exhibited in Seattle in 1908 when he was a member of the Seattle Fine Arts Association. In 1935 he exhibited at the Seattle Art Museum.

Stetcher, Karl (1831-1924)
 B. Germany. D. Wichita, Kansas, in January. AAA 1924, obit.; Fielding; Mallett; Reinbach (Wichita).
 Stetcher settled in New York during his youth and spent

414

most of his life there working as a portrait painter and craftsman. He lived sufficiently long in Wichita to be considered by Reinbach a Kansas artist.

Steuernagel, Hermann (1867–)
B. Germany. *Who's Who in Northwest Art* (Puyallup, Washington).

Steuernagle studied in Germany. He was once an art director for Pathé Pictures.

Stevens, Ernest (1872–1938)
B. Aplington, Iowa. D. probably in Torrington, Wyoming. Work: University of Wyoming Art Museum. M. Barr, 73–74.

Stevens studied at Pratt Institute and in Paris. He spent eight years in Washington, D.C., making drawings for the patent office. Then he moved West, living in Denver, Colorado; Van Tassel, Wyoming; and finally in Torrington. Barr noted that he was painting landscapes in the Torrington area in 1935. A charcoal drawing is reproduced on page 73 of Barr's exhibition catalogue.

Stewart, Harriet Gilrye Muir (–)
B. Racine, Wisconsin. Bucklin and Turner, 1932 (Lincoln, Nebraska).

Stewart studied at the University of Nebraska under Cora Parker, Hermine Stellar, and Anders Haugseth. She was a member of Nebraska Artists Association.

Stillman, (H.) Ary (1891–1967)
B. Slutzk, Russia. D. January 28, 1967, probably in Houston, Texas. Work: Houston Museum of Fine Arts; New Britain (Connecticut) Museum of Art; Sioux City (Iowa) Art Center. Benezit; Havlice; Mallett; WWAA 1936–1941 (Paris, France; New York City); WWAA 1947–1953 (New York City); WWAA 1956 (New York City and Paris); WWAA 1959–1962 (Paris); Bucklin and Turner; Ness and Orwig; James Chillman, Jr., exhibition catalogue introduction, Houston Museum of Fine Arts library; Archives of American Art, Houston branch.

Stillman, who had once lived in Omaha, in 1929 exhibited at the Art Institute of Omaha work that had previously been shown in New York City, Tulsa, St. Louis, and Paris. Probably 1929 is the year he also was in Santa Fe to do some studies of Indian life, for he exhibited a number of paintings on that subject in Paris in 1930.

Stillman's use of abstract forms in his work began during the Second World War and was a dominant characteristic of his later paintings.

Stimson, Joseph E. (1870–1952)
B. Culpepper County, Virginia. M. Barr, 31, 74.

Stimson, who settled in Cheyenne, Wyoming, in 1889, was a commercial artist and photographer. He produced a number of oil landscapes while living there. He was active as a photographer with the Union Pacific Railroad for fourteen years, and later with the Bureau of Reclamation.

Stitt, Herbert D. (1880–)
B. Hot Springs, Arkansas. Work: Wilmington Society of Fine Arts, Delaware Art Center; Little Rock (Arkansas) Art Museum. AAA 1919–1921 (Sudbrook Park, Maryland); AAA 1923–1933 (Pikesville, Maryland); Benezit; Fielding; Havlice; Mallett; WWAA 1936–1941 (Pikesville); O'Brien, 1935.

Stitt is known as a landscape and equestrian painter. According to O'Brien he was with the U.S. Cavalry on the Texas-Mexico border when he took some time off to paint landscapes in South Texas. She mentions a one-man exhibition of his work at the Arts and Crafts Center in New York, and cites the Dallas *News*, May 11, 1934.

Stockfleth, Julius (1857–1935)
B. Wyk, Island of Föhr, Denmark. Work: Rosenberg Library, Galveston, Texas. AAW v. I; Pinckney; James Patrick McGuire, *Julius Stockfleth, Gulf Coast Marine and Landscape Painter,* San Antonio: Trinity University Press and the Rosenberg Library, 1976.

Stockfleth arrived in Galveston about 1885, and returned to Wyk in 1907, seven years after he witnessed the terrible hurri-

416

cane which took six thousand lives, including those of some of his relatives. Never fully recovered from the shock, he was often seen in the area of the disaster – a broken man walking with a silver-headed cane.

Stockfleth, who began his career in Germany, had studied in Sleswick, Denmark, and served an apprenticeship with a painter in Wyk. Extant Texas landscapes and marines probably number no more than a hundred. Undoubtedly many were destroyed during the hurricane.

Stoddard, Mary Catherine (1844–)
B. Mador, Ontario. Bucklin and Turner, 1932.

The year of birth for Stoddard may be incorrect, for Bucklin and Turner give the impression that she was still active in Coral Gables, Florida; Estes Park, Colorado; and Fremont, Nebraska.

Stohr, Julie/Julia Collins (1894–)
B. St. Paul, Minnesota. AAA 1923 (Lovell, Maine); AAA 1925–1931 (Monterey, California); Benezit; Fielding; Mallett; Spangenberg, 48, 59; Polk Business Directory, 1937 (Monterey).

Stohr, whose first exhibition was sponsored by Robert Henri and George Bellows, was on the Carmel summer school faculty in 1916. She specialized in portraits.

Stojana, Gjura/Stanson, George Curtin (1885–)
B. Austria or France. Work: University of California, La Jolla; Golden Gate Park Museum, San Francisco; Museum of Archaeology, Santa Fe, New Mexico. AAA 1917–1921 (Los Angeles, California; summers, Santa Fe); Benezit; Fielding; Mallett; AAW v. I; *Who's Who in California*, 1942; Robertson and Nestor, 56; California *Arts & Architecture*, December 1932 (Los Angeles).

Stojana, who painted under both names, was active in the Southwest for a number of years. As a member of the Archaeological Institute of America he found Arizona and New Mexico of particular interest. He showed "Washing After the Snake Dance" and "La Loma" at the November 1917 dedication exhibition of the new Museum of New Mexico in Santa Fe.

Stone, Anna Belle (1874–1949)

B. Des Moines, Iowa. AAA 1929 (Seattle, Washington); Havlice; Mallett Supplement; WWAA 1936–1947 (Seattle); *Who's Who in Northwest Art;* Ness and Orwig, 1939; Pierce, 1926. California *Arts & Architecture,* December 1932 (Los Angeles, California).

Stone studied at Scripps College in Claremont, California, and at the University of Washington. Among her principal teachers were Millard Sheets, Peter Camfferman, Edgar Forkner, and Ella Shepard Bush. Work exhibited at the Seattle Art Museum and the California Palace of the Legion of Honor brought her awards. Except for a brief period in California she was active as a painter and printmaker in Seattle.

Stout, Ella J. (1877–)

B. Calistoga, California. Mallett Supplement (Newberg, Oregon); *Who's Who in Northwest Art.*

Stout studied at the Portland Art Museum School, worked in oils, and exhibited locally.

Strain, Frances/Frances Strain Biesel (1898–1962)

B. Chicago, Illinois. AAA 1921–1933 (Chicago); Benezit; Havlice; Mallett; WWAA 1936–1941 (Chicago); Sparks; Jacobson, 1932, 152; Museum of New Mexico library, Santa Fe.

Strain studied with John Sloan in Santa Fe, and exhibited "Corn Dance" and "Girl with Corn" in the Santa Fe-Taos 1920 Annual.

Straus, Meyer (1831–1905)

B. Bavaria, Germany. D. San Francisco, California, March 11. Work: Oakland Art Museum; Society of California Pioneers. AAW v. I; Lewis Ferbraché, Biographies and Notes, *The Dr. and Mrs. Bruce Friedman Collection,* California Historical Society, 1969; Betty Hoag, San Mateo County Historical Museum; Spangenberg, 24; Inventory of American Paintings, Smithsonian Institution; California State Library.

Straus was a capable painter who exhibited regularly dur-

ing the three decades he lived in San Francisco. He traveled widely for his subjects, and it is thought that he probably painted in most of the Western states. He also did figure paintings. His medium was oil.

When Straus arrived in San Francisco in 1874 or 1875, he listed himself as a "scenic artist." Apparently he planned to seek employment painting scenery for theaters. However, since poor health was his reason for being in California, he may have decided that outdoor sketching was called for. He did many landscapes of Yosemite, Marin County, and Monterey.

Strimple, Olga Maria Jorgensen (1896–)
B. Kennard, Nebraska. Bucklin and Turner, 1932 (Omaha, Nebraska).

Strimple studied at the Chicago Academy of Fine Arts, probably about 1923 when she exhibited a still-life water color at the Chicago Coliseum. She studied with Augusta Knight and exhibited with Nebraska Artists while living in Omaha.

Strobel, Oscar (1891–1967)
B. Cincinnati, Ohio. Work: Valley Bank and Trust Company, Phoenix; Austin Club, and Security Trust Bank in Austin, Texas; German Embassy, Washington, D.C.; murals, Westward Ho Hotel, Phoenix; San Marcos Hotel, Chandler, Arizona. AAA 1931 (Hollywood, California); Havlice; Mallett; WWAA 1936–1937 (Phoenix); WWAA 1938–1962 (Scottsdale, Arizona); AAW v. I; J.B.P.; "Interviews Famous Artist Here," undated, unidentified news item at Scottsdale Public Library; Richard E. Lynch, Scottsdale historian; Walter Bimson, *The West and Walter Bimson*, Tucson: University of Arizona Museum of Art, 1971.

Strobel was first in Arizona in 1926. Later he taught art at Judson School for Boys in Scottsdale. His early desert landscapes were oils, based on water-color sketches made from nature. Finding that his finished paintings lacked the "elusive charm" in his sketches, he turned to working with water color. The lighter medium seemed better suited to his work than oils because the transparent atmosphere and changing colors of the desert could be better represented.

Stuart, Ellen D. (–)
AAA 1909–1910 (Paris, France); O'Brien, 1935 (Belton, Texas).
Stuart studied with William Merritt Chase; in Paris, where she exhibited in the Salon in 1908; in Holland; and in Germany.

Stuart, Granville (1834–1918)
B. Clarksburg, Virginia. Work: Amon Carter Museum of Western Art. Amon Carter Museum of Western Art catalogue of the collection; Butte-Silver Bowl Free Public Library, Montana; Granville Stuart, *Diary & Sketchbook of a Journey to "America" in 1866, & Return Trip up the Missouri River to Fort Benton, Montana,* reprinted from the Virginia City, Montana, *Post* of January 1867, with introduction by Carl Schaefer Dentzel, Los Angeles: Dawson's Book Shop, 1963; review of this book by Michael Stephen Kennedy in *American West,* Winter 1964, 74–75.
Forty-two of Stuart's sketches illustrate his published diary. Although he probably did no more than 150 drawings and sketches in all, some have been declared equal to those of Catlin, Bodmer, and Miller. Stuart spent about forty years in the West.

Sturgeon, Ruth Barnett (1883–)
B. Sterling, Kansas. AAA 1917 (Crookston, Minnesota); AAA 1919–1925 (Council Bluffs, Iowa; summer, Sterling); Fielding; California *Arts & Architecture,* December 1932 (Los Angeles, California).
Sturgeon was a painter, an etcher, a craftsman, and a teacher. She appears to have been most active as a teacher.

Sturtevant, Joseph/J. Bevier (–)
Western History Archives, University of Colorado.
"Views of Boulder and Vicinity" is the title of a rare document dated 1880 which contains twenty-four pages of text and sketches by Sturtevant.

Sturtevant, Mrs. G. A. (–)
AAA 1913 (San Francisco, California).

Sumbardo, Martha K. (1873–1961)
B. Hamburg, Germany. D. Seattle, Washington, ca July 3.

AAA 1923–1924 (Seattle); Binheim, 1928; Pierce, 1926; Dodds, Master's thesis, 123–126; Hanford, 648; Agnes Lockhart Hughes, "The Abode of An Artist," *Overland Monthly*, September 1919, 235–236; "Seattle Artist, Mrs. C. L. Sumbardo, Dies," Seattle *Times*, July 3, 1961; "Mrs. Martha Sumbardo, Painter, Passes Away," Seattle *Post-Intelligencer*, July 4, 1961; Seattle Public Library art and artists' scrapbook.

Following several years of study at Steinert School of Fine Arts in Hamburg, Sumbardo began working as a designer for an interior decorating firm. Marriage to a Florentine artist took her to Italy where she continued to study art during the raising of three children. Widowed while they were very young, she turned to copy work in 1906. She married her employer, Charles L. Sumbardo, the following year, and in 1908 they moved to West Seattle.

Sumbardo joined the West Seattle Art Club in 1910. She painted landscapes, usually in oil. About 1916 she began teaching landscape, portrait, and miniature painting, and also wall decorating, designing, and china painting. Her Seattle residence was described as a showplace. However, she preferred to display the copies of works of old masters she had done in Europe to her landscapes.

Sumner, Donna L. (–)
Colorado College Library; Wray, Colorado Springs *Gazette*, April 2, 1916, 7/1.

Although Sumner exhibited in Colorado Springs, Colorado, rather often from 1900 to 1928, very little is known about her. The artist Henry Russell Wray wrote that she was connected with the Art Institute of Chicago, and that her minatures would find "many admirers." Besides miniatures – some painted on ivory – she painted landscapes of local scenery. In 1926 she exhibited two Palm Beach, Florida scenes.

Sutton, George Miksch (1898–)
B. Lincoln, Nebraska. AAA 1929–1933 (Bethany, Nebraska/West Virginia?); Havlice; Mallett; WWAA 1936–1947 (Bethany; Ann Arbor, Michigan); WWAA 1953–1970 (Norman, Oklahoma).

Sutton is listed as a painter, an illustrator, a writer, a lecturer, and a museum curator. His position at the University of Oklahoma was professor of zoology. Art directors disagree as to his place of birth and residence.

Swan, James Gilchrist (1818–1900)

B. Medford, Massachusetts. D. Port Townsend, Washington, May 18. Work: Smithsonian Institution, Department of Anthropology; Dr. and Mrs. Franz R. Stenzel Collection. AAW v. I; Washington State Historical Society, Tacoma; Stenzel, introduction to Portland Art Museum exhibition, September 1959, 29–38; Ivan Doig, *Winter Brothers/A Season at the Edge of America,* New York and London: Harcourt Brace Jovanovich, 1980 (no illustrations); Lucile Saunders McDonald, *Swan Among the Indians/Life of James G. Swan, 1818–1900/Based upon Swan's hitherto Unpublished Diaries and Journals,* Portland: Binfords & Mort, 1972, (no illustrations); Swan, *The Indians of Cape Flattery . . .,* Washington: Smithsonian Institution, 1890, illustrated; Swan, *The Northwest Coast, or Three Years' Residence in Washington Territory,* introduction by Norman H. Clark, Seattle and London: University of Washington Press, 1972, reprinted from Harper and Row, 1969, and Harper and Brothers, 1859; Swan, "Scenes in Washington Territory," San Francisco Evening *Bulletin,* May 9, 10, 19, 24, June 17, July 12, 1859, January 18, 1860 and Nos. 7–10, and 12; no illustrations.

Swan was in California from 1850 to 1852, and thereafter in Washington Territory. Of some 250 known drawings and sketches, 125 survive. Swan also taught his Indian guide, Johnny Kit Elsiva, to draw and paint. Swan's early arrival in Washington Territory makes his sketches of the Indians of particular importance.

Swan, Paul (1899–)

B. Ashland, Illinois. Work: murals, Kings Theatre, London; Edgewater Gulf Hotel, Mississippi. AAA 1923–1924 (Los Angeles, California); AAA 1925 (New York City and Paris); Fielding; Mallett; Bucklin and Turner; *American*

Magazine of Art, July 1923, 392–393; NMAA-NPG Library, Smithsonian Institution.

In 1926 Swan returned briefly to Nebraska—he had once lived at Crab Orchard—to fill a portrait commission and to exhibit his work. He is better known as a dancer.

Sweetser, C. K./Mrs. Albert R. (1862–)
B. Centerville, Cape Cod, Massachusetts. Work: University of Oregon. *Who's Who in Northwest Art* (Eugene, Oregon).

Sweetser was a self-taught water color artist who specialized in flower painting. The University of Oregon has 350 of her botanical paintings of Oregon wild flowers.

Swensen, Milton E. (1898–)
B. Murray, Utah. Olpin, 1980.

Swensen studied at the University of Utah from 1919 to 1922, and for a year at the Art Institute of Chicago in 1924. He worked as a free-lance ad artist and illustrator in the midwest until the late forties. Following his return to Murray, a suburb of Salt Lake City, he exhibited regularly at the Art Barn and at Utah state fairs.

Swett-Gray, Naomi (1889–)
B. Portland, Oregon. *Who's Who in Northwest Art* (Seattle, Washington).

Swett-Gray studied at the Portland Art Museum School and exhibited locally.

Swift, John T. (1893–1938)
B. Denver, Colorado. D. Boise, Idaho, August 25. Work: Veterans' Hospital, Boise. *Who's Who in Northwest Art* (Boise).

Swift studied with Henry Read in Denver and at Tyler's Night School in Chicago. He worked mainly as a commercial artist, and in all media. Paintings at the Veterans' Hospital are oils titled "The Prospector," "The Scout," "Yellow Typhoon," and "Whipping the Stream." He exhibited at Boise Art Museum.

Swink, Irene (-)
 Wilbanks, 1959, 16 (Crosby County, Texas).
 Swink was one of the first artists in the Estacado region of Crosby County, Texas. One of her landscapes was acquired prior to 1888. Her father, Judge G. M. Swink, was from Dallas.

Sylvester, Pamela Hammond (1874-)
 B. Macclesfield, England. Ness and Orwig (Council Bluffs, Iowa).
 Sylvester grew up in Iowa. She was a teacher who painted in Nebraska, Colorado, California, England, Scotland, and various midwestern states.

Symons, (George) Gardner (1861-1930)
 B. Chicago, Illinois. D. Hillside, New Jersey, January 12. Work: Metropolitan Museum of Art; Corcoran Gallery of Art; Cincinnati Art Museum; Art Institute of Chicago; Toledo Museum of Art; Fort Worth Museum; City Art Museum of St. Louis; Pasadena Art Museum, etc. AAA 1903 (Ravenswood, Illinois); AAA 1909-1929 (New York City); Benezit; Fielding; Havlice; Mallett; AAW v. I; Earle; Sparks; Neeta Marquis, "Laguna: Art Colony of the Southwest," *International Studio*, March 1920, 26-27; *Art Digest*, mid-January 1930, 18, obit.; Thurston, 190; Laguna Beach Museum of Art exhibition catalogue, July-August 1979; Inventory of American Paintings, Smithsonian Institution.
 Symons, an outdoor painter, had three favorite regions— New England, especially the Berkshires; Cornwall, England; and the American West. He worked in California as early as 1884 when he opened a studio at Montecito, near Santa Barbara. In 1902 he established a studio at Arch Bay—some say Dana Point —near Laguna Beach, California, where he painted periodically.
 Symons was a landscape painter who also painted marines when he was at Arch Bay; Thurston maintains he learned to paint them there. Symons' fame rests on his New England snow scenes, although his desert and Grand Canyon paintings were well enough received. His style was a blend of "realism with a broad, vigorous impressionistic stroke."

T

Taber, Phebe/Phoebe Thorn Merritt Clements (1834–)
B. Millbrook, New York. Gibson (Grand Rapids and Detroit, Michigan); California State Library.

Taber studied in New York City and in Paris where three of her paintings were accepted for exhibition at the Salon. She also exhibited in various American cities, especially in Detroit where she exhibited at the Institute of Arts until 1889. Fruit and flower pieces were her specialty. During the later years of her life she was active in Los Angeles and Pasadena, California, where she lived from about 1903. The Los Angeles City Directory shows her at 449 South Hill Street in 1908.

Tack, Augustus Vincent (1870–1949)
B. Pittsburgh, Pennsylvania. Work: Cleveland Art Museum; Metropolitan Museum of Art; Phillips Gallery, Washington, D.C.; Newark Museum; Speed Memorial Museum, Louisville; Nebraska State Capitol. AAA 1898 (New York City); AAA 1900–1933 (New York City; Deerfield, Massachusetts); Benezit; Fielding; Havlice; Mallett; WWAA 1936–1941 (New York City and Deerfield); Eleanor B. Green, *Augustus Vincent Tack 1870–1949: Twenty-six Paintings from the Phillips Collection,* Austin: University of Texas Art Museum, 1972.

Tack visited the Far West in the mid-1930s and painted "monumental landscapes" of the desert such as "Night, Amargosa Desert."

Taggart, George Henry (1865–)
B. Watertown, New York. Work: Mormon Temple and City Hall, Salt Lake City; Pioneer Village Collection, Lagoon, Utah; Welch Memorial Library, Baltimore; City Hall, Watertown, New York; Tusculum College, Greenville, Tennessee; Chemists Club, New York City. AAA 1905–1913 (Paris, France); AAA 1915–1921 (New York City); AAA 1923–1931 (Port Washington, Long Island); Benezit; Fielding; Havlice; Mallett; WWAA 1936–1959 (Port Washington); Olpin, 1980; Utah Art Institute, Sec-

ond Annual Report, 1900, 25-27; Salt Lake City Public Library.

While recovering his health in Provo, Utah, at the turn of the century, Taggart was active in the state's art circles. In 1900 his painting "Harvesters" won a cash award at the Utah Art Institute's annual exhibition.

Taliaferro, John (1895–)
B. Omaha, Nebraska. *Who's Who in Northwest Art* (Seattle, Washington).

Taliaferro, an advertising artist with the Seattle *Post-Intelligencer*, studied at Yale University School of Fine Arts. He worked in oil.

Tames/Thams, Ingabord (Mrs. H. P. Ashby) (–)
Boise City and Ada County Directory, 1911, as Ingeborg Thams; Wilkinson, 1927, 270.

Tames exhibited in Paris while she was studying there, and, according to Wilkinson, her "portraits showed a fine understanding of technique and values."

Tasakos, Elsie Eyerdam (1889–)
B. Willamina, Oregon. Work: Olympic View School, Seattle. *Who's Who in Northwest Art* (Seattle, Washington).

Tasakos studied at Otis Art Institute in Los Angeles and at the University of Washington. She exhibited with Northwest Artists in 1924.

Taylor, Mary (1895–)
B. Murray, Iowa. Mallett Supplement (New York); Ness and Orwig, 1939 (New York City).

Taylor was active in Colorado as a teacher and a painter while serving as Supervisor of Art in Fort Morgan.

Teague, Donald (1897–)
B. Brooklyn, New York. Work: Mills College Art Gallery; University of Oregon; University of Kansas; Phoenix Art Museum; Frye Museum, Seattle; Virginia Museum of Fine Arts. AAA 1925-1933 (New York City; New Rochelle, New York); Benezit; Havlice; Mallett; WWAA 1936-1939

(New Rochelle); WWAA 1940-1947 (Encino, California); WWAA 1953-1980 (Carmel, California); AAW v. I; Mahony; Richard Muno, *Cowboy Artists of America*, Flagstaff, Arizona: Northland Press, 1971; Carmel *Pacific Spectator-Journal*, April 1, 1956, 31-34; Carmel Public Library; Monterey Public Library; *Gallery Who's Who in Art* fact sheet, Carmel.

Although many of Teague's illustrations depended upon motion picture props as models, he had first-hand experience with his subjects from several summers on a Colorado ranch. It was this experience, wrote Muno, that "ignited" his interest in the West.

It is well to know that Teague used the pseudonym "Edwin Dawes" on many of his illustrations, apparently unaware that the painter Edwin Dawes (1872-1945) was also active.

Teape, Nancy M. Miller (1864–)
B. Marble Rock, Iowa. *Idaho Encyclopedia* (Spirit Lake, Idaho); Wilkinson, 1927, 270.

In discussing the work of Idaho artists in 1927, Wilkinson wrote that Teape's picture of Bear Grass "was wonderfully delicate and ethereal." Teape had found "this rare specimen when on one of her many excursions" in the mountains. Since moving to Idaho about 1913, she had made a special study of plants and flowers and was writing and illustrating a book on the flora of Idaho. Prior to residing in Idaho she had taught art in Colorado.

Teel, Louis Woods (1883–)
B. Clarksville, Texas. Work: McKee Foundation, El Paso, Texas. Mallett (El Paso); Fisk; O'Brien; Houston Public Library art and artists' scrapbook; Houston *Press*, April 29, 1938; Ballinger, 1976, an exhibition catalogue.

A brief stint in Detroit in the automobile industry preceded Teel's study of art. About 1916 he began specializing in portraiture, but after 1927, landscape painting was his main interest. Southwestern desert scenes comprise most of his work. Representational in style, they are painted with a view to showing the real desert – "delicate blues and lavenders . . . oddly affected by atmospheric changes" – he said. "The colors of this arid land are soft."

Terry, Florence Beach (1880–)

B. Hays, Kansas. Mallett Supplement (Seattle, Washington); Polk's Directory, 1930 (Carmel, California); *Who's Who in Northwest Art* (Seattle).

Terry studied with Robert Henri and William Merritt Chase in New York; with Gertrude Estabrooks in Chicago; at the Kansas City Art Institute; and at the University of Washington. While living in Kansas she was art department head of Ottawa University and a member of Kansas City Artists. She worked in oil and water color, and exhibited at the Seattle Art Museum in 1937.

Thayer, Emma Homan (1842–1908)

B. New York. AAA 1898–1900 shows E. Thayer (North Adams, Massachusetts); AAA 1905–1906 (Denver, Colorado); AAW v. I; *Who Was Who in America*; Colorado College Library; "An Artist's Protest," Colorado Springs *Gazette*, October 28, 1885, 2/1–2; "The Stewart-Thayer Controversy," *Gazette*, November 8, 1885, 2/1–2; Letter to the Editor by Susan Dunbar, *Gazette*, January 7, 1886, 2/1.

In 1885 Thayer published *Wild Flowers of Colorado* illustrated with sketches she made in the Colorado Rockies during the fall of 1884 when she was with a hunting party. Since she did not have sketches for spring and summer flowers, she had copied some that were painted by Colorado Springs artist Alice Stewart who was then illustrating Helen Hunt Jackson's *Procession of Flowers*. Stewart wrote the *Gazette* in protest. Thayer later published the book as *Wild Flowers of the Rocky Mountains*, but whether she credited Stewart was not determined.

In 1887 Thayer published *Wild Flowers of the Pacific Coast*. This was followed by two novels.

Thomas, Grace Sullivan [G. S. Thomas] (–)

B. Canton, Texas. Fisk, 1928, 162–163 (Abilene, Texas).

In 1920, when Thomas's family were partly grown, she began studying art at Simmons College, and in 1923 at Abilene College. By the late 1920s she had won eleven first prizes and nine seconds in Texas exhibitions. She did landscapes and still lifes. Among her teachers was Lois Hogue Shaw.

Thomson, Rodney (1878–)
 B. San Francisco. AAA 1917-1931 (New York City; New Rochelle, New York); Fielding; Mallett.
 Thomson was an illustrator who studied art in San Francisco.

Thomson, Thomas John/Tom (1877–1917)
 B. near Claremont, Canada. D. Canoe Lake. Algonquin Park, Ontario, July 8. Work: National Gallery of Canada; Hart House, University of Toronto; Art Gallery of Ontario. Benezit; Havlice; Mallett; Harper, 1966; Murray, 1973; Hubbard and Ostiguy, 1967; Wallace & McKay, 1978.
 Thomson began painting in Seattle, Washington, where he worked as a photo-engraver from 1901 to 1905. These experiments with water colors, and the early oils he did in Toronto shortly after his return gave little indication of the painter he was to become with virtually no formal training. So far as is known, he did not return to the States to paint, finding most of his subject matter in Algonquin Park.

Thorndike, Charles Jesse/Chuck (1897–)
 B. Seattle, Washington. Havlice; WWAA 1947-1953 (Miami, Florida); WWAA 1959-1962 (Miami Shores); WWAA 1966-1970 (North Miami); Pierce, 1926.
 Thorndike studied at the University of California, the University of Washington, and at Seattle Art School. He was active professionally in Seattle and in San Francisco prior to his Florida residence.

Throssel/Throssell, Richard (ca 1881–1933)
 D. Helena, Montana. Henry W. Hough, "Richard Throssel/ Photographer of the Crows," *Brand Book,* Denver Posse of the Westerners, v. 10, 1954, 29-37; Sternfels, typescript at Butte-Silver Bowl Free Public Library.
 Throssel is said by Sternfels to be part Crow, and by Hough to be French Canadian and Cree. His lifelong interest in the Crows probably began about 1902 when he took a clerical job at the Crow Agency. There he met Joseph Henry Sharp who taught him how to paint. He later turned to photography "to

make a record of the Crows and their 'old life' customs and costumes . . .," wrote Hough. Reproductions of a painting and three photographs illustrate the article.

In 1910 Throssel moved to Billings and made a name for himself as a photographer, wrote Sternfels.

Thurston, Eugene B. (1896–)

B. Memphis, Tennessee. Work: McKee Foundation, El Paso, Texas. Ballinger, 1976 exhibition catalogue; Fisk, 1928; O'Brien, 1935 (El Paso, Texas).

Thurston was eleven when his parents moved to El Paso in 1907. His first teacher was his mother, Fannie Palmer Thurston, "a gifted painter." Later he attended the Federal School of Art in Minneapolis for four years, specializing in commercial art, and then studied briefly in El Paso with Day de Ribcowsky.

Although the designing of greeting cards seems to have been Thurston's main source of income, he painted many desert landscapes and exhibited in El Paso, Phoenix, San Antonio, and New York City. An oil landscape by him won a first award at an international exposition in El Paso in 1925.

Tidden, John Clark (1889–)

B. Yonkers, New York. Work: University Club, Houston; Penn State University. AAA 1919–1925 (Houston; summer, Colorado Springs, Colorado); AAA 1927–1931 (Houston and New York City); Benezit; Havlice; Mallett; WWAA 1947 (New York City); *Texas Painters and Sculptors: 20th Century;* Houston Museum of Fine Arts library; Houston Public Library; Colorado Springs Fine Arts Center library; "Tidden Pictures at the Academy," Colorado Springs *Telegraph,* July 21, 1921.

Tidden was the first art professor at Rice University when painting and drawing classes were introduced in the Department of Architecture about 1912. He remained at Rice until the late twenties when he opened a studio in New York.

In 1921 Tidden was asked by his Colorado Springs friends to bring paintings for an exhibition at the Broadmoor Art Academy. The Colorado Springs *Telegraph* reported that he was at that time "attracting wide attention . . . through exceptionally strong

work with the brush." Six of the eight exhibited paintings were landscapes.

Tiffany, Louis Comfort (1848-1933)
B. New York. D. New York City, January 17. Work: Metropolitan Museum of Art; Brooklyn Museum; Hirschhorn Museum; National Academy of Design; Hudson River Museum, Yonkers. AAA 1898-1931 (New York City); Benezit; Fielding; Havlice; Mallett; Earle; "Water Colors by Louis C. Tiffany," *American Magazine of Art*, August 1922, 258-259; Gary Reynolds, "Louis Comfort Tiffany/ Also a Painter," *American Art & Antiques*, March-April 1979, 36-45; Inventory of American Paintings, Smithsonian Institution.

American Magazine of Art reported that Tiffany employed three different methods in his water-color painting: "transparent wash, opaque color, and the low-toned scrub method of the Dutch. . . ." His "Chinatown, San Francisco," is dated 1908; his "On the Bridge, Vancouver," August 30, 1916. His specialty was oriental scenes.

Tilghman, Stedman Richard (-1848)
D. New Orleans, Louisiana, July 26. M. Barr, 76; Nottage, 81.

Tilghman, a graduate of Baltimore Medical School, joined William Drummond Stewart's 1843 expedition to the West and sketched a number of landmarks, including Devil's Gate and Ayer's Natural Bridge.

Tilton, Florence Ahlfeld (1894-)
B. Vermillion, South Dakota. AAA 1933 (Normal, Illinois); Havlice; Mallett; WWAA 1936-1937 (Normal); WWAA 1938-1941 (North Manchester, Indiana); Bucklin and Turner, 1932 (Peru, Nebraska).

Tilton, an art teacher at Peru State Teachers College, exhibited with Nebraska Artists, and at the Art Institute of Omaha.

Timmins, Harry L. (1887-)
B. Wilsonville, Nebraska. Havlice; Mallett; WWAA 1936-

431

1941 (Greenwich, Connecticut); WWAA 1947–1959 (Encino, California); Monterey Public Library, Monterey, California.

Titsworth/Tittsworth, Ben D. (1898–)

B. Valdez, Colorado. D. Denver, Colorado, early 1970s. Colorado Springs Fine Arts Center library; *B. D. Titsworth— The Colorado Springs Fine Arts Center, 1974,* an exhibition catalogue.

Titsworth, who grew up on a ranch near Trinidad, Colorado, began drawing Western subjects at age five. His inspiration came from stories told to him by his deputy sheriff father, and from pictures of Charlie Russell's paintings. His formal training was obtained under the G. I. Bill at Colorado Springs Fine Arts Center school. In 1974, the Fine Arts Center exhibited his work.

Titsworth's main source of income was ranching, coal mining and construction work. However, he was able to sell illustrations to *Western Horseman, True West,* and *Frontier Times,* and political cartoons to the Pueblo *Chieftain.* His paintings were oils, and his best work was done before 1959.

Tobey, Mark (1890–1976)

B. Centerville, Wisconsin. D. Basel, Switzerland. Work: Seattle Art Museum; Henry Gallery, University of Washington; Metropolitan Museum of Art; Museum of Modern Art; Whitney Museum of American Art; Boston Museum of Fine Arts. AAA 1919 (New York City); Benezit; Havlice; Mallett Supplement; WWAA 1940–1941, 1959–1976 (New York art galleries); *Who's Who in Northwest Art* (Seattle); Kingsbury, 1972 and 1978; Smithsonian Institution/NCFA, *Art of the Pacific Northwest . . .,* 1974.

Tobey's years in the West began in the early 1920s when he moved to Seattle. After teaching briefly at Cornish School of Allied Arts he traveled for two years in Europe and the Near East. He returned to Seattle in 1927.

Tobey spent much of the thirties in England teaching at Dartington Hall School and experimenting with a painting technique called "white writing." It brought him considerable recognition here and abroad. His early work reflects the influence of his Northwest surroundings more than his later work.

In 1960, after years of dividing his time between Seattle and other parts of the world, Tobey moved to Basel.

Tobie, Frances Jurgens (1874–)
B. Helena, Montana. *Who's Who in Northwest Art* (Kalispell, Montana).
Tobie studied at the Art Institute of Chicago. She worked in pastel, oil, and water color, and specialized in miniatures.

Toler, Mary M. (1897–)
B. Lake Benton, Minnesota. Carmel Art Association; Harbick.
Toler was a member of the Carmel Art Association who worked in oil. No mention was made of when she settled in California. She lived in the Carmel area.

Toler, William Pinkney (1825–1899)
B. Venezuela of American parents. Oakland Museum exhibition catalogue, *Tropical Scenes*, 1971, 49–50.
Toler was educated in Washington, D.C. As a midshipman in the Navy in 1846 he helped hoist the flag up the Monterey (California) Customs House flag pole. In 1888 he had a studio in San Francisco, and he lived in San Leandro. He painted portraits and landscapes.

Tomlinson, Henry (1875–)
B. Bridgeton, New Jersey. *Who's Who in Northwest Art* (Portland, Oregon).
Tomlinson was a self-taught painter who worked in oils. He was a member of the Oregon Society of Artists.

Tompsett, Ruth R. (1889–)
B. Omaha, Nebraska. Mallett Supplement (Omaha); Bucklin and Turner, 1932 (Omaha).
Tompsett studied at several major universities, including the University of Oregon, and with a number of prominent teachers in Nebraska, California, and Massachusetts. She also attended the New York School of Art and the Art Institute of

Chicago. She taught art at North High School in Omaha, and exhibited locally and in Kansas City, Missouri.

Tonkin, Linley Munson (1877-1932)

B. Sherman, Texas. D. Denton, Texas, November 21. Work: Texas Technological College, Lubbock. AAA 1933 (McAlester, Oklahoma; Taos, New Mexico); Mallett; O'Brien, 1935; Oklahoma City Public Library; Will May, "Oklahoma Artists' Exhibition Is Best Association [of Oklahoma Artists] Has Offered," Daily *Oklahoman,* November 21, 1926; *American Magazine of Art,* February 1930, 86, and June 1929, 366; Colorado Springs Fine Arts Center library.

Tonkin was sixteen when she began four years of study at the Art Students League. In 1922, after she had reared her family, she returned to serious study, this time at the Broadmoor Art Academy in Colorado Springs. She specialized in landscape and figure painting, and within a few years her work merited attention. Will May wrote that there is "a snap and a freshness to her work that is appealing," referring to "Sarita Gomez" and "Taos Sunshine." In February 1930 *American Magazine of Art* featured her "The Right Hon. Jacob Beavers – Freed at 32," which had won honorable mention and a silver medal.

An interest in printmaking – Tonkin was also an etcher and a lithographer – led to the acquisition of one of the largest and best private collections of prints and bookplates in the Southwest.

Tonkin was active until the very last day of her life. During her belated career she had exhibitied in Washington, D.C., Southern California, Kansas City, Oklahoma City, San Antonio, Taos, and Santa Fe. She is probably best known for her lithographs.

Topschevsky, Morris (1899-1950?)

B. Blalistock, Poland. Work: murals, Abraham Lincoln Center, Chicago. AAA 1925-1933 (Chicago, Illinois); Havlice; WWAA 1938-1947 (Chicago); WWAA 1953, obit.; Sparks; Jacobson, 1932.

Topschevsky, who studied at the Art Institute of Chicago, lived in Chicago from 1910 except for 1924-1926 while studying

in Mexico City. He did some painting in Texas, said Jacobson. He was also an etcher.

Towne, C. F. (ca 1834-1917?)

B. Cobden, Illinois. D. Denver, Colorado. Denver Public Library; Bromwell scrapbook, page 48.

Towne was a minister who painted during his later years.

Townsend, Frances (1863-)

B. Washington, Maine. AAA 1921-1924 (Yakima, Washington); Benezit; Pierce, 1926.

Townsend, a landscape painter, had studied with Robert Harshe (probably when he was at Stanford University or Berkeley, California); Mary De Neale Morgan of Carmel, California; and Ambrose Patterson of Seattle. By 1926 she was teaching at Pacific Lutheran College in Parkland, Washington, and exhibiting with the Seattle Fine Arts Society.

Tracy, John M. (1844-)

B. Rochester, Ohio. Work: Society of California Pioneers. Mallett; AAW v. I; California State Library; Hartley, mimeo; Society of California Pioneers library; *Alta California,* March 27, 1870; April 28, 1870, 4/1; June 5, 1870, 2/3.

Tracy, who was mainly self-taught, studied briefly at the California School of Design while living in San Francisco in the early 1870s. His paintings sold for very small amounts, said Hartley, but after he returned to the East he sold "Autumn in the Fields" for five thousand dollars.

Caliban in his art column for *Alta,* April 28, described Tracy's "The Signal" in which an Indian appears to be signaling a party of his confederates. The setting is a barren prairie over which the sun is setting.

In June, Caliban reported that Tracy and E. A. Poole were sketching in the mountains from which they were expected to return in the fall.

Tracy also did some portrait painting while living in California. He later lived in St. Louis and in 1883 he moved to New York. Hartley said he was very successful after leaving California, seldom getting less than a thousand dollars for a painting.

Trano, Clarence E. (1895–1958)

B. Minneapolis, Minnesota. D. Whittier, California, July 26. Work: private collections. Beverly Jacobson, "Granddaughter Finds Attic full of Art," *Eight County Shopper and Entertainment Guide*, Kennewick, Washington, October 28, 1980; Cheryl Osborn, Kennewick; Pearl M. Winner, Cornelius, Oregon.

Trano was nineteen when he met Charlie Russell while working as a tour guide in Glacier National Park. Under Russell's instruction he learned to paint. It was almost the only training he received; yet he was able to make a living as an artist in California where he moved in 1923.

While employed by a greeting card company Trano was sent to an etching class. Subsequently he joined the Society of California Etchers, for etchings and woodblock prints had become a major part of his output.

Much of Trano's subject matter was gleaned from imagination or done from photographs. But he also worked at the site for landscapes. Landscapes and portraits comprise a significant part of his work and include such subjects as Blackfoot Indians and California missions.

Troccoli, Giovanni Battista (1882–1940)

B. Lauropoli, Italy. Work: Detroit Institute of Arts; Boston Museum of Fine Arts. AAA 1905–1906 (Boston, Massachusetts); AAA 1907–1921 (New Centre, Massachusetts); AAA 1923–1924 (Chestnut Hill, Massachusetts); AAA 1925–1933 (Newton Center); Benezit; Fielding; Havlice; Mallett 1936–1939 (Newton Center); Federal Writers Project, *Santa Barbara*, 96; California State Library.

Although Troccoli retained his Massachusetts address, he was living in California from about 1926 until at least 1939 when he exhibited a portrait at the Golden Gate International Exposition in San Francisco. At that time he was living in Santa Barbara. He exhibited nationally from coast to coast and won a number of important prizes.

Troy, Minerva Elizabeth [M. Troy] (1878–)

B. Vassar, Michigan. Work: Episcopal Church, Port An-

geles, Washington. *Who's Who in Northwest Art* (Port Angeles).

Troy studied with private teachers in Omaha, and probably in Detroit when Bischoff was there, for he is listed among her teachers. During the thirties she taught an art class in the adult education program in Port Angeles and exhibited locally. She was selected by a committee to do the design for an Olympic National Park postage stamp.

Truax, Sarah E. (ca 1872–1959)
B. Marble Rock, Iowa. D. San Diego, California, September 26. Work: San Diego Fine Arts Society; Women's Club, Lidgerwood, North Dakota; First Unitarian Church, San Diego; First Baptist Church, Breckenridge, Minnesota. AAA 1931–1933 (San Diego); Benezit; Havlice; Mallett; WWAA 1936–1962 (San Diego); AAW v. I; California State Library.

In 1915, Truax, who had lived in San Diego since August 1912, won silver and bronze medals at the Panama-Pacific International Exposition in San Francisco. Thereafter she exhibited nationally until the mid-forties. Her specialty probably was miniatures.

True, Clark (ca 1885–)
B. near Wichita, Kansas. Colorado College Library; Ellen O'Connor, "Clark True, Specialist in Scenes of West, Attains His Childhood Aim in Springs," Denver *Post*, March 9, 1958, 14A.

True was born on a cattle ranch and brought up on tales of the Old Chisholm Trail. His ambition to paint that era took him to Chicago to study at the Art Institute of Chicago, but World War I cut short his art education. Many years later he began studying in California with James Swinnerton, whose interest in the West matched his.

Six years of painting in Taos, Santa Fe, Albuquerque, and high mountain country followed. Then he settled in Colorado Springs and began doing portraits, murals, and subjects such as "Anthony's Farewell to Cleopatra" which is said to have brought $3,000.

Trullinger, John Henry (1870–)

B. Forest Grove, Oregon. Work: Municipal collection, Portland, Oregon. AAA 1909–1910 (Paris, France); *Who's Who in Northwest Art* (Portland).

Trullinger, who worked in oil, water color, and pastel, had studied at art academies in England and France and had exhibited in Paris in 1909. The following year he had a solo exhibition at the Portland Art Museum.

Tubbs, Ruth H. (1898–)

B. Grand Forks, North Dakota. Bucklin and Turner, 1932 (Hastings, Nebraska; Greeley, Colorado).

Tubbs studied at the University of North Dakota, and at Colorado State Teachers College in Greeley. She taught art at Hastings High School and lived in Hastings during the school year.

Tucker, Adah (1870–)

B. Helena, Nebraska. Bucklin and Turner, 1932 (Lincoln, Nebraska).

Tucker was a landscape painter who had studied in New York at Chase Art School and the New York School of Art. Among her teachers were Francis Luis Mora and William Merritt Chase.

Tufts, Florence Ingalsbe (1874–)

B. Hopeton, California. Havlice; Mallett Supplement; WWAA 1940–1941 (Berkeley, California); California State Library; California *Arts & Architecture,* December 1932 (Berkeley).

Tufts was a San Francisco resident when she married John Burnside Tufts in 1898. She studied with Godfrey Fletcher in Monterey and with Spencer Macky at the California School of Fine Arts. She began exhibiting locally about 1922. Her medium was water color, and her work won several important prizes.

Tufts, John Burnside/Dr. J. B. (1869–)

B. Boston, Massachusetts. Mallett Supplement; California State Library; California *Arts & Architecture,* December 1932 (Berkeley, California).

Tufts, a California resident since 1876, lived in Santa Cruz, San Rafael, San Francisco, and Berkeley. He studied with E. Charlton Fortune and at the California School of Fine Arts in San Francisco. He exhibited in 1928 at the San Francisco Art Association annual, and in the second annual exhibition of the Santa Cruz Art League in 1929, at which time he was living in San Francisco.

Turner, Elmer P. (1890–1966)

B. Wyoming. Work: Harwood Foundation, Taos, New Mexico. Mallett (active 1927 in New York); AAW v. I; Santa Fe Public Library.

Turner was born on a ranch in Wyoming. He graduated from Colorado State Teachers College in Greeley and later studied at the Art Institute of Chicago. He taught art for a number of years and exhibited regularly from the mid-twenties to the mid-thirties. During 1926–1928 he exhibited at the Broadmoor Art Academy in Colorado Springs such titles as "On the Wind River Trail, Estes Park"; during 1931–1936 he exhibited in Santa Fe such titles as "The Rio Grande" and "Hills Near Pojoaque."

Turner, Jean Leavitt (1895–)

B. New York City. Havlice; WWAA 1947 (San Francisco, California); WWAA 1953–1962 (Kemper Campbell Ranch, Victorville, California).

Twachtman, John Henry (1853–1902)

B. Cincinnati, Ohio. D. Gloucester, Massachusetts, August 8. Work: Phillips Collection, Washington, D.C.; Whitney Museum of American Art; Cincinnati Art Museum; Phoenix Art Museum; Joslyn Art Museum, Omaha; M. H. De Young Memorial Museum, San Francisco; Wadsworth Atheneum, Hartford, etc. AAA 1898–1900 (Greenwich, Connecticut); Benezit; Fielding; Havlice; Mallett; Earle; Gerdts, 1980, exhibition catalogue; Boyle, 1974; M. Barr, 26,76.

Twachtman did some painting in Yellowstone National Park about 1894; Major W. A. Wadsworth of Buffalo, New York, had commissioned him to do so. Although Twachtman did not

date his work, his contemporary Theodore Robinson mentions these paintings in an 1895 diary now at the Frick Art Reference Library in New York City.

Wadsworth Atheneum and Phillips Gallery have one each of Twachtman's famous "Emerald Pool" oils.

Tylor/Tyler, Stella T. Elmendorf (-)

B. San Antonio, Texas. AAA 1915 (San Antonio; listed as Elmendorf); AAA 1919–1927 (New York City); AAA 1929–1931 (New York City; listed as Elmendorf); O'Brien, 1935.

Tylor, a graduate of Texas State College for Women in 1908, later studied at the University of Texas, Columbia University, and with Robert Henri. She was a painter, an etcher, and a sculptor who exhibited nationally, and taught in Madison, Wisconsin, at the high school and at the university. She did many landscapes and flower studies.

U

Uerkvitz, Herta (1894–)

B. Wisconsin. Work: Seattle Fine Arts Society. AAA 1921 (Everett, Washington); Fielding.

Ullman, Julius (1863–)

B. Windsheim, Bavaria, Germany. Mallett (address 1934, Seattle, Washington); *Who's Who in Northwest Art* (Seattle); Adele M. Ballard, "Some Seattle Artists and Their Work" Seattle *Town Crier*, December 18, 1915, 25–35.

Ullman studied at Karlsruhe and Munich, Germany. He exhibited in Nuremberg in 1894, and Munich in 1896. He worked in oil, water color, and pastel, and exhibited at the Seattle Art Museum in his later years. His "On the East Water Way" was reproduced in the *Town Crier*.

Ulreich/Ulrich, Eduard/Edward Buk (1889-)
B. Guns, Austria. Work: Pennsylvania Academy of Fine
Arts; murals, Radio City Music Hall, New York; US post
offices in Columbia, Missouri, and Tallahasse, Florida.
AAA 1915 (Philadelphia); AAA 1917 (Kansas City, Mis-
souri); AAA 1923-1924 (Chicago, Illinois); AAA 1927-
1933 (New York City); Benezit; Fielding; Havlice; Mallett;
WWAA 1936-1953 (New York City); WWAA 1956-1962
(San Francisco, California); Inventory of American Paint-
ings, Smithsonian Institution; Viguers, 1958, 161.
Ulreich, who studied at the Kansas City Art Institute and
the Pennsylvania Academy of Fine Arts, exhibited nationally
and in Europe. Ulreich's wife Nura Woodson confirms his early
visits to Indian reservations and Western ranches to study first
hand the subjects of various paintings and illustrations.

Urmston, Germaine Bourquiun (-)
B. France. O'Brien, 1935 (San Antonio, Texas).
Urmston's work was often based on her observations dur-
ing the First World War when she was living in France. After she
moved to San Antonio, she established the French School of
Beaux Arts in 1921, and as director, probably had little time to
paint.

Usher, Ruby Walker (1889-1957)
B. Fairmont, Nebraska. Work: Pennsylvania Academy of
Fine Arts, etc. Havlice; Mallett; WWAA 1947-1956 (Holly-
wood, California); WWAA 1959, obit.
Usher began exhibiting in California in the mid-thirties.

V

Vachel, Vachell, Arthur Honywood (1864-)
B. Kent, England. Spangenberg, 46, 47 (Carmel, Califor-
nia); California State Library.

Vachel studied art briefly in Italy. He lived in San Luis Obispo prior to moving to Carmel in late 1905 or January 1906.

Vaganov, Benjamin G. (1896–)
B. Archangel, Russia. Work: San Diego Fine Arts Society; Carnegie Library, Escondido, California; mural, House of Pacific Relations, San Diego; dioramas, San Diego County Visual Education. Havlice; WWAA 1947–1953 (San Diego, California).
Vaganov exhibited in California from 1939 when he was living in Escondido until the mid-1940s.

Valentien, Albert R. (1862–1925)
B. Cincinnati, Ohio. D. San Diego, California, August 5. Work: Bowers Museum Foundation, Santa Ana, California; California State Library; San Diego Museum of Natural History. AAA 1898–1910 (Cincinnati); AAA 1913–1924 (San Diego); AAA 1925, obit.; Benezit; Fielding; Mallett; AAW v. II; California State Library; San Francisco Public Library; *California Design 1910*, exhibition catalogue, 48, 77.
When Valentien was in Europe in 1900 to receive a special gold medal at the Paris Exposition for his work at Rookwood Potteries in Cincinnati, he began painting wild flowers. He did the same thing in San Diego when he was there in 1903. He had completed 135 studies when Ellen Scripps saw them and commissioned him to paint all the state's wild flowers.
About 1908, after twenty-four years at Rookwood, Valentien moved to San Diego to carry out his commission. Not only did he travel all over California to paint wild flowers, but he became interested in the different varieties of cacti, trees, and grasses, and painted them, too. The wild flower paintings for Scripps filled twenty-two portfolios and became the property of the San Diego Museum of Natural History at Balboa Park; another fifty studies went to the State Library. The total number of paintings of California flora was over one thousand.
Valentien also is known as a landscape painter.

Van Arsdale, Arthur Lee (1896–)
B. Kentucky. AAA 1923–1927 (Edmond, Oklahoma);

American Magazine of Art, April 1924, 209; Nancy Gilson, "'We Poke' At Saving WPA Art," Oklahoma *Journal,* August 15, 1976, 10, 11, Sunday Magazine Section; Oklahoma City Public Library; Will May.

Van Arsdale grew up in Edmond, Oklahoma, where his parents moved in 1907. He studied at the Kansas City Art Institute, the Art Institute of Chicago, and the Art Students League. He was intensely individualistic and was prone to say, "I'm going to paint the way I feel whether anyone else likes it or not."

According to a brief biographical sketch in the Oklahoma City Public Library, Van Arsdale did "common subjects in an uncommon way . . . most pleasing to the eye of one who appreciates design and harmony of color. Both his still-life paintings and his landscapes are done in the decorative manner."

Art critics liked Van Arsdale's work, but a mural he did for Classen High School in 1933 did not fare well with the general public. It was found controversial, and removed from the wall. Gilson gave the details in her story for the *Journal* and urged its restoration.

Van Cise, Monona (–)
M. Barr, 29, 76.

Van Cise studied at the Art Institute of Chicago. She painted the mountains of Wyoming from 1899 to 1911 when she and her husband, a Universalist minister, moved to Idaho. Following her husband's death she moved to California where she was active until the early thirties. Then she returned to Laramie where she had begun teaching art in 1899.

Van Dalen, Pieter (1897–)
B. Amsterdam, Holland. Mallett Supplment (Seattle, Washington); *Who's Who in Northwest Art* (Seattle).

Van Dalen was a self-taught painter who worked in oil. As a member of the Painters and Sculptors' Guild of Northwest Men Painters, he may have exhibited with them.

Van Diest, Pietre Henrich (1819–1902)
Work: Western History Archives, University of Colorado, Boulder. "Surveyor with Paint Brush," Denver *Post Em-*

pire Magazine, October 17, 1965; University of Colorado Library.

Van Diest, a professor of mineralogy at Colorado School of Mines, left Denver on June 14, 1885, to survey parts of the Vigil and St. Vrain land grants along the southern boundary of Colorado. He illustrated his report with water color paintings of Raton Pass from a knoll near Trinidad, Colorado; Raton Peak and Mesa; a survey mound on Colorado's Southern border; and an early road in a ranching area of Southern Colorado. Four paintings were reproduced in *Empire* Magazine.

Van Elten, (Hendrick Dirk) Kruseman (1829–1904)
B. Alkmaar, Holland. D. Paris, France, July 12. AAA 1898 (New York City); AAA 1900–1903 (Paris); Benezit; Fielding; Havlice; Mallett; *American Art Annual,* 1898, 188; *Antiques* Magazine, January 1979, 94.

Van Elten was a landscape painter who lived in New York. He was elected to the National Academy in 1883. "View of the Rocky Mountains," dated 1884, is shown in the January 1979 *Antiques,* and "A Morning in May" was exhibited at the Fifth Annual of the Denver Artists' Club in 1898.

Van Evera, Caroline (–)
Work: South Cache High School, Hyrum, Utah. California *Arts & Architecture,* December 1932 (Coronado, California); Olpin, 1980; Heaton, 1968.

Van Leyden, Ernst Oscar Mauritz (1892–)
B. Rotterdam, Holland. Work: Whitney Museum of American Art; Albright-Knox Art Gallery; Brooklyn Museum; Tate Gallery; Lisbon Museum, etc. Havlice; WWAA 1947–1959 (Los Angeles, California); WWAA 1962–1970 (France).

Van Pappelendam, Laura (–)
B. Donnelson, Iowa. Work: Art Institute of Chicago; Chicago Municipal Collection. AAA 1917–1933 (Chicago, Illinois); Havlice; Mallett; WWAA 1936–1941 (Chicago); Sparks; Santa Fe Public Library; NMAA-NPG Library,

Smithsonian Institution; Lena M. McCauley, "Three Women Artists at Chicago Galleries," Chicago *Evening Post* Magazine of the *Art World*, April 12, 1927; see May 28, 1929, *Art World* for example of her work.

From 1917 to 1944 Van Pappelendam exhibited regularly in Chicago and vicinity. During the twenties many of her subjects were taken from Arizona, Utah, California, and New Mexico, especially the last named. She lived for some time in Santa Fe where she exhibited in 1920 and 1921 such paintings as "Acequia Madre," "Canyon Road," and "Dooryard, Santa Fe."

In 1927 Van Pappelendam exhibited forty canvases, mostly of New Mexico, at Chicago Galleries where they were reviewed favorably by Lena McCauley. "There are as many different scenic effects as there are canvases," said McCauley, alluding to Van Pappelendam's ability to convey feeling. "With a glimpse of the Placita, the heat from the walls hovers beside the cool of the shadowy places . . . The air seems to vibrate." McCauley considered Van Pappelendam one of the best instructors at the Art Institute of Chicago.

Among Van Pappelendam's teachers were George Bellows, Diego Rivera, Nicholas Roerich, and Sorolla y Bastida. She had solo exhibitions in Chicago; Milwaukee and Madison, Wisconsin; and Keokuk, Iowa. She exhibited with other artists in Philadelphia, Detroit, and St. Louis.

Van Sloun, Frank (1879–1938)

B. St. Paul, Minnesota. D. San Francisco, California, August 28. Work: Oakland Art Museum; Mills College. AAA 1909–1910 (San Francisco, California); AAA 1913 (New York City); AAA 1915–1933 (San Francisco); Fielding; Mallett; AAW v. I; California State Library; *California Art Research*, mimeo, v. VIII, 102–125; Inventory of American Paintings, Smithsonian Institution.

Van Sloun was successful in portrait, landscape, and figure painting. He worked in pastels, water colors, and oils; experimented with monotypes, lithographs, and etchings; did a series of red chalk drawings that became "very" popular; and painted murals, a list of which appears in *California Art Research*. He exhibited nationally.

In 1911 Van Sloun was teaching at the San Francisco

School of Fine Arts; in 1923 at the Art Students League; and from 1929-1932 at the University of California, Berkeley.

Van Slyck, (Wilma) Lucile (1898-)
B. Cincinnati, Ohio. Work: Dayton Art Institute. AAA 1923-1933 (Cincinnati); Mallett; *Who's Who in Northwest Art* (Big Fork, Montana).

Van Slyck studied at Cincinnati Art Academy, National Academy of Design, and Tiffany Foundation. She had solo exhibitions at the Cincinnati Art Center from 1928 through 1932, and in the late thirties she exhibited in Butte and Kalispell, Montana. She worked in oil.

Van Valkenburgh, Peter (1870-1955)
B. Greenbush, Wisconsin. Work: Academy of Science, New York; Stanford University; Bancroft Library, University of California, Berkeley; California Institute of Technology; Oakland Public Library; Iowa State College, etc. Havlice; WWAA 1941-1953 (Piedmont, California; Watsonville, California, at O'Neill Ranch); California *Arts & Architecture,* December 1932 (Oakland, California).

Van Veen, Pieter J. L. (1875-)
B. The Hague, Holland. Work: Butler Institute of American Art, Youngstown; Henry Gallery, University of Washington; collection of H. M. Queen of Belgium; Seattle Art Museum; Medical Center, New York City. AAA 1921-1933 (New York City; summer, 1921-1927, Kent, Connecticut; summer, 1929-1933, Paris); Fielding; Havlice; Mallett; WWAA 1936-1941 (New York City; summer, Paris); AAW v. I; *Who's Who in Northwest Art* (Tacoma, Washington; New York City); "Reunion in Boston: Van Gogh and Van Veen," *Art Digest,* February 1, 1941, 9; Inventory of American Paintings, Smithsonian Institution.

Van Veen exhibited nationally from 1916, often in solo shows. He was in the West by the early 1920s when he painted "The Mission of San Juan Capistrano" by royal command of Queen Elizabeth of Belgium. By 1935 he was probably spending as much time in California and Washington as he was in New

446

York, or more. His "Entrance to the Grand Canyon" establishes his presence in Arizona.

During Van Veen's late years he did a great many flower paintings. *Art Digest* reported that he had "of late . . . been concentrating upon lifting flower paintings from the purely decorative to a major art expression, richly pigmented, expertly designed and handsomely realistic." Van Veen was then exhibiting thirty of those flower paintings in Palm Beach, Florida.

Van Waganen, Margaret S. (–)
Edgar C. McMechen, "Brinton Terrace," *Colorado* Magazine, May 1947, 103, 104; Denver City Directory, 1906.

Van Waganen was a protege of the artist Anne Evans who helped finance her studies at the Art Institute of Chicago and in New York City. She returned to Denver as the wife of artist Dudley Carpenter. McMechen referred to her as the Denver girl who started the art center at Brinton Terrace about 1906.

Van Wie, Carrie (1880–1947)
B. San Francisco, California. D. San Francisco, May 27. Work: Oakland Art Museum. Oscar Lewis, *The Wonderful City of Carrie Van Wie/Paintings of San Francisco at the Turn of the Century,* San Francisco: printed by Grabhorn Press for The Book Club of California, 1963; Inventory of American Paintings, Smithsonian Institution.

Listed in the Smithsonian inventory are thirty-eight oils painted by the self-taught Van Wie between 1894 and 1913. Twenty-two reproductions illustrate the Lewis text covering the San Francisco of Van Wie's time. They include such subjects as the U.S. Mint, 1904; Letterman (or General) Hospital, 1899; the first and second Cliff House; the Spanish-American Volunteer Prison, 1899; and Fort Point (Fort Winfield Scott) as it appeared in 1898.

Varda, Jean (1893–1971)
B. Smyrna, Greece. D. Mexico City, January 10. Spangenberg, 79; Monterey Public Library; California State Library; Bob de Ross, "Now Hear This," San Francisco *Chronicle,* May 2, 1950, 15; Herbert Frank, "His Bag Is Being a Gentle Savage," San Francisco *Examiner, California*

Living Magazine, July 21, 1968, 6–7; Monterey Peninsula Art Museum docent library.

Varda was active in Paris before coming to New York in 1939, and to California in 1940. He lived in an old red barn in New Monterey for years; then he moved to the San Francisco area where he lived in a houseboat anchored near Sausalito. His specialty was portraits, but he is better known in California for his mosaics and collages. When he died, he was publicized as "the last of the Bohemians."

Vaughan, David Alfred (1891–　　)
B. Selma, Alabama. Work: San Diego Fine Arts Society. Havlice; WWAA 1947–1953 (Costa Mesa, California).

Vaughan, who exhibited mainly in California, had solo exhibitions at the San Diego Fine Arts Society in 1941, 1944, and 1946.

Vernon, Della (1876–1962)
Work: Athenian Nile Club, Oakland, California. Inventory of American Paintings, Smithsonian Institution; Walter Nelson-Rees, Oakland, California.

"High Sierra" and two other oils by Vernon are at the Athenian Nile Club. She was the wife of artist Thomas Bigelow Craig (1849–1924) who resided mainly in California and Rutherford, New Jersey.

Vesely, Godfrey Francis (1886–　　)
B. Czechoslovakia. Work: National Hotel, Nevada City, California; New Deal Cafe, Grass Valley, California. California State Library; *The Ebell Bulletin*, Long Beach, April 22, 1940, 4.

Vesely, who moved to California about 1919, taught himself to paint. He worked from nature and specialized in desert landscapes of California, Arizona, and Utah. He lived in Long Beach where he was a member of the Long Beach Art Association, and later in Grass Valley. He exhibited mainly in Long Beach.

Vickers, Bess Jarrott (　　–　　)
Wilbanks, 1959, 17–18 (Lubbock, Texas).

Wilbanks describes Vickers as one of the first of the settlers' daughters to go away to school. Vickers attended Kyd Kee College and Conservatory where she was a pupil of Eva Fowler in 1905-1906. Later she studied privately in Lubbock.

Villa, Hernando Gonzallo (1881-1952)
B. Los Angeles, California. D. Los Angeles, May 7. Work: Santa Fe Railway Collection; Laguna Beach Museum of Art. Mallet Supplement (Los Angeles); AAW v. I; Laguna Beach Museum of Art, 1979 exhibition catalogue; *California Design 1910,* exhibition catalogue 1974, 30, 49.

The Santa Fe railroad's emblem "The Chief" is the work of Villa, who was an illustrator for the company about forty years. He also worked for the Southern Pacific painting scenes along its Salt Lake route.

Villa is well known in the Southwest for his Indian and landscape paintings, but not well known for the genre scenes of the Spanish-speaking natives of early Los Angeles where he grew up. His father was an artist with a studio on the Plaza. His mother was an amateur singer. The family home was an adobe house at Sixth and Spring streets, long since displaced by commercial buildings. Villa graduated from the Los Angeles School of Art and Design in 1905 and then taught there for two years. Mainly he worked in the commercial field, illustrating books, and periodicals such as *Pacific Outlook, Town Talk,* and *West Coast Magazine;* painting Western scenes for the Santa Fe; and doing several murals.

Villeneuve, Nicholas C. (1883-)
B. Boise Valley, Idaho. Work: National Press Club, Washington, D.C.; Huntington Library and Art Gallery, San Marino. Havlice; WWAA 1938-1941 (Boise, Idaho); *Who's Who in Northwest Art* (Boise).

Villeneuve studied at the Art Institute of Chicago. He worked primarily as a cartoonist for the Idaho Daily *Statesman.* He had a solo exhibition at Boise Art Gallery in 1938.

Voigt, Edna (1895-)
B. Minneapolis, Minnesota. *Who's Who in Northwest Art* (Missoula, Montana).

Voigt studied at the University of Washington in Seattle and at Montana State Normal College in Dillon. She worked in oil and water color, and taught art in Missoula public schools.

Voisin, Adrien (1890–)

B. Islip, Long Island, New York. *Who's Who in Northwest Art* (San Francisco); *Southwest Art,* November 1975, 58–63.

Voisin studied painting and sculpture at art academies in Paris, and privately in the United States. Among his teachers was John LaFarge. He began working among the Blackfeet Indians about 1929.

Von Eichman, Bernard J. (1899–1970)

B. San Francisco, California. D. Santa Rosa, California, November 4. Work: Oakland Art Museum. Spangenberg, 79–80; St. John, 42; Monterey Peninsula Art Museum docent library; Inventory of American Paintings, Smithsonian Institution.

Von Eichman used various names during his career – Hickman, during the First World War; Eichman during the Second; and at times Van instead of Von. He was active in the San Francisco Bay Area during the twenties and thirties when he was one of Oakland's "Society of Six," of whom St. John wrote in the catalogue of Oakland Museum's 1972 exhibition. His work was abstract and innovative then, as it would be in his late years, but in between he did little painting. Sometime in the thirties he went to New York. During World War II he returned and worked in Kaiser ship yards, but he did not renew his friendships with the other members of the Society of Six.

About 1959 Von Eichman moved to Monterey, California, where he lived for about a decade; then he settled in Monte Rio near Guerneville, California. Before his death he burned much of his life's work.

Von Luerzer, Feodor (1851–1913)

B. Austria. Work: St. Louis County Historical Society, Duluth, Minnesota. Coen, 1976, 82, 83, 85, 134; Inventory of American Painting, Smithsonian Institution.

Von Luerzer lived in Duluth from 1889 to 1909, and then he moved West where he painted in the Cascade Mountains above

Lake Chelan in Washington, along the Monterey coast and the Motherlode country of California, the South Dakota Badlands, and the Couer D'Alene area of Idaho. Coen describes his style as "essentially a painterly one."

Von Perbandt, Carl (1832-1911)

B. Langendorf, Germany. D. Nahmgeist, Germany, April 6. Work: Society of California Pioneers, San Francisco; California Historical Society; Oakland Museum. AAW v. I; Arkelian; Evans; California State Library; Inventory of American Paintings, Smithsonian Institution; San Francisco *Call*, March 11, 1894.

Though not a baron, as he was frequently addressed, Von Perbandt was from a prominent German family. He arrived in New York City about 1870, and he appears in San Francisco directories from 1880 to 1897.

Von Perbandt was a lifelong advocate of painting from nature, and, according to Arkelian, he was "a sensitive translator of plant colors and atmospheres." He had studied at Dusseldorf Academy under Andreas Achenbach and Carl Lessing at a time when "landscapes were painted indoors according to rules," he told the *Call* in March of 1894. But Achenbach had broken with that tradition so he had done likewise.

Dates on Von Perbandt's paintings indicate he was working in California by 1877. He covered much the same ground for his Indian paintings as his friend Henry Raschen whose studio he shared for a while. In 1903 he returned to Germany.

W

Wack, Henry Wellington (1867-1954?)

B. Baltimore, Maryland. Work: Newark Museum; High Museum of Art, Atlanta; Delgado Museum of Art, New Orleans; Pennsylvania Academy of Fine Arts; Lincoln

Memorial University, Harrogate, Tennessee; Mary Washington College, University of Virginia; Covina (California) Public Library, etc. AAA 1921-1931 (New York City; summer, 1921-1925, Monroe, New York); AAA 1933 (Lakeville, Connecticut); Fielding; Havlice; Mallett; WWAA 1936-1941 (Lakeville); WWAA 1947 (Covina, California); WWAA 1953 (Santa Barbara, California).

Wack was a painter, illustrator, lecturer, and writer who was founder and first editor of *Field & Stream* Magazine.

Wade, Murray (1876-)
Who's Who in Northwest Art (Salem, Oregon).

Wade, who attended Mark Hopkins Art School in San Francisco, studied with William Keith and others. He did cartoons for several newspapers, including the *Oregonian* and the San Francisco *Examiner*. He worked in oils and pen-and-ink.

Wadsworth, Wedworth (1846-1927)
B. Buffalo, New York. D. Durham, Connecticut. Work: Museum of Fine Arts, St. Petersburg, Florida. AAA 1898-1925 (Durham, Connecticut); AAA 1927, obit.; Benezit; Fielding; Mallett; Young; *Facts,* March 2, 1901, 4, a Colorado Springs publication; Colorado College Library; Inventory of American Paintings, Smithsonian Institution.

W. Wadsworth in the first volume of *Artists of the American West* was an engraver active in San Francisco from 1858 to 1860. Wedworth Wadsworth appears to be the landscape painter mentioned in *Facts* magazine as W. Wadsworth. His water colors on exhibit in Colorado Springs in March 1901 received a lengthy review. His presence there at that time was not unusual for a landscape painter.

Walker, J. Edward/Edwin (-)
Work: Oakland Art Museum. California State Library; Spangenberg, 47; Inventory of American Paintings, Smithsonian Institution.

Spangenberg places Walker in Carmel, California, during the summer of 1916. He was living in Los Altos, California, in 1929 when he exhibited "Hill and Field" at the Santa Cruz art League's Second Annual.

452

Walker, Lissa/Lissie Bell (-)
B. Forney, Texas. Work: Hotel Charlottesville, Charlottesville, Virginia; Massachusetts Horticulture Society. Havlice; Mallett (Charlottesville); WWAA 1936-1941 (New York City); WWAA 1947-1953 (Boston); Fisk, 79; Wilbanks, 15.

Walker began her career in Texas. She taught at Central Plains College and Conservatory of Music, 1909-1910, and at Wayland Baptist College in 1912. She made a name for herself as a landscape painter while living in Dallas where she was active in the early 1920s. In the East she was better known as a mural painter.

Walker, Stuart (1888-1940)
D. on West Coast, January 18. Havlice; Mallett Supplement (Albuquerque, New Mexico); WWAA 1940-1941 (Albuquerque); WWAA 1947, obit.; Coke, 1963, 93.

Walker, who was active in New Mexico by the mid-1930s, was a member of the transcendental movement which Emil Bisttram and others organized in Santa Fe in June 1938. He exhibited at the Golden Gate International Exposition and the New York World's Fair in 1939.

Walkinshaw, Jeanie Walter (1885-)
B. Baltimore, Maryland. Work: Temple of Justice, Olympia, Washington; Seattle Historical Society; University of Washington. AAA 1913 (Baltimore; listed as Walter); AAA 1917-1925 (Seattle, Washington); AAA 1927-1933 (Seattle; New York City); Havlice; Mallett; WWAA 1936-1962 (Seattle); Woodbrook, Maryland); *Who's Who in Northwest Art;* Collins; Pierce; Calhoun.

Walkinshaw, who is best known as a portrait painter, illustrated *On Puget Sound* by Robert Walkinshaw, published in 1929.

Walkowitz, Abraham (1880-1965)
B. Tumen, Russia. D. January 26. Work: Brooklyn Museum; Metropolitan Museum of Art; Library of Congress; Boston Museum of Fine Arts; Museum of Modern Art, etc. AAA 1905-1933 (Brooklyn and New York City); Benezit;

Fielding; Havlice; Mallett; WWAA 1936–1962 (New York City and Brooklyn); Abraham Walkowitz, *Barns and Coal Mines around Girard, Kansas,* 1947, and *Art from Life to Life,* 1951, both published by Haldeman-Julius; *American Art Review,* March-April 1975, 47, regarding retrospective exhibition at Edward A. Ulrich Museum of Art, Wichita University.

Nearly a hundred paintings and drawings by Walkowitz were shown at the 1975 retrospective exhibition in Wichita, Kansas, including a number of Kansas subjects.

Walsh, John Philip (1876–)
B. Falmouth, Kentucky. Work: Huron, South Dakota, Municipal Collection. *Who's Who in Northwest Art* (Huron); Alyce Bates, Huron Public Library.

Walsh was a businessman who studied privately with several painters, including William Gollings of Wyoming, but was largely self-taught. He exhibited with the Independent Art League of America in New York in 1924, the Seattle Fine Arts Society in 1925, and at the South Dakota state fair in 1934. He was active in several civic organizations in Huron and was a founder of the South Dakota Society of Fine Arts.

In 1964 Walsh donated eight of his landscapes to the city of Huron where he had lived from 1901 to 1945 when he moved to Seattle, Washington.

Walsh, Margaret M. (1892–)
B. Bellingham, Washington. Mallet Supplement (Flagstaff, Arizona); *Western Artist,* April 1936, 12.

Walsh was active in Arizona during the 1930s when she showed her work, including Indian subjects, at the San Marcos Hotel in Chandler. Many of her paintings were of the Hopis.

Walter, Jeanie (See: Jeanie Walker Walkinshaw)

Walters, Emile (1893–)
B. Winnipeg, Canada. Work: California Palace of the Legion of Honor, San Francisco; Seattle Art Museum; National Museum of American Art; Newark Museum; Brooklyn Museum; Luxembourg Museum, Paris; Museum of New Mexico, Santa Fe; Houston Museum of Fine Arts;

Springville (Utah) Museum of Art, etc. AAA 1921–1925 (Oyster Bay, Long Island); AAA 1927–1933 (New York City); Benezit; Fielding; Havlice; Mallett; WWAA 1936–1941 (New York City); WWAA 1947–1966 (Poughkeepsie, New York); AAW v. I; Barr, 1954, 60–61; "Iceland's Bleakness Is Pictured," *Art Digest*, April 15, 1935, 19.

Walters grew up in Pembina County, North Dakota, and purchased his first set of paints in Grand Forks. To pay for his tuition to the Art Institute of Chicago he worked on local ranches, ushered at the Chicago Opera House, and played semiprofessional baseball in Canada. He later studied at the Pennsylvania Academy of Fine Arts and at the Louis C. Tiffany Foundation where he had a scholarship. He traveled widely for his subject matter and exhibited internationally. A number of his paintings are of the North Dakota Badlands.

Walters' parents were from Iceland. Several times he visited their homeland to paint landscapes of the ice-scarred mountains and rolling plains. The "striking sense of design" and the "skillful rendering of atmospheric effects" in these paintings is noted in Paul Barr's *North Dakota Artists*. Many of them are in Iceland and Finland collections.

Wanek, Vesta Blanch Jelinek (1872–)

B. Crete, Nebraska. Bucklin and Turner, 1932 (Loup City, Nebraska).

Wanek was a painter, an illustrator, and a teacher who had studied at Doane College, Fremont Normal, and with a private teacher in Lincoln, Nebraska. She exhibited at Nebraska fairs.

Ward, E. Grace (1877–)

B. Sparta, Wisconsin. Mallett Supplement (Stockton, California); Spangenberg, 54; Carmel, California, Public Library; California *Arts & Architecture*, December 1932 (Stockton).

Ward obtained her bachelor of arts degree from Stanford University and apparently continued to study art a number of years before teaching arts and crafts at the University of the Pacific in Stockton. As a member of the Carmel Art Association, she was known to work in oil, water color, charcoal, and pen-and-ink.

Ward, Frank (1879–)

B. Wisconsin. *Who's Who in Northwest Art* (Butte, Montana); Sternfels typescript, page 8; Nancy Dahy, Reference Librarian, Butte-Silver Bowl Free Public Library.

Ward, who worked mainly as an illustrator, a commercial artist, and a photographer for newspapers and magazines, may be the Franklin T. Ward listed in the 1915 *American Art Annual* as then living in Boston. Sternfels wrote in 1933 that his "photography and lithography rank with the best in the country" and that he was the best-known commercial artist in Montana at that time.

Ward, Lily A. (–)

Splitter, June 1959, 123.

Ward, a graduate of the New Haven Art School, opened a studio in Los Angeles, California, in 1881.

Ward, Louisa Cooke (1888–)

B. Harwinton, Connecticut. Havlice; WWAA 1956–1962 (Los Angeles, California); Collins.

Ward, a landscape and portrait painter, was active in Southern California from 1945.

Ward, Mrs. Heber Arden (–)

AAA 1919–1925 (Denver, Colorado).

Ward, William (1827–1893)

B. Leicester, England. D. Salt Lake City, Utah. Work: murals, Endowment House, Salt Lake City. Groce and Wallace; Olpin, 1980; additional information from Professor Olpin, 1981.

An apprenticeship to an architect in England prepared Ward for the work he later undertook in Salt Lake City where he settled in 1852. Brigham Young noticed his ability to design and sculpt and made him assistant architect for the City's Mormon Temple. Later, Ward left the church and moved to St. Louis, Missouri. He spent the last years of his life in Salt Lake City where he taught drawing at the University from 1889 to 1892.

Ware, Florence Ellen (1891–1972)

B. Salt Lake City, Utah. D. Salt Lake City. Work: Springville (Utah) Museum of Art; University of Utah; Laramie (Wyoming) High School. AAA 1915, 1931–1933 (Salt Lake City); Havlice; Mallett; WWAA 1936–1941 (Salt Lake City); AAW v. I; Olpin, 1980; Haseltine; M. Barr; Linford.

Prior to her lengthy career in teaching art, which began at the University of Utah in 1918, Ware studied three years at the Art Institute of Chicago. Later she studied in Provincetown, Massachusetts; Oakland and Laguna Beach, California; and in Europe and the Near East.

Ware's murals and easel paintings can readily be seen in Wyoming – she grew up in Laramie – as well as in Utah. Of her easel paintings, Olpin has written: "Ware was most effective in quiet renderings in a reduced size of fragilely sensitive and rather romantic tonal nuances. . . ."

Warner, Everett Longley (1877–1963)

B. Vinton, Iowa. D. Westmoreland, Vermont. Work: Rhode Island School of Design; St. Louis Art Museum; Toledo Art Museum; Pennsylvania Academy of Fine Arts; Art Institute of Chicago; National Museum of American Art; Oklahoma Art League, Oklahoma City, etc. AAA 1898–1910 (Washington, D.C.; New York City; Paris, France); AAA 1913–1919 (New York City; summer, Lyme, Connecticut); AAA 1921–1927 (Lyme); AAA 1929–1933 (Pittsburgh, Pennsylvania); Benezit; Fielding; Havlice; Mallett; WWAA 1936–1962 (Pittsburgh; Westmoreland). Colorado Springs (Colorado) Fine Arts Center library; "Some Federation Exhibits," *American Magazine of Art*, December 1921, 407; "Famous Landscape Painter Coming to Succeed Carlson," Colorado Springs *Gazette*, February 11, 1922; "Carnegie Institute Honors Everett Warner," *Art Digest*, May 15, 1941, 7; Grove typescript.

Warner worked in the West at least as early as 1921 when his work was shown with that of Taos and California painters in an exhibition of "Paintings of the West" mentioned in *American Magazine of Art*. He spent the summer of 1922 teaching at the Broadmoor Art Academy in Colorado Springs for which he was paid $1,000 per month.

Warner, Gertrude Palmer (1890–1981)

B. Pomona, California. California *Arts & Architecture,* December 1932 (Hillsborough, California); Monterey Public Library; Monterey Peninsula *Herald,* obit., May 25, 1981, 4.

Warner was a graduate of Pomona College who became well known on the Monterey Peninsula for her water color paintings. She was a longtime resident of Carmel Valley.

Warnock, Sada (1882–)

B. near Halsey, Oregon. *Who's Who in Northwest Art* (Oswego, Oregon).

Warnock was a sculptor and painter who studied at the University of Oregon Extension and in Portland. She exhibited locally.

Warren, Ella (–)

Ormes and Ormes, 338.

Warren opened a studio in Colorado Springs, Colorado, in the 1890s. She taught painting by having her pupils copy reproductions of paintings of landscapes and flowers.

Washburn, Cadwallader Lincoln (1866–1965)

B. Minneapolis, Minnesota. D. Farmington, Maine, December 21. Work: San Diego Fine Arts Gallery; California State Library; Musee de Luxembourg; British Museum; Corcoran Gallery of Art; Library of Congress; Lafayette (Indiana) Art Association. AAA 1898–1900 (Paris, France); AAA 1903–1906 (Minneapolis); AAA 1907–1910 (Minneapolis and New York City); AAA 1913 (Mexico; summer, Livermore Falls, Maine); AAA 1915 (Livermore Falls); AAA 1917 (New York City); AAA 1919 (Livermore Falls); AAA 1921 (Lakewood, New Jersey); AAA 1923–1925 (Minneapolis); AAA 1927–1929 (Mentone, France); AAA 1931–1933 (Englewood, New Jersey); Benezit; Fielding; Havlice; Mallett; WWAA 1936–1937 (Englewood); WWAA 1938–1941 (Lakewood); WWAA 1947–1962 (Brunswick, Maine); Earle; *American Magazine of Art,* August 1928, 448; Washington *Post,* December 23, 1965, obit.; William Holland, "The Adventures of Uncle Cad," Washington *Star*

Sunday Magazine, December 28, 1969; Diane Cochrane, "The Ten Best American Printmakers of the Thirties/How Do They Rate Today?" *American Art & Antiques,* September-October 1978, 59; Tolerton, 125; NMAA-NPG Library, Smithsonian Institution.

Washburn did not permit deafness from a childhood illness to interfere with his career as artist, amateur oologist, and briefly as war correspondent. His interest in oology took him to exotic places all over the world and provided subjects for his work. Best known for his drypoint etchings which he began making in 1903, he was also recognized for his oils and water colors.

In San Francisco in 1915, Washburn did a series of prints of the Panama-Pacific International Exposition grounds and buildings. Tolerton in *Art in California* said then that they would "undoubtedly be treasured as one of the most artistic and comprehensive interpretations of the Exposition."

During the 1920s Washburn did a series of drypoints depicting Arizona Indians. Shown in Washington, D.C., in 1926 were the following prints from the series: "The Petrarch of the Tribe," "Young Hopi Indian," "The Village Mender of Moccasins," and "A Distinguished Navajo Indian." Washburn also did a number of Western landscapes. Because he often worked in the West, he was identified with that region as one of the ten "best" Western printmakers in 1936 by the now defunct magazine *Prints.*

Watrous, Hazel (–)
　　B. Visalia, California. Spangenberg, 53-54; California *Arts & Architecture,* December 1932 (Carmel, California); Monterey Public Library.

Watrous studied art at San Jose State College, the San Francisco Art Institute, and Columbia University. Among her teachers at the Art Institute was Gottardo Piazzoni who considered her one of his most gifted pupils.

Watrous was art supervisor for the public schools of Alameda, California, before settling in Carmel in 1922 where she and Ethel Denny opened the first art gallery. Her specialty was portraiture.

Watts, Beulah (ca 1873-1941)
　　B. Homer, Texas. D. Lufkin, Texas, late July. Work: Pri-

vate collections. Fisk, 1928 (Lufkin); Dallas *News,* July 2, 1938; "Funeral held at Lufkin for Texas Artist," Houston *Chronicle,* July 31, 1941; Houston public library art and artists' scrapbook.

Watts, whose mother was a botanist, made a specialty of painting Texas pine trees. "She has put on canvas the true story of the long leaf yellow pines in their native surroundings," said Fisk who credited her with at least a thousand paintings of trees.

Watts' work was shown at the Century of Progress exhibition in Chicago, the Texas Centennial at Dallas, and in libraries and galleries in New York City, Chicago, and on the Pacific Coast. She took up flower painting in her later years.

Waynick, Lynne Carlyle [Black Eagle] (1891–)
B. Sargent, Nebraska. *Who's Who in Northwest Art* (Burton, Washington).

Waynick, who studied architecture, was mainly self-taught. He specialized in painting Indians and their ceremonies in their native settings in the Northwest and the Southwest. He was the owner of the Block House Indian Museum in Burton which is in the area of Western Washington inhabited by the Swinomish Tribe. Waynick was an adopted member of that tribe.

Weaver, Inez Belva Honeycutt (1872–)
B. Marshall County, Iowa. AAA 1933 (Stromsburg, Nebraska); Mallett; Bucklin and Turner, 1932 (Stromsburg).

Weaver, who had done drafting and designing in Hamilton, Missouri, was active in Nebraska as an exhibiting artist in the 1930s. She was a member of the Art Institute of Omaha and the Central Nebraska Art Guild.

Weiler, Louis (1893–)
B. Bavaria, Germany. *Who's Who in Northwest Art* (Quincy, Washington).

Weiler studied art in Wurzburg, Germany. He worked in oil, water color, and tempera, and exhibited mainly in Wenatchee, Washington.

Weiner, Abraham S. (1897–)
B. Vinnitza, Russia. Havlice; Mallett Supplement (Chicago, Illinois); WWAA 1947–1962 (Santa Monica, California).

Weiner began exhibiting regularly in California about 1943 when he had solo shows at the San Francisco Museum of Art and at the University of California, Los Angeles. He exhibited in group shows in the Midwest from 1931 and had several other solo shows in California in the mid-forties.

Weiner, Louis (1892–)
B. Vinnitza, Russia. AAA 1931–1933 (Chicago, Illinois); Havlice; Mallett; WWAA 1936–1937, 1940–1941 (Chicago); Sparks; Jacobson, 1932, 135, 153–154; *El Palacio,* February 24, 1932, 112.

Weiner, whose specialty was water color landscapes, exhibited regularly in Chicago from 1927, and occasionally at the Pennsylvania Academy of Fine Arts. In tune with the times he utilized abstract forms in his paintings, such as in "Eagle Dance" and "Corn Dance," given as examples by Jacobson. In 1932 Weiner exhibited at the Palette and Chisel Club the results of his previous summer's work in New Mexico.

Weir, Dorothy/Dorothy Weir Young (1890–1947)
B. New York. D. New York City, May 28. AAA 1923–1924 (New York City); AAA 1933 (New York City; summer, Ridgefield, Connecticut); Havlice; Mallett; WWAA 1936–1939 (New York City; Ridgefield); WWAA 1947, obit.; Olpin, 1980.

Weir is likely to have done some work in the West when she visited Utah with her husband Mahonri Young. She was the daughter of J. Alden Weir.

Wells, Anna M. (–)
Work: Society of California Pioneers, San Francisco. California State Library; Inventory of American Paintings, Smithsonian Institution; Evans; Koch, 200.

Koch mentions a Miss A. M. Wells who presided at the founding of the Society of Decorative Art in Santa Cruz, California, on June 1, 1885. She was then giving water color and drawing instruction in the Sunday School room of the local Episcopal Church and at her private art school which she was conducting in her home. She appears to be the same person who painted a water

color entitled "Ruins of the Adobe Mission Church, Santa Cruz," which is dated 1859.

Wells, Lucy D. (1881–)
B. Chicago, Illinois. AAA 1923–1933 (Spokane, Washington); Havlice; Mallett; WWAA 1936–1941 (Seattle, Washington); AAW v. I; *Who's Who in Northwest Art;* Binheim, 1928; Colorado Springs (Colorado) Fine Arts Center library.

Wells studied at the Art Institute of Chicago and at the Broadmoor Art Academy in Colorado Springs. Among her teachers were Ernest Lawson, Randall Davey, and Ralph Clarkson. When Binheim compiled *Women of the West,* she had been a resident of Washington state for twelve years and was then teaching at Spokane High School and Spokane Art League. She exhibited nationally in group and solo shows and was a member of Chicago Art Institute Alumni Association, Seattle Art Museum, Spokane Art Association, and the Archaeological Society.

Wescott, Sue May (See: Sue May Wescott Gill)

Whedon, Harriet Fielding (ca 1888–1958?)
B. Middletown, Connecticut. D. Burlingame, California. Havlice; Mallett Supplement; WWAA 1940–1953 (New York City); WWAA 1956 (Chicago); California State Library; San Francisco Public Library art and artists' scrapbook.

Whedon was past forty when she enrolled in the California School of Fine Arts in San Francisco. Among her teachers were Otis Oldfield, Ray Boynton, and Lee Randolph. In 1931 she began exhibiting in major California museums. Local scenes and still lifes comprised much of her work.

A resident of California since 1908, Whedon lived first in San Diego and Los Angeles before moving to San Francisco in 1922.

Wheeler, Martha M. (–)
Pacific Coast Business Directory, 1871–1873 (San Francisco, California); San Francisco City Directory, 1873–1874 (San Francisco).

Wheeler was active as a portrait painter.

Wheeler, Mary Cecil (–)
>Denver Public Library; Bromwell scrapbook; Rocky Mountain *News,* April 18, 1894, 5; C. Adrian Heidenreich, 1976 exhibition catalogue.

Heidereich wrote that Wheeler was one of three members of the first graduating class at Helena, Montana, High School in 1879 and that she was a teacher and art supervisor in Montana public schools for some forty years.

Wheeler exhibited at the Denver Artists' Club from about 1885 to 1895. According to a news item in Bromwell's scrapbook, Wheeler's portrait "Squaw's Head" was reproduced in the April 25, 1885, issue of *The Woman Voter.* Another item in the scrapbook mentions nineteen canvases exhibited by Wheeler at the Denver Artists' Club – "faithful views of the picturesque near Helena." Another item mentions the French subjects Wheeler showed in 1894. Bromwell found them "a trifle black and turbid in color," but noted many good points also.

The *American Art Annual* lists a Mary C. Wheeler living in Providence, Rhode Island, 1915–1919, but whether it was the same artist was not determined.

Wheelon, Homer (1888–)
>B. San Jose, California. Mallett Supplement (Seattle, Washington); *Who's Who in Northwest Art* (Seattle); Pierce, 1926.

Wheelon was a physician who taught himself to paint. He exhibited at Northwest Artists' annuals and at the Physicians' Art Association.

Whelan/Whelen, Blanche (–)
>B. Los Angeles, California. AAA 1919 (San Gabriel, California); AAA 1921–1933 (Los Angeles); Benezit; Fielding; Havlice; Mallett; WWAA 1936–1962 (Los Angeles); California State Library; Museum of New Mexico library, Santa Fe.

Whelan exhibited mainly in Southern California, and occasionally in Arizona and New Mexico. In 1926 she exhibited "Indian Boy, Taos" at the New Mexico Artists' Thirteenth Annual, and in 1931 she won a prize with her entry in the Arizona state fair.

White, Carrie Harper (1875–)

B. Detroit, Michigan. O'Brien, 1935 (Legion, Texas).

White studied at the Cleveland School of Art, the Architectural League in New York, and the School of Applied Design in New York. She taught at the Cleveland School of Art prior to marrying Dr. John E. White of Colorado Springs in 1900. In her late years she was active in Texas where she attended Jose Arpa's summer school sessions.

White, Minerva (1878–)

B. St. Louis, Missouri. Fisk, 1928 (Dallas, Texas).

White was the daughter of an educator. She was given early training in oils, water colors, and clay modeling, and advanced training in Chicago and Milwaukee art schools. She used Arizona Indian themes in some of her paintings and tapestries. She lived in Texas from about 1902.

White, Verner (1863–1923)

B. Lunenburg County, Virginia. D. Chautauqua, New York, August 30. Mallett; O'Brien, 1935.

White was active mainly in Europe and in St. Louis, Missouri, but he spent enough time in Texas with his family to be thought of as a Texas artist. Among his best-known paintings there are "Galveston Harbor," "Waco Country Club," and "Wichita Falls."

Whitten, Andrew T. (1878–)

B. New York City. *Who's Who in Northwest Art* (Dufur, Oregon).

Whitten studied at the Art Institute of Chicago and the National Academy of Art. He exhibited at Meier and Frank Department Store in Portland in the late 1930s.

Whymper, Frederick (1838–)

B. England. Work: Bancroft Library, University of California, Berkeley; Yale University Library; British Columbia Provincial Archives, Victoria; Glenbow Foundation, Calgary, Canada. AAW v. I; Harper, 1970; *Alta California,* March 27, 1870; April 28, 1870, 4/1; June 5, 1870, 2/3; California State Library.

Whymper was occasionally in California while serving as artist for Western Union Telegraph during construction of a line between Western United States and Alaska. In March 1870 the art columnist Caliban reported that Whymper was active in the San Francisco area, and called him "an excellent worker in water colors." In April, Caliban said he was "engaged in drawing maps of mining ground," and that a number of his Alaska and British Columbia sketches had appeared "recently in *Tour du Monde,* a journal which seeks a high standard." In June Caliban said that Whymper had completed "several excellent sketches of scenes in the vicinity of San Jose," and that some of his sketches were appearing in *Illustrated News.*

Between 1868 and 1880 Whymper published several illustrated books based on his experiences in the Pacific Northwest and California. His brother Edward (1840–1911) also was an artist. They resided in London where Edward was quite well known as an artist. Whymper probably was best-known as a writer and illustrator. His travel books were published in English, French, and German. Harper was one of his publishers.

Wickes/Wicks, Ethel Marian (1872–1940)
B. Hempstead, Long Island, New York. D. San Francisco, California, February 27. Work: Shasta State Historical Monument. California State Library; *News Notes of California Libraries,* January 1908, 14; October 1910, 538; "Art and Music," Seattle *Town Crier,* July 1, 1911, 13; July 15, 1911, 13; California *Arts & Architecture,* December 1932 (San Francisco); San Francisco *Chronicle,* February 29, 1940, 15; Inventory of American Paintings, Smithsonian Institution.

Wickes, who had studied in Paris, lived in California from 1886 to 1897, and after 1900, mainly in Pacific Grove and San Francisco.

In 1911 Wickes was in Seattle to arrange for the placing of her mural decoration in the Florence Henry Memorial Chapel. From the roof garden of the Chelsea Hotel where she was staying she painted "The Olympics from Queen Ann Hill." While in Seattle she exhibited oils and water colors in the gallery of the Washington Art Association. They included scenes of Holland, Ireland, and California.

Wickson, Guest (-)
AAA 1919-1925 (Berkeley, California); Mallett Supplement; California State Library; California *Arts & Architecture,* December 1932 (Berkeley).
Wickson exhibited water colors and oils frequently in the San Francisco area from 1920 to 1931.

Wier, Mattie (-)
Havlice; Mallett Supplement; WWAA 1940-1941 (Houston, Texas); Houston Public Library art and artists' scrapbook; Jack Flanagan, Houston.
Wier exhibited at the Houston Museum of Fine Arts in 1938 and 1939.

Wiggens, Myra Albert (1869-1956)
B. Salem, Oregon. D. Seattle, Washington, January 14. Work: Washington State Library, Olympia; Olympia Public Library; YWCA and YMCA, Yakima, Washington. AAA 1923-1925, 1929-1931 (Toppinish, Washington); AAA 1933 (Seattle); Benezit; Havlice; Mallett; WWAA 1936-1956 (Seattle); AAW v. I; Binheim; *Who's Who in Northwest Art; Western Artist,* March 1936, 11.
Wiggins had many talents—painting, photography, poetry, dramatics, writing, and music—and she worked at every one. Among her teachers were William Merritt Chase, Willard Metcalf, Kenyon Cox, and Frank DuMond. She exhibited nationally and in Canada, including several solo shows, and won a number of awards. Her specialty was still-life painting, often featuring her favorite subjects—Indian baskets and flowers. She is nationally known for her painting and internationally known for her photography.

Wikstrom, John (-)
B. Sweden. Wilkinson, 1927, 270-271.
Wikstrom studied art in Sweden and in Germany before moving to the United States where he studied privately with a Tacoma painter. He showed a number of paintings, some done in Sweden, at an Idaho exhibition reviewed by Augusta Wilkinson who found no lack of talent among Idaho's artists in 1927. She re-

466

ferred to Wikstrom's landscapes as "beautiful" with "a nice sense of design."

Wildman, Caroline Lax (-1949)
B. Hull, England. D. December 1, probably at Bellaire, Texas. Havlice; Mallett Supplement; WWAA 1940-1947 (Bellaire); WWAA 1953, obit.; Houston Public Library art and artists' scrapbook; Jack Flanagan, Houston.

Wildman, a pupil of Frederick Browne of Houston, exhibited with Southern States Art League in Montgomery, Alabama, in 1938; in San Antonio, Texas, in 1939; and regularly with Artists of Southeast Texas from the late 1930s to the mid-1940s.

Wildman, Mary Frances (1899-)
B. Indianapolis, Indiana. Havlice; Mallett Supplement; WWAA 1938-1953 (Stanford University and Palo Alto, California); California *Arts & Architecture*, December 1932 (Stanford University).

Wildman appears to be the Miss M. Wildman listed in the *American Art Annual* as living in Philadelphia from 1917 to 1925. She was a member of the Philadelphia Print Club, and she exhibited there at the Pennsylvania Academy of Fine Arts from 1928 to 1931. She exhibited in California from 1926 to 1932.

Wiley, Nan K. (1899-)
B. Cedar Rapids, Iowa. Mallett Supplement (Eugene, Oregon); *Who's Who in Northwest Art* (Cheney, Washington).

Wiley studied at the Chicago Academy of Fine Arts, the University of Oregon, Cranbrook Academy of Art, and the Academy de la Grande Chaumier in Paris. Although she specialized in sculpture, she was also active as a painter. She taught art at Eastern Washington College of Education in Cheney.

Wilimovsky, Charles A. (1885-)
B. Chicago, Illinois. Work: Art Institute of Chicago; Kansas City Art Institute; Springfield (Massachusetts) Public Library; Honolulu Academy of Art; Art Association, Cedar Rapids, Iowa; Lindsborg (Kansas) University; Bibliotheque Nationale, Paris. AAA 1907-1908 (Chicago);

AAA 1909–1910 (Chicago and Paris); AAA 1915–1921 (Kansas City, Missouri); AAA 1923–1933 (Chicago; summer 1933, Cumberland, Wisconsin); Benezit; Fielding; Havlice; Mallett; WWAA 1936–1941 (Chicago; summer, Cumberland); WWAA 1947 (Chicago); WWAA 1953–1959 (Los Angeles, California); Houston Museum of Fine Arts library.

Wilimovsky painted and exhibited in some of the Western states. His "On the Way to the Pueblo" hung at the Dallas Museum of Fine Arts in 1936 at the Texas Centennial Exposition.

Wilke, William Hancock (1880–)

B. San Francisco, California. Work: Society of California Pioneers; American Institute of Graphic Arts; etchings in many privately printed books. AAA 1915–1931 (San Francisco and Berkeley, California; summer, Sonoma and Contra Costa counties in California); Fielding; Havlice; Mallett Supplement; WWAA 1936–1953 (Berkeley); AAW v. I; Porter, and others, 1916; Society of California Pioneers library.

Wilke's career was largely that of design-manager for Shreve and Company, and illustrator. He won a gold medal for etchings exhibited at the Panama-Pacific Exposition in San Francisco in 1915.

Will, Blanca (1881–)

B. Rochester, New York. Work: University of Arkansas; Memorial Art Gallery, Rochester. AAA 1917 (Rochester); AAA 1919–1921 (Palo Alto, California, and Rochester); AAA 1923–1924 (Rochester); AAA 1925–1927 (Paris, France, and Rochester); AAA 1929–1933 (Rochester); Benezit; Fielding; Havlice; Mallett; WWAA 1936–1941 (Rochester); WWAA 1947–1962 (Winslow, Arkansas); School of American Research, 1940.

Will worked in Santa Fe, New Mexico, long enough to be included in *Representative Art and Artists of New Mexico*, published by the School of American Research in 1940. She painted in oil and water color, and did sculpture. From about 1919 she spent summers in Blue Hill, Maine.

Williams, Frederick Ballard (1871/72-1956)

B. Brooklyn, New York. Work: Grand Rapids (Michigan) Art Museum; Santa Fe Railway Collection; Metropolitan Museum of Art; St. Louis Art Museum; Dallas Museum of Fine Arts; Milwaukee Art Center; National Museum of American Art; Henry Gallery, University of Washington; Toledo Museum of Art; Montclair (New Jersey) Art Museum, etc. AAA 1898-1933 (Glen Ridge, New Jersey, and New York City); Benezit; Fielding; Havlice; Mallett; WWAA 1936-1956 (Glen Ridge); Earle; "California Pictures by Frederick Ballard Williams, N.A.," *American Magazine of Art*, November 1922, 462-463; "How to Enjoy Pictures," *Art Digest*, September 1, 1941, 33; Inventory of American Paintings, Smithsonian Institution.

"Imaginative, gay, and fanciful" is the way one critic described Williams' work, while another called him "one of the few contemporary painters whose works might be hung with those of the so-called 'Old Masters' and not be found out of accord."

Williams apparently made only two sketching trips to the West. His Grand Canyon paintings place him there about 1910. The California paintings exhibited in 1922 were from the sketching trip of 1921. For the most part he found his subjects in New Jersey near his home.

Williams, Nick (1877-)

B. Odessa, Russia. *Who's Who in Northwest Art* (Port Angeles, Washington).

Williams worked in all media, and exhibited with the Association of South Russian Artists in Odessa.

Williams, Reed (-)

AAA 1919-1924 (Los Angeles, California); Fielding; *California Arts & Architecture*, December 1932 (Hollywood, California).

Williams, a member of the Los Angeles Print Makers, was an etcher who worked mainly as a commercial artist.

Williamson, John (1826-1885)

B. Scotland. D. Glenwood, New York, May 28. Work:

Joslyn Art Museum, Omaha; Brooklyn Museum; National Academy of Design; Hudson River Museum, Yonkers. Benezit; Fielding; Groce and Wallace; Havlice; Mallett; Denver Public Library; *Kennedy Quarterly,* June 1977, No. 133; Inventory of American Paintings, Smithsonian Institution; Joslyn Museum library.

Williamson's Western landscapes are said to have the "vigor of the rugged Rockies." The following titles are listed in the Smithsonian Inventory: "Evening in the Far West" and "Morning in the Far West," both dated "before 1866," and "Overland Route to the Rocky Mountains," dated 1880. Most of Williamson's paintings feature scenes in the Catskill Mountains and along the Hudson River.

Williamson, Paul Broadwell (1895–)
B. New York City. Work: St. Mary's College, Moraga, California; University Club, San Francisco. Havlice; WWAA 1947–1953 (San Francisco).

Williamson began exhibiting in the West in 1940.

Willmarth, Kenneth L. (1889–)
B. Chicago, Illinois. Havlice; Mallett Supplement; WWAA 1940–1941 (Omaha, Nebraska); Bucklin and Turner, 1932 (Omaha).

Willmarth whose etching of the Nebraska State Capitol received favorable comment in Omaha papers, was a painter and illustrator who did mainly commercial work.

Willoughby, Sarah Cheney (1841–1913)
B. Lowell, Massachusetts. D. Port Townsend, Washington, November 7. Work: Pacific Northwest Collection, University of Washington Library. Dodds, Master's thesis, 127, University of Washington Art Library; Lucile McDonald, "A Woman Artist in Early-Day N. W.," Seattle *Times,* January 28, 1951, 4–5; typescript, University of Washington Library.

In 1862 Willoughby and ten other teachers were hired in Boston to teach at the University of Washington. They traveled there by way of Panama.

There being no art students at the University that year,

Willoughby taught music. The following year she moved to Port Townsend to teach, and two years later married a sea captain.

In 1877 Willoughby's husband became Indian agent for the Makah and Quinault Indians. Some of the drawings Willoughby made of them were sent to the Smithsonian Institution. Sketches mentioned in the various references include "The Beach at Taholah," 1886; "The British Bark," sketched December 2, 1877, the day after it was wrecked; "Indians Spearing Salmon"; and "Towers." (Sea otters were hunted from towers.)

About 1888 Willoughby returned to Port Townsend.

Wills, Mary Motz/Matz (–)

B. Wytheville, Virginia. Work: Witte Memorial Museum, San Antonio, Texas; University of Texas Memorial Museum, Austin. Havlice; Mallett Supplement; WWAA 1938-1939 (Abilene, Texas; Atlanta, Georgia); WWAA 1940-1941 (Abilene); Houston Public Library art and artists' scrapbook; Fort Worth *Telegram*, August 24, 1940; Howard S. Irwin, *Roadside Flowers of Texas*, Austin: University of Texas Press, 1961.

Wills, a pupil of William Merritt Chase, John Twachtman, and others, began about 1915 to make a specialty of painting flowers in this country and abroad. Her work, noted for its accuracy as well as its beauty, has been exhibited at the Museum of Natural History in New York City and has been used to illustrate books dealing with flora.

In August 1940, Wills went to the Big Bend country of Texas. There she produced about a thousand paintings of flowers and other plant life. Many of them were later used to illustrate Irwin's *Roadside Flowers of Texas*.

Over a period of almost fifty years Wills produced some two thousand paintings of Texas wild flowers. Three hundred and fifty of them were exhibited at the University of Texas, probably in 1940.

Wills, Olive (ca 1890–1940s)

Work: Wyoming State Art Gallery. M. Barr; *Western Artist*, February 1936, 20.

Wills studied at the Art Institute of Chicago, the New York School of Fine and Applied Arts, and Ecole d'Art in Paris.

She taught for many years in Cheyenne, Wyoming, where she published two teaching aids: a collection of still-life studies and an illustrated study of California trees. She also published the first article of significance on Wyoming artists. Entitled "Artists of Wyoming," it is in *Annals of Wyoming,* vol. 9, 1932, 688–704. In 1936 she was elected president of the Cheyenne Art Club.

Wilson, J. R. (1865–1966)

B. Millville, Missouri. M. Barr, 38, 77 (Glendo, Wyoming).

Wilson studied briefly at the Chicago Institute of Fine Arts in 1884 and again in 1905. He did pen-and-ink cartoons for a Lawson, Missouri, paper prior to homesteading in Wyoming in 1916. In 1919 he opened a store in Glendo. His landscapes of the Devil's Tower and Platte River region, which he exhibited throughout Wyoming, are said to have been well received.

Wilson, John (1832?–1870)

D. probably in San Francisco, California. California State Library; Caliban, "Art in California," *Alta California,* March 27, 1870, 2/3.

The addendum to the 1974 edition of Fielding lists a John Wilson born in 1832, and Gibson lists a John Wilson active in Detroit, 1855–1856. Following Wilson's death, he was referred to by Caliban as "one of our most distinguished artists." Caliban also wrote that Wilson was "possessed of a strong feeling for nature and had just reached that stage in art when a few more years would have placed him on the pinnacle as a landscape painter. . . . His landscapes betray a thorough knowledge of the calmer aspects of nature."

Wing, Leota McNemar (1882–)

B. Wilmington, Ohio. Ness and Orwig, 1939 (Cedar Falls, Iowa).

Wing was active in Kansas, Nebraska, and California during her years of study at the University of Kansas, the University of Nebraska, Bethany College in Kansas, and California State Normal College in San Diego.

Winkler, John William Joseph (1890/94–1979)

B. Vienna, Austria. D. El Cerrito, California, January 26.

Work: California Palace of the Legion of Honor, San Francisco; Art Institute of Chicago; Brooklyn Museum; Bibliotheque Nationale, Paris; Cleveland Museum of Art; Library of Congress; Metropolitan Museum of Art; Boston Museum of Fine Arts; Oakland Museum; San Diego Fine Arts Museum, etc. AAA 1917-1921 (San Francisco); AAA 1923-1927 (Paris and Claymart, France); AAA 1929-1931 (Berkeley, California); Benezit; Fielding; Havlice; Mallett; WWAA 1936-1947, 1962 (Berkeley); AAW v. I; Howell C. Brown, "John W. Winkler—An Appreciation," *American Magazine of Art*, June 1921, 187-190; Mills College Art Gallery, *Selections from the American Print Collection*, 1975; Oberlin College/Allen Memorial Art Museum, *The Stamp of Whistler*, 280, a catalogue prepared by Robert H. Getscher with introduction by Allen Staley; unpublished information, courtesy of Susan Crosato and Stephen Gillette, Irvine, California.

When Winkler reached San Francisco in 1910, after working his way across the nation as ranch hand in Nebraska and gold miner in Colorado, he had no idea what his life work would be. A climb up Nob Hill and the discovery of Mark Hopkins Art Institute prompted him to enroll. In 1912 he made his first etchings. Hundreds of plates of San Francisco subjects followed—some two hundred of Chinatown alone.

Winkler moved to Europe in 1922, mostly working in France and England; and when he returned to San Francisco in 1930, a slack period of production followed. In 1931 he entered a new phase. Visits to the Sierra Nevada Mountains inspired drawings of rocks and trees in conte crayon that held his interest until 1953.

Some art critics have called Winkler a "true descendant" of Whistler—not that he copied Whistler, for he had developed his own style before seeing Whistler's etchings, but because of the excellence of his work. Other critics have said that Winkler's etchings bring to mind those of Charles Meryon, another and earlier etcher of fame.

Winter, Charles Allan/Allen (1869-1942)

B. Cincinnati, Ohio. D. Gloucester, Massachusetts, September 23. Work: New Britain (Connecticut) Museum of

473

Art; Colby College Collection. AAA 1903-1933 (New York City; summer, from 1923, East Gloucester); Benezit; Fielding; Havlice; Mallett; WWAA 1936-1941 (East Gloucester); WWAA 1947, obit.; Inventory of American Paintings, Smithsonian Institution.

Winter studied at the Art Academy of Cincinnati from 1884 to 1894, and later in France and Italy with a scholarship. From 1898 to 1901 he taught at the St. Louis School of Fine Arts. Just when or how much work he did in the West was not determined, but John Sloan's painting of "Charles Winter Painting Red Rim Rock" is a New Mexico scene, indicating Winter's presence in Santa Fe, probably at Sloan's invitation.

Wire, Bess B. (–)
B. Wisconsin. *Who's Who in Northwest Art* (Ashland, Oregon).

Wire studied at Southern Oregon School of Education in Ashland, and with her husband Melville Wire. She worked in water color and pastel and did block printing.

Wire, Melville Thomas (1877–)
B. Austin, Illinois. Work: Portland Art Museum; Centenary-Wilbur Church, Portland, Oregon. AAA 1921-1924 (Oregon City, Oregon); AAA 1925 (Astoria, Oregon); AAA 1927-1929 (Pendleton, Oregon); AAA 1931-1933 (Klamath Falls, Oregon); Mallett (Albany, Oregon, in 1934); *Who's Who in Northwest Art* (Ashland, Oregon); Wilkinson, 1927, 271; Portland Art Museum library.

Wire was a minister who studied art at Willamette University in Oregon and exhibited in Portland in the late 1930s. Painting and etching were his hobbies, and he produced quite a number of Western scenes. He exhibited in Idaho in 1927 and may have lived there briefly about that time.

Wise, James (–)
Fielding addendum, 1974; Groce and Wallace; California State Library; San Francisco City directories, beginning in 1856; Pacific Coast Business Directory, 1871-73 (San Francisco).

Fielding shows Wise as a portrait and miniature painter ac-

tive 1843–1860, and Groce and Wallace show him active in San Francisco from 1856 to 1860, and suggest he may also be known as James H. Wise.

Wishaar, Grace N. (1879–)
B. New York City. Work: Hotel Del Monte, Pebble Beach, California. California State Library; Donovan, 1908, 27; *Overland* Monthly, February 1905, 171–175.

The California State Library has an undated, unidentified news item by Blanch Tisdale describing Wishaar who chose scenic painting as the best way to make a comfortable living, and the least likely to cramp her "expression" as a miniature portrait painter. After studying with William Merritt Chase at the New York School of Art, Wishaar talked her way into a job as scenic painter for New York's Herald Square Theatre. Such jobs then were not open to women.

About 1903 Wishaar moved to California. She had been employed as scenic artist at Oakland's Liberty Theater for four years when Tisdale interviewed her at work on the bridge over the stage. Tisdale described her as "young, slender, alert, [and] nervous." That the job was an exacting one requiring energy as well as alertness was borne out when Wishaar went to Mexico for four months; the first man hired in her place was in bed after a week's work.

Wishaar was in Mexico to copy a portrait of the Count of Monterey that had been commissioned by Hotel Del Monte. She also did other paintings while she was there. In the San Francisco area she did a number of miniature portraits of Oakland and San Francisco residents. These portraits are said to be in local private collections. Her memberships included the San Francisco Art Association, the San Francisco Guild of Arts and Crafts, and the Sequoia Club.

Wissenbach, Charles (1887–)
B. Darmstadt, Germany. Work: Vert Memorial, Pendleton, Oregon. *Who's Who in Northwest Art* (Pendleton).

Wissenbach was a minister who had studied at art academies in Frankfurt, Munich, and Paris. He painted, exhibited, and lectured on art in various Western cities including Portland, Oregon, and Sheridan, Wyoming. Twelve Indian portraits

in water color are (or were) at Vert Memorial. He also worked with oils.

Wissler, Brownie (1890–　　)
B. Stillwater, Minnesota. Work: Virginian Hotel, Medicine Bow, Wyoming; Brown Cattle Company, Birney, Montana; Minneapolis Federal Schools collection. *Who's Who in Northwest Art* (Birney).

Wissler, known also as Mrs. M. B. Schaudel, studied at Federal Art School in Minneapolis. Her subjects in Montana were drawn from her surroundings at King Mountain Ranch. She worked in all media and had two solo shows in 1934 and 1935 at the Frontier Shop in Sheridan, Wyoming.

Wiswall, Etna West (1898–　　)
Work: Museum of New Mexico, Santa Fe. Robertson and Nestor, 132–134.

Wiswall probably was born in Texas. She was a school teacher when she quit her job to study painting in New Mexico. She was married in Santa Fe and did little painting. Her brother Harold E. West, painter and print maker, visited her there in 1926 and later made his home there also.

Wittie, Ella C. (　　–　　)
B. Wisconsin. Bucklin and Turner, 1932 (Lincoln, Nebraska).

Wittie, who studied at the University of Nebraska, Snow-Froehlich School of Industrial Art, and with Ralph Johonnot, taught art in Nebraska schools at all levels. From 1914 she taught at the University of Nebraska. She was a member of Society of Western Artists and Nebraska Art Teachers' Association.

Wix, Otto (　　–　　)
Work: Santa Fe Railway Collection; National Museum of American Art. AAA 1898–1900 (New York City); Inventory of American Paintings, Smithsonian Institution; San Francisco City Directory, 1919.

Titles of paintings listed in the Smithsonian inventory indicate Wix's presence in Yosemite and the San Francisco Bay region. He worked in oil and water color.

Wood, A. M. (-)

AAW v. I; Harper, 1970; California Historical Society library; Inventory of American Paintings, Smithsonian Institution.

Wood was a friend of A.D.M. Cooper (1856–1924). November 15 and 16, 1887, they auctioned off a number of their paintings in San Jose, California, one of which was painted jointly. Wood's oil paintings at that auction were landscapes of Santa Cruz, the Mendocino Coast, Aptos Canyon near Loma Prieta, and an Indian encampment, all in California; the Cache la Poudre River and Boulder Creek in Colorado; the Colorado River in Utah; the Grand Canyon of the Colorado in Arizona; Mount Hood in Oregon; Yellowstone in Wyoming, etc. From abroad were scenes of Venice and Tunis, and landscapes from France and Germany.

According to Harper, Wood was active in Vancouver, British Columbia in 1895.

Wood, Grant (1892–1942)

B. Anamosa, Iowa. D. Iowa City, Iowa, February 12. Work: Art Institute of Chicago; Whitney Museum of American Art; Library of Congress; Joslyn Art Museum, Omaha; Cedar Rapids, Iowa, Community Schools; Pennsylvania Academy of Fine Arts, etc. AAA 1917–1925 (Kenwood Park, Iowa); AAA 1927–1929 (Cedar Rapids; New York City); AAA 1931–1933 (Cedar Rapids); Benezit; Fielding; Havlice; Mallett; WWAA 1936–1941 (Iowa City); WWAA 1947, obit.; *Antiques* Magazine, July 1977, 20; James M. Dennis, *Grant Wood/A Study in American Art and Culture,* New York: Viking Press, 1975, 239; Richardson, 399–400.

Famous for his portrayals of local Iowans such as "American Gothic" and "Daughters of Revolution," Wood seldom traveled far away for his subjects. Sources differ as to the year of his summer in the West, but his oil landscapes of Estes Park in Colorado bear dates of 1926 and 1927.

Wood, Hettie William (-)

Fisk, 1928 (Paris, Texas).

Wood seems to have had most of her canvases destroyed by fire. Many of her subjects were European, for she traveled ex-

tensively abroad. She had been a pupil of William Merritt Chase and others in New York City about 1900.

Wood, Mrs. Norman E. (1880–)
 B. Henrietta, Ohio. AAA 1913 (Knoxville, Tennessee); *Idaho Encyclopedia* (Boise, Idaho).
 Wood, who taught sixteen years in public schools, obtained her bachelor's degree at Ottawa University in Kansas in 1906, and also studied at the University of Oregon where she had a fellowship. She worked in oil and pastel but apparently did not exhibit.

Wood, Nan S. (1874–1961)
 B. Dayton, Ohio. Work: Dayton Art Institute. AAA 1931–1933 (Ipswich, Massachusetts; summer, Tucson, Arizona); Havlice; Mallett; WWAA 1947–1953 (Tucson); Museum of New Mexico library, Santa Fe; Inventory of American Paintings, Smithsonian Institution.
 Wood lived in Tucson as early as 1926 when her "Buttes in Salt River Valley" and "San Xavier Mission" were shown at the Thirteenth Annual Exhibition of the Artists of New Mexico. Her "Papago Indian Woman" and "Rocky Mountains," both oils, are at the Dayton Art Institute.

Wood, Robert (1889–1979)
 B. Sandgate, England. D. Bishop, California, March 14. "Celebrated Laguna Artist Dies at 92," Laguna *News-Post*, March 17, 1979; Larry Kronquist, Laguna Beach; Walter T. Foster, *Robert Wood/How Robert Wood Paints Landscapes and Seascapes*, Tustin, California: Walter T. Foster, n.d.
 Wood was the son of W. J. Wood, an English painter. Encouraged early in life to pursue a career in art, Wood enrolled in South Kensington School of Art when he was twelve. In 1912 Wood moved to Los Angeles, California, and subsequently lived in a number of states before settling in Laguna Beach in 1940; in the 1960s he moved to Bishop.
 During a lengthy career Wood painted scenes from coast to coast: the desert country of the Southwest, the Grand Tetons, the high Sierras, the Pacific Northwest, Florida, Texas, and the

Woodstock area of New York state. Many of his landscapes have been reproduced and are often seen in furniture stores and in private homes.

Woodall, Eva (–1915)
 Fisk, 1928 (Taylor, Texas).

 Woodall studied in New York City and in Europe and taught art classes in Taylor. She was "able to see and depict beauty with fidelity and charm, and created in her pupils an ambition for good art," said Fisk.

Woodman, Selden/Shelden J. (–)
 B. Maine. Work: Kansas State Historical Society. Reinbach, 584–585; Inventory of American Paintings, Smithsonian Institution.

 Woodman's early years were often ones of great poverty, said Reinbach. Yet he managed to read law and to be admitted to the bar in New York. In 1863, after practicing law two years he studied art in Chicago and went twice to Europe for further study. Among his teachers was Thomas Couture (1815–1879) known for historical and genre subjects. In 1871 Woodman settled in Topeka, Kansas, where he was active many years as a portrait painter.

Woodruff, Julia S. (–)
 AAA 1921 (Seattle, Washington); Helen Ross, "Seattle Artists to Exhibit," and "Seeing the Art Exhibit," Seattle *Town Crier,* November 23, 1912, 6, and December 7, 1912, 7, respectively; Calhoun, 20.

 Woodruff was a charter member of the Seattle Fine Arts Association, organized in March 1908. She had been studying with Birge Harrison in New York for three years when she exhibited in 1912. She continued to exhibit in Seattle at least until the early 1920s. "The Cascades," an oil, was among the canvases she showed in 1912.

Woodward, William (1859–1939)
 B. Seekonk, Massachusetts. Work: New Orleans Art Association; Delgado Art Museum; Tulane University; High Museum of Art, Atlanta, etc. AAA 1900–1927 (New Or-

leans, Louisiana); AAA 1929-1933 (Biloxi, Mississippi); Benezit; Fielding; Havlice; Mallett; WWAA 1936-1939 (Biloxi); "Noted Artist and Instructor in Carmel," *Western Arts,* February 1926, 9, published by Lewis L. Thomas; Monterey Public Library.

Woodward was in Carmel, California, early in 1926 to do some sketching. A painting from that trip is titled "Midway Point, Carmel, Calif." He was also an etcher, an architect, and a craftsman.

Works, Maud/Maude Estelle (1888–)
Mallett Supplement (Dallas, Texas).

Works was one of the artists who exhibited at the 1936 exposition held at the Dallas Museum of Fine Arts.

Wray, Henry Russell (1864–1927)
B. Philadelphia, Pennsylvania. D. Colorado Springs, Colorado. AAA 1919-1921 (Colorado Springs); AAA 1923-1927 (Colorado Springs; New York City); Benezit; Fielding; Mallett; AAW v. I; Colorado College Library; Grove typescript; Ormes and Ormes, 339-340; McClurg, typescript; various issues of *Facts,* a Colorado Springs publication.

Wray was active in Colorado Springs from 1898 as artist, writer, art critic, and civic leader. He served as secretary of the Chamber of Commerce, and as first president of the Colorado Springs Art Club. He exhibited locally a number of sketches and paintings of the surrounding landscape. He was also active in Philadelphia and New York City.

Wright, Charlotte Ingram (1899–1981)
B. Edmonton, Canada. D. Carmel, California, August 26. Monterey Peninsula *Herald,* August 27, 1981, 4; Monterey Public Library.

Wright who lived briefly in Carmel during 1935, and returned in 1963 was known locally for paintings, drawings, ceramics, and masks.

Wright, Gladys Yoakum (–)
B. Greenville, Texas. AAA 1919-1921 (Fort Worth,

Texas); Fielding (Fort Worth); Tom Allen, *Those Buried Texans,* Dallas: Hendrick-Long, 1980.

Wright studied at the McLeod School of Art in Los Angeles.

Wright, Harriet Freeman (–)
Denver City Directories, late 1880s; Colorado Springs City Directory 1900; Harriet Stauss, Colorado Springs.

Wright was active in Colorado at least as early as 1885 when she did "Holy Cross Mountain, Colorado," an oil. Several persons in Colorado Springs remember her, and one has a collection of her work.

Wurtele/Wurtelo, Isobel Keil (1885-1963)
B. McKeesport, Pennsylvania. D. July 11. AAA 1919 (Rochester, Minnesota); Mallett Supplement (Los Angeles, California); California State Library; California *Arts & Architecture,* December 1932 (Los Angeles).

Wurtele studied at the Artzberger Art School in Allegheny, Pennsylvania; the California College of Arts and Crafts in Berkeley (it later moved to Oakland); and with Hugh Breckenridge at his School of Painting. She did still lifes, landscapes, flowers, and mosaics which she exhibited in various cities, including the Exposition in Pittsburgh. She was a member of North Shore Art Association, East Gloucester, Massachusetts; Laguna Beach (California) Art Association; Women Painters of the West; and the California Art Club in Los Angeles.

Wyant, Alexander Helwig (1836-1892)
B. Evans Creek, Ohio. D. New York City, November 29. Work: Metropolitan Museum of Art; National Museum of American Art; Cincinnati Art Museum; Dallas Museum of Fine Arts; Fine Arts Gallery of San Diego; Fogg Museum, Harvard University; Cleveland Museum of Art; Detroit Institute of Arts; Henry Gallery, University of Washington, etc. Benezit; Fielding; Groce and Wallace; Havlice; Mallett; AAW v. I; Earle; *National Cyclopaedia of American Biography;* Special Collections No. 175, Northern Arizona University Library, Flagstaff; Doris Ostrander Dawdy, "The Wyant Diary/An Artist with the Wheeler Survey,

1873," *Arizona and the West,* Autumn 1980, 255–278; John C. Van Dyke, "Alexander H. Wyant," chapter in *American Painting and Its Tradition,* New York: Charles Scribner's Sons, 1919; Hartmann, 1934, 90–94; Montgomery, v. II, 967–968; National Archives.

The circumstances of Wyant's Western experience in 1873 came to light in 1976 when the University of Northern Arizona acquired his diary of field notes and sketches, made during the two months he was attached to Lt. George M. Wheeler's Geographical Explorations and Surveys West of the One Hundredth Meridian. What was known prior to 1976 was that Wyant joined a government exploring party (unnamed), suffered paralysis to his right side from overwork, exposure, and lack of food; returned to New York City a sick and crippled artist who successfully painted with his left hand after months of determined effort.

Art historians such as Van Dyke have hypothesized that Wyant attempted no Western landscapes because he better understood and had a preference for Eastern mountain scenes. At least one Western landscape by Wyant has been shown at major museums, and he probably would have done others had he received the photographs of the trip which he had requested from Wheeler in a letter he wrote in 1874 from New York. (Wyant and other artists, then as now, used photographs as aids in painting.)

Suffice it to say here that Wyant was eager to take on the West as subject matter when he reached his destination, but his painting supplies were run over by an army wagon the night he left Fort Wingate, New Mexico, for Canyon De Chelly. Paintings that may exist will have been made hurriedly at stagecoach layovers at Kit Carson, Colorado, and Santa Fe. The photographer for the Wheeler Survey in 1873 was Timothy O'Sullivan. Wyant mentioned him a number of times in his diary.

Wyeth, Newell Convers (1882–1945)

B. Needham, Massachusetts. D. Chadds Ford, Pennsylvania, October 19. Work: Indianapolis Museum of Art; Houston Museum of Fine Arts; New York Public Library; Needham Free Public Library; Charles and Emma Frye Free Public Art Museum, Seattle; Cowboy Hall of Fame, Oklahoma City; Minneapolis Institute of Arts. AAA 1907–1919 (Chadds Ford); AAA 1921–1925 (Needham);

AAA 1927–1933 (Chadds Ford); Benezit; Fielding; Havlice; Mallett; WWAA 1936–1941 (Chadds Ford and Port Clyde, Maine); WWAA 1947, obit.; AAW v. I; Earle; Betsy James Wyeth, ed., *The Wyeths/The Intimate Correspondence of N. C. Wyeth 1901–1945,* Boston: Gambit, 1971; James H. Duff, "The American West of N. C. Wyeth," *American West,* July-August, 1980, 32–41, 56–58; Duff, *The Western World of N. C. Wyeth,* Cody: Buffalo Bill Historical Center, 1980; Patricia Johnston, "N. C. Wyeth and Cream of Wheat," *American West,* July-August 1980, 42–43.

Not all illustrators of Western life experienced it first hand, and some, like Wyeth, did Western illustrations before they had a chance to experience it. Wyeth got his first taste of the West in 1904 when he spent time as a cowpuncher on a Colorado ranch near Limon. In November he set out for New Mexico by way of Durango, Colorado, and then went on to northeastern Arizona.

When Wyeth returned to Denver in mid-December, he rented a studio for two weeks, produced and exhibited four major paintings, and then returned home to produce a great many more from his sketches and remembrances. In February 1906 *Outing Magazine* sponsored a trip to Grand County, Colorado. Wyeth hoped to be back later in the year to spend some time in Montana, but the trip did not materialize.

X

Xantus, Janos (1825–1894)

B. Csokonya, Hungary. D. Budapest, Hungary, December 13. Benezit; Groce and Wallace; *Dictionary of American Biography.*

During the first year of his residence in this country Xantus worked as a laborer. On December 1, 1852, he was hired as a topographer for a Pacific railroad expedition. Afterwards he

taught languages for a while in New Orleans. From 1855 to 1857 he was among those delegated to ascertain the most practicable railroad route between the Mississippi River and the West Coast.

In the West Xantus worked for the U.S. Coast Survey, stationed at Fort Tejon and Cape St. Lucas. He completed his illustrated study of Western birds which he was then making for the Smithsonian, and it was published in the *Proceedings of the Academy of Natural Sciences of Philadelphia* (vol. X-XII, 1859-1861). During the early 1860s he was appointed U.S. Consul to Manzanillo, Mexico, where he led a scientific research party into the Sierra Madre Mountains. In 1864 he returned to Hungary.

Y

Yamagishi, Teizo (1898–)
B. Japan. *Who's Who in Northwest Art* (Seattle, Washington).

Yamagishi studied at the Tokyo Fine Arts College. He was active in Seattle at least as early as the late thirties.

Yampolsky, Oscar (ca 1892-1944)
D. Chicago, Illinois, March 17. AAA 1913 (Chicago); AAA 1915-1919 (Chicago; Crystal Lake, Illinois); WWAA 1947, obit.

Yampolsky was a painter, a sculptor, and a teacher who studied at the Art Institute of Chicago, in New York, and in Europe. He taught art at Fort Wayne (Indiana) Art School and at Washington State College in Pullman.

Yarbrough, Vivian Sloan (1893–)
B. Whitesboro, Texas. AAA 1933 (Fort Worth, Texas); Mallett; O'Brien, 1935; Registrar's records, Broadmoor Art Academy, Colorado Springs Fine Arts Center.

Yarbrough, who studied with Ernest Lawson, Randall Davey, Robert Reid, and John Sloan, exhibited rather widely during the 1930s, i.e., Denver Art Museum; New York City; Ogunquit, Maine; in Texas; and with the Southern States Art League.

Yates, Mrs. E. R. (1888–1958)
Wilbanks, 1959, 67.

Yates was a Dawson County pioneer and amateur artist who was known in the West Texas Plains region for her ranch landscapes in pastels. She was active in local art circles.

Yens/Jens, Karl/Carl Julius Heinrich (1868–1945)
B. Altona, Germany. D. Laguna Beach, California, April 13. Work: Laguna Beach Museum of Art; Los Angeles County Museum; California State Exposition Building; San Diego Fine Arts Gallery; Springville (Utah) Museum of Art; Society of California Pioneers. AAA 1903 (Boston, Massachusetts); AAA 1917–1919 (Los Angeles); AAA 1921–1933 (Laguna Beach); Benezit; Fielding; Havlice; Mallett; WWAA 1936–1941 (Laguna Beach); AAW v. I; *National Cyclopaedia of American Biography;* Laguna Beach Museum of Art, 1979 exhibition catalogue; Berry, 1924.

Yens is said to have been a muralist of importance in Germany and Scotland. Shortly after coming to the United States about 1900 or 1901, he turned to easel painting. Within the next decade he moved to Southern California where he became well-known for portraits, landscapes, genre subjects, and still lifes. In 1918 he moved to Laguna Beach where he is said to have done some of his most important work.

Yoakum, Joseph (1886–1973)
B. Navajo Reservation, Arizona. D. Chicago, Illinois.
"Galleries," Washington *Post*, December 3, 1977, E9.

Yoakum's work was featured in a Washington, D.C., exhibition that prompted the *Post's* art columnist to highlight the event. When very young Yoakum ran away from home to join Buffalo Bill's circus. He had since then moved about on two continents. When he was seventy, he began painting from memory what he remembered during his travels, especially in California,

Virginia, and China. His "delicately drawn landscapes" shown at the exhibition apparently were quite remarkable.

Yont, Lily (-)

B. Otoe County, Nebraska. Work: Omaha Public Schools. Bucklin and Turner, 1932 (Lincoln, Nebraska); Lincoln City Directory, 1915.

Yont studied with Sara Hayden at the University of Nebraska, the Boston Museum of Fine Arts School in 1910, and the California School of Arts and Crafts during the summer of 1925. She exhibited regularly with the Lincoln Art Guild, the Omaha Society of Fine Arts, and occasionally with Midwestern Artists in Kansas City, Missouri. She was the first president of the Lincoln Art Guild which she helped found in 1920.

Yoshida, Hiroshi (1876-1950)

B. Kyusha or Kurema, Japan. Work: Fogg Museum, Harvard University; Cincinnati Art Museum; Detroit Institute of Art; Henry Gallery, University of Washington; Honolulu Academy of Arts; Minneapolis Institute of Art; Newark Museum of Northern Arizona, etc. AAA 1900-1903 (Boston, Massachusetts); Benezit; Mallett Supplement (Tokyo); Roberts.

Two Grand Canyon scenes indicate Yoshida's presence in Arizona about 1925. Roberts refers to him as a "romantic-realist" whose work is in the Western style. He worked with oils in his early landscapes, but it was his water colors that brought him early fame. About 1920 he began another phase of his career—print making.

Yost, Frederick J. (1888-1968)

B. Berne, Switzerland. Work: Butler Art Institute; Akron Art Institute; College Art Association; Rockefeller Center and Radio City; Youngstown Public Schools collection; Massillon (Ohio) Museum; Library of Congress. Havlice; Mallett Supplement; WWAA 1936-1941 (New York City); WWAA 1947 (Youngstown, Ohio); WWAA 1953-1966 (Akron, Ohio); WWAA 1970, obit.

Yost was a painter, a print maker, and a muralist who was associated with the City of New York Park Department in the

1930s. He exhibited nationally in the 1940s and 1950s. His New Mexico work probably was done in the early 1930s.

Young, Dorothy Weir (See: Dorothy Weir)

Young, Ellsworth/Elsworth (1866–)
B. Albia, Iowa. Work: State Museum, Springfield, Illinois; Illinois State Teachers College; Macomb and Bloomington high schools, Bloomington, Illinois; Tolleston Public School, Gary, Indiana. AAA 1909–1915, 1919 (Oak Park and Chicago, Illinois); AAA 1923–1933 (Oak Park); Havlice; Mallett; WWAA 1936–1941 (Oak Park); Denver Public Library; Ness and Orwig, 1939.

Young was active in the West prior to the turn of the century when he worked as an illustrator for the Denver *Times* and exhibited with fellow members of the Denver Artists' Club.

Young-Hunter, Mary (ca 1872–1947)
B. Napier, New Zealand. D. Carmel, California, September 8. Monterey (California) Public Library; Polk's Salinas, Monterey, Pacific Grove and Carmel City Directory, 1930 (Carmel); California *Arts & Architecture,* December 1932 (Carmel).

Before moving to Carmel in 1921, Young-Hunter had lived in Scotland, New York City, and Taos, New Mexico. She was a portrait painter. For many years she was married to the painter John Young-Hunter, but during that period she appears to have been inactive.

Z

Zallinger, Franz (1894–)
B. Salzburg, Austria. Work: murals, Vance Hotel, Seattle. *Who's Who is Northwest Art* (Seattle, Washington).

Zallinger studied at the School of Fine Arts in Bavaria, and also in Vienna. He exhibited at the Seattle Art Museum.

Zane, Nowland Brittin (1885–)
B. Pennsylvania. Work: murals, Library, University of Oregon; theater in Salem, Oregon. *Who's Who in Northwest Art* (Eugene, Oregon).

Zane studied at the Art Institute of Chicago, the Pennsylvania Academy of Fine Arts, and at Drexel Institute. He was assistant professor of fine arts at the University of Oregon, and he exhibited at the Portland Art Museum.

Zillig, Fritz (–)
AAA 1915 (Chicago, Illinois); California *Arts & Architecture,* December 1932 (Los Angeles, California).

Zilzer, Gyula (1898–1969)
B. Budapest, Hungary. Work: Luxembourg Museum, Paris; British Museum, London; Metropolitan Museum of Art; New York Public Library. Havlice; Mallett Supplement; WWAA 1939–1941 (New York City); WWAA 1947–1953 (Hollywood, California); WWAA 1959–1970 (New York City).

Zilzer, who exhibited internationally, had several solo exhibitions in West Coast cities during the 1940s when he was working in the motion picture industry.

Zimmerer, Frank J. (1882–)
B. Nebraska City, Nebraska. AAA 1923–1927 (Lincoln, Nebraska); Bucklin and Turner, 1932; California *Arts & Architecture,* December 1932 (Los Angeles).

Zimmerer studied at the Art Institute of Chicago, the Glasgow School of Art in Scotland, and in Paris. He was active in New York City, Indianapolis, Cincinnati, Chicago, and in Missouri, principally in administrative roles such as art department head of Northwest Missouri Normal, and director for one year of the Kansas City Art Institute. In the mid-twenties he moved to Los Angeles where he worked as a commercial artist and exhibited locally.

Zorach, William (1887–1966)

B. Eurburick-Kovno, Russia. D. Bath, Maine, November 16. Work: Museum of Modern Art; Metropolitan Museum of Art; Corcoran Gallery of Art; Wichita Art Museum; Art Institute of Chicago; National Museum of American Art; Los Angeles County Museum of Art, etc. AAA 1915–1921 (New York City); AAA 1923–1925 (New York City; summer, Provincetown, Massachusetts); AAA 1927–1933 (New York City; summer, Robinhood, Maine); Benezit; Fielding; Havlice; Mallett; WWAA 1936–1941 (Robinhood); WWAA 1947–1966 (Brooklyn, New York); NMAA-NPG Library, Smithsonian Institution; "William Zorach Is Dead at 79, Eloquent Sculptor and Painter – Realist Who Is Represented in Many Collections Was Once 'Wildly Modern,'" special to New York *Times,* November 17, 1966.

During January 1979 a New York gallery presented thirty-five Yosemite scenes, the product of Zorach's summer in the Park in 1920. There were thirteen water colors, twenty pencil drawings, and two oils. His experiences of that summer are in his autobiography, *Art Is My Life,* published in 1967.

Zorach liked to work in the West, but most of his landscapes were done in the Northeast where he and his California-born artist wife Marguerite had their studios. Because he is better known as a sculptor, his paintings and linoleum and woodcut prints may not be in so many collections as his sculptures.

Zsissly (See: Malvin Marr Albright)

Zwara, John (1880–)

B. Czechoslovakia. Bucklin and Turner, 1932 (Omaha, Nebraska).

Zwara was a painter, an illustrator, a craftsman, and a cartoonist who exhibited with the Omaha Society of Fine Arts during the early 1930s or before. His education had been obtained in government schools in Bohemia, Poland, and Hungary. He may be the Jan Zwara listed in Mallett Supplement as living in Indianapolis, Indiana, by the late thirties.

Bibliography

Art and Other Dictionaries and Directories

American Art Annual. Washington, D.C.: The American Federation of Arts, 1898–1933.

Appleton, Marion Brymner (ed.). See: *Who's Who in Northwest Art.*

Benezit, E. *Dictionnaire – Critique et Documentaire des Peintres, Dessinateurs, Graveurs et Sculpteurs.* Paris: Ernest Grund, Editeur, 1907–1950; Librairie Grund, 1976.

Binheim, Max (comp. and ed.). *Women of the West.* Los Angeles: Publishers Press, 1928.

Bryan, M. B. (G. C. Williamson, supervisor). *Bryan's Dictionary of Painters and Engravers.* London: George Bell and Sons; New York: The MacMillan Company, 1903–1905.

California *Arts & Architecture*, "Directory of California Artists," December 1932. [i.e., artists who had California addresses at that time.]

Caplan, H. H. *The Classified Directory of Artists Signatures, Symbols & Monograms.* London: George Prior Publishers, 1976; Detroit: Gale Research Company, 1976.

Cederholm, Theresa Dickason. *Afro-American Artists/A Bio-bibliographical Directory.* Boston: Boston Public Library, 1973.

Clement, Clara Erskine and Laurence Hutton. *Artists of the Nineteenth Century and Their Works.* Boston: Houghton Mifflin, 1899; St. Louis: North Point, Inc., 1969.

College Art Association. *Index of 20th Century Artists 1933–1937.* New York: Arno Press, 1970.

Collins, J. L. *Women Artists in America.* J. L. Collins, 1973.

Cummings, Paul. *A Dictionary of Contemporary American Artists.* New York: St. Martin's Press, 1966; second edition, 1971.

Current Biography Year Book. New York: H. W. Wilson Company, 1939–1975.

Dawdy, Doris Ostrander. *Artists of the American West.* vol. I,

Chicago: The Swallow Press, Inc., 1974; second printing, Athens: The Swallow Press/The Ohio University Press, 1980. vol. II, Athens: The Swallow Press/Ohio University Press, 1981.

Dictionary of American Biography. New York: Charles Scribner's, 1927–1964.

Earle, Helen L. (comp.). *Biographical Sketches of American Artists.* Charleston: Garnier & Co., 1972 (Unabridged replication of 1924 edition, Michigan State Library, Lansing).

Encyclopedia of Painting (Bernard S. Myers, ed.). New York: Crown Publishers, Inc., 1955.

Fielding, Mantle (James F. Carr, comp.). *Mantle Fielding's Dictionary of American Painters, Sculptors and Engravers.* New York: James F. Carr, 1965; Green Farms, Connecticut: Modern Books and Crafts, Inc., 1974.

Fisher, Reginald (comp. and ed.). *Art Directory of New Mexico.* School of American Research. Santa Fe: Museum of New Mexico, 1947.

Gibson, Arthur Hopkin (comp.). *Artists of Early Michigan/A Biographical Dictionary of Artists Native to or Active in Michigan 1701–1900.* Detroit: Wayne State University Press, 1975.

Graves, Algernon. *Dictionary of Artists Who Have Exhibited Works in the Principal London Exhibitions from 1760–1893.* Third edition. New York: Burt Franklin, 1970.

Graves, Algernon. *The Royal Academy of Arts/A Complete Dictionary of Contributors and Their Work from Its Foundation in 1769 to 1904.* 8 vols. New York: Burt Franklin, 1972.

Groce, George C. and David H. Wallace. *New York Historical Society's Dictionary of Artists in America 1564–1860.* New Haven: Yale University Press, 1957; second printing, 1964.

Hamilton, Sinclair. *Early American Book Illustrators and Wood Engravers 1670–1870.* Princeton: Princeton University Library, 1958; vol. II Supplement, 1968.

Harbick, Lee (comp. and ed.). *Art & Artists of the Monterey Peninsula,* vols. I–III. Monterey, California. n.d. [Available at Monterey and Carmel public libraries.]

Harper, J. Russell. *Early Painters and Engravers in Canada.* Toronto: University of Toronto Press, Inc., 1970.

492

Havlice, Patricia Pate. *Index to Artistic Biography.* two vols., Metuchen, New Jersey: The Scarecrow Press, Inc., 1973; First Supplement, 1981.

Houfe, Simon. *Dictionary of British Book Illustrators and Caricaturists/1800–1914.* Woodbridge, Suffolk, England: Baron Publishing, 1978.

Idaho Encyclopedia. Federal Writers' Project of the Works Progress Administration. Caldwell: The Caxton Printers, Ltd., 1938.

Johnson, J., and A. Greutzner (comps.). *The Dictionary of British Artists 1880–1940.* England: Baron Publishing, 1976.

Kingman, Lee, Joanna Foster, and Ruth Giles Lontoft (comps.). *Illustrators of Children's Books 1957–1966.* Boston: The Horn Book, Inc., 1968.

McCoy, Garnett. *Archives of American Art.* Smithsonian Institution. New York and London: R. R. Bowker Company, 1972.

Macdonald, Colin S. (comp.). *A Dictionary of Canadian Artists.* Ottawa: Canadian Paperbacks, 1968.

McMahan, Virgil E. *Washington, D.C. Artists Born before 1900: a biographical directory.* Washington, D.C.: Virgil E. McMahan, 1976.

Mahony, Bertha E., Louise Payson Latimer, and Beulah Folmsbee (comps.). *Illustrators of Children's Books 1744–1945.* Boston: The Horn Book, Inc., 1947.

Mallalieu, H. L. *Dictionary of British Watercolour Artists up to 1920.* Suffolk: Baron Publishing, 1976.

Mallett, Daniel Trowbridge. *Mallett's Index of Artists.* New York: R. R. Bowker Company, 1935; Supplement, 1940. New York: Peter Smith, 1948, reprints.

Moure, Nancy Dustin Wall. *Dictionary of Art and Artists in Southern California Before 1930.* Los Angeles: Privately printed, 1975.

National Cyclopaedia of American Biography. New York: James T. White & Company, 1893–1969.

Ness, Zenobia B., and Louise Orwig. *Iowa Artists of the First Hundred Years.* Wallace-Homestead Company, 1939.

Olpin, Robert S. *Dictionary of Utah Art.* Salt Lake City: Salt Lake Art Center, 1980.

Paviere, Sydney H. *A Dictionary of British Sporting Painters.* England: F. Lewis, Publisher, Ltd., 1965.

Pierce, Mrs. Harry Paul. *Roll of Artists of the State of Washington.* Snoqualmie Falls, Washington, June 1926.

Roberts, Laurance P. *A Dictionary of Japanese Artists.* Tokyo and New York: Weatherhill, 1976.

Samuels, Peggy and Harold. *The Illustrated Biographical Encyclopedia of Artists of the American West.* Garden City: Doubleday & Company, 1976.

Schmidt Fine Arts, Anthony. vol. I, *American Art Annual,* 1933; vol. II, *Biographical Sketches of American Artists* (compiled by Helen L. Earle). Collingwood, New Jersey: Anthony Schmidt Fine Arts, Publisher, 1982. [Unabridged replications originally published by The American Federation of Arts and Michigan State Library, respectively.]

Smith, Ralph Clifton. *A Biographical Index of American Artists.* Charleston: Garnier & Company, 1967. [Unabridged and unaltered reproduction of the work originally published by Williams and Welkins in 1930.]

Sparks, Esther. *A Biographical Dictionary of Painters and Sculptors in Illinois, 1808–1945.* Two vols. Evanston, Illinois: Northwestern University, 1971.

Stuart, Joseph (ed.). *Index of South Dakota Artists.* Brookings: South Dakota State University, 1974.

Thieme, Ulrich, and Felix Becker. *Allegmeines Lexicon der Bildenden Kunstler.* 37 vols. Leipzig: Verlag von Wilhelm Engelmann, 1907–50.

Viguers, Ruth Hill, Marcia Dalphin, and Bertha Mahony Miller. *Illustrators of Children's Books 1946–1956.* Boston: The Horn Book, 1958.

Wallace and McKay (eds.). *Macmillan Dictionary of Canadian Biography,* 4th ed. Toronto: Macmillan of Canada, 1978.

Waters, Grant M. *Dictionary of British Artists Working 1900–1950.* Two vols. Eastbourne, England: Eastbourne Fine Art, 1975.

Who's Who in America. Chicago: A. N. Marquis Co.

Who's Who in American Art. 1936–1982. American Federation of Arts. New York: R. R. Bowker Company.

Who's Who in Art. 1927–1968. Watford: The Art Trade Press, Ltd.

Who's Who in Northwest Art/A Biographical Directory of Persons in the Pacific Northwest Working in the Media of Painting, Sculpture, Graphic Arts, Illustration, Design, and the Handicrafts. Marion Brymner Appleton, ed. Seattle: Frank McCaffrey, 1941.

Who's Who in California. Russell Holmes Fletcher (ed.). Los Angeles: Who's Who Publications Co., 1943.

Who's Who in the Pacific Southwest. Los Angeles: Times-Mirror Printing and Binding House, 1913.

Who's Who in the West. Chicago: A. N. Marquis Co.

Who's Who on the Pacific Coast. Chicago: Larkin, Roosevelt & Larkin, Ltd., 1947; A. N. Marquis Co., 1949.

Who Was Who in America. Chicago: A. N. Marquis Company.

Withey, Henry F., and Elsie R. Withey. *Biographical Dictionary of American Architects (deceased).* Los Angeles: New Age Publishing Co., 1956.

Young, William (comp. and ed.). *A Dictionary of American Artists, Sculptors and Engravers.* Cambridge: William Young and Co., 1968.

Bibliographies and Indexes

Bachmann, Donna G., and Sherry Pyland. *Women Artists: An Historical, Contemporary and Feminist Bibliography.* Metuchen, New Jersey and London, 1978.

Chamberlin, Mary Walls. *Guide to Art Reference Books.* Chicago: American Library Association, 1959.

Chicago Art Institute. *Index to Art Periodicals Compiled in the Ryerson Library of The Art Institute of Chicago.* 11 vols. Boston: G. K. Hall, 1962.

Colorado Springs Gazette Index, March 23, 1872, to December 31, 1939, compiled by Manly D. Ormes. Bulletin No. 8, Division of State Archives and Public Records, 1963.

Columbia University. *Avery Obituary Index of Architects and Artists.* Boston: G. K. Hall, 1963.

Doumato, Lamia (ed.). *American Drawing: A Guide to Information Sources.* Detroit: Gale Research Company, 1979.

Faxon, Frederick Winthrop, Mary E. Bates, and Anne C. Sutherland (eds.). *Cumulated Magazine Subject Index 1907–1949.*

Boston: G. K. Hall & Co., 1964. [See subheading Art and Artists.]

Jones, Lois Swan. *Art Research Methods and Resources/A Guide to Finding Art Information.* Dubuque: Kendall/Hunt Publishing Company, n.d.

Karpel, Bernard (ed.). *Arts in America: A Bibliography.* 4 vols. Washington, D.C.: Smithsonian Institution Press, 1979.

Keaveney, Sydney Starr (ed.). *American Painting.* vol. I. *Art and Architecture: An Information Guide Series.* Detroit: Gale Research Company, 1974.

Mason, Lauris. *Print Reference Sources: A Select Bibliography 18th-20th Centuries.* Millwood, New York: Kraus-Thomson Organization, 1975.

Westways—Touring Topics. *Cumulative Index.* Compiled by Anna Marie and Everett Gordon Hager. Los Angeles: Automobile Club of Southern California, 1961.

Books and Articles

Alexander, Irene. "Impressive Salute to Past in Carmel." Monterey Peninsula *Herald,* November 19, 1962. [Monterey, California.]

Andersen, Timothy J., Eudorah M. Moore, and Robert W. Winter. *California Design 1910.* Los Angeles: California Design Publications, 1974.

Anonymous. "Academy of Fine Arts Opens Exhibit June 6/Several Paintings by Local Artists Will Be Shown Along With Those of Classes," Colorado Springs *Gazette,* June 3, 1914, 5/5-6.

Anonymous. "'Art' and 'Carmel' Synonymous/Noted Painters Live in Colony by the Sea," Monterey Peninsula *Herald,* October 18, 1966, A3/5 and A4/3.

Anonymous. "Art Beginnings on the Pacific," *Overland Monthly,* July 1868, 28-34; August 1868, 113-119.

Anonymous. "Art Exhibit of Colorado Springs Painters Most Brilliant in History of Association/Broadmoor Art Academy," n.p.; n.d. [see vertical file, Colorado College Library.]

Anonymous. "Brilliant Work of Colorado Artists Will Be on View this Week," Denver *Republican,* April 9, 1899.

Anonymous. "In the Northwest." *Art Digest*, April 1, 1937, 25.

Anonymous. "New Mexico Colony Holds Its 25th Annual," *Art Digest*, September 1, 1938, 11.

Anonymous. "Pictures of Real Merit at Exhibit at Academy/ Paintings at Fine Arts Room by Local Artists Are Praised in Highest Terms," Colorado Springs *Gazette*, June 11, 1914, 5/2.

Anonymous. "72 Paintings by Springs Artists in Exhibition/ Second Annual Display of Works of Local Painters Shows Much Interest Here," Colorado Springs *Gazette*, June 13, 1915, 5/4.

Anonymous. "The West Reports," *Art Digest*, August 1, 1941, 17.

Art in California. See: Bruce Porter, and others.

Baker, James H., and LeRoy R. Hafen (eds.). *History of Colorado*, chap. XXIV "Literature and the Arts" by Edgar McMechen. Denver: Linderman Co., Inc., 1927.

Ballard, Adele M. "Some Seattle Artists and Their Work," Seattle *Town Crier*, December 18, 1915, 25–35.

Ballinger, James. "Faces and Moods of the American West," *Southwest Art*, January 1981, 42–51.

Ballinger, James K. "Land of Beauty and Adventure: Visiting Artists Painted Arizona," *American West*, January-February, 1981.

Barker, Virgil. *American Painting/History and Interpretation*. New York: The Macmillan Co., 1950.

Barr, Maurice Grant See: Catalogues

Barr, Paul E. *North Dakota Artists*. Grand Forks: University of North Dakota Library Studies, No. 1, 1954.

Berry, Rose V. S. "California and some California Painters," *American Magazine of Art*, June 1924, 279–291.

Blanch, Josephine. "The 'Barbizon' of California," *Del Monte Weekly*, May 13, 1911. [This article, "used by permission of the *Overland Monthly*," is available at Monterey (California) Public Library.]

Blodgett, Richard. "The Rip-Roaring, Record Breaking Western Art Market," *Art News*, December 1979, 102–103, 106–107.

Boyle, Richard J. *American Impressionism*. Boston: The New York Graphic Society, 1974.

Brown, Milton W. *American Painting from the Armory Show to the Depression*. Princeton: Princeton University Press, 1955.

Bucklin, Clarissa, and Martha M. Turner. *Nebraska Arts and Artists*. Lincoln: School of Fine Arts, University of Nebraska, 1932.

Butterfield, Jan. "Made in California," *American Art Review*, July 1977, 118–144.

Bywaters, Jerry. *Seventy-Five Years of Art in Dallas*. Dallas: Dallas Museum of Fine Arts, 1978.

_____. "Southwestern Art Today/New Directions for Old Forms," *Southwest Review*, Autumn 1947, 361–372.

Calder, Alexander, and Jean Davidson. *Calder, An Autobiography with Pictures*. New York: Pantheon Books, 1966.

Calhoun, Anne H. *A Seattle Heritage/The Fine Arts Society*. Seattle: Press of Lowman & Hanford Co., 1942.

Caliban. "Art in San Francisco," *Daily Alta California*, March 27, 1870, 2/3; April 28, 1870, 4/1; June 5, 1870, 2/3. [Caliban appears to be S. T. Stuart, a local writer.]

Carter, Kate B. (comp.). *Heart Throbs of the West*. Salt Lake City: Daughters of Utah Pioneers, n.d.

Cheney, Sheldon. "Book-Plates East and West," *Overland Monthly*, August 1908, 186–190.

City Club of Denver Fine Arts Committee. *Art in Denver*. Denver: City Club of Denver, January 1928.

Clark, Edna Maria. *Ohio Art and Artists*. Richmond: Garrett and Massie, Publishers, 1932; Detroit: Gale Research Company, 1975.

Cochrane, Diane. "The Ten Best American Printmakers of the Thirties: How Do They Rate Today," *American Art & Antiques*, September-October 1978, 52–59.

Coen, Rena N. "The Last of the Buffalo," *American Art Journal*, November 1973, 83–94.

Coen, Rena Neumann. *Painting and Sculpture in Minnesota 1820-1914*. Minneapolis: University of Minnesota Press, 1976.

Coke, Van Deren. *Taos and Santa Fe*. Albuquerque: University of New Mexico Press, 1963.

Cole, F. "Looking Back on 40 Years of Art in the Valley," *Arizona*, January 21, 1968, 12–15.

Cummings, Thomas S. *Historic Annals of the National Academy of Design*. New York: Kennedy Galleries, Inc.-Da Capo Press, 1969.

Dale, Edward Everett, and Morris L. Wardell. *History of Okla-homa.* New York: Prentice-Hall, Inc., 1948.

Dawdy, Doris Ostrander (ed.). "The Wyant Diary/An Artist with the Wheeler Survey in Arizona, 1873." *Arizona and the West,* Autumn 1980, 255–278.

Dehn, Adolf, and Lawrence Barrett. *How to Draw and Print Lithographs.* New York: American Artists Group, Inc., 1950.

Donovan, Ellen Dwyer. "California Artists and Their Work," *Overland Monthly,* January 1908, 27.

Dunn, Dorothy. *American Indian Painting of the Southwest and Plains Areas.* Albuquerque: University of New Mexico Press, 1968.

Federal Writers Project. *Santa Barbara/A Guide to the Channel City and Its Environs.* New York: Hastings House, 1941.

Fisher, Theo Merrill. "The Broadmoor Art Academy, Colorado Springs," *American Magazine of Art,* August 1920, 355–359.

Fisk, Frances Battaile. *A History of Texas Artists and Sculp-tors.* Abilene, Texas: Frances Battaile Fisk, 1928.

French, H. W. *Art and Artists in Connecticut.* Boston: Lee and Shepard, Publishers; New York: Charles T. Dillingham, 1879; Kennedy Graphics, Inc.-Da Capo Press, 1970.

Gerdts, William H., and Russell Burke. *American Still-life Paint-ing.* New York: Washington: London: Praeger Publishers, 1971.

Gerdts, William H., Jr. *Painting and Sculpture in New Jersey.* Princeton: D. Van Nostrand Company, Inc., 1964.

————, "Revealed Masters, 19th Century American Art," *Ameri-can Art Review,* November-December 1974, 77–93.

Getlein, Frank, and the Editors of *Country Beautiful. The Lure of the Great West.* Waukesha, Wisconsin: *Country Beautiful,* 1973.

Griffin, Rachael, and Sarah Munro (eds.). *Timberline Lodge.* Port-land: Friends of Timberline, 1978.

Hafen, LeRoy R. *Colorado and Its People.* vol. II, chap. XVI, "Art," by Edgar C. McMechen, 419–441; vol. III, Biog-raphies. New York: Lewis Historical Publishing Co., Inc., 1948.

Hanford, C. H. (ed.). *Seattle and Environs 1852-1924.* vol. 1,

630-655. Chicago and Seattle: Pioneer Historical Publishing Co., 1924.

Harper, J. Russell. *Painting in Canada/A History.* Toronto: University of Toronto Press, 1966.

Harshe, Robert B. "The California Society of Etchers," *Art in California,* by Bruce Porter, and others. San Francisco: R. L. Bernier, 1916, 116-120.

Hart, Ann Clark. *Clark's Point: A Narrative of the Conquest of California and of the Beginning of San Francisco.* pt. II, chap. IV, "Writers and Artists," 37-47. San Francisco: The Pioneer Press, 1937.

Hartmann, Sadakichi. *A History of American Art.* rev. ed. New York: Tudor Publishing Company, 1934.

Haseltine, James L. *One Hundred Years of Utah Painting.* Salt Lake City: Salt Lake Art Center, 1965.

Hassrick, Peter. "The American West Goes East," *American Art Review,* March-April 1975, 63-78.

————, *The Way West/Art of Frontier America.* New York: Harry N. Abrams, 1977.

Heaton, Elsie S. (ed.) and Kaysville Art Club. *Pioneers of Utah Art.* Logan: Educational Printing Service, 1968.

Hoag, Betty Lochrie. "Chronicle of Monterey Peninsula Art," *Art & Artists of the Monterey Peninsula.* vol. II., p. 10A-12. Monterey: Lee Harbick, n.d. [Available at Monterey and Carmel public libraries.]

Hogarth, Paul. *Artists on Horseback: The Old West in Illustrated Journalism 1857-1900.* New York: Watson-Guptill, 1972.

Horne, Alice Merrill. *Devotees and Their Shrines/A Handbook of Utah Art.* Salt Lake City: Deseret News, 1914.

Huckel, J. F. *American Indians/First Families of the Southwest.* Albuquerque: Fred Harvey, Indian Department, 5th ed., 1934.

Jacobson, J. Z. *Art of Today/Chicago.* Chicago: L. M. Stein, 1932.

Jacobson, O. B., and Jeanne d'Ucel. "Art in Oklahoma," *Chronicles of Oklahoma,* Autumn 1954, 263-277.

Jones, Harvey L. *Mathews/Masterpieces of the California Style.* Santa Barbara and Salt Lake City, 1980.

Kamerling, Bruce. "Theosophy and Symbolist Art/The Point Loma Art School," *Journal of San Diego History,* Fall 1980, 231-255.

Kielman, Chester V. (comp. and ed.). *University of Texas Archives...* Austin and London: The University of Texas Press, 1967.

Koch, Margaret. *Santa Cruz County Parade of the Past.* Fresno: Valley Publishers, 1973.

Lawson, T. A. *History of Wyoming.* Lincoln and London: University of Nebraska Press, 1978, 602–605.

Lewis Publishing Company. *Bay of San Francisco, a History in Two Volumes.* Chicago: The Lewis Publishing Company, 1892.

Lilly, Marie Seacord. "The Texas Wild Flower Painting Competitions," *American Magazine of Art,* June 1929, 342–347.

Linford, Velma. *Wyoming/Frontier State.* Denver: Old West Publishing Company, 1947.

Longstreth, Edward. "Topeka: A New Art Center," *American Magazine of Art,* July 1924, 354–355.

Lytle, Rebecca. "People and Places/Images of Nineteenth Century San Diego/In Lithographs and Paintings," *The Journal of San Diego History,* Spring 1978, 153–171.

McClurg, Gilbert. "Brush and Pencil in Early Colorado Springs," Colorado Springs *Gazette and Telegraph,* pt. I, November 16, 1924; pt. II, November 23, 1924; pt. III, November 30, 1924; pt. IV, December 7, 1924; pt. V, December 14, 1924; pt. VI, December 21, 1924; typescript at Colorado College Library and Colorado Springs Public Library.

McGehee, Kathe. "A Taos Legacy: The Harwood Foundation," *Art West,* May–June, 1980, 38–43.

McMechen, Edgar C. "Brinton Terrace an Art Center," *Colorado* Magazine, May 1947, 103–105.

McMechen, Edgar C. "Historic Wood Blocks," *Colorado* Magazine, September 1938, 192–195.

Martin, Francis T. B. "Early Omaha Art Organizations and Activities," 1953, n.p. [Available at Omaha Public Library.]

Maxwell, Everett Carroll. *Art and Artists of the Great Southwest.* Chicago, 1910. [Excerpted from *Fine Arts Journal* for publication in pamphlet form.]

May, Will. "Oklahoma Artists' Exhibition Is Best Association Has Offered," *Daily Oklahoman,* November 21, 1926.

Mechlin, Leila. "The Awakening of the West in Art," *Century* Magazine, November 1910, 75–80.

Montgomery, Walter. *American Art and American Art Collections.* New York and London: Garland Publishing, Inc., 1978.

Moure, Nancy Dustin Wall. "Five Eastern Artists Out West," *The American Art Journal,* November 1973, 15–31.

Neuhaus, Eugen. *The History & Ideals of American Art.* Stanford: Stanford University Press, 1931.

Nottage, James H. "A Centennial History of Artist Activities in Wyoming, 1837–1939," *Annals of Wyoming,* Spring 1976, 77–100.

O'Brien, Esse Forrester. *Art and Artists in Texas.* Dallas: Tardy Publishing Co., 1935.

O'Donnell, Mayo Hayes. "Among the Artists: Circa 1913," Monterey Peninsula *Herald,* "Peninsula Diary," October 6, 1965.

Ormes, Manly Dayton, and Eleanor R. Ormes. *The Book of Colorado Springs.* Colorado Springs: The Denton Printing Co., 1933.

Park, Marlene, and Gerald E. Markowitz. *The New Deal for Art.* Hamilton, New York: Gallery Association of New York State, Inc., 1977.

Peat, Wilbur D. *Pioneer Painters of Indiana.* Indianapolis: Art Association of Indianapolis, 1954.

Peters, Harry Twyford. *California on Stone.* New York: Doubleday, 1935.

Petersen, Martin E. "Contemporary Artists of San Diego," *The Journal of San Diego History,* Fall 1970, 3–10.

Petteys, Chris. "Colorado's First Women Artists." Denver *Post,* May 6, 1979, 36–47.

Pinckney, Pauline A. *Painting in Texas: The Nineteenth Century.* Austin: University of Texas Press, 1967.

Porter, Bruce, and others. *Art in California.* San Francisco: R. L. Bernier, 1916.

Rathbone, Perry T., and St. Louis City Art Museum. *Westward the Way.* St. Louis: Von Hoffman Press, Inc., 1954. [In collaboration with Walker Art Center, Minneapolis.]

Reid, Forrest. *Illustrators of the Eighteen Sixties/An Illustrated Survey of the Work of 58 British Artists.* New York: Dover Publications, Inc., 1975.

Reinbach, Edna (comp.). "Kansas Art and Artists," *Kansas State Historical Society,* 1926–1928, 571–585.

Richardson, E. P. *Painting in America*. New York: Thomas Y. Crowell Company, 1965.

Robertson, Edna. *Los Cinco Pintores*. Santa Fe: Museum of New Mexico, 1975.

Robertson, Edna, and Sarah Nestor. *Artists of the Canyons and Caminos: Santa Fe, the Early Years*. Layton, Utah: Peregrine Smith, 1976.

Robinson, Elwyn B. *History of North Dakota*. Lincoln: University of Nebraska Press, 1966, 517–522.

Sargent, Shirley. *Pioneers in Petticoats: Yosemite's Early Women 1856–1900*. Yosemite: Flying Spur Press, 1966.

Savage, James W., and John T. Bell. *History of the City of Omaha*. New York and Chicago: Munsell & Company, 1894.

School of American Research. *Representative Art and Artists of New Mexico*. Santa Fe: Museum of New Mexico, 1940.

Seachrest, Effie. "The Smoky Hill Valley Art Center." *American Magazine of Art*, January 1921, 14–16.

Selkinghaus, Jessie A. "Etchers of California," *International Studio*, February 1924, 383–391.

Smith, Goldie Capers. *The Creative Arts in Texas/A Handbook of Biography*. Nashville-Dallas: Cokesbury Press, 1926, 135–166.

Spangenberg, Helen. *Yesterday's Artists on the Monterey Peninsula*. Monterey: Monterey Peninsula Museum of Art, 1976.

Splitter, Henry Winfred. "Art in Los Angeles Before 1900," *Historical Society of Southern California Quarterly*, 1959, 38–57, 117–138, 247–256.

Taft, Robert. *Artists and Illustrators of the Old West*. New York: Charles Scribner's, 1953.

Talbot, Clare Ryan. *Historic California in Bookplates*. Los Angeles: Graphic Press, 1936.

Taos *News*. "Taos Art: 70 Years of Taos Art," Taos *News*, September 12, 1968.

Texas Painting and Sculpture: 20th Century. Dallas: Brodnax Printing Company, 1971.

Thiel, Yvonne Greer. *Artists and People*. New York: Philosophical Library, 1959, 1960.

Thurston, J. S. *Laguna Beach of Early Days*. Culver City: Murray & Gee, 1947.

Tolerton, Hill. "Etching and Etchers," *Art in California*, by Bruce

Porter, and others. San Francisco: R. L. Bernier, 1916, 121–126.

Torbert, Donald R. "Art and Architecture," in *A History of the Arts in Minnesota*. Minneapolis: University of Minnesota Press, 1958.

Utah Art Institute. *Report of the Utah Art Institute for the Years 1899 and 1900*. Salt Lake City: Deseret News, 1901.

Utterback, Martha (comp.). *Early Texas Art in the Witte Museum*. San Antonio: Witte Memorial Museum, ca 1964.

Van Nostrand, Jeanne. *The First Hundred Years of Painting in California, 1775–1875*. San Francisco: John Howell–Books, 1980.

Van Stone, Mary R. "The Fiesta Art Exhibition," *Art and Archeology*, December 1924, 225–240.

Webb, Edith Buckland. *Indian Life at the Old Missions*. Los Angeles: Warren F. Lewis, Publisher, 1952.

Western Woman. Los Angeles: Ada King Wallis, n.d. [Selected issues, i.e., Santa Cruz issue, vol. 13, no. 4.]

Whittmore, Margaret W. "Some Topeka Artists," *Community Arts and Crafts*, December 1927, 19.

Wilbanks, Elsie Montgomery. *Art on the Texas Plains/The Story of Regional Art and the South Plains Art Guild*. Lubbock: South Plains Art Guild, 1959.

Wilkinson, Augusta. "Art in Idaho," *American Magazine of Art*, May 1927, 270–271.

Witte, Ernest F. "The Nebraska FERA Exhibit," *Nebraska History Magazine*, January–March 1935, 57–60.

Wray, Henry Russell. "Exhibit by Springs Artists Opens Tomorrow/100 Pictures Displayed at Perkins Gallery," Colorado Springs *Gazette*, April 2, 1916, 1/3–4; 7/1.

Wybro, Jessie Maude. "California in Exposition Art," *Overland Monthly*, December 1915, 517–521.

Catalogues

Amon Carter Museum of Western Art. *Catalogue of the Collection*. Fort Worth, 1972.

Arkelian, Marjorie. *The Kahn Collection of Nineteenth Century*

Painting in California. Oakland Museum Art Department. Oakland: Oakland Museum, 1975.

Baird, Joseph A., Jr. (comp.). *The West Remembered/Artists and Images 1837–1973.* San Francisco and San Marino: California Historical Society, 1973.

Ballinger, James K. *Beyond the Endless River.* Phoenix: Phoenix Art Museum, 1979.

————, *Paintings from the McKee Foundation.* Phoenix: Phoenix Art Museum, 1976.

Barr, Maurice Grant. *One Hundred Years of Artist Activity in Wyoming 1837–1937,* with Preface by James Taylor Forrest. Laramie: University of Wyoming Art Museum, 1976.

Bermingham, Peter. *The New Deal in the Southwest.* Tucson: University of Arizona Museum of Art and The National Endowment for the Arts, 1980.

Boise Gallery of Art. *American Masters in the West/Selections from the Anschutz Collection,* with Intro. by E. F. Sanguinetti. Denver: The Anschutz Collection; Boise: Boise Gallery of Art, 1974.

Boston Museum of Fine Arts. *Frontier America: The Far West.* Boston: Museum of Fine Arts, 1975.

California Arts Commission. *Horizons/A Century of California Landscape Painting.* n.p., 1970.

California at the World's Columbian Exposition, 1893. Sacramento: State Office printer, 1894.

California Design 1910. See: Timothy J. Andersen, and others.

Dallas Museum of Fine Arts. *Exhibition of Paintings, Sculpture & Graphic Arts . . .* The Centennial Exposition, 1936.

El Paso Museum of Art. *The McKee Collection of Paintings.* El Paso: Robert E. and Evelyn McKee Foundation, 1968.

Evans, Elliot A. P. (comp). *A Catalog of the Picture Collections of the Society of California Pioneers.* San Francisco: The Society of California Pioneers, 1956, and typescript of two-page addendum.

Febraché, Lewis. *The Dr. and Mrs. Bruce Friedman Collection.* San Francisco: California Historical Society, 1969.

Forrest, James T. "The American Landscape and the West," in *Standing Rainbows: Railroad Promotion of Art, The West and Its Native People.* Topeka: Kansas State Historical Society, 1981.

Fort Worth Art Center. *The Iron Horse in Art/The Railroad as It Has Been Interpreted by Artists of the Nineteenth and Twentieth Centuries.* Fort Worth, 1958.

Gerdts, William H. *American Impressionism.* Seattle: Henry Art Gallery, University of Washington, 1980.

Gerdts, William H., Jr. *19th Century American Painting/from the Collection of Henry Melville Fuller.* Manchester, New Hampshire: The Currier Gallery of Art, 1971.

Gerdts, William H. *150 Years of Still-life Painting.* New York: Coe Kerr Gallery, Inc., 1970.

Harmsen, Dorothy. *American Western Art.* Denver: Harmsen Publishing Company, 1977.

Heidenreich, C. Adrian. *Art and Illustration of 19th Century Montana/An Exhibition at the Yellowstone Art Center,* Billings, Montana, 1976.

Holmes, William H. *The National Gallery of Art/Catalogue of Collections, II.* Washington: Government Printing Office, 1926.

Hubbard, R. H., and J. R. Ostiguy. *Three Hundred Years of Canadian Art.* Ottawa: The National Gallery of Canada, 1967.

Indianapolis Museum of Art. *Selections from the Harrison Eiteljorg Collection Western American Art,* 1976.

Karolik, M. & M., *Collection of American Water Colors & Drawings 1800–1875,* v. 1. Boston: Museum of Fine Arts, 1962.

Kingsbury, Martha. *Art of the Thirties; The Pacific Northwest.* Seattle: University of Washington Press, 1972. [Published for the Henry Art Gallery.]

———, *Northwest Traditions.* Seattle: Seattle Art Museum, 1978.

Kovinick, Phil. *The Woman Artist in the American West 1860–1960.* Fullerton, California: Muckenthaler Cultural Center, 1976.

Laguna Beach Museum of Art. *Southern California 1890–1940,* 1979.

LeRoy, Bruce. *Early Washington Communities in Art.* Tacoma: Washington State Historical Society, 1965.

LeRoy, Bruce. *Northwest History in Art 1778–1963.* Tacoma: Washington State Historical Society, 1963.

Library of Congress. (Karen F. Beall, comp.) *American Prints in the Library of Congress/A Catalog of the Collection.* Baltimore and London: The Johns Hopkins Press, 1970.

Maxwell Galleries. *American Art Since 1850.* San Francisco: Maxwell Galleries Ltd., 1968.

Minnesota Museum of Art. *Iron Horse West.* St. Paul, 1976.

Murray, Joan. *Impressionism in Canada, 1895–1935.* Toronto: Art Gallery of Ontario, 1973.

Nebraska Art Today/A Centennial Invitational Exhibition, Omaha: Joslyn Art Museum, 1967.

New York City Municipal Art Committee. *Second Annual Exhibition.* American Fine Arts Society Galleries, 1937.

Oakland Museum. *Impressionism/The California View/Paintings 1890–1930.* Oakland: Oakland Museum, 1981.

Omoto, Sadayoshi. *Early Michigan Paintings/Kresge Art Center.* East Lansing: Michigan State University, 1976.

Pagano, Grace. *The Encyclopedia Britannica Collection of Contemporary American Painting.* Chicago: Encyclopedia Britannica, Inc., 1946.

Palm Springs Desert Museum. *The West as Art,* Palm Springs, California, 1982.

Panama-Pacific International Exposition. San Francisco: The Wahlgreen Company, 1915.

Phoenix Art Museum. *Today's Artist and the West by Members of the National Academy of Design.* Phoenix: Phoenix Art Museum, 1972.

Robertson, Edna C. (comp.). *Handbook of the Collections 1917–1974.* Museum of Fine Arts. Santa Fe: Museum of New Mexico, 1974.

St. John, Terry. *Society of Six.* Oakland: Abbey Press [for Oakland Museum], 1972.

Santa Fe [Atchison, Topeka & Santa Fe] Railway. *Standing Rainbows: Railroad Promotion of Art, The West and Its Native People.* Topeka: Kansas State Historical Society, 1981. [Essays by Keith L. Bryant, James T. Forrest, and Terry P. Wilson.]

Schimmel, Julie. *Stark Museum of Art/The Western Collection.* Orange, Texas: Stark Museum of Art, 1978.

Shalkop, Robert L. *A Show of Color.* Colorado Springs: Colorado Springs Fine Arts Center. n.d.

Sierra Nevada Museum of Art. *Artists in the American Desert.* Reno, Nevada, 1980.

Smithsonian Institution/National Collection of Fine Arts. *Amer-*

ican Landscape: A Changing Frontier. Washington: Smithsonian Institution, 1966.

Smithsonian Institution/National Collection of Fine Arts. *Art of the Pacific Northwest from the 1930s to the Present.* Washington: Smithsonian Institution, 1974.

Soby, James Thrall, and Dorothy C. Miller. *Romantic Painting in America.* New York: Museum of Modern Art, 1943.

Springville Museum of Art. *Permanent Collection Catalogue.* Springville, Utah, 1972.

Stenzel, Franz R. *Early Days in the Northwest/Prints, Paintings, Drawings by James G. Swan from Collection of Dr. and Mrs. Franz Stenzel.* Portland: Portland Art Museum, 1959.

Stuart, Joseph. *The Art of South Dakota.* Brookings: South Dakota State University, 1974.

Trans-Mississippi and International Exposition, Omaha, Nebraska, 1898; reprinted in *American Art Annual,* 1898, 323.

Washington, University of/ Henry Art Gallery. *Faculty Exhibition/School of Art.* Seattle, 1966.

_____, University of/Henry Art Gallery, Richard Grove (comp.). *Henry Gallery/Five Decades, 1927–1977.* Seattle: Henry Gallery Association, Inc., 1977.

Weber, Nicholas Fox, and others. *American Painters of the Impressionist Period Rediscovered.* Waterville, Maine: Colby College Press, 1975.

World's Columbian Exposition. *The Art of the World.* New York: D. Appleton and Company, 1893.

Manuscript, Mimeographed, and Typescript References, etc.

Baird, Joseph Armstrong, Jr. *Catalogue of Original Paintings, Drawings and Watercolors in the Robert B. Honeyman, Jr. Collection.* Berkeley: The Friends of Bancroft Library, University of California, 1968. Mimeo.

Baird, Joseph Armstrong, Jr. *Directory of the Principal Art and Historical Institutions in Northern California.* Davis: Art Department, University of California, 1977.

Bromwell Scrapbook, Denver Public Library Western History Department, Denver, Colorado.

California Art Research. Twenty volumes. Federal WPA Project, 1937. Mimeo. [In various California libraries.]

Castor, Henry. *California: The First Five Hundred years; A Historical-Biográphical Almanac.* San Francisco, 1974. Photocopy of typescript at San Francisco Public Library History Room.

Colorado Springs Fine Arts Center art and artists scrapbooks; also known as Broadmoor Art Academy scrapbooks, Colorado Springs, Colorado.

Dodds, Anita Galvan. *Women and Their Role in the Early Art of Seattle.* Seattle; University of Washington, 1981. Master's thesis.

England, Bess. *Artists in Oklahoma—A Handbook.* Norman: University of Oklahoma Graduate College, ca 1965. Master's thesis.

Fletcher, Robert H. *Memorandum of Artists.* San Francisco: 1906–1907. Typescript at California State Library.

Grove, Richard. "Notes on Art in Colorado Springs 1820–1936," 1958. Typescript at Colorado College and Colorado Springs Fine Arts Center libraries.

Hagerman, Percy. "Notes on the History of the Broadmoor Art Academy and the Colorado Springs Art Center, 1919–1945." Typescript at Colorado Springs Fine Arts Center library.

Hartley, Russell. *California Artists Research Bureau.* Bulletins 1–9, June 1972–February 1973, at M. H. De Young Memorial Museum, San Francisco. Mimeo.

Maturano, Mary Lou. *Artists and Art Organizations in Colorado.* Master's thesis, University of Denver; copy at Denver Public Library.

Oakland Museum. "Partial List Excerpted from California Art History Conference and Oakland Art Museum of California Artists and Chronology of California." August 1965. Typescript at Oakland Art Museum.

Salt Lake City (Utah) Public Library art and artists' scrapbooks.

San Francisco (California) Public Library art and artists' scrapbooks.

Seattle (Washington) Public Library art and artists' scrapbooks.

Sternfels, Ida E. *Montana Art and Artists.* 1933. [Typescript available at Butte-Silver Bowl Free Public Library, Butte, Montana.]

Texas art and artists' scrapbooks, Houston Public Library Texas History Department.

Acknowledgements

Many persons and institutions helped to make this third volume of *Artists of the American West* a comprehensive reference. During three years of research in Washington, D.C., mainly at the Smithsonian's NMAA-NPG art library, there was a pleasant, at times daily, association with Library, Inventory of American Paintings, and Archives of American Art personnel. In Colorado there were weeks at Denver Public Library, Colorado Springs Public Library, the Colorado Springs Fine Arts Center, and the Colorado College Library. In Texas there were weeks at Houston Public Library, the Archives of American Art research office in the Houston Fine Arts Museum, and the Museum's excellent art library. Visits of several days each were made to San Antonio for material at Witte Memorial Museum and the Public Library; to Oklahoma City for material at the Public Library; to Salt Lake City for material at the Public Library and the University of Utah; to Arizona for material at the University in Tucson and the Public Library in Scottsdale; to Seattle for material at the Public Library, Henry Art Gallery, and the University of Washington's several libraries; to Santa Fe for material at the Public Library and the Museum of New Mexico library.

Then there was a year in Irvine, California, where pleasant and productive associations were had at the University of California Library, Newport Harbor Art Museum, Newport Public Library, and Sherman Library in Newport Beach. And there was another year in San Francisco where the public library has an exceptional art reference section. Walking distance from where I live is the San Francisco State University Library with its excellent art reference section. Personnel at Sutro Library and libraries at the San Francisco Museum of Modern Art, the Society of California Pioneers, the Book Club of California, California Historical Society, and Wells Fargo Bank were most helpful.

Trips to nearby cities where many pleasant hours were spent in libraries include San Mateo, Monterey, and Carmel public libraries; the docent library at the Monterey Peninsula Museum of Art; the University of California Library at Davis; and the California State Library in Sacramento. My apology to Oakland

Museum staff for not making full use of their library; to have done so would have tempted me to say too much about too many California artists. Not only has the Oakland Museum acquired over the years a tremendous collection of works by California artists, and artists working in California, but it has a great deal of information about those artists.

Correspondence with librarians, curators, directors, and their assistants brought quantities of useful information. I especially want to mention the following: Joslyn Art Museum in Omaha; Nebraska State Historical Society; Topeka Public Library; Kansas State Historical Society; Boise Gallery of Art, the State University Library in Pocatello, and Burley Public Library of Idaho; Butte Silver-Bowl Free Public Library in Montana; University of Nevada Library in Reno; Haggin Museum in Stockton, California; Portland Museum of Art in Maine and Portland Art Museum in Oregon; Eastern Washington State Historical Society in Spokane; Minneapolis Public Library; Minnesota Historical Society; Newberry Library in Chicago; William Rockwell Nelson Gallery in Kansas City; Newman Galleries in Philadelphia; Newark Museum in New Jersey; University of Wyoming Art Department; Baker Gallery in Lubbock and El Paso Museum of Art in El Paso, Texas; South Dakota State University's Lincoln Memorial Library and Huron Public Library; Idaho Historical Society, and North Dakota's Foster County Historical Society.

Kirsten Dahl of San Francisco volunteered a month's time from a summer vacation to be my research assistant – the only one I had, and a very good one – and my husband David R. Dawdy graciously put up with my noisy typewriter and long hours.

Index to Volumes I–III

Anderson, Carl (1856-), I
Anderson, Clarence William (1891-
1971), I
Anderson, Dorothy Visju
(1874-1960), II
Anderson, F. E. James (-),
III
Anderson, George (-), I
Anderson, Gunda J. Evensen
(-), I
Anderson, Johannes (1882-), III
Anderson, Louise C. Vallet
(-1944), II
Anderson, Viola Helen (-),
III
Andrews, Cora Mae [C.M.A.]
(1860-), III
Andrews, Fanny/Fannie (1869-),
III
Andrews, Jessie (1867-1919), III
Andrews, Willard H. (ca 1899-),
II
Angell, Truman O., Sr. (1810-1887),
III
Angelo, Valenti (1897-), II
Angman, Alfons Julius (1883-),
III
Ankeney, John Sites (1870-1946), II
Antlers, Max H. (1873-), II
Applegate, Frank G. (1882-1931), I,
II
Appleton, Norman R. (1899-), II
Armann, Kristinn P. (1889-), I
Armer, Laura Adams (1874-1963), II
Armer, Ruth (1896-1977), II
Armer, Sidney (1871-), II
Armfield, Maxwell Ashby
(1881-1972), III
Armin, Emil (1883-1971), III
Armitage, William J. (1817-1890), III
Armour, Electa M. (-), III
Arms, John Taylor (1887-1953/54), II
Armstrong, Dell Heizer (See: Heizer),
I, III
Armstrong, George Frederick (ca
1853-1912), III
Armstrong, Samuel John
(1893-), II
Armstrong, Thomas (1818-1860), I
Armstrong, Voyle Neville
(1891-), II
Armstrong, William Wallace
(1822-1914), I

Arnautoff, Victor Michail
(1896-), II
Arnstein, Helen (-), II
Arouni, N. G. (1888-), III
Arpa, Jose (1858-1952), I, II
Arriola, Fortunato (1827-1871), I
Ashby, Ingabord Tames (See:
Tames), III
Ashford, Frank Clifford (1880-1960),
II
Askenazy, Mischa Maurice
(1888-1961), I
Atkins, (William) Arthur (1873-1899),
I, III
Atkins, Florence Elizabeth
(-1946), II
Atkinson, Leo Franklin (1896-),
II
Atkinson, Marion Koogler (See:
McNay), III
Atkinson, William Sackston
(1864-), II
Attridge, Irma Gertrude (1894-),
I
Atwater, G. Barry (1892-1956), II
Atwell, Julia A. Hill (1880-1930), III
Atwood, Mary Hall (1894-), II
Atwood, Robert (1892-), I
Aubert, Mrs. Paul (-), III
Audubon, John James (1785-1851), I
Audubon, John Woodhouse
(1812-1862), I
Augsburg, D. R. (-), III
Augur, Ruth Monro (-), III
Aulmann/Aulman, Theodora
(1882-), III
Aunspaugh, Vivian Louise (1870-
1960), II
Austen, Edward J. (1850-1930), II
Austin, Amanda Petronella (1856/59-
1917), I
Austin, Charles Percy (1883-1948), I
Austin, Ella M. (1864-), II
Avery, Kenneth Newell (1883-),
II
Avey, Martha (1877-1943), II
Awa Tsireh (See: Roybal, Alfonso),
III
Ayars, Beulah Schiller (1869-1960),
III
Ayres, Thomas Almond (ca
1816-1858), I
Babcock, Dean (1888-1969), I, II

Babcock, Ida Dobson (1870-), I
Babcock, Roscoe Lloyd (1897-),
 II
Bacharach, Herman Ilfeld
 (1899-), II
Back, Joe W. (1899-), III
Backus, Mary Gannett (-),
 III
Bacon, Henry (1839-1912), II
Bacon, Irving R. (1875-1962), I
Baer, Martin (1890/94-1961), III
Bagdapoulos, William Spencer
 (1888-), I
Bagg, Henry Howard (1853-1928), I,
 III
Bagley, James M. (1837-1910), I
Bailey, Harry L. (1879-1933), III
Bailey, Henry Lewis (-), III
Bailey, Minnie Moly (1890-), I
Bailey, Roger (1897-), III
Bailey, Vernon Howe (1874-1953), I
Bailey, Walter Alexander (1894-
), II
Bailhache, Anna Dodge (-),
 II
Bain, Lilian Pherne (1873-), II
Bain, Mabel A. (1880-), III
Bainbridge, Henry (-), II
Baker, George (1882-), I
Baker, George Holbrook (1827-1906),
 I
Baker, Grace M. (1876-), II
Baker, Jennet M. (-), III
Baker, Ora Phelps (1898-), III
Baker, William Henry (1899-), II
Bakos, Josef/Joseph G. (1891-1977),
 I, III
Baldaugh, Anni (Westrum) (1886-
 1954), II
Baldridge, Cyrus Leroy (1889-1975),
 I, II
Baldwin, Clifford Park (1889-),
 I
Balfour, Helen Johnson (1857-1925),
 II
Balfour, Roberta (1871-), II
Balink, Henry/Hendricus C. (1882-
 1963), I
Ball, Katherine M. (-), III
Ballin, Hugo (1879-1956), I
Ballinger, Harry Russell (1892-),
 II
Ballou, Addie L. (1837-1916), I, II

Ballou, Bertha (1891-1978), I, III
Balmer, Clinton (-), III
Bancroft, Albert Stokes (1890-1972),
 I
Bancroft, George W. (1889-1979), III
Bancroft, William H. (1862-1920), I
Bangs, E. Geoffrey (1889-1977), III
Bankson, Glen Peyton (1890-),
 II
Banta, Mattie Evelyn (1868-1956), I
Banvard, John (1815-1891), I
Barber, Edmond Lorenzo (ca 1808-
 1870), I
Barber, Mary D. (-), II
Barbieri, Leonardo (-), I
Barchus, Eliza Rosanna (1857-1959),
 II
Barfoot, Dorothy (1896-), II
Barile, Xavier J. (1891-), I
Barker, George, Jr. (1882-1965), I
Barker, Olive Ruth (1885-), I
Barker, Olympia Philomena (1881-
), III
Barker, Selma E. Calhoun (1893-
), III
Barnes, Mathew/Matthew Rackham
 (1880-1951), I, III
Barnett, Grace Treleven (1899-),
 III
Barnett, Jay W. (1897-1959), II
Barney, Alice Pike (1857-1931), II
Barney, Esther Stevens (See:
 Stevens), II
Barnouw, Adrian Jacob (1877-1968),
 II
Barns, Cornelia (1888-1941), II
Barone, Antonio (1889-), III
Barr, Paul E. (1892-1953), I
Barr, William (1867-1933), I
Barrett, George Watson (ca 1884-
), III
Barrett, Lawrence (1897-1973), I,
 III
Barrett, William Sterna (1853/54-
 1927), III
Barrington, George (-), I
Barrows, Albert (1893-), II
Barry, John Joseph (1885-), III
Barse, George Randolph, Jr. (1861-
 1938), III
Bartholomew, C. B. (1898-), III
Bartholomew, W. N. (1822-1898), I
Bartlett, Dana (1878/82-1957), I

Bartlett, Gray (1885-1951), I
Bartlett, John R. (1805-1886), I
Bartnett, Frances Griffiths (1861-
), II
Barton, Loren R. (1893-1975), I,
 III
Basinet, Victor Hugh (1889-), II
Bassett, Reveau (1897-), I
Bateman, Talbot (-), II
Batten, (Mrs.) McLeod (-),
 III
Bauer, Frederick (ca 1855-), I
Baugh, Dorothy Geraldine (1891-
), III
Baum, Franz (1888-), III
Baumann, Gustave (1881-1971), I
Baumgartner, John Jay (1865-1946),
 II
Baumgras, Peter (1827-1903/04), I,
 III
Baxley, Ellen Cooper (1860-), II
Baxter, Edgar (-), III
Baxter, Martha W. (1869-1955), I
Baze, Willi (1896-1947), II
Beach, Celia May Southworth (1872-
), III
Beach, D. Antoinette (-), II
Beall, C. C. (1892-), II
Beaman, Gamaliel Waldo
 (1852-1937), III
Beard, Daniel (1850-1941), I
Beard, George (1855-1944), I
Beard, James Carter (1837-1913), I
Beard, James Henry (1812-1893), I
Beard, William Holbrook (1825-
 1900), I
Beardsley, George O. (ca 1867-1938),
 III
Beardsley, Nellie (-), III
Beaumont, Arthur Edwaine (1890-
 1978), I
Beauregard, Donald (1884-1914), I
Beck, Minna McLeod (1878-),
 III
Becker, Carl Joseph (See: Joseph
 Becker), I
Becker, Florence (-), III
Becker, Frederick W. (1888-1974), I
Becker, Joseph (1841-1910), I
Becker, Otto (1854-1945), I
Beckman, Jessie Mary (-1929),
 III
Beckman, John (1847-1912), III

Beckmann, Max (1884-1950), III
Beckwith, Arthur (1860-1930), I
Beecher, Genevieve Thompson (1888-
 1955), I
Beecher, Harriet Foster (1850-1915),
 II
Beechey, Richard Brydges (1808-
 1895), I
Beek, Alice D. Engley (1876-1951), I
Beggs, Thomas Montague (1899-
), II
Behman, Frederick (-), II
Behn, Harry (1898-), III
Behringer, Wilhelm (1850-1890),
 III
Beiler, Zoe Ida (1884-1969), II
Bekker, David (Ben Menachem)
 (1897-1956), III
Belden, George P. (-1871), I
Bell, Blanche Browne (1881-), II
Bell, Sidney (1888-), III
Bell, Thomas Sloan (-), II
Bellows, George Wesley (1882-1925),
 I
Belmont, Steven (1899-), II
Bemis, Maude (-), III
Bemus, Mary B. (1849-1924), II
Benak, Frank (1874-), III
Benda, Wladyslaw T. (1873-1948), I
Bendixen, George (1883-), III
Bendle, Robert (1867-), II
Benedict, Frank M. (1840-1930), II
Benedict, J. B. (-), II
Benjamin, Charles Henry
 (1856-1937), II
Bennett, Bertha (1883-), I
Bennett, Gertrude (1894-1962), I
Bennett, Joseph Hastings
 (1889-), I, II
Bennett, Richard (1899-1971), III
Bennett, Ruth Manerva (1899-1960),
 II
Benolken, Leonore Ethel (1896-),
 II
Benrimo, Thomas Duncan
 (1887-1958), II
Bensco, Charles J. (1894-1960), II
Benson, Edna Grace (1887-), III
Benson, Tressa Pond Emerson (1896-
), III
Bentley, Rachel (1894-), II
Benton, Mary Park Seavy (1815-
 1910), I

516

Benton, Thomas Hart (1889-1975),
I, II
Beran, Ann Marie Karnik (1890-
), III
Berg, George Lewis/Louis (1868-
1941), I
Bergmann, Franz/Frank Walter
(1898-), I
Bergner, John/J. Alfred (-),
III
Bergquist, F. O. (1890-1968), II
Berk, H. A. Gustav/Gustave
(-), III
Berlandier, Jean Louis (ca 1804-
1851), I
Berlandina, Jane (1898-1970), I
Berlin, Harry (1886-), II
Berman, Eugene (1899-1972), II
Berninghaus, Oscar (1874-1952) on
page 21 of, I
BeRoth, Leon A. (ca 1895-1980), III
Berson, Adolph (1880-1970), II
Bessel, Evelyn Byers (-), II
Bessinger, Frederic Herbert
(1886-), II
Best, Alice M./Mrs. A. W.
(1871-1926), II
Best, Arthur W. (1859-1935), I, II
Best, Harry C. (1863-1936), I, II
Best, Margaret Callahan (1895-),
II
Bettinger, Hoyland B. (1890-1950),
I
Betts, E. C. (1856-1917), I
Betts, Grace [Gay] May (1883-),
II
Betts, Harold Harrington (1881-
), I, III
Betts, Louis (1873-1961), III
Bewley, Murray Percival (1884-1964),
II
Beznics, George (1829-1902), I
Biddle, George (1885-1973), I, III
Bierach, S. E. (1872-), II
Bierstadt, Albert (1830-1902), I
Biesel, Charles (1865-1945), III
Biesel, Fred H. (1893-ca 1962), III
Biggers, Mattie (1872-), III
Bigot, Toussaint Francois (1794-
1869), I
Bihlman, Carl (1898-), III
Billing, Frederick William (1835-
1914), II, III

Binckley, Nella/Nellie Fontaine
(-), III
Bingham, George Caleb (1811-1879),
I
Bintliff, Martha Bradshaw (1869-
), II
Birch, Geraldine Rose (1883-1972), I
Birch, Reginald Bathurst (1856-
1943), I
Birren, Joseph P. (1864-1933), I, III
Bischoff, Eugene Henry (1880-1954),
I
Bischoff, Franz Albert (1864-1929), I
Bishop, Katherine Bell (1883-),
II
Bistram/Bisttram, Emil (1895-1976),
I
Bitterly, Lily/L. P. (-), III
Black, Laverne Nelson (1887-1939), I
Black, Mary C. Winslow (1873-1943),
II
Black, Oswald Ragan [Oz] (1898-
), II
Blackburn, Josephine Eckler (1873-
), II
Blackshear, Kathleen (1897-),
II
Blackstone, Harriet (1864-1939), II
Blackwell, Ruby Chapin (1876-),
III
Blackwell, Wenonah R. (1885-),
III
Blaine, Mahlon (-), II
Blair, Streeter (1888-1966), III
Blake, Edgar Leslie (1860/62-1949),
III
Blake, William Phipps (1826-1910), I
Blakelock, Ralph Albert (1847-1919),
I
Blakeman, Thomas Greenleaf (1887-
), II
Blakiston, Duncan George (1869-
), II
Blanch, Arnold (1896-1968), I
Blanch, Lucille (1895-), I
Blankenship, Mary Almor Perritt
(1878-1955), III
Blashfield, Edwin Howland
(1848-1936), II
Blaurock, Carlotta (1866-), III
Bledsoe, Alice E. Collins Matthews
(1872-1915), III
Bleil, Charles George (1892-), II

Blesch, Rudolph (–), II
Bloch, Albert (1882-1961), I
Bloomer, Hiram Reynolds (1845-
 1911), I
Bloser, Florence Parker (1889-1935),
 II
Blum, Jerome S. (1884-1956), III
Blumenschein, Ernest Leonard
 (1874-1960), I
Blumenschein, Mary Shepard Greene
 (1868-1958), I
Blumenstiel, Helen Alpiner (1899-
), II
Boak, Milvia W. (1897-), II
Bock, Charles Peter (1872-), II
Bodmer, Karl (1809-1893), I
Boeckmann, Carl Ludwig
 (1868-), III
Boething, Marjory Adele
 (1896-), II
Bogert, George Hirst (1864-1944), I
Bohleman, Herman T. (1872-), II
Bohney, Jessica (1886-), III
Bolinger, Ethel King (1888-), III
Bolmar, Carl/Charles Pierce (1874-
 1950), II
Bolton, Hale William (1879/85-1920),
 I, II
Bonestell, Chesley K., Jr. (1888-
), II
Bonner, Mary Anita (1885-1935),
 I, II
Bonnet, Leon Durand (1868-1936),
 II
Bontecou, Helen (1892-), II
Boone, Cora M. (1865-1953), II
Boone, Elmer L. (1881-1952), III
Booth, Eunice Ellenetta (-1942),
 II
Booth, James Scripps (1888-1954),
 III
Borein, Edward (1872-1945), I
Borg, Carl Oscar (1879-1947), I
Borghi, Lillian Lewis (1899-), II
Borglum, Elizabeth James (1848-
 1922), I
Borglum, Gutzon (1867-1941), I
Borglum, Solon Hannibal (1868-
 1922), I
Borgord, Martin (1869-1935), III
Born, Ernest (Alexander) (1898-
), II

Boronda, Lester David (1886-),
 I, III
Borthwick, John David (1825-
 ca 1900), I
Borzo, Karel (1888-), II
Bosqui, Edward (1832-1917), I
Boss, Homer (1882-1956), I, III
Boswell, Leslie Alfred (1894-), II
Boswell, Norman Gould (1882-),
 II
Bosworth, Hobart Van Zandt
 (1867-1943), II
Botke, Cornelius (1887-1954), I, III
Botke, Jessie Arms (1883-1971), I
Boundey, Burton Shepard
 (1879-1962), I
Bouzek, Cathryn (1898-), II
Bower, Frances (1877-), II
Bowers, Beulah Sprague (1892-),
 II
Bowles, Caroline Hutchinson
 (-), II
Bowling, Charles Taylor (1891-),
 II
Boyd, Byron Bennett (1887-), II
Boyd, Gilbert N. (1896-1981), III
Boyd, W. J. (-), II
Boye, Bertha Margaret (1883-),
 III
Boyle, Gertrude Farquharson (See:
 Kanno), III
Boynton, Anna E. (–), II
Boynton, Ray (1883-1951), I
Braddock, Katherine (1870-),
 II
Bradfield, Mrs. C. P. (–), III
Bradford, William (1823-1892), I
Bradley, Henry William (1813-1891),
 I
Brady, Mary C. (–), II
Braley, Clarence E. (–), III
Brandon, John Alexander
 (1870-1959), I
Brandriff, George Kennedy (1890-
 1936), I
Brandt, Henry A./Henry H. (1862-
), III
Brannan, Sophie Marston
 (–), I
Bransom, (John) Paul (1885-1979),
 III
Brasher, Rex (1869-1960), II

Braun, Maurice (1877-1941), I
Breakey, Hazel M. (1890-), III
Breckenridge, Dorothy (1896-),
 II
Breeze, Louisa (-), II
Bremer, Anne (1868/72-1923), I
Breneiser, Elizabeth Day [Babs]
 (1890-), I
Breneiser, Stanley Grotevent (1890-
 1953), I
Brenner, Carl Christian (1838-1888),
 I
Brett, Dorothy Engeme (1883-1977),
 I
Breuer, Henry Joseph (1860-1932), I
Brewer, Adrian Louis (1891-),
 III
Brewer, Nicholas Richard (1857-
 1949), I, III
Brewerton, George Douglass (1820-
 1901), I
Brewster, Ada Augusta (-),
 II
Brewster, Eugene Valentine (1871-
 1939), III
Breyman, Edna Cranston
 (-), II
Breyman, William (-), II
Brigante, Nicholas P. (1895-),
 II
Briggs, Annie F. (-), II
Briggs, Clare A. (1875-1930), III
Brinkley, Nell (1888-1944), III
Brisac, Edith Mae (1894-), II
Bristol, Olive (ca 1890-1976), III
Britton, Joseph (1825-1901), I
Broad, Thomas D. (1893-), III
Brochaud, Joseph F. (-), II
Brockman, Ann (1898-1943), I
Brodt, Helen Tanner (1834/38-1908),
 I, III
Broemel, Carl William (1891-),
 III
Bromley, Thomas L. (-), I
Bromley, Valentine Walter (1848-
 1877), I, III
Bromwell, Henrietta E. (1859-1946),
 I, III
Brook, Alexander (1898-1980), III
Brookes, Samuel Marsden (1816-
 1892), I, III
Brooks, Alden-Finney (1840-1932),
 III

Brooks, Mabel H. (-1929), II
Brotherton, Mrs. Wilber, Jr. (1894-
), III
Brotze, Edward F. (ca 1868-1939),
 III
Broughton, Charles (1864-1912), II
Brougier, Rudolphe W. (ca 1870-
 1926), II
Browere, Alburtis De Orient (1814-
 1887), I
Brown, Alfred J. (-), III
Brown, Benjamin Chambers (1865-
 1942), I
Brown, Bess L. (1891-), II
Brown, Bolton Coit (1864-1936), II
Brown, Dayton Reginald (1895-),
 II
Brown, Dorothy Woodhead (1899-
 1973), I
Brown, Eyler (1895-), III
Brown, Frances Sager Norton (1875-
), II
Brown, Grafton Tyler (1841-1918),
 I, II
Brown, H. Harris (1864-1948), III
Brown, Harrison B./Henry Bird
 (1831-1915), I
Brown, Howell Chambers (1880-
 1954), I, III
Brown, John Wallace (1850-), II
Brown, Margaretta [Maggie]
 (1818-1897), III
Brown, Tom/Thomas Austen
 (1859-1924), II
Brown, Willa M. (1868-), III
Browne, Belmore (1880-1954), I, III
Browne, Carl Albert (-), II
Browne, Charles Francis (1859-1920),
 III
Browne, Frederic William (1877-
 1966), III
Browne, Harold Putnam (1894-1931),
 III
Browne, J. Ross (1821-1875), I
Browne, Lewis (1897-1949), II
Browning, Mr. Amzie Dee (1892-
), II
Browning, J. Wesley (1868-1951), I
Brownlee/Brownlie, Alexander (-
 1905), III
Bruce, Edward (1879-1943), II
Bruff, Joseph G. (1804-1889), I

Brumback, Louise Upton (1872–1929), II
Brunet, Adele Laure (1879–), II
Brush, George de Forest (1855–1941), I
Bruton, Esther (Gilman) (1896–), I
Bruton, Helen (1898–), I
Bruton, Margaret (1894–1983), I
Bryan, William Edward (1876–), II
Bryant, Everett Lloyd (1864–1945), II
Bryant, Harold Edward (1894–1950), I
Bryson, Hope Mercereau (1877–1944), II
Buchser, Frank (1828–1890), I
Buck, (Charles) Claude (1890–), III
Buck, Margaret Warriner (1857–), II
Budworth, William Sylvester (1861–), III
Buehr, Karl Albert (1866–1952), III
Buehr, Walter Franklin (1897–1971), III
Bufano, Benny (1898–1970), II
Buff, Conrad (1886–1975), I
Buisson, Daniel Shaw (1882–1958), I
Bull, Charles Livingston (1874–1932), I
Bull, W. H. (–), II
Bullock, Mary Jane McLean (1898–), I
Bump, Elvira (1856–), III
Bunnell, Charles Ragland (1897–1968), I
Burbank, Addison Buswell (1895–), III
Burbank, Elbridge Ayer (1858–1949), I
Burdett, Dorothy May (1893–), II
Burgdorff, Ferdinand (1883–1975), I, III
Burgess, George Henry (1830–1905), I
Burgess, Henrietta (1899–), I
Burgess, William Hubert (–1893), III
Burks, Garnett (1878–), II

Burlin, H. Paul (1886–1969), I
Burlingame, Sheila Ellsworth (1894–), III
Burliuk, David/Davidovich (1882–1967), III
Burnett, Eva Kottinger (1859–1916), III
Burnley, John Edwin (1896–), III
Burr, George Elbert (1859–1939), I
Burrell, Alfred Ray (1877–1952), I
Burrell, Louise H. (–), II
Burrows, Harold/Hal Longmore (1889–1965), III
Burt, Marie Bruner Haines (See: Haines), II
Bush, Agnes Selene (–), III
Bush, Ella Shepard (1863–1953), I
Bush, Norton (1834–1894), I
Bush, Richard J. (–), I
Bushnell, Della Otis (1858–1964), III
Butler, Andrew R. (1896–), II
Butler, Bessie Sanders (1868–), II
Butler, Courtland (1871–), II
Butler, Edward Burgess (1853–1928), II
Butler, George Bernard (1838–1907), I
Butler, Howard Russell (1856–1934), II
Butler, John Davidson (1890–), III
Butler, Mary (1865–1946), II
Butler, Robert Alcius (1887–1959), III
Butler, Rozel Oertle (–), II
Butman, Frederick A. (1820–1871), I
Butterfield, Mellona (–), II
Butterworth, Ellen (ca 1873–1959), III
Byers, Ruth Felt (1888–), III
Byxbe, Lyman (1886–), I
Cabanis/Cabiniss/Cabaness, Ethan T. (–), III
Cadenasso, Giuseppe (1858–1918), I
Cadwalader, Louise (1843–), III
Cady, Charles Henry (1886–), III
Cahero, Emilio G. (1897–), III
Cahill, Arthur James (1878–1970), I
Cahill, Katharine Kavanaugh (1890–), II

520

Cahill, William Vincent (-1924), I
Calder, Nanette Lederer (ca 1867–1960), III
Caldwell, Ada Bertha (1869–1937), II
Caldwell, George Walker (1866–), I
Calkins, Bertis H. (1882–1968), II
Calkins, Loring Gary (1884–1960), III
Call, Mary E. (ca 1874–1967), III
Callahan, Caroline R. (–), II
Callcott, Frank (1891–), III
Calyo, Nicolino (1799–1884?), I
Cambuston, Henri (–ca 1860/61), III
Camerer, Eugene (1830–), I
Cameron, Anna Field (1849–1931), I
Cameron, Edgar Spier (1862–1944), II
Cameron, William Ross (1893–1971), II
Camfferman, Margaret T. Gove (1881–1964), III
Camfferman, Peter Marienus (1890–1957), I
Campbell, Albert H. (1826–1899), I
Campbell, Blendon Reed (1872–1969), I
Campbell, Frances Soulé (–), II
Campbell, Isabella Frowe (1874–), II
Campbell, Myrtle Hoffman (1886–), II
Campbell, Orson D. (1876–1933), I
Candlin, Abigail/Abbie (1885–), III
Cannon, Jennie Vennerstrom (1869–), II
Canon, Jeremy (See: Stoops, Herbert Morton), I
Cantabrana, Emily Edwards (See: Edwards), III
Capps, Charles Merrick (1898–), I, III
Capwell, Josephine Edwards (–), II
Cardero, Jose (See: Cordero), I, II
Carew, Berta (1878–1956), II
Carew, Kate (1869–), III
Carey, Rockwell W. (1882–), II
Carlsen, (Soren) Emil (1853–1932), I, III

Carlson, Charles Joseph (1860–), II
Carlson, John Fabian (1875–1945), I, III
Carlson, Margaret Mitchell (1892–), III
Carlson, Zena Paulson (1894–), II
Carpenter, Miss A. M. (1887–), II
Carpenter, Dudley Saltonstall (1870–), II
Carpenter, Ellen M. (1831–ca 1909), I, III
Carpenter, Louise M. (1865–1963), II
Carr, Emily (1871–1945), II
Carr, J. R. (–), III
Carrigen/Carrigan, Thomas G. (1896–1967), III
Carroll, John Wesley (1892–1959), III
Carrothers, Grace Neville (1882–), II
Carruth, Margaret Ann (See: Scruggs-Carruth), II
Carson, Emma C. (–), III
Carter, Charles Milton (1853–1929), I
Carter, Pruett A. (1891–1955), I
Cartwright, Isabel Branson (1885–), III
Carvalho, Solomon Nunes (1815–1897), I
Cary, William de la Montagne (1840–1922), I
Case, Harriet M. (1877–), III
Casella, Alfred (1886–1971), III
Casenelli/Casnelli, Victor (1868–1961), III
Casey, John Joseph (1878–1930), II
Cash, Idress (1893–), III
Cashin, Nora (–), II
Casilear, John William (1811–1893), I
Cassidy, Gerald (1879–1934), I
Casterton, Eda Nemoede (1877–), I
Catherwood, Frederick (1799–1854), I, III
Catlin, George (1796–1872), I
Caylor, Harvey Wallace (1867–1932), I
Chabot, Mary Vanderlip (1842–1929), III

Chadwick (-), I
Chadwick, Grace Willard (1893-1962), II
Chaffee, Olive Holbert (1881-1944), II
Chain, Helen (1852-1892), I, II
Challoner, William Lindsay (1852-1901), III
Chalmers, Helen Augusta (1880-), I
Chamberlain/Chamberlin, Curtis (-), III
Chamberlain, Judith (1893-), III
Chamberlain, Norman Stiles (1887-1961), I
Chamberlain, Samuel V. (1895-1975), II
Chamberlin, Frank Tolles (1873-1961), I
Chambers, Mary Williams (See: Kate Carew), III
Champ, Ada/Ida K. Farnsworth (1857-1921), III
Champlin, Ada Belle (1875-1950), II
Champney, E. Frère (-), III
Champney, J. Wells (1843-1903), III
Chancellor, H. (-), III
Chandler, Helen Clark (1881-), II
Chandor, Douglas (1897-1953), III
Chapin, C. H. (-), III
Chaplin, Prescott (1897-), II
Chapman, Charles Shepard (1879-1962), III
Chapman, John Gadsby (1808-1890), II
Chapman, Josephine E. (-), II
Chapman, Kenneth Milton (1875-1968), I, III
Chapman, Minerva Josephine (1858-1947), II
Chapman, Ottis F./Otto (-), III
Charlot, Jean (1898-1979), I
Chase, Marion Monks (1874-), III
Chase, W. Corwin (1897-), III
Chase, William Merritt (1849-1916), III
Cheetham, Mrs. E. E. (-), III
Cheever, Walter L. (1880-1951), II
Cheney, John (1801-1885), III

Cheney, Philip (1897-), III
Cheney, Russell K. (1881-1945), I, III
Chenoweth, Joseph A. (1891-), II
Chepourkoff, Michael G. (1899-), II
Cherry, Emma Richardson (1859-), II
Cherry, Jeanne d'Orge (1879-1964), III
Chesney, Letitia (1875-), II
Chesney, Mary (1872-), II
Chiapella, Edouard Emile (1889-1951), II
Chillman, James, Jr. (1891-1972), II
Chin, Chee (1896-), I
Chittenden, Alice Brown (1859-1944), I
Choris, Ludovik/Louis (1795-1828), I
Chouinard, Nelbert Murphy (1879-1969), I, II
Chowen, Gladys Hatch (1889-1981), III
Christensen, Carl C. A. (1831-1912), I
Christensen, Ethel Lenora (1896-), II
Christensen, Florence (-), II
Christensen, LuDeen (-), III
Christie, Mae Allyn (1895-), II
Church, Elsie G. (1897-), III
Chruch, Grace (See: Grace Church Jones), II
Ciprico, Marguerite Fretag (1891-1973), II
Clack, Clyde Clifton (1896-1955), II
Clancy, Eliza R. (-), III
Clapp, William Henry (1879-1954), II
Clark, Allan (1896-1950), I
Clark, Alson Skinner (1876-1949), I
Clark, Arthur Bridgman (1866-1948), II
Clark, Arthur W. (-), III
Clark, Benton (1895-1964), I
Clark, Eliot Candee (1883-1979), III
Clark, Emelia M. Goldworthy (1869-1955), I
Clark, Helen Bard Merrill (1858-1951), II
Clark, Lucille (1897-), III
Clarke, Frank (1885-1973), II
Clarke, John L. (1881-1970), III

Clarkson, Ralph Elmer (1861-1942), III

Clausen, Alfred Bruno Leopold (1883-), III

Clausen, Peter Gui (1830-1924), III

Claveau, Antoine (-), I

Clawson, John Willard (1858-1936), I

Claxton, Virgie (1883-), II

Cleaver, Alice Eliza (1878-), II

Cleaver, Mable (1878-), III

Cleaves, Muriel Mattocks (- 1947), II

Cleenewerck, Henry (-), II

Clement, Catherine (1881-), II

Clements, Edith Schwartz (-), I

Clopath, Henriette (1862-1936), II

Cloudman, John Greenleaf (1813-1892), I, III

Clover-Bew, Mattie/May (1865-), II

Clunie, Robert (1885-), I

Clute, Beulah Mitchell (1873-), II

Coan, Helen E. (1859-1938), II

Coast, Oscar Regan (1851-1931), I

Coates, Ida M. (-), III

Coburn, Frank (1866-1931), II

Cochran, Fan A. (1899-), III

Cockcroft, Edythe Varian (1881-), I

Cocking, Mar Gretta (1894-), II

Cockrell, Dura Brokaw (1877-), II

Coe, Ethel Louise (1880-1938), I, III

Coffman/Cauffman, Lara Rawlins (See: Rawlins), III

Cogswell, William F. (1819-1903), I

Colbert, F. Overton (1896-1935), I, III

Colburn, Eleanor Ruth (1866-1939), I

Colburn, Laura Rohm (1886-1972), II

Colby, George Ernest (1859-), II

Colby, James (ca 1822-), I

Colby, Madolin (1887-), II

Colby, Vincent V. (1879-), II

Cole, Blanche Dougan (1869-), II

Cole, George Townsend (1874-1937), I, III

Cole, Gladys (-) (See: Dawe), III

Cole, Joseph Foxcroft (1837-1892), III

Cole, Sidney Herman (1865-), III

Coleman, Edmund Thomas (1823-1892), I

Coleman, Harvey B. (-), III

Coleman, Marion Drewe (-1925), III

Coleman, Mary Darter (1894-), III

Collier, Estelle Elizabeth (1881-), II

Collins, Caspar Weaver (1844-1865), III

Collins, Edna Gertrude (1885-), III

Collins, Mary (ca 1839-1928), III

Colman, Roi Clarkson (1884-1945), I

Colman, Samuel (1832-1920), I, III

Colton, Mary Russell (1889-1971), I, II

Colton, Walter (1797-1851), I

Colyer, Vincent (1825-1888), I

Comins, Alice R. (-), III

Comins, Eben F. (1875-1949), III

Comparet, Alexis (1850-1906), I

Comstock, Anna Botsford (1854-1930), III

Comstock, John Adams (1882-1970), III

Conant, Homer B. (1880-1927), II

Conant, Lucy Scarborough (1867-1920), III

Condit, Mrs. Charles L. (1863-), II

Condon, Stella C. (1889-), III

Cone, Florence M. Curtis (-), III

Cone, Martella Lydia (See: Martella Lane), III

Connell, Mary K. (ca 1885-1971), II

Connelly, Lillian B. (-), II

Conner, Albert Clinton (1848-1929), II

Conner, Paul (1881-1968), II

Conway, John Severinus (1852-1925), II

Cook, E. F. (-), II

Cook, Paul Rodda (1897-), II

Cook-Smith/Cook, Jean Beman (1865/66-), III

Cooley, Blanche Marshall (See: Ratliff), I

Coolidge, John Earle (1882-1947), I

Cooney, Fanny Y. (See: Cory), II

Cooper, A.D.M. (1856-1924), I
Cooper, Colin Campbell (1856-1927), I
Cooper, Elizabeth Ann (1877-1936), III
Cooper, Emma Lampert (1855-1920), III
Cooper, Frederick G. (1883-1962), I
Cooper, George Victor (1810-1878), I
Cooper, James Graham (1830-1902), I
Cooper, (William) Leonard (1899-), III
Coover, Nell B. (-), II
Cope, George (1855-1929), II
Coppedge, Fern Isabel (1883-1951), III
Coppini, Pompeo Luigi (1870-1957), III
Corder, Elene Moffett (1887-), II
Cordero, José/Josef (1768-), I, II
Cormack, Claire D. Sutherland (1883-), III
Cornell, John V. (-), I
Cornwell, Dean (1892-1960), I
Corson, Stanley (1895-), II
Corwin, Charles Abel (1857-1938), I
Cory, Fanny Y. (1877-1972), II
Cory, Kate T. (1861-1958), I
Cosgrove, Earle M. (-1915), II
Costello, Valentine J. (1875-1937), II
Cotton, John W. (1868-1932), I
Cotton, Leo/R. Leo (1880-), III
Couch, Maude C. (-), III
Coughlan, A. T. (-), III
Coughlin, Mildred Marion (1895-), II
Coulter, Mary J. (1880-1966), I, III
Coulter, William Alexander (1849-1936), I
Courtney, Leo (1890-), II
Couse, Irving (1866-1936), I
Couthouy, J. P. (-), I
Coutts, Alice (-ca 1973), I
Coutts, Gordon (1868-1937), I, III
Covey, Arthur Sinclair (1877-1960), III
Covington, (Isaac) Loren (1885-1970), III
Cowles, Russell (1887-1979), I, III
Cox, Charles Brinton (1864-1905), I
Cox, Charles Hudson (1829-1901), II
Cox, Kenyon (1856-1919), I

Cox, Louise Howland King (1865-1945), I
Cox, Lyda Morgan (1881-), III
Cox, Palmer (1840-1924), I
Cox, W. H. M. (-), I
Coxe, R. Cleveland (1855-), I
Crabb, Robert James (1888-), II
Craig, Alice (-1961), III
Craig, Charles (1846-1931), I
Craig, Della Vernon (See: Vernon), III
Craig, Thomas Bigelow (1849-1924), I
Cram, Alan Gilbert (1886-1947), I
Cram, "LD" (1898-), III
Crandall, Harrison (1887-1970), III
Crapuchettes, E. J. (1889-1972), II
Craton, Bertha Alene Tatum (1885-), III
Crawford, Brenetta Hermann (1876-), III
Crawford, Dorsey Gibbs (-), III
Crawford, Esther Mabel (1872-1958), II
Crawford, Ethelbert Baldwin (1872-1921), III
Crawford, Mrs. W. L. (-), III
Crawford, Will (1869-1944), I
Cressell, William Nichol (1822-1888), III
Cressy, Herbert Chester [Birl] (1883-1944), II
Cressy, Josiah Perkins (1814-), II
Cressy, Meta (1882-1964), II
Crew, Katherin (-), II
Crews, Seth Floyd (ca 1885-), III
Criley, Theodore (1880-1930), II
Critcher, Catharine Carter (1868-1964), I, III
Crittenden, Ethel Stuart (1894-), II
Crocker, Charles Mathew (1877-1950/51), I, III
Cronau, Rudolf (1855-1939), II
Cronenwett, Clare (-), III
Cronin, Marie (-), II
Cronyn, George W. (-), III
Cross, Ernest James (-), II
Cross, Henry H. (1837-1918), I

Crouch, Mary Crete (-1931), III
Crouch, Penelope Thomas
 (-), III
Crow, Louise (1891-), II
Crowder, William (1882-), II
Crowell, Annie (ca 1862-1949), III
Crowell, Margaret (-), II
Crowther, Mollie L. Vining (1867-
 1927), III
Cruess, Marie Gleason (1894-),
 II
Culbertson, Josephine M. (1852-
 1939), II
Culmer, Henry L. A. (1854-1914), I
Cumming, Charles Atherton (1858-
 1932), I
Cundell, Nora L. M. (1889-1948), II
Cuneo, Cyrus Cincinnatti (1879-
 1916), I
Cuneo, Rinaldo (1877-1939), I
Cunningham, Florence (1888-1980),
 III
Cunningham, Theodore Saint-Amant
 (1899-), II
Cuprien, Frank William (1871-1948),
 I
Curjel, E. (-), II
Curran, Mary Eleanor (-1930),
 III
Currier, Cyrus Bates (1868-), I
Currier, Edward Wilson (1857-1918),
 I
Currier, Walter B. (1879-1934), I
Curry, John Steuart (1897-1946),
 I, II
Curtis, Elizabeth (-), II
Curtis, Elizabeth L. (1892-), III
Curtis, Ida Maynard (1860-1959), II
Curtis, Leland (1897-), I, III
Curtis, Rosa M. (1894-), II
Cutler, Frank E. (-), II
Cutting, Francis Harvey (-),
 I
Dabelstein, William F. (-1971?),
 III
Daggett, Vivian Sloan (1895-),
 III
D'Agostino, Vincent (1896/98-),
 III
Dahl, Bertha (1891-), III
Dahlgreen, Charles William
 (1864-1955), III
Dahlgren, Carl (1841-1920), I

Dahlgren Marius (1844-1920), I
Dailey, Anne Emily (1872-1935), II
Daingerfield, Elliott (1859-1932), II
Dake, Carel L., Jr. (-), III
Dake, Zahad (-), III
Dakin, Sidney Tilden (1876-1935), I
Dale, John B. (-1848), I
Dalziel/Dalzel, John Sanderson
 (1839-1937), III
Dana, Gladys Elizabeth (1896-),
 II
Dando, Susie May Berry (1873-1934),
 II
Daniell, William Swift (1865-1933), II
Dann, Frode Nielsen (1892-), I
Dann, Katherine Skeele (See: Skeele),
 I
Danner, Sara Kolb (1894-1969), I
Danziger, Abraham (ca 1867-),
 III
D'Arc, A. Jerome (-), III
Darling, William S. (1882-1963), III
Darlington, Mabel Kratz [M.R.K.D.],
 (1871-), III
Daroux, Leonora (1886-), II
Darter, Mary Sue (See: Coleman), III
Dasburg, Andrew Michel (1887-
 1979), I, II
Daudis, Jose (-), III
Davenport, Homer Calvin [Cari]
 (1867-1912), I
Davenport, McHarg (1891-1941), II
Davey, Clara (-), III
Davey, Randall (1887-1964), I, II
David, Lorene (1897-), I
Davidson, Duncan (1876-), III
Davidson, John (1890-), II
Davidson, Ola McNeill (1884-),
 III
Davies, Arthur Bowen (1862-1928), I
Davies, Ernest R. (1898-), III
Davies, Gay Williams (-),
 III
Davis, Miss A. (-), III
Davis, Mrs. Cecil Clark (1877-1955),
 I
Davis, Cornelia Cassady (1870-1920),
 I, II
Davis, Donna F. (-), III
Davis, Gerald Vivian (1899-), III
Davis, Helen Cruikshank (1889-
), III

Davis, Jessie Fremont Snow
(1887-), I
Davis, Leonard Moore (1864-1938), I
Davis, Stuart (1894-1964), III
Davis, Theodore R. (1840-1894), I
Davis, Willis E. (-), II
Davison, Edward L. (-), III
Dawe, Gladys Cole (1898-), III
Dawes, Edwin M. (1872-1945), I, III
Dawes, Pansy (1885-), II
Dawson-Watson, Dawson
(1864-1939), I
Day, Oriana (-), III
Day, Richard W. (1896-1972), II
Deakin, Edwin (1838-1923), I
Dean, Eva Ellen (1871-1954), II
Deane, Granville M. (-), III
Deane, Keith R. (-), II
Deane, Lillian Reubena (1881-),
II
Deane, Lionel (1861-), III
Dearborn, Annie F. (-), II
Deas, Charles (1818-1867), I
Deaver, Iva S. McDonald (1893-
), III
De Beukelaer, Laura Halliday/
Holliday (1885-), III
De Boronda, Tulita (1894-), II
Debouzek, J. A. (1873-), II
DeCamp, Ralph Earl (1858-1936),
I, III
Decker, John (1895-), III
De Conte, Fortune (-1897), II
De Cora, Angel (1871-1919), I
Decoto, Sarah Horner (1863-),
III
Deem, Mary Goodrich (1868-),
III
De Forest, Lockwood (1850-1932), I
DeFrasse, Louise (-), II
De Gavere, Cor/Cornelia (1877-1955),
I
Degen, Ida Day (1888-), I
de Ghize, Eleanor (1896-), III
de Gissac, F. (-), III
DeHaven, Franklin B. (1856-1934), I
Dehn, Adolf (1895-1968), I
De Joiner, Luther Evans (1886-1954),
II
De Jong, Betty (1886-1917), I
DeKruif, Henri/Henry Gilbert (1882-
1944), I

De La Harpe, Joseph (ca 1850-1901),
II
De Lamater, Edgar (1859-), I
Delano, Annita (1894-1979), II
Delano, Gerald Curtis (1890-1972), I
Delavan/Delevan, William
(-), III
del Castillo, Mary Virginia (See:
Johnston), II
De Lemos/Lemos, Pedro J. (1882-
1954), I, III
Dellenbaugh, Frederick Samuel
(1853-1935), I
Del Mue, Maurice August
(1875-1955), I
De Longpre, Paul (1855-1911), I
Del Pino, José Moya (1891-1969), I
Deming, Edwin Willard (1860-1942),
I
Deming, Mabel Reed (1874-), II
Denison, Lucy Dunbar (-),
III
Denning, Estella L. (1888-), III
Dennison, George Austin
(1873-), I
Denny, Emily Inez (1853-1918), III
Denny, Gideon Jacques (1830-1886),
I
Denny, Madge Decatur (-),
III
Denny, Milo B. (1887-), III
Denslow, William Wallace
(1856-1915), III
Deppe/Dieppe, Ferdinand
(-), I
De Ribcowsky, Dey (1880-), III
Dermody, Grace (1889-), III
DeRome, Albert (1885-1959), III
De Saisett, Ernest Pierre (-
1899), II
De Steiguer, Ida (-), III
De Suría, Tomás (1761-), I
Dethloff, Peter Hans (1869-), II
Detreville/De Triville, Richard
(1854-1929), III
De Trobriand, Philippe Regis
(See: Trobriand), I
Deutsch, Boris (1892-1978), II
De Ville, E. George (1890-1960), II
De Vol, Pauline Hamill (1893-1974),
I
Dewey, Alfred James (1874-),
I, II

De Wolf, Wallace Leroy (1854-1930), I

De Wolfe, Sara Bender (1885?-1915), II

De Yong, Joe (1894-1975), I

DeYoung, Harry Anthony (1893-1956), I, II

Diaz, Cristobal (-), I

Dickey, S. (ca 1840-), I

Dickman, Charles John (1863-1943), I

Dickson, Henry (1843-1926), III

Dickson, Lillian Ruth Durham (-), III

Dillingham, John E. (-), I

Dinning, Robert James (1887-), I

Dismukes, Mrs. E. (-), III

Dixon, Ethel (-1916), II

Dixon, Maynard (1875-1946), I

Dobos/Do Bos, Andrew (1897-), III

Dobson, Margaret A. (1888-), I

Dodge, Arthur Burnside (1865-1952), II

Dodge, Regina Lunt (-), III

Dodge, William Leftwich (1867-1935), II

Doke, Sallie George (-), II

Dolan, Elizabeth Honor (1884-1948), I, III

Dolan, Nellie Henrich (1890-), II

Dolecheck, Christine A. (1894-), II

Dolmith, Rex (1896-), III

Dolph, M. D. (Mrs. R. J.) (1884-), III

Dominique, John Augustus (1893-), III

Donaldson, Olive (-), III

Dondo, Mathurin M. (1884-), III

Donnelly, T. J. (-), I

Donovan, John Ambrose (1871-1941), III

Doolittle, Harold L. (1883-1974), I

Doolittle, Marjorie Hodges (1888-1972), I

Doran, Robert C. (1889-), II

Dorgan, Thomas Aloysius [Tad] (1877-1929), I

d'Orge, Jeanne (See: Jeanne Cherry), III

Dorgelon/Dorgeloh, Marguerite Redman (1890-), II

Dorn, Marion V. (-), III

Dorney, Genevieve (1898-1965), II

Dosch, Roswell (-), II

Dougal, William H. (1822-1895), I

Dougherty, Paul (1877-1947), I, III

Douglas, Aaron (1899-), II

Douglas, Haldane (1893-), II

Douglass, Emma Simpson (-), III

Douglass, Ralph Waddell (1895-1971), II

Dovey, Ione/Ione Dovey Betts (-), III

Dow, Arthur Wesley (1857-1922), I

Dowd, A. W. (-), III

Downes, John I. H. (1861-1933), II

Downie, Janet (-), III

Downie, Mary (-), III

Downing, Alfred (-), III

Doyle, Florence Watkins (-), III

Drake, Florence Bonn (1885-1958), III

Drake, Will Henry (1856-1926), II

Drayton, Joseph (-), I

Dressel, Emil (1819-1869), I

Dressler, Edward James (1859-1907), III

Drewes, Werner (1899-), III

Dripps, Clara Reinicke (1885-), I

Drummond, Mrs. A. A. (1856-), III

Du Bois, Patterson (1847-1917), I

Ducasse, Mabel Lisle (1895-), I

Ducker, Clara Estelle (1886-), III

Dudley, Katherine (1884-), II

Duer, Ben F. (1888-), III

Duff, Pernot Stewart (1898-), III

Duhaut-Cilly, Auguste Bernard (1790-1849), I

DuMond, Frank Vincent (1865-1951), II

DuMond, Frederic Melville (1867-1927), I, III

DuMond, Helen S. (1872-), I

Dunbier, Augustus William (1888-1977), I

Duncan, Charles Stafford (1892–
), I
Duncan, Dorothy J. (1896–), III
Duncan, Geraldine Rose (See: Birch),
I
Duncan, Johnson Kelly (–),
I
Duncan, W. M. (–), III
Dunlap, Helena (1876–1955), I, II
Dunlap, James Bolivar (1825–1864), I
Dunlap, Mary Stewart (–), I,
II
Dunn, T. Harvey (1884–1952), I
Dunn, Marjorie Cline (1894–), I
Dunnell, John Henry (1813–1904), I
Dunphy, Nicholas (1891–1955), I
Dunton, William H. (1878–1936), I
Dustin, Silas S. (1855–1940), II
Duval, Ella Moss (1843–1911), I, III
Duvall, Fannie Eliza (1861–), I
Dwight, Mabel (1876–1955), III
Dwyer, James (ca 1880–), III
Dye, Clarkson (1869–), I
Dye, Olive Leland Bagg (1889–),
I, III
Dyer, Agnes S. (1887–), I
Eakins, Thomas (1844–1916), I
East, Pattie Richardson (1894–),
I, II
Easterday, Sybil Unis (1876–1961), II
Eastman, Harrison (1822–1890/91), I
Eastman, Seth (1808–1875), I
Eastmond, Elbert H. (1876–1936), I
Easton, Frank Lorence (1884–1952?),
II
Eastwood, Raymond James (1898–
), II
Eaton, Charles Frederick (1842–
), I
Eaton, Charles Harry (1850–1901), I
Eaton, Charles Warren (1857–1937),
III
Eaton, W. R. (1850–1922), I
Eberhardt, Eugenia McCorkle (–
), III
Eckford, Jessiejo (1895–), II
Edens, Annette (1889–), II
Edgerly, Beatrice (–1973), II
Edgren, Robert W. (1874–1939), III
Edie, Fern Elizabeth (See: Knecht), II
Edmiston, Alice Richter (1874–),
II
Edmiston, Henry (1897–), III

Edmondson, Edward, Jr. (1830–
1884), III
Edmondson, Elizabeth (1874–),
III
Edmondson, William John (1868–
1966), III
Edmonston, William D. (–),
I
Edouart, Alexander (1818–1892), I
Edwards, Emily (–), III
Edwards, H. Arden (1884–1953), III
Eggenhofer, Nick (1897–), I
Eggers, Theodore (1856–), III
Egloffstein, F. W. Von (1824–
1885/98), I
Eilshemius, Louis Michel (1864–
1941), I
Eisele, Christian [Carl] (–1919),
II
Eisenlohr, Edward G. (1872–1961),
I, II
Elder, Inez Staub (1894–), II
Elkins, Henry Arthur (1847–1884), I
Elliott, Florence (1856–1942), I
Elliott, Henry Wood (1846–1930),
I, III
Elliott, Ruth Cass (1891–), I
Ellis, Clyde Garfield (1879–1970), II
Ellis, Fremont F. (1897–), I
Ellis, Harvey (1852–1904), III
Ellsworth, Clarence Arthur (1885–
1961), I
Ellsworth, Edyth Glover (1879–),
III
Elmendorf, Stella T. (See: Tylor/
Tyler), III
Elms, Willard (–), II
Elshin, Jacob Alexander (1892–),
II
Elvidge, Anita Miller (1895–),
III
Elwell, R. Farrington (1874–1962), I
Emeree, Berla Ione (1899–), I
Emerson, Sybil Davis (1892/95–),
III
Emerson, William Otto (–),
III
Emert/Emmert, Paul (1826–1867), III
Emery, Nellie Augusta Stafford
(–1934), III
Engledow, Charles O. (1898–),
III

Englehardt/Englehart, Joseph/John/ J. (-), I, III
English, Harold M. (1890-1953), I
Enser, John F. (1898-), II
Erdmann, Richard Frederick (1894-), III
Eresch, Josie (1894-), II
Erickson, Eric (1878-), III
Eriksen, Jens (-1920), III
Ernesti, Ethel H. (1880-), III
Ernesti, Richard (1856-), III
Ernst, Max (1891-1976), II
Ertz, Edward Frederick (1862-), I
Erwin, Margaret D. (-), III
Escherich, Elsa F. (1888-), II
Eskridge, Robert Lee (1891-), III
Espoy, Angel de Sarna (-), III
Euler, (Edwin) Reeves (1896-), II
Euwer, Anthony Henderson (1877-), I
Evans, Anne (-), II
Evans, Edwin (1860-1946), I
Evans, Ethel Wisner (1888-), III
Evans, Jessie Benton (1866-1954), I, II
Everett, Elizabeth Rinehart (-), II
Everett, Joseph Alma Freestone (1884-1945), I
Everett, Mary O. (1876-1948), I
Everett, Raymond (1885-), I, II
Eytel, Carl (1862-1925), I
Fabian, Lydia Dunham (1867-), II
Failing, Ida C. (-), II
Faille, Carl Arthur (1883-1952?), II
Fairbanks, J. Leo (1878-1946), I
Fairbanks, John B. (1855-1940), I
Fairchild, Hurlstone (1893-1966), I
Fallis, Belle S. (-), II
Farley, Bethel Morris (1895-), III
Farlow, May Jennings (-), III
Farnham, Ammi Merchant (1846-1922), III
Farnsworth, Ada/Ida (See: Champ), III
Farnsworth, Alfred Villiers (ca 1858-1908), I, III

Farnsworth, Ethel Newcomb (1873-), III
Farnsworth, Louise Richards (-), III
Farny, Henry F. (1845-1916), I
Farr, Ellen Frances Burpee (1840-1907), III
Farrell, Margaret C. Taylor (1883-1972), III
Farrer, Cornelia Hart (See: Hart), I
Farrington, Walter (1874-), II
Fassett, Elisha S. (-1903), III
Faul, Henry (See: Glendinen), III
Fausett, Lynn (1894-1977), I
Fay, Nellie (1870-), II
Fazel, John Winfield (1882-), II
Fechin, Nicolai Ivanovich (1881-1955), I
Fee, Chester Anders (1893-1951), III
Fehmel, Herbert (1898-1975), III
Feitelson, Lorser (1898-), II
Fenderich, Charles (1805-ca 1887), I, III
Fenn, Harry (1838-1911), I
Fenyes, Eva Scott (1846-1930), II
Ferguson, Elizabeth Foote (1884-), II
Ferguson, Lillian Prest (1869-1955), II
Ferran, Augusto (1813-1879), I
Ferris, Bernice Marie Bransom (1882-1936), III
Fery, John (1859-1934), I
Feurer, Karl (-), III
Ficht, Otto C. (-), III
Field, M./Mrs. Heman H. (1864-1931), III
Field, Marian (1885-), III
Fiene, Ernest (1894-1965), I
Filippone, John C. (1882-), III
Finta, Alexander S. (1881-1958), II
Firebaugh, Nettie King (-), II
Firks, Henry (-), II
Fisher, Flora Davis (1892-), III
Fisher, Harrison (1875-1934), I
Fisher, H. Melville (1878-1946), II
Fisher, Howard (1889-), II
Fisher, Hugo (1853-1916), I
Fisher, Vaudrey (1889-), III
Fishwood, Hazel C. (1889-), III
Fiske, Frank Bennett (1883-1952), I
Fisken, Jessie (1860-1935), II

Fitz Gerald, J./Jean Maurice (1899-), III
Fitzgerald, James (1899-1971), II
Fitzgerald, May Eastman (1894-), III
Fitzgibbon, James L. (-), III
Fjellboe, Paul (-), II
Fleck, Joseph A. (1892-1977), I
Fleming, Alice (1898-), III
Fletcher, Annie C. (-), III
Fletcher, Calvin (1882-1963), I
Fletcher, Frank Morley (1866-1949), I
Fletcher, Godfrey Bockius (1888-1923), I
Flynn, Ruby M. (1895-), III
Folawn, Thomas Jefferson (1876-), II
Foltz, Lloyd Chester (1897-), II
Fonda, Harry Stuart (1863-1942), I
Foote, Mary Hallock (1847-1938), I
Forbes, Helen Katherine (1891-1945), I
Forbush, Marie R. (-), III
Force, Anne (1884-), III
Force, Clara Gunnison (1852-1939), II
Ford, Arva (1890-), III
Ford, Helen Louise (1879-), I
Ford, Henry Chapman (1828-1894), I
Foresman, Alice Carter (1868-), II
Forkner, Edgar (1867-1945), II
Forman, Kerr Smith (1889-), II
Forsberg, Elmer A. (1883-), III
Forslund, A./Mrs. Victor (1891-), III
Forster, Washburne (1884-), II
Forsythe, Clyde (1885-1962), I
Fortune, E. Charlton (1885-1969), I
Foster, Arthur Turner (1877-), III
Foster, Ben (1852-1926), I, III
Foster, Bertha Knox (1896-), II
Foster, Grace (1879-1931?), II
Foster, Will (1882-1953), I
Foster, Willet S. (1885-), II
Fournier, Alexis Jean (1865-1948), III
Fowler, Ethel Lucile (-), III

Fowler, Eva/Evangeline (-), II
Frame, Stateira Elizabeth (1870-1935), III
Francis, Gene (See: McComas), III
Francis, Muriel Wilkins (1893-), II
Francis, Robert Talcott (1873-), III
Francisco, John Bond (1863-1931), I
Frang, Emil L. (1885-), III
Frank, Eugene C. (1840-1914), II
Frankl, Paul Theodore (1886-1958), III
Franklin, Mrs. Arla (1897-), III
Franklin, Dwight (1888-1971), I
Frantz, Alice Maurine (1892-), II
Frantz, (Samuel) Marshall (1890-), III
Fraser, (Thomas) Douglass (1883-1925), I
Fraser, John Arthur (1838-1898), I
Frazee, Isaac Jenkinson (1858-1942), II
Frazer, Mabel Pearl (1887-), I
Frazier, John Robinson (1889-1966), II
Frederick, George (1889-), III
Frederiksen, Mary Monrad (1869-), I
Free, Mary Arnold (1895-), II
Freedman, Ruth (1899-), III
Freeman, W. R. (ca 1820-1906), I
Fremont, John (1813-1890), I
French, Grace Ann (1858-1942), II
Frenzeny, Paul (1840-), I
Fretelliere, Louise Andree (1856-1940), III
Frey, Charles D. (1881-1959), II
Friend, Washington F. (1820-1886), II
Fries, Charles Arthur (1854-1940), I, III
Fripp, Charles Edwin (1854-1906), I
Fritz, Eleanor Virginia (1885-), II
Froelich, Maren Margrethe (1868-1921), I, III
Froment-Delormel, Jacques V. E. (1820-1900), I
Frost, Arthur Burdett (1851-1928), I

Frost, Francis S. (1825-1902), II
Frost, George Albert (1843-), I
Frost, John/Jack (1890-1937), I
Fuertes, Louis Agassiz (1874-1927), II
Fuller, Adella Ryan (ca 1861-), II
Fuller, Alfred (1899-), II
Fuller, Ruth B. (1893-), III
Fuller, William (-), III
Fullerton, Alice V. (1854-1950), III
Fulop, Karoly (1898-), II
Fulton, Cyrus James (1873-1949), II
Fulton, Fitch (1879-), I
Furlong, Charles Wellington (1874-1967), II
Fursman, Frederick Frary (1874-1943), III
Fursman, Mary O'Farrell (-), III
Furuya, Kinzo/Kiuzo (-1929), III
Gaastra, Bonney Royal (-), III
Gale, Edmund Walker (1884-), I
Gale, Goddard (-1938), II
Gale, Jane Green (1898-), II
Galloway, Gene (1897-), III
Gamble, John Marshall (1863-1957), I
Gammon, Estella M. (1895-), III
Gannett, Ruth Chrisman Arens (1896-), III
Garbett, Cornelia Barns (See: Barns), II
Garden-Macleod, Louise E. (See: Macleod), II
Gardner, Gertrude Gazelle (1878-1975), III
Garland, Marie Tudor (1870-), II
Garnsey, Julian Ellsworth (1887-), II
Garrison, Martha [Minta] H. (1874-), II
Garth, John (1889-1971), II
Gaskin, (George) William (1892-), II
Gaspard, Léon (1882-1964), I
Gaul, (William) Gilbert (1855-1919), I
Gaw, Eleanor D'Arcy (-) III
Gaw, Hugh (-), II
Gaw, William A. (1891-1973), I

Gay, Auguste F./Gus (1891-1949), III
Gay, Mary (-), II
Gearhart, Frances Hammel (-1958), II
Gearhart, May (1872-1951), I
Geary, Fred (1894-1955?), III
Geiger, Marie J. (1887-), III
Geise, Rose M. (1895-), II
Geiser, Bernard (1887-), II
Gellenbeck, Ann P. (-), II
Gellert, Emery (1889-), I
Gellert, S. M. (1884-), III
Gelwicks, Frances Slater (-1915), II
Genter/Gentler, Paul Huntington (1888-), II
Gentilz, Theodore (1819-1906), I
George, (Helen-) Margaret (-), II
Gere, Nellie Huntington (1859-1949), II
Geritz, Franz (1895-1945), I
Gerlach, Albert Anthony (1884-), II
Gerrer, Robert Gregory (1867-1946), II
Gerrity, John Emmett (1895-), II
Gerstle, Miriam Alice (1898-), II
Gerstle, William Lewis (1868-), I
Gerten, John (1888-), III
Gervasi, Frank (1895-), III
Ghirardelli, Alida (-), II
Gibberd, Eric Waters (1897-1972), I
Gibbs, George (1815-1873), I
Gibbs, Ralston Snow (-), III
Gibson, (Mestre) Lydia (1891-), II
Gideon, Sadie Cavitt (-), III
Gideon, Samuel Edward (1875-1945), II
Gifford, Charles B. (1823-1880), I
Gifford, Robert Swain (1840-1905), I, III
Gifford, Sanford Robinson (1823-1880), I, III
Gilbert, Arthur Hill (1894-1970), I
Gilbert, Ralph (1884-), III
Gilbert, Robert (-), II
Gilchrist, Meda (-), II
Gilder, Robert Fletcher (1856-1940), I

Gildersleeve, Beatrice (1899-), II
Gile, Selden Connor (1877-1947), I
Gill, De Lancey (1859-1940), II
Gill, Minna Partridge (1897-1964),
 III
Gill, Miriam Fort (-1917), III
Gill, Ross R. (-), III
Gill, Sue May Wescott (1890-),
 III
Gillam, William Charles Frederick
 (1867-), II
Gillette, Frances (1880-), II
Gillette, Lester A. (1855-), III
Gilley, Samantha Vallient
 (ca 1869-1938), III
Gilliam, Marguerite (See: Hubbard),
 II
Gilstrap, W. H. (1840-1914), I, III
Gimeno, Harold (1897-), II
Gimeno, Patricio (1864-1940), II
Girard, Joseph Basil (1846-1918), III
Girardin, Frank J. (1856-1945), II
Gjonovich, Miles (1892-), II
Glass, Bertha Walker (1884-), I
Gleason, (Joe) Duncan (1881-1959), I
Glendinen, J. Y. (-), III
Gloe, Olive (1896-), I
Glover, Edwin S. (1845-1919), III
Gluckmann, Grigory (1898-), III
Goddard, Florence M. (-), II
Goddard, George Henry (1817-1906),
 I, III
Goeller-Wood, E. Shotwell (1887-
), II
Goldberg, Reuben Lucius (1883-
 1970), II
Golden, Charles O. (1899-),
 I, III
Goldstein, Louise Marks (1899-),
 II
Goldworthy, Philoma (ca 1895-),
 III
Gollings, (Elling) William (1878-
 1932), I
Golton, Glenn (1897-), II
Gonzales, Boyer (1878-1934), II
Gonzales, Xavier (1898-), II
Goodan/Goodin, Tillman P. (ca 1896-
 1958), II
Goodloe, Nellie Stearns (-),
 III
Goodwin, Philip R. (1882-1935), II

Goodwin, Richard LaBarre (1840-
 1910), I
Gookins, James F. (1840-1906?), I
Gordon-Cumming, Constance F.
 (1837-1924), I, III
Gore, John Christopher (1806-1867),
 III
Goss, Louise H. (-), II
Gotzsche, Kai G. (1886-), I
Gould, Carl Frelinghuysen (1873-
 1939), III
Gourley, Bess E. (-), I, III
Gove, Eben Frank (1885-1938), III
Grabill, Nora Kain Nichols (1882-
), III
Graf, Gladys H. (1898-), II
Grafström, Olaf Jonas (1855-1933),
 I, III
Graham, Charles (1852-1911), I
Graham, Robert Alexander (1873-
 1946), I, III
Graham, William (1832-1911), I
Grain, Frederick (-c1879), II
Grandmaison, Nicholas de
 (1892-1978), I
Grandstaff, Harriet Phillips
 (1895-), II
Graner, Luis (1867-1929), III
Grant, Blanche Chloe (1874-1948), I
Grant, Charles Henry (1866-1939), I
Grant, Frederic Milton (1886-1959),
 III
Grant, Gordon Hope (1875-1962), III
Graves, Helen D. (1899-), III
Graves, Martha Primrose (1873-
 1966), I
Gray, Kathryn (1881-1931), II
Gray, Mary Chilton (1888-), II
Gray, Percy (1869-1952), I, II
Gray, Una (-), II
Gray/Grey, William Vallance (-
), III
Grayson, Andrew Jackson (1818-
 1869), III
Greathouse, Mrs. G. W. (-),
 III
Greatorex, Eliza Pratt (1820-1897), I
Green, Emma Edwards (-1942),
 II
Green, Hiram Harold (1865-1930), II
Green, Jay S. (1892-1984), III
Green, Rena Maverick (1874-), I

Greenbaum, Joseph (1864-1940),
I, III
Greenbury, George C. (-),
III
Greenbury, William (-), III
Greene, E./Edmond? (ca 1830), III
Greene, LeRoy E. (1893-), I
Greener, Charles Theodore (1870-
1935), II
Gregg, Paul (1876-1949), I, II
Grell, Louis Frederick (1887-1960),
II
Gremke, Henry Deidrich [Dick]
(1860/69-1939), I, III
Grenet, Edward Louis (1856-1922), I
Grier, Auda Fay (1898-), III
Griffen, (William) Davenport (1894-
), III
Griffin, James Martin (1850-),
I, III
Griffin, Walter (1861-1935), III
Griffin, Worth Dickman (1892-),
II
Griffith, Armand Harold (1860-1930),
III
Griffith, Conway (1863-1924), II
Griffith, Lillian (1889-), II
Griffith, Louis Oscar (1875-1956), II
Griffith, William Alexander (1866-
1940), I, III
Grigg, Joanna S. (-), II, III
Grigware, Edward Thomas (1889-
1960), I, III
Grimm, Paul (1892-1974), III
Grist, Franklin R. (-), III
Griswold, J. C. (1879-), III
Grob, Trautman (-), I
Groesbeck, Dan Sayre (1878-1950),
II
Groll, Albert Lorey (1866-1952), I
Grosse, Garnet Davy (1895-), II
Grosser, Eleanor M. (-), II
Grosz, George (1893-1959), III
Grothjean, Francesca C. R. (1871-
), II
Grubb, Ethel McAllister (1890-),
II
Gruder, Carl (-), III
Gruenfeld, John Caspar (1872-1954),
II
Grunsky, Carl Ewald (1855-1934), I
Guenther, Pearl Harder (1882-), I

Guerin, Jules (1866-1946), III
Guillot, Ann (1875-), II
Guislain/Guislane, J. M. (1882-),
I, III
Gullickson, Gustav I. (1855-1941), I
Gundlach, Max (1863-), II
Gunn, Florence (ca 1899-1969), II
Guptill, Thomas Henry (1868-),
III
Gustavson, Henry (1864-1912), III
Gustin, Paul Morgan (1886-1974),
I, III
Haag, Herman H. (1871-1895), I
Habeger, Ruth (1895-), II
Hackwood, Harriet Chapin McKinlay
(1874-), III
Haddock, Arthur (1895-1980), II
Hader, Berta Hoerner (-1976), II
Hader, Elmer Stanley (1889-), II
Hadra, Ida Weisselberg (1861-1885),
I
Hafen, John (1856-1910), I
Hafen, Virgil O. (1887-1949), I
Haffer, Virna/Mrs. N. B. Randall
(1899-), III
Haffner, F. J. (-), II
Hagendorn, Max (1870-), II
Hager, Luther George (1885-1945), I
Hagerman, Percy (1869-1950), I, III
Hagerup, Nels (1864-1922), I
Hahn, Carl William (1829-1887), I
Haig, Emily (1890-), III
Haig, Mabel George (1884-), I
Haines, Marie Bruner (1884-), II
Hale, Ellen Day (1855-1940), III
Hale, Florence Keffer (1887-),
III
Hale, Girard Van Barkaloo (1886-
1958), III
Hall, Arthur William (1889-), I,
III
Hall, Cyrenius (1830-), I
Hall, Florence Slocum (-), II
Hall, Howard H. (-), III
Hall, Leola (-), II
Hall, Norma Bassett (1889-1957), I,
III
Hall, Parker L. (1898-), II
Hall, Robert H. (1895-), III
Hall, Sydney Prior (1842-1922), I
Halseth, Edna Scofield (See:
Scofield), II

Halsey, Anna Mary McKee (1865–
), III
Haltom/Halton, Minnie Hollis
(1889–), II
Hamilton, Doris W. (–), III
Hamilton, Edgar Scudder (1869–
1903), II
Hamilton, Hamilton (1847–1928), I
Hamilton, James (1819–1878), I
Hamilton, Minerva Bartlett (1864–
), I
Hammarstrom/Hammerstrom, H. C.
(–), III
Hammerstad, John Olson (1842–
1925), III
Hammock, Earl G. (1896–), I
Hammond, Leon W. (1869–), III
Hamp, Margaret (ca 1830–1921),
I, III
Handforth, Thomas Schofield (1897–
1948), I, III
Hankins, Vina S. (1878–), III
Hannis, Geneva Grippen (1868–),
III
Hannon, Olga Ross (1890–), II
Hanscom, Trude (1898–), I
Hansen, Armin Carl (1886–1957), I
Hansen, Ejnar/Einar (1884–1965), I
Hansen, Herman Wendelborg (1854–
1924), I
Haradynsky, E./Frank Stadter
(–), III
Harding, Goldie Powell (1892–),
I
Harding, Neva Whealey (1872–),
II
Hardman, Maud R. (–), III
Hardwick, Lily Norling (1890–),
II
Harlan, Thomas (–), III
Harland, Mary (1863–), II
Harle, Annie L. (–1922), III
Harley, Steven W. (1863–1947), I
Harman, Jean C. (1897–), III
Harmer, Alexander F. (1856–1925), I
Harmer, Thomas C. (1865–1930), II
Harmon, Charles Henry (–1936),
I, III
Harms, Alfred (–), III
Harn, Alice Moores (1855–1931), III
Harpe, Sophie Elaine (1895–1981), III
Harper, William A. (1873–1910), II

Harpold, Gertrude M. (1888–), I
Harrington, Joseph A. (1840–1900), I
Harris, George Maverick (1889–),
II
Harris, Grace Griffith (1885–), I
Harris, Greta (–), II
Harris, Lawren Stewart (1885–1970),
III
Harris, Samuel Hyde (1889–1977), II
Harrison, (Thomas) Alexander (1853–
1930), I
Harrison, (Lowell) Birge (1854–1929),
I, III
Harshe, Robert B. (1879–1938), II
Hart, Alfred A. (1816–), I, III
Hart, Cornelia (1889–), I
Hart, Lantz/Lance Wood (–1941),
III
Hart, Sally (1891–), III
Hartley, Marsden (1877–1943), I, III
Hartman, (C.) Bertram (1882–1960), I
Hartmann, Sadakichi (1869–1944), II
Hartnett, Eva Valker (1895–), I
Hartshorne, Harold (–), III
Hartwell, Emily S. (–), III
Hartwell, Nina Rosabel (1861–1917),
II
Harvey, Eli (1860–1957), I
Harvey, Paul (1878–1948), II
Harwood, Burt C. (1897–1923), I
Harwood, Harriet Richards (–
1922), III
Harwood, James T. (1860–1940), I
Hashimoto, Michi Yosida (1890–
), III
Haskell, Ernest (1876–1925), I
Haslehurst, Minette Tucker (–
), III
Hassam, (Frederick) Childe (1859–
1935), III
Hastings, Marion Keith (1894–),
II
Haswell, Robert (–), I
Hatfield, Dalzell (1893–1963), II
Hatfield, Karl Leroy (1886–), II
Hatlo, James [Jimmy] (1897–1963),
III
Hauge, Marie Gjellstad (–),
III
Haugseth, Andrew John (1884–),
III
Hauser, John (1859–1913), I

Hauswirth, Frieda (1886-), I
Haverstick, R. E./Jake (1898-1961),
 III
Hawkins, Grace Milner (1869-),
 II
Hay, Jean M. (-1942), III
Hayden, Harriet Clark Winslow
 (1840-1906), II
Hayden, Sara Shewell (-),
 I, III
Hayes, Lee (1854-), II
Haynes, Elsie Haddon (1881-1963),
 II
Hays/Hayes, Ethel (1892-), III
Hays, William Jacob (1830-1875), I
Hayward, Alfred (1893-), III
Hazard, Arthur Merton (1872-1930),
 II
Hazen, Bessie Ella (1861-1946), II
Hazen, Fannie Wilhelmina (1877-
), II
Heade, Martin Johnson (1819-1904),
 I
Heaney, Charles Edward (1897-),
 I, III
Heap, Gwinn Harris (1817-1887), I
Heath, Carroll D. (1880-), III
Heath, Edda Maxwell (ca 1875-1972),
 II
Heath, Frank L. (1857-1921), I, III
Heath, Lillian Josephine (1864-1961),
 II
Heath, William Albert (1840-1911),
 III
Hebert, Marian (1899-1960), II
Hedrick, Mary S. (1869-), III
Heerman, Norbert Leo (1891-),
 III
Heger, Joseph (1835-1897), I
Heil, Elizabeth (1877-), II
Heine, Minnie B. (1869-), I
Heinze, Adolph (1887-1958), II
Heisser, Margareth E. (1871-),
 III
Heitmann, Charles G. (-),
 III
Heizer, Dell (1877-1964/65), I, III
Hekking, William Mathews (1885-
 1970), II
Held, John, Jr. [Cari] (1889-1958), III
Heller, Bessie Peirce (1896-), II
Heller, Leonard G. (1893-1966), III

Helwig, Arthur Louis (1899-),
 III
Heming, Arthur (1870-1940), I
Hemstegger, L. G. (-), III
Henderson, Evelyn (-), II
Henderson, John R. (-), III
Henderson, William Penhallow (1877-
 1943), I
Hendricks, Emma Stockmon (1869-
), II
Hendrickson, David (1896-), III
Hendrie, Marion G. (-), III
Henke/Hencke, Burnard A. (1888-
 1949), III
Henkel, Estella M. (1889-), III
Hennessy, Stephen (1893-), III
Henning, Virginia (ca 1881-1962), II
Hennings, E. Martin (1886-1956), I
Henri, Robert (1865-1929), I, II
Henry, Harry Raymond (1882-1975),
 III
Hensley, Mercedes H. (1893-),
 III
Herbert, Marian (See: Hebert), II
Herkomer, Herman Gustave (1863-
 1935), I
Herminghaus, Ernst (1890-), III
Herold, Don (1889-1966), I
Herold, J. J. (1866-), III
Heron, Edith Harvey (1895-), II
Herrick, Hugh M. (1890-1946), II
Herrick, Margaret Cox (1865-), I
Herrick, William F. (-ca 1906), I
Herring, Fern Lord (1895-1975), III
Herrington, Florence E. (-),
 II
Herrmann, Fernande Luise (-
), II
Hersch, Lee F. (1896-), I
Herter, Adele (1869-1946), III
Herter, Albert (1871-1950), II
Herzog, Herman (1832-1932), I, III
Hess, Sara M. (1880-), III
Hessova/Hess, Bess/Beatrice (-
), II
Hetrovo, Nicolai/Nicholas (1896-
 ca 1959), III
Heuston, George Z. (1855-1939), I
Heyneman, Julia/Julie H.
 (1871-1943), III
Heywood, Herbert (1893-), III
Hiatt, Maurine (1898-), II

Higgins, Eugene (1874-1958), I
Higgins, Victor (1884-1949), I
Hildebrandt, Edouard (1817-1868/69),
III
Hiler, Hilaire (1898-1966), II
Hill, Abby Williams (1861-1943), I
Hill, Alice Stewart (-), II
Hill, Andrew Putnam (1853-1922), I
Hill, Edward Rufus (-), I
Hill, Evelyn Corthell (1886-), I
Hill, John Henry (1839-1922), II
Hill, Lavina Baker (-), III
Hill, Raymond Leroy (1891-1980),
III
Hill, Robert Jerome (1878-), II
Hill, Stephen G. (ca 1819-), II
Hill, Thomas (1829-1908), I
Hilliard, W. H. (1836-1905), II
Hills, Anna Althea (1882-1930), I
Hilton, William Hayes (1829-1909),
II
Hinchman, John Herbert (1884-
1948), II
Hinckley, Thomas Hewes (1813-
1896), I
Hinkle, Clarence Keiser (1880-1960),
I
Hinkle, Elizabeth H. (ca 1876-1972),
II
Hinkle, Lucile Bernice (1895-), II
Hird, Herbert Shaw (1886-), III
Hirst, Sue (-1928), III
Hitchcock, David Howard (1861-
1943), I
Hitchens, Joseph (1838-1893), I
Hitchings, Henry (-1902), II
Hittle, Charles J. (1861-1938), I
Hoar, Frances (1898-), II
Hobart, Clark (1870-1948), I
Hobart, Gladys Marie (1892-), II
Hobby, Charles Frederick (1886-
), II
Hochderffer, George (1863-1955), II
Hockaday, Hugh (1892-1968), I
Hodge, Helen Francis (-), II
Hodges, Frederick (1858-1926), III
Hodges, Marjorie (See: Doolittle,
v. I), II
Hoen, Elizabeth (-), II
Hoerman, Carl (1885-1955), II
Hoerner, Berta (See: Hader), II
Hoffman, Frank B. (1888-1958), I
Hoffman, Polly (1890-), II

Hoffman, Victor (1834-), II
Hoftrup, Julius/Julian Lars
(1874-1954), I
Hogner, Nils (1893-1970), I, II
Hogue, Alexander (1898-), I
Hogue, Lois (See: Shaw), II, III
Hohnstedt, Peter L. (See: Holmstedt),
III
Holcomb, Maurice S. (1896-), III
Holden, James Albert (-), II
Holden, Sarah G. (-), I
Holdredge, Ransom Gillet (1836-
1899), I
Holliday, Robert (-), II
Hollier, Harold S. (1886-), III
Hollingshead, Mary/M. Mary (1897-
), III
Holman, Abigail (1876-), II
Holmberg, Samuel (ca 1885-1911),
III
Holme, John Francis/Frank (1868-
1904), II
Holmes, F. Mason (1858-1953), I
Holmes, Harriet Morton (-),
II
Holmes, Mildred M. (1897-), III
Holmes, Ralph William (1876-1963),
I, III
Holmes, William Henry (1846-1933),
I
Holmlund, Marvin N. (1896-), II
Holmstedt/Hohnstedt, Peter L.
(ca 1872-1957), III
Holslag, Edward J. (1870-1925), II
Holsman, Elizabeth A. Tuttle
(1873-), III
Holt, Geoffrey (-), III
Holt, Henry (1843-1922), I
Holt, Percy William (1895-), II
Hölzlhuber, Franz (1826-1898), II
Hondius, Gerrit (1891-1970), III
Hong, Anna Helga (See: Rutt), II
Hooper, Annie Blakeslee (-),
II
Hooper, Floy (1898-), III
Hooper, Rosa/Rose (1876-), II
Hooper, Will Phillip (1855-1938), I
Hope, Thelma Paddock (1898-),
II
Hopkin, Robert (1832-1909), III
Hopkins, Charles Benjamin (1882-
), I

536

Hopkins, George Edward (1855–), III
Hopkins, Lin/A. Linton (1886–1968), I
Hopkins, Ruth Joy (1891–1973), I
Hopper, Edward (1882–1967), I
Hoppin, Augustus (1828–1896), I
Hopps, Nellie (See: Howard), II
Horder, Nellie P. (1885–), I
Horne, Alice Merrill (1868–1948), III
Horsfall, Robert Bruce (1868–1948), I
Horton, Charles Orson (1896–), II
Horvath, Ferdinand Huszti (1891–), II
Hoskins, Gayle Porter (1887–1962), II
Hosmer, Laurence F. (1895–), II
Hosoda, Kuraju (1885–), III
Hough, Walter (1859–1935), III
Houghton, Arthur Boyd (1836–1875), I, III
Houghton, Merritt Dana (1846–1919), III
Houlahan, Kathleen (1884–1964), II
House, Dorothy (1899–), III
House, Howard Elmer (1877–), II
Howard, Eloise (1889–), III
Howard, Florence (–1914), II
Howard, John Galen (1864–1931), III
Howard, Lillian A. (–), III
Howard, Mary R. Bradbury (1864–), II
Howard, Nellie Hopps (–), II
Howard, Robert Boardman (1896–), I
Howard, Rose/Rosine (See: Salisbury), III
Howell, Eugenie James (1883–), I
Howland, Alfred Cornelius (1838–1909), II
Howland, John Dare (1843–1914), I
Hoyer, F. M. (1863–), III
Hubacek, William (1864–1958), II
Hubbard, Bess Bingham (1896–), II
Hubbard, Marguerite (Gilliam) (1894–), II
Hubbell, Henry Salem (1870–1949), III

Hubbert, Lily Saxon (1878–), III
Huddle, Nannie Z. Carver (–), II
Huddle, William Henry (1847–1892), I, II
Hudson, Charles Bradford (1865–1939), I
Hudson, Grace Carpenter (1865–1937), I
Huett/Huet, Fred (1838–1916), I
Huffsmith, Dolly (1896–), III
Hufstedler, Mrs. E. Virgil (–), III
Hughes, Daisy Marguerite (1883–1968), II
Hughes, Marie Gorlinski (–), III
Hukari, Oscar (1878–), III
Hulbert, Katherine Allmond (–1937), II
Hull, Marie A. (1890–), I
Hull, Mary L. (1877–), II
Hullenkremer, Odon (1888–1978), II
Hulme, Harold Emluh (1882–), III
Hunley, Katharine Jones (1883–1964), II
Hunnius, Carl Julius Adolph (1842–), III
Hunt, Esther (1885–), II
Hunt, Thomas L. (1882–1938), I
Hunter, Isabel (1878–1941), I
Huntington, Charles S. (–), III
Huntington, Daniel Riggs (1871–), II
Huntoon, Mary (1896–), II
Huntsman, S. Ralph (1896–), III
Hurst, Clara Scott (1889–), II
Hurtt, Arthur R. (1861–1938), II
Husted, Elvera C. (–), II
Hutchens, Frank Townsend (1869–1937), II
Hutchings, Augusta Ladd Sweetland (–1881), III
Hutchings, Elvira Sproat (1842–ca 1917), III
Hutchins, Charles Bowman (1889–), II
Hutchins, Sheldon F. (1886–), III
Hutton, William Rich (1826–1901), I, III

Hutty, Alfred Heber (1878-1954), I
Hyde, Helen (1868-1919), I
Hyde, Josephine E. (1885-), III
Hyde, Marie A. (1882-), II
Hyer, Florine (1868-), III
Hyer, Robert Stewart (1860-1929), III
Iannelli, Alfonso (1888-1965), II
Ikard, Virginia (1871-), III
Ilyin, Gleb A. (1889-1968), III
Ilyin, Peter Alexander (1887-1950), I
Imhof, Joseph A. (1871-1955), I
Immel, Paul J. (1896-), II
Ingels, Frank Lee (1886-1957), II
Inman, John O'Brien (1828-1896), II
Inness, George (1825-1894), I
Inness, George, Jr. (1854-1926), I
Iredell, Russell (1889-1959), II
Ireland, Leroy (1889-1970), III
Irvin, Marie Isabella Duffield (1863-1932), III
Irvin, Rea (1881-1972), II
Irwin, Benoni (1840-1896), II
Isaacs, Walter F. (1886-1964), II
Ishii, Kowhoo (1897-), III
Ivanoff, Eugene Samson (ca 1898-1954), III
Ivey, John J. (-), II
Ivey, Joseph (-), I
Iwonski, Carl G. von (1830-1922), I
Jack, Gavin Hamilton (1859-1938), III
Jackman, Oscar Theodore (1878-1940), II
Jackson, David E. (1874-), III
Jackson, Jessie/Jesse Short (-), III
Jackson, Martin Jacob (1871-1955), II
Jackson, Roy (1892-), III
Jackson, W. C. (-), II
Jackson, William Franklin (1850-1936), I
Jackson, William Henry (1843-1942), I
Jacobsen, Norman (1884-1944), III
Jacobson, Julia C. (1879-), III
Jacobson, Oscar Brousse (1882-1966), I, III
Jacques, Emil (1874-1937), II
James, Bess B. (1897-), III
James, Jimmie (1894-), III

James, Rebecca Salsbury (1891-1968), II
James, Roy Walter (1897-), II
James, Will/Wm. James Dufault (1892-1942), I
Jamieson, Agnes D. (-), II
Janin, Louise (1892-), III
Janousek, Louis (1856-1934), II
Jansson, Alfred (1863-1931), II
Jaques, Bertha E. (1863-1941), II
Jaques, Francis Lee (1887-1969), III
Jarvis, W. Frederick (1868-), III
Jeffreys, Arthur Bishop (1892-), III
Jemne, Elsa Lauback (1888-), III
Jenkins, Hannah Tempest (-), II
Jenkins, John Eliot (1868-), II
Jenkins, Marian Brooks (1885-1944), III
Jenks, Albert (1824-1901), I
Jenks, Dea S. (-), III
Jensen, Dorothy Dolph (1895-), II
Jenson, Edgar M. (1888-1958), III
Jenssen, Haakon A. (1883-), II
Jepperson, Samuel Hans (1855-1931), I
Jerome, Irene Elizabeth (1858-), II
Jewell, Foster (1893-), II
Jewell, Wynn R. (-), III
Jewett, William Smith (1812-1873), I
Johanson, Erik (1874-), III
John, Grace Spaulding (1890-1972), I, II
John, Margaret Sawyer (1871-), II
Johnson, Arthur Monrad (1878-1943), III
Johnson, C. Everett (1866-), II
Johnson, Carrie Rixford (1873-1961), II
Johnson, Catherine C. (1883-), III
Johnson, Cordelia (1871-), I
Johnson, Frank Tenney (1874-1939), I
Johnson, George/G. A. (-), III

Johnson, Herbert (1878-1946), III
Johnson, Ida (ca 1852-1931), III
Johnson, June Greevy (1890-),
III
Johnson, Mamie (C. Irwin)
(1879-), III
Johnson, Marie Runkle (1861-),
II
Johnson, Mary Totten (1885-),
III
Johnson, Minnie Wolaver
(-), III
Johnson, Thomas Berger (1890-
1968), III
Johnson, Wayne (1872-1950), I, III
Johnston, Edith Constance (1890-
), III
Johnston, Eliza Griffin (-),
III
Johnston, Frederic J. (1890-), II
Johnston, Margaret Isabelle (1884-
), III
Johnston, Mary Virginia (1865-),
II
Johonnot, Ralph Helm (-1940),
III
Jones, D. Paul (-), III
Jones, Elberta Mohler (1896-),
I
Jones, Emma McCune (1873-),
II
Jones, Esther A. (-), II
Jones, Grace Church [Jonzi]
(-), II
Jones, Ida Stone (1867-1944), I
Jones, L. Lova (1874-1951), II
Jones, Martha Miles (1870-1945), II
Jones, Mary Elizabeth (See: Kast),
III
Jones, Seth C. (1853-1930), III
Jones, Wendell Cooley (1899-),
II
Jonnevold, Carl Henrik (1856-1930),
I
Jonson, Raymond (1891-1982), I
Jorgensen, Christian (1860-1935), I
Jorgensen, Ejler A. Christoffer
(1838-1876), III
Joslyn, Florence Brown (ca 1881-
1954), III
Joullin, Amedee (1862-1917), I
Joullin, Lucile/Lucille (1876-1924), I
Jourdan, Alda (1889-), III

Judd, Frank Willson (-), III
Judia, B. T. (ca 1880-), II
Judson, Almira Austin (-),
II
Judson, Charles Chapel (1864-1946),
I
Judson, William Lees (1842-1928), I
Juleen, Lee D. (1891-), III
Jump, Edward (ca 1832-1883), I
Junge, Carl Stephen (1880-), III
Justice, Martin (-), III
Kahler, Carl/Karl (1855-), III
Kahler, Joseph A. (-), III
Kaltschmidt, Oscar (-), III
Kaminski, Edward B. (1893-1964), II
Kane, Paul (1810-1871), I
Kangoony, Gregory (1895-), II
Kann, Frederick I. (1886-), III
Kanno/Kenno, Gertrude Boyle (1876-
1937), III
Karras, Spiros John (1897-), II
Kasimer, Luigi (1881-1962), I
Kassler, Charles Moffat, II (1897-
), II
Kast, Mary Elizabeth Jones (1857-
1942), III
Katada, Selsuro (-), II
Katchamakoff, Atanas (1898-),
II
Kato, Kentaro (1889-1926), II
Katz, Leo (1887-), II
Kauffer, Edward McKnight (1890-
1954), II
Kaufmann, Ferdinand (1864-), II
Kavanaugh, Katharine (See: Cahill),
II
Kay-Scott, Cyril (1879-), II
Kayser, Louise Darmstaedter (1899-
), III
Keane, Theodore J. (1880-), III
Kearfott, Robert Ryland (1890-),
III
Keating, Mary Aubrey (1898-1953),
II
Keatinge, Elizabeth (1885-), III
Keck, Josephine Frances (1860-),
III
Keefer, Elizabeth E. (1899-), II
Keeler, Charles Butler (1882-1964), I
Keeler, Julia Annette (1895-), II
Keeler, Louise Mapes (Bunnell)
(-), II
Keener, Anna E. (1895-), I

Keffer, Frances (1881-1954), III
Kegg, George W. (1884-1943), II
Keihl, Mabel C. (1899-), III
Keith, Elizabeth Emerson (1838-1882), III
Keith, William (1838-1911), I
Keller, Arthur I. (1867-1924), I
Keller, Clyde Leon (1872-), II
Keller, Edgar Martin (1868-1932), II
Keller, George Frederick (-), II
Keller, Henry George (1869-1949), I, III
Kellogg, Joseph Mitchell (1885-), II
Kelly, John Melville (1877-), II
Kelly, Louise Minert (1879-), III
Kelly, Myrle E. (1891-), III
Kemble, Edward Windsor (1861-1933), I
Kemp, Oliver (1887-1934), II
Kempf, F. P. [Tud] (1886-), III
Kempf, Thomas M. (1895-), III
Kempster, Frances Saunders (-), III
Kendall, Marie Boening (1885-1953), II
Kende, Geza (1889-), III
Kennedy, Leta M. (1895-), II
Kennedy, Martha (1883-), II
Kennedy, Samuel James (1877-), III
Kennicott, R. H. (1892-), II
Kensett, John Frederick (1816-1872), I, III
Kent, Celia Burnham (See: Seymour), III
Kent, Dorothy (1892-), III
Kenyon, Zula (-), III
Kepps, Alfred (-), I
Kerby, Joseph (1857-1911), I
Kern, Edward Meyer (1823-1863), I
Kern, Richard H. (1821-1853), I
Kernodle, Ruth (-), III
Kerns, Fannie M. (1878-1968), II
Kerns, Maude Irvine (1876-1965), I
Kerr, Adma Green (-), III
Kerr, Irene Waite (1873-), I
Kerr, James Wilfrid (1897-), II
Kersey, Pliny Earle (1850-1873), III
Kervily, George Le Serrec de (1883-), II

Keszthelyi, Alexander Samuel (1874-1953), II
Ketcham, Rosemary (ca 1872-1940), II
Ketchel, H. M. (1865-1934), II
Key, John Ross (1832-1920), I, III
Kidd, Hari Matthew (1899-), II
Kihn, Wilfred Langdon (1898-1957), I
Kilpatrick, Aaron Edward (1872-1953), I
Kimball, Ranch S. (1894-1980), III
Kimbrough, Frank Richmond (- 1902), III
King, Minnie Clark (1877-), III
King, Sara (1892-), II
Kingan, Fred J. (-), I
Kingan, Samuel Latta (1869-1943), I, II
Kingsley, Elbridge/Eldridge (1842-1918), II
Kingsley, Rose (1845-1925), I
Kinney, Charlotte Conkright (-), I
Kinzinger, Alice Fish (1899-1968), II
Kinzinger, Edmund Daniel (1888-), II
Kirby, C. Valentine (1875-), III
Kirkham, Reuben (1845-1886), I
Kirkham, Richard A. (ca 1850-1930), III
Kirkland, Forrest (1892-1942), II
Kirsch, Agatha Beatrice (1879-), I
Kirsch, (Frederick) Dwight, Jr. (1899-), I, III
Kissel, Eleanor M. (1891-1966), I, II
Kitt, Katherine Florence (1876-), II
Kittinger, Peg Phillips (1896-), II
Kitts, Jasmine/Jessie de Lancey (1869-), II
Klauber, Alice (1871-1951), I
Kleiber, Hans (1887-1967), I
Klein, Lillie V. O'Ryan (-), II
Kleinschmidt, Florian Arthur (1897-), III
Kleiser, Lorentz (1879-1963), II
Kleitch/Kleitsch, Edith/Edna (1890-1950), III
Kleitch/Kleitsch, Joseph (1885-1931), I, III

540

Klepper, Frank Earl (1890–1952), I, III
Kley, Alfred Julius (1895–1957), III
Klinge, Nellie Killgore (–), III
Klinker, Orpha (1891–1964), I
Klumpke, Anna Elizabeth (1856–1942), I
Knapp, William A. (–1934), I
Knecht, Fern Edie (–), II
Knecht, Karl Kae (1883–1972), II
Knee, Gina (1898–), I
Knight, Augusta (–1937), II
Knight, Frederic (1855–1930), III
Knight, Louis Aston (1873–1948), III
Knight, S. Dubois (–), III
Knochenmuss, Fanny Chase (1883–1962), II
Knopf, Nellie Augusta (1875–1962), II
Knott, Arthur Harold (1883–), II
Knott, Franklin Price (1854–1930), I
Knott, John Francis (1878–1963), I
Knowles, Joseph (1869–1942), II
Knox, Katherine (1878–1965), II
Koch, Berthe Couch (1899–1975), II
Koch, George Joseph (1885–1951), III
Koch, Karl F. (1888–), III
Koen/Kohn/Koehn, Irma Renè (–), III
Koerner, William Henry Dethlef (1878–1938), I
Kohlmeier, Helen Louise (1888–), II
Koiransky, Alexander (1884–), III
Koogler, Jessie Marion (See: McNay), III
Koopman, Augustus B. (1867–1914), III
Koppel, Charles (–), I
Korda, Augustyne/Augustine/Augustyn (1894–), III
Korybut, Kasimir (1878–), II
Kosa, Emil (–), II
Krasnow, Peter (1886–1979), II
Krauth, Charles Philip (1893–), II
Kremser, Harry Edward (1890–), III
Kress, Frederick B. (1888–1970), III

Krieghoff, Bill/William G. (1876–1930), I
Kristoffersen, J. K. (1877–), III
Kroll, Leon (1884–1974/75), I
Kromer, Carol A. (1892–), II
Kroupa, Bohuslav (–), III
Krueger/Kruger, Richard (–), III
Kruse, Max H. (–), III
Kuchel, Charles Conrad (1820–1864?), I
Kuck, Martha D. (–), II
Kuhler, Otto C. (1894–1977), I
Kuhn, Walt (1877–1949), I
Kummer, Julius Hermann (1817–ca 1869), I
Kunath, Oscar A. (–1909), I
Kuniyoshi, Yasuo (1889–1954), I
Kuntz-Meyer/Kunz-Meyer, Prof. (–), III
Kurtzworth, Harry Muir (1887–), II
Kurz, (Rudolph) Friedrich (1818–1871), I
Kusianovich, Daniel (1899–1965), II
Kutcher, Ben (1895–1967?), II
Labaudt, Lucien Adolph (1880–1943), I
Lackey, Vinson (1889–1959), III
Ladd, Laura D. Stroud (1863–1943), III
Laidlaw, Cora M. (1863–), III
Lakes, Arthur (1844–), III
Lamade, Erich (1894–1969), II
Lamb, Frederick Stymetz (1863–1928), III
Lambdin, Robert L. (1886–), I
Lambdin, Victor B. (–), III
Lambert, Fred (ca 1886–), II
Lambourne, Alfred (1850–1926), I
La Mond, Stella Lodge (1893–), II
Lamson, James (–), I, III
Landacre, Paul Hambleton (1893–1963), I
Landaker, Harold (ca 1892–1966), III
Lane, Loubeth King (–), III
Lane, Martella Lydia Cone (1897–1962), III
Lanfair, Harold Edward (1898–), II
Langsdorff, Georg Heinrich von (1774–1852), I

Langston, Lucy E. (ca 1894-1966), II
Lanham, Alpha Johnson (-), III
Lanham/Langham, Emily (1895-), II
Lanman, Charles (1819-1895), III
Lapham, J. M. (-), I
Laplace, Cyrille (1793-1875), I
La Rosa, Vincenzo (ca 1871-1925), III
Larrinaga, Juan B. (1885-), II
Larrinaga, Mario (1895-), II
Larsen, Ben (1892-), III
Larsen, Bent Franklin (1882-1970), I
Larsen, Bessie (1889-), III
Larsen, Mae Sybil (-1953), III
Larsen, Morten (1858-1930), III
Larsson, Karl (1893-1967), II
La Salle/Lassell, Charles (1894-1968), I
Lash, Lee (1864-), III
Lasky, Bessie (1890-1972), II
Latham, Barbara (1896-), I
Latimer, Lorenzo P. (1857-1941), I
Latoix, Gaspard (-), II
Lauderdale, Ursula (1879-), II, III
Laudermilk, Jerome Douglas (1893-1956), II
Laurence, Sidney M. (1865-1940), II
Laurie-Wallace, John (See: Wallace), II
Lauritz, Paul (1889-1976), I
Lavender, Christ (-), I
Lavender, Eugenie (1817-1896), I
Law, Harry V. (-), II
Lawford, Charles (-), III
Lawrence, David Herbert (1885-1930), III
Lawrence, Herbert Myron (1852-1937), III
Lawson, Ernest (1873-1939), I, II
Layham, Julia Sherwood (-), II
Lazarus, Edgar M. (1868-1939), III
Leach, Maud A. (-), I
Leadbetter, Noble (1875-), III
Leaming, Charlotte (1878-ca 1972), I
Leaming, Susan F. (-), II
Learned, Harry (-), I
Leavitt, Agnes (1859-), II
Ledgerwood, Ella Ray (-1951), II

Lee, Arthur T. (-), III
Lee, Bertha Stringer (1873-1937), I
Lee, Ida Fursman/Furzman (-), III
Lee, Joseph (1827-1880), I
Lee, Leslie William (1871-1951), II
Lee, Selma (1879-), II
Leeper, Vera Beatrice (1899-), III
Leggett, Lucille W. (1896-), I
Leggett, Mabel E. (1878-), III
Leich, Chester (1889-), III
Leigh, William Robinson (1866-1955), I
Leighton, Kathryn Woodman (1876-1952), I
Leith-Ross, Harry (1886-), III
Leland, Clara Walsh (1869-), II
LeMaster, Harriet (1883-), III
Lemmon, Sara A. P. (-), I
Lemos, Frank B. (1877-), II
Lemos, Pedro J. (See: DeLemos), I, III
Lenders, Emil W. (ca 1865-1934), I, III
Lent, Frank T. (-), I, III
Lasaar, Charles M. (1884-), II
Leslie, Jean Gorman (1888-), II
Leslie, Virginia (-), III
Lester, Leonard (1876-1952), II
Lester, William Harold (1885-), II
Letcher, Blanche (-), II
Leutze, Emanuel (1816-1868), I
Levings, Mark McCall (1881-1957), II
Levitt, Joel J. (1875-), III
Levy, Beatrice S. (1892-), III
Levy, Nat (1896-), II
Lewis, Alonzo Victor (1886/91-1946), II
Lewis, Han (-), II
Lewis, Harry Emerson (1892-1958), II
Lewis, Herbert Taylor (1893-1962), III
Lewis, (L.) Howell (ca 1853-1935), III
Lewis, Jeannette Maxfield (1894-1982), I, III
Lewis, Mary Amanda (1872-1953), III
Lewis, Minard (ca 1812-), I

Lewis, Phillips Frisbie (1892–1930), I
Leyden, Louise Hannon (1898–),
III
Lichnovsky, Jennie M. (–),
III
Lichtner, Charles S. (1871–), III
Lie, Jonas (1880–1940), III
Lightfoot, Mary L. (1898–), III
Liljestrom, Gustav F./Gus
(1882–1958), III
Lillywhite, Raphael (1891–1958), I
Lind, Edward G. (1884–), III
Lindberg, Thorsten Harold F.
(1878–), III
Lindhardt, Dagmar B. (1881–),
II
Lindneux, Robert Ottakar (1871–
1970), I
Lindsay, Andrew Jackson (–
1895), I
Lindsay, Lilah Denton (–1943),
III
Lindsay, Ruth Andrews (1888–),
II
Lingan, Penelope Bailey (1860–),
II
Link, Carl (1887–1968), I
Linnell, Lilian B. (1894–), III
Linnen, Virginia Mitchell Hoskins
(1848–), III
Litchfield, Donald (1897–), II
Little, Gertrude L. (1887–1977), II
Littlejohn, Hugh Warwick (1892–
1938), II
Littlejohn, Margaret Martin (1885–
), II
Lloyd, Lucile (1894–1941), I
Lochrie, Elizabeth (1890–1981), I
Lockwood, Florence (1896–1963), III
Lockwood, Ward (1894–1963), I, III
Loemans, Alexander F. (–1894?),
II
Loft, P. (–), II
Logan, (George) Maurice (1880–1977),
II
Lombard, Warren Plimpton (1855–
1939), III
Lombardo, Emilio Vincent (1890–
), III
Lone Wolf (See: Schultz), I
Long, Stanley M. (1892–1972), I
Loomis, (William) Andrew (1892–
), II

Loomis, Chester (1852–1924), II
Loomis, Manchus C. (–), III
Loomis, Pascal (1826–1878), I
Lopp, (Harry) Leonard (1888–), I
Lorenz, Richard (1858–1915), I, III
Lorie, Hortense Plaut (1879–), II
Lorraine, Alma Royer (1858–1952), II
Lotave, Carl G. (1872–1924), I, III
Lotz, Matilda (1861–1923), I
Love, Charles Waldo (1881–1967),
I, III
Lovins, Henry (1883–1960), II
Lowdon, Elsie Motz (1883–), II
Lowrie/Lowry, Eleanor (1875–),
III
Lozowick, Louis (1892–1973), III
Ludlow, Fitz-Hugh (1836–1870), I
Ludovici, Alice Emelie
(1871/72–1957), I
Ludovici, Julius (1837–1906), I
Lukits, Theodore Nicholas
(1899–), II
Lum, Bertha Boynton (1897–1954),
III
Lundborg, Florence (1871–1949), I,
III
Lundin, Emelia A. (1884–), III
Lundmark, Leon (1875–), II
Lungkwitz, Herman (1813–1891), I
Lungren, Fernand Harvey (1859–
1932), I
Lussier, L. O. (–), II
Lyle, Jeannette E. (1883–), III
Lyser, Edna Potwin (1880–), III
McAfee, Ila (1897–), III
McAllister, E. P. (–), II
McArdle, Henry Arthur (1836–1908),
I, II
McArthur, Betty/Bettie (1865–),
III
McBride, Eva Ackley (1861–1928), II
McBurney, James Edwin (1868–
1955), II
McCague, Lydia Scott (1870–),
II
McCaig, Flora Thomas (1856–1933),
III
McCall, Alice Howe (1882–), III
McCan, James Ferdinand (1869–
1925), II
MacCannell, Earl E. (1885–), III
McCarter, Henry Bainbridge (1864–
1942), III

McCaslin, Louise (1896–), III
MacChesney, Clara Taggart (1860–1928), I
McClain, George M. (1877–), III
McClaire, Gerald Armstrong (1897–), III
McClellan, Cyranius Bolliva (ca 1827–), II
McCloskey, Alberta Binford (1863–1911), III
McCloskey, William Joseph/John (1859–1941), III
McClung, Florence White (1896–), I, III
McClure, Lillie Delphine (1864–), III
McClusky, Grace Dictover (1891–), I
McClymont, John I. (1858–1934), I
McComas, Francis J. (1874–1938), I
McComas, Gene Baker/Gene Frances (1886–1982), III
McCord, George Herbert (1848–1909), I
McCormick, Donald (1898–), II
McCormick, Howard (1875–1943), I
McCormick, M. Evelyn (1869–1948), I, II
McCoun, Alice Louise Troxell (1888–), II
McCrea, Samuel Harkness (1867–), II
McCreery, Franc Root (1888–1957), II
McCrossen, Preston (1894–), II
McCulloch/McCullough, Maxie Thomas (1874–), II
McDade, Ira (1873–), III
McDermitt, William Thomas (1884–), II
McDermott, Cecelia (–), III
MacDonald, Katharine H. (1882–), II
Macdonald-Wright, Stanton (1890–1973), I
McElroy, Jane (–), II
McEwen, Alexandrine (–), III
McEwen, Katherine S. (1875–), I, II
McFee, Henry Lee (1886–1953), III
McGaw, Blanche Evelyn Baldwin (1874–), II

McGee, Will T. (–), II
McGill, Eloise Polk (1869/72–1939), II
McGill, Leona Leti (1892–), II
MacGilvary, Norwood Hodge (1874–1949), II
McGlynn, Thomas A. (1878–1966), I, III
McGrath, Lenore K. (Ostrander) (–), II
McGraw, Hazel Fulton (1897–), II
McGregor, Charles Malcolm (1868–1941), III
McGuire, Myrtle (1897–), III
Mac-Gurrin, Buckley (1896–), II
Machefert, Adrien Claude (1881–), II
McIlvaine, William, Jr. (1813–1867), I
McIlwraith, William Forsyth (1864–1939), I
Mack, Alexander Watson (1896–), III
Mack, Leal (1892–1962), I
McKay, Fawn Brimhall (1889–1960), III
McKechnie, Mary (1887–), III
McKenna, Helen (–), III
McKenna, William (ca 1866–), III
Mackenzie, Catherine (1896–), III
Mackenzie, Florence L. Bryant (1890–), II
McKim, C. C. (–), III
McKinstry, Grace Emmajean (– 1936), II
Macklin, Lida Allen (1872–), III
Macknight/MacKnight, Dodge (1860–1950), II
Macky, Constance L. (1883–1961), II
Macky, Eric Spencer (1880–1958), II
MacLaren, Thomas (–1928), I, III
MacLean, Christina (1853–), II
McLean, (Lydia) Grace (1885–), II
McLellan, Ralph D. (1884–), III
McLendon, Louise (–), II
MacLennan, Eunice Cashion (1886–1966), I
MacLeod, Alexander S. (1888–), I

Macleod, Louise Elizabeth Garden (1857-1944), II

McLoughlin, Gregory (1889-), III

McMahon, Emily Mahon (1882-1974), III

McMahon, Harolde A. (1889-), III

McManus, George (1884-1953/54), II

McMicken, Helen Parker (1856-1942), I

McMillan, Mary Lane (-), II

McMurdo, James T. (-1955), II

McMurtrie, William Birch (1816-1872), I

McNay, Marion Koogler (1883-1950), III

McNeely, Perry (1886-1966), I

MacNeil, Hermon Atkins (1866-1947), I

McNulty, William Charles (1884-1963), III

McVeigh, Blanche (1895-1970), III

MacWhirter, John A. (1839-1911), III

Maack, George J. (-), III

Macy, William Starbuck (1853-1945), III

Madsen, Otto (1882-), III

Maher, Kate Heath (-), III

Mahier, Edith (1892-), I, III

Maiben, Henry (-), III

Mains, J. R. (ca 1833-), II

Maison, Mary Edith (1886-1954), II

Major, William Warner (1804-1854), I

Mako, B. (1890-), II

Malm, Gustav N. (1869-1928), III

Malone, Blondelle Octavia Edwards (1879-1951), III

Manbert, Barton (-), II

Mangravite, Pepino (1896-), I

Mann, Virginia (-), II

Mannheim, Jean (1863-1945), I

Manoir, Irving K. (1891-), II

Manon, Estelle Ream (1884-), III

Manser, Percy L. (1886-), III

Manuel, Donaldo (1890-), III

Many, Alexis B. (1879-1938), II

Maratta, Hardesty Gillmore (1864-1924), II

Marble, John Nelson (1855-1918), II

Marchand, John N. (1875-1921), I

Mari, Valere/Valerius de (1886-), II

Marin, John (1872-1953), II

Marlatt, H. Irving (-1929), I

Marlow, Lucy Clare Drake (-), III

Marple, William L. (1827-1910), I, III

Marriott, Fred M. (1805-1884), I

Marryat, Samuel Francis (1826-1855), I

Marsh, Charles Howard (1885-1956), II

Marsh, Harold Dickson (1889-), II

Marsh, Lucile Patterson (1890-), III

Marsh, Mary E. (-), II

Marshall, Frank Howard (1866-1945), II

Marshall, Mary (-), III

Martin, E. Hall (1818-1851), II

Martin, James H. (-), II

Martin, Jo G. (1886-), III

Martin, John A. Lee (-), I

Martin, John Breckenridge (1857-1938), I, II

Martin, Sue Pettey (1896-), II

Martin, Thomas Mower (1839-1934), I

Martinet, Marjorie D'orsi (1886-), II

Martinez, Alfredo Ramos (1872-1946), II

Martinez, Crescencio (-1918), III

Martinez, Julian (1897-1943), III

Martinez, Pete (1894-), I

Martinez, Xavier (1869-1943), I

Marulis/Marusis, Athan (1889-), III

Mason, Doris/Dora Belle Eaton (1896-), III

Mason, Elizabeth (1880-1953), I

Mason, Roy Martell (1886-1972), I

Massenburg/Massenburgh, Eugenia C. (1869-), III

Mast, Clara Glenn (1880-1947), III

Masterson, James W. (1894-1970), I

Matheson, Johanna (See: Mathieson), III

Mathews, Alfred E. (1831-1874), I

Mathews, Arthur Frank (1860-1945), I, III

546

Miller, Marie Clark (1894-), I
Miller, Maude Albeva (1883-), II
Miller, Mildred Bunting (1892-),
 I
Miller, Myra (1882-1961), II
Miller, (T.) Oxley (1855-1909), III
Miller, Ralph Davison (1858-1945),
 I, III
Miller, Richard Emil (1875-1943), II
Miller, Rose Kellogg (1890-), III
Miller, William Rickarby (1818-1893),
 III
Milleson, Royal Hill (1849-), III
Millier, Arthur Henry Thomas (1893-
 1975), I, II
Milligan, Gladys (1892-), III
Mills, John Harrison (1842-1916), I
Milsk, Miss Mark (1899-), III
Miner, Frederick R. (1876-), II
Mitchell, Alfred R. (1888-1972), I
Mitchell, Arthur R. (1889-), I, II
Mitchell, Eleanor B. (1872-), II
Mitchell, Gladys Vinson (1894-),
 II
Mitchell, Laura M. D. (1883-1965), I
Mitchell, Mabel Kriebel (1897-),
 III
Mizen, Frederic Kimball (1888-1965),
 I
Mocine, Ralph Fullerton (-),
 II
Modjeska, Marylka H. (1893-),
 II
Modra, Theodore B. (1873-1930), II
Moellman, Charles Frederick (1844-
 1902), III
Moerenhout, Jacques Antoine (1796-
 1879), I
Mohling, Fred H. (1894-), II
Molina Campos, Florencio (1891-
), II
Mollhausen, Heinrich Baldouin
 (1825-1905), I
Monges, Henry B. (1870-), II
Monhoff, Frederick (1897-), II
Monkvold, Oscar E. (1891-1958), II
Monroe, Laura P. (-), II
Monserud, Wilma (1899-), II
Montalboddi, Raffaelo (-),
 II
Montgomery, Alfred (1857-1922), II
Montoya, Alfredo [Wen'Tsireh]
 (-1913), III

Montrichard, Raymond Desmus
 (1887-), II
Moody, Edwin (-), I
Moon, Carl (1878/79-1948), I
Moon, Grace (-1947), II
Moore, Edwin S. (-), I
Moore, Frank Montague (1887-1967),
 I
Moore, (Harry) Humphrey (1844-
 1926), II
Moore, John Marcellus (1865-),
 II
Moore, Percy Caruthers (1888-),
 III
Moore, Sarah Wool (-), III
Moore, Thomas James/Tom (1892-
), I
Mopope, Steven (1898-1974), III
Mora, Francis Luis (1874-1940), I
Mora, Joseph Jacinto (1876-1947), I
Moran, Earl (Steffa) (1893-), III
Moran, Edward (1829-1901), I
Moran, Mary Nimmo (1842-1899), II
Moran, Paul Nimmo (1864-1907), II
Moran, Peter (1841-1914), I
Moran, Thomas (1837-1926), I
Morey, Anna Riordan (1857-1925), I
Morgan, Charles L. (1890-), II
Morgan, Charlotte E. Bodwell
 (-), II
Morgan, Jean Scrimgeour (1868-
 1938), III
Morgan, Mary A. (1880-), III
Morgan, Mary De Neale (1868-1948),
 I
Morgan, Theophilus/Theodore J.
 (1872-1947), III
Morris, Adelaide (1881-), II
Morris, Elizabeth H. (1887-), III
Morris, Florence Ann (1876-1947), I
Morris, James Stovall (1898-), II
Morris, Louise (1896-), II
Morris, William Charles (1874-1940),
 I
Morris, William H. (1834-1896), I
Morris, William V. (1821-1878), I
Morrison, Louise Gertrude (1873-
), III
Morrison, May (-), III
Morrow, Julie Mathilde (-),
 II
Morrow, Marie Catherine Rusche
 (1892-), III

Morse, Samuel F. B. (1885-1969), III
Morse, Vernon Jay (1898-1965), II
Morton, Charlotte A. (1885-),
III
Moser, (John) Henri (1876-1951),
I, III
Moses, Thomas G. (1856-1934), III
Mosler, Henry (1841-1920), I
Moss, Charles Eugene (1860-1901), I
Mott-Smith, May (1879-1952), II
Mount, William Sidney (1807-1868), I
Mountfort, Arnold G. (1873-1942), II
Mowbray, Henry Siddons (1858-
1928), II
Moylan, Lloyd (1893-), I
Mruk, Walter (1895-1942), II
Mudge, Zachariah (-), I
Muehlenbeck, Herbert P. (1886-
), III
Mueller, Alexander (1872-1935), II
Mueller, Lola Pace (1889-), II
Mueller, Michael J. (1893-1931), II
Muench, Agnes Lilienberg (1897-
), II
Mukoyama, K. (-), II
Mulford, Laura Lenore (1894-), I
Muller, Dan (1888-1977), I, II
Mullgardt, Louis Christian (1866-
1942), II
Mulroney, Regina Winifred (1895-
), III
Multner, Ardis (1899-), III
Mulvany, John (1844-1906), I
Mummert, Sallie Blyth (1888-),
III
Muncy, Milton A. (-), III
Mundy, Louise E. (1870-1952), I
Munger, Gilbert Davis (1836/37-
1903), I, III
Munn, Marguerite Campbell
(-), III
Munras, Esteban (-1850), II
Munroe, Marian (-), III
Munsell, William A. O. (1866-),
II
Munson, Linley (See: Tonkin), III
Murie, Olaus Johan (1889-1963), I
Murphy, Harry Daniels (1880-),
II
Murphy, James Edward, Jr. (1891-
1965), II
Murphy, Lawrence M. (1872-1948),
II

Murphy, Minnie B. Hall (1863-),
II
Murray, Frederick S. [Feg] (1894-
1973), I
Murray, Ralph V. (1897-), III
Musgrave, Arthur Franklin (1878-
1969), I, III
Mutton, Hilda (-), III
Myers, Datus E. (1879-1960), II
Myers, Frank Harmon (1899-1956),
I, III
Myers/Meyers, Lloyd Burton (1892-
1954?), II
Myers, O. Irwin (1888-), III
Myers/Meyers, William H. (1815-
), I, III
Myrick, Margaret Wilson (-
), III
Myrick, Roberta Neal Miller (1866-
1947), III
Nahl, Charles Christian (1818-1878),
I
Nahl, H. W. Arthur (1833-1889), I
Nahl, Perham Wilhelm (1869-1935), I
Nahl, Virgil Theodore (1876-1930),
I, III
Nankivell, Frank Arthur (1869-),
II
Nappenbach, Henry (1862-1931), I
Narjot, Erneste (1826-1898), I
Nash, Louisa (-), III
Nash, Wallis (1837-1926), III
Nash, Willard Ayer (1898-1943),
I, III
Nason, Daniel W. (-), I
Nau, Carl W. (-), II
Nave, Royston (1876-ca 1931), II
Neal, David Dalhoff/Dolhoff (1838-
1915), I
Nedwill, Rose (1882-), I
Neebe, Minnie Harms (1873-),
III
Needham, Charles Austin (1844-
1923), III
Neilson/Nielson, Charles P. (-
1966), II
Neilson, Thomas Raymond (1886-
), III
Nelson, (Ernest) Bruce (1888-1952), I
Nesemann, Enno (1861-1949), I
Neubauer, Margaret Barnett
(ca 1899-), III
Neuhaus, Eugen (1879-1963), I

Newberry, John Strong (1822-1892),
I
Newby, Ruby Warren (1886-1952), II
Newcombe, Warren (1894-), I
Newell, George Glenn (1870-1947), I,
III
Newsom, Archie T. (1894-), I
Newton, Helen F. (1878-), II
Neyland, Watson (1898-), II
Nice, Blanch Heim (1892-), II
Nicholl, Thomas Jeffs (1851-1931), I
Nichols/Nicols, Audley Dean
(1875-1941), II
Nichols, Harley De Witt (1859-1939),
I, III
Nichols, Pegus/Peggy Martin (1884-
1941), II
Nicholson, Isabel Ledcreigh (1890-
), II
Nicholson, Jennie M. (1885-), III
Nicholson, Lillie May (1884-1964),
III
Nicoll, James Craig (1846-1918), III
Nielsen, Holger (1883-), III
Nielsen/Neilsen, Mr. Kay (1886-
1957), II
Nielson, Harry A. (1881-), III
Nimmo, Louise Everett (1899-1959),
I
Nishii, K. (-), III
Noble, John (1874-1934), I, II
Noble, Mamie Jones (1874-), I
Nomura/Nomoura, Kenjiro (1876-
1956), II
Nordberg, C. Albert (1895-), II
Nordfeldt, Bror Julius Olsson
(1878-1955), I, III
Norling, Ernest Ralph (1892-),
II
Norskov, Hedvig (1889-1931), III
Northington, Clara Beard (1882-
), III
Norton, Elizabeth (1887-1967), I
Norton, Helen Gaylord (1882-1965), I
Norton, John Warner (1876-1934), I
Noyes, George Loftus (1864-1954), II
Nugent, Meredith (1860-1937), II
Nuhn, Marjorie Ann (1898-), III
Nuttall, Thomas (1786-1859), II
Nutting, Myron Chester (1890-),
III
Nye, Elmer Lesly (1888-), II
Nye, Myra (1875-1955), II

Oakes, Mrs. A. T. (-), III
Obata, Chiura (1885-1975), I, III
O'Brien, Michael Edward (1854-
1936), III
O'Brien, Smith (-), II
O'Donnell, Julian E. (1896-), II
Oehler, Helen Gapen (1893-1979), III
Oestermann, Mildred Caroline
(1899-), II
Officer, Thomas Story (1810-1859), I
Ogden, Henry Alexander (1856-
1936), III
Ogilby, Robert E. (-1884), I, III
O'Hara, Eliot (1890-1969), II
O'Kane, Regina (-), II
O'Keeffe, Georgia (1887-), I, II
O'Keeffe, Ida Ten Eyck (1889-1961),
III
Oldfield, Otis (1890-1969), I, III
Olds, Elizabeth (1897-), I, III
Oleson, Julie Haskell (1870-), III
Oliver, Joseph Kurtz (-), III
Oliver, Myron Angelo (1891-1967), II
Olsen, Teckla (1889-), III
Olson, Albert Byron (1885-1940),
I, III
Olson, Callie Williams (-), II
Olson, J. Olaf (1894-), II
Olson, Joseph Oliver (-), III
Olstad, Einar Hanson (1876-), I
O'Malley, Power (1870-1946), II
Onderdonk, Eleanor Rogers (1886-
1964), III
Onderdonk, Julian (1882-1922), I, II
Onderdonk, Robert J. (1852-1917), I
O'Neil/O'Neill, James Knox (1847-
1922), I, III
Orchardson, Charles M. Quiller
(1873-1917), II
Ord, Edward O. C. (1818-1883), III
Ord, Edward O. C., Jr. (1858-1923),
III
Ormes, Eleanor R. (ca 1865-1938),
III
Orr, Alfred Everitt/Edward (1886-
), II
O'Ryan, Lillie V. (See: Klein), II
Osgood, Samuel Stillman (1808-
ca 1885), I
O'Shea, John (1881-1956), II
Osthaus, Edmund H. (1858-1928), I
Ostner, Charles Leopold (1828-1913),
I

Paxson, Stella (–), III
Paxton, William A. (–), III
Payne, Edgar (1882–1947), I
Payne, Elsie Palmer (1884–), I
Payne, Lura Masterson (–), III
Peabody, Lucy L. (–), III
Peabody, Ruth Eaton (1898–1967), II
Peale, Titian Ramsey (1799–1885), I
Pearce, Edgar Lewis (1885–), III
Pearce, Helen S. (1895–), I
Pearce, Mary Blake (1890–), III
Pearson, Anton (1892–), II
Pearson, Edwin (1889–), I
Pearson, Ralph M. (1883–1958), I, II
Pease, Lucius C. [Lute] (1869–1963), I, III
Pease, Nell Christmas McMillan (1873–1958), III
Pebbles, Francis Marion (1839–1928), I
Peck, Anne Merriman (1884–), III
Peck, Charles (1827–1900), III
Peck, Orrin (1857/60–1921), I
Pedersen, Conrad Georg (1887–), III
Pedrose, Margaret Bjornson (1893–), III
Peers, Marian/Marion (–), II
Pegram, Marjorie (–), III
Peirce, Joshua H. (–), I
Peixotto, Ernest Clifford (1869–1940), I
Pelenc, Simeon (1873–1935), III
Pelton, Agnes (1881–1961), I, III
Peña, Tonita [Quah Ah] (1895–1949), III
Penelon, Henri (1827–1874/85), I
Pennell, Joseph (1857–1926), III
Penniman, Leonora Naylor (1884–), I
Pennoyer, A. Sheldon (1888–1957), I
Pentenrieder, Erhard (1830–1875), I
Percival, Olive (–), III
Percy, Isabelle Clark (West) (1882–1976), I, III
Perkins, Katherine Lindsay (–), II
Perl, Margaret Anneke (1887–), II
Perret, Ferdinand (1888–1960), II

Perry, Clara Fairfield (–1941), III
Perry, Enoch Wood (1831–1915), I
Perry, Winifred Annette (–), III
Pescheret, Leon Rene (1892–1961), III
Peters, Charles Rollo (1862–1928), I
Peters, Charles Rollo, III (1892–1967), II
Peters, Constance Evans (ca 1870–1935), I
Petersen, Einar C./Einer (1885–), III
Petetin, Sidonia (–), II
Peticolas, Arthur Brown (–), III
Petit, Dale (1898–), III
Petri, (Friedrich) Richard (1824–1857), I
Petrovits, N. Paul (–), III
Pettingill, Lillian Annin (1871–), III
Peyraud, Frank Charles (1858–1948), III
Phair, Ruth (1898–), III
Phelps, Edith Catlin (1873–1961), I
Philipp, Werner (1897–1982), III
Phillips, Bert Geer (1868–1956), I
Phillips, Claire Dooner (1887–), I
Phillips, Walter Shelley (1867–1940), III
Phipps, William/W. F. (–), III
Phister, Jean Jacques (1878–ca 1949), II
Phoenix, Frank (–1924), II
Piazzoni, Gottardo (1872–1945), I
Pickering, Hal (–), II
Pickett, James Tilton (1857–1889), I
Picknell, William Lamb (1853–1897), III
Pierce, B. W. (–), III
Pierce, Lucy Valentine (1890–), II
Pierce, Martha (1873–), I
Pierce, Minerva (–), I
Pierce, William H. C. (1858–), II
Piercy, Frederick Hawkins (1830–1891), I
Pietierre, P. (–), III
Pinnington, Jane (ca 1896–), II

Piper, Natt (1886–), II
Pissis, Emile M. (1854–), III
Pitts, Lendall (1875–1938), II
Pittwood, Ann (1895–), III
Pixley, Emma Catharine O'Rielly
 (1836–), III
Pizzella, Edmundo (1868–1941), II
Platt, George W. (1839–1899), I
Plaw/Plau, Eleanor Walls (1878–
), III
Plein, Charles M. (–1920), III
Plotkin, Peter (–), III
Plowman, George Taylor (1869–1932),
 II
Pneuman, Mildred Young (1899–
), II
Podchernikoff, Alexis Matthew
 (1886–ca 1933), I, III
Pogany, William Andrew [Willy]
 (1882–1955), II
Pogson, Annie L. (–), II
Pohl, Hugo David (1878–1960), II
Point, Nicolas (1799–1868), I
Polkinghorn, George (1898–), II
Pollak/Pollack, Max (1886–1970), II
Pollock, A. M. (–), III
Polowetski, Charles E. (1884–),
 II
Pomeroy, Elsie Lower (1882–1971), II
Pommer, Julius (1895–1945), II
Pommer, Mildred Newell (1893–),
 I
Pond, Willi Baze (See: Baze), II
Poock, Fritz (1877–1944?), II
Pool, Eugenia Pope (–), III
Poole, Eugene Alonzo (1841–1912), II
Poole, Horatio Nelson (1885–1947), I
Poor, Henry Varnum (1888–1970), I
Poore, Henry Rankin (1859–1940), I
Pope, John (1821–1881), I
Pope, Marion Holden (1870–1958), I
Poray, Stan Pociecha (1888–1948), II
Porter, Bruce (1865–1953), I
Porter, Frederic H. [Bunk] (1890–
 1976), III
Porter, W. F. (–), III
Porter, William Solon (–),
 III
Postle, (Katherine) Joy (1896–),
 III
Potter, A. L. (–), III
Potter, Louis McClellan (1873–1912),
 II

Potter, William J. (1883–1964), I
Potter, Zenas L. (1886–1958), II
Potthast, Edward Henry (1857–1927),
 I, III
Potvin, Lora Remington (1880–),
 III
Powell, Arthur James Emory (1864–
 1956), II
Powell, Caroline Amelia (1852–1934),
 III
Powell, Doane (1881–1951), III
Powell, H. M. T. (–), I
Powell, Jonathon B./J. S. (–
), II
Powell, Jeannette M. (ca 1871–1944),
 II
Powell, Lucien Whiting (1846–1930),
 I
Powell, Myra Grout (1895–), III
Powell, Pauline (1876–), I
Powers, Helen (–), III
Powers, Jane Gallatin (–1944),
 III
Prather, Ralph Carlyle (1889–),
 III
Pratt, Henry C. (1803–1880), I
Pratt, Irwin (1891–1955), III
Pratt, Lorus (1855–1923), I
Pratt, Lorus, Jr. (1894–1964), III
Prendergast, John (–), I
Prentice, Sydney C. (–), III
Preuss, Charles (1803–1854), I, III
Price, Clayton S. (1874–1950), I
Price, Eugenia (1865–1923), I, III
Price, Garret/Garrett (1896–),
 III
Price, Lida Sarah (–), III
Price, Minnie (1877–1957), I
Price, William Henry (1864–1940), II
Prideaux, Mado M. (–), III
Pries, Lionel H. (1897–), II
Prior, Melton (1845–1910), I
Prior, Ruby Adair (See: Adair), I
Pritchard, George Thompson (1878–
), III
Probst, Thorwald Albert (1886–1948),
 II
Proctor, Alexander Phimister (1862–
 1950), I
Proper, Ida Sedgwick (1873–1957), II
Pushman, Hovsep T. (1877–1966), II
Puthuff, Hanson Duvall (1875–1972),
 I

Pyle, Clifford Colton (1894–), II
Quesenburg/Quesenberg, William (1822–1888), III
Quigley, Edward B. (1895–), I
Quinan, Henry B. (1876–), II
Quinlan, Will J. (1877–), III
Quinton, Cornelia Bentley Sage (1876–1936), I
Rabino, Saul (1892–), II
Raborg, Benjamin (1871–1918), I
Radford, Zilpha (1885–), III
Rahtjen, Fitzhugh (–), II
Raleigh, Henry Patrick (1880–), III
Ralston, J. Kenneth (1896–), I
Ramsey, Lewis A. (1873–1941), I
Randall, D. Ernest (1877–), II
Randall, George Archibald (1887–1941), II
Randall, Ida A. (–), III
Randlett, Mamie Randall (–), III
Randolph, Lee F. (1880–1956), I
Rankin, Mary Kirk (1897–), I
Rankin, Myra Warner (1884–), I
Ranney, William (1813–1857), I
Ransonnette, Charles (–), I
Raphael, Joseph M./Joe (1869–1950), I, III
Raschen, Henry (1856–1937), I, II
Rathbone, Augusta Payne (1897–), I
Ratliff, Blanche Cooley (1896–), I
Raulston, Marion Churchill (1883–1955), II
Rauschnabel, William F. (–), II
Ravagli, Angelino (1891–), II
Ravalli, Antonio (1811–1884), I
Ravlin, Grace (1873–1956), II
Rawles, Charles S. (–), III
Rawlins, Lara/Lara Cauffman (–), III
Raymond, Grace Russell (1876–), II
Raymond, Kate Cordon (1888–), III
Rea, Lewis Edward (1868–), I
Read, Frank E. (1862–), III
Read, Henry (1851–1935), I
Reade, Roma (1877–1958), I
Reaser, Wilbur Aaron (1861–1942), I

Reaugh, Frank (1860–1945), I
Reckless, Stanley Lawrence (1892–), II
Red, Harold Doak (–), III
Redd, Lura (1891–), III
Rederer, Franz (1899–1965), II
Redin, Carl (1892–1944), III
Redmond, Granville Seymour (1871–1935), I
Redwood, Allen C. (1844–1922), I
Reed, Doel (1894–), I, III
Reed, Earl Meusel (1894/95–), II
Reed, Peter Fishe (1817–1887), III
Reeder, Walter Edwin (1893–), III
Reedy, Leonard (1899–1956), I, III
Reese, Walter Oswald (1889–), III
Reeser, Lillian (1876–), II
Reeves, Joseph Mason, Jr. (1898–1973), II
Regalado, Manuel Rivera (1886–), II
Regamey, Felix Elie (1844–1907), I
Reichmann, Josephine Lemos (1864–1938), III
Reid, Albert Turner (1873–1955), I
Reid, Aurelia Wheeler (1876–1969), II
Reid, Robert (1862–1929), I, III
Reiffel, Charles (1862–1942), I
Reimer, Cornelia (1894–), I
Reimers, Johannes (–), III
Reimers, Marie Arentz (1859–), III
Reiss, F. Winold/Winold Fritz (1886–1953), I
Reitzel, Marques E. (1896–1963), II
Remington, Frederic (1861–1909), I
Renner, Otto Hermann (1881–), II
Renshawe, John H. (1852–1934), II
Revere, Joseph Warren (1812–1880), I
Rey, Jacques Joseph (1820–1899?), I
Reynard, Grant Tyson (1887–1968), I, III
Reynolds, Alice M. (–), II
Reynolds, Clara P. (–), III
Reynolds, George (–), II
Reynolds, Harry Reuben (1898–1974), I
Rezac, Henry (1872–1951), II

Rhodes, Helen Neilson (1875-1938), I, III

Ribcowsky, Dey de (See: De Ribcowsky), III

Rice, Lucy Wilson (1874-), II

Rice, William Seltzer (1873-1964), II

Rich, John Hubbard (1876-1954), I

Richards, F. De Berg (1822-1903), III

Richards, Lee Greene (1878-1950), I

Richards, Samuel (1853-1893), III

Richards, William Trost (1833-1905), III

Richardson, Edward M./Ed (-), III

Richardson, Mary Curtis (1848-1931), I

Richardson, Theodore J. (1855-1914), II

Richardson, Volney Allan (1880-), II

Richardt, Joachim Ferdinand (1819-1895), I

Richmond, Evelyn K. (1872-), II

Richmond, Leonard (-1965), III

Richter, Albert B. (1845-1898), I

Richter, Henry Leopold (1870-1960), I, III

Rickard, Marjorie Rey (1893-1968), II

Riddell, William Wallace (1877-1948), II

Riddlesbarger, Sara K. (1869-), III

Ridelstein, Maria Von (1885-1970), III

Rider, Arthur Grover (1886-1975), II

Rider, Charles Joseph (1880-), II

Rieber, Winifred (1870-1963), I

Riesenberg, Sidney H. (1885-), I

Riess, William J. (1856-1919), II

Rife, Dwight W. (1896-), II

Righter, Alice L. (1874-), II

Righter, Mary (-), II

Rindisbacher, Peter (1806-1834), II

Rindlaub, Mrs. M. Bruce Douglas (-), II

Ring, Alice Blair (1869-1947), II

Ripley, Thomas Emerson (1865-), II

Rippeteau, Hallie Crane (-), III

Risher, Anna Priscilla (1875-), II

Rising, Dorothy Milne (1895-), I

Ritschel, William (1864-1949), I, III

Ritter, Anne Gregory (1868-1929), I, III

Rivera, Diego (1886-1957), II

Rix, Julian Walbridge (1850-1903), I

Rixford, Caroline (See: Johnson), II

Robbins, Frederick Goodrich (1893-), I

Robbins, Leona (-), III

Robbins, Vesta O. (1891-), III

Roberts, Georgina Wootan (1891-), III

Roberts, Hermine Matilda (1892-), II

Roberts, Maurine Hiatt (See: Hiatt), II

Robertson, Jane Porter (-), II

Robinson, Adah Matilda (1882-1962), I, III

Robinson, Alfred (1806-1895), I

Robinson, Boardman Michael (1876-1952), I, III

Robinson, Charles Dorman (1847-1933), I

Robinson, Charles Hoxey (1862-1945), II

Robinson, Delia Mary (-), III

Robinson, Irene Bowen (1891-), II

Robinson, (Virginia) Isabel (1894-), II

Roca, Stella McLennan (-1955?), III

Rochard, Pierre (1869-), II

Rockwell, Bertha (1874-), II

Rockwell, Cleveland (1836-1907), I

Rockwell, Elizabeth A. (-), III

Rockwell, Etta Maia Reubell (1874-), III

Rocle, Margaret K. (1897-), II

Rocle, Marius Romain (1897-), II

Rode, Cora (1898-), III

Rodriguez, Alfred C. (-1890), I

Roeder, John (1877-1964), III

Roerich, Nicholas (1874-1947), II

Roethe, L. H. (1860-), I

Rogers, Charles A. (1848-), I, III

Rogers, Charles H. (–), I
Rogers, Eleanor Gale (–), II
Rogers, Margaret Esther (1872–1961), I
Rogers, William Allen (1854–1931), I
Rohland, Caroline Speare (1885–1965), III
Rohland, H. Paul (1884–1949), III
Rollins, Helen Jordan (1893–), I
Rollins, Warren E. (1861–1962), I
Rolshoven, Julius C. (1858–1930), I
Romero de Romero, Esquipula (1889–1975), II
Roney, Harold Arthur (1899–), II
Ronnebeck, Arnold (1885–1947), II
Root, Anna Stewart (–), III
Ropp, Roy M. (1888–), II
Rorphuro, Julius J. (1861/62–1928), I, III
Rose, Ethel Boardman (1871–1946), II
Rose, Guy (1867–1925), I
Rosenberg, Louis Conrad (1890–), II
Rosenthal, Doris (ca 1895–1971), I
Rosenthal, Mildred (1890–), II
Rosenthal, Tobias Edward/Toby (1848–1917), I
Ross, Gordon (1873–1946), III
Ross, Harry Dick (1899–), III
Ross, Mary Herrick (–), II
Ross, Sue Robertson (–), III
Ross, Thomas (–), I
Rost, Miles Ernest (1891–1961), III
Rothery, Albert (1851–1915), I, III
Rothstein, Theresa (1893–), II, III
Roybal, Alfonso [Awa Tsireh] (1895–1955), III
Rozaire, Arthur D. (1879–1922), II
Rudersdorf, Lillian C. (1882–), II
Rudhyar, Dane (1895–), II
Rudolph, Alfred (1881–1942), I
Rudy, James F. (–), II
Rungius, Carl (1869–1959), I
Runquist, Albert Clarece (1894–1971), II
Runquist, Arthur (1891–1971), II
Rush, Olive (1873–1966), I, III
Russell, Charles M. (1864–1926), I
Russell, Morgan (1886–1953), II

Russell, Shirley M. Hopper (1886–), III
Russon, Joseph F. (1874–1958), III
Ruthrauff, Frederick G. (1878–1932), II
Rutland, Emily (1892–), I, III
Rutledge, Ann (1890–), II
Rutledge, Bertha V. (1890–), II
Rutt, Anna Hong (1895–), II
Ruxton, George Frederick A. (1820–1848), I
Ryan, Charles James (1865–1949), III
Ryan, William Redmond (ca 1827–1855), II
Ryder, Chauncey Foster (1868–1949), I
Ryder, Worth (1884–1960), I
Ryland, C. J. (1892–), III
Rymer, William C. (–), III
Saalburg, Allen Russell (1899–), II
Sacks/Sachs, Joseph (1887–), III
Sage, Cornelia Bentley (See: Quinton), I
Saint-Clair, Norman (1864–1912), I
Saint John, J. Allen (1872–), III
Salazar, Maria (1893–), II
Salisbury, Cornelius (1882–1970), III
Salisbury, Rosine Howard (1887–1975), III
Salz, Helen Arnstein (1883–1978), II
Salzbrenner, Albert (–), II
Samman/Sammann, Detlef (1857–), II
Sample, Paul Starrett (1896–1974), I
Sampson, S. Andrea (1891–), III
Samuel, W. G. M. (1815–1902), II
Sandefer, Lucile Gilbert (–), III
Sandefur, John Courtney (1893–), II
Sanden, Arthur G. (1893–), III
Sanders, Helen Fitzgerald (–), III
Sanders, Mrs. A. H. (1892–), III
Sandham, J. Henry (1842–1910), I
Sandona, Matteo (1881–1964), I
Sandor, Mathias (1857–1920), I, III
Sands, Gertrude (1899–), II
Sandusky, William (1813–1846), I
Sandzen, Sven Birger (1871–1954), I, II

Santee, Ross (1889-1965), I
Sargeant, Geneve Rixford (1868-1957), I
Sargent, John Singer (1856-1925), III
Sargent, Lloyd L. (1881-1934), III
Sargent, Paul Turner (1880-), II
Sauerwen/Sauerwein, Frank Paul (1871-1910), I
Savage, Marguerite Downing (1879-), III
Sawyer, Edmund Joseph (1880-), II
Sawyer, Myra Louise (-1956), I
Sawyer, Philip Ayer (1877-1949), I, III
Saxod, Elsa Florence (1892-), III
Sayer, Edmund Sears (1878-), II
Sayre, F. Grayson (1879-1938), I
Scammon, Laurence Norris (- 1939), II
Schaefer, Harry (1875-1944), III
Schafer/Schaeffer, Frederick (1839/41-ca 1917), I, III
Schaffer, L. Dorr (-), II
Schaldach, William Joseph (1896-), III
Schechert, Dorothea (1888-), III
Scherbakoff, Sergey John (1894-), I
Scheuerle, Joe (1873-1948), I
Schevill, William V. (1864-), II
Schildhauer, Mrs. Henry (- ca 1927), III
Schille, Alice O. (1869-1955), III
Schimonsky, Stanislas W. Y. (-), I
Schiwetz, Edward M. [Buck] (1898-), I, II
Schlaikjer, Jes William (1897-), II
Schlueter, Lydia Bicky (1890-), III
Schmedtgen, William Herman (1862-1936), III
Schmidt, Albert H. (1883-1957), II
Schmidt, Karl (1890-1962), II
Schmidt, Otto (-1940), II
Schmidt, Theodor B. W. (1869-), III
Schmitt, Paul A. (1893-), II
Schneider, Isobel (1880-1962), II

Schneider, Otto Henry (1875-1950), II
Schofield/Schoenfeldt, Flora Itwin (1879-), III
Schonborn, Anton (-1871), I, III
Schoonover, Frank Earle (1877-1972), II
Schott, Arthur (ca 1813-1875), I
Schouler, William C. (1852-ca 1927), II
Schreck, Horst (1885-), I
Schreyvogel, Charles (1861-1912), I
Schroder, Arnold (-), II
Schroeder, George Eugene (1865-1934), II
Schroff, Alfred Hermann (1863-1939), II
Schuchard, Carl (1827-1883), I
Schulman, Abraham Gustav (1881-1935), II
Schultz, F. W. (-), III
Schultz, George F. (1869-), II
Schultz, Hart [Lone Wolf] (1882-1970), I
Schumann, Paul R. (1876-), II
Schupbach, Hedwig Julia (1889-), III
Schupbach, Mae Allyn (See: Christie), II
Schuster, Donna Norine (1883-1953), II
Schuyler, Remington (1887-1955), II
Schwankovsky, Frederick John (1885-), II
Schwartz, Davis Francis (1879-1969), I
Schwartz, Mrs. Morris (-), III
Schwartz, William Samuel (1896-), III
Schwarz, Frank Henry (1894-1951), II
Schwentker, Hazel F. (1894-), II
Scofield, Edna M. (-), II
Scott, Anna Page (-1925), II
Scott, Carlotta B. (1886-1972), II
Scott, Clyde Eugene (1884-1959), I
Scott, Julian (1846-1901), I
Scott, Nellie Burrell (-1913), II
Scott, Quincy (1882-), II
Scruggs/Scruggs-Carruth, Margaret (1892-), II

Scudder, Alice Raymond (–),
 II
Scutt, Winifred (1890–), II
Seabury, Roxoli (1874–), III
Seaman, Ada (–), III
Seaquest, Charles L. (1864–1938), III
Sears, Benjamin Willard (1846–1905),
 II
Sears, John/Jack Septimus (1875–
 1969), III
Seavey, Julian Ruggles (1857–1940),
 II
Seavey, Lilla B. (–), II
Seawell, Henry Washington (–
), II
See, Imogene (1848–1940), II
Seeberger, Pauline Bridge (1897–
), II
Seely, Walter Frederick (1886–),
 II
Seewald, Margaret (1899–), II
Segesman, John F. (1899–), III
Seideneck, Catherine Comstock
 (1885–1967), III
Seideneck, George J. (1885–1972), II
Seielstad, Benjamin Goodwin (1886–
), III
Sekido, Yoshida (1894–), II
Seltzer, Olaf Carl (1877–1957), I
Senat, Prosper Louis (1852–1925), II
Sepeshy, Zoltan L. (1898–1974), II
Serbaroli, Hector (1886–), II
Seton, Ernest Thompson (1860–1946),
 I
Setterberg, Carl (1897–), III
Severance, Julia Gridley (1877–),
 III
Sewall, Blanche Harding (1889–),
 II
Sewall, Howard S. (1899–1975), II
Seward, Coy Avon (1884–1939), I
Sexton, Frederick Lester (1889–),
 II
Seyffert, Leopold (Gould) (1887–
 1956), I
Seymour, Celia Burnham (1869–
 1958), III
Seymour, Ralph Fletcher (1876–
 1966), II
Seymour, Samuel (1797–1823), I
Shannon, Aileen Phillips (1888–
), II

Shapleigh, Frank Henry (1842–1906),
 I
Sharp, Joseph H. (1859–1953), I
Sharp, Louis Hovey (1875–1946), II
Sharp, William (ca 1802–1900), II
Sharp, William A. (1864–1944), II
Shattuck, (William) Ross (1895–
), III
Shaw, Harriet McCreary Jackson
 (1865–1933), I
Shaw, Horatio W. (1847–1918), III
Shaw, Jack (1898–), III
Shaw, Lois Hogue (1897–),
 II, III
Shaw, Stephen William (1817–1900), I
Shaw, Sydney Dale (1879–1946), I
Shawhan, Ada Romer (1865–1947),
 III
Shead, Ralph (–), II
Shear, Fera Webber (1893–), II
Sheckell, T. O. (–), II
Sheckels, Glenn (–1939), III
Shed, Charles Dyer (1818–1893), I
Sheeler, Charles (1883–1965), II
Sheets, Nan (1885–1976), I, III
Sheffers, Peter Winthrop (1893–
 1949), II
Shepard, Clare (See: Shisler), II
Shepard, William E. (1866–1948), I
Shephard, Minnie (–), III
Shepherd, J. Clinton (1888–), III
Shepherd, Nellie Ellen (1877–1920), II
Sheridan, Joseph Marsh (1897–),
 II
Sherman, Elizabeth Evelyn (1896–
), II
Sherman, John (1896–), I
Sherrer, Sabrina Doney (1857–1930),
 II
Shettle, William Martin (–1923),
 I
Shields, Emma Barber (1863–1912),
 II
Shindler, Antonien Zeno (ca 1813–
 1899), II
Shinn, Alice R. (–), III
Shiras, George E. (–), II
Shirlaw, Walter (1838–1909), I
Shisler, Clare Shepard (–),
 II
Shiva, Ramon (1893–1963), II
Shively, Douglas (1896–), II

Shockley, May Bradford (1879-),
 II
Shonnard, Eugenie Frederica (1886-
 1978), I
Shorb, Mrs. D. L. (-), II
Shore, Henrietta M. (1875-1963), II
Shorey, Maude Kennish (1882-),
 III
Short, Jessie Glen Francis (See:
 Jackson), III
Shoven, Hazel Brayton (1884-),
 II
Shrader, Edwin Roscoe (1879-1960),
 I
Shumate, Frances Louise (1889-
), III
Shupp, Alice Connel (1896-), II
Shurtliff, Wilford Haskill (1886-
), II
Shuster, Will (1893-1969), I
Shuttleworth, J. D. (-), III
Siboni, Emma Benedikta (1877-),
 II
Sichel, Harold M. (1881-), II
Siegfried, Edwin (1889-1955), III
Siegriest, Louis B. (1899-), I
Sill, Robert A. (1895-), III
Silsby, Clifford F. (1896-), II
Silsby, Wilson (1883-1952), II
Silva, William Posey (1859-1948),
 I, III
Silvius, Paul T. (1899-), II
Simkins/Simpkins, Martha (-
), II
Simmang, Charles (1874-), II
Simmons, Edward Emerson (1852-
 1931), III
Simons, George (1834-1917), I
Simpson, E. V. (-), II
Simpson, Marian/Marion (1899-),
 II
Simpson, Roberta (1897-), III
Simpson, William (1823-1899/1903), I
Singerman, Gertrude Sterne (-
), II
Skeats, Miall (1858-1928), II
Skeele, Anna Katherine (1896-1963),
 I
Skelly, Alta L. (1896-), II
Skelton, Leslie James (1848-1929), I
Skelton, Phillis Hepler (1898-),
 II
Skene, Harold V. (1883-), II

Skinner, Charlotte Butler (1879-
), I
Skinner, Mary Dart (1859-), I
Slack, Erle B. (1892-), III
Slaughter, Mrs. John B. (1858-1947),
 III
Sleeth, L. MacDonald/MacD. (1864-
 1951), II
Sloan, Edna (-), II
Sloan, (James) Blanding (1886-),
 II
Sloan, John (1871-1951), I, II
Sloan, Lydia May/Mary (1890-),
 III
Slutz, Helen Beatrice (1886-), II
Small, Hazel (-), II
Small, Mrs. Robert E. (-1912),
 III
Smalley, Katherine (-), I
Smart, Edmund Hodgson (1873-
 1942), II
Smart, Emma (1862-1924), I
Smedley, William Thomas (1858-
 1920), I
Smellie, Robert (-ca 1908), II
Smeraldi, John D. (ca 1868-1947), III
Smet, Pierre-Jean, De (1801-1873), I
Smillie, George Henry (1840-1921), I
Smillie, James David (1833-1909), I
Smith, Annie (-), II
Smith, Camille (1892-), II
Smith, Charles L. A. (1871-1937), II
Smith, Clemie C. (-), III
Smith, Dan (1865-1934), I
Smith, David H. (1844-1904), I
Smith, De Cost (1864-1939), I
Smith, Dorman Henry (1892-1956), I
Smith, E. Bert (-), II
Smith, Edwin James (1899-), II
Smith, Elmer Boyd (1860-1943), II
Smith, Ernest Browning (1866-1951),
 II
Smith, Eugene Leslie (See: Smyth),
 III
Smith, F. Carl (1868-1955), I
Smith, Francis Drexel (1874-1956),
 I, III
Smith, Francis Hopkinson (1838-
 1915), I
Smith, Gean (1851-1928), I
Smith, George N. (-), III
Smith, George Washington (1876-
 1930), II

558

Smith, Gladys Nelson (1888-), III
Smith, Helen Stafford (1871-), I
Smith, Holmes (1863-1943), III
Smith, Houghton Cranford (1887-), III
Smith, Howard Everett (1885-1970), II
Smith, Irwin/Irvin Elwood (1893-), II
Smith, Isabel E. (1843?-1938), I
Smith, Jack Wilkinson (1873-1949), I, III
Smith, Jerome Howard (1861-1941), I
Smith, John Francis (-), II
Smith, Katharine Conley (1895-), III
Smith, Katharine English (1899-), II
Smith, Lillian B. (-), II
Smith, Lillian Wilhelm (1882-1971), II
Smith, Linus Burr/Barr (1899-), II
Smith, Margery Hoffman (1888-), II
Smith, Marie Vaughan (1892-), III
Smith, M. Lavinia Olin (1878-), III
Smith, Marietta Riggs (-), II
Smith, Paul Kauvar (1893-), II
Smith, Ralph Waldo (1877-), I
Smith, Russell (1812-1896), I
Smyth/Smith, Eugene Leslie (1857-1932), III
Smythe, William (1800-1877), I
Snider, Louise Bohl (1893-1955?), III
Snow, E. E. (-), II
Snyder, Amanda (1894-), III
Sohon, Gustavus (1825-1903), I
Somervell, W. Marbury (-), II
Sondag, Alphonse (1873-), III
Sonnichsen, Yngvar (1875-), I
Sooy, Louise Pinkney (1889-1965), II
Sorkner, E./Edgar Forkner? (1867-1945), II
Souder, Mary Rinard (1879-), II
Southworth, Frederick W. (1860-1946), II
Soutter, Louis J. (1871-1942), I, III

Spafard, Myra B. (-), II
Spalding, Elisabeth (ca 1869-1954), II
Spalding, Eliza Hart (1807-1851), I
Spang, Frederick A. (1834-1891), III
Sparks, Arthur Watson (1870-1919), I
Sparks, Will (1862-1937), I
Spaulding, Grace (See: John), I, II
Spencer, Guy Raymond (1878-1945), II
Spencer, Margaret Fulton (1882-), II
Spencer, Robert (1879-1931), I
Spens, Nathaniel (1838-1916), I
Spivak, H. David (1893-1932), I
Spohn, Clay Edgar (1898-), II
Sprague, Elizabeth (-), II
Sprague, Isaac (1811-1895), I
Sprague, Julia Frances (1826-1886), I
Spratt, Alberti Lamb (1893-1950), II
Sprenkle, Arthur George (1881-), II
Sprinchorn, Carl (1887-1971), III
Springer, Eva (1882-1964), I
Squires, C. Clyde (1883-1970), III
Squires, Harry (1850-1928), I
Squires, Lawrence (1887-1928), I
Squires, Warren (1886-1938), I
Sroufe, Susan E. (-), III
Stacey, Anna Lee (-1943), II
Stacey, John Franklin (1859-1941), II
Stackpole, Ralph (1885-1973), I
Stadter, Frank (See: Haradyniski), III
Stafford, Cora Elder (-), III
Stahl, Marie Louise (-), III
Stair, Ida M. (1857-1908), II
Staley, Willie Anna (ca 1865-), II
Stanley, Charles St. George (-), I, II
Stanley, George (-), I, II
Stanley, John Mix (1814-1872), I
Stansfield, John Heber (1878-1953), I
Stanson, George Curtin (See: Stojana), I, III
Stanton, John Aloysius (1857-1929), I, III
Stanton, Lucy May (1875-1931), II
Staples, Clayton Henri (1892-), I
Stark, Jack Gage (1882-1950), I, III
Starkey, Jo-Anita (1895-), II

559

Starr, Katharine Payne (1869–),
II
Starr, Nellie S. (1869–), III
States, Mignon T. (1883–), III
Stedman, Esther (–), III
Stedman, Wilfred Henry (1892–1950),
II
Steele, Albert Wilbur (1862–1925), II
Steele, Bess (–), III
Stegall, Irma Matthews (1888–),
I
Stein, Aaron (1835–1900), I
Steinegger, Henry (ca 1831–), I
Stell, Thomas M., Jr. (1898–),
III
Stellar, Hermine Josephine (–
1969), III
Stensen, Matthew Christopher (1870–
), II
Stephen, Jessie (1891–), III
Stephens, Clara Jane (–), II
Stephens, Richard (1892–), III
Stephenson, Estelle J. (ca 1885–
), III
Stephenson, Lee Robert (1895–),
III
Sterba, Antonin (1875–), II
Sterchi, Eda Elisabeth (1885–),
II
Sterling, Lewis Milton (1879–),
III
Sterne, Maurice (1877–1957), I
Sternfield, Edith Alice (1898–),
II
Stetcher, Karl (1831–1924), III
Stetson, Katherine Beecher (1885–
1979), II
Steuernagel, Hermann (1867–),
III
Stevens, Ernest (1872–1938), III
Stevens, Esther (1885–), II
Stevens, Helen B. (1878–), II
Stevens, Kelly Haygood (1896–),
II
Stevens, Lawrence Tenney (1896–
1972), II
Stevens, Ruth Tunander (1897–),
II
Stevens, Stanford (1897–1974), II
Stevens, Will Henry (1881–), II
Stevenson, Edna Bradley (1887–
), I

Stewart, Dorothy Newkirk (1891–
1955), II
Stewart, Harriet Gilrye Muir (–
), III
Stewart, Le Conte (1891–), I
Stewart, Worth (–), II
Stieffel, Hermann (1826–1886), I
Stillman, (H.) Ary (1891–1967), III
Stimson, John Ward (1850–1930), II
Stimson, Joseph E. (1870–1952), III
Stinchfield, Estelle (1878–1945), II
Stinson, Lucile S. (1898–), II
Stirling/Sterling, Dave (1889–1971), I
Stitt, Herbert D. (1880–), III
Stobie, Charles S. (1845–1931), I
Stockfleth, Julius (1857–1935), I, III
Stockton, Pansy (ca 1894–1972), II
Stoddard, Mary Catherine (1844–
), III
Stohr, Julie/Julia Collins (1894–),
III
Stojana, Gjura/George Curtin
Stanson (1885–), III
Stoll, John Theodor Edward (1889–
), I
Stone, Anna Belle (1874–1949), III
Stone, George Melville (1858–1931),
II
Stone, Viola Pratt (1872–1958), II
Stonier, Lucille Holderness (1886–
), I
Stoops, Herbert Morton (1888–1948),
I
Storm, Alfrida Anna (1896–), I
Story, Julian Russell (1857–1919), I
Stout, Ella J. (1877–), III
Stover, Allan James (1887–), II
Stowitts, Hubert J. (1892–), II
Strahaln, Frank (1879–1935), II
Strain, Frances (1898–1962), III
Strang, Ray C. (1893–1954), I
Strater, Henry (1896–), I, II
Straus, Meyer (1831–1905), I, III
Streator, Harold Arthur (1861–1926),
II
Streight, Howard (1836–1912), II
Strimple, Olga Marie Jorgensen
(1896–), III
Stringfield, Vivian F. (ca 1882–1933),
II
Strobel, Oscar (1891–1967), I, III
Strong, Elizabeth (1855–1941), I

Strong, Joseph Dwight, Jr. (1852–1899), I

Struck, Herman (1887–1954), I

Stuart, Ellen D. (-), III

Stuart, Frederick D. (ca 1816-), I

Stuart, Granville (1834–1918), III

Stuart, James Everett (1852–1941), I

Stuber, Dedrick Brandes (1878–1954), II

Sturgeon, Ruth Barnett (1883-), III

Sturges, Lee (1865-), I

Sturtevant, Joseph/J. Bevier (-), III

Sturtevant, Mrs. G. A. (-), III

Sully, Alfred (1820–1879), I

Sumbardo, Martha K. (1873–1961), III

Sumner, Donna L. (-), III

Sutter, (Walter) Samuel (1888-), II

Sutton, George Miksch (1898-), III

Suydam, Edward Howard (1885–1940), I

Svoboda, Josef Cestmir (1889-), II

Swain, Francis William (1892-), I

Swan, James Gilchrist (1818–1900), I, III

Swan, Paul (1899-), III

Swan, Walter Buckingham (1871-), I

Swartz, Harold C. (1887-), II

Swasey, William F. (-), I

Sweeney, Dan (1880–1958), I

Sweetser, C. K./Mrs. Albert R. (1862-), III

Swensen, Milton E. (1898-), III

Swett-Gray, Naomi (1889-), III

Swift, Florence Alston (1890-), II

Swift, John T. (1893–1938), III

Swing, David Carrick (1864–1945), I

Swink, Irene (-), III

Swinnerton, James (1875–1974), I

Sykes, John (1773–1858), I

Sylvester, Pamela Hammond (1874-), III

Symons, (George) Gardner (1861–1930), I, III

Taber, Phebe Thorn M. C. (1834-), III

Tabor, Robert Byron (1882-), I

Tack, Augustus Vincent (1870–1949), III

Tadama, Fokko (1871–1937), II

Taggart, George Henry (1865-), III

Tait, Agnes (McNulty) (1897-), II

Talberg, Carl H. (1882–1973), II

Talbot, Catherine (-), II

Taliaferro, John (1895-), III

Tallant, Richard D. (1853–1934), I

Tames, Ingabord (Ashby) (-), III

Tamotzu, Chuzo (1891–1975), II

Tanaka, Yasushi (1886-), II

Tanberg, Ella Hotelling (1862–1928), II

Tapp, Marjorie Dodge (1884-), II

Tappan, William Henry (1821–1907), I

Tasakos, Elsie Eyerdam (1889-), III

Tatum, Edward H. (1879-), II

Tauszky, David Anthony (1878-), II

Tavernier, Jules (1844–1889), I

Taylor, Bayard (1825–1878), I

Taylor, Edward De Witt (1871–1962), II

Taylor, Frederick T. (ca 1840–1927), I

Taylor, James Earl (1839–1901), I

Taylor, Mary (1895-), III

Taylor, Minnie C. (1865-), II

Taylor, Rolla S. (1874-), II

Taylor, Will Ladd (1854–1926), II

Teague, Donald (1897-), I, III

Teape, Nancy M. Miller (1864-), III

Teasdel/Teasdale, Mary (1863–1937), I

Teel, Louis Woods (1883-), III

Teesdale, Christopher Hugh (1886-), II

Teichert, Minerva Kohlheep (1889–1976), II

Teichmueller, Minette (1872-), I

Temple, C. M. (-), II

Terry, Eliphalet (1826–1896), II

Terry, Florence Beach (1880–),
III
Terry, John Coleman (1880-1934), II
Thayer, Emma Homan (1842-1908),
I, III
Theiss, John William (1863–), II
Theobald, R. C. (–), II
Thoma, Eva (–), II
Thomas, Alice Blair (–), II
Thomas, D. F. (–1924), II
Thomas, Grace Sullivan (–),
III
Thomas, Helen Haskell (–),
II
Thomas, Marian (1899–), II
Thomas, Marjorie Helen (1885-1978),
II
Thomas, Stephen Seymour (1868–
1956), I, II
Thomason, John William, Jr. (1893–
1944), I
Thompson, Hannah (1888–), II
Thompson, John Edward (1882–
1945), I
Thompson, Thomas Hiram (1876–
), II
Thomson, Adele Underwood (1882–
), II
Thomson, Rodney (1878–), III
Thomson, Tom John (1877-1917), III
Thorndike, Charles Jesse (1897–
), III
Thorndike, Willis Hale (1872-1940),
II
Throssel, Richard (ca 1881-1933), III
Thudicum, Roberta (See: Balfour), II
Thurston, Eugene B. (1896–), III
Thurston, Jane McDuffie (1887–
1967), II
Tibbles, Yosette La Flesche (1854–
1903), I
Tidball, John Caldwell (1825-1906), I
Tidden, John Clark (1889–), III
Tietjens, Marjorie Hilda (1895–),
II
Tiffany, Louis Comfort (1848-1933),
III
Tilghman, Stedman Richard (–
1848), III
Tillotson, Alexander (1897–), II
Tilton, Florence Ahlfeld (1894–),
III

Timmerman, Walter (–), II
Timmins, Harry L. (1887–), III
Timmons, Edward J. Finley (1882–
1960), II
Tindall, N. (–), I
Tingley, Blanche (–), II
Tirrell, John (ca 1826–), II
Titsworth, Ben D. (1898–), III
Titus, Mr. Aime Baxter (1883-1941),
II
Tobey, Mark (1890-1976), III
Tobie, Frances Jurgens (1874–),
III
Tobriner, Haidee (1879–), II
Todhunter, Francis A. (1884-1962), I
Toeplitz, Charlotte V. (1892–), II
Tofft, Peter (1825-1901), I
Tojetti, Domenico (1817-1892), I
Tojetti, Edouardo (1852-1930), I
Tokita, Kamekichi (1897-1948), II
Toler, Mary M. (1897–), III
Toler, William Pinkney (1825-1899),
III
Tolman, Ruel Pardee (1878-1954), II
Tomlinson, Henry (1875–), III
Tompkins, Florence Johnson (1883–
), I
Tompsett, Ruth R. (1889–), III
Tonk, Ernest (1889–), I
Tonkin, Linley Munson (1877-1932),
III
Topschevsky, Morris (1899-1950?),
III
Torrey, Elliot Bouton (1867-1949), I
Towne, C. F. (ca 1834-1917?), III
Towner, Miss Xaripa (–), II
Townsend, Frances (1863–), III
Townsley, Channel Pickering (1867–
1921), II
Tracy, John M. (1844–), I, III
Trano, Clarence E. (1895-1958), III
Tranquillitsky, Vasily G. (1888–),
II
Traver, (Charles) Warde (1880–),
II
Travis, Diane (1892–), II
Travis, Kathryne Hail (1894-1972), II
Travis, Olin Herman (1888-1975), I,
II
Trease, Sherman (1889-1941), II
Treidler/Triedler, Adolph (–),
II

563

Van Veen, Pieter (1875–), I, III
Van Vleck, Durbin (–), I
Van Waganen, Margaret S. (–), III
Van Wie, Carrie (1880–1947), III
Van Zandt, Hilda (1892–1965), II
Varda, Jean (1893–1971), III
Varian, Lester E. (1881–1967), I
Vaudricourt, Augustus de (–), I
Vaughan, David Alfred (1891–), III
Vavra, Frank J. (1898–1967), I
Vernon, Della (Craig) (1876–1962), III
Vesely, Godfrey Francis (1886–), III
Vickers, Bess Jarrott (–), III
Vierra, Carlos (1876–1937), I
Vik, Della Blanche (1889–), II
Villa, Hernando Gonzallo (1881–1952), I, III
Villeneuve, Nicholas C. (1883–), III
Villiers, Frederick (1852–1922), I
Vinatieri, Frank Villiet (1891–1965), II
Vincent, Andrew McDuffie/McD. (1898–), II
Viojet, Jean Jacques (1799–1855), I
Visher, Edward (1809–1879), I
Vitousek, Juanita Judy (1892–), I
Vivian, Calthea Campbell (1857–1943), II
Vogel, Elmer Henry (1898–), II
Voigt, Edna (1895–), III
Voisin, Adrien (1890–), III
Volck, Frances/Fannie (–), II
Vollmer, Grace Libby (1884–1977), I
Von der Lancken, Francis/Frank (1872–1950), II
Von Eichman, Bernard J. (1899–1970), III
Von Hassler, Carl (1887–1969), II
Von Langsdorff, Georg H. (See: Langsdorff), I
Von Leurzer, Feodor (1851–1913), III
Von Perbandt, Carl (1832–1911), I, III
Von Schmidt, Harold (1893–), I

Von Schneidau, Christian C. (1893–1976), II
Voss, Nellie Cleveland (1871–1963), II
Vreeland, Francis William (1879–1954), II
Vysekal, Edouard Antonin (1890–1939), II
Vysekal, Luvena Buchanan (–1954), II
Wachtel, Elmer (1864–1929), I
Wachtel, Marion Kavanaugh (1875–1954), I
Wack, Henry Wellington (1867–1954?), III
Wade, Murray (1876–), III
Wadsworth, W. (–), I
Wadsworth, Wedworth (1846–1927), III
Wagenhals, Katherine H. (1883–), II
Waggoner, Elizabeth (–), II
Wagner, Blanche Collet (1873–1957), II
Wagner, Rob/R. L. (1872–1942), I
Wagoner, Harry B. (1889–1950), II
Waldo, Eugene Loren (1870–), I
Walker, J. Edward (–), III
Walker, James (1819–1889), I
Walker, John Law (1899–), II
Walker, Lissa/Lissie Bell (–), III
Walker, Stuart (1888–1940), III
Walker, William A. (1838–1921), I
Walkinshaw, Jeanie Walter (1885–), III
Walkowitz, Abraham (1880–1965), III
Wall, Bernardt (1872–1956), II
Wall, Gertrude Rupel (1881–1971), II
Wallace, John Laurie (1864–1953), II
Wallace, Lew/Lewis (1827–1905), I
Walsh, John Philip (1876–), III
Walsh, Margaret M. (1892–), III
Walter, Jeanie (See: Walkinshaw), III
Walter, Solly H. (1846–1900), II
Walter, Valyne G./V.G. (1898–), II
Walters, Carl Albert (1883–1955), II
Walters, Emile (1893–), I, III
Walton, Henry (1820–1873), I
Wandesforde, Juan Buckingham (1817–1902), I

Wanek, Vesta Blanch Jelinek (1872–
), III
Wanker, Maude Walling (1882–),
I
Ward, E. Grace (1877–), III
Ward, Frank (1879–), III
Ward, Harold Morse (1889–1973), II
Ward, J. Stephen (1876–), II
Ward, Jean S. (1868–), II
Ward, Lily A. (–), III
Ward, Louisa Cooke (1888–), III
Ward, Mrs. Heber Arden (–
), III
Ward, William (1827–1893), III
Wardin, Frances Mitchell (1888–
), II
Ware, Florence Ellen (1891–1972),
I, III
Warhanic, Elizabeth C. (1880–),
II
Warner, Everett Longley (1877–
1963), III
Warner, Gertrude Palmer (1890–
1981), III
Warner, Nell Walker (1891–1970), I
Warner, William R. (ca 1885–1947),
II
Warnock, Sada (1882–), III
Warre, Henry James (1819–1898), I
Warren, Ella (–), III
Warshawsky, Abel George (1883–
1962), I
Warshawsky, Alexander (1887–),
II
Washburn, Cadwallader L. (1866–
1965), III
Washburn, Max Murray (1888–),
II
Waterbury, Laura Prather (–
), II
Waterman, Myron A. (1855–1937), II
Watkins, Catherine W. (–),
II
Watkins, Susan (1875–1913), II
Watrous, Harry Willson (1857–1940),
I
Watrous, Hazel (–), III
Watrous, Mary E. (–), II
Watson, Adele (1873–1947), II
Watson, Jesse Nelson (1870–), II
Watts, Beulah (ca 1873–1941), III
Watts, Eva A. (1862–), II

Watts, William Clothier (1864–1961),
II
Waud, Alfred R. (1828–1891), I
Waynick, Lynne Carlyle (1891–),
III
Weaver, Buck (1888–), I
Weaver, Inez Belva Honeycutt
(1872–), III
Webb, Edith (1877–1959), II
Webb, Margaret Ely (1877–1965), II
Webb, Vonna Owings (1876–1964), I
Webber, John E. (1752–1793), I
Weedell, Hazel Elizabeth (1892–),
II
Weeks, Isabelle May Little (1851–
1907), II
Weggeland, Danquart Anthon (1827–
1918), I
Weiler, Louis (1893–), III
Weinberg, Emilie Sievert (1882–
1958), II
Weiner, Abraham S. (1897–), III
Weiner, Louis (1892–), III
Weir, Dorothy (Young) (1890–1947),
III
Weisser, Leonie Oelkers (1890–),
I
Welch, Ludmilla (1867/76–), I
Welch, Thaddeus (1844–1919), I
Wells, Anna M. (–), III
Wells, Lucy D. (1881–), I, III
Wenck, Paul (1892–), I
Wenderoth, August Frederick (1825–
), I
Wendt, Julia Bracken (1871–1942), I
Wendt, William (1865–1946), I
Wentz, Henry Frederick (1876–1965),
II
Werner, Fritz (1898–), II
Werntz, Carl N. (1874–1944), I
Wescott, Sue May (See: Gill), III
Wesselhoeft, Mary Fraser (1873–
), II
Wessels, Glenn Anthony (1895–),
II
West, Benjamin Franklin (1818–
1854), II
West, Isabel Percy (See: Percy), I, III
West, Virgil William (1893–1955), I
Westfall, Tulita Bennett (1894–1962),
II
Weston, Mrs. Otheto (1895–), II

Westrum, Anni von (See: Baldaugh), II
Weygold, Frederick P. (1870-1941), I
Weyss, John E. (1820-1903), I
Whedon, Harriet Fielding (ca 1888-1958), III
Wheelan, Albertine Randall (1863-1954), II
Wheeler, Janet D. (-1945), II
Wheeler, Martha M. (-), III
Wheeler, Mary Cecil/Cecilia (-), III
Wheelock, Warren Frank (1880-1960), II
Wheelon, Homer (1888-), III
Wheete, Glenn (1884-), II
Wheete, Treeva (1890-), II
Whelan/Whelen, Blanche (-), III
Whetsel, Gertrude P. (1886-), II
Whitaker, Frederic (1891-1980), II
Whitcraft, Dorothea Fricke (1899-), II
White, Carrie Harper (1875-), III
White, Edith (1855-1946), II
White, Inez Mary Platfoot (1889-), II
White, Jessie Aline (1889-), II
White, Minerva (1878-), III
White, Nona L. (1859-1937), I
White, Orrin Augustine (1883-1969), I
White, Verner (1863-1923), III
Whiteham, (Edna) May (1887-), II
Whiteley, Rose (-), II
Whiteside, Frank Reed (1866-1929), I
Whitlock, Frances Jeannette (1870-), II
Whitlock, Mary Ursula (1860-1944), II
Whitman, Paul (1897-1950), II
Whittemore, Frances Davis (1857-1951), II
Whittemore, Margaret Evelyn (1897-), II
Whitten, Andrew T. (1878-), III
Whittredge, Worthington (1820-1910), I
Whymper, Frederick (1838-), I, III

Wiberg, Fritjof (-), II
Wiboltt, Aage Christian [Jack] (1894-), II
Wickes/Wicks, Ethel Marian (1872-1940), III
Wickson, Guest (-), III
Wideman, Florence P. (1893-), II
Widforss, Gunnar Mauritz (1879-1934), I
Wieczorek, Max (1863-1955), I
Wieghorst, Olaf (1899-), I
Wier, Mattie (-), III
Wiggins, Myra Albert (1869-1956), I, III
Wikstrom, John (-), III
Wilcocks, Edna Marrett (1887-), II
Wilcox, Frank N. (1887-1964), II
Wildhack, Robert J. (1881-1940), II
Wildman, Caroline Lax (-1949), III
Wildman, Mary Frances (1899-), III
Wiles, Lemuel Maynard (1826-1905), I
Wiley, Nan K. (1899-), III
Wilford, Loran Frederick (1892-1972), II
Wilimovsky, Charles A. (1885-), III
Wilke, William Hancock (1880-), I, III
Wilkin, Mildred Pierce (1896-), II
Wilkins, James F. (ca 1808-1888), I
Wilkinson, Edward (1889-), II
Will, Blanca (1881-), III
Willard, Frank Henry (1893-1958), II
Willard, Howard W. (1894-1960), II
Willard, Miss L. L. (1839-), II
Willey, Edith Maring (1891-), II
Williams, Clifton (1885-), II
Williams, Frederick Ballard (1871-1956), III
Williams, Jim/James Robert (1888-1957), I
Williams, John Caner (ca 1814-), II
Williams, J(ohn) Scott (1877-1975), II
Williams, Lawrence Pickett (1899-1927/30?), II
Williams, Louise Houston (1883-), II

Williams, Nick (1877-), III
Williams, Reed (-), III
Williams, Virgil Macey (1830-1886), I
Williamson, Clara McDonald (1875-
 1976), II
Williamson, John (1826-1885), III
Williamson, Paul Broadwell (1895-
), III
Williamson, Shirley (-), II
Willis, J. R. (1876-), II
Willis, Katherine (-), II
Willis, Ralph Troth (1876-), II
Willits, Alice (1885-), II
Willmarth, Kenneth L. (1889-),
 III
Willmarth, William (1898-), II
Willoughby, Sarah Cheney (1841-
 1913), III
Wills, Mary Motz/Matz (-),
 III
Wills, Olive (ca 1890-1940s), III
Wilson, Charles Theller (1855-1920),
 II
Wilson, Donna A. (-), II
Wilson, Floyd (1887-), II
Wilson, Hazel Marie (1899-), II
Wilson, Helen (1884-), II
Wilson, J. R. (1865-1966), III
Wilson, Jeremy (1824-1899), II
Wilson, John (1832?-1870), III
Wilson, William J. (1884-), II
Wilwerding, Walter Joseph (1891-
 1966), I
Wimar, Charles (1828-1862), I
Winchell, Ward (-), II
Winebrenner, Harry Fielding (1885-
 1969), II
Wing, Leota McNemar (1882-),
 III
Winkler, John W. (1890-1979), I, III
Winter, Charles Allan (1869-1942),
 III
Winterburn, George T. (-),
 II
Winterburn, Phyllis (1898-), II
Wintermote, Mamie W. (1885-),
 II
Wire, Bess B. (-), III
Wire, Melville Thomas (1877-),
 III
Wirth, Anna Maria Barbara (1868-
 1939?), II
Wisby, Jack (1870-1940), I

Wise, James (-), III
Wiser, Guy Brown (1895-), II
Wishaar, Grace N. (1879-), III
Wissenbach, Charles (1887-), III
Wissler, Brownie (1890-), III
Wiswall, Etna West (1898-), III
Withrow, Eva/Evelyn Almond (1858-
 1928), I
Wittie, Ella C. (-), III
Wix, Otto (-), III
Wolf, Hamilton (Achille) (1883-1967),
 II
Wolle, Muriel Sibell (1898-1977), I
Wood, A. M. (-), I, III
Wood, Annie A. (See: Nan S. Wood),
 II, III
Wood, Charles Erskine Scott (1852-
 1944), II
Wood, E. Shotwell (See: Goeller-
 Wood), II
Wood, Grant (1892-1942), III
Wood, Hettie William (-),
 III
Wood, Katheryn Leon (1885-1934), II
Wood, Madge McAllister (-
), II
Wood, Mrs. Norman E. (1880-),
 III
Wood, Nan S. (1874-1961), III
Wood, Robert (1889-1979), III
Wood, Stanley Huber (1890-1970), I
Wood, Stanley L. (1866-1928), I
Woodall, Eva (-1915), III
Woodman, Selden/Shelden J. (-
), III
Woodruff, Julia S. (-), III
Woodson, Marie L. (1875-), II
Woodville, Richard Caton, Jr. (1856-
 1927), I
Woodward, William (1859-1939), III
Woollett, William Lee (-), II
Woolley, Virginia (1884-1971), II
Woolsey, Wood W. (1899-), II
Wores, Theodore (1859-1939), I
Works, Katherine S. (1888-), II
Works, Maud/Maude Estelle (1888-
), III
Worrall, Henry (1825-1902), I
Worthington, Mary E. (-),
 II
Wostry, Carlo (1865-1930), I
Woy, Leota (1868-), II
Wragg, Eleanor T. (-), II

Wray, Henry Russell (1864-1927),
I, III
Wright, Mr. Alma Brockerman
(1875-1952), I
Wright, Charlotte Ingram (1899-
1981), III
Wright, Gladys Yoakum (-),
III
Wright, Harriet Freeman (-
), III
Wright, James Garfield (1881-),
II
Wright, Jennie E. (-), II
Wright, Stanton MacDonald (See:
MacDonald), I
Wright, Thomas Jefferson (1798-
1846), I
Wueste, Louise Heuser (1803-1875), I
Wurtele/Wurtelo, Isobel Keil
(1885-1963), III
Wyant, Alexander Helwig (1836-
1892), I, III
Wulff, Timothy Milton (1890-),
II
Wyatt, A. C. (-1933), II
Wyeth, Newell Convers (1882-1945),
I, III
Wyttenbach, Emanuel (-1903),
II
Xantus, Janos (1825-1894), III
Yamagishi, Teizo (1898-), III
Yampolsky, Oscar (ca 1892-1944), III
Yarbrough, Vivian Sloan (1893-),
III
Yard, Sydney J. (1855-1909), I
Yardley, Ralph O. (1878-), II
Yates, Frederick (1854-1919), I
Yates, Mrs. E. R. (1888-1958), III
Yeager, Walter (1852-1896), I
Yelland, Raymond Dabb (1848-1900),
I
Yens, Carl Julius Heinrich
(1868-1945), I, III
Yoakum, Joseph (1886-1973), III
Yont, Lily (-), III
Yoshida, Hiroshi (1876-1950), III

Yost, Frederick J. (1888-1968), III
Young, Aretta (1864-1923), I
Young, Dorothy Weir (See: Weir), III
Young, Ellsworth (1866-), III
Young, Florence (1872-), I
Young, Frank Herman (1888-1964),
II
Young, Harvey Otis (1840-1901), I
Young, John J. (1830-1879), I
Young, Mahonri (1877-1957), I
Young, Mattie/Myrtle M. (1876-
), II
Young, Phineas (1847-1868), I
Young-Hunter, John (1874-1955), I
Young-Hunter, Mary (ca 1872-1947),
III
Younkin, William LeFevre (1885-
), II
Yphantis, George (1899-), II
Zakheim, Bernard Baruch (1898-
), II
Zallinger, Franz (1894-), III
Zane, Nowland Brittin (1885-),
III
Zetterlund, John (-), II
Ziegler, Eustace Paul (1881-1969), I
Ziegler, Henry (1889-), I
Ziegler, Samuel P. (1882-1967), II
Zillig, Fritz (-), III
Zilverberg, Jake (1886-), II
Zilzer, Mr. Gyula (1898-1969), III
Zim, Marco (1880-), II
Zimbeaux, Frank Ignatius (1861-
1935), I
Zimmerer, Frank J. (1882-), III
Zimmerman, Ella A. (-), I
Zimmerman, Frederick Almond
(1886-1974), II
Zogbaum, Rufus Fairchild (1849-
1925), I
Zorach, Marguerite Thompson (1887-
1968), II
Zorach, William (1887-1966), III
Zsissly (See: Malvin Marr Albright),
III
Zwara, John (1880-), III